BACHELOR JAPANISTS

Modernist Latitudes

Modernist Latitudes

Jessica Berman and Paul Saint-Amour, Editors

Modernist Latitudes aims to capture the energy and ferment of modernist studies by continuing to open up the range of forms, locations, temporalities, and theoretical approaches encompassed by the field. The series celebrates the growing latitude ("scope for freedom of action or thought") that this broadening affords scholars of modernism, whether they are investigating little-known works or revisiting canonical ones. Modernist Latitudes will pay particular attention to the texts and contexts of those latitudes (Africa, Latin America, Australia, Asia, Southern Europe, and even the rural United States) that have long been misrecognized as ancillary to the canonical modernisms of the global North.

Barry McCrea, *In the Company of Strangers: Family and Narrative in Dickens, Conan Doyle, Joyce, and Proust*, 2011

Jessica Berman, *Modernist Commitments: Ethics, Politics, and Transnational Modernism*, 2011

Jennifer Scappettone, *Killing the Moonlight: Modernism in Venice*, 2014

Nico Israel, *Spirals: The Whirled Image in Twentieth-Century Literature and Art*, 2015

Carrie Noland, *Voices of Negritude in Modernist Print: Aesthetic Subjectivity, Diaspora, and the Lyric Regime*, 2015

Susan Stanford Friedman, *Planetary Modernisms: Provocations on Modernity Across Time*, 2015

Steven S. Lee, *The Ethnic Avant-Garde: Minority Cultures and World Revolution*, 2015

Thomas S. Davis, *The Extinct Scene: Late Modernism and Everyday Life*, 2016

Carrie J. Preston, *Learning to Kneel: Noh, Modernism, and Journeys in Teaching*, 2016

Gayle Rogers, *Incomparable Empires: Modernism and the Translation of Spanish and American Literature*, 2016

Donal Harris, *On Company Time: American Modernism in the Big Magazines*, 2016

Celia Marshik, *At the Mercy of Their Clothes: Modernism, the Middlebrow, and British Garment Culture*, 2016

CHRISTOPHER REED

BACHELOR JAPANISTS

JAPANESE AESTHETICS AND WESTERN MASCULINITIES

COLUMBIA UNIVERSITY PRESS NEW YORK

COLUMBIA UNIVERSITY PRESS
PUBLISHERS SINCE 1893
NEW YORK CHICHESTER, WEST SUSSEX

cup.columbia.edu

Library of Congress Cataloging-in-Publication Data
Names: Reed, Christopher, 1961– author.
Title: Bachelor Japanists : Japanese aesthetics and Western masculinities /
 Christopher Reed.
Description: New York : Columbia University Press, [2016] | Series: Modernist
 latitudes | Includes bibliographical references and index.
Identifiers: LCCN 2016026230 | ISBN 9780231175746 (cloth : acid-free paper) |
 ISBN 9780231175753 (pbk. : acid-free paper) | ISBN 9780231542760 (e-book)
Subjects: LCSH: Aesthetics, Japanese. | East and West. | Masculinity in art.
 | Masculinity in literature. | Queer theory.
Classification: LCC BH221.J3 R44 2016 | DDC 111/.8509—dc23
LC record available at https://lccn.loc.gov/2016026230

Columbia University Press books are printed on permanent and durable acid-free paper.
Printed in the United States of America

Cover Design: Lisa Hamm
Cover Image: © The Metropolitan Museum of Art. Art Resource, NY

CONTENTS

A NOTE ON NAMES AND TERMS

To avoid intrusive anachronism, my approach to rendering Japanese terms and names is consistently inconsistent. For the order of family and given names, I have followed my sources, adopting whatever practice seems standard in reference to the person in question. In cases that might seem ambiguous, I follow common library practice in underlining the first letter of the family name at first instance; thus, Osamu Noguchi and Okakura Kakuzo. Similarly, rather than consistently imposing a current specialist orthography for commonly used terms in my older Western sources, such as Noh, I maintain the older romanization.

ACKNOWLEDGMENTS

"IT WOULD PROBABLY NOT BE WORTH THE TROUBLE OF making books if they failed to teach the author something he had not known before, if they did not lead to unforeseen places, and if they did not disperse one toward a strange and new relation with himself. The pain and pleasure of the book is to be an experience." Those are Foucault's words (from the preface to the second volume of *The History of Sexuality*). I certainly learned a great deal in the process of researching and writing this wide-ranging book. And I was fortunate that any pains were vastly outweighed by the pleasures of constructing this study of eccentricity (more on that term in the last chapter), the thesis of which, I have sometimes joked, is "You're never gonna believe this next part."

I have many people to thank, undoubtedly first my family—parents, grandparents, aunt, brother, husband—all of whom are or were connoisseurs of eccentricity in themselves and others. In a contemporary culture that often seems to me hell-bent on conformity, I am very fortunate in my relations.

This book also has an origin in the introductory Japanese classes taught by Akiko Hirota (who will always be "Hirota-sensei" to me), which over thirty years ago enthralled me, along with any number of undergraduates at Amherst College, with an idea of Japan as both fascinatingly bizarre and warmly familiar. She was among many of my wonderful teachers.

I also want to thank the scholars specializing in the study of Japan, starting with Laura Hein at Northwestern University who welcomed a wandering modernist into the outer reaches of their field. The collegiality of this cohort has been an important impetus to this study, and I am grateful for the encouragement and advice of Jon Abel, Heather Bowen-Struyk, and Carrie Preston, among others. I am grateful, too, for the input and encouragement of my new colleagues at Penn State, whose brilliance and breadth of knowledge continue to amaze me, and who have encouraged my interdisciplinary explorations: Michael Bérubé, Tina Chen, Eric Hayot, Janet Lyon, Anne McCarthy, and especially Robert Caserio, who has changed my life in many ways.

I benefitted in very tangible ways from a number of individuals and institutions, starting with a series of provosts at Lake Forest College: Janet McCracken, Rand Smith, and the late, lamented Steve Galovich, who somehow suspected something would come of it when he sent me to Japan for the first time. I am grateful, too, to my department heads at Penn State, Robin Schulze, Mark Morrisson, and Bob Burkholder, for supporting this project and for easing a professional transition into cultural and visual studies. For their support of time and other resources, I also thank the Institute for the Arts and Humanities and the College of Liberal Arts, especially Associate Dean Eric Silver, at Penn State. And I am grateful to the Massachusetts Historical Society, the Georgia O'Keeffe Research Center, and the Clark Art Institute for residential grants that enabled research and writing for this project.

Residential research fellowships are as good as the colleagues you share them with—and mine were wonderful. Libby Bischof, Jonathan Walz, Jonathan Weinberg, Claire Bishop, John Pfeffer, Mark Reinhardt, Lisa Salzman, and Beat Wyss: thanks to all of you for exemplifying the invigorating potential of scholarly community.

No researcher can ever adequately thank the librarians and archive managers who offered resources and encouragement in otherwise often solitary settings. I am especially grateful to Cory Stevens at Lake Forest, Karen Bucky at the Clark, and Madame Colette Cortet at Musée Le Vergeur.

Many other friends and colleagues offered practical help, references, and resources along the way. A partial list includes Margie Beal, Emily Brink, Alan Chong, André Dumbrowski, Matthew Kangas, Ukiko Kato-Ueji, Judith S. Kays, Jongwoo Kim, Carolyn Lucarelli, Joseph Michels, Alan Scott Pate, Joyce Robinson, Christopher Shirley, Willa Silverman, Julian Stair, Rebecca Walkowitz, Pamela Warner, and Steven Watson.

The readers of Columbia University Press (you know who you are) offered supportive but very incisive and detailed criticisms of drafts of this text, which resulted in a much better final product. I also want to thank Jessica Berman and Paul Saint-Amour for including this book in the Modernist Latitudes series, as well as Senior Editor Philip Leventhal, Editorial Assistant Miriam Grossman, and Ben Kolstad and Kara Stahl, all of whom worked thoughtfully to rescue this project from various author-induced crises.

My two most faithful and loving readers are Chris and Mary Kay. This is for them.

BACHELOR JAPANISTS

INTRODUCTION

The whole of Japan is a pure invention. There is no such country, there are no such people. . . . The Japanese people are, as I have said, simply a mode of style, an exquisite fancy of art.
—Oscar Wilde

If I want to imagine a fictive nation, . . . I can . . . isolate somewhere in the world (*faraway*) a certain number of features . . . and out of these features deliberately form a system. It is this system which I shall call: Japan.
—Roland Barthes

BACHELOR JAPANISTS

These two strikingly similar assertions by prominent European writers bracket the time period covered in this book. Oscar Wilde's observation, published in 1889, capped the first phase of Japanism[1] in the West, which began in the 1860s, following the collapse of Japan's near-total restrictions on foreign trade and travel. Wilde's statement comes in "The Decay of Lying," his manifesto for creative, rather than mimetic, art. Alluding to a recent exhibition of Mortimer Menpes's paintings of Japan, Wilde complained, "One of our most charming painters went recently to the Land of the Chrysanthemum in the foolish hope of seeing the Japanese. All he saw, all he had the chance of painting, were a few lanterns and some fans" (figure 1.1).

For Wilde, Menpes's failure to find Japaneseness in Japan was a matter of style. Menpes's popular, conventionally picturesque paintings, drawings, and prints depict props that signified Japan in the West. But they are not

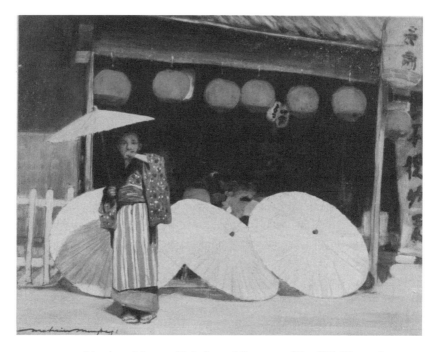

FIGURE 1.1. Mortimer Menpes, *Umbrellas and Commerce*, 1887–1888. Watercolor, as reproduced in *Japan: A Record in Color by Mortimer Menpes* (1901).

Japanese. The Japanese, said Wilde, are "a mode of style, an exquisite fancy of art." Citing Hokusai and Hokkei, Wilde asserted, "The Japanese people are the deliberate self-conscious creation of certain individual artists." Japanese-ness, located in art, no longer requires Japan. Wilde concluded,

> And so, if you desire to see a Japanese effect, you will not behave like a tourist and go to Tokio. On the contrary, you will stay home, and steep yourself in the work of certain Japanese artists, and then, when you have absorbed the spirit of their style and caught their imaginative manner of vision, you will go some afternoon and sit in the Park or stroll down Piccadilly, and if you cannot see an absolutely Japanese effect there, you will not see it anywhere.[2]

A similar emphasis on perception and self-invention animates *Empire of Signs*, Roland Barthes's collection of essays occasioned by his three trips to Japan in 1966 and 1967. A tumultuous century after Western voyagers began

filling library shelves with travel memoirs claiming authentic insight into the culture of Japan, Barthes announced, "I am not lovingly gazing toward an Oriental essence—to me the Orient is a matter of indifference, merely providing a reserve of features whose manipulation—whose invented interplay— allows me to 'entertain' the idea of an unheard-of symbolic system, one altogether detached from our own." The lesson of Japan for Barthes was "the possibility of difference, of a mutation, of a revolution in the propriety of symbolic systems."

Like Wilde, Barthes does not locate Japaneseness in a place called Japan. But if for Wilde Japaneseness offered a new way of seeing, for Barthes, more complexly, Japan offered a new way of seeing himself being seen, which resulted in a new relationship to language. About himself, Barthes wrote, "The author has never, in any sense, photographed Japan. Rather, he has done the opposite: Japan has starred him with any number of 'flashes'; or better still, Japan has afforded him a situation of writing." Japan allowed Barthes to "descend into the untranslatable . . . until everything Occidental in us totters and the rights of the 'father tongue' vacillate—that tongue which comes to us from our fathers and which makes us, in our turn, fathers and proprietors of a culture which, precisely, history transforms into 'nature.'"[3] Barthes's growing sense of the "*repressive* value" of text as the "level" at which "the morality and ideology of a society are above all invested" animated his delight in a Japanese "situation" that allowed freedoms he associated with images to trump the authority of text in the West.[4] Reflecting later on this book about the "system of signs I call Japan," Barthes emphasized that it "occupied a moment in my life when I felt the necessity of entering completely into the signifier, i.e., of disconnecting myself from the ideological instance as signified, as the risk of the return of the signified, of theology, monologism, of law." Japan, said Barthes, manifests "a partial but indisputable superiority over our Western societies, where the liberation of the signifier has been hampered for more than two thousand years by the development of monotheism and its hypostases ('Science,' 'Man,' 'Reason')." Linking the "fundamental absence of monotheism" to what he saw as the free play of signifiers in Japan, Barthes credited his experience in Japan with turning him toward a "novelistic" prose that flouted the conventions of authoritative articulation he associated with Western religions.[5] Scholars characterize Barthes's shift as his escape from an authorial identity associated with bitter critiques of French culture in favor of a movement in which "his work turned toward himself as perceiving subject of a world increasingly apprehended as

the cultural space of erotic (tacitly homosexual) desire."[6] "Here [in Japan]," Barthes wrote, "I am protected against stupidity, vulgarity, vanity, worldliness, nationality, normality."[7]

For both Barthes and Wilde, Japan was not a destination, and seeing—or being seen in—Japan was not a way of adding incrementally to knowledge about the world. Rather, Japan allowed the unlearning—ignoring or subverting—of authoritative "truths" in one's home culture, creating a point of departure in an act of self-invention. What Barthes says of haiku goes for Japan as a whole: "You are entitled, says the haiku . . . you yourself (and starting from yourself) to establish your own notability."[8]

Barthes and Wilde shared more than this idea of Japan as a mode of self-invention. Their writings are often linked in histories of criticism,[9] and it is tempting to relate their fundamentally allied viewpoints to their shared status as sexual outsiders, alienated from the norms of their culture—from the idea of normality itself—by their erotic attraction to other men. Both were what might be called, following trends in scholarship and popular culture, queer, a term intended to supplant the overspecificity of both the pathological category homosexual and its upbeat, politically progressive recasting as gay by including a range of identities associated with rejection of or exclusion from conventions of monogamous heterosexuality.[10] But the confrontational post-gay politics associated with this use of queer fit awkwardly when retroactively applied to Wilde and Barthes—or to the other figures taken up in this study of the century, roughly 1860 to 1960, of Japanism's efflorescence. I turn instead, therefore, to the term bachelor.

Positive connotations associated with knighthood and education bolstered the status of bachelors until the nineteenth century, when the term took on troubling connotations of deviance from bourgeois family norms.[11] Its implications were ambiguous: "bachelor life" implied a heterosexual excess that deviated from propriety differently than the connotations of the phrase "confirmed bachelor" suggested. For this book, that ambiguity is useful for designating a category capacious enough to include the Parisians Henri Cernuschi and Edmond de Goncourt, personifications, in chapter 1, of the "bachelor life" and the "confirmed bachelor," respectively; the late-marrying or early-widowed Bostonians (yes, some of my bachelors are women) from chapter 2; and the more obviously—which is not to say openly—homosexual men taken up in chapter 3.

This is not simply a rhetorical convenience. The usefulness of the term bachelor registers social patterns in the period before the general acceptance

of medical notions of sexual identity in the second half of the twentieth century.[12] *Bachelor*, then, does not stand in for *homosexual* or *gay* the way unnuanced deployments of *queer* often do. Not to be coy about definitions, some of my bachelor Japanists, had they come of age later, undoubtedly would have identified—or been identified by others—as homosexual or gay. But they did not, and some would not, and their range of experience and expression was neither enabled by the solidarity attached to affirmations of sexual identity nor limited by its definitional boundaries. Uniting and defining bachelors as an identity category was less a positive attraction to a sensibility or "lifestyle" associated with eroticism between men and more a shared alienation from powerful cultural imperatives during the century historians call "the era of mandatory marriage."[13] In retrospect, therefore, the extravagant performances of bachelor Japanism explored in this book constitute a pre-history, not of the medical category *homosexual*, but of certain ideas and practices related to, but exceeding, that identity. In the context of the figures in this study, Wilde, who was both a husband and a father, qualifies among the more heteronormative Japanophiles. What these bachelor Japanists had in common was a life experience that provoked them to learn—in contradistinction to what they were authoritatively taught—that conventions are neither immutable nor inevitable, neither natural nor right.

QUEER AND AWAY: THREE CASE STUDIES

If conventions are a matter of art in its most basic sense of artifice—the product of human creation, what Wilde calls *style* and Barthes calls *signs*—one of the most compelling proofs of this contingency is another culture with different conventions. Nonconformists of all kinds have looked to cultures distant in time or place to forge identities that resist the pejorative terms of their own culture by imagining allegiance elsewhere. Such imagined allegiances play out particularly strongly in relation to sexuality, where deviance strains or ruptures home ties with parents, siblings, and childhood communities. Jonathan Dollimore argues, "For homosexuals more than most, the search for sexual freedom in the realm of the foreign has been inseparable from a repudiation of the 'Western' culture responsible for their repression and oppression," linking this dynamic to Barthes's ideal "that the subject may know without remorse, without repression, the bliss of having at his disposal

two kinds of language; that he may speak this or that, according to his perversions, not according to the Law."[14]

Although I reject the term *queer* to describe the bachelors in this study, as this invocation of Dollimore shows, my book draws on a scholarly tradition designated as "queer theory" to offer new perspectives on Japanism. From Dollimore's argument twenty-five years ago that "what we learn" from Barthes and Wilde, among others, is that "deviant desire brings with it a different kind of political knowledge" of cultural difference, to Michael Warner's more recent theorization of a "stigmaphile world" in which "we find a commonality with those who suffer from stigma and in this alternative space learn to value the very things the rest of the world despises," queer theorists have explicated and encouraged important but often overlooked or reviled imbrications of sexual nonconformity with forms of difference understood as geographic and/or racial.[15] This topic—even narrowed down to Japanism, and further to bachelor Japanism—is too vast for a comprehensive overview. Any illusion of comprehensiveness, moreover, would undercut the appreciation of diversity this investigation of dissent from normativity seeks to subtend. What follows, therefore, are three case studies of bachelor Japanism in particular times and places: late nineteenth-century Paris, turn-of-the-century Boston, and mid-twentieth-century Seattle.

Chapter 1, on Paris, explores *japonisme*'s role in the formation of ideologies of avant-gardism and influence—key concepts in modernism's self-understanding. This focus uncovers the high stakes embedded in debates over who in the West first "discovered" Japanese art. The answer—the eccentric bachelor brothers known collectively as "*les Goncourt*"—is significant less as a fact of chronological priority than because their realization of *japonisme* as a form of intense homosocial domesticity became paradigmatic of the uses of Japanese art in late nineteenth-century Paris, and because this paradigm was then energetically suppressed. The Goncourts' shared house exemplified one manifestation of bachelor *japonisme*—but only one. Chapter 1 compares the Goncourt house with other bachelor dwellings that instantiated other kinds of *japonisme*: Henri Cernuschi's house museum, where rationality and republicanism seemed to order the world to its farthest corners, and Hugues Krafft's Midori-no-sato, which aimed to recreate the environment of a Japanese gentleman in meticulous detail.

Chapter 2 shifts from bachelor domesticity to the institutionalization of Japanism in the museum culture epitomized by Boston's Museum of Fine Arts, to this day the pre-eminent public collection of Japanese art

in the West. Unlike the European culture of display that has been widely analyzed for its role in constituting Europe's authority over a feminized Near-Eastern Orient,[16] Bostonians used collection and display to contest European superiority by claiming allegiance to an elite, masculine version of Japan. This Bostonian version of Japan had—and still has—enormous consequences in defining Japanese "art" (and thus "art history") against feminized categories of visual culture commonly dismissed with terms like "vogue," "fashion," and "craze." As these ubiquitous terms suggest, institutionalized Japanism requires continual policing of the dubious boundaries that rule kimonos and middle-class décor outside a rubric of "art" that includes samurai armor, temple vestments, and the accoutrements of the tea ceremony.

Japanism is haunted not only by implications of femininity but by the presence of actual women at the heart of Japanist communities in Paris, Boston, and Seattle. This book attends to both the repression of middle-class femininity in the construction of authoritative forms of Japanism and the crucial—but overlooked—place of women among the bachelor Japanists: the completely forgotten Madame Desoye, who was arguably the first *japoniste*; the almost forgotten Duchesse de Persigny, who built the first Japanese house in France; the celebrated Bostonian Isabella Stewart Gardner, whose Japanism was posthumously suppressed; and the author Nancy Wilson Ross, whose influential advocacy of Zen attracts no scholarly attention today. Paradoxically, my focus on the "bachelorness" of Japanism brings into view women who have been obscured in more conventional accounts of Japanism that accept, rather than interrogate, its gender politics.

Chapter 3, sited in Seattle on the northwest coast of the United States, uses a biographical armature to structure a global itinerary for its case study on the pervasive form of Japanism centered on Zen Buddhism and an aesthetic of simplicity that rejects worldly hierarchies. The long career of the painter Mark Tobey intersected with an extraordinary range and variety of twentieth-century Japanists—including potter Bernard Leach, Tobey's fellow painter Morris Graves, composer John Cage, and the Japanese-American modernist artists George Tsutakawa and Paul Horiuchi—at the same time that his art came to be identified strongly with Seattle. This chapter follows Tobey's trajectory in order to examine the development of Seattle's Japanist regionalism in relation to other kinds of identity: spiritual, sexual, national, and ethnic. Noting the roots of this popular and—at least nominally—populist Japanism in Walt Whitman's ideals of American democracy, chapter 3 traces this strand

of bachelor Japanism from its beginnings as a minority mode of exoticist sublimation, through its deployment in American triumphalism after World War II, to its exhaustion as a discourse of Otherness at a time when rhetorics of universal truths and global friendship pointed toward the assimilation of Japanese people and customs in the modern American middle class.

JAPANISM AND/AS MODERNISM

It should be clear that this book is not about Japan. It is about Western conceptions of Japan as the farthest extreme of the "Far East"—what the French call the Extrême-Orient—as they intersect with the development of modern ideas of identity and sexuality. Far away and isolated by geography and politics, Japan until the 1860s registered weakly on the Western consciousness as a subcategory, not so much of China but of the conceptual and aesthetic structures known as chinoiserie, in which "japanwork" signified lacquer from anywhere in East Asia, just as "china" signified (as it still does) porcelain. As literary theorist Thomas Beebee describes,

> Through the middle of the nineteenth century, Japan's chief peculiarity among the countries of the Orient lay in its isolationism, which made it unavailable to the West. Rather than lying open to colonization and dismemberment, like China or the Levant, Japan removed itself from the map, becoming a cipher to be more richly filled in by the imagination. Thus, more than any other Oriental country, Japan was not "an actual place to be mystified with effects of realness, [rather] it existed as a project of the imagination, a fantasy space or screen onto which strong desires—erotic, sadistic or both—could be projected with impunity."[17]

Beebee's argument that Japan's isolation intensified its value as a site of Orientalist fantasy introduces his study of literary modernism. Noting how Vincent van Gogh's 1887 paintings of Japanese prints used decorative framing and kanji characters as visual quotation marks to emphasize their status as images, Beebee uses the term japanery to distinguish Van Gogh's modernism from the realism of conventional Orientalist imagery that makes "the viewer into an invisible tourist."[18] For Beebee, japanery describes the self-consciousness about what Wilde called "style" and Barthes called "signs" that instigated the formal innovations of the modernist prose poem.

Beebee's location of "japanery" at the heart of modernist formal innovation might seem at odds with Earl Miner's argument that awareness of Japan came along too late to affect a "Victorian temper" so strong that it could be "extremely flexible before the variety and contradictions of the realities of the age." Classing Japanism as just "one of the many forces" that were "absorbed by the Victorian sensibility," Miner concludes, "It cannot be said that Japan . . . changed the Victorian sensibility to any calculable degree."[19] These divergent views are artifacts of their respective ages: Miner's postwar short-shrifting of Japan's place in foundational forms of Western thought echoes American art criticism of the era (as discussed in chapter 3), whereas Beebee's more recent study stresses modernism's global networks. But neither critic is wrong. Their complementary arguments describe two interdependent aspects of late nineteenth-century culture. The stability of nineteenth-century beliefs about truth and reality was what allowed alternatives embodied by Japan to play out as style—as artifice or sign—positioning Japanism as a forerunner of the formalism that shook twentieth-century art and literature to the core.

This dynamic is exemplified by the souvenir survey book *Gems of the Centennial Exhibition*, published in 1877 (see figure 2.1). Explaining why "no department of the great fair attracted such throngs of admirers" as did the Japanese displays, it observes that "the vigorous and truly national" art of Japan offered an alternative to the trajectory of Western art, with its emphasis on "perspective and fine modeling":

> In brief, this nation conceives Art as best fulfilling its function when it affects the imagination by a limitless suggestiveness, rather than when pleasing the senses by superior skill in imitation or illusion. As a corollary of this, . . . the forms in Japanese art . . . are marked by amazing vigor and vitality. . . . Every line and tint has a direct and energetic meaning.

Similarly, the Japanese

> delight in color for its own sake. . . rises to the dignity of a distinct, independent faculty. . . . They appear to have solved the problem of color in a way which the European has never dared to attempt. Their combinations, balancing of masses, fineness of gradation, variety, intensity, boldness . . . are such as to astonish the unaccustomed eye.[20]

When such appreciation of deployments of form, line, and color was later articulated in the avant-garde doctrine of "art for art's sake," the references to Japan remained. Lecturing across America in 1882, Wilde asserted that "the secret of Japan's influence here in the West" was the Japanese recognition that painting "is a certain inventive and creative handling of line and color which touches the soul—something entirely independent of anything poetical in the subject—something satisfying in itself."[21] Such critiques located Japan at the origin of modernist challenges to "Western traditions and assumptions" that, as Jan Hokenson puts it, were "left intact" by the "pallid Islamic exoticism" of the mid-nineteenth century.[22] Thus, it was that Japan's marginality to the eighteenth-century Orientalism undergirding the Victorians' confident worldview allowed Japanism, its novelty untapped, to figure so centrally in a second wave of Orientalism, which upended Victorian self-confidence through challenges to fundamental Western ideas about the nature of representation, truth, and civilization itself.

Japan, then, was the hinge between two stages of primitivism: one used depictions of the East to confirm the superiority of the West; the other undermined Western ideas of depiction altogether, fundamentally challenging what Westerners thought they knew.[23] Of course, there was no single moment of rupture. A few Victorian discontents cited Japan to critique the West, and examples of twentieth-century figures clinging to imperial hierarchies abound. But something changed by the turn of the century. At that point, it was still common for textual and visual representations of Japan (like Menpes's paintings) to sustain conventional styles of representation in order to claim the authority of firsthand observation in conventional Cartesian terms (that is, by asserting a single vantage point from which a privileged viewer understands by seeing without being seen), but these were readily recognized as old-fashioned. In contrast, self-consciously modern deployments of Japan disauthorized Western systems of belief and representation, revealing their artificiality in ways that opened up possibilities to imagine alternatives.

JAPAN AS ORIGIN AND OPPOSITE

Japan's marginality in the first phase of Orientalism and its centrality in the second reflect its twice-ultimate status. Geographically at the far end of the *Extrême-Orient*, Japan was also chronologically the final act in the

Western repertoire of "primitive" elsewheres. When American warships under Commodore Matthew Perry "opened" Japan in the mid-1850s, it was clear that the curtain was rising on the finale in the drama of Western imperial expansion into unknown civilizations. That script, readable to everyone, was avidly read by the Japanese in the nearby light of China's collapse. In response, Japan deployed Orientalist myths to engage Western powers, triangulating among them to avoid domination by any one, while simultaneously modernizing along Western lines in order to present itself as an empire in its own right.

Japanese strategies of self-mythification, only recently acknowledged with terms like *Occidentalism* and *reverse Orientalism*, powerfully inflected the ideas of Japan held by the Western men discussed in this book. When Mark Tobey and Bernard Leach traveled to Asia in 1934, they experienced a Japan that had organized itself to engage Westerners in the production of a Japanese authenticity enshrined in rural potteries and, quite literally, in Zen temples.[24] This dynamic was not new. Japanese officials recognized the eminent Bostonians who traveled to Japan at the turn of the century as influential Americans and directed them to people and places that contributed to their perceptions of Japan as an ancient and complex civilization. Ernest Fenollosa's *Epochs of Chinese and Japanese Art* never pauses to ask why, in 1884, "I had credentials from the central government" to force the reluctant priests at the temple of Hōryū-ji to unveil Korean statues that had not been seen for two centuries, in its rush to report, "They resisted long, alleging that in punishment for the sacrilege an earthquake might well destroy the temple," but, "finally we prevailed."[25] Nor did it occur to Denman Ross, a major donor to the Japanese collections at Boston's Museum of Fine Arts, to wonder why, when he traveled in Japan in 1908, he was invited to "join the government Commission for the Selection of National Treasures."[26] These men, like other Japanists, accepted the Japan they "discovered" (Fenollosa's term for unveiling the statue) as the truth of the *Extrême-Orient* they wanted to find. (Without the statue, Fenollosa says, "we could only conjecture as to the height reached by [Korean] creations.")[27]

As Westerners hurled themselves at Japan with the fervor characteristic of theatrical finales, their sense that they were recording Orientalism's geographical and chronological culmination played out in descriptions of Japan as the paradoxical origin and opposite of the West. Victorians in Japan repeatedly announced that they had discovered a version of ancient Greco-Roman culture. "Those who land for the first time in the more

remote parts of Japan find themselves...face to face with scenes and customs irresistibly recalling what is known of those of ancient Greece and Rome," wrote British naval commander Cyprian Bridge in 1875. Bridge compared the boats on Japan's Inland Sea to Greek vessels; a Japanese farmer, he said, "might pass for an Oriental Cincinnatus"; Japanese dances "might have been performed in days of old by hands of modest Dorian youths and maidens in honour of the far-darting Apollo"; and "the flowing robes of the comfortable classes in the streets of towns closely resemble the togas of the Romans, but not more closely than does the short tunic of the women, the *chitôn* of the Greeks."[28] A year later, the "first problem" posed by the French scholar of religions Émile Guimet on his arrival in Japan was to explain how the "ugly" Japanese engineers returning on his ship from their studies in the United States could be met by such beautiful servants: "A group of young Romans . . . escaped from the works of Cicero . . . nothing Asiatic in their physiognomy; these are certainly the sons of Brutus that we see coming toward us."[29] Guimet's implication that, by adopting Western clothes, the Japanese engineers revealed themselves as ugly Asians exposes the implications of the West's paradoxical placement of a purely Eastern Japan at the origin of the West.

Such references persisted into the 1880s. James Whistler's famous "Ten O'Clock Lecture" of 1885 asserted (rather confusedly as regards the medium of Japanese fan decoration) that "the story of the beautiful is already complete—hewn in the marbles of the Parthenon—and broidered, with the birds, upon the fan of Hokusai—at the foot of Fusi-yama."[30] Mortimer Menpes's articles from Japan insisted

> Art in Japan is living as art in Greece was living. . . . If one could be as fortunate to-day as the man in the story, who came in his voyages upon an island where an Hellenic race preserved all the traditions and all the genius of their Attic ancestors, he would understand what living art really signifies. What would be true of that imaginary Greek island is absolutely true of Japan today.[31]

And Wilde's objections to Menpes's naive reportage of Japan is buttressed in "The Decay of Lying" with an analogous argument about popular fantasies concerning "the ancient Greeks": "Do you think that Greek art ever tells us what the Greek people were like?" Wilde asked, arguing that Classical Greece is also an aesthetic construct rather than a sociohistorical reality.[32]

Japan's role in disrupting hierarchies of East and West is exemplified by its comparison with modern Greece. The travel narrative "A Cruise in Japanese Waters," which was serialized in 1858–59 by another British naval officer, Sherard Osborn, asserted, "Japan shows signs of a high order of civilisation, energy, industry and wealth, which modern Greece decidedly does not exhibit, whatever it did in olden days." More frequently, however, Japan's status was asserted by contrast with China, where, by the 1850s, the so-called Opium Wars had soured Orientalist fantasies into disdain for what Osborn called "strong-smelling China and its unpoetical inhabitants."[33] More than a half-century later, the British classicist Goldsworthy Lowes Dickinson, arriving in Japan after several months in China wrote, "It's so pleasant to find an Eastern civilization holding its up head [sic] and keeping its own not, as in China, sadly decaying."[34] French *japonistes*, antagonistic to Britain's dominant presence in China, were especially critical of the result. Félix Régamey prefaced his guide to Japanese artistry with a comparison to China, which "presents to view the most abject and revolting assortment to be found in the world of famished, infirm, and deformed people." He reported, "China is a centre as hostile to art as to strangers. . . . I speak from experience."[35] More colloquially, Edmond de Goncourt reported an 1875 conversation with Henri Cernuschi, who had toured Japan and China collecting artifacts for his house museum in Paris:

It was a desolate picture painted by Cernuschi of the Celestial Empire. He spoke at length of the putrefaction of the cities, the countryside like a cemetery, the gloom, sadness, and stultifying misery that beset the whole country. China, according to him, stinks of shit and death.[36]

Such observations culminated a long history of racial arguments justifying European exploitation of China by claiming the Japanese as Europeans. Englebert Kaempfer's eighteenth-century travel narratives, published in several editions and various languages in the 1850s, posited the Japanese in contrast to the "purely Asian" Chinese as the lost tribe of Babylon, and many nineteenth-century texts infuse comparisons between Japan and ancient Greece with assertions of a Semitic or even Aryan origin for the Japanese "race."[37] Queen Victoria's special high commissioner in China confirmed this opinion: "The Japanese, with skins as white as our own, cannot be the descendants of the yellow sons of Han."[38]

Travelers to Japan found their sense of its Europeanness confirmed by the landscape. Osborn, asserting that "the scenery was neither Indian nor Chinese," instructed readers wanting to envision the Bay of Edo to imagine

> the fairest portion of the coast of Devonshire, and all the shores of the Isle of Wight. . . . In every nook and valley, as well as along every sandy bay, place pretty towns and villages, cut out all brick and plaster villas with Corinthian porticoes, and introduce the neatest *chalets* Switzerland ever produced. . . . For background scatter . . . the finest scenery our Highlands of Scotland can afford.[39]

Similarly, Rutherford Alcock, the first British consul in Japan, fired the imagination of readers in 1861 with the idea that Japan reproduced "in all the details and distinctive characters (with much greater knowledge of the arts of life and a more advanced material civilization)" the culture "such as our ancestors knew in the time of the Plantagenets. . . . We are going back to the twelfth century of Europe, for there alone we shall find the counterpart of 'Japan as it is.'"[40] Comparisons between Japan and medieval Britain were popularized by A. B. Mitford's 1871 *Tales of Old Japan*. This much-loved picture book, which claimed among its enthusiastic readers Aubrey Beardsley and Edmond de Goncourt, cast the samurai as knights-errant, drawing parallels, for instance, with "Edinburgh in olden time."[41] So widespread was this chivalric comparison that even the usually Anglophobic (being Greek-Irish) Lafcadio Hearn, in his story "A Conservative," had his fictional world-traveling samurai confess that he "liked the English people better than the people of the other countries he visited; and the manners of the English gentry impressed him as not unlike those of the Japanese samurai."[42]

If for Alcock, Mitford, and their readers, ideas of Japan as England confirmed a sense of pride, others found that the unspoiled island of the East confirmed the degradation of modern Britain. "Japan is Japan of the Middle Ages, and lovely as England may have been, when England could still be called merry," Dickinson reported in his dispatches to the *Manchester Guardian*:

> And the people are lovely too. . . . Instead of the tombstone masques that pass for faces among the Anglo-Saxons, they have human features, quick, responsive, mobile. Instead of the slow, long limbs creaking in stiff integuments, they have active members, for the most bare or moving freely in loose robes. . . . I do not know what they think of the foreigner. . . . They let his stiff, ungainly presence move among them unchallenged. Perhaps they are sorry for him.[43]

Dickinson was franker in his letters, writing to a friend in England from Japan, "I really begin to look with horror on our civilisation."[44] As late as 1935, Bernard Leach published a "Letter to England" praising the Japanese, who, "in the midst of their modernity . . . have not yet lost some of the virtues of medievalism . . . and consequently in their work there is still much more thought and thoroughness than amongst a longer industrialised people who are jealous of their individual rights in time and money."[45]

American Japanists also found their ideologies confirmed by East Asia. Comparisons of China and Japan reflected poorly on Europe while confirming beliefs in America's own noble savages. The New Englander Edward Morse contrasted Japanese graciousness with Chinese rudeness but concluded with a gesture of solidarity with colonial subjects, saying, "It made me mad, and yet considering the horrible way they have been universally treated by Christian nations, I don't blame them in the slightest. Indeed, if I was a Chinese, I would do the same and much worse."[46] Reiterating the contrast between the Japanese and the "dirty and rough" Chinese, he compared the Japanese to the disappearing natives of his own country: "Their self-composure, or rather reticence, in grief reminds one of the North American Indian."[47]

Despite their various politics, however, Japanists agreed in casting Japan as Orientalism's final frontier: the point after which, for the world traveler, East becomes West again and the last historical opportunity to experience a civilization so distinct and complex that it could fill the rhetorical space created for ancient Greece but now exhausted in relation to the cultures on Europe's eastern frontiers. Japan in the nineteenth century was, thus, powerfully cathected as both the origin of and an alternative to home. That both attitudes were compatible is shown by the fact that the same people advocated them. Comparisons of Japan to medieval England in Rutherford Alcock's popular 1863 *The Capital of the Tycoon* coexist with his claim, much paraphrased by journalists, that, "Except that they do not walk on their heads instead of their feet, there are few things in which they do not seem, by some occult law, to have been impelled in a perfectly opposite direction and a reversed order":

> They write from top to bottom, from right to left, in perpendicular instead of horizontal lines, and their books begin where ours end. . . . There old men fly kites while the children look on; the carpenter uses his plane by drawing it *to* him, and their tailors stitch *from* them; they mount their horses from the off-side—the horses stand in the stables with their heads where we place their tails, and the bells to their harness are always on the hind

quarters instead of the front; ladies black their teeth instead of keeping them white, and their anti-crinoline tendencies are carried to the point of seriously interfering not only with grace of movement but with all locomotion, so tightly are the lower limbs, from the waist downwards, girt round with their garments;—and, finally, the utter confusion of sexes in the public bath-houses, making that correct, which we in the West deem so shocking and improper, I leave as I find it—a problem to solve."[48]

Edward Morse's travel diary, noting that "in many operations we do just the reverse of the Japanese, and this feature has been commented on a thousand times," goes on to offer almost exactly the same examples.[49] By 1890, Basil Hall Chamberlain's alphabetically arranged *Things Japanese* carried an entry on "Topsy-turvydom" beginning, "It has often been remarked that the Japanese do many things in a way that runs directly counter to European ideas of what is natural and proper," and concluding,

> In Europe, gay bachelors are apt to be captivated by the charms of actresses. In Japan, where there are no actresses to speak of, it is the women who fall in love with fashionable actors.
>
> Strangest of all, after a bath the Japanese dry themselves with a damp towel!

As these examples suggest, mores of sex, gender, and bodily propriety were among the Western certainties about what was natural that Japan opened to question. Chamberlain's "Topsy-turvydom" entry observes, "To the Japanese themselves our ways seem equally unaccountable. It was only the other day that a Tōkyō lady asked . . . why foreigners did so many things topsy-turvy, instead of doing them naturally, after the manner of our country-people."[50]

Sexual dynamics were implicit in comparisons of Japan with ancient Greece. Historian Toshio Yokoyama points out how "references to the classical world" allowed nineteenth-century writers "to discuss openly certain topics about Japan, which were taboo under Victorian notions of 'respectability' and 'decency.'" Yokoyama quotes Bridge's description of Japanese farm workers: "the men exposing nearly the whole of their thick-set muscular bodies to the sun, and the women as lightly clothed as the 'single-garmented' Spartan maidens."[51] In 1886, Henry Adams wrote letters from Japan describing how he came "across shrines of phallic symbols in my walks, as though I were an ancient Greek."[52] Adams's travel companion, the artist John La Farge, recognized his

own Occidental perspective on the near-naked runners pulling his *kuruma*: "the vague recall of the antique that is dear to artists—the distinctly rigid muscles of the legs and thighs, the ripping swelling of the backs" that "seemed a god-send to the painter." But he presented as fact his explanation that

> The *gei-shas* are one of the institutions of Japan,—a reminder of old, complete civilizations like that of Greece. They are, voluntarily, exiles from regular society and family, if one can speak of consent when they are usually brought up to their profession of the "gay science" from early girlhood. They cultivate singing and dancing, and often poetry, and all the accomplishments and most of the exquisite politeness of their country. They are the ideals of the elegant side of woman. To them is intrusted [sic] the entertainment of guests and the solace of idle hours. They are the *hetairai* of the old Greeks—and sometimes they are all that that name implies.[53]

Looking beyond heterosexuality, the pioneering socialist sexologist Edward Carpenter devoted a chapter of his 1914 *Intermediate Types Among Primitive Folk* to the "Samurai of Japan," who "afford another instance of the part played by the Uranian love in a nation's life, and of its importance; and what we know of their institutions resembles in many respects those of the Dorian Greeks." His chapter on religion also reports that, "Bonzes, or Buddhist priests, have youths or boys attached to the service of the temples. Each priest educates a novice to follow him in the ritual, and it is said that the relations between the two are often physically intimate." He concludes, "In all the Buddhist sects in Japan (except Shinto) celibacy is imposed on the priests, but homosexual relations are not forbidden."[54] G. L. Dickinson, announcing that "Japan is the only country I have visited which reminds me of what I suppose Ancient Greece to have been," reported, "The costume of the men, leaving bare the legs and arms, and their perfect proportions and development, were a constant delight to me. The most Hellenic thing I ever saw was a group of Japanese youths practising jiu-jitsu naked under the trees of a temple garden, or by moonlight on the seashore."[55]

ALTERNATIVE IDENTITIES

Western travelers' perceptions of Japan as a civilization paradoxically exotic and familiar, other and origin, enabled their own extravagant slippages of identity. Take, for example, the Frenchman Hugues Krafft and the American

William Sturgis Bigelow. Their contributions to the Japanism of Paris and Boston, respectively, drew from their experience in Japan during the winter of 1882–83 when the men "joined in great friendship," as Krafft's travel memoir puts it. Issues of identity become hopelessly—or hopefully—promiscuous in Krafft's description of "le Dr W. S. B. . . . de Boston" as "almost as Parisian as the true children of Lutetia [the Roman name for Paris]," because, "he drew from Paris the love of the bibelot, which made of him a *japoniste* of the first order and one of those whom this ravishing country will long detain." Contrasting Bigelow's sensitivity with British imperviousness to foreign cultures, Krafft reiterates the implication that succumbing to the ravishment of Japan confers a kind of Frenchness. But even this adopted or assigned national identity grows unfixed as Krafft recounts how, although Bigelow often talked of continuing his travels to China or the West Indies (just as Krafft in Japan put off resuming his own *tour du monde*), "his passion for Japan transported him, however, and he decided to remain for an indefinite period." There, according to Krafft,

> He initiated himself more and more into Japanese mores and traditions; he enjoyed discovering things that ordinary travelers never even suspected, and understood more and more the subtleties many others trampled over as unconsciously or even with the same prejudices as those Japanese dedicated to progress who have returned from Europe and America imbued with corrupting ideas.[56]

In this passage, Bigelow (and, by implication, Krafft, too) is distinguished from other Occidentals by a Japanese authenticity that makes him more Japanese than the Japanese corrupted by experience in the West.

Such slippages persisted from the late nineteenth century through the twentieth. Bernard Leach in the early 1920s promoted his Japanist ceramics with this endorsement from an anonymous Japanese "contemporary" (in fact Yanagi Sōetsu): "He probably got nearer to the heart of modern Japan than the ordinary Japanese did."[57] The essays of Alex Kerr—originally published in a Japanese magazine in 1991–92 and collected in an anthology he wanted to title *Remembrance of Beauty Past* [*Ushinawareshi Bi wo Motomete*] in homage to Marcel Proust (another stylist fascinated by Japan)—emphasized his Westerner's perspective to interest Japanese readers in what he argued were the devalued and disappearing aspects of their own cultural heritage. Seizing on the idea that it took a Westerner to awaken the Japanese to the loss of their

own culture, critics praised these essays, which, collected as an anthology, became the first book by a non-Japanese to win the Shinchō Gakugei Literature Prize for nonfiction.[58]

JAPAN AND ORIENTALISM

The impulse of much recent scholarship has been to overlook—or disparage—such identity shifts. Following Edward Said's influential 1978 *Orientalism*, scholars often reified an East/West binary in projects that emphasized the appropriative and exploitative aspects of Western constructions of the East. Without denying the importance of scholarship by Said and those he inspired, especially concerning the ongoing implications of Orientalism for the Orient "adjacent to Europe," this book takes an approach more attuned to the heterogeneity other writers find in Orientalism in general, and that scholars of Japan insist on.[59] If my interest in the rich history of self-invention allowed by the idea of Japan in the West needs defending against the unremittingly pejorative cast given the idea of Orientalism by Said and his followers, I offer two lines of analysis: first, attention to the history of Japan's relationship to Western imperialism, and second, a critique of the misogynist and homophobic biases in many arguments that claim to reprove Western Orientalism from the perspective of the East.

So specific is Japan's history as both subject and agent of colonial dynamics that it has been suggested that Said's "generalizations" about Orientalism "apply to perhaps every area of the Far East except Japan."[60] This may overstate the case, but it is undeniable that Japan's very late "opening" to the West afforded Japan clear prescience concerning the likely outcome of the imperial dynamics initiated when American gunboats demanded commercial access to its harbors. Determined to resist the logics of colonization playing out from the Near East to China, the Japanese engaged in their own acts of trans-Pacific identification, projecting themselves at home and abroad as the equal—in learning and culture, in commercial and industrial prowess, and in imperial ruthlessness—of Western powers. One result, as Andrew Thacker points out, is that Said's focus, in the opening chapter of *Orientalism*, on Andrew Balfour's speech to Parliament asserting a racial basis for Britain's imperial domination of Egypt ignores that "just a couple of miles west of the House of Commons, at the same time, crowds of British subjects, many doubtless supportive of Balfour's point of view, were visiting

the Japan British Exhibition. This, in contradistinction to the case of Egypt, offered an Oriental country that governed itself and wished to be regarded by Europe as an equivalent imperial power."[61]

Western scholarship on Japanism has scanted these topics, perpetuating myths of a timeless Japanese aesthetic and overlooking the effects of Japan's global self-positioning on the Japanese. Elements of this history, as it relates to the people and products Westerners encountered, thread through the studies of Japanism in this book. I turn here, therefore, to a literary example to suggest the workings of these dynamics in Japan. Early in Tanizaki Junichiro's 1928 novel *Some Prefer Nettles*, Kaname, the Tanizaki-like protagonist, rifles through what the narration specifies as the 360 octavo pages of the seventeen volumes of the Burton Club edition of the *Arabian Nights*, looking for the "full-page copperplate" pictures "teeming with naked harem ladies." He is disappointed that the text adjacent to each "engaging illustration . . . generally turned out to be quite ordinary." More rewarding are the footnotes that yield details about "intriguing Arab customs" and sex scenes censured by previous scholars.[62] Tanizaki's carefully—even lovingly—elucidated practice of Orientalism performed by a Japanese initiates a plot (including a Eurasian prostitute who enhances her allure with false claims of Turkish maternal lineage) in which Kaname moves from Western-style romances of the Near East to a fascination with traditional Japaneseness. In the 1920s, Tanizaki shifted from a writing style modeled on Wilde and other Decadents toward what he perceived as an authentic Japanese style rooted in the *Tale of Genji*, which he spent the rest of his life translating into modern Japanese. This turn toward Japan took part in the nationalist reinvention attending Japanese expansion into China and Korea as it competed with Western empires. Addressed both to Western observers and to the Japanese themselves, the construction of what Barthes might call "Japanicity" through artifacts like the *Tale of Genji* reflects complicated circuits of power, identification, and pleasure between Japan and the West and back again.[63] Until Tanizaki's updating, many Japanese read *Genji*, not in its difficult eleventh-century Japanese, but in Arthur Waley's popular English translation. The popularity of this previously recondite story in Japan reflected Western values in both the classification of this (very) long narrative as a "novel" and the emphasis on what was perceived as the text's "medieval" qualities.[64]

My focus on bachelor Japanists prompts attention to dynamics of gender and sexuality in *Some Prefer Nettles*. Kaname starts the story a married man, but when—like Bigelow in Krafft's description—he is seduced by Japan, the

experience transforms him into a bachelor. In contrast to his modern wife's active desire for conventional marriage to another man, Kaname is continually made passive—ravished but baffled—by his attraction to old habits and customs, from the evident pleasures of puppet shows and lacquered lunch boxes to the more idiosyncratic joys of dark wooden bathrooms full of mosquitoes and the crooked teeth of old-fashioned girls. Over the course of the novel, Kaname gradually accedes to his wife's divorce and remarriage, as he gives in to his desire for old Japanese things, an attraction that is presented, from the first pages of the book, as a kind of post-heterosexual masculinity. Initially belittling the collecting habits of the father-in-law who becomes his role model, Kaname says, "I read somewhere the other day that men who are too fond of the ladies when they're young generally turn into antique-collectors when they get old. Tea sets and paintings take the place of sex."[65] And although the narration details Kaname's failed sex life with his wife and unsatisfactory sex life with the Eurasian prostitute, the nature of both his and his father-in-law's physical relationship with the old-fashioned girl O-hisa fades into allusion: the narration has her offering massages and, in the novel's last lines, slipping into Kaname's room after his bath with an armful of antique woodblock-print albums. The passion between O-hisa and her men, though hetero, is not necessarily sexual and seems to fall into a kind of unsayability—a love that dare not speak its name, as Wilde might put it.

Much also remains unsaid in period texts by and about my already-cited bachelor buddies Bigelow and Krafft. Bigelow's "air of repression, of self-concealment" is remarked on in recent scholarship that, noting his all-male island summer retreat and fascination with judo and Buddhism, quotes a contemporary's coy description: he "emanated a peaceful radiance mingled with a faint fragrance of toilet water."[66] Matching Bigelow's attraction to judo, Krafft's memoirs and photographs record his fascination with sumo. Krafft's text dwells on the wrestlers' bodies—"very fat or else truly superb men, built like so many Hercules"—as he joins the "thousands of male spectators, to the exclusion of all women" in admiring the "parade of torsos" that showed off their "*avantages musculaires.*"[67] Krafft's illustration of sumo wrestlers in his *Souvenirs de notre tour du monde* (figure 1.2), which may be the first photograph of sumo in a Western publication, certainly captures the physicality of the sport. Its emphasis on the spectacle of male bodies in close contact characterizes many of Krafft's sumo photographs, including, among those he distributed to libraries and learned societies, a pair comparing a wrestler posing in his street clothes and in his minimal *fundoshi* (figure 1.3). Intimations

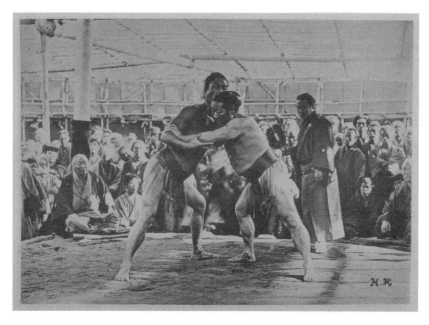

FIGURE 1.2 Hugues Krafft, *Réprésentation de lutteurs japonais*, 1882–1883. Photograph illustration in *Souvenirs de notre tour du monde* (1885).

FIGURE 1.3 Hugues Krafft, *Lutteur en costume de ville* and *Lutteur en costume de combat*, 1882–1883. Prints at the Japan Society, London, and the Musée Le Vergeur, Reims.

here of Krafft's interest in physical contact between men are confirmed by a photograph he did not distribute: this one shows his brother and one of their French traveling companions stripped to their sumo belts preparing to grapple (figure 1.4).

Krafft's delight in male physicality contrasts sharply with his response when Bigelow took him to the Yoshiwara prostitution district. Reporting that the *guéshas* were so proper they hesitated to appear in public with foreigners and insisted on occupying a separate stall when the men took them to the theater, Krafft insisted that, "whatever their private conduct," geishas are not *joros* [courtesans] but "artists" who "preserve and promulgate the melodies and lyrics of their country." Describing geishas as the nicest class of Japanese woman foreigners can meet, he concluded, "Woe betide any of us who among these young women did not remain within the bounds of the strictest politeness."[68] For Bigelow and Krafft, Japan was a site of masculine camaraderie and physicality, of sports like sumo and judo, and of travel with other men, both companions and the near-naked runners who pulled their carts.[69] Interactions with Japanese women, who enacted traditional modes of song, dance, and conversation, were encounters with history and carried none of the expectations of marriage or sex attached to Occidental women. In contrast to both his irritation (narrated at length) about the tedious parties thrown by Western women in Japan and his delight in the sumo fighters, the final lines of Krafft's memoir of Japan return to its women, who appear here—in a manner strikingly like Tanizaki's doll-like O-hisa four decades later—as personifications of Japanese traditions that, while undoubtedly patriarchal projections, are not erotic:

> Mild, patient, raised with the idea of affectionate submission, she makes the well-being of her lord and master the goal of her existence; always happy and smiling, with a natural sense of devotion heightened by her education, she exercises an influence weak in appearance, but which nevertheless penetrates so far into all the details of life that it constitutes, without any doubt, one of the principal magnets of this country secretly dominated by her.
>
> May the women of Old Japan, as faithful guardians of the foyers, long contribute, by cultivating the rituals of the great traditions of the past, to the development of a virtue their sons risk unlearning: legitimate pride in "nationality"![70]

This gendered constitution of Japanese nationalism—a nationalism so newly minted as to require quotation marks—in terms of artful, sexless femininity

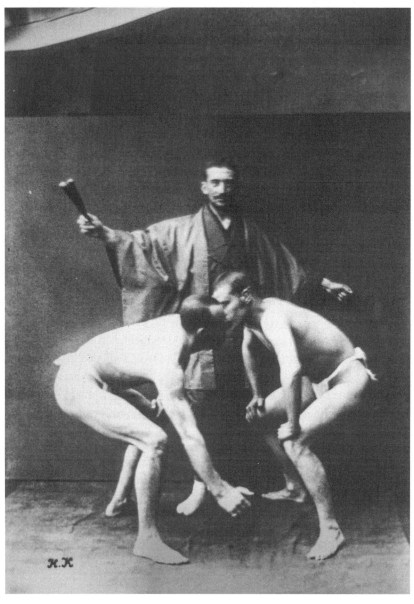

FIGURE 1.4 Hugues Krafft, *Edouard et Charles en lutteurs*, 1882–1883. Print at the Musée Le Vergeur, Reims.

was used in Japan to oppress Japanese women and deployed abroad to mask or mitigate Japanese military ambitions. Alongside these implications, however, it also registered an unheterosexual fascination with feminine artifice that accorded with other queer elements in travelers' accounts of Japan: its similarity to ancient Greece; its pleasure quarters with processions of elaborately dressed, untouchable prostitutes; its history of samurai and Buddhist monks with their beloved acolytes; its public baths and cross-dressed *kabuki* actors; its near-naked male runners who attach themselves to foreigners. These ubiquitous features of Western accounts of Japan are now customarily passed over or trivialized. Even less discussed is the attraction of gay men to Japan, a phenomenon treated only obliquely in accounts such as Edmund de Waal's *The Hare with Amber Eyes*, which describes his beloved uncle's long-standing domestic partnership in Tokyo with a Japanese man, or Ian Buruma's discovery that the English-language books that had been donated to a Japanese university library where he studied reflected the tastes of an English expatriate who collected "accounts by obscure countesses of the Oscar Wilde they had known" along with "first editions of Aubrey Beardsley, J-K Huysmans, and Ronald Firbank" and "photographic books of naked German youths," souvenirs of an earlier expatriate episode in Berlin in the 1930s.[71] The reticence concerning homosexuality among Western men in Japan is paralleled by the silence surrounding one scholar's suggestion that among the Tokugawa Japanese, "the links between those who studied the West and those who favoured *nanshoku* [sex between men] are oddly close."[72]

These are issues that Said's approach to Orientalism precludes or evades, despite—as both John Treat and Tom Hastings observe—the powerfully homoerotic dynamics of the painting chosen for his book's cover: Jean-Louis Gérôme's *The Snake Charmer*.[73] Characterizing Said's evasion of homosexuality as "politely Victorian," Treat observes, "Many of the Orientalists Said takes up were homosexual, or rumored to be. But that is a circumstance that intrudes on Said's argument only at its edges." Treat is less tactful about Said's followers, whose energetic denunciations of "fantasies of illicit sexuality" set in the East, far from critiquing imperialist attitudes, he argues, unwittingly rehearse nineteenth-century attitudes of "missionaries of a scandalized West."[74] Hastings locates these Orientalist dynamics more firmly in Said's writings. Noting that Said ignores twentieth-century scholarship on sex and gender, Hastings ties Said's "tendentious elision of issues of sexuality, his reduction of sexual relations to a phallocentric gender axis, and his effacement of the homosexual identity of many of the authors prominently cited

throughout his study" to outdated assumptions of a masculine heterosexual "homogeneity that does not exist" among "Orientalists, or, for that matter 'Orientals.'" Hastings concludes that, "Said can be accused of helping to create, and not simply present, a discourse of Orientalism, thereby implicating himself in the very repressive structures of knowledge that he initially sets out to dismantle."[75]

VISUALITY AND JAPANISM

This book seeks to redress both the suppression of sexuality in Said's influential formulation of Orientalism and its fixation on texts to the exclusion of visual culture. These are related projects. The exclusion of sexuality from Said's formulation of Orientalism is tied to the absence of visual culture in his analysis, twin lacunae revealed by the challenge that the book's cover illustration poses to the text's arguments. Visuality is central to Japanism. Even arguments primarily focused on, and presented as, texts invoke visual art: both Wilde and Beebee cite painters to bring Japan into arguments about Western prose styles; both Barthes's *Empire of Signs* and Krafft's *Souvenirs* emphasize their authors' identities as photographers (in Barthes's case, a photographer who is also "starred" in images by other photographers).[76] That most definitive of Japanist texts, Pierre Loti's 1888 novel *Madame Chrysanthème*, presents itself as originating in an image: Loti's dedication asserts that he writes in order to explain the tale behind "a certain photograph—rather ridiculous I must admit—representing that big fellow Yves, a Japanese girl, and myself."[77]

On a basic level, visuality must be crucial to intersections of cultures that do not share a written or spoken language. "Thus it is the sense of sight that is above all called into play," explained Félix Régamey in his first letter from Japan in 1876.[78] The role of the visual in creating Western knowledges of Japan was historicized as early as 1884, when William Ernest Henley, writing in the *Magazine of Art*, recalled,

> As first revealed it was a jumble of oddities and splendors—of comic prints and royal tissues, of priceless lacquers and irresistible ivories, of magnificent porcelains and prodigious bronzes and little marvels of ironwork and chasing: flung together in defiance of chronology from all the points of a new Unknown; unstoried save in a language none could speak, written in characters none could decipher.

More than simply substituting for written language, however, visuality was fundamental to what the Occident imagined Japan to be. Henley, after commending scholars whose mastery of written Japanese allowed them to write sober histories of Japanese art, dismissed this linguistic approach. "You might read [such a history] from end to end; and if it were not for the pictures, you would hardly know in what the essence of Japanese consists," he wrote, asserting that "the delicacies and fantasies" of Japanese art "are beyond language"[79]—an odd claim coming from a poet but one that echoed established rhetorics of Japanism. Philippe Burty, who coined the term *japonisme* for the title of a series of articles published in 1872, cast it as a visual phenomenon. Having struggled unsuccessfully to learn to read Japanese, Burty explained, he discovered the books of prints that taught him everything worth knowing about Japan: "Whoever wants to know how and what the Japanese think must research the albums" that are the

> keys to their life and the record of their thoughts. . . . What I have learned about the psychology of the Japanese is sure. I do not always know what causes their anger, their terror, their laughter, their kisses but I know precisely that their artists have rendered these sensations, these sentiments, or these acts with the precision and poetry that is art and a universal language.[80]

Zacharie Astruc's 1867 articles on Japanese art insisted that it was not worth "worrying oneself over decoding" Japanese texts because the Japanese "want to be seen" in their visual art—this in contrast to "the Arab revealing his personal life to our gaze by the extreme circumspection of his gesture—kept at some distance—hardly displaying his actions and never performing them."[81]

Although Astruc recommended this form of "dialog with a people" to those "comfortably seated in a good armchair," travelers also registered the contrast between Japan and the Near East in terms of visuality. Where early nineteenth-century visitors to the Near East described themselves as overwhelmed by new sights, voyagers to Japan consistently described an experience of familiar imagery come to life.[82] An 1873 travel memoir by the Austrian diplomat Baron Joseph Alexander von Hübner characterized the "grotesqueness" of Japanese bodies as something he had seen in art "a thousand times."[83] Edward Morse in 1877 described his first sight of a Japanese town as recalling "the various pictures we had seen on fans and which we thought were exaggerations."[84] Émile Guimet, writing in 1878 about his first impressions of Japan two years

before, described "the Japanese woman" as "truly the painting on the screen that we already know" and noted with surprise about Japan, "Moment to moment you recognize a view, a pose, a group, a scene you have seen already on porcelains or in paintings; and the scene is real, the group smiles at you, the pose is not a fiction, the view is not a dream; you wake from a Japan you believed was a convention in order to enter, walk, act in a true, incontestable Japan that welcomes you like a friend and differs not at all from the one you saw in dreams."[85]

Such observations remained ubiquitous through the 1880s. The poet Rudyard Kipling, peering out a porthole at his first view of Japan in 1889, saw that "rock and tree and boat made a panel from a Japanese screen."[86] The painter John La Farge, entering Yokohama harbor in 1886, jotted on an envelope, "It is like the picture books. Anything that I can add will only be a filling in of detail."[87] His traveling companion, Henry Adams, referring to the vogue for Japanese decoration on dishware, wittily compared his first week in Japan to wandering, "so to express it, in all the soup-plates of forty-eight years' experience."[88] Loti, as the narrator of Madame Chrysanthème, delighted by his first day in Japan in 1885, described the country as "this tiny, artificial, fictitious world, which I felt I knew already from the paintings of lacquer and porcelains." The actual Louis-Marie Julien Viaud (Loti's real name), describing how he purchased his temporary Japanese wife, made repeated recourse to art to explain his bride. In his journal, he recorded, "I have already seen her portrait everywhere, on parasols, at the bottom of teacups."[89] In a letter to a naval colleague, he wrote, "Last week I married, for one month renewable, before the Japanese authorities, a certain Okané-San. . . . You have already seen her doll-like figure on every fan."[90] To Juliette Adam, the publisher who described herself as Loti's "intellectual mother," he asserted, "Okané-San is clothed just like those mincing women on the walls of your Oriental room."[91]

These repeated expressions of the reliability of the imagery on objects to convey the truth of Japan contributed to Japanism's central place in modernism. Literary theorist Bill Brown identifies the 1860s as a watershed in Western attitudes toward things as bearers of ideas. His analysis of how "anthropology's museal era" institutionalized a new faith in objects' ability to represent peoples offers a context for the passion late nineteenth-century collectors invested in acquiring and illustrating Japanese things—and for the ability of those things to disturb Western worldviews.[92] Though travelers were initially pleased that the look of Japan confirmed its image in art, longer

acquaintance with Japanese artfulness unsettled Westerners' sense of them-
selves. What Kipling on his first day in Japan described as "the surpassing
'otherness' of everything around me" undid the confidence of this seasoned
traveler to the East. "Feeling for the first time that I was a barbarian, and no
true Sahib," Kipling reported that Japan made him see himself as "a bog-
trotting Briton," "large and coarse and dirty."[93] Likewise, Loti, another con-
fident narrator of the East, interrupts his narration in *Madame Chrysanthème*
to confess that although "this sounds very pretty, and written down looks
very well, . . . in reality, however, it is not so; something, I know not what,
is wanting, and it is all very paltry." In contrast to earlier sites of his popular
Orientalist tales—the "isles of Oceania" and the "quarters of Stanboul"—
Loti complains, "Here, on the contrary, words exact and truthful in them-
selves seem always too thrilling, too great for the subject; seem to embellish
it unduly. I feel as if I were acting, for my own benefit, some wretchedly trivial
and third-rate comedy."[94]

This crisis of self-perception was related to sex: Kipling and Loti have in
common that, by their own accounts, they were both more shaken by Japan
and more frankly interested in sex than were their traveling companions
(Kipling's unnamed professor and Loti's fellow sailor, Yves). Their trou-
bling moments of self-deprecation as bog-trotting barbarian or third-rate
comedy actor counterpoint manifestations of amazement at a place where
Western rules of propriety did not apply. That sights in Japan transgressed
Western sexual norms is a recurring theme of travel memoirs, which invari-
ably describe encounters with near-naked runners and totally naked bath-
ers. Fascination with Japanese nakedness predates the opening of Japan.
J. M. Tronson, who participated in one of the first British military mis-
sions to Japan in 1854, reported that on landing, "we first directed our steps
towards the Bath House, having heard much of this strange establishment."
His curiosity was gratified in finding men, women, and children together,
all "perfectly naked," an experience that alienated him from his own cultural
norms—he contrasts the "Adam-and-Eve-like" simplicity of the Japanese
with "our artificial habits and customs."[95] The look of Japan challenged the
Western correlation of visual with moral propriety and undermined travel-
ers' confidence in their own identities and their capacity to make sense of
what they saw. Loti, looking at the photograph of himself, Yves, and Chry-
santhème cited in the dedication to his novel is struck that "we look like a
supremely ridiculous little family drawn up in a line by a common photog-
rapher at a fair."[96] The sight of himself seen by a Japanese camera casts Loti

in his own eyes as the patriarch of a family comprised of another man and their Japanese child.[97]

For those like Loti who did not share Tronson's faith in Japanese sexual innocence, seeing Japan was deeply disquieting. Loti was troubled by the look of his temporary bride's female relatives: "For women who, not to put too fine a point upon it, have come to sell a child, they have an air I was not prepared for: I can hardly say an air of *respectability* (a word in use with us, which is absolutely without meaning in Japan) . . . and really it all resembles, more than I could have thought possible, a *bonâ fide* marriage." Similarly, memoir after memoir from the men who traveled to Japan in the nineteenth century worried over the beauty of the *Yoshiwara* (prostitution district). The description of "the quarter of vice" in a travel narrative published in 1887 by British major Henry Knollys is typical:

> So far from all being, as might be expected, flaring and glaring, meretricious gaudiness, vicious noise and still more vicious sight, precisely the converse in the case. There is a subdued but cheerful hum throughout; street after street of the parallel rows, broad, clean, and neatly kept, is beautifully lighted up with numerous immense coloured oiled-paper lamps, shedding in every corner a prettily softened glow. All is outward propriety and decorum.

Like Loti, Knollys was fascinated by this sight of decorous indecorum. His account culminates in a fantasy, the sexual implications of which become unspeakable: "The whole tenor is such that an English girl of eighteen, unless she were precociously knowing, or acquainted with the language, might wander through these realms unsuspecting, unshocked, and unmolested. I dare enter into no further details."[98] This fantasized meeting of East and West found its discomfiting realization in Sir Henry Norman's 1891 *The Real Japan*. Although Norman dismisses as "unmitigated rubbish" Knollys's account of the respectability of prostitutes in Japan, he too contrasts the Yoshiwara—"as quiet and orderly as Mayfair or Fifth Avenue"—with the "riot, drunkenness and robbery" of Western brothel districts, recommending the Japanese model for study. Only one aspect of the Yoshiwara aroused Norman's unmitigated condemnation: the confusion of visual signs created by women "dressed in what passes for European costume—a sight of indescribable vulgarity and horror. This exhibition is barbarous and offensive in the extreme, and the authorities would be well advised to suppress it immediately."[99]

SIGHT AND SUBVERSION

The subversive implications of Knollys's fantasized and Norman's witnessed meeting of East and West in the Yoshiwara matched equally disturbing—or enthralling—implications of the look of Japan that turned up at home. European men describing the Yoshiwara compared the prostitutes' elaborate kimonos to those coveted by European women. Loti mined this claim for maximum salaciousness:

> Many women in Paris—who I have no doubt would be quite scandalized by all this—own, admire, and do not hesitate occasionally to wear these beautiful Japanese dresses . . . that have come from there barely soiled, but already worn just a bit (as can be guessed by a certain attenuation of the colors, a certain scent in the silk). Well, I regret to tell them, but these dresses are the cast-offs of the women of the Yoshiwara, or perhaps of the young gentlemen even less worthy of attention who play the roles of the great coquettes on the stage.[100]

Loti's evocation of Western ladies unwittingly dressed as Japanese prostitutes or transvestite actors indulges a fantasy of naïveté among Europeans that is belied by period accounts. Guy de Maupassant's novels of the mid-1880s unambiguously associated *japonisme* with sexual impropriety. In *Pierre et Jean*, a mother and her illegitimate son "decorated like a Japanese lantern" the dining room of the elegant apartment he acquired with the inheritance from his biological father.[101] In *Bel-Ami*, Maupassant's novel of Parisian social climbing, both men and women deploy *japonisme* in schemes of seduction. Here the ambitious but poor Georges Duroy deploys Japanese décor to deceive his wealthy mistress about his finances:

> He pondered how to arrange the room to receive his mistress while concealing as much as possible the poverty of the place. He had the idea of pinning little Japanese bibelots to the wall, and bought for five francs a whole collection of crepe papers, little fans, and little screens, with which he hid the stains that were too obvious on the wallpaper. On the window panes he applied transparent pictures showing boats on rivers, flocks of birds across red skies, colorful women on balconies, and processions of little black men over plains covered in snow.

His room, just big enough to sleep and sit in, soon looked like the interior of a painted paper lantern.[102]

Madame de Marelle is charmed by the effect—and why not, for she seduced Duroy with her own *japoniste* display, receiving him for the first time at home in "a Japanese robe of pink silk embroidered with golden landscapes, blue flowers, and white birds" in a scene that prompts this comparison with a woman who had received him in Western *déshabille*:

> He found her completely tempting in her brilliant soft robe, less refined than the other in her white robe, less coy, less delicate, but more spicy and exciting.
>
> When he found Madame Forestier near him, he felt above all the desire to lie at her feet, or to kiss the fine lace of her bodice and slowly breathe in the perfumed warm air that rose from it, sliding between her breasts. Near Madame de Marelle, he felt in himself a more brutal, specific desire, a desire that tingled in his hands before the curves covered in light silk.[103]

Connotations of sexual transgression attached to the vogue for Japan in the West are clear in Loti's dedication of *Madame Chrysanthème* to the Duchesse de Richelieu. Loti asks the duchess—and by extension his readers—to suspend moral judgment by reading his book as one would look at a Japanese object: "Kindly welcome my book with the same indulgent smile, without seeking therein a meaning either good or bad, in the same spirit that you would receive some quaint bit of pottery, some grotesquely carved ivory idol, or some preposterous trifle brought back for you from this singular fatherland of all preposterousness."[104] Knowledgeable readers of the dedication would have understood that moral relativism adhered not only to the Japanese artifact (here Japan itself), but also to the viewer/reader Loti conjures, for, despite her grand title, the beautiful and scandalous Duchesse de Richelieu began life as Alice Heine, the daughter of a Jewish merchant in New Orleans.

Looking back on this era, Proust's *Remembrance of Things Past* invokes this seductive, but superficial, *japonisme*. The narrator disparages Odette's flat full of oversized chrysanthemums and Japanese bric-à-brac, including "a large Japanese lantern suspended on a silk cord (but which, in order not to deprive visitors of the up-to-date comforts of Occidental civilization, was lit with gas)." The corrupt artifice of this Japanese décor is matched by Odette, whose pink silk robe in Japanese style bared her neck and shoulders as she flirted with

her Oriental ornaments, pretending to be frightened by her "fiery-tongued dragons painted on a vase or embroidered on a screen," kissing her jade toad, blushing over the indecency of her orchids and chrysanthemums.[105] The cultural and moral degradation of Odette's *japonisme* is paralleled by linguistic corruption in her slangy use of the Japanese word *mousmé*, popularized by *Madame Chrysanthème* to indicate a sexually desirable girl: "Nothing is more disgusting," the narrator observes.

But professed horror at Odette's sexual and linguistic transgressions parallels a fascination with the subversive effects of the East that allowed *Remembrance of Things Past* to slough off conventional restrictions on both the techniques (a narrative voice that indulges vast leaps in space, time, and subjectivity) and the topics (perverse eroticisms, not only heterosexual and homosexual but also in the bond between mother and young son, for instance) of novelistic representation. Jan Hokenson argues that references to the Orient allowed Proust to create "a counter-system of non-European aesthetics active through the text. The Japanese allusions in particular function contrastively to highlight the impasse in canonical Western aesthetics (thus replicating the Impressionists' experience in discovering *ukiyo-é*, the Japanese prints)." To take one crucial example, the moment when young Marcel realizes the fundamentally relative and subjective nature of perception—that joy and sadness inhere in the seer rather than the thing seen—is marked by his memory of trips along the road home when the apple trees "basked in the setting sun, had a Japanese design to their shadows." Echoing his descriptions of Japanese prints, Proust recalls, "There was even a moment at certain sunsets where a pink layer of sky was divided as if by a line from the green or black layers," and "You could see a bird flying in the pink . . . almost touching the black." Proust concludes, "And in this way, it was on the Guermantes road that I learned to distinguish my successive internal states."[106]

Remembrance of Things Past epitomizes Wilde's injunction to learn to see in a Japanese way. This classic of modernist literature culminates a series of nineteenth-century Japanist texts, among them *Madame Chrysanthème*, in which Japan repeatedly provokes Loti to recall both his childhood and his experiences in other parts of the Orient. He justifies these deviations from his narrative with the explanation:

An incongruous interruption is quite in keeping with the taste of this country; everywhere it is practiced, in conversation, in music, even in painting;

a landscape painter, for instance, when he has finished a picture of mountains and crags, will not hesitate to draw in the very middle of the sky a circle, or a lozenge, or some kind of framework, within which he will represent anything incoherent and inappropriate: a bonze fanning himself, or a lady taking a cup of tea. Nothing is more thoroughly Japanese than such digressions made without the slightest àpropos.[107]

For both Proust and Loti, invocations of Japan subverted both Western sexual norms and narrative conventions.

These literary examples suggest the subversive potential of Japanese art as it flooded into Western markets in the late nineteenth century. Its challenge to Western norms operated, as described by Loti, on the level of style, but Japanese objects could also carry an erotic iconography that flouted Western propriety. Most obviously illicit were the pornographic *shunga* prints and paintings quietly amassed by collectors like Bigelow and more openly admired by Aubrey Beardsley, who incorporated into his own art visual quotations from works in his collection of what one contemporary called "the wildest phantasies of Utamaro . . . the finest and most explicitly erotic Japanese prints in London."[108] Beardsley's open enjoyment of Japanese erotica was not the norm, however. The friend Beardsley commissioned to bring him prints from Paris described the album as "so outrageous that its possession was an embarrassment" and was horrified to find that "the next time I went to see him, he had taken out the most indecent prints from the book and hung them around his bedroom."[109] Most nineteenth-century scholars and collectors obscured the eroticism of Japanese imagery, in the process creating networks of insiders bonded by their access to this art: communities, that is, grounded in sexualized knowledges or sensibilities concerning the look of Japan.

This aspect of Japanism was not limited to prints. Travelers' accounts allude to the eroticism of Japanese art in a variety of media, which seems connected to the attractions of shopping in Japan. The Bostonian Percival Lowell described the fascination of Japanese curio shops that "open their arms to you" and peddlers' booths that "deliberately make eyes at you," so that "opposed as stubbornly as you may be to idle purchase at home, here you will find yourself the prey of an acute case of shopping fever before you know it."[110] Kipling described seeing in a shop a *netsuke* of a "Rabelaisan badger who stood on his head and made you blush though he was not half an inch long."[111] Loti compared Japanese women to

the art objects of their country, bibelots of extreme refinement, which it is wise to sort through before bringing them to Europe lest some obscenity lurk behind a stem of bamboo or under a sacred stork. One may compare them also to those Japanese fans that, opened from right to left, present the sweetest flowering branches, and then change and display the most revolting indecencies if one opens them the other way, from left to right.[112]

If these visitors were intrigued, others were outraged. An account of Japan published in London in 1862 reported that "little innocent-eyed children, toddling by their fond father's side, or nestling in their mother's bosom, may be seen playing with toys so indecent, that one longs to dash them from their tiny hands and trample them under foot." This text went on to warn,

> In shopping in Japan, the greatest care must be exercised to guard against the acquisition of indecencies which are found not only in books and pictures, but are painted on their porcelain, embossed on their lacquer, carved in their ivory, and surreptitiously conveyed into their fans. Mr. Alcock made a purchase of illustrated books destined for some children in England, and it was only by a fortunate accident that he discovered among them, before they were dispatched, pictures which would have disgraced [the pornographic book dealers in] Holywell Street. I was deeply grieved to learn that even the sacred character of the Bishop of Victoria, who had neglected the precaution of minute examination, could not save him from a similar outrage. Had not an acquaintance providentially examined his porcelain cups, they would, in all probability, have been stopped at the English Custom-House as inadmissible, even as the private property of a bishop.[113]

Whether fascinated or horrified, such accounts register the potential of Japanese visual culture to disrupt Western sexual norms. Occidentals alienated—to various degrees and for various reasons—from the sexual conventions of their home cultures turned to the look of Japan, collecting Japanese art, photographing Japan, and making their own art in a Japanese style. In Europe and North America, there emerged communities of Japanists, often comprising respected authorities, that rehearsed and elaborated subversive knowledges of Japan, in the process shaping both Western understandings of the East and, through the dynamics of reverse Orientalism, Japan's understanding of itself. These communities of Japanists overlapped with developing

sexual subcultures, a history of complex interweavings of ethnic and sexual identity that is only recently beginning to be recognized and explored.

The case studies in the following chapters take up specific instances of the broad ideas proposed here. These are not the only stories that could be told about bachelor Japanism—it is remarkable is how many bachelors there were among the adventurers and scholars who shaped perceptions of Japan through the late nineteenth and into the twentieth century—and each of these chapters might have made a book in itself. In addition to differences of time and place, each case study brings to light different questions about Japanism's ideological, institutional, and artistic effects. This diversity is intended to work against totalizing definitions of Japanism. Too many studies of Japanism—as of Orientalism—totalize, either to celebrate or to condemn. I hope instead this history is able to register the accomplishments and pleasures—including the absurdities characteristic of fantasy—attendant on constructions of Japanism at the same time that it acknowledges the privileges and exclusions entailed in those constructions, for these dynamics are now more relevant than ever. In today's environment of Internet access; international art fairs; and global travel for trade, tourism, and teaching, it would be hard to identify any cultural actor who has not made imaginative use of some (self)-exoticized Other.

If, to put it polemically, we are all Japanists (and everyone is somebody's Japan), we have moved beyond the simplistic binaries of East and West enacted in Orientalist discourse and the critical counterdiscourse it engendered. I do not pretend that the Japanists presented here were all as self-conscious as Wilde and (especially) Barthes in recognizing the role of their own agency in generating their perceptions of Japan, but to balance that caveat, neither Wilde nor Barthes concentrated his intellectual or material resources on Japan as did the Japanists discussed in this book. I hope, however, that the case studies that follow offer ways to think complexly and creatively about our own investments in otherness, attentive in both cautionary and celebratory ways to our own agency.

1. ORIGINATING JAPANISM

FIN-DE-SIÈCLE PARIS

MODERNISM AND JAPONISME

As the ubiquity of the term *japonisme* suggests, the French got there first. But though their primacy is clear, just where—or what—"there" is is less certain. This chapter approaches that question by way of Jean-Paul Bouillon's advice that histories of *japonisme* jump "the tracks of neo-positivist art history—vain quest for a 'first' date of penetration, determination of 'influences,' reports on 'sources' of inspiration" in order to focus on "the signification of the moment."[1] Michel Melot, too, calls for studies of *japonisme* to move beyond source hunting and chronology to ask what was "the role and the significance of Japonisme in French society during the second half of the nineteenth century? This question must be posed lest we go on seeing in it just the insignificant whimsy of a group of artists and amateurs provoked by the chance encounter of the two civilizations."[2] Taking up these challenges, this chapter on the decades from the 1860s through the 1880s begins by analyzing how

chronology debates themselves play a crucial role in modernist ideologies. It then takes up the variety of *japonismes* at this era by exploring three *japoniste* houses—all bachelor quarters—created between 1870 and 1885, each in its own way paradigmatic of the ways Japanese aesthetics figured in French culture at this time.

Studies of *japonisme* dwell on origin claims, which, competitively exaggerated in the first place, are further exaggerated by historians keen to perform the role of scholarly debunker of myths in favor of facts. But myths are key to the meanings of *japonisme* and, because "the field of art criticism matured in the midst of the Japan craze of the 1870s and 1880s,"[3] to modernism in general. Crucial modernist concepts were worked out in relation to Japanese aesthetics, which were central to the development of the Impressionist and Post-Impressionist painting at the heart of the modernist canon. Among these was the idea of *influence*, which Michael Baxandall calls the "curse of art criticism" for its "wrong-headed grammatical prejudice about who is the agent and who the patient: it seems to reverse the active/passive relation."[4] This misconception is important because the modernist ideology of art as an active expression of individualism renders passivity anathema.[5] Modernist critics and historians ritually conjure originality from "influence," therefore, by fixing on questions of who came first and who followed: the paradigmatic avant-garde artist reifies his invidualism by "borrowing" (the term masks the nature of an appropriation with no expectation of return) something from a social group not accorded the authority of individualism (the Japanese, Africans, children, mental patients, and so on) and passes that "influence" on to other groups denigrated in modernist rhetoric with terms like "follower" or "fashion." Arguments over who the first *japoniste* was are, thus, high-stakes debates about who made modernism and who got "influenced" in a system where originality is everything. Differing accounts of which Parisian "discovered" Japanese prints—an artist? a collector? a dealer? a radical? a reactionary? a family man? a bachelor? a woman?—enact conflicting aesthetic and cultural ideologies about modernism and its constituencies.

The First Japoniste(s)

Partisan debates over *japonistes'* origin claims have focused on the bachelor brothers Edmond and Jules de Goncourt. And no wonder. When Edmond de Goncourt asserted that he and his brother bought their first album of

Japanese prints in 1852, the context offered naysayers an irresistible mixture of notoriety, self-aggrandizement, iconoclasm, and fiction. His 1881 book, *La maison d'un artiste* (*The House of an Artist*), asserted the status of the collector/decorator as a creative artist, taking readers on a rapturous, excrutiatingly detailed tour of his home. Pausing on the stairs, Goncourt asserts the brothers' claim to be the original *japonistes*:

> This album (a reproduction of legendary scenes acted out by dolls in the temple of Kannon) purchased in 1852 was for my brother and me the revelation of this artistic imagery still very vaguely known to Europe, which then gained enthusiasts like the landscape painter Rousseau, and now has such great influence on our painting.[6]

Goncourt's remark flouts every tenet of the origin narrative modernists had created for *japonisme* by the early 1880s. Goncourt's prints are not the Japanese landscapes the Impressionists admired, and he credits Théodore Rousseau, who died in 1867, rather than Whistler or any of the Impressionists, with the "great influence" of Japanese imagery on modern painting. Finally, the date is a blatant fiction. Goncourt introduces his Japanese albums as "books of sunlit images, in which, during the gray days of our sad winter with its rainy, dirty skies, we sent the painter Coriolis searching—or, rather, we searched ourselves—for a bit of the joyous light of the Empire known as the Empire of the Rising Sun."[7] The reference here is to the artist protagonist of the brothers' novel *Manette Salomon*, written between 1864 and 1866 but set in 1852. Fusing fact and fantasy under the sign of identity—Coriolis personifies the Goncourts' collective sensibility—Goncourt claims as the date he and his brother first bought Japanese prints the year they were acquired by this fictional character.

This was too much for proponents of French modernism like Raymond Koechlin. The heir to an industrial fortune, Koechlin headed the Louvre's donors' council from the 1900s to the 1920s. His own collection of Japanese prints, begun in the 1890s, was part of a project to document art and design significant to French aesthetic accomplishment. Koechlin's sober-sided history of these prints' contribution to modern French art and design dismissed Edmond de Goncourt, who "pretended to have purchased the first shipments by chance between 1850 and 1860, but he was doubtless bragging."[8] Koechlin set the tone for later critics' exclusion of the Goncourts from accounts of *japonisme* because of their "chronic addiction to antedating."[9]

What such accounts miss is that the Goncourts' style of alienated self-aggrandizement infused the first assertions of *japonisme* with associations of the exotic and grotesque. Exaggerating their role in *japonisme* was like insisting on the aristocratic "de" in their surname (to the point of suing—unsuccessfully—to prevent another family using the name *de Goncourt* in relation to a different estate of the same name), all the while acknowledging that the title had been recently purchased and they were "not rich and very far from being noble."[10] From their first publications—theater reviews in newspapers run by a cousin—the Goncourts' appeal lay in a writing style that sparkled with original neologisms as it offered a stimulating mix of outrageous gossip, outbursts of self-regard, and contempt for contemporary authorities and social norms.

As if all that were not troubling enough to chroniclers invested in ideologies of modernist progress, the Goncourts' claims to priority as *japonistes* grounded the taste for Japan in a context so homosocial as to be defiantly anti-heteronormative. Originating, according to Edmond, in their mother's dying act of linking the brothers' hands, their remarkable symbiosis was manifest in coauthored novels and a journal written in the first person singular and published as the record of "two lives inseparable in pleasure, in labor, in pain . . . two minds receiving from contact with people and things impressions so similar, so identical, so homogeneous, that these confessions can be considered the expression of a single *me* and a single I."[11] Their allies promoted this singular identity. The novelist Émile Zola emphasized the Goncourts' physical similarities, and Philippe Burty, who coined the term *japonisme*, published a description of the brothers "only living for one another," in which he recalled being struck when he first met them by how "everything melded together. First one, then the other, referred to the same work either published or in progress as 'my book.' I noticed sentences begun by one taken up in the middle by the other."[12] Exasperated that other critics failed to recognize their accomplishment in having minimized "that great *impedimentum* to man, love of women" to "five hours a week, from six to eleven, and not a thought before or after," the journal insisted, "Love's *égoïsme à deux* we have at full power and without cease in our brotherhood."[13] When critics mocked the "*bizarrerie*" of this collaboration, the Goncourts responded indignantly, "It is our marriage, the household of our fraternity they attack. They hate us for our love!"[14]

These attitudes worried commentators at the time and since. Much Anglophone scholarship follows historian Roger L. Williams's furious presentation

of the Goncourts in his 1980 *The Horror of Life*—this title refers to Williams's warning that Goncourt novels "were flowers of illness meant to sicken us with reality, in the hope that we might come to share the horror of life that could make paralytics of us all." Complaining that "no biographer has portrayed them as the emotional cripples they were, as sick, pathetic men, in retreat from existence," Williams traces the mid-twentieth-century's indulgence of "alienation" and "radical political jargon" to a misplaced reverence for the Goncourts and other "literary giants of nineteenth-century France," whose faults he exposes in a series of biographical "medical studies" premised on the idea that all these "distinguished French writers" suffered from syphilis. Confident that deviation from monogamy makes a man a "pathetic failure in love," Williams attributes the shortcomings of the Goncourts' fiction— "we do not warm up to them as beloved or admired writers"—to the way "they deliberately isolated themselves from the world" through their "bizarre brotherhood."[15] Such phrases as "retreat from existence" and "isolated . . . from the world" applied to men so undeniably caught up in the social swirl of nineteenth-century Paris exemplify how readily normativity mistakes itself for universality. Williams presents as self-evident proof of the Goncourts' pathology their professed disdain for democracy and delight in confounding patriarchal norms through a union in which "we are now like two women who live together, whose health is identical, whose periods come at the same time."[16] Art historians citing Williams have belittled the backward-looking Goncourt brothers as "resentful and bitter children of the nineteenth century" who "considered themselves born too late to enjoy the effervescent leisure and languorous sensuality that noble elites had enjoyed during the era of the *fêtes galantes*," and pathologized their dissent from the consensus of progress as a "convergence of their social critique and their psychological perversion."[17]

Such diagnoses of the Goncourts are useful primarily for revealing the normative boundaries policed around a modernism whose growth is imagined, by contrast, as healthy. From the late nineteenth century onward, modernist rhetoric has celebrated the avant-garde in masculine terms as individualist, competitive, and procreative both aesthetically and sexually, with the corollary that the "evolution" of modern art and the "improvement" of design for objects of daily life involve the elimination of individuals and elements denigrated as feminine or inverted, decorative or domestic.[18] In this system, it is unthinkable that *japonisme* could have originated in the practices of antique collecting and interior décor performed by a bachelor-brother couple whose self-described "marriage," most of it enacted as mourning, undercut

modernist teleologies of progress along with bourgeois domestic norms and ideas of gender. The painter Paul Cézanne, noting that Edmond lacked a "*bourgeoise*" (middle-class wife), followed the waspish Jules Barbey d'Aurevilly in dismissing Edmond himself as "*la veuve*" (the widow), a remark that was recorded and publicized by his influential dealer in a demonstration of a core dynamic of avant-garde self-definition, in which old-fashioned femininity is imputed to others as a way of bolstering the speaker's claims for avant-garde status.[19] Twentieth-century historians reenacted these nineteenth-century paradigms, disparaging the Goncourts' self-aggrandizing exaggerations in rhetorics equally extreme and counterfactual.[20]

Impulses to reject the Goncourts' chronological primacy among *japonistes* play out in misrepresentations of what *japonisme* is. The Goncourts are said to "have claimed that they were the first to introduce Japanese art to the West" so that this can be disproved by citing examples of Japanese art in European curiosity collections long before.[21] In fact, what the Goncourts claimed in the provocative style that made their coauthored journal such popular reading was this:

> The taste for *chinoiserie* and *japonaiserie!* This taste, we had it from the first. This taste, which today invades everything and everyone down to idiots and bourgeois ladies, who more than we propagated it, felt it, preached it, converted others to it? Who was enthralled by the first albums and had the courage to buy them?
>
> In our first book, [titled] In 18 . . . , a description of a mantel of Japanese bibelots earned us the honor to be labeled as some kind of baroque fools and people without taste, and caused Edmond Texier to demand our internment in [the asylum at] Charenton.[22]

What the Goncourts assert here is that they propagated a taste, that is, a mode of perceiving—what Wilde calls a style, that, like Barthes's "*faraway*," is not defined by accurate study of Japan. Chinoiserie and *japonaiserie* are jumbled together. The bibelots on their fictional mantel were Chinese— "two incense burners of Tonkin bronze"—whereas the Japanese decoration that later editions of the novel describe as "a very beautiful *japonaiserie*," which seemed to be painted by "some Philippe Rousseau of Yamato province" (this Rousseau was a well-known French painter of farmyard scenes), appeared in the 1851 first edition as "a very beautiful *chinoiserie*: on a background of black lacquer varnished like a holly leaf, some Philippe Rousseau

of Koueï-tchéou had thrown big swaggering roosters dashed out in five golden lines"[23] When the Goncourts insisted on their primacy in the history of *japonisme*, therefore, both the substance and the form of their claims were cast not as fact but as a performance of style characterized, first by their male collectivity, and then by their competitive hostility toward other critics (Texier), their antagonism toward institutions of social order (the asylum), and their contempt for everyone else—figured as "idiots" and "bourgeois ladies." This was the original tenor—unapologetically subjective, unmistakably homosocial, and virulently antagonistic—of the Parisian enthusiasm for Japan.

This journal passage was not published until 1888. By then it echoed claims Edmond de Goncourt had advanced in the introduction to his 1884 novel *Chérie*, which located *japonisme* firmly in brotherly bonds where mutual love and shared antagonism toward the outside world were inextricable. Here Goncourt invoked his brother's voice, recalling a conversation in 1870, just a few months before Jules's death. He sets the scene: The brothers are walking in the Bois de Boulogne, "a silent walk, as is taken in those moments of life between people who love one another and hide from each other their sad, fixed thought." Suddenly, Jules bursts out with a stuttering enumeration (registered by dashes and ellipses) of the brothers' accomplishments: first, they invented the realist novel; second, they sparked the revival of eighteenth-century French art and décor; finally, "That description of a Parisian room furnished with japonaiseries published in our first novel, in our novel En 18 . . . , which appeared in 1851 . . . yes in 1851 . . . —show me the *japonisants* of that era. . . ." Citing "our acquisitions of bronzes and lacquers at that time," Jules stresses the brothers' "discovery in 1860 at [the shop] La Porte Chinoise of the first Japanese album known in Paris . . . known, at least, to the world of writers and painters." Doesn't this purchase, and "the pages consecrated to things from Japan" in their books of the 1860s, Jules demands, make the Goncourts "the first promoters of this art . . . this art in the process, without anyone suspecting it, of revolutionizing the optics of occidental peoples?" These accomplishments, Jules concludes

after a pause and with a revived look of intelligent life in his eye,—these are the three great literary and artistic movements of the second half of the nineteenth century . . . and we brought them about, these three movements . . . we poor nobodies. Well! When one has done that . . . it's really difficult not to be *someone* in the future.

With that, Edmond's introduction concludes, "And, my faith, the dying man on the wide path of the Bois de Boulogne may well have been right."[24] In summary, the Goncourts' claim to have originated *japonisme* turned first on their observation of Japanese bibelots in middle-class décor in the 1850s, then on their introduction of Japanese prints to "the world of writers and painters" in the early 1860s, and then, importantly, on their association of these trends with other mid-nineteenth-century innovations, including realist fiction and the retro-fashion for eighteenth-century visual culture. Edmond's presentation of this argument as a "bitter and painful complaint" on behalf of "my poor brother" grounds his claims to have originated *japonisme* in the bonds linking alienated men.[25]

The Goncourts' claim to primacy was not all bluster. Their 1861 journal repeatedly records delighted perception of what seemed a startling new aesthetic:

> I have never seen anything so prodigious, so fantastic, so admirable and poetic as art. There are finely differentiated tones like the tones of plumage, brilliant as enamels; poses, *toilettes* [a term that denotes hair style and make-up], faces, women who seem to have come from a dream; the naïveté of a primitive style, ravishing and of a character that surpasses Albert Dürer. A magic fills our eyes like perfume the Orient. An art that is prodigious, natural, as various as flora, as fascinating as a magic mirror.[26]

A few months later, another journal entry admires "the ink sketches of Japanese artists, which have the spirit and picturesque touch of a chalk drawing by Fragonard,"[27] and references to Japanese art persist in the journal over the following few years. Although it cannot be claimed that the Goncourts—or anyone else in France—concentrated their attention on Japanese art in the early 1860s, the Goncourts have a credible claim to be the first to appreciate Japanese prints not as preliminary sketches, repertoires of stock images for decoration, or documentary records of nature or social mores, but as art in their own right with an aesthetic power comparable to—even surpassing—the West's.

Even the Goncourts' detractors grudgingly allow—as a "limitation"—their originality in assessing Japanese art as a tradition comparable to Western canons at a time when even writers promoting French interest in Japan accepted that "European art has nothing to learn from Japanese painting."[28] In January 1862, the Goncourts' third journal entry on Japanese art asserts, "Art is not

one, or rather there is not one single art. Japanese art is as great as Greek art." This entry goes on to compare Eastern and Western art: "Greek art, quite frankly, what is it? Realistic beauty. No fantasy, no dream. . . . Not that grain of opium, so sweet, so soothing to the soul, in these representations of nature or man."[29] The first published iteration of this claim for the supremacy of Japanese art came in the journal extracts anthologized in 1866 as *Idées et sensations*. Here an encomium to the extravagant fantasy of Japanese art is buttressed with a dismissive comparison to the monsters in Ingres's paintings and the proposal that the Japanese boast an ideal of the grotesque, equal and opposite to Western ideals of the beautiful.[30]

When Edmond de Goncourt published an edited version of the 1860s journal in 1887, he synthesized several entries on Japanese art into one, heightening the provocation in the comparison between Japanese and Greek art by attacking the "idealism that the Institute professors of art would lend" to Greek art. Emphasizing that the brothers' target was less Greek art than the meanings authorities attached to it, Goncourt dismissed scholars' idealizing gloss on the Classical sculpture now known as the Belvedere torso, saying, "the Vatican torso is a torso that digests humanly, and not a torso that feeds on ambrosia, as Winckelmann wanted to believe it to be."[31] This argument picks up on unpublished passages in the brothers' journal. After visiting a new museum established by Napoleon III in 1862, they wrote,

> Decidedly, I detest these Greeks and these Romans. It is the art they drummed into us. It represents above all an academic idea of Beauty. Academic people, academic art, academic era, all serve to bring glory and paychecks to elderly professors. This beauty brings on the boredom of maxims repeated as punishment—and I turn to leafing through a Japanese album, I dive into these colored dreams.[32]

Here it is explicit that the taste for Japanese art was both a challenge to authoritative Western cultural norms and a means of imagining alternatives. For the Goncourts, the taste for Japanese art distinguished outsiders from insiders. And you had to choose. About people who claim to respond to both Greek and Japanese art, the journal says, "My conviction is that they feel nothing."[33] To appreciate Japanese aesthetics was to distinguish oneself from academics, from the ideology of imperial museums, and from social norms more generally.

The Goncourts' journal entries cast their antagonistic delight in Japanese art as a bachelor taste. The rapturous 1861 passage, for instance, conflates the "differentiated tones" of the prints with the women they depict, "who seem to have come from a dream." An admiration shared between men for Japanese prints is an admiration shared between men for (the idea of) Japanese women and vice versa. Another passage from 1863 compares East and West in the distinctive voice of the brothers' collective bachelor I:

> The other day I bought some Japanese albums of obscenities. This delights me, amuses me, and charms my eye. I see it as outside obscenity, which is there, and seems not to be there, and which I do not see, so much does it disappear into fantasy. The violence of the lines, the unexpectedness of the combinations, the arrangement of the accessories, the caprice in the poses and props, the picturesqueness, and, so to speak, the landscape of the genital parts. Looking at it, I think of Greek art, boredom in perfection, an art that will never cleanse itself of this crime: *academicism*.[34]

A remarkable journal entry of 1864 encapuslates all these connections, linking the Goncourts' taste for Japanese art and eighteenth-century French painting (here personified by Jean-Antoine Watteau) with their alienation from bourgeois aesthetic and sexual norms:

> Strolling along the Boulevard at eleven thirty at night, I picked up this remark from a man to woman: "Farewell, my pineapple juice!"
>
> Chinese art, and above all Japanese art, these arts that seem to bourgeois eyes such an unbelievable fantasy, are drawn from nature itself. Everything they do is taken from observation. They render what they see: the incredible effects in the sky, the stripes on a mushroom, the transparency of a jellyfish. . . .
>
> Basically it is no paradox to say that a Japanese album and a painting by Watteau are drawn from the intimate study of nature. Nothing like this in the Greeks. . . .
>
> Eating a banana, one might say one is eating the clitoris of a fruit. [This remark was edited for the 1887 publication of the journal to "One might say one is eating more than a fruit."] All of it, right out to the skin, is artful! Everything from the Orient is like this.
>
> European nature seems like prison-work. Our little products, regular and methodic, seem like they were made on an assembly line.[35]

For the Goncourts, a taste for Japan took part in a broader challenge to Western norms, both sexual and aesthetic. Though this attitude may undermine projects to construct a "healthy" legacy for modernism, it cannot be wished away by banishing the Goncourts from chronologies of *japoniste* collecting, for it animates their popular fiction, which played a central role in setting the terms by which Parisians understood Japan.

The first Fictions of Japonisme

The idea of bachelor *japonistes* enthralled by their prints is central to the Goncourts' 1867 *Manette Salomon*, the novel that prompted Edmond de Goncourt to date the brothers' own Japanese print collection to the story's setting in 1852. Loosely based on the Goncourts' youthful experiences in the art world, this popular novel pioneered romantic clichés of the artist as a young man flouting middle-class familial norms in the garrets of Paris. In a pivotal scene in the shared studio and bachelor quarters of a trio of artists, the painter Coriolis de Naz flips through albums of Japanese prints. This scene warrants close examination as the first literary depiction of *japonisme*.

The setting is a winter day in Paris: "mournfully, infinitely, desperately gray," runs the narration in the first sentence of a long paragraph describing the oppressive "cold light" that "slips down from the shapeless plaster walls onto the palette that loses its colors, and then takes the painter's brush and replaces it with his pipe." In response, the painter Coriolis,

after several half-hearted attempts to work . . . would take from a credenza a handful of albums with motley covers embossed, stippled, or woven with gold and bound with silk thread. Throwing them to the floor, he stretched over them, lying on his stomach, propped on both elbows with his hands in his hair, he looked at them, leafing through these pages like ivory palettes loaded with colors from the Orient, mottled and dotted, gleaming with purple, ultramarine, emerald green. And a day in fairyland, a day of nothing but light without shadows, would rise for him from these albums of Japanese compositions. His gaze penetrated the depths of straw-colored heavens that bathed in fluid gold the outline of creatures and countryside; he lost himself in the azure blue that drenched the pink tree blossoms, in the enamel blue framing the snow-white flowers of the peach and almond trees, in the great crimson sunsets radiating blood-red rays, in the splendor of stars eclipsed

by a flight of migrating cranes. Winter, the gray of the days, the poor shivering Parisian sky—he left them behind; he forgot them on the shores of seas as clear as the sky on which rocked the dancing barges of tea drinkers; he forgot them in these fields of lapis boulders, in the greening of plants with their feet in the water near bamboo groves or flowering hedges that create a wall of huge bouquets. Before him unfolded a land of red houses with screens for walls, their rooms painted as if by nature, so simple and so lively, interiors shimmering and shining playfully with all the reflections from the varnished wood, the enameled porcelains, the lacquered gold, the tawny luster of the Tonkin bronzes. And all of a sudden as he gazed, a flowering page seemed to be an herb garden in the month of May, a burst of Spring freshly gathered, rendered in watercolor in the budding young tenderness of its color. There were zigzags of branches, or rather drops of color weeping tears onto the paper, or rains of characters falling and playing like swarms of insects in the rainbow of cloud drawing. Here and there, shorelines revealed shiny white beaches teeming with crabs; a yellow door, a bamboo trellis, a fence of bluebells hint at the garden of a teahouse; the capricious landscape tossed temples against the sky wedged on the crags of a sacred volcano; all the fantasies of the land, of plantlife, of architecture, of rocks, tear at the horizon with their picturesqueness. From the depths of Buddhist monasteries rays of light emerged and escaped in flashes, bursts of yellow throbbing with flights of bees. And gods appeared, their heads haloed with willow branches and their bodies vanishing in the cover of fronds.

Coriolis continued to leaf through the pages; before him passed women, some winding cherry-colored silk, others painting fans; women taking little sips from red lacquered cups; women looking into magic bowls, women gliding in little boats on rivers, calmly contemplating the poetry of the flowing water. They wore dazzling, soft gowns, the colors of which seemed to die out at the bottom, sea-green gowns with shells where the shadows of sea monsters floated, gowns embroidered with peonies and griffons, gowns of feathers, of silk, of flowers and birds, exotic gowns that opened and unfolded on the back like butterfly wings, twirled in swirling waves around the feet, clung to the body, or rather took flight while clothing it in a magical fantasy of heraldic design. Tortoiseshell pins stuck in their hair, these women displayed pale faces with powdered eyelids, their eyes raised at the corner like a smile; and leaning on balconies, chin on the back of the hand, silent, dreamy . . . they seem to chew over their life while nibbling an edge of their sleeve.[36]

The most striking aspect of this evocation of *japonisme* is its length. What is quoted here is almost all of chapter 47. This long passage is a short chapter devoted entirely to the idea that the consumption of Japanese prints offers an escape from modern urban life—and from embodied heterosexuality. This escape is proffered not just by what is depicted, although Japanese nature and culture—the latter in the form of domestic interiors—are presented as deeply attractive. The prints become an alternative ecosystem: "All of a sudden as he gazed, a flowering page seemed to be an herb garden in the month of May" watered by rains of pure color and calligraphic characters "falling and playing like swarms of insects in the rainbow of cloud drawing." With this reference to the visual integration of Japanese language into these images, the language of the French description—*"des gouttes de couleur pleurant en larmes sur le papier, ou des pluies de caractères jouant et descendant comme des essaims d'insectes dans l'arc-ciel du dessin nué"*—begins to fall and play in its own near-nonsensical cascade of fantasy, which then leads to the appearance of disembodied supernatural figures.

Disembodiment is key to the pleasures of the prints, in which no embodied images of men are acknowledged—a telling elision in this detailed ekphrasis given the frequency with which Japanese prints depict men. Here masculinity is embodied in the viewer, who lies on the floor with his albums, first delighting in their colorful wrappers woven in gold and stitched with silver, then opening them to reveal the landscapes and figures within. The evocation of sexual congress in the visual consumption of Japanese print albums persists in the way the images of landscapes merge with images of women, a transition illuminated by the invocation of the "picturesqueness" (*leur pittoresque*) of things seen on the horizon in the landscapes and the "picturesqueness" (*le pittoresque*) of "the landscape of the genital parts" in the Goncourts' 1863 journal entry about the album of erotic prints. But in this erotic dynamic, the female body is displaced. When women's bodies are not turning into landscapes, they are disappearing into the fantastic details of their costume. Neither heterosexual congress nor its pornographic simulacrum, the practice of masculinity enacted in the consumption of Japanese prints, is carried out—in this instance in an artist's studio with other artists—by men together.

The danger of introducing actual women into this homosocial community is the central theme of *Manette Salomon*. The novel's title character appears just briefly, as an unnamed little girl, in the first half of the book, which focuses on the three artist buddies (the novel's working titles—*Les Artistes* and *The Langibout Studio*—reflect this original emphasis). The book divides, significantly,

at the chapter about the Japanese albums. In contrast to the fluid fantasies of chapter 47, chapter 48 opens with the abrupt cries of a bus conductor announcing stops in modern Paris. Coriolis and his friend Anatole are seeking Manette, now grown to become a ravishingly seductive "Oriental"—that is, Jewish—beauty. The rest of the book traces her destruction of Coriolis's dignity, his friendships with men, and his artistic career. Thus, the pioneering *japonisme* of chapter 47 represents the apogee of a collective masculine ideal destroyed when Coriolis makes the mistake of moving from homosocial fantasies associated with timeless Oriental women to a relationship with a real one in the modern world. When, in 1868, Félicien Rops gave the Goncourts a drawing of a woman inspired by *Manette Salomon*, they praised him for recognizing "the contemporary woman's look of cruelty, her steely gaze, her ill-will towards men, neither hidden nor dissimulated, but demonstrated in her entire appearance."[37] The contrast with the fantastized women depicted in Japanese prints could not be starker.

ALTERNATIVE ORIGINS, OTHER FICTIONS

Shortly after the publication of *Manette Salomon*, the Goncourts were delighted to report the book was "a success, much to our surprise," though they noted it was not without its detractors, "who called us: Japanese!"[38] *Manette Salomon's* popularity is evidence of a reading public fascinated by the bohemian avant-garde that quickly became a definitive feature of modernism. Histories of modernism produced such overblown claims for the radicality of this avant-garde that it is worth noting that the young artists *Manette Salomon* depicts were not politically rebellious, and certainly not revolutionary. On the contrary, the milieu depicted by the Goncourts perfectly exemplifies sociologist Raymond Williams's analysis of the avant-garde as a "class fraction" of the bourgeoisie, its innovations arising from within the class that populates the art world and aimed at transforming—not overthrowing—that class.[39] The centrality of Japanese prints in the Gouncourts' paradigmatic portrayal of the avant-garde locates *japonisme* at the origin of this distinctively modernist social structure.

In retrospect, the only element missing from the Goncourts' paradigm-setting narration of the role of Japanese prints in the Parisian avant-garde is a description of Coriolis's acquisition of his album. But origin myths are called into discourse only after an ideology takes hold. The absence in *Manette*

Salomon of what became a much-rehearsed trope of purchase as discovery is evidence of *japonisme*'s incipience in the mid-1860s and thus confirms *Manette Salomon*'s foundational status in the history of the Parisian reception of Japanese art. When *japonisme*'s origin stories began to appear in the late 1860s, they centered on tales of men together in homosocial avant-garde networks that closely echo the one the Goncourts described. It could fairly be said that the fictional Coriolis and his friends—young painters, not eccentric bachelor-brother collectors—supplanted the Goncourts, their creators, in accounts of *japonisme*'s beginnings.

Japonisme's first origin story came in 1868 from the critic known as Champfleury in an article with the punning title "*La mode des japoniaiseries*" (the extra "i" invokes *niaiserie* [silliness] and *nier* [to negate]).[40] He cast an unnamed "strange poet and man of the world" with a love of brilliant colors as the man first attracted by the "bizarre colors of the goods displayed" at a little shop near the Tuileries in Paris—readers in the know recognized the allusion to Charles Baudelaire. "He entered, rummaged through the Japanese albums, sat down, engaged in conversation with the bored saleswoman, fanned himself with the fans, smoked a cigarette of horrible Japanese tobacco, and returned singing of Japan with all his might." Champfleury went on to explain that "every year this capricious poet invented some bizarre fancy to amuse himself for a few months," but, in this case, his enthusiasm became an "obsession, which throughout the time of his mania, he imposed upon all his friends." Among the friends who now crowded the shop, "rarely leaving the spot without taking with them some curiosity," was a young American painter living in London. This reference is to Whistler, whose Japanese purchases turned up in "Franco-American paintings that hurt the eyes of people naïve enough to take up the task of jurors for art exhibitions: since the colors were different and new, they turned up their noses." By rejecting Whistler's paintings, Champfleury concludes, the jurors turned "controversial Japan" into a school of art in its own right. This cycle of artistic notoriety into convention, his account emphasizes, began as a social bond among men: "the friends of the poet."[41]

The tone of Champfleury's narrative is ambiguous. Historians assess it variously as a fond reminiscence of a friend endeared by Baudelaire's "caprices," a satire of the "craze" for Japan, or a condemnation of the vogue for the "bizarre."[42] That this account went uncontested for a decade, however, underlines the nascent state of *japonisme* in the 1860s, when it remained too marginal to require an origin myth of unambiguous heroism. A decade later,

however, Champfleury's ambiguity and casual acknowledgement of how avant-garde tendencies are quickly institutionalized into their own schools required revision. This need was met by Ernest Chesneau, who in 1878 proposed a now-familiar chronology of *japonisme*: "In reality, it was through our painters that the taste for Japanese art took root in Paris, was communicated to the art lovers, to the fashionable, and in time imposed on the decorative arts." Chesneau spins this tale:

> It was a painter strolling around a shop of those Far Eastern curiosities that were then jumbled confusingly together under the common term of *chinoiseries*, who discovered in a recent shipment from [the French port of] Havre pages painted and pages printed in color, albums of sketches in which outlines stood out from fields of pale color with an aesthetic character—both in color and design—quite different from the character of the Chinese objects. This took place in 1862.

Chesneau admits he does not know which artist "first had the lucky hand, the penetrating eye to discover amid the confusions of dead China the clear lights of living Japan." It might have been Whistler, or it might have been someone else, he says. But he is sure it was a painter whose "enthusiasm consumed all the studios with the rapidity of a flame running along a trail of gunpowder."[43] Chesneau's description of the ensuing enthusiasm—"one could not keep oneself from admiring the unexpectedness of the compositions . . . the richness of tone, the originality of the picturesque effects"—echoes the attitudes the Goncourts gave their fictional artists. Chesneau had reviewed *Manette Salomon* when it was published in 1867, but he took no special note of "the writers Edmond and Jules de Goncourt" when he now listed them among the wave of collectors he insists followed the artists' lead.[44]

The appeal of the idea that an artist originated *japonisme* was quickly registered in Philippe Burty's 1880 novel of the art world, *Grave Imprudence*. Its protagonist, a bachelor artist, is "very proud" that he was the first to buy an album of Japanese colored prints depicting birds and flowers.[45] Also in 1880, a chatty column in the magazine *La Vie moderne* took up the question of "who was the first to discover Japan," first proposing the writer Théophile Gautier, who "did not want to give his name" to the phenomenon, so awarding the distinction to "our friend Bracquemond." In this account, the artist Félix Bracquemond "by chance" noticed a Parisian shipping agent who, "to protect his merchandise from the shocks of the voyage," packed it with albums of

Hokusai prints "that had already arrived wedged between who knows what products exported from Yokohama."[46] This anecdote became canonic in histories of *japonisme*. A quarter-century later, two articles by Léonce Bénédite, based on interviews with Bracquemond, assigned the date of 1856 to his discovery but shifted the setting to the workshop of the printer Auguste Delâtre, retaining the claim that, "because of its supple and elastic materials," the album of prints "had served to pack porcelains shipped by some Frenchmen established in Japan."[47]

Bénédite was determined to assert a date that would make Bracquemond the first *japoniste*. He begins, "In 1856—the date of the year is certain, though I do not know if Bracquemond could certify the month and the day—in 1856, one fine morning," and ends "Until then, in truth, one could rightly say that no one, absolutely no one, in France knew the art of Japan."[48] In fact, this date, two years before France established commercial relations with Japan, is dubious, and even in Bénédite's story, Bracquemond did not see the book of prints again for more than a year.[49] Scholars have proposed 1859 and 1862 as more likely dates for Bracquemond's discovery,[50] but the real problem with Bénédite's account is that he cannot decide what it means. Torn between the contradictions built into avant-garde conceptions of influence and originality, Bénédite asserts both that Bracquemond was "the inventor of Japanese art" and that "there was nothing to it really, and Japan intervened as a stimulant in Bracquemond's career only after that career was well underway."[51] These self-canceling formulations leave Bracquemond paradoxically the "inventor of Japanese art"—a Japanese art invented in France, hence clearly *japonisme*—unaffected by the Japanese aesthetics he supposedly made influential.

These competing and contradictory claims to name the Parisian who "discovered" Japanese prints have busied historians to uncover the kernels of truth around which the myths of *japonisme* grew. Scholars doubt that Hokusai prints were exported as packing materials around Japanese porcelains, noting that his works were expensive in Japan and banned from export, so that "clearly, cost and status precluded their use as packing for china."[52] Meanwhile the letters often cited as evidence of Parisian interest in Japanese prints in the early 1860s reveal a level of attention that barely qualifies as superficial. Baudelaire, giving Japanese prints as Christmas presents in 1861, compared them to "*images d'Epinal*," Breton woodblock prints that were a popular form of folk art, and advised that "framed in bamboo or red lacquer they make a great effect."[53] Some histories of *japonisme* cite the illustrations of artists, beggars, and peddlers copied from the little sketch-like Japanese prints known as

manga that appeared in the Baron de Chassiron's 1861 book, Notes sur le Japon, la Chine, et l'Inde, but Chassiron classified these as "natural history" illustrations with no suggestion of any aesthetic significance.[54] Also around 1860, and even drier than Chassiron's Notes, an edition of the Recueil de dessins pour l'art et l'industrie (Sourcebook of Drawings for Art and Industry) included motifs of birds and wildflowers identified as taken from Japanese screens, lacquers, and other objects, although they were copied from manga.[55] Delâtre printed the Recueil de dessins pour l'art et l'industrie, so it is plausible that manga—or reproductions of manga—could have been seen in his workshop in the early 1860s by Bracquemond or, for that matter, by Jules de Goncourt, who also printed his etchings, sometimes with Bracquemond's help, at Delâtre's studio.[56] But manga, although technically Japanese woodblock prints, and sometimes by "masters" like Hokusai, are not the colorful images the Goncourts put in the hands of their fictional artists or Chesneau described as consuming the studios of Paris like fire. And the Recueil's obfuscation of these manga sources with claims that the motifs came from more valuable decorative objects reinforces the point that manga did not seem artistically significant. In short, the expressions of delight in polychrome Japanese prints that animate the Goncourts' journal of 1861 remain the earliest documentation of what became japonisme.

Ultimately, however, debates over the timing and nature of the first sightings of Japanese prints are less significant in themselves than for what they reveal about the meanings attached to Japanese aesthetics in nineteenth-century Paris—and today. The prints-as-packing story, for instance, encapsulates two myths: one of Japan as a place so abundant in art and artists that it casually discards what look like masterpieces in the West, another of the avant-garde artist whose disdain for convention prompts him to find beauty where it is least expected. The same story turns up again applied to collectors associated with the avant-garde. Koechlin, who dismissed the Goncourts' "bragging," reported—implausibly—that Théodore Duret, one of the Impressionists' first critical champions, was shocked, years after visiting Japan in 1871, "when one day on the docks of London he noticed marvelous prints that were being used to pack merchandise in crates. They had never shown these to him during his voyage to Japan . . . at most, he might have noticed the gesticulating actors and variegated landscapes on tissue paper or in a few soiled albums. But this time it was something altogether different, and he sensed a work of art."[57] After Bénédite worked the prints-as-packing motif into Bracquemond's story, he insisted it was "Bracquemond's propaganda that made them sought out." Listing those Bracquemond attracted to

the shop, Bénédite acknowledged "the Goncourt brothers, who, primed by their eighteenth-century culture, rendered Japanese art the service of escorting it from the tangled limbs of curiosity and introducing it into the living realm of History."[58] Preserving the primacy of the artist as the first *japoniste*, Bénédite cast the Goncourts in a subordinate role linked to their association with the old-fashioned art of the Ancien Régime.

By the time the contest over *japonisme's* origins began around 1880, the Goncourts were famous—or notorious—for their high-handed iconoclasm, passionate advocacy of eighteenth-century culture, and eccentric bachelor coupledom, in which one of the brothers, though constantly invoked, had been dead since 1870. Those motivated to ensconce the *japonistes* in a heroic history of modernism sought alternative origin myths in—what sounds like an oxymoron but is not—avant-garde respectability by substituting individual artists for this strange male couple of collectors. Take Ernest Chesneau, the author of the influential account asserting *japonisme's* beginnings among unnamed painters. Although art history remembers Chesneau for publishing in avant-garde magazines and promoting Édouard Manet and the Impressionists, this political supporter of the Bonapartes was the press officer for the government-sponsored art academy, an affiliation so close that the academy's press releases were known as "Ernestines."[59] When he turns up in the Goncourts' journal entries of the early 1860s, it is as an affable guest at parties—and as the butt of jokes about his Christlike appearance and earnest devotion to his wife and numerous children.[60] For his part, Chesneau's two reviews of *Manette Salomon* in 1867 criticized the alienated and cynical depiction of modern painters, complaining that "the resulting picture is too dark" and urging the brothers to stress common human emotions. Chesneau concluded with a plea on behalf of the prototypical Parisian bourgeois: "I might wish that Monsieur Prudhomme might emerge from reading their books a little less upset."[61] If the Goncourts mocked Chesneau as a personification of convention, it is equally clear that this respectable art-world functionary rejected these cynical discontents as the originators of the *japonisme* he promoted as a salutary influence on French art and design.

Modernist art history sustained Chesneau's mythology, rehearsing tales of individual artistic creativity in order to ground accounts in which artists "influence" the taste of collectors and critics, whose secondary role as "followers" of trends is gendered feminine by association with consumption and domestic display. Readers might never guess from the secondary literature that Bracquemond and the Goncourts—Edmond in particular—were friends

(or that Braquemond's art was strongly oriented toward designs for the decoration of ceramics in a wide variety of styles).[62] By the 1970s, Anita Brookner's assertion, in an essay on the Goncourts, that "credit for the taste [for Japan] is generally, and rightly, given to the painters Bracquemond, . . . Monet and Whistler" exemplified the twinned art historical reflexes to attribute innovation to famous artists and to upgrade those—like Bracquemond, and, arguably, Whistler—who were primarily known as designers or printmakers to the status of "painters."[63] The catalog for a groundbreaking 1975 museum exhibition on *japonisme* left the Goncourts unmentioned while awarding "considerable credence" to the story of the "discovery" of Japanese prints by Bracquemond.[64] Klaus Berger's influential 1980 history of *japonisme* followed what he called Chesneau's "compass" in order to rule the Goncourts out of the ranks of *japonisme*'s 1860s "pioneers and visionaries."[65]

JAPONAISES AND JAPONISTES: WOMEN IN THE SPACES OF JAPONISME

If the ideologies of the avant-garde inflected origin stories for *japonisme* away from the eccentric homosociality of the Goncourts, the alternatives they favored were no less homosocial—but their masculinity was far more normative. In Champfleury's account, Baudelaire's discovery of Japanese art resulted in a vogue among "the poet's friends." For Chesneau, the single— albeit unknown—male painter's discovery of Japanese prints led to a "group of artists and critics" who came together around 1868 for monthly dinners under the rubric of the *Société japonaise du Jinglar*. Bracquemond and Burty were among the eight members of the Jinglar, along with Zacharie Astruc, who in 1867 wrote some of the first French articles on Japanese art.[66] Adopting fanciful versions of Japanese customs for their meetings, the men ate with chopsticks and, in Chesneau's words, "drank only the national *sake* from which the name of the society derived."[67] The mock-Japanese name Jinglar referenced *sake* with a variation on *ginglard*, slang for a cheap, sharp wine that supposedly provoked its consumers to *ginguer*—dance a jig.

The few archival traces of the *Société japonaise du Jinglar* reveal something far more ribald than the group's presentation in histories of *japonisme* as a "private club devoted to understanding Japanese art."[68] Letters announcing the monthly meetings spoof military summons; one concludes, "Those who do not fulfill their duty will immediately see their behavior denounced to the

Mikado, the Tycoon, and all the thunder-bursts of Japan."[69] A *sake*-centered poem attributed to Astruc and dedicated to Bracquemond casts the society's eight members as *bonzes* (Japanese monks):

Le Jinglar est une liqueur	Jinglar is a liquor
Faite pour écumer aux bronzes;	Made to foam in bronzes
Elle exalte, à Paris, le coeur	In Paris it lifts up the heart
Et l'art précieux de huit bonzes.	And the precious art of eight bonzes.
Les Bouddhas, sous les pins géants,	The Buddhas under giant pines,
Dans les fleurs du lotus magique,	In the magic lotus flowers
L'adoraient—leurs regards béants	Adored it—their wide-eyed gazes
Remplis d'un songe léthargique	Filled with a lazy dream
Salut! vin des mystérieux	Hail, wine of the mysterious
Par toi s'éclairent nos délires	You illuminate our revels
Maître des pinceaux et des lyres	Master of the brushes and the lyres
Tu viens du Japon glorieux	You come from glorious Japan
Evoquant de nouveaux usages	Summoning new customs
Pour être chanté des Sages.	To be hymned by Sages.

A print by Jinglar member Marc-Louis Solon confirms the Society's identity as a men's drinking club and makes explicit its organization around an aesthetic associated with a mystified, exotic, and erotic femininity that excluded actual women. In Solon's image (figure 1.1), the Jinglar is a circle of eight drinking cups, each engraved with the initial of one of the group's members, arrayed around the voluptuous cloud-borne figure of a nude Japanese female who fills the cups with the blood flowing from her belly as she commits ritual suicide. This composition of the men's wine cups arranged around an "erotico-blasphemous" image of the "licentious geisha" (to quote one scholar's apt terms) offers graphic proof of *japonisme*'s origins as a form of masculine sociability forged around a self-consciously fantastical idea of Japan.[70]

The homosociality of *japonisme* is elso evident in what goes unsaid. Throughout more than a century of debates over who should be in the roster of original *japonistes*, one point is assumed: they were all men.[71] And yet, to return to *japonisme*'s originary moment is to discover a female as central—and perhaps as mystical—as the Jinglars' symbolic geisha. When

FIGURE 1.1 Marc-Louis Solon, *Société du Jing-lar*, c. 1868. Etching. Private collection.

the *japonistes*—and their apologists—argued over who "discovered" Japan in a Paris shop, the shop they referred to was personified by its owner and chief operative, Madame Desoye. Memoirs and letters refer to this enterprise as "Madame Desoye's" or "*chez La Japonaise.*"[72] Although there was a Monsieur Desoye, he goes unremarked in descriptions of the shop during his lifetime, and after his death around 1870, his widow continued the business until 1887.[73] The fictional *japoniste* painter in Burty's 1880 novel *Grave Imprudence* buys his first album of Japanese prints in "Madame Desoye's shop on her arrival from Japan."[74] Champfleury's account of Baudelaire's encounter with Japanese prints opens with the assertion that "everyone must know the influence of Madame D, known as *La Japonaise.*" In this telling, Baudelaire made the shop famous. On his first visit, he "engaged in conversation with the bored saleswoman," and his enthusiasm changed her life, "the poet's friends never anymore forsaking the little shop and rarely leaving the spot without taking with them some curiosity," with the happy result that "the woman's boredom disappeared."[75] But what might *La Japonaise* have said that would have so intrigued the poet in the first place?

Madame Desoye might have spoken of Japan, about which she apparently knew a lot. When the visiting Englishman William Michael Rossetti in 1864 recorded in his diary a visit "to Dessoye's [*sic*], the Japanese shop in the Rue de Rivoli," he reported, "Madame Dessoye told me some particulars about Japanese matters." She was able to explain who was depicted in Japanese prints—"a figure with a robe figured with leaves of a tree is the Tycoon (pronounced with the English 'i')"—as well as the uses of Japanese ceramics—"Boyce's teapot is a marriage-pot used on those occasions only." Rossetti says that Madame Desoye's information came from "the Japanese Ambassadors," a reference to a diplomatic mission that year that tried to persuade the French to help Japan defend Yokohama harbor against the Americans.[76] But accounts by the mission's members tell a different story. Strolling the streets near their hotel, four delegates reported that they "visited a shop which sold only goods from our country. The shopkeeper could understand Japanese a little. . . . We were told that his wife understood Japanese very well, but she was not there that evening. We heard that they had stayed in Yokohama for three years."[77] Given their mission's purpose, these officials may have been nonplussed to discover such evidence of the Yokohama trade in Paris, and they did not record a return visit. The embassy's barber evinced no such qualms, however. His account of repeated visits to the store selling Japanese goods reports that

there was a girl aged about 17 or 18 in the shop. I learned that she had lived quite a long time in our Yokohama since her childhood and had mastered Japanese well. As I went there from time to time, she asked me in a manner really like that of a Japanese girl whether my parents were alive or whether I had brothers. Once, when she asked me to what Buddhist sect I belonged, I answered that it was the Hokke sect. Then she announced that this was a very noisy sect! If even young girls are thus well informed, there must be people in the West engaged in Japanese studies and making *waka* poetry. I was indeed dumbfounded.[78]

Although these accounts do not name the store's proprietors, and too little is known about Madame Desoye to know if she could have passed for a teenager or grew up in Yokohama, no other shop in Paris in 1864 could have offered Japanese visitors this experience of familiarity with their home culture.

Supplementing her expertise about Japan, Madame Desoye developed a comprehensive knowledge of her clientele and their collections, which she used to stoke their competitive acquisitiveness. Dante Gabriel Rossetti (William's brother) reported after a visit to the Desoyes' in 1864, "The mistress of the shop . . . told me, with a great deal of laughing about Whistler's consternation at my collection of china."[79] Whistler emerges the victor in another story of Madame Desoye's competitive collectors: Edmond de Goncourt recalled that the artist arrived at a dinner party carrying a fan she sold him despite having promised it to his fellow diner Zacharie Astruc.[80] If one were fairly to assess who in Paris in 1864 had the strongest claim to expertise about Japanese art and its European collectors, the pre-eminent *japoniste* would likely be Madame Desoye.

This was not the judgment of the chroniclers who consolidated the tales of *japonisme*'s origins, however. Like the Goncourts, Madame Desoye was written out of the story. Bénédite's account of Bracquemond's primacy in discovering Japanese prints used the term *pacotille*—haphazard or shoddy merchandise— to describe the goods the Desoyes shipped to Paris supposedly packed in Japanese albums, and he insisted that the merchants unpacked and exhibited their wares "without understanding, certainly, their artistic value."[81] The memoirs of Raymond Koechlin, who was too young to know Madame Desoye or her shop, repeat the term *pacotille* to describe her goods as he disparages the stories told by "honorable Parisian shopkeepers" about the "masterpieces" of Japanese art they had "pillaged": "The merchants played a good hand in spreading such a pretty story, since no one went there to see, and the humblest art lover

in Paris could flatter himself, if he had the heart to, in owning the spoils of illustrious lords of the Far East."[82] Such twentieth-century accounts reinforced the authority of artists and experts by ignoring the testimony of nineteenth-century observers, from the Rossetti brothers to the members of the 1864 Ikeda Mission, who were struck by Madame Desoye's knowledge about Japan and its exports.

There was more than erudition at the heart of Madame Desoye's appeal to the *japonistes*, moreover. Champfleury's description of her establishment records that "the afternoons rolled by in dissertations about Japanese art intermingled with compliments for the lady."[83] Assessing this "personage of almost historical stature," Edmond de Goncourt described "that store in the rue de Rivoli, where the fat Madame Desoye sits enthroned in her jewels like a Japanese idol!" Her shop, Goncourt says, "was the place, the school so to speak, where this great Japanese movement, which today extends from painting to fashion, developed." And the "originals"—among whom he names Baudelaire, Burty, and "my brother and myself"—were "as in love with the shopkeeper as with the trinkets." Goncourt continues,

> In that shop of oddities so prettily made and always caressed with sunlight, the hours passed quickly in looking at, turning over, and handling things made delightful to touch; and all that amid the chatter, the laughter, the crazy outbursts of that comic and bawdy creature circulating around you, rubbing up against your chest, interrogating while jostling you with her potbelly.
>
> A good girl and a better saleslady was that white Jewess, who revolutionized Japan with her transparent complexion—and whom those stricken with the fevers of that country, when she brought quinine, believed very sincerely to be the Virgin Mary appearing in the Far East.[84]

This memory echoes the *japoniste* tropes laid out in *Manette Salomon*: associations of Japanese objects with sunlight, the tactile pleasure of turning things over to reveal something unexpected, the flouting of conventional forms of language and expression (*pouffements fous* [crazy outbursts]), all related to a female allure that is sensual without inviting heterosexual response. Madame Desoye embodies a transgressive excess of femininity—she is fat, covered with jewels, bawdy, intrusive with her questions and pushy potbelly—that easily overwhelms the conventional femininity of the Virgin Mary, for whom this "Jewess" is mistaken by hallucinatory Occidentals in Japan.

More interesting than the sexy, suicidal geisha conjured by the Jinglar Society, Edmond de Goncourt's evocation of Madame Desoye as "La Japonaise" might also be characterized as an "erotico-blasphemous" idol around whom the original *japoniste* men congregated, drawn by the challenge to convention she embodied. Like the Jinglar Society, her shop—or "school so to speak"— offered a site where men bonded in temporary, colorful reprieve from gray days in Paris, with all that the climate symbolized about bourgeois propriety. But it could not last. One salient difference between the Jinglar club and Madame Desoye's shop is that the latter did not limit its membership. Goncourt complained in 1875 about the expansion of Madame Desoye's clientele beyond the all-male "originals" he named to include "following us, the band of painters of fantasy" and "finally, the fashionable men and women who pretend to have *artistic natures*."[85] A few years later, he described the showrooms of her upscale successors as brothels where "high society lovers find a meeting place," recalling how "Madame Desoye's japonaiserie business benefited a great deal from the *chance* encounters that took place there between men and women who came in to see, to buy a bibelot."[86] Unlike Madame Desoye, these "high society" dealers were all men who socialized as equals with their clients and were taken seriously as *japonistes* at the time and by historians since.[87]

This transformation of the sites of *japonisme* from avant-garde venues to gathering places for ladies—women from the same class as the male *japonistes*—parallels shifts in the dynamics of *japonisme* itself. As early as 1872, a fashion plate in the magazine *La Mode Illustrée* showed well-dressed women in a shop displaying Asian goods,[88] and through the 1870s, enthusiasm for Japanese art expanded beyond all-male groups of amateurs. The supplanting of feminine mystifications by actual middle-class women created a crisis for the meaning of *japonisme* so fundamental that, in some scenarios, it destroyed the allure of Japan altogether. This is the plot of the first *japoniste* opera, Camille Saint-Saëns's two-character (plus off-stage soprano chorus) *La princesse jaune*, which premiered in 1872. The painters' studio in *Manette Salomon* finds an echo in the setting: a studio in a bourgeois house, where, with a gray snowy day visible through the windows, Kornélis writes poems while his cousin Léna paints porcelain. This room is dominated by the image of a Japanese woman described in different stagings of the opera as a statuette or as a painting on a panel, cabinet door, folding screen, or fan—such is the interchangeability of *japonaiseries*. Whatever the medium, the image enthralls Kornélis, who writes it love poems in Japanese. The opera opens as Léna, who is in love with Kornélis, discovers these poems and reads—sings—them out

loud in great distress. In the next act, Kornélis, alone in the room, falls into a reverie while gazing at the Japanese image. When Léna returns and starts to paint her vases, Kornélis hallucinates that she is the Japanese maiden and that he is in Japan. The libretto calls for Léna's dress to become a kimono while the scenery transforms, following the words of his song, into a Japanese house and garden, complete with "bronze monsters that defend the boundary of the garden all in flowers." The depicted Japanese figure, meanwhile, becomes Occidental. Léna's delight in Kornélis's amorous attentions turns to horror when she realizes he is hallucinating. As he awakes, Kornélis realizes his error and declares his love for her. After briefly worrying that he will be attracted next by a dancer from the Ganges, a "white houris," or an Ethiopian with "wooly hair blacker than the night," Léna is reassured by his renunciation of japonisme—"to the devil with Japan!"—and allows herself to be taken into his arms.[89]

"This innocent little work was greeted with the most ferocious hostility," Saint-Saëns recalled; it was given just five performances.[90] The critical rejection of La princesse jaune is usually ascribed to the music, which evoked Japan through an innovative use of bells and the first deployment of the pentatonic scale in European opera.[91] One critic objected to "the great wealth of effects but no melody," and Saint-Saëns reported that another complained that he could tell neither the key nor the time signature of the overture.[92] But criticism of La princesse jaune partook in the language of anxious masculinity. It was dismissed as an "infantile puerility" and "an emasculated [Charles] Gounod, without depth and without color."[93] Accusations of childish unmanliness anticipated more explicit attacks on Saint-Saëns's sexuality during World War I, when his disparagement of German music was countered with imputations of his homosexuality. A recent biography of Saint-Saëns speculates about his brief, unhappy midlife marriage to the sister of a man with whom he took "frolicking swims" at the floating public pool in the Seine this way: "He may have forced upon himself a confusion of brother and sister . . . just as Kornélis confuses the figurine and real girl in La princesse jaune."[94] A complementary line of analysis might relate critics' anxieties about the opera's masculinity to its failure to sustain the homosocial fictions of japonisme. Léna—a middle-class young woman who, with her fashionable vase painting, is a japoniste in her own right—destroys the fantasy of the masculine dream featured on posters for the opera (figure 1.2). Her presence locates japonisme solidly in the bourgeois domestic sphere, shattering its escapist effects by returning Kornélis to a conventional romance plot that

FIGURE 1.2 Poster for Camille Saint-Saëns's opera *La princesse jaune*, 1906.

binds him to middle-class hearth and home. At the same time, Léna's words debunk *japonisme* as just another fantasy for men, along with Indian *bayadères*, Persian *houris*, and black-haired Ethiopians.

Saint-Saëns's *La princesse jaune* is today overshadowed by another *japoniste* opera, Puccini's 1904 *Madama Butterfly*. Here, too, the Western wife is cast as the ruthless destroyer of a male fantasy of romantic immersion in a feminized Japan, a punctured ideal simultaneously indulged and mourned by the suicide of the title character. In real life, the male *japonistes* did not surrender without a fight. From the mid-1870s on, avant-garde painters disparaged European women who took up Japanese aesthetics as unladylike. Édouard Manet's 1877 *Nana*—a depiction of a prostitute from Zola's novel *L'Assommoire* of the same year—stands before a Japanese screen decorated with cranes, *grues* in French, slang for prostitutes. The same screen, augmented with Japanese fans, is the background of Manet's 1874 *Woman with Fans*, a portrait of the scandalous Nina de Villard, whose friends and lovers included many in the Parisian avant-garde. The implications of the painting

were clear enough that her estranged husband intervened to stop Manet from exhibiting the painting, which remained out of sight in his studio until his death. More fans depicting cranes and geishas formed the background for Claude Monet's life-sized *La Japonaise* (originally exhibited as *Japonnerie*) of 1876 (figure 1.3). Here a woman, modeled by Monet's wife, tosses a flirtatious glance over her shoulder as she twirls toward the viewer in a kimono embroidered with a strangely lifelike image of a warrior unsheathing his sword. Monet here rendered his dark-haired wife as a blonde, recalling Goncourt's description of Madame Desoye—another Frenchwoman known as *La Japonaise*—as *la blanche Juive* (the white Jewess). The painting was a sensation with critics, who relished the sexual implications of the "two heads, one of a *demi-mondaine* on the shoulders, the other a monster placed we dare not say where," and Monet begged Manet's brother in a letter not to repeat something Monet told him for fear of gossip about the image, which he later called "*une saleté*"—filth.[95]

Monet's painting was notorious enough to be evoked in Burty's novel of *japonisme*, *Grave Imprudence*, in which the artist Brissot paints Pauline

FIGURE 1.3 Claude Monet, *La Japonaise*, 1876. Oil on canvas. Museum of Fine Arts, Boston.

against a gray background wearing a Japanese mask and "looking behind her, over her shoulder" in a kimono "embroidered across her lower back with a cardinal-red crayfish on a bed of shrimp," its "orangy red" lining setting off her skin "like a white peony in a fistful of red poppies." Burty's narration makes the connotations of Monet's painting explicit. Seeking to avoid the "glacially provocative nudity" of Classical figures, his fictional artist paints a modern woman degraded by ignorance and sex. He "wanted no mistaking the subtle expression of the subject," insisting that "his figure of a courtesan must be naïve in her vile purpose." Although, in the novel, the painting goes unfinished when Pauline—having given up on Brissot as "trop 'Monsieur'" for marriage—returns to her fiancé, the sketches make the artist famous.[96]

It might be going too far to claim, as Michel Melot does, that the entire purpose of nineteenth-century japonisme was to render upper-bourgeois indulgence in prostitution acceptable—or at least equivocal—by associating this practice with the status of art, although Melot's analysis of how Henri de Toulouse-Lautrec's lithographs challenged that mechanism of idealization is astute.[97] But Melot's emphasis on the way japonisme aestheticized prostitutes can be turned around to argue that reiterated associations of japonisme with prostitution worked to protect avant-garde japonisme from middle-class wives. Certainly, male japonistes anxious to distinguish feminine fashions and domestic rituals from their practices of collection, connoisseurship, and carousing were quick to attach pejorative associations to women's interests in Japan. If, by the 1880s, associations between licentious women and japonisme became too numerous to catalog, so too did art-world complaints about abuses of the taste for Japan committed by—or for—middle-class women. Prints by japoniste artists literalized the growing feminine fashion for Japan with images of Western ladies overwhelming Japanese things.[98] In Henry Somm's 1881 Japonisme, a fashionable Parisienne in a huge bonnet towers over tiny Japanese men who emerge from an album to hail her with a fan, lantern, and cup of tea (figure 1.4).[99] Henri Guérard, a few years later, depicted a crowd of miniature Japanese workmen drawn from manga who explore a giant woman's shoe as if it were the proverbial elephant investigated by blind men (a motif he also illustrated) (figure 1.5). Incongruous juxtapositions of scale in both these images suggest the overwhelming threat Western women posed to japonisme.

Anxieties over gender and japonisme ricochet wildly though an 1882 article by the jeweler Lucien Falize, another man who claimed "that intimate

FIGURE 1.4 Henry Somm (François Clément Sommier), *Japonisme*, 1881. Drypoint etching. Metropolitan Museum of Art, New York.

FIGURE 1.5 Henri-Charles Guérard, *The Assault of the Shoe*, 1888. Etching, 167 × 252 mm (image/plate); 199 × 281 mm (sheet). Restricted gift of Anne Searle Bent, 2009.663, Art Institute of Chicago. Photograph © Art Institute of Chicago.

satisfaction of being among the first to understand" Japanese art. He complains that "Japan opened itself to us and, while a small group of artists thrilled and rejoiced at the fresh scents of that virgin art, fashion, that ever-alert panderer, seized the new idea, turned it over to commerce, prostituted it in the boutique, rolled it in the mud of the lowest craftwork, stripped it, dirtied it, and the poor girl, ashamed, sprawled across our discount shops."[100] Here *japonisme* figures as a washed-up prostitute, violated not by men, but by her commerce with "*la mode*"—fashion, from the "boutiques" to "discount shops," all associated with middle-class female consumers. This metaphor tellingly follows another in which this *japoniste* of the 1860s now finds "my love is not extinguished, but it is calmer, as happens when the fever of possession has calmed and one sees in broad daylight one's mistress of the night before: she is still beautiful, smiling and full of grace, but one hesitates to take her as a wife." Addressing the masculine community of *japonistes*, Falize asks,

> Haven't we, all of us artists, cohabited to some degree with the Japanese fairy? Hasn't each of us had children born of that love? The little ones so resemble their mother that it would be criminal to repudiate her, but, before giving them our name, making her French through marriage, let us check to make sure she is not already too demanding a mistress, and if in this household we would know how to dominate her enough to remain masters at home.

Assuming the blasé tone of a man of the world, Falize—as Léna in *La princesse jaune* predicted—seems willing to move on to other exotic lovers in accordance with tastes that change "every four or five years." Falize's construction of *japonisme* as doubly unladylike—both threatened by and threatening to standards of middle-class femininity—registers the *japonistes'* panic over the intrusion of women into the spaces of masculine fantasy. His reluctance to marry "the Japanese fairy" inscribes *japonisme* as a bachelor taste.

If prints and polemics registered the problem of women's intrusion into the spaces of *japonisme*, one solution was to reify the fantasy of *japoniste* masculinity in private. The decade between the mid-1870s and the mid-1880s saw the realization of a number of bachelor residences as evocations of Japan.

BACHELOR JAPONISTE QUARTERS, PART I: THE HOUSE-MUSEUM OF HENRI CERNUSCHI

Henri Cernuschi's *japonisme* grew from an extravangant act of homosocial mourning. Japan was the first stop on a journey to Asia undertaken by this fifty-year-old economist, banker, and republican revolutionary in 1871 after the collapse of the Paris Commune following the Franco–Prussian War. During those chaotic days, Cernuschi and his friend Théodore Duret were arrested and sentenced to death while trying to rescue another friend, Gustave Chaudey, from prison. Although they escaped, they learned Chaudey had been executed the night before. In the months afterward, Cernuschi was unable to work or sleep. "The atrocious loss I suffered of Chaudey decided me on this absence," he wrote to explain his departure for Asia.[101] Duret echoed Cernuschi, telling the painter Camille Pissarro, that having "lost a great friend . . . I have only one wish, to leave, to flee Paris for a few months."[102] The two bachelors set out for Asia in September of 1871.

Cernuschi and Duret claimed they knew nothing of Asian art and had no plans to collect when they left. Asserting their status among the first *japonistes* (of course!), Duret later claimed that at the time, Japanese art was "almost unknown in Europe. We had only seen a few rare objects displayed at the Exposition of 1867" and "the name Hokusai had emerged only among a few researchers. . . . We therefore left Europe knowing nothing of hitherto hidden Japanese art."[103] In fact, Duret had reported on the Japanese exhibits at the Great London Exposition as early as 1862.[104] But claims of shared discovery animate his published account of their trip:

> As soon as we disembarked at Yokohama, we began buying bibelots. That is the first thing Europeans setting foot in Japan do. We began like everyone, without a fixed plan, without preconceived notions, going along a bit by chance, although we were quickly attracted to the bronzes.[105]

By the time they headed home in October 1872, Duret bragged to Manet, "Cernuschi is bringing from Japan and China a collection of bronzes the like of which has never been seen anywhere. There are pieces that will bowl you over; that is all I am telling you!"[106] Cernuschi's purchases—over nine hundred crates containing approximately 1,500 bronzes, followed by an equal number of ceramics purchased by an Italian silk trader who was traveling

around in Japan—constituted a collection critics hailed as "more than in all the museums of Europe put together."[107]

A collection this large was clearly intended for display. But Cernuschi did not offer it to a museum. Instead, in 1873, he commissioned an unusual house to showcase his Asian bronzes and ceramics, along with textiles, hanging scrolls, and ivories. In a huge central room—twenty meters (sixty-six feet) long and twelve meters (forty feet) high—tiers of shelves filled with metalwork were presided over by a monumental bronze Buddha, four and a half meters (fourteen feet) high (figure 1.6). If its position on a raised plinth evoked a Japanese temple, this was a temple devoted to the ideals of the collector.

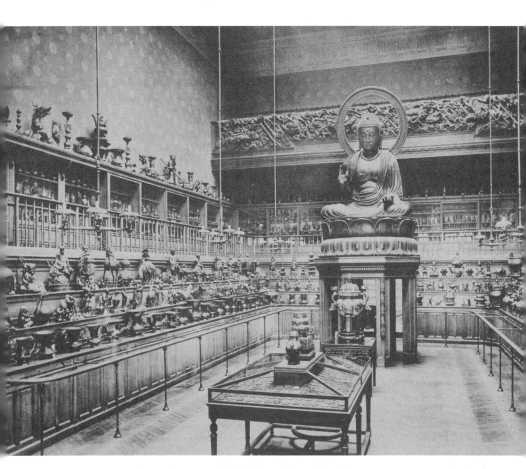

FIGURE 1.6 Musée Cernuschi, Buddha Hall, c. 1897. Pierre Despatys, *Les musées de la ville de Paris* (1900).

Cernuschi sited his house museum just outside the Parc Monceau on a gated one-block avenue of mansions that epitomized the displays of wealth that made *Monceau* slang for the newly rich.[108] To this day, his house stands out from its mansard-roofed neighbors for its severe Neoclassical style, evocative of Cernuschi's native northern Italy (figure 1.7). Below the roofline, sculpted herms—allusions to the bearded god Hermes, thus associated with phallic power and the luck of travelers—resemble Cernuschi himself, who was described by a contemporary as "a wiry great devil, long-haired and bearded with laughing eyes sparkling with good humor."[109] On the *piano nobile*, polychrome mosaics depict Aristotle and Leonardo da Vinci, twin avatars of Cernuschi's energetic rationalism (figures 1.8 and 1.9). Cernuschi's republican ideals were encoded on the bronze double doors at the entry, which were decorated with plaques inscribed with the words *Février* and *Septembre*, the months in which republican governments were established in France (in 1848 and 1870). Newspapers reported that the "soberly elegant and noble" façade and "roof in the Italian style" expressed

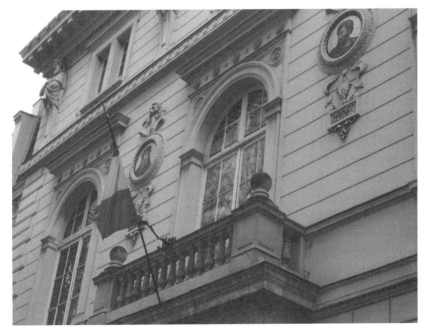

FIGURE 1.7 Musée Cernuschi, façade detail. Photograph by Christopher Reed.

FIGURE 1.8 Musée Cernuschi, façade decoration of Leonardo da Vinci. Photograph by Christopher Reed.

FIGURE 1.9 Musée Cernuschi, Buddha Hall ceiling. Photograph by Christopher Reed.

Cernuschi's personality as explicitly as the plaques that "attested to the immutable tenacity of his ardent convictions."[110]

This architectural language continues on the interior, where the hall of the "Great Buddha," flooded with light from a massive neo-Palladian window, evokes the *portego* of a Venetian palace. Above the Buddha, Neoclassical ceiling coffers bear escutcheons with the phrase *"Libertas et Virtus"* (figure 1.10). Plaques naming the Asian cities Cernuschi visited—Japanese on one wall, Chinese on the other—create a frieze below this ceiling (figure 1.11). Painted decorations around the ceiling of the staircase center on the names of continents—Asia, Europa, America—crossed with palms of peace. East Asia is here structured by an architecture linking Italian grandeur with cosmopolitan Enlightenment ideals.

As central to Cernuschi's identity as his Italian roots and republican ideology was his status as a bachelor. Despite its imposing central interior space, his house on a narrow lot that was the last site to be developed on the elite Avenue Vélasquez is noticeably smaller than the vast dynastic residences nearby, its scale indicative of its status as a *"maison de célibataire"* (bachelor's residence).[111] Cernuschi's own rooms—a study and a bedroom—were adjacent to the Buddha hall, and, like it, lined with shelves displaying objects

FIGURE 1.10 Musée Cernuschi, façade decoration of Aristotle. Photograph by Christopher Reed.

FIGURE 1.11 Musée Cernuschi, Buddha Hall frieze panel. Photograph by Christopher Reed.

from his collection. Contemporaries were struck by the undomestic character of this nominally domestic space. One recalled,

> I wager that visitors to the Cernuschi museum thought that the host . . . did not live in the décor they observed. Nevertheless he lived there . . . among these monstrous divinities, between furnishings that were primarily display cases. One hardly dared sit on a chair, so much did one have the impression it must be the guard's.[112]

Cernuschi's bedroom sparked consistent—if conflicting—comment. One account, marveling over Cernuschi's simple habits, describes just a cast-iron bed and plain table; another, focusing on the "pitchers, kettles, and vessels associated with tea" displayed on shelves around the walls, reports that his room was called the "hall of teapots"; a third says it was entirely hung with Oriental silks.[113]

"In this sumptuous domicile, amid his collection, the spirits, the gods and the goddesses, Cernuschi lived tranquil and serene. There he often hosted meals and parties for friends, artists, literary people, financiers," avers his biographer, quoting the reminiscences of theater manager Jules Claretie about a luncheon for actors "amid the Japanese marvels gathered

at the house."[114] According to journalist André Maurel, "Cernuschi . . . did not much like to allow his domicile to be penetrated by the varied curious types his collections attracted. Journalists above all were excluded for fear of their articles! One had to be among his friends to be received."[115] But this socialite had a lot of friends. Visiting Cernuschi in 1883, the American Japanist Edward Morse characterized him as "an old bachelor," and reported, "Breakfast for fifteen or twenty is served at 12; certain of his friends have a standing invitation to come in any Sunday."[116] Maurel recalled an occasion in 1889 when "a crowd—a *select* crowd—was admitted to circulate through the house" at a costume party attended by 2000 guests.[117] At this event, Maurel, dressed as a choirboy, was hoisted on the shoulders of a man in blackface to retrieve a rose someone had thrown into the great Buddha's outstretched hand; later, the republican politician Léon Gambetta "harangued the crowd at the foot of the Buddha. It was an orgy of lights and oriental furnishings."[118] Louis Gonse, whose pioneering survey of Japanese art illustrated items from Cernuschi's collection, remembered attending one of Cernuschi's parties costumed as a Japanese nobleman in a *Noh* mask and elaborate eighteenth-century kimono, accompanied by Tadamasa H̲ayashi, a leading dealer in Japanese art, "disguised as an old beggar with a wrinkled head and quivering jaw. The effect was irresistible."[119] Guests at another gala included the neurologist Jean-Martin Charcot dressed as a savage and trailing on a leash a great dane costumed as a lion. At dawn, Cernuschi, waving a French flag, led the singing of "La Marseillaise."[120] Cernuschi's private space, in short, was the setting for extravagant performances of identity among an influential public.

Evoking Cernuschi's life in this exotic setting, his contemporaries dwelt on his bachelor habit of socializing with women of the stage. Articles about his collection invariably highlighted a dramatic gilded wooden tiger he bought from the cash-strapped actress Sarah Bernhardt. In some accounts, she simply arrived with it in her carriage; in others, she proposed the purchase in a letter explaining that at a moment when "I am as poor as my ancestor Job . . . I turn to you because my tiger is *superb* and *Japanese*."[121] Other memoirs record a luncheon with literary men and a young ballerina, who confessed her distress at finding herself pregnant:

When after the coffee we passed into the Japanese temple, Cernuschi proudly showed us his Buddha, at once superb and hideous in its authenticity.

—How horrible! . . . exclaimed the little dancer. I cannot look at that!

Well, said the good Cernuschi in a paternal tone:

—Look at it nevertheless, my girl! It has already prevented several births![122]

This site of bachelor *japonisme* attracted the attention of novelists. Alphonse Daudet's 1884 *Sapho*, a tale of men and their mistresses subtitled *The Mores of Paris*, opens with its young protagonist, new to Paris, at a costume party thrown by a man notorious for consorting with actresses. The bearded host is introduced as a "figure of artistic Paris ten or twelve years ago, very good-natured, very wealthy, with a taste for art, and that free-and-easy manner, that contempt for public opinion, which result from a life of travel and bachelorhood." His "tales of travel" seem "appropriate among the Oriental hangings, the gilded Buddhas, the bronze chimeras, the exotic luxuriousness of that vast hall where the light fell from a high window."[123] Though in real life Cernuschi died peacefully in 1896 at the age of seventy-five and was laid out amid banks of flowers in front of his giant Buddha, Daudet has this extravagant bachelor commit suicide by jumping from the high window in imitation of the mistress he spurned.

The lethal creative license excercised in Daudet's *Sapho* is one register of the competitive antagonism toward Cernuschi in the Goncourts' circle. After lunching at Cernuschi's new house in 1875, Edmond de Goncourt recorded in his journal that "the rich collector has given his collection a setting at once imposing and cold as a Louvre. . . . On these high white walls, against the Pompeian-brick color favored by our museums these objects from the Far East seem unhappy."[124] When Goncourt included that passage in the version of the journal published during Cernuschi's lifetime, he omitted the rest of the sentence: "one would say that an evil spirit transported them to a palace imagined by a sense of taste both grandiose and bourgeois." After the meal, which Goncourt called "a thousand times better . . . than the conception of the house-museum," there was a "tour of the two thousand bronzes, pots, porcelains, that whole innumerable collection of imaginative forms." Goncourt admired the bronzes, disparaged the ceramics, and regretted that, "as for ivories, wood sculptures, chased iron, as for all those little, exquisite objects by which may be recognized the art lover with good taste: nothing, nothing, nothing."[125] A few weeks later, Goncourt dismissed Cernuschi's establishment with a single phrase: "The fantasies and monsters of Japan displayed by gaslight, it just doesn't do."[126] At this point, Cernuschi disappears from the journal.

Goncourt's silence about Cernuschi's house museum did not betoken indifference, however. Although by the 1860s the Goncourts associated Japanese prints with artists and East Asian bric-à-brac with bourgeois domesticity, it was not until the early 1870s—just when Cernuschi opened his house museum—that the Goncourts began to present themselves as collectors of Japanese art. Their house proposed a competing version of bachelor *japonisme*.

BACHELOR JAPONISTE QUARTERS, PART 2: THE MAISON DES GONCOURT

The Goncourt brothers' domestic invocation of Japan marked a shift in identity that coincided with their move from an apartment in central Paris to a house in suburban Auteuil in 1868. Until that point, the Goncourts, despite their pioneering purchases of albums of Japanese prints, had not acquired other kinds of Japanese art. The collections of art and objects that made their Paris apartment the talk of the town aimed to recreate the living spaces of eighteenth-century French aristocrats.[127] By the time Edmond de Goncourt inventoried the Auteuil house a decade after its acquisition, however, every room held, along with relics from the Ancien Régime, objects from East Asia, primarily Japan.

The eclecticism of the Goncourts' décor signified its coherence as an expression of personal taste. Their house was not a museum. The brothers owned no great paintings and made no claims for the significance of individual pieces. Instead, their collection of eighteenth-century French drawings, prints, furniture, textiles, decorative objects, and other artifacts created a setting for performances of identification with the outdated and overthrown. Edmond de Goncourt's description of the brothers' collection of eighteenth-century ephemera—handbills, pamphlets, tickets, wedding announcements, and more—reads like a manifesto for the marginal: "These nothings, these pass-keys of circulation, touched and retouched by the hands of yesteryear and bearing the dirt of humanity long gone, speak to me more loudly than the documents of great, cold History, and if my brother and I were able to revive a bit of the life of the past in our historical writings, we owed it to the study of these infinitely little things, scorned before us."[128] A similar spirit animated the Japanese collections. Goncourt's journal described his delight in purchasing a Japanese "*objet de la vie intime*" (object of intimate life), in this case an *inro*, the carved purse worn by Japanese men to carry small personal items: "It is extraordinary the pleasure procured by an art lover from the possession of a perfect object:

it is so rare, the bibelot that gives you complete satisfaction!"[129] These priorities blurred the boundaries between the Goncourts' collections and the brothers themselves. The art critic Gustave Geffroy reported that the Goncourts "gave the Auteuil house a particular and significant physiognomy, resembling their individuality as intellectuals and artists."[130] Louis Gonse identified Edmond de Goncourt, "the most ultrarefined and passionate of perhaps all our collectors," completely with the objects he collected: "They are the flesh of his flesh and the blood of his blood."[131] But no one identified the Goncourts with their collection more insistently than Edmond de Goncourt himself, for whom the retro-exotic eclecticism of the Auteuil house signified, paradoxically, a coherent modern masculinity defined by alienation from bourgeois gender norms.

Goncourt's claims for his home as a site of modern masculinity were couched in the irascibly iconoclastic terms that drew readers to his writings. In 1860, the brothers' journal fretted over the disappearance of "our Paris, the Paris where we were born," observing after a visit to a new "big *café-concert*" (an establishment offering food and entertainment), "Social life here is beginning to undergo a great evolution. The interior goes away. Life returns to becoming public."[132] When the Goncourts published this passage in the first book of extracts from their journal in 1866, they streamlined and heightened the rhetoric: "The interior will die. Life threatens to become public."[133] In both the original 1860 entry and the 1887 published journal, this analysis is occasioned by the observation "I see women, children, households, families, in this café" and ends with the expression of feeling like a *voyageur*, a visitor in one's own country: "I am a stranger to what is coming, to what is, as to these new boulevards." The published version adds, as explanation of the boulevards being rebuilt under the direction of Baron Haussmann, that they are "without curves, without chance perspectives, implacable in their straight lines . . . which make one think of some American Babylon of the future," a phrase that has been much (and mis-) analyzed for what it says about the rebuilding of Paris.[134] What is overlooked is how the Goncourts' alenation originated in anxiety over heteronormativity as bourgeois families took over the *café-concert* identified as "*cette patrie de mes goûts*" (that country of my tastes), a feeling they compared to the replacement of Paris's narrow, crooked streets by an authoritative system of straight lines that allows no variation in perspective.[135]

By 1881, when he published La maison d'un artiste, Edmond de Goncourt was in full retreat from a public realm he claimed was untenable for modern man, "whose existence is no longer exterior as in the eighteenth century, who is no longer butterflying around in society from the age of seventeen

until his death." Because "life today is a combative life," the "human creature" has been forced inside, made "to want the four walls of his home [Goncourt's use of the English word stresses the novelty of this concept] to be agreeable, pleasant, amusing to the eyes."[136] With wives and children intruding on public space, the home, in this eccentric argument, becomes men's space, as

> less worldly habits brought with them a lessening of the role of women in masculine thought . . . man's interest, straying from the charming being, turned in large part toward pretty inanimate objects, the passion for which is invested a bit with the nature and character of love. In the 18th century, there were no young *bibeloteurs*: that is the difference between our two centuries. For our generation, *bricabracomania* is just a stopgap for women who no longer possess man's imagination. . . .[137]

This bachelor manifesto exemplies why, in Anita Brookner's words, "art historians have always had a certain amount of difficulty in defining their attitude towards the brothers Goncourt."[138] One response has been the psychosexual pathologization of the Goncourts underwritten by creative mistranslations that turn this passage into a confession of "immediate gratification" through "momentary abandon in aesthetic debauchery."[139] But less antagonistic responses also misrepresent the Goncourts by making them conform to mainstream modernist agendas. Rémy Saisselin's book, borrowing Edmond de Goncourt's neologism *bricabracomania* for its title, endorses Goncourt's connection of collecting to the anxieties of modern life but shies away from his affective phrases and dramatic metaphors—"anxiety of the heart . . . the sadness of the present day, the uncertainty of tomorrow, the birth, feet first, of a new society." Using paraphrase to align Goncourt with standard, vaguely Marxist, modernist platitudes, Saisselin writes that Goncourt "linked it [*bricabracomania*] with an uneasiness of the soul, the loneliness and emptiness of the human heart in the new industrial society and its modern cities." Wishing away Goncourt's emphasis on men without women, Saisselin reduces Goncourt's claims to truisms: "In the ennui and anxiety of the modern city with its fast pace, men and women, according to Goncourt, sought stability, durability, happiness, and spiritual value in the enjoyment and possession of works of art."[140]

Brookner struggles to articulate art history's "dissatisfaction, or rather discomfort," with the Goncourts, citing the "curiously inverted . . . innovations" and "particular brand of taste, which they cultivated to excess." Their "particular inversion is easy to sense but hard to define: it is in some ways

bound up with an excessive pride taken in taste, their taste, for objects of the past, considered . . . as vehicles for the emotional associations and sensual connotations they brought in their wake," she says. The Goncourts' antagonistic attachment to the outdated violates what Brookner calls "the lines of demarcation" modernist practice takes for granted, including distinctions between "professional and amateur" and the "fine and applied arts."[141] What Brookner describes, though she does acknowledge it, comes very close to the sensibility called Camp, as it was theorized by Susan Sontag in 1964: a "taste" characterized by "love of . . . artifice and exaggeration," of the "old-fashioned, out-of-date, démodé." Camp, Sontag says, "risks . . . fully identifying with extreme states of feeling," and she notes the "peculiar relation" between Camp and the people sexologists called inverts: "While it's not true that Camp taste is homosexual taste, there is no doubt a peculiar affinity and overlap."[142]

What late twentieth-century art historians sensed but wouldn't say, in short, was the Goncourts' queerness, which troubled myths of modernism's roots in japonisme the same way that Andy Warhol's queerness challenged high modernism's hegemony. Sontag's "Notes on 'Camp' " locates a legacy for Pop Art among the dandies who were the Goncourts' contemporaries and followers. The Goncourts intriguingly resembled Warhol (or vice versa) in their love of scandal, their trend-setting taste for the overlooked and the exotic, their blurring of boundaries between consumption and production, the paradoxical exclusivity of a private life performed in public through the mass media— and of course their blatant rejection of heteronormative family values enacted in a space that came to signify this deviance. If Warhol's signature space was a repurposed Manhattan industrial loft known as the Factory, the Goncourts' was an eighteenth-century house near the Bois de Boulogne.[143]

The acquisition of Japanese art and the move to Auteuil are closely linked in the Goncourts' journal. An entry a month after they bought the house for twice what they had budgeted opens by citing this reckless expenditure and goes on immediately to note another extravagant purchase: "2000 francs, a price beyond the whim of an emperor or a Rothschild, for a Japanese monster, a mesmerizing bronze I don't know what told us we had to possess."[144] Ten days later, the journal reports that "the first quill sharpened in our house" signed the receipt for this "vasque au monstre japonais,"[145] which Edmond describes in loving detail in La maison d'un artiste:

From a tripod representing angry ocean waves rises a bronze vase a meter high, a pot-bellied vase ending in the form of a wide-rimmed basin. On the

belly riven with streams of water rises in high relief a horned dragon with bulges of flesh in tongues of fire and spurs like a rooster: *Tats-maki*, the dragon of typhoons, whose body, twisting and contorting like a serpent, appears in patches above the rigid waves. There is nothing more terrifyingly alive through the artifice of art than this mythical monster in a bronze that resembles blackened leather, beautified by the darkest patina and as sonorous as a bell metal rich with silver.[146]

Invoking sight, sound, and touch, Goncourt both anthropomorphizes this vessel—two allusions to its belly—and mystifies it in a language of the irrational that echoes the emotions associated with buying the house. Just as the massive Buddha at the center of Cernuschi's house museum represented his incorporation of Asia into his identity as a cosmopolitan republican, this monumental vessel signaled its owners' identity, but in relation to a very different idea of Japan, one associated with the intoxicating, exaggerated beauty of the grotesque they had articulated in the 1866 *Idées et sensations*: "Over there the monster is everywhere. It's the decoration and almost the furnishing of the house. It's the *jardinière* and the incense burner. . . . In the world of pale women with painted eyelids, the monster is a daily, familial, beloved image."[147]

The brothers' acquisition of this dramatic Japanese vase signaled a renegotiation of their relation to modernity as they moved beyond claims of nostalgic identification with the eighteenth century. Awkwardly for authors whose singular voice was forged through disdain for the modern bourgeoisie, Auteuil was so explicitly an upper-middle-class suburb that the conditions of sale for houses specified that they must be occupied "bourgeoisly" (*bourgeoisement*).[148] Nor could the Goncourts claim lordly dominatation over the neighborhood. Their house occupied an undesirable site facing the rail line to Paris, near the busy station and subject to vibrations from the trains. Most significantly for men who flaunted their aristocratic name, they sold their ancestral home in Lorraine to afford the new house. Changing rhetorical tacks, they framed their investment in their new house as a break with the past made by men modern enough to cast off

that bit of family pride, that great landed estate of our grandfather, that venerable, respected, and sacred ground to which, despite the modesty of their income, our father and mother had stubbornly clung . . . thinking thus to preserve for their children the influence of *property*, that assurance

of position and income which only land could furnish in the eyes of an old family during the reign of Louis Philippe. . . . Finally . . . we succeeded in getting rid of this chief nuisance of our life.[149]

As a signifier of modernity, the Goncourts' monumental Japanese vase complemented their newfound indifference to their French patrimony. *Japonisme* was cutting edge in 1868, as a result of the *Exposition Universelle*, where Japanese displays took prizes in many of the decorative arts categories and caused a sensation among the *cognoscenti*. Organized by three competing shogunates and augmented with nongovernmental displays by Japanese merchants, these exhibits presented a large and varied assortment of textiles, lacquerware, porcelains, and metalwork, all contextualized by hugely popular re-creations of a princely hunting pavilion and a "farm" comprising a teahouse and a residence for geishas. Everything was for sale, and what was not purchased during the exhibition was auctioned afterward, flooding Paris with Japanese objects and inspiring a wide range of derivations and imitations.[150]

The Exposition was important for all the first generation of *japonistes*. It sparked the intoxicating—and intoxicated—fervor of the *Société du Jinglar*, whose members were struck by Japan's displays and by the unexpected "furor" aroused by Bracquemond's prize-winning dinner service featuring motifs from Japanese *manga* and other prints (figure 1.12).[151] Interest in Japanese art emerged so quickly that Burty's first review of Bracquemond's "original and contemporary" dishware when the Exhibition opened in 1867 made no reference to Japan.[152] But this popular dinnerware became such a symbol of *japonisme* that a decade later, Chesneau—anticipating Bénédite—found himself caught between the desire to celebrate Bracquemond as "the first example" of a French designer drawing from Japanese sources and his anxiety to insist that these sources compromised neither the artist's individualism nor his Frenchness. "All he had borrowed from the Japanese artists was a greater freedom in arranging the motifs than was the custom in French decoration, that is to say the arbitrary displacement of the focus, the rupture of equilibrium and the distribution of forms," Chesneau insisted, before acknowledging, "He also borrowed from them their way of summary modeling in flat color, which gives the idea of an object without aiming for illusion; also their way of accentuating in the design, which consists of strongly accentuating, even at the risk of exaggeration, the essential character of the form."[153] Edmond de Goncourt was, typically, skeptical. Dismissing the "dinner service that created a revolution" as "fundamentally, nothing but tracings

FIGURE 1.12 Félix Bracquemond, *Service Rousseau*, 1866–67. Photograph by Christopher Reed.

from Japanese albums," he acknowledged its popularity with a remark that manages simultaneously to belittle both conventional taste and the new fashion: "It's curious, the revolution brought by Japanese art to a people enslaved, in the realm of art, to Greek symmetry, and who suddenly conceive a passion for a plate where the flower is not exactly in the middle."[154]

By the time of this remark in the mid-1870s, Goncourt could afford to be haughty, having avidly collected Japanese art for ten years. But to return to 1867 is to find the Goncourts newly dazzled by Japan. Jules reported to Burty that the brothers spent twelve hours one day "giving ourselves an indigestion of the Exposition. We saw everything! Everything!! Everything!!! . . . Your vices give us pleasure. *Japonaiserie for ever!*"[155] Jules's teasing characterization of the not-yet-named *japonisme* as Burty's "vice" marks a moment just before the brothers began to identify themselves with the taste for Japan:

1868 was when they first asserted their claim to be the original *japonistes* based on their earlier appreciation of Japanese prints and their fictions set among Japanese bibelots. It was also the year they acquired the "*vase-monstre*" Edmond later cited as evidence of their status among the first *japonistes*, asserting its purchase took place "at a time when *japonaiserie* was not yet at all in fashion."[156]

Claiming an originating role in *japonisme*, the Goncourts insisted on the groundbreaking modernity of their taste and distinguished themselves from the vogue for Japan that rippled through the middle classes. Assertions that their taste differed completely from bourgeois fashion were as vehement as they were frequent during the brothers' move to Auteuil. Characterizing their purchase of a house in a bourgeois suburb as "so unreasonable to bourgeois reason," they associated this recklessness with feelings of drunkenness or debauchery. The same terms characterize accounts of their acquisitions of Japanese art, starting with the "mesmerizing bronze":

> Fundamentally, it is strange, this mass of powerful emotions that we are developing in our placid life—we, with our cool demeanor, and so crazy inside, so passionate, so in love. For we call "in love" only the man who ruins himself to possess what he loves, woman or thing, art object alive or otherwise.[157]

Recording an outing with Burty to see some "captivating and hallucinogenic art" just imported from Japan in 1874, Edmond wrote,

> We spent hours, so many hours that it was four when I had lunch. These orgies of art—the one this morning cost me more than five hundred francs—leave me as exhausted and shaken as after a night of gambling. I come away with a dryness in the mouth that only the seawater of a dozen oysters can refresh.[158]

Thus, *japonisme* functioned as a form of excessive, passionate, irrational investment antagonistic to bourgeois norms—prime among them hetero-normativity. Marveling over "the sort of sensual pleasure that people with a retina like mine experience in pleasuring their eyes over the contemplation of porphyric splashes in the colored enamel tear of a Japanese pot," Edmond announced in 1888 that "a passion for the art object—and for the object of industrial art—has killed for me the attraction of women."[159]

A *japonisme* that excluded women was not a lonely enterprise. The appreciation and acquisition of Japanese objects was a pleasure Edmond de Goncourt shared with other men. In one of the most provocative of many provocative displacements of heternormativity recorded in the brothers' journal, Edmond in 1877 described the wedding of Burty's daughter. Following a ceremony at the local government hall—"The proclamation of the union of man and woman in these civic institutions really resembles too much the sentence pronounced by the judge presiding at a criminal court"—a church wedding, and a reception, Burty, "whose paternity seems to have arrived at the last limit of duties and obligations," took Goncourt aside. As the guests dispersed midafternoon and the bride's mother prepared her for the wedding bed, Burty "solemnly pulled out for me from its silken purse a little box he had me admire," and the two men went off "japonizing" (*japoniser*) together at various art dealers.[160]

These close friendships with other *japonistes* were secondary to Edmond's bond with his brother, however. Jules died in 1870 at the age of thirty-nine, not quite two years after the move to the house in Auteuil. "The death came when the furniture had just barely found its place," recalled Zola, contrasting his first visit to the house when the brothers "filled it with their gaiety at work, their fever for literary fisticuffs," with the time

> I saw the house again, so sad and so empty. Edmond, left alone, his whole being uprooted, abandoned it. He no longer had the courage to turn the little mansion into the artistic retreat of which the two of them had dreamed when they escaped to this verdant backwater of Paris.

Zola credited the house with "slowly reattaching" Edmond to life as, unable to write, he could work in the garden or "climb ladders to hang drawings." Ultimately, he concludes, "It was the house that saved the author."[161] Zola here glosses over another trauma of 1870–71: the Prussian siege of Paris followed by the bloody rise and fall of the Commune, during which Edmond took refuge with the more centrally located Burty. Though the neighboring houses were reduced to smoking ruins, his stood, albeit riddled with holes from bullets and shells. Goncourt compared his garden to an abandoned cemetery, its spring leaves covered in plaster dust and burnt paper, dead branches everywhere, and, in the middle of the lawn, a shell crater large enough "to bury three men."[162]

It was this doubly funereal house that Goncourt filled with things from Japan, as in the words of his friend Pol Neveux, "wanting to escape his

mourning, to exile his visions and dreams, he suddenly became enamored by the art of the Far East."[163] Japanese art became a way of both escaping and remembering Jules, whose last years had been his first years as a *japoniste*. In Jean-François Raffaëlli's larger-than-life portrait of Edmond in his "grand salon," the potbellied *vase-monstre* the Goncourts had purchased together seems to stand in for the brother who died (figure 1.13). Critics at the 1888 Salon, where the portrait was first exhibited, called the figure of Edmond "pale and lugubrious," "spectral," and "cadaveresque."[164] He leans on the vase that, in an echo of the brothers' pairing in a small double portrait on the wall behind, evoked the spirit of Jules, which Zola insisted was key to understanding the house: "The Auteuil house would be empty," without "that dear shadow, so much wept over, of the dead brother. . . . That memory is what softens and warms this old-boy lodging, which would be cold without it, for one detects there none of a woman's warmth."[165] For Goncourt as for Cernuschi, *japonisme* was intimately connected to a powerful homosociality manifest in mourning.

Thus, did the personal combine with the cultural in a *japonisme* that linked mourning for one man to a sense that, since the Franco–Prussian War, Japan and France shared the unhappy status of ancient civilizations distinguished by refined traditions of art and courtly culture that were now threatened by the domination of stronger, crasser empires.[166] When Paris fell to the Germans in 1871, Goncourt's journal recorded his "feeling of exhaustion at being French; the vague desire to go find a country where the artist could have his thoughts in peace."[167] In a sensitive interpretation of Goncourt's orchestration of his domestic interior, art historian Ting Chang interprets his placement of a large etching of Watteau's *Embarkation for Cythera* amid the Japanese lacquers and ceramics lining the staircase to the reception rooms where most of the Japanese art was displayed (figures 1.14 and 1.15). Chang reads this installation as Goncourt's bittersweet salute to the *japonisme* that supplanted the eighteenth-century legacy of French glory lost to the Prussians, for the painting the etching reproduces—a Rococo fantasy of departure for utopia— belonged to the Prussian court, a testament to an era when Germany's rulers followed French fashions.[168] For Goncourt, as for Cernuschi, the collection and display of Japanese art was both a way to mourn losses in France and a source of renewal.

If Cernuschi and Goncourt expressed their *japonisme* by furnishing bachelor quarters open to a large circle of invitees, Goncourt reached for both a larger public and a more explicit identification with his collections. His 1881

FIGURE 1.13 Jean-François Raffaëlli, portrait of Edmond de Goncourt, 1888. Oil on canvas. Musée des Beaux-Arts, Nancy.

L'EMBARQUEMENT POUR CYTHERE. AD CYTHERA CONSCENSIO

FIGURE 1.14 Antoine Watteau, *Embarkation for Cythera*, c. 1740. Engraving in *L'Œuvre d'Antoine Watteau Peintre du Roy en son Académie Roïale de Peinture et Sculpture gravé d'après ses tableaux et desseins originaux tirez du cabinet du Roy et des plus curieux de l'Europe par les soins de M. de Jullienne*, volume 2. Metropolitan Museum of Art, New York.

two-volume *La maison d'un artiste* documents and publicizes his house on his terms. The book's original title, *La maison d'un artiste du XIXe siècle*, made the house an argument for Goncourt's status as a modern artist, a claim repeated in a description of the book in his journal: "I am taking the direction of one of the great movements in the taste of today and of tomorrow."[169] Part autobiography, part art history, part collection catalog, part ekphrastic exercise,

FIGURE 1.15 Goncourt house, staircase wall, 1886. Print at Bibliothèque nationale de France.

La maison d'un artiste is an original, if unstable, fusion of literary genres.[170] At its worst, it becomes an unreadable inventory. At its best, however, *La maison d'un artiste* offers a pioneering exploration of the domestic interior as significant of psychological interiority—in this case of a psychology structured around mourning.

La maison d'un artiste begins and ends with death. Goncourt's short preface concludes by asking, "Why not write the memoirs of things among which a human existence has run its course?"[171] More than seven hundred pages later in a text presented as a visit to the house, we mount a staircase where eighteenth-century French drawings alternate with Japanese *kakemonos*; ascend to the attic; and pass frames that need gilding, broken Japanese bric-à-brac, and shelves of contemporary literature to arrive at "the student garret where my brother liked to work, the room chosen by him to die in" with the furnishings preserved just as he left them. There, "on certain anniversaries and sad days, when the long unforgettable past of our life as two returns to my heart, I go up to that room, I sit in the big armchair near the empty bed . . . , I give myself the sad pleasure of remembering." In these rituals of remembering, Jules first appears as "my good and handsome brother," but then come memories of his slow, delirious death, when "the cold sweat from his head pressed against my chest soaked through my clothes and undershirt," while his body twitched like "a wounded bird trying to fly," acted out habitual movements of reading and writing, or expressed "bodily love for other visions he called out to with hands outstretched, waving them kisses." Finally, in death, Jules becomes "no longer my brother" but a work of art: "The indefinable smile on his violet lips gave him a troubling resemblance to a mysterious inhuman face by Da Vinci that I saw in some dark corner in Italy in who knows what picture or Museum."[172] This fusion of corporeal intimacy, emotional devotion, and androgynous aestheticism, which completes the house tour, echoes a letter Edmond wrote Burty on the day Jules died, which was published in the journal *Rappel*: "I have just given my brother's cadaver its final *toilette*, washed with my tears."[173] Critics cited Edmond's reliving of Jules's death as key to the book. A review by his friend Julia Daudet noted the "intimate chapters" that "lend this work by a contemporary in the full flower of his talent and life the solemn, slightly melancholy charm of a posthumous work."[174]

Goncourt's display of emotion emphasizes his house's status as the site and the expression of *notre vie à deux* ("our life as two"), an intimate bond between the bachelor brothers in defiance of social norms. This unconventional bachelor domesticity was signaled by *japonisme* in Goncourt's

presentation of the house and in accounts by others. The entrance hall set the tone. Zola explained, "It is not the bare and banal vestibule of bourgeois houses. It is cheered, almost seems to be heated, by the porcelains, the bronzes, and above all by the *foukousas*."[175] Gustave Geffroy contrasted the house's "bourgeois and discreet" façade with "an artistic impression [that] lets loose with an extraordinary intensity from everything that surrounds the visitor": on a leather wall-covering of "parrots on a sea-green background, . . . everywhere, on this background, are hung *foukousas*, those squares of embroidered silk, softly nuanced, on which the Japanese artists have placed their strong and emphatic design." (This wall covering is visible in photographs of the stairway.)[176] These reports pale before Goncourt's own description, which cites the "fantastic gilded parrots" on the walls before listing "against this leather, in a calculated disorder . . . all sorts of striking, eye catching things, brilliant copper cut-outs, gilded pottery, Japanese embroideries, and still more bizarre, unexpected objects, astonishing in their originality, their exoticism." These objects, he remarks, remind him of the eighteenth-century Jesuit who said, "Here are things I do not know, I must write a book about them."[177] For Goncourt, as for Barthes a century later, Japan became an occasion for writing.

And sex is never distant in Goncourt's writing of Japan. A paragraph cataloging the objects in the entry hall—a bronze hanging planter, a panel ornamented in mother-of-pearl and tortoiseshell, an open fan, a Chinese porcelain fly cage in imperial yellow—culminates with a description of a ceramic plaque decorated with a flowering peach branch in a screen-shaped wooden frame, "which shows you the decoration of the mystical and religious nook in the room of a prostitute in a teahouse, the kind of altarpiece before which she places a flower in a vase."[178] At the top of the stairs, on a landing where more Japanese porcelains are displayed, are the myriad albums of Japanese prints, their contents lovingly detailed for forty pages, concluding with "a word about the erotic albums":

> The Orient does not have our modesty, or at least it has a different modesty. . . . First and foremost, it must be said, these images have nothing of the cold nastiness of the Occident, and even of China. They are enormously cheerful like the portfolio of a god of Gardens where the indecency of things is redeemed by a naïveté of early times and—shall I say it?—by the michelangelesque drawing.[179]

Goncourt's presentation of Japanese art misses no opportunity to challenge propriety. He uses his prints to critique Western ideas about the body, including distinctions between male and female, plants and people, and the relationship of the body to its parts. Goncourt's discussion of the erotic albums opens by quoting Léon de Rosny's translation of a Japanese popular song of the prostitution districts, which describes the study of "the science of flowers" among the "professors" who populate the Yoshiwara. The "professors," referred to as male in de Rosny's translation, linger over their make-up, then use their beauty to entice the flowers to bed; the song is rendered with such sentences as "He lets fall back his black hair capable of capturing the heart of a thousand men."[180] In this topsy-turvy erotic world, the prints depict such scenes as a sleeping woman who dreams of a phallus that, dressed in a kimono, performs a fan dance—"one of the most eccentric compositions ever to emerge from the mind and mark of an artist in an hour of libertine fancy," Goncourt happily notes.[181]

Continuing to flout bourgeois propriety, Goncourt's textual house tour leads readers into his bathroom, where he confides that, "when I comb my hair or brush my teeth," he likes to distract himself with something colorful to look at, "and that is why my bathroom is literally covered with porcelains and watercolors." A loving inventory of this most private of rooms follows: above the doors are academic studies of reclining female nudes; below these, hanging on each door, "shivering in the air currents, a *kakemono*," one painted with flowers, the other with a rooster. There are more eighteenth-century things: a saucy painting, an elaborate mirror, a marble shelf on which are displayed German crystal toilet items so as to catch the sun and—"*contraste bizarre*"—a Japanese panel on which a mother-of-pearl dried fish is rolled up in seaweed studded with coral. And "around all these objects, from floor to ceiling . . . plates, plates, plates," interspersed with Chinese and Japanese vases and bottles on little racks, and, "amid all this pottery from Asia," an eighteenth-century German "statuette of a little Chinaman, with cheeks barely pink in his white face," whose head bobbles on a gilded bronze mechanism—this was "the first bibelot purchased by my brother."[182] Goncourt's inventory lends credibility to Alphonse Daudet's report that, because this room was "like the whole house, invaded by kakemonos and display cases," its owner had to bathe in the kitchen.[183] Topping it all off, the bathroom ceiling is painted with "an enlarged copy of a page from a Japanese album titled *The Birds and Flowers of the Four Seasons* . . . , a copy executed in oil by my 'Anatole' from *Manette*

Salomon." Here it is clear that this house tour is a fantasy, not of Japan, but of the imaginary world of the Goncourts. Goncourt even creates a new plot for Anatole—the artist who was not corrupted by Manette—assuring readers that he "did not terminate his existence in the Jardin des Plantes the way he ends up in the novel." Bringing in recent history by alluding to the brutal imprisonment of the Communards, Goncourt reports of Anatole, "He is, I think, still very much alive, and still unlucky; after the Commune, not that he did anything for it, he was clapped in the brig so long that, on the day of his release, when he came to eat his first meal on dry land, he had a moment of hesitation, about a fork and how to use it."[184]

Goncourt's self-registration through *japonisme* continues through a *cabinet*, a small display space variously identified, in the 140 pages dedicated to describing it, as the *cabinet de l'Extrême-Orient* and the *cabinet de japonaiseries.* Goncourt details this room's Chinese and Japanese porcelains, bronzes, jade and rock crystal carvings, samurai swords, lacquers, embroideries, carved pipes, and pipe cleaners, along with myriad tiny *netsukes* depicting "comic, erotic, and philosophic" subjects (figure 1.16). Beyond this room is a tiny boudoir entirely lacquered in black. An elaborate kimono embroidered with gold

FIGURE 1.16 Goncourt house, *Cabinet de l'Extrême-Orient, panneau du fond avec la grande vitrine des porcelaines,* 1886. Print at Bibliothèque nationale de France.

and silk is thrown over a small sofa, and on the walls, Goncourt reports, are "hung just three objects of high taste": an embroidery representing a gnarled bamboo in threads of yellow and red gold; a lacquer panel with a still life of a flowering magnolia in ivory, jade, bronze, and ceramic; and a silk Persian rug. Above it all, on the ceiling, is a square of yellow silk on which the notorious *salonière* Princess Mathilde Bonaparte, who called the Goncourts her "lapdogs" (*bichons*), had "thrown birds and flowers watercolored in Japanese taste."[185]

This is the last room on Goncourt's tour of the floors below the attic. And here, as in the entrance hall, the Japanese objects occasion writing:

> It's strange, but now when I prepare myself to write a little piece, any kind of piece, a piece that has nothing to do with bric-à-brac, to get in training, to get equipped, to make the stylist spring forth from the lazy writer reluctant to face the painful extraction of style, I need to spend an hour in this Oriental *cabinet* and boudoir. I have to fill my eyes with the patinas of the bronzes, the varied golds of the lacquers, the iridescences of the fired things, the glints of the wood and ivory, the jades, the colored glass, the shimmering of the silk *foukousas* and the Persian rugs, and it is only through the contemplation of these bursts of color, through the excitement, the irritation one might say, of this vision that, little by little and—I repeat, without this having anything to do with the subject of my composition—I feel my pulse quicken and very gently I am filled with that little mental fever without which I can write nothing that works.[186]

Here Goncourt anticipates both Barthes and Wilde, as he makes the glints and flashes of the Orient both the key to his process and the basis of a style, not of depicting or imitating East Asia, but of representing his own vision.

THE AFTERLIFE OF THE MAISON DES GONCOURT

Goncourt's transformation of Japan into a personal style distinguishes his *japonisme* from evocations of Japan ranging from Mortimer Menpes's illustrative paintings to Braquemond's appropriation of *manga* motifs. Though undeniably personal, Goncourt's eclectic, inverted style was at odds with the look of individualism that characterized modernism. Because Goncourt transgressed canons of taste that in the twentieth century assumed the authority of fact, the *japonisme* of the Maison des Goncourt was written out of art history.

As a warning of the danger posed by the Goncourts to what art history construed as knowledge, Raymond Koechlin claimed that he was so put off by the "particularly refined taste" of La maison d'un artiste that as a young man he boycotted exhibitions of Japanese art.[187] More recently, art historians have exluded the Goncourt house from art history by denying its contents the status of art. We read that "the oriental objects prized by Edmond may be above all catalogued in the category kitsch," with the explanation that Goncourt believed

> the richness of materials and colors, the opulent look, the tinsel, the complex techniques, these are the favored criteria that determine the superiority of an object of art. In this, Edmond was very much of his era with its love for the overstuffed upholstery and knickknack taste that represented financial opulence rather than aesthetic sensibility or archeological knowledge.[188]

Such critiques say less about the nineteenth century than about the prejudices of the twentieth—prejudices that sustained myths of modernist high culture as not effete, not invested in conspicuous consumption, but truly aesthetic and knowledgeable. If these propositions are dubious, the imposition of the label kitsch is just wrong. There was nothing inexpensive, popular, or aesthetically conventional—the hallmarks of kitsch—in the Goncourts' japonisme.[189] Kitsch here is a euphemism for Camp, an allied term of modernist taste policing, but one that would register the way high modernist aesthetics reinscribe the bourgeois sex and gender norms that underpinned twentieth-century notions of healthy adult identity. "Camp taste turns its back on the good–bad axis of ordinary aesthetic judgment," Sontag explains. "What it does is to offer for art (and life) a different—a supplementary—set of standards."[190]

Art historians have sought to foreclose those alternatives, dismissing the Goncourts' retro-aesthetic as mere petulance. "Fated to live in a world without legal aristocracy and gracious sociability, the brothers de Goncourt translated their anger and resentment toward the nineteenth century into the creation of an alternative world of eighteenth-century arts," reports Debora Silverman. Such antagonism occasions misrepresentation. Her characterization of the Goncourts' house as a "citadel of aristocratic reaction" is supported by her description that "incised in the iron balcony over the entrance was a medallion with a portrait of Louis XV," signaling what Edmond de Goncourt called "the richest and most complete container of the eighteenth century that exists in Paris."[191] What Goncourt actually wrote on the first page of La maison d'un artiste about the medallion attached to (not incised in) the balcony

is more insouciant than reactionary: "That head, which some passers-by stare at fiercely, is not at all—need I say it?—an announcement of the political opinions of the owner; it is quite simply the signboard for one of the nests most crammed with eighteenth-century things that exists in Paris."[192] After he replaced the medallion with one representing his brother Jules, Edmond wrote, "I feel a sensation of happiness to see this house where my brother died bearing on its façade a lovely signature of the Goncourt."[193]

But the bond between bachelor brothers is as suspect as the Goncourts' dissent from political rhetorics of progress and leads to further misrepresentation of their domestic aesthetic. Edmond's reiterated provocation that collecting substitutes for heterosexuality—for himself and for modern men in general—Silverman transforms into an assertion that "the Goncourts . . . pressed their feminized objets d'art into the service of their erotic needs." Turning to an example, she says, "The theme of the objets d'art as surrogate sexual companions and as vehicles of vicarious union emerged as Edmond describes sleeping in the bed occupied by the princesse de Lamballe."[194] Again, Edmond's text is different—and far more interesting. After announcing his ironic skepticism about the bed's history—it "would pass for the bed" where the princess slept—he says that he likes sleeping in it because, "in the morning, when I open my eyes," his first sight is an ensemble of objects that "gives me the impression of awakening, not in this time that I do not like, but at the time that has been the subject of my studies and the love of my life: in some castle room of a Sleeping Beauty from the time of Louis XV spared from the revolution and the vogue for mahogany." This evocation of fabulous awakenings is matched with an equally dramatic, but also poignant, description of falling asleep in this bed overlooked by a mirror where, "in the pallid depths of the dark glass, in its sheen of pearl black, beneath the white canopy . . . , the portrait of Jules is reflected,—far away."[195]

Far from a "psychological perversion" in which objects become "erotic substitutes for real women," this is a fantasy of escape from the present into an imagined past—and from the imperatives of heteronormativity into a realm where bonds between men meld ambiguously with scenarios that, like the allusion to awakening in Sleeping Beauty's castle, invoke a body without fixed gendered position. Contemplating eighteenth-century women's toiletries, Goncourt writes that "handling these pretties . . . touching and turning these vessels, these boxes, these flasks, these scissors that for years were the little tools of the work of elegance and grace for the women of the era, the wish comes over you to rediscover the women they belonged to and to dream

these women—the little object of gold or porcelain lovingly caressed in the hand."[196] This passage has been read—and pathologized—as Edmond's substitution of objects for heterosexual contact, but its implications are more ambiguous. For it is Edmond's hands that "touch and turn" the "little tools" that were handled by the eighteenth-century women who are then dreamed into being, so that the caressing hand of the final phrase becomes both his and theirs—or his as theirs. This work of imaginative projection also returns Edmond to his brother, with whom in 1862 he had published *Woman in the Eighteenth Century*, a series of lovingly detailed vignettes describing the lives of women during the Ancien Régime drawn largely from prints and other ephemera in their collection.

"Camp taste has an affinity for certain arts rather than others. Clothes, furniture, all the elements of visual décor, for instance, make up a large part of Camp," writes Sontag, noting that, "Camp is the triumph of the epicene style. (The convertibility of 'man' and 'woman,' 'person' and 'thing.')" Sketching a history of Camp, Sontag analyzes it as the persistence of aristocratic taste in an age without "authentic aristocrats" and observes, "The dividing line seems to fall in the 18th century; there the origins of Camp taste are to be found."[197] Sontag's "Notes on Camp," a key text in challenges to the authority of modernism during the 1960s, evokes the Goncourts in so many ways that they emerge as central figures in the prehistory of Camp—and thus of the sexual subcultures that arose as exclusions from the rigid sex and gender norms of the middle class in the twentieth century. The Goncourts' significance in that history may be measured by the paradigmatic status their house took on for other bachelors—and for their domiciles, actual and fictional.

The Comte de Montesquiou recalled that, as a young man, he would stand outside "that famous 'Maison d'un artiste,'" and one day made so bold as to steal a souvenir leaf from the ivy. Citing "the volumes of *La maison d'un artiste* leafed through a hundred times," he reported that, after making his first purchases of Japanese art at the Exposition of 1878, "there hardly passed a day that did not see me bring back to my own 'house of an artist' one of these captivatingly attractive objects."[198] The rooms he furnished for himself at the top of his family's Paris mansion in the 1880s dazzled one visitor as "a vague dream of the Arabian Nights translated into Japanese," complete with a bed in the shape of "a black dragon . . . carrying the pillow in a coil of his tail and peering out at the floor with glassy, rolling eyes."[199]

The fame of these actual rooms paled in comparison to the fictional spaces created by Joris-Karl Huysmans in the novel *À Rebours*, published in

1884. Three years before, Huysmans had written Goncourt a fan letter about *La Maison d'un artiste*, listing the book's accomplishments, culminating with "finally that exquisite and precious art of Japan, isolated and explained, rendered visible, palpable, transmuted into an equivalent jewelwork of words by the artist's learned alchemy." Huysmans concluded by assuring Goncourt, "If I have had the ambition to write, I owe it to your books."[200] When *À Rebours* appeared, Goncourt claimed the novel for a lineage of bachelors in which the text "seems like the book of my much-loved son" and the main character, Jean des Esseintes, is the bachelor who should marry his own fictional character Chérie.[201] Soon, however, the popular success of *À Rebours* provoked Goncourt's resentment. He complained that readers who fell into "admiring stupefaction over Huysmans' discovery of des Esseintes' *oranged* interior" overlooked how hard he had worked in his own house to harmonize his pink *foukousa*, yellow Kutaniware decorated with mauve chrysanthemums, and *kakemono* with the crane on the bluish background with the golden leaves, all surrounded by Chinese porcelains and Japanese bronzes. In contrast to this subtle visual complexity of juxtaposed objects, Goncourt groused, "this *oranged* . . . is, in the end, a color of a painting, not a room."[202]

If the legacy of extravagant bachelor dwellings marked by the display of Japanese objects aroused ambivalence in its progenitor, he was not the last to be so affected. "I am strongly drawn to Camp, and almost as strongly offended by it," Sontag said.[203] For more conventional twentieth-century commentators, the balance clearly fell the other way. Perhaps the Goncourts brought it on themselves with their eagerness to self-diagnose such rarified nervous illnesses of the modern age as *bricabracomania*. Their infatuation with medico-scientific terminology anticipated the twentieth century's faith in taxonomies of deviance, most notably the "homosexual," an identity marked by aesthetically and affectively distinctive subcultures paradoxically modern but antagonistic to the normativizing values of modernism. If the Goncourts sensed the allure of this paradox, they underestimated how difficult it would be to occupy this position during a century when the authority of science underwrote the ideas of ethics and truth around which other institutional forms—including the arts—were organized.

As early as 1886, Paul Bourget's essays on "contemporary psychology" cited the Goncourts as quintessential moderns: "No one since Balzac so altered the art of the novel. . . . Right in the middle of the Second Empire, they were both of them men of letters from 1880." For Bourget, this modernity was a pathology,

"a hyperacuity of sensations," a "voluntary illness" literalized in Jules's prema-
ture death, with *japonisme* as a symptom.[204] Bourget argued that, unlike ear-
lier eras characterized by the harmonious aesthetic of the church, palace, or
temple, modernity's quintessential institution was the museum, where "derac-
inated" art objects from all over the world become "a means of access into for-
eign personalities." As evidenced by *La maison d'un artiste*," Bourget said, "the
Goncourt brothers were men of the museum, and in that they were moderns
with all the force of the word." They lived in and for "a little museum cease-
lessly expanded" with its "drawings and etchings, bronzes and porcelains,
furniture and tapestries, right up to foukousas and kakékmonos from Japan."
There, "the unexpected forms of Japanese art flattered their eyes, which a too-
complex education had made comparable . . . to the palace of a disgusted glut-
ton."[205] Bourget's analysis, drawn heavily from Goncourt's self-presentation,
was less critique than *homage*. Along with Huysmans, Zola, and Daudet, Bour-
get had a standing invitation to the Sunday afternoon gathering of literary men
Edmond de Goncourt inaugurated in 1885. (Women were expressly excluded
until the evening.) Goncourt called this club the *Grenier* (Attic). The group was
named for its meeting place: rooms Goncourt remodeled for the purpose with
Japanese decorations in his house's upper story, where his brother died.[206]
Goncourt relished Bourget's diagnosis—and even more Zola's jealousy that he
was not accorded his own chapter in Bourget's study.[207]

Pathologizing rhetorics by and about the Goncourts quickly turned pejo-
rative, however. By 1892, Max Nordau's *Entartung* (*Degeneration*), a critique of
modern culture that was quickly translated into several European languages,
attacked the Goncourts (and Zola) for their Impressionist literary prose, a
symptom of the degeneration of culture he claimed was also manifest in the
eclectic look of the modern house, with its "fierce or funny Japanese masks"
and "squatting or standing Buddha," among other exoticisms. In the chapter
titled "Diagnosis," Nordau, writing as a "physician" who "devoted himself to
the special study of nervous and mental maladies," dismissed the "literary
mind's" lofty talk of "a restless new ideal by the modern spirit" as, at best,
ignorant self-deception. On the contrary, he argued, modern art forms were
evidence of serious and contagious pathologies, among them "the present
rage for collecting, the piling up, in dwellings, of aimless bric-à-brac, which
does not become any more useful or beautiful by being fondly called *bibelots*."
Citing other medical authorities, Nordau called the "irresistible desire among
the degenerate to accumulate useless trifles" *oniomania*, to this day the medi-
cal term for what is commonly known as compulsive shopping disorder.[208]

By the 1970s, the adoption of medical paradigms into the language of art history allowed Anita Brookner to distinguish confidently between the Goncourts' "sick Romanticism, Romanticism as disability" and "healthy Romantics" like Zola, although both Bourget and Nordau presented Zola and the Goncourts as part of the same phenomenon.[209]

Whether admiring or admonitory, however, discussions of the Goncourts' dissent from ideologies of progress center on their Japanese collections. Unlike the fusion of *japonisme* with the energetic republicanism manifested in Cernuschi's bachelor residence, the Goncourts' *japonisme* was nostalgic and frankly fantastic—far more like Wilde's (another of Nordau's targets), a self-conscious expression of style. But these competing *japonismes* were not Paris's only options. After seeing Cernuschi's house museum for the first time in 1875, Edmond de Goncourt complained about this record of travel to the East, "I am sorry that he did not give it the hospitable and pleasant environment of a house from over there, a little rediscovered corner of the country."[210] Of course, Goncourt's house did not either. Goncourt himself never left Europe. His many acquisitions of Japanese metalwork, ceramics, and textiles during the 1870s came through Paris dealers, and his house made no effort to convey Japanese domesticity. Both Goncourt and Cernuschi framed collections of Japanese objects in Western architectural and decorative systems significant of Western ideologies they wanted their houses to embody. It took another bachelor *japoniste* to attempt what Goncourt and Cernuschi did not: the recreation of Japan in France.

BACHELOR JAPONISTE QUARTERS, PART 3: HUGUES KRAFFT'S MIDORI-NO-SATO

Hugues Krafft came of age in the shadow of Cernuschi's house museum. Or vice versa. In the late 1860s, when "Hugo" was a teenager, his parents—wealthy German immigrants—built one of the large family mansions on the exclusive Avenue Vélasquez where Cernuschi located his museum in 1873. When, in 1885, Krafft erected a Japanese house on his family's hunting estate near Versailles, it differed as sharply from Cernuschi's museum as from the values represented by his family's nearby *hotel*. Rather than displaying Japanese objects in the context of a European home, Krafft made a bid for authenticity pitched as an alternative to both European domestic conventions and to what had become, by the mid-1880s, the conventions of *japoniste* décor.[211]

Hugues Krafft's attraction to Japan took part in a broader rebellion against expectations by the oldest son of Baron Guillaume Krafft, who made a fortune in the champagne business, and Emma Mumm Krafft, who inherited a larger fortune from the same source. Educated at Eton during the Franco–Prussian War, the trilingual Hugo yearned to be an artist but was apprenticed in the champagne cellars to learn the business until his father's death in 1877 freed him from this career path. His mother's death in 1880 left him a wealthy man.[212] At this point, he cast off any lingering sense of responsibility to the duties of stewardship of capital and propagation of heirs that were central to bourgeois masculinity.[213] Turning away from the family business, Krafft also declined to marry and make a family of his own. In 1881, he set off on a global tour he defined by its homosociality: "I did not undertake a voyage for purposes of scientific discovery; I did not accomplish any special mission; I simply went around the world in good company, with my brother and two close friends."[214]

Like Duret and Cernuschi, Krafft claimed no interest or expertise in Japan before he arrived there. His group wound its way east at a leisurely pace through India, Southeast Asia, and China before reaching Japan in August 1882. Krafft's published account of this *tour du monde* recorded the group's five-month stay in Japan, but, in fact, he sent his companions on, remaining on his own in Japan for three more months. In a letter to his sister, he explained,

For me there was a choice to be made—a decisive choice—between big game hunting in America on one hand, and all the tempting satisfactions Japan offers in the way of nature and art bibelots on the other; and honestly between the two I did not hesitate. . . . While our "party" will be in the grips of the progressive and electrified Yankees, I will still be enjoying curious and singular sights; I will be buying bibelots; I will be taking photographs and I will be sketching in order to preserve a maximum of memories from this little paradise of nature.[215]

This catalog of activities offers only a partial account of Krafft's doings in Japan during the time his friends were away.[216] As discussed in the introduction, Krafft fell in with William Sturgis Bigelow's circle of expatriate Bostonians. With them, he attended *geisha* performances and sumo competitions, with their spectacles of muscled torsos. He was also drawn to *kabuki*, which he said "enlightened the foreigner about the philosophy and extraordinary force of resistance" that characterize the Japanese, particularly "the

coldness and exterior impermeability one notes in daily relations, where affections and friendships are hidden beneath manners imprinted with the most formal politeness."[217] Krafft's claims about Japanese life are unusual. Virtually every other Western visitor noted the affection shown between Japanese parents and children, but Krafft reported that they neither hugged nor kissed. Other Europeans' perceptions of Krafft's own "coldness" and dissimulation of "affections and friendships" suggest that he sought, and there found, in Japan endorsement for his own habits, creating the basis for an identification—unique in France at the time—with the look of vernacular Japanese life.[218]

Krafft commissioned his Japanese house in February 1883, while he was palling around with the Bostonians. At this time, Edward Morse was researching his first book on Japan, *Japanese Homes and Their Surroundings*, and in the same month that Krafft commissioned his house, Bigelow abandoned the foreigners' settlement in Yokohama in favor of a traditional house in Tokyo. There, Krafft reported, "He adopted a way of life to which few Occidentals lend themselves, but which is the only one possible for those who want to be in daily contact with the national civilization of the country."[219] The Bostonians' influence is registered in the English terms, such as "sliding screens," that pepper Krafft's excited letters about Japanese dwellings.[220] He wrote to his sister about Bigelow's house, "I will certainly be envious of him for that with its cool mats, its sliding screens, its gardens perfumed with the scent of plum trees in flower and complete with charming little hedges and clumps of quivering bamboo."[221]

Bigelow's "way of life" in Tokyo made his house the headquarters for his circle of expatriate men for whom he hosted dinners with eminent Japanese and organized excursions to sumo and fencing matches, *kabuki* and *Noh* performances, and the Yoshiwara. Krafft relished the masculinity of this circle, contrasting Bigelow's Tokyo establishment sarcastically with the Yokohama rituals of lawn tennis, "where the women shine in the first ranks," and dinners after which the guests were subjected to "the false notes of Mrs. X, . . . the twitterings of Miss Y . . . the melodious dreaming of Mrs. Z. . . . Those women are really very good to offer themselves as spectacle to one another."[222] To leave Yokohama was to reject a social life structured around middle-class femininity.

As with other circles of bachelor *japonistes*, however, women were not altogether absent from this community of Bostonians abroad. There were Japanese women: the *geishas* Bigelow invited to join his parties at the theater

and an innkeeper from the resort town of Nikko who visited Krafft in his Yokohama residence.[223] And there were Western women who transcended bourgeois femininity. When Isabella Stewart Gardner traveled to Japan in the summer of 1883, her disdain for the Yokohama "foreigners . . . who are here for money-getting" was encouraged by Bigelow, who, she reported, "is constantly . . . telegraphing to us that we must go up to Tokio for this or that or the other."[224] While Bigelow opened his Tokyo home to Boston's version of female aristocracy (their relationship is taken up in the next chapter), Krafft fell in with the real thing: Albine Maria Napoléone Ney de La Moskowa, Duchesse de Persigny. The recently widowed duchess first appears in Krafft's letters as the subject of Yokohama gossip about her prodigious appetites for alcohol and bibelots. Omitted from his reports to his sister were the stories of her scandalous infidelities. The two outsiders quickly bonded, and Krafft wrote to his sister, "Poor woman, I think I pity her more than the world blames her; her family life must not often glow warmly, and it seems to me that she would willingly cling to Japan and to those she meets here. . . . We are now on the best of terms."[225] Krafft concluded that he and the duchess shared "a crush on Japan" (une toquade pour le Japon)—the same phrase he used to describe his affinity with Bigelow.[226]

Krafft's friendship with the duchess included a shared enthusiasm for Japanese houses. He effused that Japanese domestic décor "absolutely defies description with its thousand ravishing details. Some rooms, like some little gardens, are adorable candy boxes, little masterpieces of patience and taste that one would like to be able to import and install at home on the far side of the seas."[227] When he wrote that phrase to his sister, it was the expression of a wish; by the time he published it in the 1885 Souvenirs de notre tour du monde, he and his aristocratic friend had acted on the impulse, commissioning two complete houses to be transported to France. The disassembled houses traveled with the duchess to Cannes, where she installed hers in the rose garden of her Villa des Lotus. But not right away. An article about her gardens in La Vie à la campagne (Country Life) reported that when she arrived in Cannes with the houses and a team of Japanese carpenters, they realized no one had thought to bring the necessary Japanese tools, which she sent the men back to Japan to collect. Not until her house was built did the duchess invite Krafft to retrieve the materials for his house and bring a Japanese carpenter to his estate outside Paris to assemble them.[228]

It is not clear if the two houses were exactly the same. Period sources call hers a teahouse but offer little description. Krafft called his a zashiki, a term

FIGURE 1.17 Hugues Krafft, *Tokio—Jardin particulier et pavilion de thé*, 1882–83. Photograph illustration in *Souvenirs de notre tour du monde* (1885).

designating a space for receiving guests that he also applied to a tea pavilion he admired on the Tokyo estate of the noble Mito family, which had been repurposed as a French officers' club (figure 1.17).[229] Krafft's house (figure 1.18), outfitted with the furnishings, utensils, and costumes of Japanese domestic life, attracted detailed commentary. Visitors described an eight-*tatami*-mat reception room, the standard size for tea ceremonies, as well as a six-mat chamber that could be used for sleeping, equipped with futons and mosquito nets. A closet off the bedroom was discreetly described in an 1891 book on Japanese design as containing "a basket in blue porcelain"; nearby and accessible from the porch, "which completely surrounds the apartments, as a ring does

FIGURE 1.18 Hugues Krafft, Midori-no-sato with Japanese workman, c. 1895. Print at Musée Le Vergeur, Reims.

a finger," a washbasin stood on an ivy-covered, sawed-off tree trunk. Separate from the house, but also accessible from the porch, was a room with a bath, a kitchen, and a servant's bedroom embellished with a Shinto shrine.[230]

Once his Japanese house was assembled, Krafft renamed his country estate Midori-no-sato, which he over-elaborately translated as *Colline de la fraiche verdure* (*Hill of Fresh Greenery*) (the common Japanese name more literally means "green place"). When Krafft officially opened his house in 1886 at a ceremony that included the Japanese ambassador (figure 1.19), the duchess's precedence made his the second Japanese house in France. But it was the first to boast a Japanese garden. Working initially from his notes and memories of Japan with his French groundskeeper, and later with Wasuke Hata, who came to Paris to create the Japanese garden at the 1899 *Exposition Universelle*, Krafft moved mountains (or at least large hills), dug ponds and waterways, and planted hundreds of trees, shrubs, and flowers ordered from Japan.[231] A cover story in *La Vie à la campagne* in 1909 celebrated Midori-no-sato as the largest Japanese garden in France. By then, it featured, in addition to the house and picturesque waterways, a Japanese entrance gate, several types of Japanese

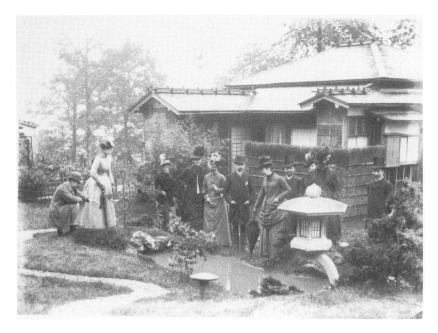

FIGURE 1.19 Hugues Krafft, reception at Midori-no-sato attended by the Japanese ambassador to France, June 19, 1886. Print at Musée Le Vergeur, Reims.

bridges, a bonsai garden, and a shrine, complete with a symbolic *torii* gateway, lantern, basin, and gray stone smiling Buddha. The article asserts, "It is not without emotion that this scene will be contemplated by those who have seen the like in Japan."[232]

This promise of the illusion of Japan made Midori-no-sato a pilgrimage point for *japonistes*. Cernuschi and Goncourt signed the guestbook, as did the Goncourts' friend, Princess Mathilde. Robert de Montesquiou met Krafft through the Japanese gardener they shared and brought Marcel Proust to visit in 1895.[233] Photographs document visits from Raymond Koechlin and Louis Gonse, with their families decked out in kimonos, using Japanese utensils and sitting on *tatami* with various degrees of aplomb (figure 1.20). Krafft's guestbook filled with comments affirming his accomplishment of authenticity. A Japanese art dealer wrote, "Contemplating the greenery of the hills, I take tea and believe I am in my country"; his brother added, "I had the impression of finding myself back in my country." Another Japanese echoed the sentiment in a poem written in *kanji*:

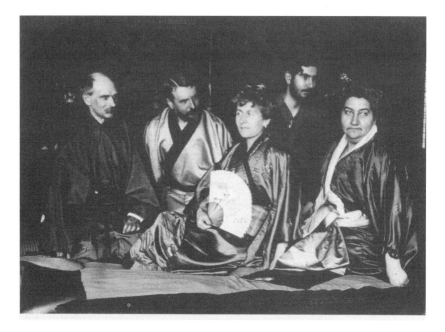

FIGURE 1.20 Hugues Krafft, guests at Midori-no-sato, July 9, 1899; *left to right:*
Siegfried Bing, Louis Gonse, Madame Roujon, Emmanuel Gonse, Madame Anna
Gonse. Print at Musée Le Vergeur, Reims.

What a surprise! In this distant land,
the landscape, just like the house
bathed in fog
as in my land in spring

Okakura Kakuzo, the Japanese most closely associated with Bigelow's circle,
visited in 1887 and left his own poem, concluding, "The décor of the garden
surprises my traveler's heart. . . . Far from my country, my soul is sad."[234]
Louis Gonse, who, despite authoring the first survey of the history of Japa-
nese art, never traveled to Japan, reported that "when one finds oneself in
the middle of this garden or in this house with the shutters open on a beauti-
ful spring or fall day, one feels exactly the sensations the Japanese have for
nature."[235] The illustrator Félix Régamey, who had been to Japan, said that,
standing on "a bridge of red lacquer" above a little waterfall, looking up at
the Japanese house, "all that is wanting to the balcony, standing out from the

white background of the papered frames, are some little mousmés in dazzling robes, to render the illusion complete."[236]

If there were no mousmés in Krafft's Japan, neither were there many French women. Although Régamey published an account of the house narrated as a visit by a countess enthralled with Japanese décor, Krafft responded frostily to one of the Japanese art dealers who attended the opening of Midori-no-sato when he forwarded such a request: "In my view, Madam the Baroness Durieux will not find in my little Japanese 'zashiki' . . . the sort of things that will give her ideas for furnishing a modern salon 'à la japonaise.' "[237] Here Krafft reiterated a point he made during a slide lecture to a scholarly society in which he stressed the "simplicity" of Japanese houses: "I want to insist particularly on this essential point, because I found, contrary to my expectations when I arrived in Japan, the Japanese arrangement of interiors was completely different from what I had erroneously imagined from a perspective shared by everyone whose knowledge of Japan comes from reputation alone," Krafft told his audience. "There are then, Sirs, in dwellings of all types, neither grand decorated porcelains nor multicolored embroideries used as curtains or ornament, no extraordinary furniture of lacquer or wood, no bibelots of bronze or ivory, in short, none of those luxurious or exotic objects with which we decorate our rooms 'à la japonaise.'"[238]

Distinguishing his zashiki from feminine fashions for japonesque décor, Krafft aligned authenticity with masculinity. He arranged to exhibit, and later donate, his collection of men's accoutrements—samurai arms, armor, and ceremonial kimonos—at the Musée des arts décoratifs. By joining scholarly organizations related to travel and ethnography, he recreated in these all-male groups the pleasures of the Japanist circles he had enjoyed in Tokyo. For these organizations, Krafft's credentials were his photographs. An ambitious early adapter of new photographic technologies who set up his own darkroom in Yokohama, Krafft is credited as the first in Japan to use the dry-plate photography that allowed for shorter exposure times than did the landscapes and studio-posed genre scenes produced by many photographers in Japan and collected by tourists (although Krafft also purchased hundreds of these).[239] Krafft exhibited his photographs widely, insisted on new printing technologies to reproduce a those in his Souvenirs de notre tour du monde, and donated groups of his photographs to learned societies and museums.[240]

Krafft's photographs supported his stance of rigrous authenticity. Like the studio photographers who served the tourist trade in Japan, Krafft sometimes photographed women and children, but most of his pictures—which

he presented grouped into series, mounted, and labeled to suggest voyages within Japan—depict Japanese men. A series of eighty-two numbered photographs (many now missing) donated to the Japan–London Society begins at a house in Yokohama, proceeds to just outside the gate of this foreigners' district, then goes to Mito Park in Tokyo (documenting the zashiki Krafft admired), then to sites in Kyoto, before offering views of two routes between Tokyo and Kyoto: the coastal Tokaido road and the more mountainous inland Nakasendo. This imagined excursion does not replicate Krafft's itinerary (he and his companions set off on the Tokaido and returned on the Nakasendo before exploring much of Tokyo), but the pictures capture Krafft's enthusiasm. "Japan is decidedly the country for excursions," he exclaimed in his travel memoir, relishing this expedition of men: "What a procession! Fourteen jin-riki-shas with two runners each make, with Ito [the interpreter], a party of thirty-two men! A whole little battalion!"[241] Krafft's photographs record the variety of conveyances his party used on their trip and the porters who powered them (figure 1.21). The text of his *Souvenirs de notre tour du monde* urges readers to "admire with us our untiring and cheerful runners" as they wash their "admirably muscled naked limbs" in the fountains they pass and reports that, though they wear vests in the presence of policemen, they prefer to run attired in only their *fundoshi* (loincloths). He also draws attention to the two tattooed runners in his group: "The designs in flat tones of blue and red blend admirably with their suntanned skins, which are remarkably soft and supple."[242] Krafft sketched and photographed his porters repeatedly. His inventories of photographs and drawings document many more such pictures—each identified with the name of the man who posed—than are accessible in archives today. And he returned to France with a sedan chair in which he was ferried about in Japan (figure 1.22).[243]

Krafft's presentation of Midori-no-sato echoed his documentation of Japan. Along with the series of photographs depicting Japan that Krafft gave to the Japan–London Society, for instance, a second set of twenty-five photographs presents itself as another trip, this one to the version of Japan Krafft created in France. Starting from the "great entrance gate" and working toward the house, these pictures take viewers on a tour of Midori-no-sato (figure 1.23). Like his pictures from Japan, which document Japanese workmen in the outfits associated with their work as porters, priests, carpenters, and fishermen, the authenticity of his estate is suggested, not by the *mousmé* some visitors were pleased to imagine, but by the repeated figure of a Japanese carpenter in his characteristic uniform tending the gardens, both

FIGURE 1.21 Hugues Krafft, *Passage d'une rivière, sur le Tokaïdo*, 1882. Photograph illustration in *Souvenirs de notre tour du monde* (1885).

FIGURE 1.22 Hugues Krafft, *Kago à Hakoné*, 1882. Print at Japan Society, London.

FIGURE 1.23 Hugues Krafft, "Zashiki" et "toro," c. 1885. Print at Japan Society, London.

full-sized and bonsai (figures 1.24, 1.25, and 1.26).[244] The implied analogy between these two numbered sets of photographs asserts Krafft's conception of Midori-no-sato as the truth of Japan, a truth he embodied—in contrast to the other *japonistes*—by the look of Japanese men.

A CODA ABOUT JAPONISME'S BEGINNINGS

By the mid-1880s, Parisian fascination with Japan was manifest in three exemplary *japoniste* houses, each very different, but all the domiciles of bachelors. Here the rejection of the role of *paterfamilias* played out—for Cernuschi, for the Goncourts, and for Krafft—in houses that rejected the look of bourgeois domesticity. In these houses, these men—to return to Barthes's remark with which his book, and this book, began—were able to "isolate somewhere in

FIGURE 1.24 Hugues Krafft, *Petit charpentier* and "*Jin-riki-sha*," 1882. Prints at Japan Society, London.

FIGURE 1.25 Hugues Krafft, *Jardinier taillant un cèdre*, c. 1885. Print at Japan Society, London.

FIGURE 1.26 Hugues Krafft, *Jardin miniature*, c. 1885. Print at Japan Society, London.

the world (faraway) a certain number of features . . . and out of these features deliberately form a system" they called "Japan." These systems were not the same. Cernuschi's cosmopolitan rationalism was a far cry from both the Goncourts' keyed-up proto-Campiness and Krafft's meticulous illusionism. But in each case, an idea of Japan authorized extravagance in its literal sense of going beyond. Most obviously, the idea of Japan exceeded the boundaries of modern France. This idea was literalized for the travelers Cernsuchi and Krafft, whose houses presented themselves as records of their journeys. The nostalgic cast of the Goncourts' *japonisme* made Japan an escape from time as well as place.

If these *japoniste* houses exceeded the here and now, they also stood outside conventional forms of middle-class French domesticity oganized around ideas of futurity embodied in family legacy, an issue that all three owners addressed by setting the terms on which their houses would live on after them. Cernuschi left his house to the city of Paris to open as a museum, ensuring its perpetuation as a site of Enlightenment cosmopolitanism. Edmond de Goncourt took the opposite tack. Having preserved his house in the text of *La maison d'un artiste*, he announced, "I do not want for the objects I have possessed, after me, burial in a museum, that place where people pass by bored

without looking at what is before them. I want each of my objects to bring to its owner, a very distinct being, the little burst of joy I had in buying it."[245] By dispersing his collections, Goncourt pursued his ideology of collection as self-expression to its logical conclusion. In his absence, the objects had no reason to remain together, and Goncourt wanted them to become the raw materials of someone else's manifestation of sensibility. In a final delicious paradox, moreover, the money raised by the auction perpetuated his antagonistic persona. Disdaining the institutionalizaton of his collections into any form of authoritative display, he also stipulated that the proceeds from the sale fund a prize—the Prix Goncourt, ongoing to this day—for writers overlooked or rejected by the French Academy.

Unlike, Goncourt, Cernuschi and Krafft cherished their status as exemplary French citizens, an identification rendered tenuous by their foreign surnames. Both demonstrated their allegiance to France by dedicating their japoniste dwellings to the public good. Where Cernuschi in the 1890s turned his home and collections over to the city of Paris, Krafft three decades later sacrificed his association with Japan in a bid to embody ths history of his native French city of Reims. After the first World War, which drew attention to the conflict between his German heritage and his French citizenship, Krafft in 1925 auctioned his Japanese collections to fund the reconstruction of a war-damaged seventeenth-century house adjacent to the cathedral in Reims that was—and still is—a museum of local history.[246] Occupying an apartment in this house museum until his death in 1935 at the age of eighty-two, he abandoned Midori-no-sato to the elements.

These houses of Cernuschi, the Goncourts, and Krafft, well known in their era to a wide array of amateurs and specialists, and to a broader public through their appearances in print, offered three distinct paradigms of japonisme. Their shared association with bachelors, moreover, prefigures the attraction of other men—Vincent van Gogh, Henri de Toulouse-Lautrec, Robert de Montesquiou, Marcel Proust—to the look of Japan. If each of these houses signaled a different form of dissent from heteronormativity, what also unites them in retrospect is their exclusion—despite their unmissable scale and claims to chronological precedence—from the accounts of the japonisme that remain central to understandings of the avant-garde. But this emphasis on exclusion cannot be the last word—not after we have explored the worlds created by these bachelor japonistes with, I hope, a pleasure that undercuts those exclusionary dynamics and the authority they support. As a gesture toward recognizing the multiplicity of japonismes, this chapter concludes by

looking briefly at one more artifact: a text even less known than any of the houses, but one that encapsulates the eccentric charms of bachelor *japonisme* as they lingered into the 1890s.

In 1893, the artist Jules Adeline and the playwright Eugène Brieux collaborated on a little book (figure 1.27) titled *Mi-Ki-Ka: japonaiserie rouennaise rimée* (*Rhymed Rouen Japonaiserie*), which they had privately printed "*pour les seuls amis japonisants*" (for the Japanizing friends alone). The book tells the story of its title character, a roly-poly *Noh* figure that, at about two feet tall, dominated a collection of Japanese dolls owned by Adeline (figure 1.28), who was a close friend of Rouen native Henry Somm, the printmaker who specialized in scenes of doll-like Japanese figures and giant ladies of fashion (see figure 1.4).[247] Mi-Ki-Ka shared his name with one of Adeline's cats, which was said to behave like the cats pictured in Japanese prints, but such fanciful transcultural identification was not confined to felines.[248] The image of Mi-Ki-Ka turned up next to Adeline's self-portrait in an 1883 print and alongside the artist's name on his visiting cards. Mi-Ki-Ka also played a role in the homosocial networks of *japonistes*. In 1890, Adeline gave the Japanese art dealer Siegfried Bing a hand-colored version of the same image of Mi-Ki-Ka that appears as the booklet's frontispiece.[249]

The Rouenais rhyme that is the text of the Mi-Ki-Ka book tells the doll's story in his own words. Perched on his shelf, dreaming of a homeland where he was

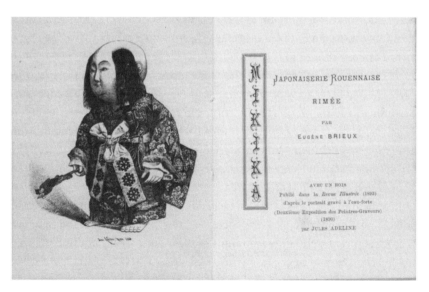

FIGURE 1.27 Jules Adeline and Eugène Brieux, title page and frontispiece to Mi-Ki-Ka, *japonaiserie rouennaise rimée* (1893).

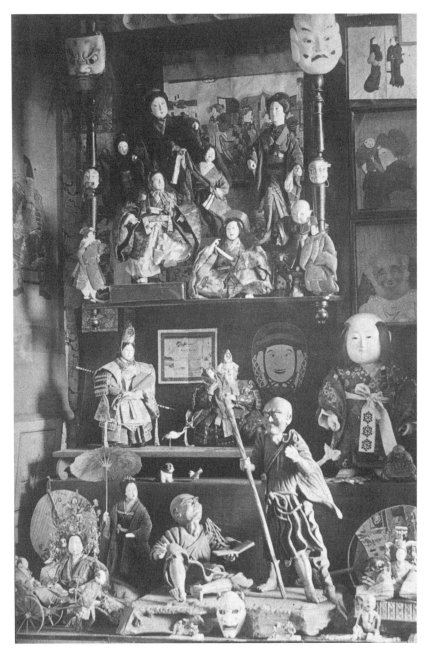

FIGURE 1.28 Jules Adeline's collection of Japanese dolls, c. 1883. Print at Bibliothèque municipale de Rouen.

"born of a Mousmé," Mi-Ki-Ka addresses his audience of big-footed barbarians, "whose strange names have no K / Gray men who live in a gray atmosphere," as he casts a critical eye on France, where "they speak a foreign language and mispronounce my name, Mi-Ki-Ka." What redeems "Rouen, this place they call picturesque, which is almost never dry" are "my two fathers." "*Chez nous les pères vont par paires*" ("Here fathers come in pairs"), the poem punningly explains. One father is an artist known for his depictions of Rouen and his love of cats; the other is "the very author of this poem." After more complaining about the gray weather; old buildings; and greedy, miserly people of Rouen, Mi-Ki-Ka concludes that he would throw himself to his death from his shelf were it not for his "owner and master, *un Rouenais non filateur*" (a Rouenais not a mill owner):

Chez lui je me trouve à mon aise	With him I find myself at ease,
Car il aime en écervelé	For he loves heedlessly
Notre belle île japonaise;	Our beautiful Japanese isle;
C'est un Japonais exilé.[250]	He is an exiled Japanese.

In these phrases, the animated Japanese doll-man escapes bourgeois provincialism in inclement France—Barthes, in another context, calls Rouen "a real referent if ever there was one"[251]—by finding himself at home with a *japoniste* whose love flouts rational or productive criteria of assessment ("*écervelé*") by giving in to a passionate identification with an aestheticized idea of Japan ("*notre belle île japonaise*").

Whimsical. Eccentric. Decadent. Self-indulgent. Characterizations of *japonisme*, whether admiring or pejorative, register its essential qualities as a performance of fantasies that offered alternatives to conventional identities associated with nations, cities, and, of course, gender.[252] The poem's phrases echo Krafft's letters to his sister explaining why he stayed in Japan—"The fact is that I feel one could be no more at ease (*à l'aise*) and satisfied than here"[253]—even as its sentiments repeat what Krafft said of the Bostonian William Sturgis Bigelow (quoted in the introduction): that his intuitive love of Japan rendered him more Japanese than the Japanese. Such associations allowed *japonisme* to express fantasies of fitting in elsewhere at the same time that it cast dissent from social norms not as deviant, but as extra ordinary. These paradigms, generated in Paris and enacted in the establishment of *japoniste* bachelor domiciles, inflected the reception of Japanese aesthetics not only in France but, as the next chapter takes up, in art insitutions across the Atlantic.

2 BACHELOR BRAHMINS

TURN-OF-THE-CENTURY BOSTON

Massachusetts has a long history with Japan. In 1799, the first merchant ships from Japan arrived in Salem, and soon American vessels under contract to the Dutch East India Company were regularly bringing commercial cargos augmented by woodblock prints, paintings, and ceramics.[1] These artifacts attracted little notice, however, when they were displayed with other memorabilia at the East India Marine Society, a philanthropic organization of Salem sea captains that included a "museum of natural and artificial curiosities, particularly such as are to be found beyond the Cape of Good Hope or Cape Horn."[2] That changed when American navy ships under the command of Commodore Matthew Perry opened Japan to direct trade with the United States in the 1850s, but by then, Boston had supplanted the port of Salem. In Boston, the idea of Japan—more specifically, a fantasy of Japanese masculine aristocracy—concentrated ideals of personal and civic identity at

a time when new attitudes about gender and heredity challenged the city's elite. Institutionalized in Boston's flourishing museums, this manifestation of bachelor Japanism had profound implications both locally and for Western understandings of Japan in general, down to the present day.

Boston's civic ideal is captured in the city's sobriquet, the Hub, which originated in Oliver Wendell Holmes's popular "Autocrat of the Breakfast Table" columns in the Atlantic Monthly in 1858, when a "jaunty-looking" visitor remarked that Bostonians believe the "Boston State-House is the hub of the solar system."[3] Holmes was skewering Boston's prideful provincialism, but the name stuck. Boston is still known—in Boston—as the Hub. Neither America's largest city nor the seat of national government, not the home of financial markets or the center of a particular industry, nineteenth-century Boston staked its reputation on its universities, libraries, museums, and auditoriums, which justified the city's claim to another sobriquet: the "Athens of America." Attributed by the 1866 Bacon's Dictionary of Boston—itself evidence of the city's apparatus of self-mythification—to an 1819 description of the city as the "best regulated democracy that ever existed," the slogan quickly attached to Boston's cultural institutions.[4] Intended as approbation, this phrase invites critique, for Boston exemplified many of the contradictions between the ideals of democracy and the practices of a self-perpetuating elite that characterized ancient Greece.

Boston's paradoxical ideal of a democracy strictly regulated through elite institutions, historians have argued, became a paradigm for the development of American high culture broadly, offering ideologies that sustained hereditary power and privilege in the absence of—and in competition with—European aristocracies. In this analysis, Boston's cultural pre-eminence reflects the strength of the city's class hierarchies: "Its elite—the Boston Brahmins—constituted the most well-defined status group of any of the urban upper classes of this period."[5] Yet another significant sobriquet coined by Holmes, "Boston Brahmin," with its allusion to Indian caste hierarchies sanctified by religion, registers the impulse among Boston's elites to define themselves by invoking non-European social hierarchies. "There is nothing in New England corresponding at all to the feudal aristocracies of the Old World," is the opening sentence of "The Brahmin Caste of New England," the first chapter of Holmes's The Professor's Tale, which was serialized in the Atlantic Monthly in 1860. Holmes continues, "There is, however, in New England, an aristocracy, if you choose to call it so, which has a far greater character of permanence. It has grown to be a caste." Here the Brahmins are presented

as one of the "races of scholars among us, in which aptitude for learning" is "congenital and hereditary." Holmes does not justify his Indian allusion beyond remarking that the Brahmin protagonist of his novel hails from one of the towns near Boston whose "Oriental character . . . consists in their large, square, palatial mansions, with sunny gardens around them."[6] Such vagueness allowed the term Boston Brahmin to remain current through the later decades of the nineteenth century, even as Japan replaced India as Boston's exotic exemplar of social stratification. The result was a mode of Japanism strikingly different from the japonisme of Paris. From its inception, however, Boston Brahminism, too, was bachelor business.

Holmes personified New England's "Brahmin caste" as a "youth" he characterized as "commonly slender,—his face is smooth, and apt to be pallid,—his features are regular and of a certain delicacy, . . . his lips play over the thought he utters as a pianist's fingers dance over their music." So keen is the association of Brahminism with bachelordom that the Holmes-like narrator of The Professor's Story worries at length that his letter of recommendation for the "altogether too good-looking" young Brahmin protagonist might lead to his teaching "a room-full of young ladies," for "what I dreaded most was one of those miserable matrimonial misalliances where a young fellow who does not know himself as yet flings his magnificent future into the checked apron-lap of some fresh-faced, half-bred country girl." If the "rays of a passionate nature" were to fall on his "large, dark eyes," the narrator worries dramatically, "they would be absorbed into the very depths of his nature, and then his blood would turn to flame and burn his life out of him, until his cheeks grew as white as the ashes that cover a burning coal."[7]

Gender anxiety also besets the canonical Boston novel, Henry James's The Europeans, serialized in the Atlantic Monthly in 1878 but set at mid-century. Here the upper-crust Mr. Wentworth is visited by a nephew and niece who, raised in Europe, treat Boston as just another site of primitive picturesqueness. Finding "plenty of local color in the little Puritan metropolis," the nephew comments, "The way the sky touches the house-tops is just like Cairo; and the red and blue sign-boards patched over the face of everything remind one of Mahometan decoration." When his niece, now a baroness, compares Boston girls to those in Britain and Holland, Wentworth replies huffily, "I think you will find that this country is superior in many respects to those you mention." Wentworth is particularly worried by his niece's failures of deference: "He felt almost frightened. He had never been looked at in just that way—with just that fixed intense smile—by any women; and it perplexed and weighed upon him."

The Europeans grants its most glamorous Bostonian the allure of China. Mr. Acton's house is furnished with "the most delightful *chinoiseries*—trophies of his sojourn in the Celestial Empire." The baroness is impressed. "A man of the Chinese world! He must be very interesting," she exclaims. As her enthusiasm attests, however, China was already familiar to—and dominated by—Europeans. The "opening" of Japan gave Americans a chance to restart the clock on global competition, providing a "profoundly empowering" alternative to the intimidating history of civilization embodied in Europe's "ancient monuments, palaces, and museums," historian Christine Guth argues. "To a one," she reports, American travel narratives of Japan "reveal a strong sense of pride and even proprietorship over Japan's relationship with the West, owing to Perry's role in its 'opening.'"[8] This dynamic characterized American responses to Japan's exhibits at the 1876 World's Fair in Philadelphia (figure 2.1). Praising "the variety and beauty" of the Japanese display, the massive *Illustrated History of the Centennial Exhibition* announces, "The visitor who makes even a hasty inspection of the display," must "amend his ideas of Japan" in light of the "abundant evidences that it outshines the most cultivated nations of Europe in arts which are their pride and glory, and which are regarded as among the proudest tokens of their high civilization." Turning to specifics, the guide reports that Japanese bronzework "cannot be reproduced by the most skilful artificer in either Europe or America," while Japanese porcelain "is an old art, and attained perfection in Japan long before it was known in Europe."[9] Historian Neil Harris concludes that Americans at the exhibition "seemed to take pleasure in the fact that Europe's boasted antiquity was dwarfed by this visitor from the East. The Orient could be used to strike back at the pretensions of the Old World, which for so long had reminded Americans of their youth and lack of cultivation."[10]

Bostonians embraced this competitive enthusiasm for Japan and its arts, exploiting travelers' comparisons between Japan and ancient Greco-Roman culture (discussed in the introduction) as a counterweight to European authority. The Harvard-trained Ernest Fenollosa, who went to Japan in 1878 to teach philosophy at the new Tokyo Imperial University, claimed his interest in Japanese art began when he acquired a sculpted bodhisattva with "a beautiful plastic play of drapery over the shoulder, so like a Roman emperor's portrait-statue that he affectionately called it 'Caesar.'"[11] By 1884, Fenollosa asserted that his study of Japanese art was "just as important at bottom as much of what the world's archeologists are doing in Greece and Turkey," and this argument for a "Pacific School of Art" equivalent to that centered on "the

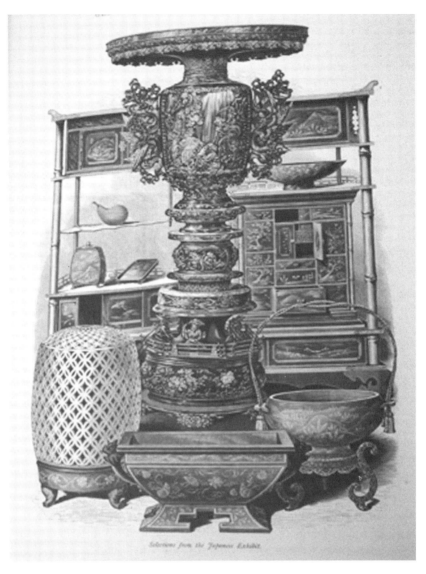

FIGURE 2.1 *Selections from the Japanese Exhibit.* Illustration in George T. Ferris, *Gems of the Centennial Exhibition* (1876).

east end of the Mediterranean" structured his influential *Epochs in Chinese and Japanese Art* when it was posthumously published in 1913.[12] Visiting Fenollosa in Japan in 1888, the painter John La Farge compared "Japanese metalwork— for instance, the sword guard or the knife handle" to Classical Greek craftsmanship, citing each as "an epitome of art, certainly a greater work of art than any modern cathedral."[13] The antagonistic tenor of the Brahmins' claims was registered by Basil Hall Chamberlain, an English scholar resident in Japan, in a comment about the Boston Japanist Percival Lowell: "Quote Greece to him, and it is like a red flag to a bull."[14] If Japan offered elite Bostonians abroad an alternative to the authority of European antiquity, it also solved a problem at home, where the authority of Gothic and Renaissance art worried the Protestant elite at a time when Catholic Europeans—mainly of Irish and Italian descent—were becoming Boston's majority. In contrast, the 1900 census counted just twenty-nine Japanese in Boston's population of half a million.[15] Engagement with Japan offered upper-crust Bostonians a way to compete with both European elites and local Catholics.

The ideologies of Boston's elite were instantiated nowhere more clearly than at the Museum of Fine Arts, which, along with the Boston Symphony Orchestra, was, in the words of sociologist Paul DiMaggio, a creation "of the Brahmins, and the Brahmins alone."[16] Founded in 1870, this museum— like many others in late nineteenth-century New England—reflected both a heightened interest in national and regional identities and a confidence that these identities were manifest in objects that could be collected, studied, and displayed. This curatorial theory of "object lessons," constituted, in Bill Brown's words, an "object-based epistemology" animated by the "belief that objects (as opposed to words) would speak to more people (young and old, immigrants and natives) in a universal language."[17] The lessons taught by the Museum of Fine Arts quickly shifted away from the inclusive rhetorics that had justified its founding. Although its first logo featured three interlocked rings labeled "Art," "Education," and "Industry," the new museum asserted a specialized role distinct from the educational mission of anthropological, ethnographic, or national history museums, as well as from museums founded to improve design in craft and industry. In the "fine arts" museum, DiMaggio explains, "high culture was created systematically and formally through organizations that served to separate it and its public from popular culture and from the populous itself."[18] By 1906, Henry James's "American Scene" essays contrasted the Museum of Fine Arts with the bustling Boston Public Library nearby. Overwhelmed by the library's raucously undeferential

crowds—so unlike exclusive European libraries, James explained—he took "refuge from it in craven flight, straight across the Square, to the already so interesting, the so rapidly-expanding Art Museum," where "things sifted and selected have, very visibly, the effect of challenging the confidence even of the rash."[19]

Among the "things sifted and selected" to chastise the "rash," many came from Japan. No European or American museum had a specialist department of East Asian art in 1890 when Fenollosa was summoned from Japan to head the Boston museum's new Department of Japanese Art, which, as the second geographically defined curatorial area, balanced the Department of Classical Antiquities (there was also a Department of Prints). Announcing Fenollosa's arrival in Boston, the *Sunday Herald* gloated, "The pre-eminence of the museum in its facilities for the study of the art of the most refined of living artistic peoples is practically impregnable."[20]

The pioneering Japanese department was part of an ongoing and ambitious program of expansion. By 1906, when James's "American Scene" appeared in London's *Fortnightly Review*, he complained that the "accumulated and concentrated pleasantness" of the Museum of Fine Arts would soon be sacrificed to a relocation to larger quarters. For James, this expansion demonstrated an American tendency to overcompensate for a culturally deprived past by generating cultural institutions that exceeded the worth of its citizenry: "In the early American time, doubtless, individuals of value had to wait too much for things," but now the vast new cultural institutions of America "are waiting for individuals of value."[21] The new Museum of Fine Arts registered this dynamic with an architecture that matched expanded galleries with a narrowed audience. Where the broad pedagogical mission of the old museum was symbolized by its Neo-Gothic building modeled on London's South Kensington Museum (now the Victoria and Albert Museum) and located in the easily accessible Copley Square (figure 2.2), the new museum took the form of an Athenian temple and was sited in an upscale residential district developing along a park-lined boulevard called the Fenway (figure 2.3). The museum's director described the new building's organization, which grouped displays by culture and era, as "not a question of technique, such as would govern in an industrial museum, but a unity of artistic spirit and artistic purpose."[22] Reviewers contrasted the new museum's evocative "logic of time and place" with "the rigid order of the department store—ceramics here, textiles there, metals in another place."[23] Thus distinguished from the logics of manufacture and mass consumption, the mission and architectural expression of the

FIGURE 2.2 Museum of Fine Arts, Boston, 1876. Photograph provided by the Boston Public Library.

FIGURE 2.3 Museum of Fine Arts, Boston. Photograph provided by the Boston Public Library.

new Museum of Fine Arts today sound unremarkable, but this is because they established paradigms for the modern art museum, as, DiMaggio argues, the same process played out "in other American cities . . . to a large extent influenced by the Boston model."[24]

This context helps explain Boston Japanism's most distinctive feature: the institutional scale on which Bostonians collected. When Fenollosa's collection of Japanese art was accessioned at the Museum of Fine Arts in 1911, it comprised 17,000 objects, not including prints. William Sturgis Bigelow during his lifetime donated approximately 75,000 items—50,000 prints, 400 paintings, and 26,000 other artifacts—to the museum.[25] By comparison, Henri Cernuschi's house-museum in Paris opened with 1500 bronzes and a like number of ceramics; the auction of Edmond de Goncourt's East Asian collections comprised 1637 lots; and when Charles Lang Freer's collection of Oriental art passed to the Smithsonian Institution's Freer Gallery of Art on his death in 1919, it held approximately 9500 objects, 1800 of which were Japanese.

Bigelow, who followed his father as a Harvard-appointed trustee of the Museum of Fine Arts, epitomized the Boston collectors' ambitions. His first acquisition from Japan was a samurai sword bought in Rome when he was twenty-five; just five years later, in 1880, he was able to loan the museum almost six hundred Japanese objects acquired primarily in Paris: 177 *netsuke*, 116 swords, and 111 pieces of lacquerware, along with a smaller number of embroideries, woodcarvings, ceramics, and bronzes.[26] In 1881—still before he went to Japan—Bigelow lent the museum five hundred more Japanese works.[27] Even Bostonians without the ambition or expertise to collect for museums bought on an institutional scale. The poet Henry Wadsworth Longfellow warned his bachelor son Charley, whose around-the-world voyage stalled for two years in Japan between 1871 and 1873, "Don't ruin yourself buying strange bronzes. You will have a perfect musaeum [sic] of curiosities; and I shall have to put a Mansarde [sic] roof on to your part of the house to hold them!" Undaunted, Charley announced that he was sending home "eighteen large cases . . . enough to fill two or three large express wagons. Where we shall stow them all when they arrive, I can't imagine." The poet complained that his son was sending home "screens without end and boxes without number," and Charley's sisters despaired of finding room when thirty "cases of Japanese curios" arrived.[28] On his return, Charley used some of the objects he collected to turn a sitting room in his father's house into a "Japan Room," replacing the Indian décor—souvenirs of an earlier journey—with an

evocation of Japan that included fans adhered to the ceiling (figure 2.4).[29] Although most of Charley Longfellow's Japanese artifacts were dispersed without record, probably to friends and relations,[30] so many Boston travelers donated their purchases to local institutions that, by 1900, the city's museums held the largest collection of Japanese objects anywhere in the world outside Japan. In this respect, Boston lived up to its sobriquet, becoming the hub of object-based scholarship on Japan in the West.

A second—and related—characteristic of the Boston Brahmins' engagement with Japan was their powerful identification with its masculine aristocracy, this in contrast to the Parisian avant-garde's fascination with geishas and at a time when other Americans associated Japanism with femininity. The narrator of Mark Twain's 1880 satire of globe-trotting Americans, *A Tramp Abroad*, comments, "Many people say that for a male person, bric-a-brac hunting is about as robust a business as making doll-clothes, or decorating

FIGURE 2.4 Charles Longfellow's sitting room, 1899. Longfellow House– Washington's Headquarters National Historic Site, archive no. 3008-2-9-5. National Park Service.

Japanese pots with decalcomanie butterflies would be."[31] Boston Japanism, however, was a masculine fantasy of princes and knights. Percival Lowell, visiting Japan in the summer of 1883, was inspired by an abandoned Japanese castle to marvel over the tangibility of the Japanese nobility:

> Sitting by the window and looking at the old feudal remains below . . . all tended to carry my thoughts back to the middle ages, or was it only to my own boyhood when the name *middle ages* almost stood for fairy land? And yet all of this had been a fact, even while I had been dreaming of it. My dreams of Western feudalism had been co-existent with Eastern feudalism itself. So it was only eleven years ago that the last Daimio of the place left the castle of his ancestors forever.[32]

When John La Farge, on his second day in Japan in 1886, was taken by Bigelow to a *Noh* performance, he felt so at home in the "atmosphere of good breeding" created by the "distinguished-looking audience" comprised of "people belonging to the old régime" that, after watching the reactions of "a former *daimio*, a man of position, his face a Japanese translation of the universal well-known aristocratic type," he convinced himself, "after a time" and "even though I only vaguely understood what it was all about," that, like the *daimio*, he knew which actors "did not come up to a proper standard." La Farge concluded about his time with Bigelow, "One feels the citizen of the world that he is when he touches little details of manners here, now as familiar to him as those of Europe."[33] This was the Brahmin fantasy of participation in a masculine elite that could rival European aristocracies.

IMAGINED ARISTOCRACIES AND THE POLITICS OF TASTE

Boston's claims to aristocratic taste played out quite explicitly in relation to Japanese prints and ceramics. Where Parisians competed for primacy as print lovers, Bostonians excluded prints from the rubric of Japanese art. The politics of these preferences were clear on both sides. Théodore Duret praised Hokusai as a "man of the people" who struggled for recognition against the prejudices of official art academies and their aristocratic patrons, comparing Louis XIV's disdain for Dutch paintings of common folk to the attitudes of aristocratic Japanese toward Hokusai's imagery.[34] When Bostonians took up Japanese art, they sided with the king. Fenollosa inveighed against the

Parisian enthusiasm for ukiyo-e exemplified in Louis Gonse's 1883 survey *L'art japonais*. Like Duret, Gonse presented Hokusai as "an artist of the people who died overlooked or despised by the noble class," asserting, "from our European perspective, he is the greatest, the most sympathetic" of all Japanese artists.[35] Reviewing Gonse's book, Fenollosa disagreed:

> No European would think of mistaking the saloon lounger with his pomade and diamonds, and showy clothes, for a gentleman. . . . So in the case of Hokusai and the Ukiyoe we miss all that indefinable something which is implied in the word "taste," and we hear only the clever talk of the barber and bar-tender, or the unpoetical song of the rural poet, or the absurd masquerading of a second-class actor who is not at heart a gentleman.
>
> . . . Even his very birds are coarse and vulgar, with heads quite like people of the lowest caste. He saw life through a vulgar eye, quite as the hostelers, and pimps, and people of the lower classes generally saw it.[36]

Gonse fought back. Dismissively saluting the "precise and practical spirit" of Fenollosa and other Anglophone scholars who established the chronologies of Japanese painters, Gonse asserted the authority of his modern Parisian taste to judge the merit of the art, praising Hokusai and his colleagues for bucking authority. "To Japanese eyes," the popular style "remained of an inferior rank, good for satisfying the instincts of the populace, but unworthy of the attention of proper personages," he acknowledged, but "the vulgar school, emanating from the very entrails of the nation is the popular expression of the Japanese genius without any foreign element; to my eyes, therein lies its most original, most complete form, the one that allows us to penetrate most intimately into the spirit of Nippon."[37]

If, for Gonse and other *japonistes*, the taste of individual Parisians ("to my eyes") sanctioned a populist antagonism toward social hierarchies, for Fenollosa, manifestations of taste either confirmed or betrayed claims to participation in a transhistorical, transcultural elite. The articulation of this ideology in Fenollosa's review of Gonse's book became a manifesto for its author and for the Boston Japanists more generally. After his review appeared in the *Japan Weekly Mail*, Fenollosa had it printed as a pamphlet, which he sent to influential Bostonians, who saw to its republication in the Brahmins' favored newspaper, the *Boston Evening Transcript*, where it appeared with an introduction warning it "will certainly break the hearts of those who have placed so high an

estimate on the value of Hokusai." It was then republished as a booklet titled *Review of the Chapter on Painting in Gonse's "L'Art Japonais."*[38]

While Fenollosa was arguing over Hokusai, another prominent Boston Japanist, Edward Morse, initiated a parallel debate about pottery. In 1883, just back from eight months in Japan where he worked closely with Fenollosa, Morse published in the *Evening Transcript* and in a national magazine an exposé of what was billed as a "Historical Collection of Imperial Satsuma" at a Boston trade fair. "In Japan such a thing as imperial Satsuma is not known," Morse explained. About the works on display, he concluded, "Among the lot is a number that the commonest coolie in Japan would not mistake" as originating elsewhere than Satsuma. Asserting that most of the works displayed "come under the definition of 'Yokohama muki,' a contemptuous term given by the Japanese to stuff made for exportation," Morse suggested sarcastically that the exhibit "may be intended to represent the historical way in which our people have been shamefully humbugged on Satsuma."[39] In 1890, Morse returned to the attack, this time targeting a lavishly illustrated book, *Japanese Pottery*, by the British collector James Lord Bowes. Complaining of Bowes's inclusion of "gaudy vases, plaques, and grotesque figures made expressly for export," Morse encouraged American readers to dismiss the author's European credentials: "We are not concerned with the statement on the title-page that the author is 'His Imperial Majesty's Honorary Consul for Japan at Liverpool.' "[40] This review, too, was widely circulated. Reprinted and augmented in various periodicals, it was finally published as a little book with a long title: *Reviews from the New York Nation, Boston Transcript and New York Studio of the Work of James L. Bowes, Esq., Entitled "Japanese Pottery."* Between these two episodes, Morse laid out his views on Japanese ceramics in his own book, *Japanese Homes and Their Surroundings*, and in an illustrated article on "Old Satsuma" pottery in *Harper's* in 1888 (figures 2.5 and 2.6).

Morse's book begins by establishing his Boston Brahmin *bona fides* with thanks to both Fenollosa and the volume's dedicatee, "Dr. W. S. Bigelow, whose delightful companionship I enjoyed during the collection of many of the facts and sketches contained in this volume, and whose hearty sympathy and judicious advice were of the greatest service to me." Morse's text reports that, following the "revelation" of the displays of "the Japanese exhibit at the Centennial exposition in Philadelphia,"

the more intelligent among our collectors soon recognized that the objects from Japan divided themselves into two groups—the one represented by a

ODD TYPES OF SATSUMA AND SPURIOUS BOWL.

FIGURE 2.5 Illustration from Edward Sylvester Morse, "Old Satsuma." *Harper's New Monthly Magazine*, September 1888.

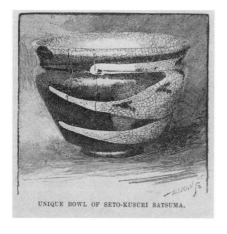

UNIQUE BOWL OF SETO-KUSURI SATSUMA.

FIGURE 2.6 Illustration from Edward Sylvester Morse, "Old Satsuma." *Harper's New Monthly Magazine*, September 1888.

few objects having great intrinsic merit, with a refinement and reserve of decoration; the other group, characterized by a more florid display and less delicacy of treatment, forming by far the larger number.

Objects in the latter crowded category "were made by the Japanese expressly for the foreign market . . . , with few exceptions being altogether too gaudy and violent to suit Japanese taste. Our country became flooded with them; even the village grocery displayed them side by side with articles manufactured at home for the same class of customers."[41]

Morse's disdain for contemporary Japanese ceramics and their grocery-shopping Western consumers complemented his valorization of an aristocratic past. His "Old Satsuma" conjured long-gone days when "observant and patient workers . . . under the patronage, or rather in the service, of some Daimio or other exalted personage" made the pots admired by Japanese connoisseurs: "Questions of cost, which under all circumstances were too vulgar to consider, never entered into the matter. It was sufficient reward for the potter to merit the approval of his master." But now

> the vulgar taste of the ordinary curio hunter demanded pretentious decoration and gaudy colors. . . . In vain did the native dealer expose for sale the beautiful old wares of his country—the pottery simple and unpretentious yet beautiful for its graceful shape and delicious glaze. The merit and refinement of simplicity could not be appreciated by the outside barbarian. The exposure of such treasures was like flinging pearls before swine, and so the pearls were daubed and bedizened. . . . All this mass of meretricious stuff, made solely for the foreigner, finds its way to this country and to Europe by the cargo, where it is sold as "Old Satsuma," "Imperial Satsuma," "loot from some Buddhist temple," or, indeed, by means of any unfathomable lie that can animate and victimize the innocent public.[42]

Morse did not blame Japanese potters for succumbing to vulgar Occidental demands. He admired Japan and often criticized Western middle-class habits and manners—especially those of women—by comparison. A typical passage from his published travel diary describes a Japanese maid, concluding, "The manners and refinement of these people are equal, if not superior, to those of our best society at home."[43] But if the Japanese were not responsible for the collapse of their high culture, neither could they redeem it. The rhetorics of social Darwinism that informed the Brahmins' beliefs in their superiority

infused their thinking about Japan. In a letter Morse quoted to introduce his Japanese travel diary, Bigelow complains of Morse "still frittering away your valuable time" on the fossil studies that first brought him to Japan and exhorts,

> Honestly, now isn't a Japanese a higher organism than a worm? Drop your damned Brachiopods . . . and remember that the Japanese organisms which you and I knew familiarly forty years ago are vanishing types, many of which have already disappeared completely from the face of the earth, and that men of our age are literally the last people who have seen these organisms alive. For the next generation the Japanese we knew will be as extinct as Belemnites.[44]

Just as the onus in Morse's remarks about maids falls on women at home to improve their "manners and refinement" to emulate the deferential Japanese, in this view of disappearing Japanese traditions, agency rests with the enlightened Western collector, who is tasked with preserving the taste of a vanishing population of aristocratic Japanese connoisseurs.

As in the debate over prints, the advocates of "decorated ceramics" fought back, challenging the social implications of Morse's aesthetic hierarchies. Responding to Morse's *Harper's* article on "Old Satsuma," Frank Brinkley, an Irishman resident in Japan since 1867, objected that Morse directed "Western attention to the groove in which the taste of ninety-nine percent among Japanese virtuosi has travelled," but this "faithfulness to the canons of the tea clubs seemed likely to betray him into an exaggerated estimate of the sober and sombre types of Japanese ceramic productions—types which the world ought not to be taught to consider representative of the country's best art." Brinkley, whose circles included the European architects and artists brought to Japan to teach Western modes of art and design, encouraged both Westerners' adaptations of Japanese aesthetics and Japanese efforts to adapt indigenous modes to new markets.[45] His article, first published in the *Japan Weekly Mail* (which he owned) and reprinted in the *Boston Herald*, disparaged the primitivist antiquarianism of the "Tea Cult" as "affectations," warning that, "the observances of the *cha-no-yu* cult and the influences it exerted on Japanese civilization belong, in many respects, to the petty side of the national character."[46]

Bowes's *Japanese Pottery* criticized unnamed "Western collectors" who, in favoring "the rude undecorated pottery of the middle ages," were "blindly"

accepting a "faulty standard current in Japan."[47] Later, rebutting Morse's critical review, Bowes called him "the High Priest of the curious cult" of the tea ceremony, the prejudices of which made him "unable to see any beauty in the artistic works produced during the past two centuries, when Japan . . . made such wonderful advances in every branch of art."[48] To buttress his case, Bowes reprinted an article of Brinkley's lashing out at the tea masters who "decline to admit foreign neophytes into the penetralia of their ideality" while they treasure artifacts from the scrap heaps of two-century-old potteries: "Their shriveled shapes and blotched surfaces suggested beauties imperceptible to the profane crowd." Arguing that "we cannot conceive of how the spirit of true art could ever have elaborated a code that dictates the very formulae of admiration to be employed by its devotees and buries their fancies under a mountain of rigid conventionalities," Brinkley concluded that "Japanese art has been hampered, not promoted, by the tenets of the Tea Clubs" and that "the spirit of true Japanese art rose superior to these cramping influences" in "hundreds of exquisite objects which American connoisseurs will soon, we trust, learn to appreciate at their real value."[49]

The contest here—as with Fenollosa's debate with Gonse over Hokusai— is between two ideas of taste: one the internalization of an elite standard, the other an expression of creative individualism. That Morse's tastes were acquired, not innate, redounded to his credit in Boston. In *Harper's*, Morse explained that he was not intuitively drawn to the aesthetics of the tea ceremony: "The fastidious way in which these specimens are carefully removed from their boxes and silk coverings, and afterward held in the two hands as tenderly, nay, as caressingly as a mother holds her first-born, seems the veriest absurdity, until one has come to appreciate the intrinsic merit and beauty in their unobtrusive glazes."[50] His hagiographic biographer assured readers, "Edward Morse was endowed with an observant eye, an amazingly retentive memory for form and fact, and an analytical mind. He had, however, no aesthetic feeling."[51] Instead, Morse asserted social criteria. Belittling Bowes's concentration on colorful "decorated ceramics," Morse argued that collectors should focus on "the pottery made for the better classes—the poet, the artist, the scholar, the lover of tea and flowers." [52]

Like Bowes and Brinkley, the Parisian *japonistes* were skeptical about Boston's taste. The dealer Siegfried Bing reported after a visit to the United States that, although America boasted sizable collections of Japanese art, they were "in general composed of objects without the delicacy" appreciated by French collectors.[53] The dealer Tadamasa Hayashi likely had Morse in mind when he

reassured Edmond de Goncourt of Paris's primacy in collections of "delicate things from Japan." New York, he said, followed Paris, but other American collections were *magasins* (shops) rather than *cabinets* (collectors' rooms).[54] The allusion here is not just to the supradomestic size of Bostonians' collections but to their grounding in criteria other than personal taste.

Paris dealers, of course, had a stake in contesting Morse's priorities, which undermined the existing Western market for Japanese ceramics. So did Brinkley, who hoped to sell his collection of over eight hundred Chinese and Japanese ceramics to the Museum of Fine Arts, where it was exhibited in 1884.[55] But equally, Morse's adoption of a tradition sanctioned by a tradition of elite Japanese taste worked to his benefit both in Japan and at home. In Japan, Morse was admitted to the all-male circles of scholarly amateurs who practiced the tea ceremony; his teacher told him he was the first foreigner to be so honored.[56] At home, Morse's expertise on Japan won him fame, fortune, and a place in Boston's elite. Through January and February 1882, Morse delivered a series of lectures on Japan commissioned by the Lowell Institute, concluding with "Keramic and Pictorial Arts" and "Antiquities."[57] Newspapers praised the lectures, which filled the vast Huntington Hall at the Massachusetts Institute of Technology, citing Morse's "happy faculty of presenting to his hearers valuable information in the most pleasing and popular manner" as he illustrated his points with photographs, blackboard diagrams, and artifacts from his Japanese travels.[58] The *Boston Evening Transcript* reported that "no other of the several winter courses has been so thronged and no other has given such apparent delight. The audiences have surged up to the very platform steps," before going on to doubt that a "semi-developed race" like the Japanese could really be so civilized.[59] Morse's rapt audiences included such Boston eminences as Percival Lowell and William Sturgis Bigelow. Jack and Isabella Stewart Gardner had Morse repeat the lectures for an invited audience at their home. Inspired by Morse, Bigelow arranged to accompany the charismatic scholar to Japan.

By the time Morse attacked Bowes's book in 1890, he was working to convince the Museum of Fine Arts to buy his own 3,600-piece Japanese ceramics collection to complement its recent acquisition of Fenollosa's Japanese paintings, which were purchased for the museum by the Brahmin philanthropist Charles Goddard Weld. Critiquing Bowes, Morse outlined "what a complete collection of Japanese pottery should be" in terms that appealed to Boston's elite. Allowing just "a few" examples of "the common ware of the masses . . . to show how tasteful even common pottery is in an artistic country" and a

representative selection of the "pre-historic and early lathe-turned pottery of the country," the collector's focus, Morse argued, should be "objects used by the more refined classes for the tea ceremonies, for the writing-table, for the serving of wine, for flowers, and for house adornment more generally," as well as unique and eccentric vessels that "excite the admiration of the tea-lover . . . because they come from the site of some famous kiln, or were used by some celebrated man in past times. . . . Above all, no collection would be worthy of the name that did not include as far as possible the marks of the various potters."[60] This outline exactly described Morse's collection, and the pitch worked. Although the fundraising campaign to acquire Morse's collection for the museum met with public indifference, Bigelow led a group of wealthy patrons in underwriting the purchase, which included an agreement to employ Morse as the "Keeper of Japanese Pottery."[61] The official *Handbook of the Museum of Fine Arts*, reprinted every few years into the 1920s, instructed viewers, "The casual visitor may enjoy the collection by simply noticing the remarkable qualities of glaze, the curious motives of design, the variety of form, and, above all, the reserve and sobriety shown in the decorative treatment."[62]

IMPLICATIONS FOR INSTITUTIONS: ART HISTORY AND MUSEUMS

Art history's verdict on the debates over Japanese prints and ceramics is split. Western museum collections and exhibitions have vindicated the Parisian enthusiasm for *ukiyo-e* prints but have followed Boston's deference to the tea-ceremony aesthetic of the Japanese elite. The result is that the ornate and colorful "decorated ceramics" from Japan attract little scholarly attention, and Meiji exportware—despite its international popularity and appeal for many middle-class Japanese as evidence of their nation's engagement with global modernity—is still routinely dismissed from the purview of art history altogether.[63] The combination in Western conceptions of "Japanese art" consisting of gaudy prints of actors and geishas enjoyed by patrons of the pleasure quarters with simple ceramics prized by elite connoisseurs is conceptually unstable. The longevity of this illogical mix, however, reflects the development of Western arts institutions in the service of two imbricated constituencies: the avant-garde, which took up the prints as a mode of primitivist exoticism, and ruling-class patrons keen to distinguish art from popular visual culture.

At the Museum of Fine Arts, Japanism was central to generating the exclusions that defined "art." The acquisition of vast quantities of things from Japan helped provoke a shift in the museum's mission, as it turned away from plaster casts of European masterpieces displayed for the edification of a broad public that could not travel to see the originals, and toward the stockpiling of unique original objects acquired by local elites as evidence of world travel and global knowledge, though they might never be publicly displayed. For a time, the two agendas competed. The museum's operating budget continued to fund the purchase of reproductions so ambitiously that, by the mid-1890s, Boston had the largest collection of casts of European sculptures in America (and the third largest in the world). In contrast, the museum owned only about one hundred oil paintings (three hundred more were on view as loans).[64] The Japanese collections presented by the Brahmins dwarfed these holdings of Western art, literally reorienting the museum's purpose—and its audience. As the critic Frank Jewett Mather put it, "The sheer mass of the Morse collection of Japanese potteries is appalling to anybody but a specialist," an effect their display in forty glass-fronted cases crammed with similar small objects grouped primarily according to place of manufacture did little to dispel (figures 2.7 and 2.8).[65] When museum officials began planning the new building, a position paper prepared for the trustees argued, "It is necessary to be frank; our personal appreciation and devotion must not blind us to the facts: . . . THE PUBLIC DOES NOT LOOK AT JAPANESE POTTERY." The recommendation was to "put these collections, therefore, excepting a few of their very choicest examples" in a "study series" away from the public galleries.[66] Although this plan was advanced as a way to engage the public, by this point, the idea of the museum's audience had narrowed. When the new building opened in 1909, Mather praised the "dual system of classification, one for showing, another for keeping its treasures," the latter "accessible but not offered to all comers." He concluded, "It is the first time . . . that the dual arrangement has had a trial on an impressive scale . . . and I believe that the example of the Boston Museum must sooner or later be followed by all institutions whose fealty is primarily not to scholarship but to the cultured public."[67] The uncultured were no longer a constituency.

Even for the cultured public, the limited-access study collections segregated objects viewers might want to see from those the authorities decided should be visible. In 1921, the brothers William S. and John T. Spaulding bequeathed their collection of over six thousand Japanese prints to the

FIGURE 2.7 The Morse Collection of Japanese pottery at the Museum of Fine Arts, as photographed before 1907. *Handbook of the Museum of Fine Arts Boston* (1907).

FIGURE 2.8 Pottery of the province of Sanuki, case 19 of the Morse Collection of Japanese pottery at the Museum of Fine Arts, as photographed before 1907. *Handbook of the Museum of Fine Arts Boston* (1907).

Museum of Fine Arts with the proviso that "they shall never be exhibited in the galleries of the museum." Although John Spaulding funded a "special custodian" to show the prints to interested visitors, the money was not used for that purpose, and when the prints were finally deposited at the museum in 1941, it was announced that works in the collection were available to "special applicants at the office of the Asiatic Department."[68] At a further extreme, Okakura Kakuzo, on Bigelow's instructions, acquired "three cases of books, prints, and pictures (of Amorous Subjects)," as he put it in a letter alerting his colleagues to their arrival (figure 2.9).[69] Judging this work important enough to the museum's collection to justify intervention with both Japanese and American government officials in order to circumvent restrictions on the export and import of erotic materials, Bigelow wrote to President Roosevelt, explaining, "Every Museum, like every Library, has things of value that are not for the general public."[70] This acquisition was

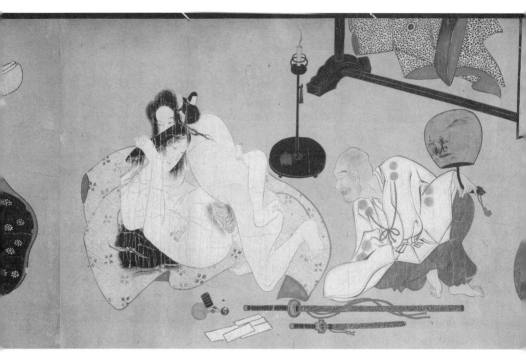

FIGURE 2.9 Kano School (formerly attributed to Shôi), scenes of dalliance in interior settings (detail). Japan, Edo period, late Kan'ei (1624–44) to Kanbun (1661–73) eras. Handscroll: ink, color, gold, and silver on paper; ivory roller ends. Overall: 32.5 × 530.8 cm (12 13/16 × 209 in). Image: 32.5 × 457.3 cm (12 13/16 × 180 1/16 in). William Sturgis Bigelow Collection, RES 09.230, Museum of Fine Arts, Boston. Photograph © 2015 Museum of Fine Arts, Boston.

not publicly announced, and even the in-house catalogs offered no description of the erotic subject matter. To this day, the records of the scroll paintings in this collection are sequestered in a supplemental volume—separately titled in Japanese—of the museum's otherwise bilingual, recently published catalog of its *ukiyo-e* paintings.[71] There is no public catalog of the museum's Japanese books and prints.

Among the consequences of organizing museums to privilege collection over pedagogical display, two had profound effects on the twentieth century's conception of art history. First, the constitution of these collections as scholarly resources defined scholarship in art history as the study of the forms of

visual culture associated with the Western avant-garde and the global elite. Second, access to these collections conferred social status. Today's common practice of granting special access to contributing museum "members" may be traced to the Museum of Fine Arts, where, in the mid-1880s, members of the Boston Athenæum, a private library that had loaned the museum photographs of European art and architecture, objected to paying admission and to the limited periods when staff allowed public access to this collection. Special privileges for Athenæum members were arranged, and similar privileges for museum donors at various levels followed, institutionalizing patrons' sense of themselves as a cultured elite.[72] Similarly, the museum's policy that "names of givers are permanently attached to objects purchased with their gifts" was distinctive enough to warrant statement in the *Handbook* the museum published for visitors.[73] With both Fenollosa and Morse installed in the 1890s as curators of their own collections—an arrangement that provoked the gossipy attention of Paris *japonistes*[74]—hierarchies of specialist knowledge and insider social status overlapped further.

At the Museum of Fine Arts, the pedagogy of the Japanese art displays was explicit. Fenollosa's first exhibition, *Hokusai and His School*, exploited the artist's name recognition while scanting the prints for which he was famous. There were just thirteen Hokusai prints against one hundred sixty paintings and drawings by Hokusai and other artists. This focus on fine-art media did not make for popular appeal. One reviewer commented that "the Hokusai pictures at the museum . . . are worthy of more attention than they seemed to be getting when I was at the museum the other day," for "I was alone in looking at them, and yet there were many people in the other galleries."[75] But the exhibition made a point. Fenollosa's catalog cast Hokusai as representative of a failed movement "to bring the common people into conscious participation in the high life of the nation," a failure ascribed to lack of leadership from above: "The upper classes of the military aristocracy for the most part stood aloof," while the "literary and commercial men . . . were too often content to lose precious opportunities in narrowly conceived individual experiments." The result was "Ukiyoe, 'The Painting of the Floating World,' which deliberately throws to the winds all ideal standards, literary, religious, moral, or aesthetic, and . . . undertakes in terms interpretable by the common people to mirror for its own amusement the passing fashions and the vulgar recreations of the day." The best Fenollosa could say of this art "cut off from the sympathy and experience of the cultivated classes, compelled to suit the taste of comparatively uneducated

patrons," was that it "did not for more than a century fall into hopeless vulgarity and degradation." His warning that "some misconception has led European writers for the most part to rank Ukiyoe as the culminating wave of Japanese pictorial production" informed his description of the culture that produced it: "Yedo during this period was not unlike Paris under the Second Empire."

Thus did the catalog of the first American exhibition devoted to a Japanese artist present Hokusai as a cautionary tale: Failing to find elite patronage, "he never realized to the full the latent possibilities of [his] genius." Boston audiences were warned that "it would be an injustice to our best standards and to the memory of other men to blind ourselves to the importance of his shortcomings," which where made explicit: "His view was on a level with that of the people. Cut off from all the higher oriental ideals of religion, of philosophy, of poetry, of refined manners, of prophetic insight, of chastened spirit, he could not rise above essentially vulgar aims." The role of the museum was explicitly at issue in this lesson. Fenollosa described Hokusai as "cut off from contact with the great masterpieces of an earlier Chinese and Japanese art," because, "in his day, there were no public museums. The collections belonging to temples and to private owners were, for the most part, closed to the common people." And he speculated,

If he could have known intimately the really great men of his day . . . , if the keen scholars, the profound statesmen, the men of trained insight and judgment could have recognized and deliberately guided his genius into normal channels, as a Medici recognized the new-born lights of his generation, we might have had a Japanese art without rival for centuries.[76]

Fenollosa's text exemplifies cultural historians' arguments that exhibition paradigms established at Boston's Museum of Fine Arts register how, for "a dominant status group, it is important that their culture be recognized as legitimate by, yet be only partially available to, groups that are subordinate to them."[77] The first exhibition of the new Department of Japanese Art taught that taste derives from instruction by an elite channeled through the institution of the "public museum," which assumes the role played by the Medici in Renaissance Florence—an idea that continues to resonate in common conceptions of Japanese art as a manifestation of refined taste and in associations of art museums with the social elite.

FICTIONS ENABLING AND EXCLUSIVE

Notwithstanding the confidence of their original iteration or their lasting authority, Brahmin ideas of "Japanese art" should not be mistaken for facts. Their definitions and ideals were ideologies, "enabling fictions" that, as Rita Felski uses the phrase, engendered a collective identity while obscuring "actual material inequalities and political antagonisms."[78] Examination of these inequalities and obfuscations clarifies the mechanisms of exclusion that defined Brahmin Japanism as an expression of both class and gender hierarchies. Here it is relevant that the best known spokesmen for Brahmin ideals were not Brahmins themselves. Neither Fenollosa nor Morse was born into Boston's upper crust. Fenollosa's mother came from respectable Salem stock, but his Spanish-born father was the family's music teacher. Morse was a Congregationalist preacher's son from Portland, Maine. These able, ambitious men made their way to Harvard, the heart of Brahmin intellectual culture, where their intelligence and energy attracted the patronage of wealthy Bostonians. Unlike their patrons, Morse and Fenollosa did not seek Japan to escape a life of constricting privilege. Both responded to financial inducements to teach there—Fenollosa taught political theory and philosophy, Morse Darwinian biology—and in Japan, they relied on men like Bigelow and institutions like the Museum of Fine Arts to support their research and collecting.[79]

For Fenollosa and Morse, paradigms of aristocratic norms internalized through diligent study were both a scholarly agenda and a way of life adhered to with a fervency that afforded those born to the elite some amusement at their expense.[80] When Henry Adams, a recent widower, and his friend John La Farge, estranged from his wife, took a restorative trip to Japan in 1886, "the two bachelors," as Christopher Benfey calls them, were hosted by Bigelow and Fenollosa.[81] Adams's letters cast Fenollosa as the personification of the Brahmin taste police. "Fenollosa is a tyrant, who says we shall not like any work done under the Tokugawa Shoguns," he reported a week into his trip, noting that this ruled out everything he and La Farge had seen in Tokyo, "but it seems we are to be taken to Nikko shortly, and permitted to admire some temples there." From Nikko, Adams complained that Fenollosa "is now trying to prevent my having a collection of Hokusai's books. . . . My historical indifference to everything but facts, and my delight at studying what is hopefully debased

and degraded shock his moral sense." Mocking Fenollosa's adoption of an elite form of Buddhism (which he studied with Bigelow), Adams continued, "He has joined a Buddhist sect; I was myself a Buddhist when I left America, but he has converted me to Calvinism with leanings toward the Methodists." When the joking stops, Bigelow's name returns to Adams's account, as he admits, "I buy pretty nearly everything that is considered good by Bigelow and the Fenollosas."[82]

The public face Fenollosa and Morse gave Brahmin Japanism did not always correspond to behind-the-scenes practice. Morse's published disparagement of ceramics dealers who presented exportware as "loot from some Buddhist temple" sits awkwardly with his travel diary's descriptions of his buying trips through rural Japan with Fenollosa and Bigelow as "raids" or "ransacks."[83] In theory, these expeditions were structured by an equal division of labor, with Morse collecting pottery, Fenollosa paintings, and Bigelow samurai armor. In practice, Bigelow often shared with Fenollosa the cost—and thus the ownership—of expensive paintings, ensuring that they could not be sold without his permission. The nature of these excursions may be assessed from a letter written in 1883 by Bigelow in Japan to Morse back in Massachusetts, reminiscing about their adventures the year before. Using his nickname for Morse, Bigelow wrote,

Everything is just as it was a year ago—but—we miss the old Woolly. We want to see the look that he used to wear when he came in from a raid round a new town, accompanied by two or three grinning, astonished & obsequious doguyas [curio dealers], bearing a pile of boxes & loose pots.—And then the triumph of the O.W. when he displayed his treasures—got them all out on the floor, finally producing from his pocket as a thing too precious to let the other men bring home, some particularly demoralized-looking old coprolite—"A Koyashi, by God!—650 years old—a genuine Unko Koyashi [these are invented names; both unko and koyashi are Japanese terms for manure; a coprolite is fossilized manure] with a stamp! . . . & I got this for 15 sen!" . . . And we want to see his expression of insidious lechery as he enquires of the little fat girl, with an air of ingenuousness that would have done credit to the serpent in Eden—"Nanto Kagaite imasuka?" [What are you thinking of?]—He knows all the time what she was thinking of, & what is more, she knew all the time what he was thinking of.—Ah well!—I think the O.W. would like, though, to see the young lady who is bringing in our frugal meal at this moment. Oyoshi san is her name. Age about 17—pretty

as Jap. servants go—& possessed of the peculiar charm of unconsciousness which characterizes the lean & sassy young waiter girls at a yankee country hotel. . . .[84]

Like the collections of aristocratic erotica Bigelow quietly sequestered in storerooms at the Museum of Fine Arts, the "refinement" of Brahmin circles in Japan allowed a measure of ribald homosociality that was obscured in their public presentations of Japan. But while Bigelow could tease Morse about his connoisseurial practices, Morse—who delighted in comparing his collection to those in Europe and never tired of telling stories of baffling Japanese tea ceremony masters with his recondite knowledge of old ceramics—never questioned the erudition of his Boston patrons.

In this context of patronage by bachelor Brahmins like Bigelow and Lowell, both Fenollosa and Morse downplayed their status as married men whose wives accompanied them to Japan. Fenollosa's boast that he was adopted—"artistically, of course, not legally, though under Tokugawa it would have been legal"—into a respected family of Japanese artists "authorizing me to use the name Kano Yei—(Yei being the first character of the artistic names of all past men of the line)" is analyzed by Josephine Park as an assertion of "a family lineage without the trappings of marriage."[85] The idea of Japan as a man's world informs Morse's published travel diary, *Japan Day by Day*, so thoroughly that through almost nine hundred chatty pages ranging over topics as personal and informal as his fleabites and propensity to warm his stockinged feet by standing where a fat man recently sat, he mentions his wife just once, twenty-five pages from the end, when "Prince Nabeshima invited me to dinner, and as Mrs. Samuel Bright was visiting us she was also invited along with Mrs. Morse." Morse's point is that Mrs. Bright, although he had instructed her that "cultivated Japanese had outgrown whatever belief in Buddhism or Shinto they may have had," made a "somewhat embarrassing inquiry" about religion at dinner, which was "skillfully" handled by the prince.[86] The implication that Western women are out of place in Japan buttresses Morse's observation that Japanese men are indifferent to marriage: "It seems to be an event that the Japanese never talk about, and when one is married it is always a matter of surprise."[87] Back in Boston, Morse manifested a boyish masculinity, joining the elite all-male Tavern Club, where he "gravitated to the 'Hellions Table' . . . where the maddest pranks and most undignified actions went on," and gained a reputation for what one historian describes as "calculated uncouthness with Boston society matrons."[88]

Morse maintained his privileged position among his Brahmin sponsors throughout his long life. Fenollosa did not. His dramatic expulsion from Brahmin circles—and from Boston—followed his violation of the rule that heterosexuality remain unobtrusive. In 1895, he divorced Lizzie Fenollosa to marry Mary McNeil, one of his assistants at the museum. The scandal was not divorce, which was discouraged but tolerated in Boston high society. What was scandalous was divorce closely followed by remarriage, which was evidence of an undisciplined heterosexuality. Fenollosa's transgression was heightened by the women involved. Lizzie Fenollosa was from a prominent Salem family and quietly fulfilled her role as hostess for her husband's Brahmin patrons. The beautiful and ambitious Mary McNeil was unignorable. A native Alabaman divorced from an American diplomat who had been posted to Japan, she moved to Boston specifically to work with Fenollosa in 1894. She was also a poet and author, profiled in the journal *Current Literature* as "ambitious, her consuming desire being to write a Japanese novel in which true character will be portrayed and reality will dissolve the haze with which Americans regard that foreign people."[89]

The Brahmin condemnation was absolute. Although Fenollosa's contract with the Museum of Fine Arts had recently been renewed, he was forced to resign, and his name was dropped from exhibits of his collection.[90] The newlyweds left Boston, never to return. After several months in New York and a trip through Europe, they settled in Japan.[91] When Fenollosa died in 1908, his Brahmin contemporaries were still outraged. Bigelow wrote to his widow, "He was exceptional in many ways. But he erred in thinking that he could be exceptional in all ways," concluding, "If he could have made the best of himself he would have been a great man.—He did a great deal of good in the world as it was."[92] The obituary in the reunion book of Fenollosa's Harvard class struck a similar note, citing his accomplishments but warning, "perhaps too audaciously realizing his own unusual genius and therefore feeling justified in being a law unto himself, thus transcending some of the conventions and suffering the inevitable consequences, he was certainly one of the most interesting personalities of his day." Its author, Nathan Haskell Dole, though Fenollosa was his daughter's godfather, had forbidden his family to mention Fenollosa's name.[93] Echoing Fenollosa's own remarks in his Museum of Fine Arts catalog on Hokusai—that despite his "artistic genius of great capacity . . . it would be an injustice to our best standards and to the memory of other men to blind ourselves to the importance of his shortcomings"—Dole's obituary concluded, "One may not be blind to the mistakes of a friend,

and yet may treasure the memory of that friend as one of the most precious possessions of life."[94] Thus Brahmin rhetorics of submission to convention trumped claims of accomplishment or affection.

Other rhetorics were undone as a result of this episode, however. Fenollosa's expulsion from Boston occasioned a turnaround in his writings on Japanese prints. In *The Masters of Ukiyoe*, produced to accompany an exhibition that toured from New York to Cincinnati and Chicago in 1896, these artists are no longer the "vulgar school," but the "Popular School of Japanese Artists," described as "the special organ of expression of the common people." Although Fenollosa reiterated doubts about "the European estimate" of Hokusai, he wrote, "We have to admit that, in this very worldly side of his genius, lay Hokusai's peculiar power."[95] These changes registered a new context, as in New York the Fenollosas were taken up by a circle of feminists who published the magazine of the General Federation of Women's Clubs. In 1896, the magazine, which had been titled *The New Cycle*, reorganized as *The Lotos*, with a cover designed by Fenollosa's curatorial assistant, Arthur Wesley Dow. An announcement to readers in the last issue of 1895 explained the magazine's new focus on "the whole subject of art" and the "authoritative presentation of Oriental art, philosophy and life."[96] Fenollosa wrote the opening article on "The Symbolism of the Lotos" for the first issue of the journal, which also carried two poems by his wife (still using the name Mary McNeil Scott) as well as her article "Poetry in its Relation to Life" and an article by Dow on "The Responsibility of the Artist as an Educator." Also in this issue, a review of Fenollosa's new *ukiyo-e* catalog and exhibition praised the show as "the most minute historical study ever yet made in Japanese art, confining itself to . . . the school of Ukiyoe, or the Common People." Concluding, "there is an interest that strikes a deeper chord than any sounded by a historian's scholarly approbation or an artist's novel delight. It is the great tie of humanity, of sympathy, of kinship," the anonymous reviewer asked, "Where else in the world shall we find, for instance, the commonest household tasks, sweeping, cooking, clothes-washing, made, not only picturesque but absolutely poetic. The most menial of tasks is treated with a delicacy, sympathy and refinement that completely eliminates all suggestion of vulgarity or coarseness." The review concluded that from *ukiyo-e*, "we may learn our close relation, not only in art and aspiration but in the deepest things of life, to our gentle Oriental friends and brethren."[97]

Fenollosa's article "Art Museums and Their Relation to the People," which ran in two subsequent issues of *The Lotos*, completed his repudiation of his

former patrons. It opens, "Heretofore in America art has been considered a superfluous thing, a luxury of the rich, the delight of the special scholar and critic," and argues that because "beauty [is] no monopoly of the few but the heritage of all mankind. . . . Art education in our public schools, in our civic life, is a duty we owe especially to the poor, the children of the laboring classes. It is for them . . . we found our art museums."[98] Among the feminists in New York, rather than the Brahmins in Boston, there was no more talk of the Medici.

FICTIONS OF JAPANISM AND GENDER

There was only so much the Fenollosas could do to challenge Boston hierarchies in articles about art, however. The sheer quantity of novels by and about upper-crust Bostonians is testament to the way the alibi of fiction allowed authors to approach topics that were otherwise taboo. The competing impulses of discretion and confession that attracted Bostonians to fiction could make a substantial study in itself, and the popularity of the resulting novels of manners set in Boston confirms historians' claims for the importance of Boston Brahminism in setting the style of the American elite. Few women were better placed to critique Brahmin gender dynamics than the second Mrs. Fenollosa.

When the novel *Truth Dexter* appeared under a pseudonym in 1901, an amused *New York Times* review began, "Poor Boston! By what miracle of constitutional robustness does she endure all the attacks made upon her in fiction!" and concluded, "Heaven protect the author when Boston begins to resent his thrusts at her foibles."[99] Written in Japan, *Truth Dexter* charts the struggles of an aptly named Alabama girl (she is both truthful and righteous) thrown into Boston's upper crust. Truth fights for her man against Orchid, the "reigning belle of the Boston season," whose sitting room is dominated by a smirking Buddha. Spoofing both Boston's *Atlantic Monthly* magazine and Percival Lowell, whose 1894 *Occult Japan* was followed in 1895 by a book on Mars, Orchid provokes a man she is pursuing by pretending to mistake him for the one "who wrote that splendid article in the last 'Pedantic' upon the occult influence of Mars." More seriously, the novel pitches in bitter rivalry two compelling female characters who together reflect aspects of the author. Like Truth, Mary McNeil Fenollosa was an Alabaman condescended to by New Englanders. Like Orchid, she was an intelligent, articulate, beautiful woman with a strong

interest in international relations (a prescient analysis of the instability threatening the balance of power in Europe and advocacy of an Anglo–Japanese alliance make up a lengthy dinner-party discussion at the center of the novel) in a culture where complaints about women's domineering social role buttressed norms that trivialized educated women. "The modern woman is far above housekeeping. She must broaden her mind, and elevate her soul," Truth's new husband sarcastically explains before launching into a full-page list of Boston women's activities ranging from "They go to dress-makers and hair-dressers, Turkish baths, manicures, chiropodists, palm-ists, astrologers, and masseuses" to "They discuss Theology in the same breath with the latest tonic. They quote Emerson, and tear one another's characters to pieces with the same smile." Ultimately, Boston expels both Truth and Orchid. Truth returns to Alabama. Orchid dashes her Buddha to the floor, asserting that the dent "will add fifty dollars to his antiquity," and sails away.[100] A popular success, *Truth Dexter* ran to a second edition, and Mary Fenollosa published eight more novels (not set in Boston), several of which were adapted for the stage and movie screen.

If Brahmin social norms discouraged community among women, how-ever, they had the opposite effect among men. So powerful were Boston's associations between all-male intellectual community and bachelordom that Brahminism of the Boston variety might be described as an early form of what the twentieth century came to call sexual identity. Although historians focused on the Brahmins' impressive economic privilege have overlooked the unusual gender dynamics within this powerful class, the idea of a maleness that deviated from masculine norms characterized Bostonian Brahminism from the beginning. In Holmes's "The Brahmin Caste of New England," the prototypical slender, smooth-faced Brahmin youth is distinguished from "the common country-boy, whose race has been bred to bodily labor" and from the descendants of the merely rich: "ancient maidens,—with whom it is best that family should die out." In contrast, the "harmless, inoffensive, untitled aristocracy" of Brahmin scholars carries on, "break[ing] out every generation or two in some learned labor," although the clarity of this legacy may be "dis-guised under the altered name of a female descendant."[101]

No such feminine muddling troubles George Santayana's *The Last Puritan*, coyly subtitled *A Memoir in the Form of a Novel*. This six-hundred-page book appeared in 1936 as a late-in-life anomaly among the verses and treatises of the Harvard poet and philosopher and tells a tale of bachelors, or more specifically, what Santayana called "erotic friendships" among the men of

New England's most privileged classes.[102] Echoing Holmes's assertions about "races of scholars" almost a century earlier, a central theme of The Last Puritan is masculine inheritance. Written in a style that, like so much writing about Boston by Bostonians, hovers between satire and eulogy, Santayana's narrative of upper-crust Boston lays out the apparent oxymoron of a genealogy of bachelors.

"Ancestry" is the title of part I of The Last Puritan, but the lineage described is less about people than about place. The novel's first lines set the stage: "A little below the State House in Boston, where Beacon Street consents to bend slightly and begins to run down hill, and where across the Mall the grassy shoulder of the Common slopes most steeply down to the Frog Pond, there stood in the year 1870—and for all I know there may still stand—a pair of old brick houses." One house, modernized with the times, does not interest the narrator. The other house, however, is described as "an aged Cinderella" who "had long since buried her Prince Charming, and nun-like had hidden her hands in her sleeves and shut her eyes to the world."[103] In this manifestation of unmarriedness—simultaneously widowed Cinderella and nun—lives Nathaniel Alden, the first of three generations of Alden bachelors.

Nathaniel, who is raising his half-brother, Peter, banishes the teenager to a "Camp for Backward Lads" in Slump, Wyoming, for the offense of evincing an interest in girls. The interest quickly passes. Although Peter is the only Alden man who becomes a husband, his marriage, prescribed to cure an unnamed malaise, strains all but legal definition. The doctor Peter consults about his condition arranges for him to wed his own daughter, a young woman who admires her father's work as "so much sounder and more decent than Krafft-Ebing's," and whom Peter finds "almost as fine and vigorous as a young male . . . somewhat like a blond athlete past his prime, and grown a bit fat." For her part, Harriet, a snob with an eye on the Alden name and fortune, responds indignantly to her father's cautions about finding sexual fulfillment with Peter, insisting, "I infinitely prefer my own sex." Though she acknowledges that "there must be children," she proclaims, "Do you suppose any woman who respects herself would demand a—a—a useless assiduity in her husband as if she had married him for pleasure?" The "great bond" between Peter and Harriet on their honeymoon is a shared love of "antiquity shops," which becomes sufficient premise for the birth of their only child, Oliver. Having produced the heir who grows up to become the bachelor "last Puritan" of Santayana's title, Peter returns to live with his male crew on his yacht. Oliver dies, unmarried and childless, dispatched by an automobile crash after realizing he was "like Uncle Nathaniel": "I am, and I'm proud of it."[104]

Taking any of this seriously may be a challenge. But Santayana did. This lifelong bachelor and Harvard professor, though alive to the ridiculous side of Brahmin masculinity, was moved by stronger, conflicting reactions. Nostalgia for the deep homosocial bonds this culture fostered warred with Santayana's anger over what he saw as its lethally stultifying effects on the generation of men he taught at Harvard in the early twentieth century. Peter Alden, the personification of fin-de-siècle Brahminism who links the first and third generation of bachelors, is named Peter, Santayana said, because in the modern American "absence of any tradition in which the poet or God-intoxicated man could take root," he "simply *Peters* out."[105] Readers took it seriously, too. Despite dialogue consisting of long passages of philosophical rumination—"you make us all talk in your own philosophical style," one character complains to the narrator[106]—The Last Puritan became a bestseller and 1937 Book of the Month Club selection. For the apparently substantial number of readers fascinated by Boston mores, Santayana drew attention to—among other habits—the Brahmin bachelors' association with Japan.

Santayana was delighted when characters in what he called his "somewhat farcical sketch of old Boston" were identified with their real-life inspirations, though he cautioned that "those of the characters that have originals at all, usually have more than one."[107] One model for Peter Alden was widely recognized as Beacon Street's eminent resident, William Sturgis Bigelow. Santayana, who, from the age of eight, was raised in Boston with his three Sturgis half-siblings, knew of Bigelow, but the correspondence is not exact. Bigelow's Beacon Street houses were not the fictional Alden house, and Bigelow neither married nor fathered a son. Other similarities are striking, however. Both the fictional and actual Brahmin studied medicine at Harvard and in Paris, although Bigelow studied with Louis Pasteur, whereas Santayana's character, more provocatively, worked with the proto-psychologist Jean-Martin Charcot. Both gave up the practice of medicine when they returned to Boston, and both became world travelers whose munificence enriched Boston museums.[108] Santayana housed the fictional Peter Alden on a yacht that brought the Orient with him wherever he went. Furnished inside with gilded Buddhas and lacquer panels, it was decorated outside with a figurehead described to Oliver by his father's handsome young captain as "a flying swan in black and silver, with a red beak. It was a Japanese design your father found somewhere and adapted." Peter, telling his son why he christened his boat the *Black Swan*, says, "You know I like Orientals, and their way of using words is far subtler than ours. There's no poetry in identifying things that look alike. But the

most opposite things may become miraculously equivalent, if they arouse the same invisible quality of emotion."[109]

It goes almost without saying that no actual Asians intrude upon Santayana's evocation of Boston's elite social circles. What Peter Alden—anticipating Roland Barthes—likes about "Orientals" is what he imagines is another culture's relationship to naming, knowing, and bonding ("their way of using words" so that "the most opposite things may become miraculously equivalent"). In Boston, Santayana suggests, ideas of Oriental mysticism justified forms of homosocial bonding in excess of Western conventions. Studying Buddhism and Shinto allowed Brahmins abroad to assert a scholarly purpose that distinguished them from the common run of traders and travelers. More fundamentally, Japanese religions, as perceived by the Brahmins, offered a powerful alternative to Occidental religious norms, supplanting ideas of a holy family with ideals of spiritual transmission among and between men.

JAPANISM AND/AS RELIGION

Japanism did not introduce Buddhism to New England. As early as 1842, Ralph Waldo Emerson's lecture "The Transcendentalist" asserted that "the oriental mind has always tended to" what he calls "largeness":

> Buddhism is an expression of it. The Buddhist who thanks no man, who says, "do not flatter your benefactors," but who, in his conviction that every good deed can by no possibility escape its reward, will not deceive the benefactor by pretending that he has done more than he should, is a Transcendentalist.[110]

These ideas explain why the first English translation of a Buddhist text—a portion of the Lotus Sutra taken from the French—appeared in the Transcendentalist journal *The Dial* in 1844. Long attributed to Henry David Thoreau, this translation was the work of the *Dial*'s editor and business manager, Elizabeth Palmer Peabody. Another New England intellectual, Lydia Maria Child, contributed to early Anglophone analysis of Buddhism with her encyclopedic 1855 *The Progress of Religious Ideas Through Successive Ages*. Both these women's texts emphasized parallels between Buddhism and Western thought—and neither attracted much notice in an era when American interest in Eastern religion centered on Hinduism.[111]

By the time Bigelow, Morse, and Fenollosa convened in Japan in 1882, American accounts of Buddhism had changed. American missionaries and scholars condemned Buddhism as "atheistic," "nihilistic," "quietistic," and "pessimistic" in contrast with Western "theism, individualism, activism, and optimism."[112] For Bigelow—strongly committed to a nontheistic Darwinism he associated with his medical training, yet having abandoned his career in a struggle with his father, who favored surgery over research and disapproved of Pasteur—Buddhism was attractive for exactly the reasons authorities rejected it. Bigelow embraced Buddhism as escape—from the body, its circumstances, and the authority of empirical science: "In Tendai and Shingon training one of the first things you have to learn is to think of your body as different from what it is," he said, explaining that the "object of training is to disregard sensory experiences at will" so as to "be free to build up a universe by imagination":

Faith is saying you believe something when you know it isn't so. That is really it. Be able to construct your own world, your own conditions without regard to the conditions that are imposed on you through your senses. In all Western science passivity is the test of truth. You are passive to things that come through your senses, whereas the great object of [Buddhist] training is to get your mind so accustomed to acting independently of your sense as to be able to think what you want without regard to them.[113]

Escapism fused with elitism in attracting Bigelow to the Tendai and Shingon Buddhist sects. Both he and Fenollosa (before his disgrace) defined their Buddhist practices against more popular—and populist—versions. Fenollosa spurned Isabella Stewart Gardner's queries about an article on Buddhism with the remark that Buddhists reject "newspaper apostleship," which he called "vulgar, to say the least, though aggressively American."[114] Bigelow distinguished his Buddhism from simpler forms like Zen and Shin, describing the latter as a "very big and popular and kind of easy-going sect . . . the Salvation Army of Buddhism."[115] In contrast, he stressed the venerable legacy and "very beautiful" aesthetic refinement of Tendai and Shingon ritual. But even here, there were distinctions of taste. Describing rituals "a little heavy with ceremonial [sic] for ordinary purposes," Bigelow confided, "a priest once said to me, 'There is a question of good style and bad style about it.' "[116] In a 1908 lecture at Harvard that was then published as a book, Bigelow asserted that, although Tendai and Shingon ritual have roots "so long . . . that there is

no historic record of its origin, and there is reason to believe that it antedates written history altogether," these sects are "nearly allied to Brahminism, to which [they are] historically directly related . . . the more deeply they are studied, the closer is the connection found to be."[117]

Thus, Boston's Japanists found in—or made of—Buddhism a Brahminism of their own, venerable and hierarchical enough to rival the Episcopalianism of the city's elite. Bigelow referred to his teacher, Keitoku Sakurai, as "Archbishop" (translations in Bigelow's lifetime and today generally use Abbot to designate this head of the Hōmyōji temple north of Kyoto[118]), and he carefully preserved certificates of his studies accompanied by typewritten translations detailing titles such as "Doctor of the Authorized Three Divisions of the Great Law"; a footnote in the transcript explains, "This is the highest degree in scholarship conferred by the Tendai sect."[119] These certificates, with their long lineages of "lineal transmitters"—men who channeled the "eternally fixed religious discipline sprung from the Buddha" from the historical Buddha, through Keitoku, to Bigelow—grounded his understanding of Buddhism as a genealogy of men. His perception of Buddhism as an elite fraternity is clear in the notebook in which he recorded insights gleaned from his conversations with the "Archbishop":

—From the religious point of view it is impossible for a priest to have a wife.
—Buddhism is like an emperor. If you set him on common things he can't do them as well as a petty officer. So Buddhism. This is why priests withdraw from the world.[120]

In another set of notes, Bigelow distinguished the Buddhism of "the common people," which deals with "the ordinary relations of life," from what "the priests themselves study," which he describes as "the closer relation of mind and mind."[121]

Bigelow fused the refined and reclusive male homosociality of this Buddhism with ideas of reincarnation and what he called "thought transmission." In his Harvard lecture, titled "Buddhism and Immortality," Bigelow explained that where the West "regards the body inherited from the parents," the East "says that the soul has renewed its relations with the material world by rebirth." Reincarnation preserves what Bigelow calls *character*, which need not follow biology: "The soul follows its strongest ties. These are generally the family ties, but not always; and the soul always finds its own level where its own character is most at home." Thought transmission, too, was a matter

of character and justified Bigelow's reclusiveness. He cautioned his Harvard audience that, though a minority of "people of thoroughly good character, or under the guidance of people of thoroughly good character" may attempt the meditative practices of "non-apparent"—his term for esoteric—Buddhism, these practices are "liable to be dangerous" for common folk.[122] Bigelow claimed to have communicated mentally from Boston with his Buddhist teachers in Japan, but he warned about "the direct transfer of consciousness from one mind to another":

> Nothing is so common in this world as thought transference, and most of the good and most of the mischief in the world is done by that; not by talking but by transference. That is why it is desirable to keep in contact with decent people rather than with roughs. It is not what they say; it is getting their minds hitched up with yours more or less and dragging your mind down to the level of theirs so that you get to like what they like, admire what they admire and dislike what they dislike—the wrong things right through.[123]

Such justifications for an exclusivity compatible with Boston Brahmin social hierarchies contributed to Buddhism's appeal as an alternative, all-male, form of family legacy. This dynamic is evident in a letter Bigelow wrote to the Episcopalian clergyman Phillips Brooks in 1889, when he had been in Japan for seven years, asking him to, "Please report me of sound and disposing mind to my father. . . . He does not take any stock in Buddhism, and thinks that I am hovering on the verge of lunacy because I do not come home and get up some grandchildren for him, like a well regulated Bostonian."[124] Linking Buddhism and bachelorhood in deficance of his father, Bigelow made himself a son to his celibate teacher. He "could not say enough of [Keitoku's] kindness and understanding," contemporaries recalled, and cared for him in his last illness "as a filial child would his benevolent father."[125] For Bigelow, who asserted he "had become aware of his own former incarnations," Buddhism offered an imagined, self-perpetuating, elite community of men.[126]

When Percival Lowell went to Japan at the age of twenty-eight in 1883, he fell in with Bigelow, who invited him to theater parties, dinners with Japanese intellectuals, and sumo and fencing matches.[127] Just five years apart in age, the two men shared family connections—Lowell's mother was a Bigelow—and familial anxieties. Having set out for Japan after abandoning a career managing his family's investments and terminating an engagement

of marriage with a suitable Boston girl, Lowell, too, was alienated from his father and from Bostonian expectations concerning adult masculinity.[128] He emulated Bigelow by using his influence to secure diplomatic privileges for a house in Tokyo rather than living, as the law required, among the Yokohama expatriates he—echoing Hugues Krafft's misogynist accounts of life on the bluff—dismissed as "fair missionarinesses."[129]

At first, however, Lowell was as baffled in Japan as he had been at home. When Jack and Isabella Stewart Gardner arrived in Japan several months after Lowell, Jack reported Lowell was "beginning to collect in a mild way Japanese pictures and books."[130] Isabella commented, "*Poor Percy!* . . . He takes a great interest in everything . . . but there is always something pathetic about him. . . . Somehow, his pleasant things always seem to fall flat."[131] But Lowell found his voice in the Orient. He wrote four books on Asia, including *The Soul of the Far East*, one theme of which is a critique of the attitude of filial "attentive subordination" he saw underlying Confucian culture: "For a father sums up *in propria persona* a whole pedigree of patriarchs whose superimposed weight of authority is practically divine. This condition of servitude is never outgrown by the individual, as it has never been outgrown by the race."[132] Acknowledging that similar ideas animate ancient Classical and Judeo-Christian thought, Lowell casts his own rejection of patriarchal will as evidence of Westerners' evolutionary advance.

Lowell's 1888 *The Soul of the Far East* was bracketed by two other books, one on Korea in 1886, the other, published in 1891, on Japan's Noto Peninsula. Both present his status as explorer in rhetorics of matrimony beyond marriage to women. *Chosön, The Land of the Morning Calm: A Sketch of Korea* opens by casting travel writing as ersatz marriage: "Now that you and I, gentle reader, have journeyed so many thousand miles in company, we should surely have learned to know each other, for nothing, we both admit, so reveals character as travel,—except marriage."[133] *Noto: An Unexplored Corner of Japan* frames Lowell's relationship to this place, which "to most of my acquaintance . . . was scarcely so much as a name, and its local inhabitation was purely cartographic," as a form of upper-class flirtation and courtship:

Scanning, one evening, in Tōkyō, the map of Japan, in a vague, itinerary way, with the look one first gives to the crowd of faces in a ballroom, my eye was caught by the pose of a province that stood out in graphic mystery from the Western coast. It made a striking figure there, with its deep-bosomed bays. . . .

"The name too pleased me," Lowell continues. "It suggested both womanliness and will. The more I looked the more I longed, until the desire carried me not simply off my feet, but on to them."[134] *Noto*'s dedication to another bachelor, the British expatriate Basil Hall Chamberlain, presents the book as a kind of wedding: "For you, my dear Basil, the confidant of my hopes toward Noto, I know I may look for sympathy now that my advances have met with such happy issue. . . . And so I ask you to be my best man in the matter before the world." Here East Asian travel—and travel writing—stands in for marriage for this self-described "respectable misogynist" whose ribald letters to male friends acknowledge consorting with geishas despite "my well known antipathy to the sex."[135]

Despite another of Lowell's antipathies toward home—what Chamberlain called his "violent hostility" to Christianity—he was not seduced by the Brahmin Buddhism that he and Bigelow discussed into the night.[136] When Fenollosa teasingly suggested that Lowell "become a buddist [*sic*] priest," he commented, "I might be tempted to do so not as a priest but as a philosopher."[137] It was not until his third trip to Japan in 1891 that Lowell found religion. And when he did, it was not Buddhism but Shinto. At a shrine on Mount Ontake, a volcanic peak he described as almost unknown to foreigners, Lowell witnessed three youthful pilgrims induce in one another trances in which they seemed to be physically possessed by a local god (figure 2.10). *Occult Japan*, Lowell's last book on East Asia, opens with the claim that these "spirit possessions," although they may have been absorbed "without acknowledgment" into some Buddhist sects, were not "importations from China and India but aboriginal originalities of the Japanese people. They are the hitherto unsuspected esoteric side of Shintō, the old native faith."[138] Lowell's letters record his immediate reaction of exultation at having seen a "Shinto mesmeric show . . . as far as I can learn undescribed and unheard of. Bigelow and Buddhism are not in it!"[139] Lowell was thrilled to discover a Japanese religion to rival that of his fellow Brahmin.

Lowell's *Occult Japan* argues strenuously for Shinto's "essentially Japanese" status. "The faith of these people's birthright, not of their adoption," he called it: "Buddhist they are by virtue of belief. Shintō by virtue of being."[140] More Japanese than Buddhism, Shinto is also, in Lowell's account, more masculine. His book describes luncheon parties he arranged where men representing various Shinto sects, clad "only [with] one of my smallest towels," walked across coals, climbed ladders of sword blades, and called down fire for his guests. The spirit possessions enacted at Lowell's house were carried

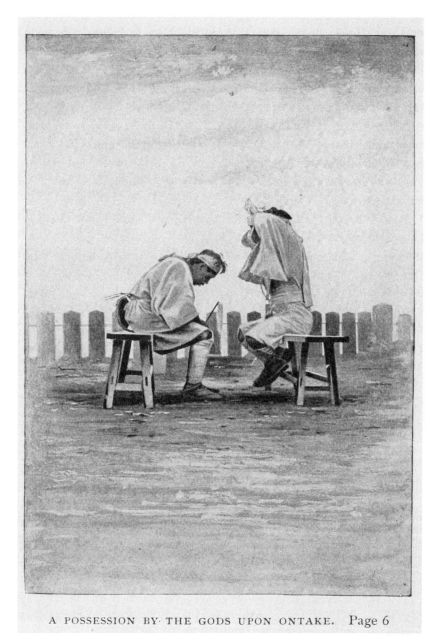

A POSSESSION BY· THE GODS UPON ONTAKE. Page 6

FIGURE 2.10 A *Possession by the Gods upon Ontake*. Illustration in Percival Lowell, *Occult Japan* (1894).

out by men and involved the temporary incarnation of gods in male bodies—with one exception that served to prove the rule. When Lowell hosted a demonstration of the rare "Buddhist trances" he claimed were borrowed from Shinto, a god babbling bogus prophecies took over the body of a "maiden." Contrasting this with the laconic, physically strenuous Shinto possessions, Lowell concluded, "The great ease of possession [was] due, I am convinced, to the sex of the subject." Acknowledging that Shinto gods are of both sexes, Lowell nevertheless described Shinto spirit possession as a masculine practice, characterizing as "certainly not specially feminine" the "divine copartnership" manifest in the willingness of a "multiplicity of gods that deign to descend in one and the same trance." Reasoning that because the Japanese are less evolved than "Aryan folk," and thus closer to "the race characteristics" that are "most deeply graven into the character of the individual," Lowell explained that "in Shintō god-possession we are viewing the actual incarnation of the ancestral spirit of the race. The man has temporarily become once more his own indefinitely great great-grandfather."[141]

The ideas of generational descent from man to man proposed by Bigelow's advocacy of Buddhist reincarnation and Lowell's study of Shinto spirit possession created similar enabling fictions of elite masculine legacy to counter Western norms of gender and generation. The effects of these ideas on Bigelow and Lowell were different, however. *Occult Japan* concluded a trajectory of Lowell's writings on East Asia that historian Jackson Lears analyzes as a projection onto Japan of his anxieties about patriarchal authority in order to repudiate them through "a racist condescension toward Oriental character [that] helped create a negative identity against which Lowell could define a stronger sense of self."[142] As exercises in overcoming father figures, Lowell's books seem as much a repudiation of Bigelow, his older cousin and sponsor in Japan, as of Augustus Lowell. Bigelow's reactions go unrecorded, but Basil Chamberlain, another of Lowell's slightly older sponsors in Japan, deplored his development. Complaining early in 1893 that Lowell's "personality and impersonality theory of the difference between Western and Far-Eastern folk is . . . hardening into an *idée fixe*," Chamberlain went on to report, "I sometimes try to argue these points with Lowell; but he jokes one off, and thinks one below the level of general ideas,—'unscientific,' which word is, to him, the sum of all foolishness." A few months later, Chamberlain, citing Lowell's dogmatism over "the 'impersonality of Orientals,' etc." protested that his writings

bend the facts to suit the preconceived ideas, seasoning the whole with verbal fireworks. What he produces is good of its kind. Pity that the kind should be so damned bad! It was not always so. He was more human when he first began to write. Now he has hardened down into a machine. . . . I don't like the opinions . . . and I don't like the flippant way they are expressed. A few years ago it would have seemed impossible to me that I should ever have come to think thus about Lowell. But doubtless we have both changed. He has become more certain of everything, and I have become less certain of most things.[143]

After the publication of *Occult Japan*, Lowell shifted his attention from Asia to the solar system. Devoting his resources to an observatory to substantiate his belief in the existence of intelligent life on Mars, he initiated research that, after his death, led to the discovery of Pluto, the celestial body so named to start with his initials.

Lowell's superciliously anecdotal accounts of Shinto as a form of primitive ancestor worship differ from Bigelow's earnest evocations of Buddhist reincarnation. Bigelow's yearnings for mystical connections with other men across distances of time and place resonate with patterns Christopher Nealon finds in "queer writers and artists" of the early twentieth century to turn "exile from sanctioned experience, most often rendered as the experience of participation in family life and the life of communities" into imaginary "reunion with some 'people' or sodality who redeem this exile and surpass the painful limitations of the original 'home.'" Willa Cather's novels, for instance, create what Nealon calls "affect-genealogies," a "lineage of invisible kin" apart from "the traditional heterosexual marriage plot." Nealon provocatively links Cather's novels with mid-twentieth-century physique magazines, arguing that these very different cultural forms "share a rich admiration for the beauty of young men"—a "secret of beauty" that promises "a social bond" in the present and a "dream of affiliation" across history.[144] What might seem a far-fetched connection from Bigelow through Cather to magazines like the *Grecian Guild Pictorial* pulls closer on analysis of an essay in that magazine's spring 1956 issue by George Quaintance, "America's greatest physique artist." Quaintance writes:

I do know that we are not born into this life anew. We come here equipped with the experience and the memories of many lives we have lived before— with a background of knowledge that has nothing to do with our parents or our direct ancestry. . . .

That is why I do not believe in heredity. No one should, for as long as one believes that he is born of a certain family, a certain race, color, religion—into a certain locality, country, language, profession—he will be chained by this belief. . . .

Nealon analyzes this "hilarious, heartbreaking" passage as a response to "the two acutest pressure points facing any queer child . . . : what to make of one's family, or one's alienated place in it, and how one is related to the larger story of History."[145]

Bigelow, who struggled—unsuccessfully, in his own late-life estimation—to use Buddhism to overcome *bonno* (states of mind he described as associated with lust and folly),[146] undoubtedly would have rejected an association with physique magazines or other forms of later twentieth-century queer identity. But the pressures of family, race, locality, and profession on men like Bigelow and Lowell would be hard to overstate. These drove both men to Japan and to ideas of Japanese religion connected to nonfamilial, masculine genealogy. Bigelow's writings closely parallel Nealon's analysis of how Quaintance's "thoughtlessly appropriative, escapist" imagery became "a gateway to the dream of affiliation" with men from the past. About Quaintance's contention that "as I came to feel and know all the past great events and the many lives I was sure I was mixed up with in some way through a thousand years of History . . . I knew I was there and saw them happen!" Nealon notes that these "past great events" were all "wars or white exploration of the West," a dynamic echoed by Bigelow's enthusiasm for the "raids" and "ransacks" he undertook with Morse and Fenollosa in rural Japan. When Nealon observes that Quaintance's historical scenarios were "linked by the absence of women and the possibility of nudity,"[147] his language anticipates the characteristics of the establishment Bigelow created back in Boston. Here Bigelow realized his ideal of withdrawal from the world into a community both elite and intensely homosocial, which he hoped to pass on to a spiritual son.

THE PRIVATE SPACE OF BRAHMIN JAPANISM: W. S. BIGELOW'S TUCKANUCK

Boston did not share Paris's enthusiasm for the public culture of bachelor Japanist domesticity. On the contrary, although Boston's bachelor Japanists displayed Japanese objects in their homes, this practice went unacknowledged.

The veil of discretion drawn around the Japanists' homes bespeaks a growing anxiety about the look of bachelor dwellings at a time when Japanese décor was increasingly associated with femininity and in a city where one in five men remained unmarried at age forty-five—only San Francisco had consistently higher rates. A summary of the 1885 census noted that "there are 18,204 more women than men in the city, and the greater portion of the surplus females are in half a dozen wards,—these principally in the fashionable quarter of the city."[148] Back in 1877, the chapter on bedrooms in Clarence Cook's *The House Beautiful* illustrated, as appropriate furniture for a man's bedroom, "a Japanese affair" that "in ten years' use has proved a good friend" (figure 2.11). Explaining that, "in its own land, it was at once traveling trunk and bureau," Cook reported that such items were "the only piece of furniture they can be said to have."[149] By the time Boston's collectors returned from Japan in the 1880s, however, such associations were overwhelmed by the femininity imputed to the "Japan craze"—a dismissive phrase said to have been coined by Edward Morse.[150] On the very few occasions when Bostonians' bachelor quarters were mentioned in print, references to East Asian elements were subordinated to evidence of conventional virility. The published journal of the bachelor playwright Thomas Russell Sullivan records a dinner in 1892 at Bigelow's after which the host "showed us heaps of his treasures in Japanese gold carvings and embroideries" but this generalization quickly cedes to a lengthy description of a portrait of Napoleon, which concludes—more

Grand Combination Trunk Line.
No. 90.

FIGURE 2.11 Japanese trunk. Illustration in Clarence Cook, *House Beautiful* (1877).

proof of Boston's rivalrous eye on European aristocracies—"How little he [Napoleon] would have imagined that in a few short years, he would serve only to decorate the wall of an American, the least of many curios!"[151] A eulogistic reminiscence of Bigelow in the *Atlantic Monthly* described "his handsome rooms . . . full of precious objects," including "Chinese porcelains, bronzes, and tapestries" and "a priceless collection of Chinese glass" as well as "on the mantelpiece . . . some very beautiful Buddhas and a great many photographs of lady friends."[152]

It was not Bigelow's Beacon Street townhouse that attracted comment, but Tuckanuck, the island estate off the Massachusetts coast that its owner compared to "the smallest cruising yacht."[153] Picking up this language, the poet Charles Warren Stoddard opened an article about Tuckanuck with "I am going to sea in a bowl-of-an-island, where . . . there will be absolutely nothing to do but eat and sleep and read and write and talk and think and boat and bathe and fish, and shoot at a target, or play games in airy costumes that are suggestive of the Golden Age of Greece; for there are no women there."[154] An entry in Sullivan's journal noted that at Tuckanuck, "as there are only male servants, pajamas, or less, are the only wear." His next entry begins, "At Tuckernuck living independently in the open air, playing golf and tennis, bathing in the magnificent surf without hampering garments, to dry in the sun like a seal, afterward, on the warm sand," and goes on to report that "George Lodge, our new poet is here."[155] Four summers later, the youthful George Cabot Lodge wrote to Bigelow in an ecstasy of anticipation about another visit, "With your permission, kind Sir! surf, Sir! and sun, Sir! and nakedness!—Oh Lord! how I want to get my clothes off—alone in natural solitudes."[156] This masculine nudity was associated, as Stoddard's reference suggests, with Classical Greece, but also with Japan, where the nakedness of the porters who conveyed travelers around the countryside was a topic of conversation in Bigelow's circle.[157] The imperative to nudity at Tuckanuck was so strongly associated with Bigelow that he could joke with Lodge that he did not winter in Palm Beach because they are "conventional there about bathing clothes."[158]

All this found its way into Santayana's *The Last Puritan*, in which Peter Alden lives on a yacht anchored off various points along the Massachusetts coast. Peter's son, Oliver—whom Santayana acknowledged was based in part on George Cabot Lodge[159]—is overwhelmed when the handsome young captain of the yacht inducts him into the pleasures of skinny-dipping off the *Black Swan*, saying, "Good Lord, you don't want a bathing suit here. This isn't one

of your damned watering-places with a crowd of old maids parading along the front." Here the homosocial impinges on the homoerotic as young Oliver notices that the captain he calls Lord Jim "wore no underclothes" and that "while in his clothes he looked like any ordinary young man of medium height, only rather broad shouldered, stripped he resembled, if not a professional strong man, at least a middle-weight prize-fighter in tip-top condition, with a deep line down the middle of his chest and back, every muscle showing under tight skin."[160]

That these suggestive accounts come from published sources—all except Santayana's novel published during Bigelow's lifetime—confirms what histories of sexuality report: that while gender norms were a powerful force in turn-of-the-century bourgeois culture, conceptions of homosexual identity spread slowly following their "invention" by German medical specialists, not achieving widespread currency until the 1940s.[161] In contrast to anxieties about the femininity associated with Japanist interior décor, accounts of the unremittingly masculine environment of Tuckanuck freely invoked the Orient. The central library room at Tuckanuck was decorated with East Asian artifacts, and customs of nakedness could be carried on in inclement weather in a sunken Japanese tub.[162] Stoddard described Bigelow meeting his guests on the dock as "a tall figure clad in pajamas. . . . He descended with the air of an Eastern potentate, and gave us welcome with Oriental grace." This potentate was quintessential Brahmin: an amalgam of exotic fantasies elite and homosocial. The latter point is almost compulsively reiterated in Stoddard's descriptions of the house where Bigelow "was the lord and master" as "a unique and ideal bachelor bungalow, admirably adapted to the purposes for which it was intended—the happy and sometimes hilarious summer home of the bachelor host and his masculine and unencumbered guests."[163]

One can only speculate what the *Ave Maria* magazine's readers—predominantly female, Catholic, and land-locked—made of Stoddard's paean to Boston's elite masculine Japanism.[164] When, in Sinclair Lewis's 1920 novel *Main Street*, Carol Kennicott of Gopher Prairie, Minnesota, hangs an obi on her living room wall and entertains in Chinese trousers, her neighbors find her "Japanese dingus" "absurd," and her husband complains that the outfit "shows your knees too plain."[165] For Bigelow's potentate pose to be perceived as something other than farce or decadence required a community of attuned and sympathetic collaborators. These were not lacking. The roster of visitors to Tuckanuck ranged from Japanists like Morse and Lowell, through a wide swathe of eminent Bostonian artists, writers, and medical men, to President

Theodore Roosevelt. Stoddard's article energetically rehearsed the attitudes of an admiring "bungalowee," taking as fact the erudition implied by Bigelow's "library to last a man a lifetime . . . books of all descriptions, in various languages, many of them very rare and fine," and his "very powerful microscope" and "big telescope" through which visiting "young scientists" could study the seaweed and the horizon. These scientific tools were not turned to empirical study, however, but to theatrical fantasy. The seaweed under the microscope revealed "visions of fairy-land or fairy-sea. . . . 'Twas Alice in Wonderland on a more wonderful scale," with "most of the *dramatis personae* on this submarine stage . . . encased in flittering armor and richly decked with jewels." The telescope turned a distant vista into "a make-believe island in a play: a bit of scenery that has been run on at the back of the stage," and rendered a view of fishermen fanciful, "a bit like a mechanical landscape in a German clock." Meanwhile, outside the window, the seabirds practiced "stage-falls" into the water, and an apparently blossom-covered branch brought into the house turned out to be covered with butterflies that flitted away so that "all that was left to us was the memory of something fairylike and hardly to be believed."[166] Nature and knowledge at Tuckanuck merged reality with fantasy.

No one was more taken with Tuckanuck than George Cabot—known as "Bay" or "Bey" (short for "Baby")—Lodge, the son of Bigelow's Harvard friend (and Massachusetts senator) Henry Cabot Lodge. In addition to relishing Tuckanuck's norms of undress, the young poet gravitated toward what Henry Adams called the "atmosphere of Buddhistic training and esoteric culture" that Bigelow cultivated: "The oriental ideas were full of charm, and the oriental training was full of promise." Adams explains. For his part, Bigelow recognized one of the Buddhist elite in the twenty-one-year-old man endowed with, again quoting Adams, "a splendid physique, a warmly affectionate nature, a simple but magnificent appetite for all that life could give, a robust indifference or defiance of consequences, a social position unconscious of dispute or doubt."[167] Bigelow arranged for Lodge to study at his monastery in Japan, writing, "He has much earnestness of character and firmness of purpose. He comes of a very good family."[168] Though Lodge did not go to Japan, he bonded with Bigelow. Sending him a new poem titled "Nirvana," Lodge wrote, "No one will understand it except you."[169] When Lodge's poem titled "Tuckanuck" appeared in *Harper's* in the summer of 1896, it hymned an island where "the wind sea-laden loiters to the land/ And on the naked heap of shining sand/ Th' eternity of blue sea pales to spray" as an alternative to

conventional religion: "In such a world we have no need to pray," the poem says, for "the holy voices of the sea and air / Are sacramental." On Tuckanuck:

> . . . we take from Nature's open palm
> The dower of the sunset and the sky,
> And dream an Eastern dream, starred by the cry
> Of sea-birds homing through the mighty calm.[170]

Lodge's marriage in 1900 did not weaken his links to Bigelow and to Tuckanuck. After visiting the island in July 1909 with the New York playwright Langdon Mitchell—another married man with whom he bonded in bachloresque rants against modern marriage—Lodge reported to Bigelow, "I've just returned home from Tuckanuck, browned the most beautiful color by ten glorious days of sun . . . your presence was the one thing we longed for. . . . There was hardly an hour down there when I didn't think of you and long for you."[171]

Bigelow willed Tuckanuck to Lodge. His hopes for this genealogy of enlightened men were destroyed, however, when the younger man died on the island in August 1909 of a heart attack after being poisoned by a bad clam. Bigelow, devastated, forsook Tuckanuck the following summer. When he returned in 1911, he reported that after a few days, he felt "a sense of companionship. I find that Bey is with me all the time, and enjoying things as he used to."[172] Unable to sustain this imagined communion, however, Bigelow abandoned Tuckanuck in 1912 with the comment in his logbook, "It is inexpressibly sad since Bey left."[173]

If Bigelow failed to realize his dream of transmitting Tuckanuck and all it represented to the next generation, his investments—spiritual and financial—in Japan had another issue. It was "partly through the influence of Dr. Bigelow," reports a history of the Lodge family, that Bey's wayward younger brother John Ellerton Lodge became "one of America's great Orientalists."[174] John Lodge's career began in 1911 when this Harvard drop-out and would-be artist impulsively married an Irish-Canadian nurse Bigelow had hired for him during a protracted illness.[175] Now needing a career, he was foisted on the Museum of Fine Arts as a curatorial assistant in Asian art. There he thrived, eventually becoming the curator in Boston and the first head of the Freer Gallery at the Smithsonian, positions he held concurrently from 1920 to 1931. Downplaying the conflicts between these posts while emphasizing his Brahmin curatorial ideology in a letter to the Boston museum's director in 1923, Lodge characterized the Freer's public opening as "a deplorable event,

the accepted fate of all museums [that] is in my opinion quite unimportant except insofar as it subjects valuable and often irreplaceable property to the misuse and abuse of people preponderantly unfit to be brought in contact with it, and seriously interferes with the important work of the institution involved."[176] John Lodge's dominion over both the foremost American collections of East Asian art registers the authority of the Brahmins' institutional engagement with Japanese visual culture. It was in museums that Boston's most significant spaces of Japanism were created.

THE PUBLIC SPACE OF BRAHMIN JAPANISM, PART 1: THE FIRST MUSEUM OF FINE ARTS

By the turn of the century, Boston's Museum of Fine Arts was the world's preeminent institution for the study of Japanese art. "In no other museum can Japanese pictorial art be studied to such advantage. The collections of kakimono, makimono [vertical and horizontal paintings], screens, prints, and books is [sic] without rival, even in Japan," announced the museum's annual report in 1901.[177] At this point, however, the Japanese displays were sequestered in two upstairs rooms and a corridor. After Fenollosa's abrupt departure in 1896, followed by the brief tenure of Arthur Wesley Dow, the curatorship of the East Asian collections was overseen by nonspecialists, bachelors from wealthy families with Harvard connections: Walter Mason Cabot from 1899 to 1902, then Paul Chalfin.[178]

This fallow period for the Department of Chinese and Japanese Art, as it was called from 1903, coincided with an era of dramatic growth for the museum as planning began for the new, much larger, building near the Fenway. The trustees, determined to set a global standard, sent the museum's director, along with the chairman of the building committee and the architects, to Europe for three months, where they visited over one hundred museums in thirty cities and prepared a report on their facilities. Meanwhile, a temporary structure with movable floors was built on the new site to allow for two years of experiments in the lighting and scale of the galleries. It was into this dynamic atmosphere that in 1904 William Bigelow brought Okakura Kakuzo.

Okakura was as close as a Japanese could be to the Boston Brahmins. The son of a samurai turned prosperous silk merchant, he was born in 1862 in the foreigners' enclave of Yokohama, where he was schooled in English. This facility earned him a place, at the age of fifteen, in the first class of the Tokyo

Imperial University, where foreign faculty taught in English. There Okakura met Fenollosa, who hired him as an interpreter, a capacity in which he also worked for Morse, Bigelow, and La Farge, travelling with them as they studied Buddhism and bought art. La Farge's *An Artist's Letters from Japan* is dedicated to "Okakura-san . . . because for a time you were Japan to me." Embracing his patrons' preference for aristocratic Japanese culture, Okakura promoted Fenollosa's campaign to preserve traditional Japanese art techniques against Western-style art training. When, in 1886, a commission of the Japanese Ministry of Education to reform art education sent Okakura on a year-long tour of art schools starting in the United States, he set sail for America with Fenollosa, Adams, and La Farge and continued with Fenollosa to Europe. (He signed Hugues Krafft's guestbook at Midori-no-sato in February 1887.) On his return to Japan, Okakura helped establish the government-sponsored Tokyo Fine Arts School (*Tokio Bijitsu Gakko*), which adapted Western academic administrative structures to teach traditional modes and media of Japanese art—with the significant exception of woodblock printing.[179] Appointed director in 1888, Okakura mandated a uniform of quasi-medieval tunics for the faculty and students.[180]

Okakura turned to his Boston patrons when he was ousted from the directorship in 1898.[181] With $10,000 from Bigelow and others, Okakura founded the Nippon Bijutsuin, which he translated as "Hall of Fine Arts," omitting the national reference to Japan (*Nippon*) and emphasizing its status as a "club" of artists and apprentices.[182] The *Museum of Fine Arts Bulletin* described the Bijutsuin as "representative of a protest against the abandonment by the Japanese of the artistic ideals of the East for those of the West."[183] The introduction to Okakura's 1903 book, *The Ideals of the East*, explained, "If we say that Mr. Okakura is in some sense the William Morris of his country, we may also be permitted to explain that the Nippon Bijutsuin is a sort of Japanese Merton Abbey."[184] Unlike Morris's nostalgic England, however, Okakura's modernizing Japan took little interest in new work made with old techniques. Japanese critics panned the Bijutsuin artists, and money ran short. Okakura turned again to Boston, asking Bigelow to telegraph the word "Possible" if he could arrange employment at the Museum of Fine Arts.[185] When Okakura arrived in Boston in March 1904, Bigelow wrote his fellow Harvard-appointed trustee, "Okakura, the best art critic and English scholar in Japan, is here. I hope we can get him to give us a little help at the M.F.A. It is a rare chance. I will pay him . . . if the committee will not, but we had better work him for all he is worth while he is here. He is a queer duck, but he knows a lot."[186] Okakura

came to work a week later with a letter from Bigelow instructing Paul Chalfin to "give him every assistance in your power in examining the collections at the museum."[187] It was the first the curator knew of the arrangement.

Okakura made himself indispensable in Boston. With the help of assistants he brought from the Bijutsuin, which ran courses in the conservation of traditional Japanese arts, he finished a preliminary catalog of the Japanese collection in his first ten months on the job and began repairing lacquers and metalwork. His flattering assessment of the museum's collection appeared in its *Bulletin* of January 1905 and was reprinted in its *Handbook* in 1906. "It is only upon examining it since last March that I begin to realize its preëminent place among the Oriental collections of the world," Okakura asserted. "I do not now hesitate to say that in point of size it is unique, and that in quality in can only be inferior to the Imperial Museums of Nara and Kioto; while for the schools of Tokugawa painting it is unrivalled anywhere." Despite its riches, however, Okakura suggested that the collection was poorly managed. "I wonder that the collection has not hitherto received more general attention, or become the object of the serious consideration that it warrants." He intimated that the problem was non-Japanese staff. "Japanese and Chinese art require to be interpreted from within like European art, and their productions are to be treated neither as curiosities nor phantasies."[188] He was more direct in conversations with the museum's director, whose notes record Okakura arguing that "the Museum treated Japanese art as a fad or joke but not seriously" and that "a proper curator . . . should be a scholar with a knowledge of Chinese and Japanese" and at least five years' training in Japan. Okakura "felt with regard to Mr. Chalfin that he would never be able to subordinate his ideas and feelings to objects which were so foreign to his convictions as those of oriental art."[189] Chalfin resigned a few months later, solaced by a fellowship to study mural painting in Italy.

Although in Japan Okakura had advocated laws restricting art exports, in Boston he urged a campaign of acquisition, saying that from both the museum's and "the Japanese point of view . . . this collection should completely illustrate the history of Japanese art for the benefit of the Western world.[190] Despite the museum's large holdings of Japanese paintings, ceramics, metalwork, and lacquers, one shortcoming Okakura pointed to was that the "sculpture was yet in its infancy as a collection."[191] Within weeks, he was dispatched to Japan with funds from donors, led by Bigelow, to fill the gaps in the museum's collection. When Okakura sent back to the museum twelve Buddhist sculptures, the oldest dating to the eighth century, these were announced as "the most important acquisitions of the year by way of purchase," and "a

specially fitted room" was designed for them, replacing a room that had displayed coins.[192] This display opened to the museum's donors on February 1, 1906, and to the public the next day.[193]

What came to be called the "Japanese Cabinet" marked a departure for the museum. The same report that in 1903 advocated the sequestration of the Morse collection to study rooms away from the exhibition galleries also took up the question of special architecture for particular collections. Here Matthew Prichard, a British member of the director's staff, cautioned, "We risk, in attempting it, violating the spirit of great restraint that is imposed on us by our reverence for the arts. A work of art, it has been said, does not need the help of a background, but only to be unhindered by it." Prichard quoted (in French) Julien Guadet, the reigning authority on architectural theory at the École des Beaux-Arts, asserting, "There is no more shocking nonsense than the false conception that consists of placing Japanese collections, for example, in a faux-Japanese décor." Warning about "the feeling of a lack of refinement that a histrionic treatment of objects involves," this document concluded, "In the end it is a question of taste."[194] This argument, pitched in Bostonian terms, should have been persuasive. But the annual report of the Department of Chinese and Japanese Art concluded with a defensive description of its new gallery:

> The Japanese Cabinet is an attempt to furnish for the objects there exhibited a background somewhat similar in tone to that which would be found in some old temple in Japan. It does not in any way try to reproduce the interior of a temple, but merely aims to render an atmosphere of dignified simplicity suitable to the proper exhibition of its contents. The dais and the moulding half-way up the wall are of cypress, treated by an "age" stain to a silvery brown, while the walls up to the moulding are covered by undyed burlap, above which is plain white plaster.[195]

Another department report cited "the use of vitrified gauze shoji in the lower halves of the windows [that] has both softened and diffused the light, at the same time eliminating the disturbing influence of outside scenes." More provocatively, it emphasized the "notable and significant fact that the students of art in the Museum seem to choose this room in preference to any other as a place in which to spend their occasional moments of leisure."[196] Thus did the idea of Japan contest the authority of Europe, as personified by British administrators quoting École des Beaux-Arts professors.

The author of these descriptions of the Japanese Cabinet was Francis Gardner Curtis, another Brahmin bachelor. (He married in 1913 at the age of forty-five and died two years later.) Curtis was a powerful ally for Okakura in Boston. While in Japan over the winter of 1899–1900, he studied painting at Okakura's Bijutsuin, to which he also contributed financially. Then and during a longer stay in 1902–03, he participated in the association's exhibitions.[197] On his return to Boston in 1903, Curtis moved back to his mother's townhouse on Marlborough Street, and it was there that Okakura lived when he arrived the following year. The day Okakura came unannounced to work at the museum, Curtis accompanied him to ensure a respectful reception.[198] Curtis continued to help Okakura, overseeing the day-to-day activities of the curatorial department when he was away. He was designated Associate of the Department in 1906 and upgraded to Associate Curator the following year, but as late as 1913, a citation of Curtis's position in a Boston newspaper noted that "he practically gives his services, so that he is pretty much on his own time when here."[199]

On the basis of Curtis's description of the Japanese Cabinet, he has been credited with its design. But Okakura was in residence during the room's planning and installation, which might best be understood as a collaboration. Not simply a partnership between Okakura and Curtis, this evocation of "some old temple in Japan" gave form to Brahmin ideas of Japan as an exemplary alternative to the West. When Okakura arrived in Boston in 1904, he had just published *Ideals of the East with Special Reference to the Arts of Japan* (the announcement of his appointment in the annual report follows the idiosyncratic spelling of his name in the 1903 first edition). Its often-quoted first sentence—"Asia is one"—sets up the book's argument for a unified Asian culture as a counterweight to the West, with Japan as Asia's epitome, thanks to its "unique blessing of unbroken sovereignty, the proud self-reliance of an unconquered race, and the insular isolation which protected ancestral ideas and instincts," all of which make "Japan the real repository of the trust of Asiatic thought and culture."[200] Okakura's ideas are now commonly linked to Japanese nationalism and pan-Asian resistance to Western imperialism, but Kōjin Karatani has pointed out the centrality of Fenollosa's Hegelianism and Western definitions of art in Okakura's supposedly indigenous ideology.[201] It was not just Fenollosa, however, but the whole community of museum-making Boston Japanists, with their veneration for aristocratic tradition, who informed Okakura's thinking. "It is in Japan alone that the historic wealth of Asiatic culture can be consecutively

studied through its treasured specimens," Okakura proclaimed. "Thus Japan is a museum of Asiatic civilization," preserving a legacy for the day when "Japan . . . returns upon her past, seeking there for the new vitality" to counter "the scorching drought of modern vulgarity [that] is parching the throat of life and art."[202]

Okakura's next book was even more deeply embedded in Brahmin ideology. *The Book of Tea*, published in 1906, is often said to have been assembled by John La Farge from notes Okakura prepared for the lectures he offered wealthy Boston ladies who met at the Museum of Fine Arts to sew silk bags for the Japanese treasures as they sipped tea.[203] Though the ladies did sew and Okakura did lecture, these chapters have other origins.[204] His text clearly addresses Western audiences, opening with the question, "When will the West understand, or try to understand, the East?" The essays that follow purport to explain Japan through the tea ceremony, a drama "whose plot was woven about the tea, the flowers, and the paintings." Okakura here authorized a Brahmin version of Japan, simultaneously dispelling Western associations of tea, flowers, and art with femininity and invoking standards of elite taste. He describes a Japan where "the tea-master, Kobori Enshu, himself a daimyo, has left to us these memorable words: 'Approach a great painting as thou wouldst approach a great prince'" and where people remember the "eminent Sung critic" who said, "In my young days I praised the master whose pictures I liked, but as my judgment matured I praised myself for liking what the masters had chosen to have me like." Learning to reverence art as a form of deference to masculine aristocracy, Okakura cast Japan—the Japan embodied in the collections of the Museum of Fine Arts—as an acquired taste and a counterforce to "this democratic age of ours" when "men clamour for . . . the costly, not the refined."[205]

This vision of Japan as an antidote to modern Western culture justified the design of the new room at the old Museum of Fine Arts. Completed over the winter of 1905–06, the Japanese Cabinet offered an Eastern alternative to the Western style of the rest of the building, realizing ambitions Boston Japanists had held for decades and presaging what was to come in the new museum. Bigelow wrote as a member of the building committee,

There ought to be at least one big Japanese room in the new building. Dr. Weld had the right idea when he proposed in the '80's to fit up such a room in Japanese style. I have always been very sorry that his plan was for some reason or other not carried out. It would be the best thing possible, with one exception, namely, to buy the whole inside of a big temple over

there, have it taken down in sections, numbered and set up here in a room built of dimensions to fit it.[206]

The construction of the new building for the museum offered an opportunity to give permanent architectural expression to these ideas.

THE PUBLIC SPACE OF BRAHMIN JAPANISM, PART 2: THE SECOND MUSEUM OF FINE ARTS

When it opened in November 1909, the new Museum of Fine Arts represented the Brahmin vision of—and to—the world:

> Standing before the main entrance, with its four-column portico above the treble doorways, the spectator will be impressed with the dignity of the mass and the refinement of the details. In style and handling, this central feature of the design shows a discriminating reverence of the past and a spontaneous effort in terms of the present.

Thus the museum stated its goals, promoting architect Guy Lowell's "freely interpreted" Classicism as a style that "will readily appeal to the rather conservative taste of a community that does not easily accept new departures in architecture."[207] One man's dignified is another man's dull, and Frank Jewett Mather, reporting for *London's Burlington Magazine*, disparaged the façade as lacking "variety." Mather was impressed when he stepped inside, however. "On entering, a glance to the right and left reveals the bilateral division which, with occasional exceptions, is carried through the museum. We may turn to the right and Greek cases, or to the left and Japanese potteries—to the art of the West or the East" (figure 2.12).[208]

So central to the museum's identity was this new layout that a schematized version of the plan replaced the outdated logo on the title page of the *Handbook*, where it was accompanied by a statement identifying the museum as "maintained and developed wholly by the gifts of private citizens" (figures 2.13 and 2.14). The side-to-side balance of East and West was complemented by a hierarchical organization up and down, with open storage areas on the ground floor, including the Morse collection of pottery, signifying the richness of the collections from which curators selected the pieces showcased in the spacious galleries above. This architecture emphasized the authority of curatorial selection, inducting visitors into the ideology proposed in the *Book*

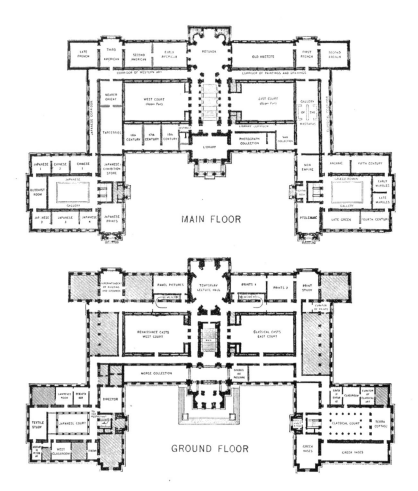

FIGURE 2.12 Floorplan of the Boston Museum of Fine Arts, 1909.

of Tea, where maturity is signaled by "liking what the masters had chosen to have me like." The new museum, thus, gave architectural form to the Brahmins' self-image as the fulcrum between Athens and Japan.

In practice, the balance tipped toward Japan. Okakura put the point plainly in a letter to Ned Holmes, the museum's director (and Oliver Wendell Holmes's grandson), in which he urged resources for more acquisitions:

The Chinese and Jap. Department is the most important branch of the Museum,— a branch which is truly important to the whole world. However

FIGURE 2.13 Title page, *Handbook of the Museum of Fine Arts* (1906).

FIGURE 2.14 Title page, *Handbook of the Museum of Fine Arts* (1922).

valuable our collection of Greek art or European painting may be it will be idle to compare it with the wealth of the British Museum, the National Gallery of England, or the Louvre, where in Eastern art we hold a paramount place which these museums will never attain *if we do not neglect our duties toward the collection.*[209]

Outsiders agreed. "For visitors already familiar with the galleries of Europe and America, the most astonishing and memorable feature of the Boston museum is its Japanese and Chinese collection," reported the New York artist Walter Pach in a review of the new building in *Harper's*.[210] The reasons were several. Against the studied neutrality of the Classical and European galleries as "unnoticeable voids in which beautiful objects may attain their fullest value," in the words of Mather's review, the Asian wing offered a striking contrast (figure 2.15).[211] "The art of a country reflects its civilization and ideals; placed amid foreign and uncongenial surroundings, it loses much of its significance," begins a description of the Asian galleries issued by the Museum on the opening of the new building. It continues, drawing attention to the

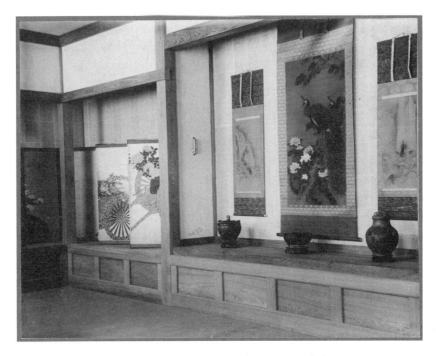

FIGURE 2.15 Gallery of Japanese Paintings at the Museum of Fine Arts, c. 1910.
Photograph provided by the Boston Public Library.

"use of natural wood and plaster . . . which has ever appealed to the finer
sensibilities of the Japanese," the " 'shoji' or sliding screens of paper," and
the " 'tokonoma' or raised recess of honor." The goal was to create for the
objects on display "a background and atmosphere suggestive of that which
might originally have been theirs. [212]

The contrast between the Eastern and Western approaches to display was
most dramatic in the double-height, sky-lit courtyards at the center of each
wing in the symmetrical building. The stark "Classical Court," installed "for
the present" with plaster casts of Greek sculptures, was cited in guidebooks
and museum publications only to give directions to the galleries around
it.[213] The "Japanese Court" that mirrored it, however, was noticed in every
description of the museum, illustrated as a "unique feature" in Pach's article
on the new building in *Harper's* and pictured on postcards (figure 2.16).[214]
One guide to the new museum instructed, "Everyone must stand for a few
minutes in the gallery above, and look down upon the Japanese garden . . .

FIGURE 2.16 Japanese Court, Museum of Fine Arts, Boston, c. 1910.

with delightful stone lanterns and grotesque carvings, and its cool lily pool in which the fat Oriental gold fish disport themselves."[215] Mather described this space as "a garden with a presiding Buddha," a reference to the thirteenth-century sculpture of the multi-armed esoteric Buddhist deity, Aizen, donated by Francis Gardner Curtis, that terminated the long axis.[216] And it was likely Curtis who wrote the museum's explanation of the new space: "The garden is treated in the semi-formal style of a temple fore-court" with "columns and brackets" in the style of "those used during the Nara period (eighth century A.D.) when Japanese temple architecture reached its noblest development."[217] Such scholarly explications coexisted with franker acknowledgments of the fantastical aspects of the design. The *Boston Evening Transcript* quoted a curator who justified the papyrus growing in the ponds by saying that although it "is not a native Japanese plant . . . it ought to be."[218] For the *Nation's* reviewer, the Japanese Court was "not a museum feature" but "rather an oasis provided for the wearied visitor, where he may halt and, freeing himself of the bustling associations of every day, let a little of the mysterious calm of the sacred East fill his harassed consciousness. The end of our visit is peace."[219]

Having created a temple forecourt, the curators turned a large adjoining gallery into a temple with an elaborately carpentered ceiling and altar-like niches where monumental Buddhas were displayed (figure 2.17). A guidebook to the museum explained, "A little temple has been prepared for them—not the copy of an actual temple, but a room in the true spirit, symbolical of a Japanese temple—and each Buddha sits enshrined in dignity."[220] Though the

FIGURE 2.17 Buddhist Room at the Museum of Fine Arts, c. 1910. Photograph provided by the Boston Public Library.

elaborate architecture of the Buddha Hall was anachronistic to most of the sculptures,[221] the culminating gallery of the Asian wing of the Museum of Fine Arts successfully incarnated the Brahmin ideologies of the Bostonians who created it. As a "little temple," it presented a congregation of gods-as-art to be visited reverentially—as the author of *The Book of Tea* might have put it, "as thou wouldst approach a great prince."[222]

The Buddha Room was—and remains—popular, but its deviation from curatorial norms worried professionals. The museum's director, writing in *Museums Journal*, allowed that this room's Japanese architectural elements "perhaps go too far."[223] In the *Burlington*, Frank Mather tempered his praise for the Asian galleries with a critique of what he called the "more ambitious" but "ill-advised" sculpture room: "It is a sightly place, but it seems to me to offend against sound museum canons in making an exhibit of what is after all mere setting."[224] *The Nation's* reviewer opined, "It is just such a setting as an amateur of taste might contrive for his treasures, and this may seem both its eulogy and condemnation. It smacks of amateurism. It puts the setting in competition with the jewels."[225] But this effect was praised in the more populist *Outlook* magazine as a salutary contrast to museums where "officialdom has driven out the brooding spirit of the collectors"; here in the "new palace of fine arts in the Boston Fenway," viewers could enjoy "the most intimate, the most personal, museum in the world. . . . Chinese [sic] sacrificial bronzes tended by reverent hands ever since they were made, away back in the third century, seem not to have passed into the soulless clutches of an institution, but to be adopted pets of the curator."[226] For admirers and detractors alike, institutionality was trumped by a presentation that draws attention to the sensibility of the men who assembled and designed the exhibition.

An expression of collective Brahmin ideology, the new galleries were most immediately the work of Francis Gardner Curtis and Ralph Adams Cram, an architect whose Japanism developed in Boston's Wilde-inspired Aesthetic circles in the early 1890s.[227] In 1892, Cram cofounded a short-lived quarterly, *The Knight Errant, Being a Magazine of Appreciation,* which, following British models, combined Japanism with romantic medievalism. When *The Knight Errant* commissioned a piece on "The Significance of Oriental Art" from then-curator Fenollosa, the resulting essay appealed to the Aesthetic interest in androgyny by focusing on a modern *kakemono* owned by Bigelow that depicted "the Bodhisattwa Kwannon, one of the most beautiful figures in the Buddhist Pantheon, [who] is on the feminine side of her bi-sexual nature" (figure 2.18). Fenollosa's familiar themes of Japanese art as an alternative to

FIGURE 2.18 Nishiyama Hoyen, *The Bodhisattwa Kwannon*. Frontispiece illustration of *The Knight Errant* (October 1892).

"the debasement, the exaggeration, the appeal to vulgar feeling, the dominance of the comic which for the most part deface the residue of modern oriental art, even the art of Hokusai" were heightened by his conclusion's personal address to *The Knight Errant*'s readers. He demanded, "Does it as a whole say something sweet, and intimate, and pure to you? Then you have comprehended Japanese Art."[228] The following article in this issue of the magazine, Herbert Copeland's "Of Camera Obscuras and Japanese Crystals," developed claims for its readers' intuitive understanding of Japan. Mapping a dichotomy between Western scientific realism and Eastern romance in modern novels, Copeland deplored French realists who "make a show of . . . the commonplace and the brutal" and praised the "romantic novel" for realizing the Wildean proposition that "beautiful immorality is less objectionable than moral vulgarity." To exemplify this Oriental devotion to beauty indifferent to conventional morality, Copeland chose a local tale of sexual transgression, Nathaniel Hawthorne's *The Scarlet Letter*.[229] Thus were Boston, Aestheticism, and Japanism united.

By the time he designed the Japanese rooms at the Museum of Fine Arts, Cram had abandoned Aesthetic publishing to become Boston's pre-eminent

architect. Though he specialized in Episcopalian churches, Cram had expe-
rience in Japanist design, having used Morse's book on Japanese houses to
create a Japanesque residence for Arthur Knapp, one of *The Knight Errant's*
contributors, in 1894.[230] After a trip to Japan in 1898—where he announced,
"Japan is as much more wonderful, beautiful and exquisite than I ever dreamed
in my wildest moments. This is absolutely true"—Cram added a tea pavilion
to Knapp's residence.[231] Cram's letters from Japan boast about his bachelor
life of dalliances with geishas and flirtations with women in the expatriate
community and report, "I am learning an enormous amount about Japanese
architecture under the guidance of Fenollosa who loves me like a brother."[232]
The effects of Fenollosa's fraternal pedagogy are clear in Cram's aesthetic
judgments. Anticipating a trip to Kyoto and Nara, he wrote, "I shall see some
realy [sic] good architecture. All the work here and at Nikko is late Tokugawa
and therefore bad."[233] After visiting Kamakura he reported, "I don't hesitate
to say that it was the greatest event of my life to date. No words can describe
the glory of the old pre-Tokugawa temples and their surroundings."[234] Fenol-
losa's influence is equally apparent in the essays Cram published as *Impressions
of Japanese Architecture and Allied Arts* in 1906. Echoing Fenollosa and Okakura,
Cram asserted that "Japan is the vortex of the East . . . the sole representa-
tive of Asiatic civilization," and he assessed the temples of the "Nara-period"
(which for him extended from the sixth to the eleventh century) as indicat-
ing "inevitably a school of architecture quite worthy to take its place with the
already recognized schools of Classical, medieval, and Renaissance Europe."
As in the West, however, the venerable beauty of ancient architecture is lost
on all but an elite. The beauties of Nara design "fritter themselves away in the
trivialities of the Tokugawa régime," exemplified by "the crowded temples of
the Tokugawa period that rise in every village in Japan" with their "coarsened
and vulgarized" details and "cheap and tawdry" ornament. The only thing
worse was modern Japanese architecture, as "the nobles are building pal-
aces from European designs that would dishonour a trans-Mississippi city or
a German suburb."[235] As with Morse and Fenollosa, Cram's scholarship on
Japanese aesthetics plays out as a demonstration of good taste.

This was the taste on display in the Boston museum's Asian wing. Cram
himself signed the architectural drawings his firm produced for the Asian
galleries, and the issue of the museum's *Bulletin* published for the opening
of the new building referred readers to his *Impressions of Japanese Architecture*
to explain the designs.[236] The rooms demonstrate what Cram's essays pres-
ent as the two-fold essence of Japanese architecture: first, "it stands alone

as the most perfect mode in wood the world has known," and second, "it is the architecture of Buddhism, and it must be read in the light of this mystic and wonderful system." As a result, Japan's "early temples . . . are dreamlike and visionary. Under their shadows alone could one understand a little of Buddhism."[237] The galleries instantiate this ideology of Japanese temple architecture as Buddhist pedagogy.

To learn about Buddhism in the shadows of its architecture was to absorb a form of elite masculinity. For Cram, Buddhism was personified by "a priest I had the privilege of knowing in Kyoto at the great temple of Nishi Hongwani":

> a scholar of the utmost erudition, of noble and knightly blood, a living exposition of high breeding and courtly manners; withal a poet, a philosopher, and a connoisseur.
>
> As I sat before this calm, courtly ecclesiastic, a model of so nearly all that is admirable in men, surrounded by the masterpieces of the great painters of the seventeenth century, it was impossible to refrain from drawing a contrast between certain of the denominational missionaries I had met and this grave representative of an august philosophy, with his slow smile and unfathomable eyes.[238]

Such accounts of venerable Buddhist masculinity unite Japanese priest and Bostonian traveler as part of a knightly aristocracy that, transcending nationality and trumping other forms of class competition, is recognizable to itself around the globe.

This was the fantasy spectacularly staged at the new Museum of Fine Arts. Behind the Athenian façade, displays of beautiful and valuable objects assembled by local collectors were organized so as to balance Orient and Occident, asserting a measured, evaluative authority over the world with Boston at the center—"the Hub"—of a patrician connoisseurship infused with ideals of masculine community. Much has been made of the efforts at this era by Edward Perry Warren, younger brother of the board of trustees' president, Samuel Warren, to ensure the representation of homoerotic imagery in the museum's holdings of ancient Greek and Roman art. In 1928, after the death of John Marshall, his much-loved collaborator in collecting, the younger Warren consoled himself with the idea that through their joint efforts "something has been done for the Museum," concluding, "For the Museum was truly a paederastic evangel. It must be counted as a result of love."[239] Little attention has been paid to links between this aspect of the Greco-Roman collections

of the Museum of Fine Arts and the Japanese collection, although Bigelow's donation to the museum to commemorate Okakura's death in 1913 included a selection of Greek vessels, some decorated with scenes of homoerotic court-ship.[240] The two sides in the balance of East and West monumentalized in the layout of the new building were, thus, united in their idealization of bonds between elite men.

Crucial to the masculinization of Japan presented at the museum was the establishment of the temple—rather than the house—as the paradigmatic Japanese space. This marked a significant new shift away from the emphasis on Japanese domesticity manifest in Krafft's Midori-no-sato, Morse's *Japanese Homes and their Surroundings*, and the popularization—and feminization—of Japanist interior decoration since the 1880s. In 1872, a Buddhist temple that opened in Paris sparked no interest among the *japonistes*,[241] and as late as 1893, when Okakura's Fine Arts School outfitted Japan's pavilion at Chicago's Columbian Exposition, the celebrated Ho-o-den boasted an exterior mod-eled on a temple but was furnished inside to evoke aristocratic living spaces. Even at the Museum of Fine Arts, Walter Mason Cabot, during his short ten-ure as Asian art curator at the turn of the century, proposed installing a gal-lery in the old building as a Japanese house.[242] But domestic associations were not the Brahmins' cup—or book—of tea. Although these Bostonians, when in Japan, distinguished themselves from merchants and missionar-ies by occupying Japanese houses, they did not recreate these spaces when they returned.[243] The institutionalization of the study of East Asian art in the West, historians have argued, required its disassociation from domestic-ity.[244] Thus, Morse's scholarly authority in Japanese ceramics was built on his disparagement of the "decorated ceramics" that ornamented middle-class dining rooms, while his *Japanese Homes and their Surroundings* repeatedly con-trasted the simplicity of Japanese interiors with the "ostentation" and "false display" of Western houses.[245]

The Oriental wing of the new Museum of Fine Arts, organized around its temple garden and shrines, reified this ideology. In the museum's *Handbook* for visitors, the section on East Asian art opens with an introduction by Curtis:

So different from ours are the conventions of the Oriental artist that the 'queerness' of everything at first overshadows all else. . . .

One unfamiliar with the art of the extreme Orient . . . will recognize, perhaps, a certain charm of line, color, or composition, little dreaming that what is before him may be a subtle exposition of cosmic philosophy.[246]

This was the pedagogy of galleries in which the look of a Japanese Buddhism passed down through generations of learned men supplanted Asian art's associations with decoration in order to transform "queerness" into a "cosmic philosophy."

BACHELOR JAPAN

If the temple architecture of the East Asian exhibits at the Museum of Fine Arts reflected the Brahmins' idea of Japan as a site of elite masculine spirituality in general, the displays confirmed the specific beliefs of their primary benefactor. Bigelow's Tendai form of Buddhism incorporated meditation focused on painted mandalas and monumental sculptures, and he cited the museum's installations to explicate practices in which "union and identification" with "Divinity" is achieved by imagining "that you are a three-dimensional reflection in a glass of that statue, that you are the statue."[247] Bigelow's ideological investment in this version of Buddhism as the truth of Japan helps explain Okakura's obfuscatory reports to the museum's trustees about the circumstances that made it possible for him to acquire such temple treasures. Implausibly positing the already abated exigencies of Japan's war with Russia with making Japanese individuals and temples willing to sell, Okakura avoided acknowledging the rapidly diminishing authority of recondite and costly Buddhist sects in modern Japan.[248] The representation of Japan in the museum's galleries and storerooms fused this idea of Japan-as-Buddhist-temple to the reification of the homosocial expatriate networks the objects' donors had enjoyed in the East. Charles Goddard Weld was yachting around Japan with Charley Longfellow in 1885 when he fell in with Fenollosa and Bigelow, who persuaded him to buy Fenollosa's art collection for the museum. Another patron, the Harvard professor Denman Ross, paid for most of the monumental sculptures that populate the Buddhist Room today. For Ross, trips to Japan contributed to an identity that combined blustery confidence in his mastery of global canons of taste with participation in masculine networks in which the homosocial merged with the homoerotic.[249]

Ross came from Boston's elite. He was named for his uncle, Matthias Denman Ross, a real estate developer who helped found the Museum of Fine Arts in the 1870s. By the time Denman Ross went to Asia in 1908, he was primed by thirteen years on the museum's board of trustees to admire the art of Japan's aristocratic past in ways that redounded to the authority of Boston's taste.

Modern Japanese art he dismissed: "Hardly anything worth looking at. It is dismal to see how the lessons of Sculpture and of Painting have passed away," he wrote in his diary. He was equally put off by how the Japanese displayed the art he admired. "Many beautiful things very badly exhibited," he said of one museum. "Not the least sign of good taste either in choice of the pieces to be shown or in the arrangement of them." At the temples in Nara he complained of the "wonderful things . . . seen under the most unfavorable circumstances," concluding, "The Nation is unworthy of possessing such masterpieces when it makes no proper exhibition of them. We do more for Japanese art than the Japanese."[250]

Such assessments are interspersed in Ross's diary with expressions of appreciation of the beauty of the naked and nearly naked Japanese men he encountered, including a sumo wrestler who "was well made and fine in color even having fine teeth." His resolutions to acquire "attractive" East Asian men as servants at home alternate in his diary with outbursts of indignation at American trade unions and immigration policies that admit "all the ruffians of Southern Italy and Sicily" while excluding the "quiet, peaceful, industrious, economical, and productive" Japanese and Chinese who would "give us good work cheap"—though he is clear "that citizenship should be in our country reserved exclusively for people of English Stock."[251] These themes repeat through Ross's diaries from two subsequent art-buying trips to Japan in 1910 and 1912, during which he assessed the beauty of Japanese men with connoisseurial aplomb. Schoolboys wrestling on a beach "were well made and good looking and except for their loin cloth, naked. It was delightful to see them in this scene"; a boy who rows him "was plain in his face [but] superbly made, with a skin of most beautiful texture and color. It was a sight to see the movements of his body as he rowed us along keeping a perfect rhythm." Pages of admiring notes on individual artworks and the precepts collected in Paul Carus's *The Gospel of Buddha* jostle with disparaging remarks about "the silly new museum" and "the almost equally silly old one. Why don't they stick to their own architectural motives[?]"[252]

Ross's diaries exemplify with brutal clarity what Karatani calls the "bracketing" function of aesthetics in Western thought. "What Kant constituted as a condition for the judgment of taste was the stance of seeing a certain object with 'disinterestedness,' namely, to see it by bracketing cognitive and ethical concerns," Karatani writes: "With Kant it became clear that what makes art art is the subjective act of bracketing other concerns." For Karatani, the "aestheti-centrism" of the "Japanophiliac" deploys this bracketing to

balance submissive admiration of ancient Japanese art and philosophy with assertions of authority over the knowledge and concerns of contemporary Japanese, "who live their real lives and struggle with intellectual and ethical problems inherent in modernity." This division becomes complicit with imperialism when aesthetes praise the objects they constitute as "art" while exploiting the cultures that produced them. As Karatani notes, Japan has played both roles in this dynamic. Subject to Westerners' aesthetic/imperial gaze, Japan turned an imperial eye on its Asian neighbors, a development he associates with Okakura's influence (informed by Kant through Fenollosa) at the time Japan shifted from defending its sovereignty to justifying its own imperial projects.[253]

Karatani's trenchant analysis suggests a relationship between Ross's connoisseurship of Japanese art and his appreciation of Japanese male bodies. Karatani locates the aesthete's pleasure in the act of bracketing: a ritual of submission to what he knows "he can dominate if he wants to" that parallels the pleasure of the masochist who submits to a master "only in a relationship wherein his superiority to the master is confirmed and he can play within a set of rules that does not violate his ultimate security."[254] Ross's admiration for the muscle-toned skin of living Japanese (echoing Krafft three decades earlier), along with his admiration for the art and ideals of Japanese long dead, together define—in their confident exercise of the connoisseurial agency to select—authority over what they admire. This dynamic is clearest when Ross stumbled across practices he could not master. "Where is their Michel Angelo?" he wondered in his diary a month into his first trip to Japan, prompted by seeing the "wonderful figure" of a naked man digging clay. But the absence of a Japanese version of Michelangelo's fusion of artistic genius and homoerotic sensibility does not lead Ross to question ideas of representation or sexuality in the East or the West. The same diary entry, after acknowledging "I could not possibly get my feet into my lap in Buddha fashion," expresses bafflement over the hours of meditation performed by the young priests at a temple where the acolyte who showed him around was a "healthy, strong, good looking boy with a clean cut face and bright eyes. . . . I wonder what these meditations mean for a boy like that."[255] Again the speculation is left unpursued, however, with the implication that anything Ross does not understand is unknowable or insignificant. The next entry is the one that concludes, "We do more for Japanese art than the Japanese."

Ross's moments of wonder are far outweighed by the confidence that was central to his celebrated pedagogy. His Harvard courses were famous

for combining practice in design and color theory with confident connois-
seurial evaluation of objects from his eclectic collection of art from around
the world in a wide variety of media. When he lent the Museum of Fine Arts
a group of artifacts acquired "some in Asia, some in Egypt, some in Europe,"
he explained, "The beauty and value of the object are discovered by compar-
ing it with other objects of the same kind. It is the eye, of course, that tells
us what is better and what is best. To know the best of its kind we must have
seen it. The best is then our standard of judgment."[256] That Ross's pedagogy
deeply impressed the men he taught at Harvard is registered in their descrip-
tions of the transformation of this "dumpy Anglo-Saxon" or "nattily dressed
stock-broker" into what one alumnus called "the oriental sage we knew."[257]

As with perceptions of Bigelow as an "Eastern potentate," such attribu-
tion of Asianness to the authority of elite white men says as much about Bos-
ton audiences' desire to find personifications of a global aristocracy in their
midst as about the individuals who filled those roles. These local ideologies,
however, infused much larger professional networks and broadly accepted
knowledges of Asia in the West. Laurence Sickman, curator of Asian art and
long-time director of the Nelson-Atkins Museum in Kansas City, for instance,
cited Ross as "the most influential man in his life." Though Ross had retired
when Sickman came to Harvard to study Asian art in 1929, he "had the young
man to his home twice weekly for dinner and lessons in connoisseurship."[258]
This vignette of the elderly Ross inducting the handsome young student
from Colorado into the etiquette and attitudes of Boston's bachelor Japanists
encapsulates a dynamic in which ideas about East Asian aesthetics helped
to constitute—and, in turn, were inflected by—the structures and ideologies
of the Brahmins who created standards for museums throughout the United
States and beyond. One of Sickman's first acts at the Nelson-Atkins was to
construct a temple room in which to display Chinese painting and sculpture.

A JAPANISM OF HER OWN:
ISABELLA STEWART GARDNER'S HOUSE MUSEUM

If, as this chapter has argued, the definition of Japanese "art" constituted in
the West constitutes a mode of bachelor Japanism powerfully inflected by
the ideologies of Boston Brahmin masculinity, the fervor with which that
category was protected is exemplified, not only in the myriad condescend-
ing comments about Japanist vogues, fashions, and crazes associated with

middle-class women, but in the look of another Boston landmark, just a few blocks away from the Museum of Fine Arts: the house museum of Isabella Stewart Gardner.[259]

Isabella Stewart's status as a bride in "the bosom of one of Boston's old Brahminical families" was likened by her friend John Jay Chapman, a fellow New York transplant, to that of "a fairy in a machine shop."[260] This oft-quoted phrase obscures less fanciful implications of the fact that, after she married John "Jack" Lowell Gardner in 1860, this woman who would live to be eighty-four became "much of an invalid."[261] The death of her first child and a subsequent miscarriage deepened a depression from which she recovered through a campaign of travel far from Boston. Between 1867 and 1875, the Gardners toured western Europe, Scandinavia, Russia, and the near East. She was enamored with Venice, and the Gardners began renting the Palazzo Barbaro for the summer months. These voyages furnished the outfits and associates that allowed Gardner to present herself as a cosmopolitan in Boston, where stories of her extravagance flourished. An 1895 newspaper profile reported, "For twenty years and more she has kept Boston society talking about her. In the Hub her eccentricities are as well known as they are expected."[262] Gardner, in short, beat the pseudo-aristocratic Brahmins at their own game. Her first biographer begins by describing Boston as a place "where pride of race flourishes" in order to contrast local assertions of descent from pilgrims on the *Mayflower* with Gardner's claim to descend from Mary Stuart, Queen of Scots, whose relics she collected—along with, just for good measure, images and artifacts associated with other queens named Isabella.[263]

Gardner's competitive response to the caste she married into was underestimated by the Brahmins at the Museum of Fine Arts, where her husband was a trustee and the museum's treasurer from 1886 until his death in 1898. And there were other family connections. Jack's sister married into another Boston family associated with the museum; her son J. Randolph Coolidge Jr.—Isabella's nephew—was a trustee for thirty years and the museum's acting director in 1906 when its expansion plans were approved. There was, therefore, every reason to expect Isabella Gardner to follow other Brahmin women in quietly supporting the museum initiatives overseen by the men of her class.

The first intimation of Gardner's deviation from this self-effacing role came in 1882, when her brother-in-law spurned her advice to purchase John Singer Sargent's *El Jaleo* for the Museum of Fine Arts. As the museum's centennial history ruefully notes, although J. Randolph Coolidge Sr.'s "Beacon Street house was liberally adorned by naked ladies in marble, bronze, and oil,"

he passed over Sargent's dramatic image of a Spanish gypsy dancer, choosing instead a conventional academic painting titled *The Friend of the Poor*, which depicted Christ appearing in the house of suitably awed peasants. Adding insult to injury, his brother, Thomas Jefferson Coolidge, bought the racy Sargent for his own house but ignored Gardner's advice to light it from below in order to reinforce the dramatic illumination in the composition, in which the dancer is lit by footlights. Over thirty years later, when the elderly T. J. Coolidge lent Gardner his famous Sargent, she had a room built to display it lit as she had suggested. The story goes that Coolidge was so impressed he gave her the painting.[264]

That triumph was in the future, however, when the Gardners made Japan their first stop on a 'round-the-world tour in 1883. In Tokyo, Bigelow and Lowell squired the visitors to theaters, tea ceremonies, and teahouses. Bigelow also took them shopping. Jack Gardner reported that Bigelow "has given up much of his time to taking us about and put us in the way of buying good things, which generally have to be picked one by one in little booths perhaps miles apart."[265] Isabella's account was that "we have drunk gallons of canary colored tea out of their dear little cups and have eaten pounds of sweets, as we three have sprawled about on the soft, clean mats, in the funny little shops, looking at curios," though she noted that "we . . . very seldom buy anything."[266] Bigelow was frustrated. He complained to her about some hanging scrolls, "Why under heaven did you not buy them? Fenollosa and I can't afford such luxuries, and it is your mission to bring them home, as nobody else can."[267] About a small Buddha statue he encouraged her to purchase, Bigelow wrote to Gardner, "If I get home and find no Buddha in your front entry to say my prayers to—I will commit Hara Kiri on your best parlor carpet."[268] She ran the risk. A decade later, when Gardner bought a Botticelli painting that the Museum of Fine Arts failed to find funds for, Bigelow congratulated her on behalf of "the Art Museum Trustees" for her "most mu- & magnificent performance." Enlisting her in the Brahmin rivalry with New York, he wrote, "Really, we shall have to put up a statute [sic] to you, right under the picture, and when the haughty New Yorkers come here and ask with an aristocratical sneer whether we have any pictures in our Museum as good as the Marquand Collection, we shall say—casually—'Oh yes—we have the best Botticelli in America—would you like to look at it?' And we shall watch them wilt and slink away."[269]

Bigelow's various presumptions—to direct Gardner's purchases, to enlist this native New Yorker in Boston's bid for cultural supremacy, to foresee her

collection coming to the Museum of Fine Arts—were unwarranted. By 1896, Gardner, in a letter gloating over the interest Bigelow and other trustees showed in a Titian she had acquired, referred to plans for "my Museum."[270] The architect the Gardners commissioned to design a gallery attached to their Beacon Street house had completed the plans when, in December 1898, Jack Gardner died. Within weeks, Isabella bought land in the new residential district of the Fenway and initiated the construction of a museum conceived as an expression of her own ideals.

Turning an austere brick face to the street, Gardner's museum "has the look of secrecy that we remember in many foreign treasure houses," reported John La Farge.[271] Newspapers registered the building's secretive effect as a marker of female will unsanctioned by masculine logics. "The latest whim of America's most fascinating widow," which was "going up before the astonished gaze of residents of the Back Bay district," was mistaken for a warehouse or a brewery, even before it was surrounded by "the weirdest wall ever conceived by whim of woman."[272] The scale of this "whim" was clearly institutional. The *New York World* reported in 1902 that the "wonderful building" was "destined to be regarded by the public at large as an important treasure of the city like the Public Library, the Art Museum, Trinity Church, or the State House." Gardner inaugurated her museum on New Year's Eve 1903 with a party featuring a concert of choristers accompanied by fifty members of the Boston Symphony Orchestra.[273]

Where other Boston institutions manifested a collective masculine authority, however, Gardner conceived the building she called Fenway Court as a personal memorial, commissioning a tablet placed high over the door and inscribed "The Isabella Stewart Gardner Museum in the Fenway MDCCCC." Though that tablet was covered with a marble slab until her death, during her lifetime her authority was announced in the only other signage on the façade: an escutcheon depicting a phoenix over the motto "C'est Mon Plaisir" (figure 2.19). As early as 1891, Gardner characterized her art collection with the phrase "Everything here is a remembrance."[274] Now her museum, designed as an inside-out palazzo around a glass-roofed courtyard embellished with Italian architectural fragments, evoked her association with Venice. Each room integrated paintings and sculptures with furniture, fabrics, and flowers chosen and arranged for an effect dramatic yet domestic, asserting a feminine accomplishment to rival Brahmin masculinity.

At first, Asian art was peripheral to Gardner's project. While her museum was under construction, she bought more than one hundred fifty Asian pieces,

FIGURE 2.19 Isabella Stewart Gardner Museum, detail of plaque on the façade. Photograph by Christopher Reed.

mainly architectural elements, from Boston dealers, and Bigelow helped her negotiate the purchase of a group of eight large Chinese Buddhist sculptures, which did not compete with the museum's concurrent campaign to acquire art from Japan. But when Fenway Court opened in 1903, most of the Asian art remained in storage. A "Chinese Room," in keeping with Fenway Court's overall aura of a Venetian palazzo, had the form and scale of a Western salon, dominated by an enormous fireplace. This room evoked not China but the European vogue for *chinoiserie*. Japanese panels and screens, along with some large Chinese embroideries, hung flat against the wall like paintings, while one of the Chinese Buddhas and bric-à-brac from all over East Asia sat in and on glass-fronted display cases (figures 2.20 and 2.21).

The artifacts in the Chinese Room complemented a portrait epitomizing Gardner's self-fashioning as a Venetian noblewoman. In yet another appropriation of the masculine prerogatives of her class, Gardner was painted by Anders Zorn, who, a recent study concludes, "perfected a graphic language which captured that idiosyncratic American combination of personal power and practicality that typified the values cherished by the highest stratum of the American business and political masculine elite at the *fin de siècle*."[275] For Gardner, Zorn produced a memorable evocation of feminine authority. Unlike Zorn's male sitters who typically sit or recline, Gardner, arrayed in her

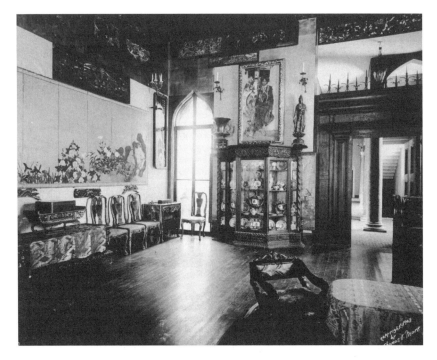

FIGURE 2.20 First Chinese Room, Fenway Court, 1903.

signature long string of pearls, strikes a self-conscious pose. Throwing open glass doors onto a balcony of the Palazzo Barbaro with the waters of the canal illuminated by fireworks outside, she fills her venerable aristocratic setting with a vivacious confidence that seems to ripple from her outstretched hands, which are reflected in the glass doors in a way that fuses her figure with that environment (figure 2.22). In 1906, Henry Adams wrote to Gardner after seeing Fenway Court for the first time to praise what he called her "Special Creation," concluding, "I feel as though you must need something—not exactly help or flattery or even admiration—but subjects."[276]

John La Farge and Henry Adams—both men with a close but ironic perspective on Boston and its Brahmins—welcomed Gardner's anti-institutional institution. "Trying to disentangle the threads of a sensation of delighted relief in any visit to Fenway Court," La Farge contrasted it to "the annoyance, the monotony, of Museum galleries" that confer "an unreal appearance of competition and scholastic rivalry to [the] remains of individual effort."

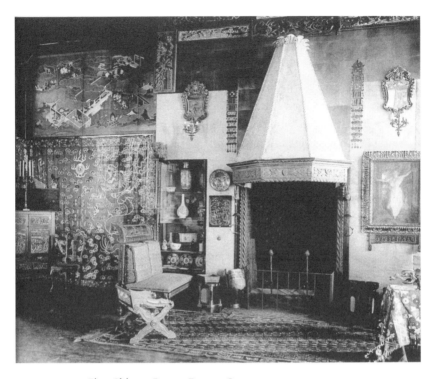

FIGURE 2.21 First Chinese Room, Fenway Court, 1903.

FIGURE 2.22 Anders Zorn, *Isabella Stewart Gardner in Venice*, 1894. Oil on canvas. Isabella Stewart Gardner Museum, Boston.

In Gardner's house, as in the houses of old families in Europe, he said, it seemed "that theories of art were put aside, that orderly suggestion of schools and instruction from them had to be adjourned, and we rediscovered these things for ourselves."[277] Adams was, typically, pithier when he concluded that a visit to Fenway Court proved "Mrs. Gardner hates a picture gallery almost as much as I do."[278] Even Matthew Prichard, who had advocated against the creation of the first Japanese room at the Museum of Fine Arts, came around, now arguing that objects in a museum

> are have-beens. To renew their benign vitality you would have to take them out of museums. . . . They are all very well where they are for the purposes of the intellect whose eyes, says Bergson, are ever turned to the rear. But though "we think backwards we live forwards," and for purposes of life these things must be where they are attached to action. Mrs. Gardner's attempt is a capital re-animating operation.[279]

By 1906, Gardner's competitive acquisition of masterpieces of European art prompted Bigelow to warn his fellow trustees against alerting her to their potential purchases.[280] As Prichard's conversion suggests, she also competed with the museum for the allegiance of its staff. Gardner's protégé and first biographer, Morris Carter, whom she hired from the Museum of Fine Arts library, recalled, "As Mrs. Gardner took the deepest interest in the development plans for the new building of the Art Museum, she frequently invited the members of staff" to dine.[281] Curators, including Paul Chalfin, were part of Gardner's circle, as was conservator John Briggs Potter, who lived in a ground floor flat at Fenway Court while he repaired some of her Renaissance paintings.[282] Potter's residency at Fenway Court followed that of Matthew Stewart Prichard, who had been recruited from Edward Perry Warren's circle of bachelor connoisseurs in England to serve as the museum's second in command in 1902. Seizing upon their mutual—and mutually dubious—claims to Stuart ancestry, Gardner installed Prichard in the small flat during his first few months in Boston.

Prichard and Gardner became fast friends, stoking one another's antagonism toward those in charge of the Museum of Fine Arts. Their attitude toward these authorities and Boston social conventions in general is clear in a 1905 letter in which Prichard responds to Gardner's teasing report that Okakura accused him of "growing commonplace" with the prediction, "I shall buy a dog, hire a mistress, drink cocktails and join the Tavern Club, . . . speak with

bated breath of the Director, refer to Bigelow & Morse as authorities on art, go to church . . . marry (in the end)."[283] Gardner encouraged similar irreverence among the other young men in her circle. A 1901 letter from Bernard Berenson disparages "the directors of our Museum of Fine Arts" for spending big money on bad paintings by famous names: "Dr. Bigelow, a charming[,] refined, cultivated person is one of them is he not? Well (this is strictly private) we talked about pictures, and he believed himself very, very wise. . . . But he made me and other people smile and if he knows so much, how did he let his colleagues buy such a repainted [Velasquez] picture!"[284] In 1904, Gardner delightedly reported to Berenson that when Okakura began "cataloguing the Japanese things that have been huddled there since Fenollosa's time, [he] finds forgeries and forgeries!!! And has great contempt for Fenollosa."[285]

Okakura was Gardner's greatest conquest in her battle for the allegiance of Museum men. Although Bigelow brought him to Boston and the Museum of Fine Arts, Okakura quickly became part of Gardner's circle. By the summer of 1904, he and his two assistants from the Bijutsuin were living on Gardner's country estate in Brookline. "Have I told you of my oriental life there[?]" she wrote to Berenson in August. "We sit under the trees, one of them sketches (*not* in our manner), one arranges flowers as only they can, and through it all we become far away and hear only Okakura's voice as he tells those wonderful poems and tales of the East." A few months later, Okakura joined Gardner at the head of her table when she threw a Christmas dinner for the "waifs and strays who don't have family here," Prichard, Potter, and Chalfin, among them.[286] And a few weeks after that, he hosted a candlelight tea ceremony— often cited as the first tea ceremony in America—at Fenway Court. Bigelow, who was one of five guests, thanked Gardner by commending her for "bringing not only the bones but the soul of Cha-no-yu to the Fenway—I should never have supposed it possible."[287]

Bigelow's incredulity must have increased the following spring when Okakura and Gardner staged a "Japanese Festival Village" in the concert hall at Fenway Court as a fundraiser for a local hospital. "It took a whole month for the Japs to make a little village in my Music Room," she reported, but the effect was worth it. Okakura procured from New York Japanese trinkets to sell, and there were

> 4 or 5 shops on each side, down the middle a wide street, the Shrine of the Red Fox with his lanterns and Torii on the stage, where at the side of the shrine is the Tea House. They seem to be in a large garden, for there

is a huge trellis of wisteria, cherry trees in full bloom and the dark sweet-
smelling pines. . . . There are jinricksha rides, games, selling penny toys,
singing, dancing, and last and very first—the jiujitsu men. They are won-
derful and *beautiful* too.[288]

Gardner's "Japanese Festival Village" participated in a well-rehearsed form of
popular—and populist—spectacle. The first touring "Japanese Village" came
to Boston in 1886, and similar entertainments graced world's fairs, including
the one in St. Louis in 1904.[289] But Gardner's village was also true to her con-
ception of her museum as a manifestation of "remembrance," for it evoked
her experience of Japan, where she shopped for trinkets and reveled in the
spectacle of sumo—an excursion not organized by Bigelow, who reserved
sumo for his male visitors. In Boston, Gardner was notorious for attending
boxing matches; now, writing from Japan in 1883, she extolled sumo with
similar insouciance, concluding one account in her letters with, "Please don't
be shocked dear. . . . I shall go to see the Missionaries when I go back to
Osaka, to atone."[290]

If Gardner's enthusiastic re-creation of popular Japan diverged from the
idea of Japan—and of Bostonians in Japan—presented at the Museum of Fine
Arts, Okakura kept a foot in both camps. His encouragement of Gardner's
interests contrasts sharply with Fenollosa's attitude when, as curator at the
museum, he rebuffed her questions about an article her friend, the journalist
Francis Marion Crawford, had written about Buddhism by accusing Crawford
of trying to "work the occult 'boom' for all it may be worth" in a vulgar bid
for "accredited authority."[291] Okakura did not guard his authority so bellig-
erently. He enlisted Gardner and other Boston ladies to host tea parties to
promote the artists he brought from the Bijutsuin.[292] At Fenway Court, he
lectured on Japanese art—Denman Ross attended and described the speaker
as "so interesting, so attractive"[293]—and produced plays he had written based
on Japanese myths. He presented Gardner with his own set of tea ceremony
utensils and wrote her poems, including "The Taoist," which is dedicated "On
the Birthday of the Presence 1911" and begins, "She stood alone on Earth—an
exile from Heaven. Of all immortals she was the flower."[294]

Despite the sympathy between Gardner and Okakura, however, the gen-
dered boundaries of the Japanist contingent at the Museum of Fine Arts
remained unbreached. Gardner neither underwrote Okakura's purchases for
the museum nor enlisted his help to acquire Asian art herself.[295] Only after
his death in 1913 did she begin buying "exactly the type of Chinese objects

Okakura had acquired for the Museum of Fine Arts."[296] At this point, she renovated the old "Chinese Room" to display early Renaissance Italian art and created a new room—referred to both as the "Chinese Room" and the "Buddha Room"—in a basement space (figure 2.23). This room's significance as a memorial both to Okakura and to the importance of their relationship was

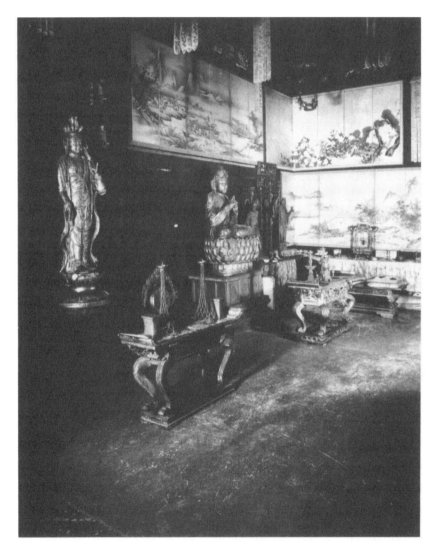

FIGURE 2.23 Second Chinese Room, Fenway Court, 1926.

expressed in Gardner's signature vocabulary of architectural fragments: the door was crafted from twenty-four woodblocks that had been used to print illustrations for the short-lived magazine of Okakura's Nippon Bijutsuin.[297] Inside, she displayed the bronze Buddhas acquired under Bigelow's supervision along with her more recent purchases of Chinese and Japanese art, the tea utensils Okakura had given her, and his lunchbox, which Ross donated "to put with the other things which you are keeping in his memory."[298]

Guests described Gardner's subterranean gallery as "rather awful in its dark thrill, like a tomb" and reminisced, "Do you remember the night you carried the lantern down the corridor to the then new Chinese Room and . . . you shown [sic] it about the darkness. Oriental emanations were mysteriously pungent to me. That was a magic evening!" Boston's mayor reported that Gardner told him "she had been communing with her Buddhas" and commended "the courage Mrs. Gardner must have possessed to dare go down there alone."[299] The dramatic lighting of the Buddha Room links it to Gardner's display of Sargent's El Jaleo, which was installed as part of the same renovation. Where the latter is famous, however, the former has been forgotten. Gardner's lighting of the Sargent has been analyzed as her response to Joseph Urban's innovative stage design for the Boston Opera during this period. (He went on to fame designing for the Ziegfeld Follies and the Metropolitan Opera in New York.)[300] If Gardner drew from the theater for her renovations at Fenway Court, another precedent was the "Buddha Room" at the Museum of Fine Arts, which, as Noriko Murai puts it, "reinforced the crepuscular image of the East as religious, peaceful, and mysterious." Suggesting this connection, Murai nevertheless insists that an "unbridgeable cultural and aesthetic gulf" separated Gardner's "Asian-inspired Victorian occultism" from Okakura's ideals enshrined in the Museum of Fine Arts.[301] But Okakura actively collaborated in Gardner's mythmaking, and the Museum's evocation of Japan was equally a Victorian fantasy. Alan Chong argues that Gardner's "more picturesque and far more atmospheric" installation "more specifically suggested a working temple, worn by age and use. The installation of panels, temple hangings, and implements provided a rendering of a temple's decoration more complete than in any museum of the time."[302] From this perspective, Gardner's Buddha Room takes its place with the rest of her museum as a one-woman challenge to the Brahmin masculinity of the Museum of Fine Arts.

If Gardner's Buddha Room functioned as a gendered provocation to the institutionally sanctioned spaces of Boston Japanism, it aligned with other elements at Fenway Court that suggested commentaries on Brahmin

landmarks. A Roman marble relief of a maenad over the fountain in Gardner's courtyard, for instance, recalled a much-publicized episode in 1897 when prominent clergymen and civic leaders joined with temperance advocates to force the removal of Frederick MacMonnies's bronze maenad (titled with the Latin-derived term *Bacchante*), which had been donated to the Boston Public Library by its New York architect, Charles McKim, to be the centerpiece of its courtyard fountain. Objections to this figure of "a drunken woman, unclothed, unquiet, vile," as Harvard professor Barrett Wendell put it, asserted Brahmin dominance of Boston's cultural institutions at a time when recent immigration made Irish-Americans—pejoratively associated with drunkenness—the city's majority. The rejected sculpture on its plinth of green Irish marble was promptly acquired by the Metropolitan Museum, ensuring New York's delighted perpetuation of this tale of Boston prudishness.[303] At Fenway Court, the maenad was placed with other venerable representations of "unquiet" women—Roman statues of goddesses and a mosaic floor depicting Medusa—in the courtyard where Gardner liked to pose on a marble throne.

While Boston indulged—and even encouraged—Gardner's queenly performances, her late-in-life incursion into Japanism was another story. Non-Bostonians welcomed her relationship with Okakura. In 1914, Bernard Berenson's wife, Mary, described how Gardner, weeping, said that "perhaps she would have gone to her grave with her hard heart and selfish character if it had not been for a Japanese mystic named Okakura . . . from him she learnt her first lesson of seeking to love instead of to be loved," concluding, "It was really touching. She is truly one of the most astonishing personalities we have ever known, and at last we really care for her as a human being."[304] Bostonians saw things differently. William Sturgis Bigelow, also in 1914, summed up Brahmin resentments toward Gardner in a letter to his old friend William Cabot Lodge: "She is incredibly vain, meddlesome and impulsive, and I am sorry to say that I think she has not a very keen sense of the distinction between loyalty and treachery. She would make friends with anybody, or sacrifice any friend, for a caprice."[305]

Such private outbursts notwithstanding, Brahmin mores met challenges to authority with a public silence matched with behind-the-scenes tactics of suppression. Gardner's second "Chinese Room" elicited both responses. Although the Gardner Museum's claim to fame is that it preserves the "disposition or arrangement" of her collection exactly as she left it, this oft-quoted phrase from her will referred to "the first, second, or third stories of said museum." This loophole allowed that, as a recent Gardner Museum publication puts it,

"After Isabella Gardner's death, the Chinese Room was not regularly opened to the public, nor was its presence indicated in the museum's guidebooks and catalogs."[306] Japanese screens from this room were moved elsewhere in the museum, and its other contents put in storage. In 1970, the sale of Gardner's East Asian art was approved on the recommendation of a director's report that the works "are not of great importance. Particularly in comparison to the collection at the Museum of Fine Arts."[307] The space became a café and shop, effectively eliminating any trace of Gardner's Japanism.

Like Edmond de Goncourt, Gardner's extravagant domesticity attracted popular fascination, fervent admiration from a small coterie, and the censure of modern tastemakers. Reporting on a tour of Fenway Court late in 1903, Mary Berenson wrote, "The whole thing is a work of *genius*. You can't think how disgusted people have been . . . at hearing us say so. They do long to hear evil of her and her works."[308] Lewis Mumford in 1926 blamed Gardner's eclectic display of "scattered objects . . . in a building which was—one hardly knows which to call it—a home and a museum" for setting "a pattern for the homes of rich people in America for a whole generation; and so, at tenth hand, it became a pattern for the poorest suburban villa, with its standardized reproductions of dressers and tables and carpets."[309] Given that rich people had been decorating with antiques and less rich people had been emulating them with copies for decades, this imputation of malevolent influence seems to respond less to the look of Fenway Court than to Gardner's flouting of authoritative taxonomies of exhibition ("scattered objects") and building type ("a home and a museum"). One taxonomy Bostonians invested with special significance was the division between a "Japan craze," pejoratively associated with women, and a Japanism imagined in accordance with Brahmin mores of masculinity. Though Gardner's aspirations to queenliness could be accommodated to Brahmin fantasies of rivalry with European aristocracies, when she added claims to share in the Buddhist understanding that was a hallmark of Brahmin masculinity, even her admirers—including the all-male board of trustees appointed in her will and their successors—abandoned her. Relegating her Buddha Room to oblivion, they erased Gardner's bid to participate in a Japanism fashioned around ideals of masculinity at once elite and exotic.[310]

LAST WORDS: JAPANISM RE-VIEWED

The Brahmins' formidable powers of exclusion, this chapter has shown, strongly inflected authoritative ideas of Japanese "art" and "religion," two

Western terms awkwardly applied to Japanese visual and spiritual practices. This chapter has emphasized the queerness—both in the sense of oddness and its allusion to non-normative sexualities—of Brahmin Japanism as a way of decentering that still-prevalent authority. As with the previous chapter, however, I am reluctant to let exclusion be the last word. This chapter, therefore, also concludes with a poem that registers the productive strangeness of Japanism, here of the Brahmin variety but for a woman: Amy Lowell, Percival's younger, dramatically unruly, "bachelor" sister.[311]

Lowell's style of what she called "polyphonic prose" compares closely to the free verse modernists like Ezra Pound modeled on translations of Japanese poetry. Her self-consciousness concerning this poetic mode as a form of Japanism is explicit in "Guns as Keys: and the Great Gate Swings," a lengthy prose poem published in 1917, which figures the "opening" of Japan by juxtaposing writing styles associated with East and West. Part I presents scenes from Perry's voyage in prose, while concurrent episodes in Japan are described in Japanesque free verse. The Perry passages cast a critical eye on American attitudes and motives:

> These monkey-men have got to trade, Uncle Sam has laid his plans with care. . . . Commerce-raiding a nation; pulling apart the curtains of a temple and calling it trade. Magnificent mission! Every shop-till in every by-street will bless you.[312]

The Japanese scenes evoke images from woodblock prints, an effect the poet attributed to her brother, recalling that when she was a child, "every mail brought letters, and a constant stream of pictures, prints, and kakemonos flowed in upon me, and I suppose affected my . . . childhood imagination."[313] That some of her poems deploy translations of passages from Goncourt's books on *ukiyo-e* suggests a more studied approach to Japanese prints, however.[314] As Perry's boats enter Japanese waters in part II of the poem, the style shifts. The Japanesque mode disappears, as both the American and Japanese perspectives are rendered in prose passages, which conclude, "You have blown off the locks of the East, and what is coming will come."

Following the two long sections of "Guns as Keys," a short "Postlude" in three parts takes up the outcomes of the opening of Japan. First, a verse in Japanesque style describes an abandoned "ancient, crumbling Castle" of the type that thrilled Percival Lowell with its intimations of the recently vanished feudal order. This evocation of a lost Japan is followed by two prose passages, both dated "1903." In Japan, a young man carves into a tree a suicide note

that concludes, "Extreme pessimism and extreme optimism are one," then throws himself over a waterfall. (The scenario draws on an article published by a Japanese student at Harvard.)[315] Meanwhile in America, crowds flock to an exhibition of James Whistler's Japanesque paintings in Boston. The poem concludes, "Pictures in a glass-roofed gallery, and all day long the throng of people is so great that one can scarcely see them. Debits—credits? Flux and flow through a wide gateway. Occident—Orient—after fifty years."[316]

Unlike Boston's male Japanists, with their claims to comprehend and explicate the Oriental Other, Amy Lowell drew attention to the way Western interaction with Japan collapsed binaries, among them pessimism and optimism, debit and credit, East and West, and, as she put it in an explication of the poem, "Commercialism versus Art."[317] While the timeless aesthetic represented by the abandoned castle is rendered in the free verse Lowell used to signify a Japanese authenticity undone by the arrival of men like her brother, twentieth-century Japan, with its ecstatic suicide, spoke the same language as twentieth-century Boston, with its crowds flocking to the Japanesque paintings of a reluctant native son. (Whistler was born near Boston, in the city named for the Lowell family, although he later famously said, "I shall be born where and when I want, and I do not choose to be born in Lowell.")[318] The conclusion of "Guns as Keys" suggests that Japanism in Boston comes down to this middle-brow mob scene, which was neither the feminized "craze" Morse disparagingly imagined playing out on the shelves of village grocery stores nor the fantasy of a masculine elite recognizing and reincarnating itself above subordinate strata of class or sex.

Amy Lowell's poem did not undo the influence of the authoritative distinctions that sustained Brahmin Japanism, but it suggests an alternative perspective on the relationship between Japan and the West. Her "epic of modernity, concentrated into thirty pages," as her fellow poet Bryher called it, depicts "the falling of outworn barriers to be replaced by a new restriction."[319] If this was true among the Boston Brahmins, it was also true in other American contexts in which more democratic aspirations animated circles of bachelor Japanists, for these, too, ultimately fell into new restrictions. That history is taken up in the following chapter.

3 SUBLIMATION AND ECCENTRICITY IN THE ART OF MARK TOBEY

SEATTLE AT MIDCENTURY

Spectacles of Libertad

Brahmin fantasies of assertive transnational aristocracy, significant as they were, were not the only American manifestation of Japanism. Where Bostonians looked to samurai knights, esoteric Buddhist ritual, and the refinement of the tea ceremony, other Japanists found in practices such as Zen Buddhism and calligraphy very different—broadly pacifist and anti-hierarchical—ideals. This version of American Japanism might be traced back to Walt Whitman, who, in 1860, responded to Japan's first diplomatic mission to the United States with a hymn to the principle of "Libertad!" Whitman located *Libertad* not in Japan but in the meeting of East and West he witnessed when his countrymen—"Superb-faced Manhattan/ Comrade Americanos"—turned out to greet the parade of "two-sworded princes, Lesson-giving princes" who came "Over sea, hither from Niphon." Whitman celebrated the spectacle

When million-footed Manhattan unpent descends to its pavements. . . .
When Broadway is entirely given up to foot-passers and foot-standers—
 When the mass is densest,
When the facades of the houses are alive with people—When eyes gaze,
 riveted, tens of thousands at a time.

This moment inspires an intoxicating vision of America as both global meeting point and spiritual offspring of East and West:

And you, Libertad of the world!
You shall sit in the middle, thousands of years,
As to-day, from one side, the Princes of Asia come to you,
As to-morrow, from the other side, the Queen of England sends her
 eldest son to you.
 . . .
Young Libertad! With the venerable Asia, the all-mother,
Be considerate with her, now and ever, hot Libertad—for you are all,
Bend your proud neck to the long-off mother, now sending messages
 over the archipelagoes to you, young Libertad.

With Europeans' westward expansion now "accomplished" and "the orb enclosed," Whitman heralds the prospect of Asians' quest for liberty:

They shall now be turned the other way also, to travel toward you thence,
They shall now also march obediently eastward, for your sake, Libertad.[1]

A century later, the artist Mark Tobey thought of Whitman as he drafted the introduction to a book reproducing his sketches and paintings of Seattle's Pike Place Market.[2] Recalling his first visit to the market, Tobey opens with a query: "What is your lineage?" he asks a man. "Among so many faces and surrounding bustle I had picked him out as someone I'd like to know. He had looked at me with his friendly eye . . . but I did not expect the answer I got. 'Adam and Eve—just like you, my son.'" This assertion of a shared humanity leads Tobey to reminisce about the

Men—many of them making the Market, their place of gathering, almost a
home. One knew that they lived in furnished rooms—run-down hotels—
some habitués of the Skid Road at night and the Market in the day. Gathered

as they did in small groups they were like islands in the constant stream of people. All kinds of people. The long L-shaped market alive with them and from everywhere. . . .

. . . Harrys, Jacks, and Jims darting here and there and one unsteady on his feet. . . . As I walked down this fabulous array of colors and forms, but not only colors and forms, there were faces pinched—drawn, flattened, full like the moon, eyes of watery blue or black gazing at you or staring half-closed from another world.

Tobey's tone evokes Whitman, whom he cites by comparing the market to "the battlefields where Walt Whitman's tenderness counted so greatly with the dying," even as he acknowledges that the allusion fits awkwardly on "what looks like a strange, contented people surrounded with the good things of life all possible in relation to their pocketbook."[3] What was behind this allusion advanced only to be immediately retracted (it did not make it into the published version of the essay) was Tobey's aspiration to inhabit the poet's role as visionary, transcending the boundaries of geography and class to hymn a universal humanity that unites East and West in the distinctive modern space of the American city.

Written in the mid-1960s to introduce a book of paintings and drawings made around 1940, Tobey's words recall the early 1920s, when he came to Seattle from New York. Ranging across a half-century that saw profound changes in Western attitudes toward Japan, and alluding to Whitman, another half-century earlier, Tobey's remarks engage the temporal span of Japanism covered in this book but gesture toward a Western deployment of Japanese aesthetics very different from Parisian showplace houses and Boston museums. No less than the figures behind those sites of display, however, Tobey's market men, living in flophouses along the "Skid Road" that gave its name to such neighborhoods of undomesticated men, were bachelors. Their place in Tobey's Whitmanesque imaginary marks another kind of bachelor Japanism.

The bachelor Japanism personified by Tobey was both persistent and significant. Tobey turns up in an extraordinary number of important episodes in twentieth-century Anglo-American cultural history, always equipped with an idea of the East that intersects meaningfully—if sometimes contradictorily—with phenomena definitive of modernism and modernity: avant-garde ideologies ranging from the primitivist veneration of "craft" to the most cerebral forms of conceptual art, minority sexual identities forged in shame, the intensity of

modern cities, Western adoption of Eastern religions, World War, Cold War, and racial dynamics in the middle class. His ubiquity allows this chapter, by following Tobey's biography, to trace this strand of bachelor Japanism through the tumultuous decades from the 1920s to the 1960s.

SPIRITUALITY AND/AS SUBLIMATION

Tobey's background and habits linked him to the market men he described and depicted. The youngest child of a poor family, he quit high school to help support his parents by working as an illustrator in Chicago, picking up what art training he had in weekend classes and on the job. Throughout his life, Tobey was peripatetic and ascetic, "usually camped out in his homes, doubtless feeling freer, more tentative that way, so that fate would not get his address," one friend recalled.[4] When, in his twenties, he began to aspire to a career as an artist, he made trips to New York, where he achieved a small reputation with strikingly realistic portrait drawings of literary figures and fashionable mural decorations for, among other clients, the editor of *Vogue*.[5]

Tobey's attraction to ideas of the East began in Manhattan, where invocations of the esoteric and exotic were hallmarks of the avant-garde. He was introduced to the Bahá'í World Faith by Juliet Thompson, a well-connected portraitist whose Greenwich Village house, shared with fellow artist and Bahá'í Marguerite "Daisy" Pumpelly Smyth, was a center of artistic and spiritual ferment. Enacting the universalism of the Bahá'í creed, "All ages, sexes, skin colours, and degrees of wealth and servitude, used to foregather at 48 West Tenth," reports one memoir of this "house dedicated to `Abdu'l-Bahá," the son of the Persian founder of the Bahá'í faith and its great promoter. "Often when you were let in the front door, you heard His voice—the recorded, spontaneous chant made in 1912—loudly reverberating through the rooms."[6] When Tobey met Thompson at a dinner party, a conversation about socialism—"because in those days everyone was talking Socialism"— "grew into her idea of painting my portrait."[7] While he was modeling, Tobey recalled, "upon a wall in her studio, near where I was seated there was a photograph of a man with a white beard, wearing a white turban." Thompson "grew quite excited" when he recounted "a very strange and powerful dream" about the depicted figure. A few months later, she invited him to the Bahá'í summer school in Eliot, Maine. Over the course of three months there, Tobey said, "Gradually it dawned on me that this little group of people with

their prayers, their smiling faces, and their unbounded enthusiasm regarding this new religion really had a new spirit; anyway, something I couldn't exactly put into words, but convinced me that what they believed was the truth. At times it seemed to me their prayers and enthusiasm were excessive and made me wonder, but what I felt held itself above any personal peculiarities."[8]

Important as this episode turned out to be, it was not Tobey's only youthful flirtation with the exotic. He also attached himself to the short-lived Inje Inje Movement, named by critic Holger Cahill for the "dubious Inje Inje Tribe," supposedly "in South America among the wilder primitives" with "only two words in their language, which were eked out by looks, gestures, words, and so forth."[9] Nor was Tobey's yearning for vague elsewheres and attraction to the Bahá'ís' supra personal universalism unique to him. Similar dynamics characterized the Buddhism of the Boston Brahmins discussed in the previous chapter and many other sects. The African-American intellectual Alain Locke—like Tobey, struggling with his sexuality—also became a Bahá'í in 1918.[10] Matthias Bärmann has astutely observed that Tobey's gravitation to the "new spirit" of Bahá'í, with its "expanding of individual life toward the universal," coincided with another formative experience in 1918, when, during the Armistice celebrations, he recalled, "I found myself dancing in the streets; it was the one time I was completely integrated with the mass spirit."[11] Both experiences of "the sudden loss of self, the dissolution into an enveloping whole," Bärmann suggests, countered sensations of isolation and anxiety that beset homosexuality at this era.[12] Less sympathetically, Tobey's fellow Seattle painter Morris Graves remarked, "Tobey was attracted to Lawrence of Arabia but so closeted that he found expression only via the more elevating Islam of Baha'i."[13] Both these retrospective inferences are supported by Tobey's letters from the Bahá'í school in 1918, which mix expressions of delight that "I have come into the light of the teachings of Baha 'O'Ala and Abdul Baha" with professions that "this means absolutely the command over my lower self" and "I trust this Winter will be free from 'Buggers' and that God will grant me my fresh point of view."[14] Years later, Tobey told an interviewer that Bahá'u'lláh (the standard romanization of Tobey's "Baha 'O'Ala") taught that "the more we can transcend the animal qualities within us the more we will approach what they call the spiritual."[15]

The transcendence of the spiritual over the physical—a common feature of many religions—is signified by the term "sublimation," literally the raising up of what is considered base. Though the particulars of dogmas differ, their shared dynamic calls for a general theory of sublimation informed by

the two thinkers most commonly associated with the term, Edmund Burke and Sigmund Freud. Both illuminate Tobey's engagement with the East. For Burke, the sublime indicated a masculine spiritual communion superior to sensual engagement with feminine beauty.[16] For Freud, sublimation was the displacement of sexual "energy" into other modes of "uniting and binding."[17] Together, these connotations suggest the attraction of sublimation for men struggling with imperatives to heteronormativity.

In Tobey's case, acceptance into New York's Bahá'í community coincided with a trajectory that culminated in his marriage in 1923.[18] Though the marriage lasted only three months and Tobey omitted it from published biographical chronologies (often claiming he moved to Seattle in 1922), continuing references to it in Bahá'í publications sublimate his "celibacy" into an artistic eccentricity shared with similar men. A posthumous tribute to Tobey in a Bahá'í magazine says of his marriage, "We understood, from a source we trusted, that . . . things had gone so badly between them that he had to sneak back for his clothes. We could not find out much about this, being afraid to ask. He had an equally difficult experience learning to drive a car."[19] The same essay turns his longstanding relationship with Pehr Hallsten into evidence that Tobey "always had disciples around him, learning both the Bahá'í Faith and his art," explaining, "Mark had a great liking for people's quirks, and Pehr was an eccentric's eccentric."[20]

The documentary record clarifies what such accounts obscure: Mark Tobey married Dorothy Earle in Croton-on-Hudson, New York, on February 13, 1923; by May, he was hiding from his wife, whose increasingly bitter and imperious letters to his art-world friends record her futile attempts to find him. That summer, Tobey moved to Seattle, a destination he later described as "the farthest possible place after his divorce."[21] From Seattle, he reported to the New York interior decorator and fashion writer Muriel Draper, "I'm as 'clear' as I know how without my husband which is you, darling."[22] Tobey's Campy tone speaks volumes about his participation in another New York milieu he inhabited, one very different than the Bahá'ís.

Although Tobey came to be closely identified with Seattle, his initial plan was to teach there for a term and then "pray god for sheckels for my ticket back where I belong."[23] His first letters to Draper mock the local ethos of exoticist boosterism, which pitched Seattle as the gateway to both Asia and America's northwest coast. The Alaska–Yukon–Pacific Exposition held in Seattle in 1909 visualized these ideas in an official seal featuring a blonde female bearing gold nuggets being offered a train and a ship by two kneeling women:

a dark-haired personification of "the Pacific Slope" and a kimono-clad personification of "the Orient" (figure 3.1).[24] Visitors entered the fairgrounds through an Oriental gateway made of Native American totem poles wired so the eyes lit up at night (figure 3.2). Inside was a pavilion sponsored by the Japanese government and an entertainment midway lined with pagoda-shaped

FIGURE 3.1 Seal of the Alaska–Yukon–Pacific Exhibition, 1909, as reproduced on a commemorative plate. Photograph by Christopher Reed.

FIGURE 3.2 South entrance, Alaska–Yukon–Pacific Exposition, 1909. Special Collections, neg. no. Nowell x1990, University of Washington Libraries.

souvenir stalls and featuring such attractions as a "Chinese Village" and the "Streets of Tokio" (figure 3.3). After the Expo, Seattle continued to promote itself as a nexus of Eastern, Western, and Native American cultures. Tobey wrote to Draper, " 'The great future of Seattle' awaits your coming and I hope my going. The war hoop is gone—old Indians squat bedecked in straw sailors and shirt waist and skirt and offer the most priceless object of beauty since 1492—an Indian basket. Visit the Alaskan stores + see how badly the Japanese can Alaskanize a piece of ivory."[25]

Condescension turned to fascination, however, when Tobey discovered the Market. His embrace of Seattle fused Bahá'í inclusiveness with other allusions to Eastern spirituality. A letter to Draper (in Tobey's occasionally illegible handwriting) exults,

> Everything I look at is made new[?] in me until I nearly burst. I am anxious to take you to the Public Market—What a humanity and what an offering nature makes. I get so psychically full of huge squash millions of long green onions eggs apples bananas and eggplants and then the darlings who stand back of them and all the other twisted beauties buying and then hands moving back and forth. A blind man sits squeezed in a triangle corner. He reads a blind bible and his thin blue veined wrist has a bracelet tattooed on it. Everyone is moving forward and backward and turning and slipping and I feel they are all headed toward the love I feel pouring out of me but they don't know I'm there. Sometimes I feel like an invisible Buddha—an ethereal replica of a stone one and I sit in a coffee stall very still and look out with only my eyes. The rest seems like the interior of the statue and I feel and watch the whole universe moving around me in all its color and forms and then I know how I love life.[26]

In this first iteration of themes that returned in Tobey's writing about the Market two decades later, the flux and flow of the crowd evokes an ideal of love that transcends—or evades—the personal, an effect achieved through identification with the Buddhist spirituality of the East.

Little of Tobey's art from this era remains. A 1918 watercolor titled *Conflict of the Satanic and Celestial Egos*, painted in the first flush of his exposure to Bahá'í, confirms his turn to faith was a way of asserting "command over my lower self" (figure 3.4). Here dark and light air-borne figures hover over two manifestations of a nude man, whose outstretched arms and raised knee simultaneously suggest erotic abandon and echo the pose of the back-to-back crucified Christs

UNION CIRCLE

FIGURE 3.3 Japan Pavilion seen from Union Circle at the Alaska–Yukon–Pacific Exposition, Seattle, as illustrated in the souvenir book *Alaska–Yukon–Pacific Exposition* (1909).

FIGURE 3.4 Mark Tobey, *Conflict of the Satanic and Celestial Egos*, c. 1918. Watercolor. Private collection. © 2015 Mark Tobey/Seattle Art Museum, Artists Rights Society (ARS), New York.

silhouetted in the background. In Tobey's art, as in his writings, such expressions of anguish were twinned with self-presentations as prophet or seer. Self-portraits from the early 1920s, one in dramatic Futurist style (figure 3.5), emphasize his wavy hair and solemn, staring eyes, confirming recollections of the artist at this period as "robust, handsome and already with a beard like a Titian portrait" and "a handsome, restless stranger of thirty-two, with blazing copper hair, a temperament to match, and no money." [27]

When Tobey's attention turned outward, his art registered a fascination with the bonds connecting men away from home and family. The poet Kenneth Rexroth recalled Tobey "painting skidrow figures, migratory workers, lumberjacks, and sailors."[28] Two such works, *Two Men on a Bus* (figure 3.6) and *Dancing Miners* (figure 3.7), suggest end points on a scale of homosocial intimacy from the placid to the exuberant. The latter, copied from a Gold Rush–era photograph, Tobey described to Draper as "a rather glorious 1898 canvass [sic]—two miners dancing life size":

> They look in love with something of that Blakian [sic] aspect of a bearded God recognizing a mortal and the latter caught up in his larger rhythms. The color is moving and beautiful. The little man has on a red shirt and shoeless red socks. It will be called a Homosexual canvass and I shall need to be near *you* [*you* is underlined nine times] when I show it.[29]

FIGURE 3.5 Mark Tobey, *Self-Portrait*, c. 1920. Pastel. Location unknown. © 2015 Mark Tobey/Seattle Art Museum, Artists Rights Society (ARS), New York.

FIGURE 3.6 Mark Tobey, *Two Men on a Bus*, 1927. Oil on canvas. Location unknown. © 2015 Mark Tobey/Seattle Art Museum, Artists Rights Society (ARS), New York.

FIGURE 3.7 Mark Tobey, *Dancing Miners*, c. 1930. Oil on canvas, 170.2 × 99.7 cm (67 × 39 1/4 in). Eugene Fuller Memorial Collection, 42.19, Seattle Art Museum. © 2015 Mark Tobey/Seattle Art Museum, Artists Rights Society (ARS), New York.

As an ambitious effort of sublimation, Tobey's reach for "Blakian" signifi-cance in this monumentalized image from a local history of intimacy among men takes its place with other paintings from the early 1930s, ranging from a group of nearly naked acrobats (figure 3.8) to presentations of Biblical subjects—*Christ and the Poor* (figure 3.9) and *Entombment* (figure 3.10)—that depict these episodes as intimate interactions among naked men. The titles of Tobey's painting from 1934 (most now lost) run a homosocial gamut from the portentous *Dance of the Men of the House of Perfection* to the vernacular *Strong Men*.[30] About the latter, Tobey's report that "the figures are 7 feet high and I think it is powerful" suggests a bid for sublimity in this circus subject similar

FIGURE 3.8 Mark Tobey, *Acrobats*, c. 1930, as reproduced in Muriel Draper, "Mark Tobey," *Creative Art* (October 1930). © 2015 Mark Tobey/Seattle Art Museum, Artists Rights Society (ARS), New York.

FIGURE 3.9 Mark Tobey, *Christ and the Poor*, 1933. Pencil and ink on paper. Location unknown. © 2015 Mark Tobey/ Seattle Art Museum, Artists Rights Society (ARS), New York.

to that of the life-size *Miners*.[31] Taken together, these works engage ideas of a love between men at once spiritual and so physically intimate that "it will be called . . . Homosexual."

Looking back through Blake and Whitman to exalt the bonds between men in Seattle's Gold Rush history, Tobey's art also anticipates aspects of Marsden Hartley's late paintings—his clowns, shirtless fishermen, scantily clad boxers, lumberjack lifeguards, and sauna goers—especially when in solemn conjunction with Christ (figure 3.11). Tobey later recalled that when he lived in New York, "I was seeing Marsden Hartley daily," and he kept a still life

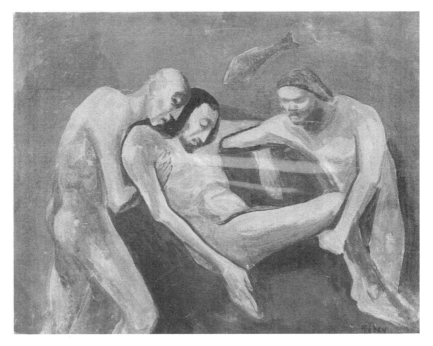

FIGURE 3.10 Mark Tobey, *Entombment*, 1933. Tempera on paper on board. Private collection. © 2015 Mark Tobey/Seattle Art Museum, Artists Rights Society (ARS), New York.

of pears by Hartley—along with a photograph of Whitman—in his studio.[32] He told a younger gay artist, "When I was your age, I used to have coffee with Marsden Hartley in New York, just as you and I are doing now. And when Hartley was the age you are now, he used to see Albert Pinkham Ryder and have coffee with him. So you are now part of a tradition that goes all the way back to the great Albert Pinkham Ryder. And that is something to be taken very seriously!"[33] This idea of a legacy of artists—outsiders and visionaries— fired Tobey's imagination.

An introduction Hartley wrote for an exhibition of Tobey's art in New York in 1931 reads like a manifesto for both artists. Hartley begins by lashing out against "trivial modernists" who cluster at the extremes of abstraction or of photographic realism, and defends Tobey as

a thinker and a mystic—what an anomaly, what a *faux pas* to have something to reveal in art these days. . . . He is a searcher and a revealer of the

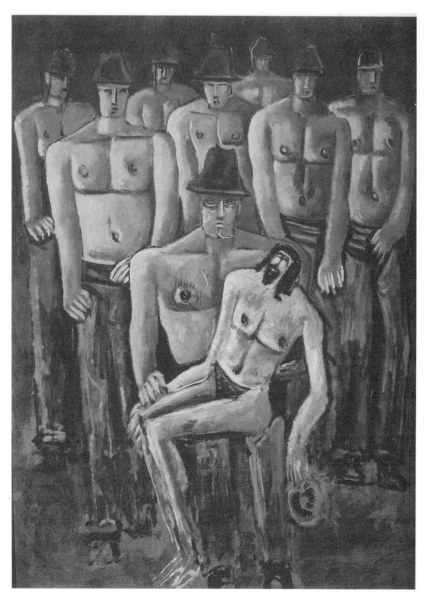

FIGURE 3.11 Marsden Hartley, *Christ Held by Half-Naked Men*, 1940–41. Oil on fiberboard. Hirshhorn Museum and Sculpture Garden, Smithsonian Institution. Gift of Joseph H. Hirshhorn, 1966.

inner condition, ostracized as this condition is apt to be by the worshippers of the actual appearance of things. . . . Tobey is, I repeat, an out and out clairvoyant, a revealer of what is not to be seen by the eye but penetrated by the mind.[34]

Hartley's assertions about alienation and insight were cited by Tobey as "the only sympathetic article on my work."[35] But there is something in this verbiage less of revelation, as it claims, than of sublimation. Both Burke's natural sublime and Freud's unconscious resonate in Hartley's assertion that Tobey "has seen clearly and felt with special gravity the depths of the tides that wash against the barricades of the human spirit." Hartley's own art has been convincingly (if long posthumously) analyzed as a sublimation of homosexuality into celebrations of a virility he ascribed to the men he loved: soldiers and fisherfolk, lumberjacks and boxers[36]—a catalog of masculine types comparable to Tobey's "skidrow figures." Hartley's description of Tobey's 1931 exhibit as "made up of human gestures and human states of being, of spiritual entities relating to their respective types in which the life of each is locked and sealed with a spiritual permanence," exemplifies a tendency toward high-flying obfuscation shared by both artists that might be understood as a sublimation of denigrated passions into exalted abstractions. Differentiating Hartley and Tobey, however, were the ways contemporary racial discourses played into their beliefs. Where Hartley was drawn to ideas of racial purity that associated "white" northern European skin tones with the light of reason, Tobey was drawn to Bahá'í ideals of global harmony, quoting Bahá'u'lláh to predict "The East and West will embrace as long-lost lovers."[37]

ENGAGING THE EAST: SEATTLE AND DEVON

Tobey's travels during the 1920s and '30s focused his interest in the East from vague invocations of alternative spirituality to more specific engagement with individuals and art forms associated with China and, especially, Japan. Unlike nineteenth-century Paris and turn-of-the-century Boston, with their tiny populations of Japanese, Seattle, when Tobey arrived in 1923, had 8000 Japanese residents living in its "Japantown," the second largest such area (after Los Angeles's "Little Tokyo") in the United States. Trade with Japan constituted more than half the freight through the port of Seattle, and Japanese farmers rented almost three-quarters of the stalls at the Public Market, where, despite

Tobey's idealistic evocations of multiracial egalitarianism, there was constant tension between the Washington Farmers Association, which represented Japanese farmers, and the White Home Growers Association, which, as its name implies, belligerently spoke for everyone else.[38] Racial segregation was built into Seattle social structures, with many residential areas off limits to Japanese and theaters that restricted nonwhites to balcony seats. A state law passed in 1921 banned the sale or lease of real estate to people ineligible for American citizenship, which included all Japanese immigrants. Newspapers, including the *Seattle Star* and the Hearst-owned *Seattle Post-Intelligencer*, were openly racist, and a powerful Anti-Japanese League advocated policies culminating in the notorious federal Immigration Act of 1924, which cut off immigration from Japan.

In this context, Tobey, shortly after arriving in Seattle, began to study brush painting with a Chinese art student at the University of Washington while haunting "the small Chinese and Japanese colonies operating their various businesses on their special streets," as his friend, the journalist Janet Flanner, put it. Flanner, who had known Tobey since his time in New York, credited the "alien contemplative spirit" of Bahá'í with arousing his curiosity about these "influences from China and Japan . . . faintly deposited in exile." In Seattle's shops, she reported, Tobey saw "badly colored cheap Japanese paper prints" and

> nobler and more costly . . . XVIIth–XVIIIth century Chinese Ancestor Portraits, then still available; a refined ancient art, in which, by long practise, line dominates mass and even seemingly eliminates its presence. Tobey became intensely interested in the Eastern bamboo brush stroke which produced this delicacy of speculative line.[39]

Flanner's description of Eastern line overcoming mass echoes Tobey's published recollection of "my first lesson in Chinese brush from my friend and artist Teng Kwei. The tree is no more a solid in the earth, breaking into lesser solids bathed in chiaroscuro" (figure 3.12). Unlike Western conventions of mass revealed by light and shadow, with Eastern ink painting, "there is pressure and release. Each movement, like tracks in the snow, is recorded and often loved for itself," Tobey wrote in a memoir published on the occasion of a major exhibition at the Whitney Museum in New York in 1951. Here he recalled the effect of Teng's instruction, in which the physicality of what is depicted gives way to the rhythmic act of depiction, a repeated "pressure

Mark Tobey 先生惠存

中國滕白也拜贈
16/12/1926

FIGURE 3.12 Photograph of Teng Kwei dedicated to Mark Tobey, 1926. Mark Tobey Papers, Special Collections, neg. no. UW 23723z, University of Washington Libraries.

and release" that is "loved for itself" until "the tree in front of my studio in Seattle is all rhythm, lifting, springing upward!"[40] Tobey does not say so, but the physicality of Teng's teaching must have been inflected by his unusual specialization in a form of ink painting using fingers and fingernails, which earned the handsome and charismatic young Chinese artist a measure of celebrity, first in Seattle and then in a 1928 exhibition that toured the United States and brought him to New York and on to a fellowship at Harvard.[41]

For Tobey, Eastern art fused seeing and feeling in ways that undercut the cerebral attitudes he associated with the West. "The old Chinese used to say, 'It is better to feel a painting than to look at it,'" Tobey asserted, and he referred to the "Oriental" way of loving, "through the eyes."[42] Often Tobey phrased challenges to Western representational conventions as questions posed by Teng: "Why do Western artists only paint a fish after it is dead?" Why do Western artists make pictures "that looked like holes in the wall?"[43] Tobey used the East Asian art and artists he encountered in Seattle to de-center Western conventions of perception and even of reality in favor of a physicality not explicitly erotic but broadly sensual. These ideas came

gradually, however. Teng's calligraphic teaching barely registers in the art Tobey produced from the late 1920s through the early 1930s. And when he left Seattle, his route to Japan ran through England.

In 1931, Leonard Elmhirst, an idealistic British agricultural reformer who had worked in India for Rabindranath Tagore, and his American wife, Dorothy—equally idealistic and, as an heir of the Whitney family, very wealthy—hired Tobey, along with a dancer and a puppeteer, away from the teaching staff of Nellie Cornish's progressive art school in Seattle to teach in the "Dance Mime" program at Dartington Hall, their "Educational Experiment," a self-sustaining farm and school on a medieval country estate in rural Devon.[44] There Tobey taught evening art classes attended by students, staff, and other faculty. His notes for an opening address to the class describe its purpose as "furthering towards the realm of identity of being; so that we may be better equipped to know of what a real unity is composed—not uniformity but the unity of related parts." Tobey's manifesto continues,

> What is the foe to our finding a voice of our own? I should say fear. Fears governed by public opinion, by ideas of friends, by accepted patterns of traditional modes of thought. From where can the release from all this rigidity of pattern come? To me, it must come from the Creative Life. That life, which, drawing upon the vital forces within us, gives us power to begin to think and to feel for ourselves, in our own individual way.[45]

In this pedagogy of nonconformity, "release"—the same term Tobey applied to calligraphic brushwork—is a freeing from social norms.

"I AM EXCITED," Tobey printed in capital letters centered on the page of a letter announcing his appointment to Dartington.[46] And no wonder. The Elmhirsts' idealistic vision of education included research trips for their faculty to study and collect artifacts useful for teaching from the far corners of the globe. The Elmhirsts sent Tobey's puppeteer colleague, Richard Odlin, to southeast Asia in 1931, and, during the summer of 1932, sponsored Tobey to go Mexico to join Marsden Hartley and the dancer and choreographer Martha Graham, "two of my dearest friends," as his travel proposal put it (Graham had taught at the Cornish School in the summer of 1930). In 1934, the Elmhirsts sent Tobey to East Asia with Dartington's ceramist, Bernard Leach.

Leach was not the only figure at Dartington with ties to the East. Uday Shankar, the Indian dancer and choreographer, taught there periodically, and Arthur Waley, the translator of Chinese and Japanese texts, was such a

frequent visitor that Tobey described him as "in residence."[47] In a letter to Leonard Elmhirst, however, Tobey cited Leach as "the one influence on my work."[48] Leach, who was born into a family of missionaries and colonial administrators, had been raised in China and Japan until he was sent to school in England when he was ten. Having trained as an artist, Leach returned to Japan in 1909 at the age of twenty-two, remaining for almost twelve years. Establishing himself in Japan as a champion of modern art, Leach transmitted Western modernists' enthusiasm for folk art to the cosmopolitan circle of Japanese artists around Yanagi Sōetsu, himself an energetic promoter of the idea of indigenous folkcraft in Japan. Yanagi introduced Leach to potters who seemed to realize primitivist ideals of unself-conscious purity and beauty. When Leach returned to England in 1920, it was as a proselytizer for such Japanese potters and their methods.

If in Japan Leach embodied a cosmopolitan modernism centered in the West, in England he presented himself as a personification of Japan. Yanagi's endorsement of Leach as "nearer to the heart of modern Japan than the ordinary Japanese" (quoted in the introduction) lent authenticity to the pottery he established in rural Cornwall. There he implemented—with varying degrees of technical proficiency—Japanese ceramic techniques, often combined with decorations evocative of rural Japan (figure 3.13). Leach opened his 1928 manifesto, A Potter's Outlook, with "Having become a potter in Japan" and went on to assert that "my birth in China and education in England" meant that "I have naturally had the antipodes of culture to draw upon, and it was this which caused me to return to Japan where the meeting of East and West has gone furthest." Like Edward Morse in Boston, Leach upheld "Japanese Tea-Master's wares" as the standard for the production and appreciation of ceramics. Challenging British art potters who drew from Chinese prototypes to make ornamental vases, Leach popularized the terminology *ethical pots* as part of an argument for an aesthetic of daily life that he contrasted with other potters' "limited and expensive pieces" acquired by "collectors, purists, cranks or 'arty' people rather than by the normal man or woman."[49] By 1933, the *Times* commended an exhibition of his work with the explanation, "Such Oriental flavour as Mr. Leach preserves is Japanese rather than Chinese, which means that his pots approach more closely to domestic uses."[50] This articulation of Japaneseness as a form of populism-in-principle informed Leach's ambition, when he came to Dartington in 1932, to lead a team of potters producing a range of ceramics based on East Asian prototypes.

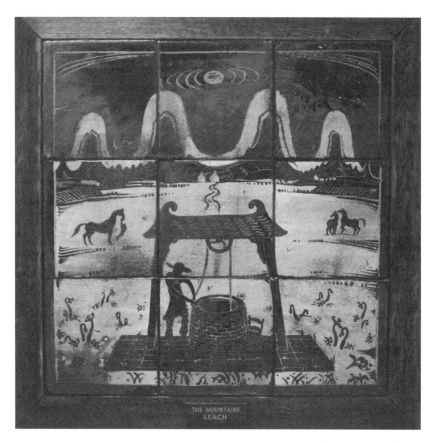

FIGURE 3.13 Bernard Leach, *Well Head and Mountains*, 1926–29. Panel of tiles. York Art Gallery, York. Photograph by Christopher Reed.

In Dartington's cosmopolitan atmosphere of social reform and aesthetic avant-gardism, the terms with which Leach and Tobey imagined the East were mutually inspiring. Leach's claims to embody a synthesis of East and West appealed to Tobey's Whitman-infused Bahá'í ideals. Tobey dated the start of their relationship to their first meeting in 1932, when Leach's "expression over a painting I had made concerning the carrying on of the Whitman tradition had stuck with me and I felt in some way that there would be a tie of friendship."[51] Leach recalled, "There was an immediate exchange between us. He talked to me about the Bahá'í Faith, sharing with me his books."[52] Leach immersed himself in the study of Bahá'í and grew a beard in imitation

of his new friend.[53] A letter from Tobey to Leach, who was visiting his family in Cornwall between terms, suggests both the intensity of their relationship and the degree to which it revolved around evocations of the East. Drawing long lines on the paper, Tobey wrote, "I *long* _____ very long _____ to have you back. The place is deadly without you." He then reported,

I've cleaned my room for your august presence next term. Have a white Japanese lantern up. . . . During the cold spell I put down the gay Mexican rug. It sufficed for a time. It's up now. I'm sick of too much color or objects. (Haven't had sukiyaki since you left). Also have a beautiful dwarf Japanese tree—beautiful in my window.[54]

When Leach proposed a study trip to Japan "prepatory [sic] to starting serious work at Dartington in the direction of making stoneware in larger quantities and in finer quality," the Elmhirsts suggested Tobey go along.[55]

Approaching the East with Bernard Leach

The Elmhirsts' proposal to send Leach and Tobey together to East Asia came with some advice: Leonard recommended that they book cabins on opposite ends of the ship. Although impractical—the two ended up sharing a cabin—the suggestion was not unsound, for Tobey and Leach bickered their way around the globe. Their intense dynamic of argument and reconciliation exemplifies the little-analyzed bonds between different kinds of bachelors. For a man resolving to divorce his wife in order to make a life with a younger woman—this was a decision Leach came to during this voyage—a return to bachelorhood is charged with conflicting emotions, among them desire, guilt, and the opprobrium experienced by those outside the heteronormative sanction of marriage.

This terrain was familiar for Tobey, who first fell in love with a "somewhat older" man a quarter-century before. This unrequited romance, in his telling, offers a textbook example of sublimation: "It wasn't mutual between us. It is a terrible thing to be in love and then realize that the person you love doesn't feel the same way you do. I went through a crisis, then something very beautiful happened to me. I can't explain it to myself even now." As a result, Tobey said, he changed: "I wasn't the same person who had declared my feelings to

him so openly."[56] For Tobey, trauma around sexuality had, long since, been transmuted into the persona of mystic and teacher. Leach, whose pedagogical authority was rooted in a rhetorics of everyday ethics, was an ambivalent newcomer to any affiliation of bachelor outsiders, however. Recalling their relationship, Tobey wrote of Leach at Dartington "not wanting to be with me really yet something within him or my own intentions brought him into my orbit more than I think his own tastes cared to be."[57] Now, in a letter from the ship Tobey reported,

> The situation has forced Bernard and I to[,] more honestly than we've ever wanted to[,] give out and Bernard I believe has had to go beyond his detail [sic] vision (of my little faults) to what I am underneath and to accept me as a person with different tastes and ideas. . . .
>
> I believe he has hated and resented taking something of what he has wanted from me and couldn't imagine that anyone with my weaknesses could have anything deposited within them so opposite.[58]

Pages from an autobiography Tobey drafted trace these shifting power dynamics as Leach's reluctant intimacy and judgmental authority shifted to vulnerability:

> One morning he came before I was up. . . . After sitting quietly in the little narrow room he burst forth with the sins of his sexual life. . . . I wanted to help if possible so very quietly told him the sins of my sex whose magnitude and variety must of [sic] done a great deal to relieve him.[59]

Leach's confession likely extended beyond his affair with Laurie Cookes, an assistant at Dartington, to a longer history of fraught heterosexual infatuations he elsewhere justified as forms of "sense experience" associated with Eastern masculinity.[60] The specifics with which Tobey trumped Leach's "sins" with his own go unrecorded. But the importance of this encounter, insisted upon in various venues by both Tobey and Leach, is illuminated by queer theory's explications of the dynamics of shame.

Mid-twentieth-century psychologists described "the shame–humiliation response" as a uniquely human "inner torment" that results from "a loss of feedback from others, indicating social isolation and signaling the need of relief from that condition." Originating when the infant first experiences the caregiver's inevitable lack of undivided attention and the appearance of

unfamiliar faces in place of the expected nurturer, "later in life this same reaction occurs under similar circumstances, i.e., when we think we have failed to achieve or have broken a desired bond with another." Exemplifying such instances, psychologist Silvan Tomkins listed, "If I wish to hug you or you hug me or we hug each other and you do not reciprocate my wishes, I feel ashamed. If I wish to have sexual intercourse with you but you do not, I am ashamed." These examples suggest how certain "sources of shame" become familiar for sexual minorities, and Tobey's memory of his first romance— "It is a terrible thing to be in love and then realize that the person you love doesn't feel the same way you do"—exemplifies this dynamic. But shame can also be aroused by anxiety about the future: "After infancy, this reaction may also occur in response to frustration of symbolic and/or anticipated needs," Tomkins says.[61]

Eve Sedgwick takes up these formulations with emphasis on the idea that shame is central to constructions—or reconstructions—of identity. Shame constitutes the infant's sense of self as distinct from the caregiver and persists into adult life in a way that "attaches to and sharpens the sense of what one is. . . . It is the place where the *question* of identity arises most originally and most relationally." A bond forged through "a performance of sexuality organized around shame," thus, expresses a desire that can be understood "as a kind of prototype of, not 'homosexuality,' but queerness" understood in contradistinction to "other ways of experiencing identity and desire."[62] Michael Warner expands on Sedgwick's analysis to explore "the centrality of a rhetoric of shame in Whitman's poetry," both in relation to sexual dynamics of veiling and to how his "apparently artless verse, sounding a barbaric yawp, was part of [a] transmuting performance" of the shame of American provincialism "in relation to Europe"—twinned categories of identity both central to Tobey's status at Dartington. Warner argues that the "kind of social knowledge" registered by shame as "an affect of defeated reciprocity" connects to the experience of sexual minorities "not just because such desire is statistically less likely to be returned . . . , not because it is expected to be unreturned, nor even because I expect that the object of my desire ought to be reluctant, but because the entire possibility of a willing partner has no place in the imagery and institutions of social belonging."[63]

These theorizations of shame illuminate the dynamic between Leach and Tobey during their voyage East, as Leach fell into a crisis over the tangled sexual relationships he had left behind exacerbated by anxieties over his "symbolic and/or anticipated needs" as he neared Japan after fourteen years

representing Japanese pottery in England without achieving the authority enjoyed by his Japanese mentors. Tobey conceived his reciprocal confession of "the sins of my sex" as part of a campaign to forge a new level of intimacy with the anxious Leach. A letter from this period reports,

> To dig to some honest level after all these years of camouflage sometimes takes all the effort I have but [is] usually worth it. It sometimes takes days before I can muster courage to strike him enough to release the flow of resentment he seems to hold about me—innumerable little things that nearly astonish me. It is one of the strangest relationships I have ever had. . . . In some ways it is worse of a trip around Leach and Leach around me than one around the world.[64]

Writing about the situation to the Elmhirsts, Tobey awkwardly evokes—in order to cancel—memories of his marriage, as if the relationship with Leach now stood in for that liaison: "I've never known such hours of tension in my life (my marriage isn't in it) and why such a state existed when no physical thing was there I can't say unless it was a spiritual battle of some sort." He concludes, "I think we won out over it and the fear accompanying it. I feel happier as I near China and Japan."[65] Leach's published accounts also stress resolution. He describes how, at the height of a "flaming row, telling each other off in no uncertain terms," Tobey quietly touched his knee and/or looked into his eyes (depending on the version of the story), saying, " 'Bernard, do we want to do this?' I answered, 'No Mark.' We never did again."[66]

In both men's narratives, their relationship changed as they neared the Orient that would test the abstractions around which each had organized his identity in the West. If Leach panicked at the prospect of being thrust into the role of sexual and geographic outsider, Tobey drew confidence from the imminence of an Orient that promised to realize sublimations that—through avant-garde primitivism, Bahá'í spirituality, and interaction with Seattle's East Asian immigrant culture—had long characterized his artistic, emotional, and erotic life. Tobey's imagined Orient, anxiously constructed over years on the sexual and cultural margins, promised more enabling access to the East than was offered by Leach's claims to authenticity. Tobey later wrote rather disparagingly of Leach, "While he had lived a great many years in the East, he showed no signs of any quietude nor contemplation."[67] Once in China, Tobey let Leach precede him to Japan, writing, "As I see it I will mean more to you and Japan coming later, and you will mean more to me,

coming when you have had a chance to catch your breath. I know I love you more deeply while writing this than ever before and feel in much deeper contact."[68] This self-possession and frank acknowledgment of intimacy between men—both unusual in Tobey's correspondence—was occasioned by arrival in East Asia. Although Leach in Japan rapidly reconstructed his confidence and authority, sloughing off Tobey in the process, Tobey carried associations with his breakthrough from shame to intimacy through most of his four months in the Orient, and these feelings continued to suffuse his associations with the art of the Far East.

Counter Encounters: Tobey and Leach in China and Japan

Tobey's journal attests to the importance he attached to his voyage:

> We are passing from the Western to the Eastern hemisphere. That is I feel as tho' we were for we are in the Suez Canal and it is the first day of Spring. Last night . . . I felt as tho' a knife were cutting my life in two separate parts. The part with all its stirring if multitudinous aspects of phenomenal friends—relations—travelling back and forth from Am[erica] to Europe seems dark—like a dark slice of marble cake. Does that mean the other half is to begin with lights[?][69]

And, having primed himself for a new experience, he had it. Following the ship's first stop in the eastern hemisphere, Tobey's journal compares what is now Sri Lanka to "looking in a kaleidoscope of broken Gauguin paintings on glass."[70] A letter reports that "my eyes have been shattered with more color than ever before in my life. . . . I really don't know when I have seen so much beauty male and female nor so much color as in Colombo."[71] In an unpublished essay titled "Eight Hours in Colombo," Tobey renders his experience in self-consciously modernist prose:

> The temple attendant bright eyes circle covertly upon you while soft words and warm brown hand movements explain Buddha life. Gift offering humbly petitioned extracts shining circle coin. . . .
>
> Priests shaven in Buddha clad orange yellows gaze upon you with eyes softer than image painted, plaster postured temple Buddhas. Their singing

dark arms heavily fleshed repose languidly against the many standing out hot orange cloth folds.

Here too his attention is drawn to the natives' androgynous beauty:

> Born to the heat, sun reddened men stand in attitudes feminine, lifting daintily the long sarong above their knees they hold it revealing the long dark legs shining in dark skin color. . . . The long black hair ripples on shoulders squared; they move and stand in Buddha posturings of man in woman and woman in man.[72]

Tobey's delight contrasts with Leach's anxiety. His published memoir explains that in Colombo he and Tobey "agreed to separate, partly because I wanted to be more alone; time in which to think. All my thoughts were back in England and fraught with tension and sadness." In this frame of mind, he visited a Christian missionary who brought him to a Buddhist funeral: "Somehow this fitted with my mood." Leach also noted color "combinations differing from ours. I remember black, puce, vermillion. The plus and negative of colour was unlike that of the West, exciting and pungent." Although he records that Tobey, "too, as a fellow artist, had noticed this same phenomenon," the two men's accounts differ sharply. Where Tobey's fascination with the vibrant colors leads to a highly embodied, frankly sensual engagement with the Buddhists, Leach's nihilistic witness of the cremation is expressed in words that echo his own anxieties: "A strange passing of a man from this to another world."[73]

These divergent modes of engagement continued as the two men traveled farther east. During a week of watercolor sketching in Hong Kong—"the place of my birth," Leach's memoir notes—Tobey "was fascinated by the vertical signboards outside every shop—characters black on white, red on gold," while "I was absorbed in the beauty of the hand-made, brown-sailed Chinese junks tacking across the land-locked harbour amongst the varied ships of the world." This difference is clear in their sketches: Tobey's nearly abstract jumbles of vertical planes contrast with Leach's picturesque images, which he later reproduced in a book dedicated to Tobey (figures 3.14 and 3.15). If Leach's melancholy nostalgia—"in my heart a lifetime's memories of childhood"—provoked him to see the Orient in picturesque counterpoint to a modernity represented by all "the varied ships of the world," it also blinded him to Tobey's interest in East Asia's modern, urban energy. Leach recalled, "In the street, we were both struck by . . . the quiet, orderly behaviour of

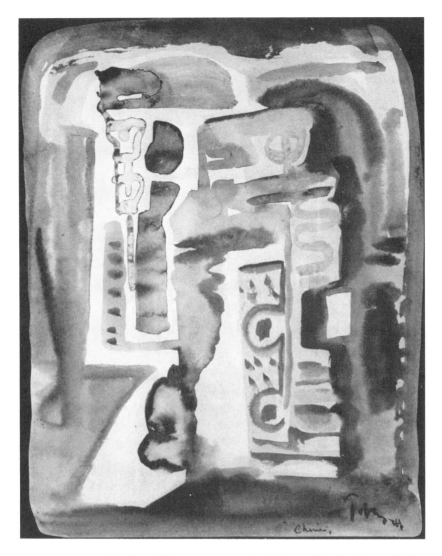

FIGURE 3.14 Mark Tobey, *China*, 1934. Watercolor. Private collection. © 2015 Mark Tobey/Seattle Art Museum, Artists Rights Society (ARS), New York.

the busy crowds."[74] Tobey's memoir, however, links the exotic signage to the urban turmoil:

> Thousands of Chinese characters are turning and twisting; every door is a shop. The rickshaws jostle the vendors, their backs hung with incredible loads. The narrow streets are alive in a way that Broadway isn't alive.

FIGURE 3.15 Bernard Leach, *Hong Kong Harbour*, 1934. Ink drawing, as reproduced in Bernard Leach, *Drawings, Verse, and Belief*. (1974).

> Here all is human, even the beasts of burden. The human energy spills itself in multiple forms, writhes, sweats, and strains every muscle towards the day's bowl of rice. The din is terrific.[75]

From Shanghai, their next stop, Tobey wrote to the Elmhirsts describing "alleys with Sing Sing girls riding in their lantern lit rickshaws—Dance halls

full of Greta Garbo Chinese girls," summing up, "I feel Shanghai is New York. I feel tantalized here by almost anything and I wonder how I can leave it behind. The language, the beautiful character writing—the unconventionality of the life everywhere—God! I wonder what I can do about it."[76] This fascination with modern urban spectacle suffuses Tobey's engagement with the East and presages changes in his art intimated by a painting, titled *Shanghai*, in which the calligraphic shop sign is central (figure 3.16).

In Shanghai, Tobey and Leach parted ways. Leach went on to Japan, while Tobey moved in with Teng Kwei, who had returned to China in 1932. "Will I be able to adjust as well as he did in America[?]" Tobey wondered in his journal, recalling from Teng "never once any expression of homesickness—only once an expression of resentment against 'the American bulldog.' "[77]

FIGURE 3.16 Mark Tobey, *Shanghai*, 1934. Watercolor. Private collection. © 2015 Mark Tobey/Seattle Art Museum, Artists Rights Society (ARS), New York.

They resumed their ink-brush studies, this time focusing on calligraphy; Tobey reported that Teng assessed the results of his three weeks in Shanghai as the equivalent of three years of practice (figure 3.17).[78] In Shanghai, Tobey visited exhibitions of both Chinese and modern Western art, attended concerts, lectured at an art school—"With Kwei translating I shall attempt to reinstate their own appreciation of their own work"—and visited the elderly Florence Ascough, who had collaborated with Amy Lowell to translate Chinese poetry.[79] His letters compare his immersion in China to "a forest—every day I go a little deeper—in fact I suppose I am pretty deep already comparing myself to other westerners for I have lived practically Chinese since my arrival . . . living with my friend Teng Kwei has given me an 'open sesame' which had made my visit deeply satisfactory."[80]

Tobey's pleasure in losing himself in an East Asian version of Ali Baba's magic cave is matched by his delight at being freed from the meanings inscribed in the West on his own body. Even as he noted how Teng was constantly berated by his mother for not marrying, Tobey reported:

Three days and nights in a Chinese household. I feel I know more about China than if I had stayed in hotels in all the principal cities. . . . Three of us sleep in one room in which we also eat. Everyone dresses in front of everyone else and the female servants don't seem to care.[81]

Another letter about Chinese art observes, "They are not figure or nude conscious."[82] For Tobey, East Asian social habits and aesthetic traditions seemed to transcend the gendered visibility of the body.

FIGURE 3.17 Mark Tobey, calligraphy practice, 1934. Ink. Dartington Hall Trust Archives. © 2015 Mark Tobey/ Seattle Art Museum, Artists Rights Society (ARS), New York.

When Tobey went on to Japan, his time was divided. In an episode later repeatedly invoked as the key to his career, Tobey pursued his interest in East Asian calligraphy by studying for a month at a Zen temple. Exemplifying the anxious rhetorics of avant-garde originality in relation to "primitive" sources (discussed in chapter 1), Western writers who cite this episode to explain Tobey's signature style fall back on generalizations about Japan and Zen that obscure the elements of cosmopolitan modernity of this setting. As late as 1984—the last major American museum exhibition dedicated to Tobey—the catalog published by the National Gallery in Washington, D.C., reported, "In Tobey's notes (the only place where the name or location of the monastery is recorded) it looks to be called Emperfuji, but the word is difficult to decipher with any certainty."[83] In fact, Enpuku-ji, just south of Kyoto, was a center for the instruction of Westerners in Zen Buddhism, what the *New York Times* described in 1932 as "a hostel which has been specially built for foreign comfort and dedicated in the name of world peace to foreigners in search of the wisdom the of the East."[84] The motivating force behind this enterprise was D. T. Suzuki, a Japanese scholar who had lived for a decade in the United States, where he married an American from a Bahá'í family and whose translations and essays on Buddhism were widely read by Anglophone audiences. Suzuki's presentation of Zen as "the ultimate fact of all philosophy and religion" and, therefore, "very much alive also in Christianity, Mahommedanism, in Taoism, and even in positivistic Confucianism," took part in the universalist aspirations of the Bahá'ís.[85]

Suzuki was traveling in China when Tobey stayed at Enpuku-ji, but Tobey was deeply impressed by a man he called "Toshio," almost certainly T̲esshu Kozuki, the painter and calligrapher in charge of the temple. An entry in Tobey's journal records,

Toshio the painter is a remarkable looking Japanese in that his eyes are very large and of a deep brown color. His rather long black hair is beginning to gray underneath. Tall and well built he gives me a sense of freedom and independence. Last night he appeared at the moon window and said in slow but well enunciated English—pardon me I am the painter who live in the house down the road and I would like to make your acquaintance. . . . Today I had called at his little house and found him painting a Buddhist figure on stretched silk with a black robed monk sitting beside him. After a while another came and sat quietly in the corner. We looked at books on Chinese and Japanese art.

A later entry reports, "Whenever he ["the abbot"] is compelled from within to write, the sutra are sung."[86] Here Tobey's sensations of "freedom and independence" are tied to the embodied masculine presence—brown eyes, long hair, good build—at the center of an all-male community where brush painting was a respected spiritual practice. Years later, Tobey said simply, "When I get into the old monks who did calligraphy then I'm very happy."[87]

Tobey's interest in the embodied figure of the Eastern artist coincided with exhilaration over his liberation from Western ideas and identity. In an essay comparing Eastern art's emphasis on line with Western art's emphasis on mass, Tobey recalled, "When I resided at the Zen monastery I was given a sumi-ink painting large free brush circle to meditate upon (figure 3.18). What was it? Day after day I would look at it. Was it selflessness? Was it the Universe—where I could lose my identity?" He explained, "The old Japan with its Zen teaching and philosophy of Taoism found . . . the circle of emptiness freed by the imagination permitted one to reach a state of mind which released him from having to consider someone else's ideas."[88] These published testimonials to the identity-transcending, idea-releasing effects of the ensō (the Zen circle) seem related to the specificity of Tobey's recollection that it was in this circle—the moon-window and also the line that is the trace of physical gesture—that "Toshi" appeared, all the more embodied as Tobey happily shed his own sense of embodiment.

Tobey did not claim authenticity. "I realized, while struggling in China and Japan with sumi ink and brush . . . that I could never be anything but the Occidental I am," he said, and while "I have attempted meditation in a Zen

FIGURE 3.18 Tesshu Kozuki, Enso calligraphy, date unknown. Ink on silk. Photograph by Bruce C. Kennedy.

monastery and have talked with a few abbots . . . , I have never experienced Satori or Enlightenment."[89] Nevertheless, allusions to Zen and "old Japan" became central to his reputation from the 1960s onward, as Western critics and historians rehearsed a small repertoire of Tobey's statements rather in the manner of Zen *koans*. Compounding the paradox of quoting remarks about the instability of identity to brand the individualism of a single artist, their reiteration obscures how Tobey's interest in Japan and China melded what was old with what was new. Tobey's reports to the Elmhirsts at Dartington deploy modernist, stream-of-consciousness prose to describe his experience in Japan. One letter begins,

> Dearest Dorothy
> Hot—hotter—hottest—a sun-baked Tokyo—with its maddening motor-cars driven at terrific speed. Horns hooting and hooting, street cars and of course bicycles. What a modern city—and yet I might not be anywhere in a western capital for here peeping thru—the Japanese character in clothes—getas clattering amidst the leather footfalls on pavements. . . .

And continues:

> A mixed up town with mixed up clothes, word signs speaking in East-West alphabetic—remnants of samurai walking down man and master on hurrying thoroughfares—bill pasted and banner flung strung with black and red chinistic characters or spelling their meaning thru rapid grass hiragana characters, blood without bones. Radios squawking or guzzling gargle-toned sore-throat muttering racked by filed [?] overtones. High shrill girly-girl songs jazz-bazzed East-West twizzy-twanged thump-stop jazzed time accompanied by flute and clarinet obligatoes sad tunes woven through your mind while your bunny-bum regions bounce as you sit quietly eating your "mask melon."[90]

This cascade of words performs a modernism that adheres both to Tokyo and to the artist perceiving it. Hartley's prose is similar, and both men admired Gertrude Stein, whom Hartley knew well and Tobey visited on a pilgrimage to Paris in 1925; Tobey also professed admiration for the writings of Virginia Woolf and James Joyce.[91] His cosmopolitan modernist perspective informs the conclusion to this word torrent about Tokyo, which alludes to the "thousands of young Japanese rushing through Paris and Berlin life and hurrying

home to erect temples of memory to the Edelweiss and fleur-de-lis pastures of the night life of foreign capitals."[92]

Tobey's modern perspective on Japan gains a critical edge when he gets beyond the bustling urban streets. Almost alone among men who traveled to Japan, Tobey noticed the predicament of Japanese women. The "modern girls breezing down the streets in their high heels, printed western dressing fluttering," he told Dorothy Elmhirst, are "like the wooden facades of the buildings where behind they return to the patriarchal power of their private life."[93] His journal records, "I have visited the Japanese male in all his supremacy sitting in his own house drinking his saki [sic], growing his rice fields, cutting his bamboo and being served in company by his delightful old mother kneeling behind his chair (for he likes to sit western style with western friends) and while bowing low serves from her knees and bended back."[94] It is likely that this observation was occasioned by Tobey's introduction to Leach's circle of modernized Japanese aesthetes. The undated diary entry preceding this one is an account of a day trip with Leach and Yanagi to see a potter who had set up in the rural town of Mashiko, and this seems the most likely circumstance in which Tobey would have encountered "the Japanese male" at home on a farm. His dismayed reaction, however informed it may have been by his friendships with modern Western women such as Juliet Thompson and Muriel Draper, may also register his disappointment when the sight of Japanese heteronormativity interrupted his experience of Japan's homosocial artistic communities.

Tobey's reactions to East Asia—an outward-focused fascination with the urban jumble of unreadable signs and elation at transcending his own embodiment through spiritual fusion with the homosocial brush-writing rituals of Zen monasteries—contrasted with Leach's ego-boosting reception in Japan, which quickly alleviated the identity crisis he experienced during the voyage east. As with Tobey, Leach's engagement with Japan is commonly presented in the West as an unfiltered absorption of authentic Japanese tradition with little regard to the individuals and institutions that constructed his experience. Recent scholarship by Yuko Kikuchi and Edmund de Waal, however, reveals Leach's importance for the Japanese as both a conduit of Western ideas about the "primitive" and an incarnation of Western interest in the role of traditional Japanese arts in global modernism.[95] As a welcoming present for Leach when he arrived at the port of Kobe one of Yanagi's colleagues compiled a seven-hundred-page book about him, comprising reprints of his essays, accolades from his friends, and more than

one hundred pictures of his work. In response to Leach's comment that the sumptuous book made him feel "I were dead and reading my own epitaph," his Japanese hosts replied, "Now you start another life."[96] Toured by Yanagi around potteries, schools, and museums, Leach rapidly warmed to his new identity as *sensei* (master). In a magazine Yanagi edited, Leach wrote, "As to the 'sensei' business, apart from being flattering and pleasant to a point, I have no difficulty in accepting the role when it comes to artistic values and meanings, interpretations and designing capacity—simply because, saving Yanagi, Hamada, Tomimoto, and Kawai [three Japanese potters], who are also 'sensei,' there are no others who can confidently show and explain the way to this younger generation and to the half-attached world of connoisseurs and art-lovers who are mostly very 'boggled' by the complexities of inter-continental art and life."[97]

Leach's essays in Yanagi's magazine *Kogei* (*Craft*) in May 1935 contrast with Tobey's ruminations on Japan almost point by point. Leach complained about his first impressions of modern Japan upon disembarking from the ship in Kobe: "That first distracted, side-glance, observation of flimsy formless, poster-hidden Japanese street life—radio blaring to right and left—cheap and ugly foreign style buildings cheek by jowl with low wooden Japanese buildings—equal mixtures of clothing—insistent hooting of cars (as in Italy)." He wrote that his dismay at the urban cacophony, which enthralled Tobey, was relieved only by entering

a quiet Japanese interior with all its quiet inward refinement of beauty. It is the finest example in the world of taste and it contains asymmetric elements of decoration of unique significance—that left-handed perception of the Orient—of Laost'ze, of Zen, which I believe is the kernel of the especial values eastern man has discovered, not for the East alone, but for the future, and the world as a whole.

Asserting his authority to assess the "problems" of modern Japan, Leach reported that the Japanese assured him that "they felt there had been no European since Lafcadio Hearn who had so lived into [sic] the life of Japan, but that whereas with him the understanding was limited to old Japan, with me they felt I knew their contemporary problems as one of themselves and could therefore offer out of my own background of the West criticism and interpretation as an understanding friend."[98] He, therefore, offered his Japanese (Anglophone) readers a list of his corresponding "Loves" and "Hates":

LOVES	HATES
. . .	
A Japanese interior:	Any new Tokyo exterior:
Fuye and Shakuhachi	Street radios, sentimental
[Japanese flutes]:	popular songs, the loud
"Semi" [cicadas], street	speaker in every railway
calls, frogs, the nightingale:	station:
The manners of a host	The "no manners" of petty
and hostess:	officials:

Locating Japan's relevance to the modern world in its traditional domestic interiors, Leach disparaged "the change in Japanese womanhood" that "struck me much more forcibly" than the look of the cities. Western clothes on Japanese women, he complained, made them look like "Bond Street Prostitutes."[99]

Though Tobey and Leach traveled to East Asia together, their very different modes of engagement with those they found there—and the very different ways East Asians engaged with them—exemplify something of the variety and complexity of Japanism. By the time Tobey returned from his time in "in a Zen monastery where he was staying somewhere in southern Japan, practicing meditation" as Leach dismissively put it, their versions of the Orient were incompatible. "It became clear to both of us . . . that the life I was living in Japan was not suitable to his needs," Leach's memoir reports, "so, after a week or two together, he decided to go home to America."[100] To the Elmhirsts, Leach wrote, "In spite of the frictional lightening between us at close range his going is a personal loss and impersonally it is a pity because he would have made a reputation in Japan and so few artists with brains behind their eyes have been in the East."[101]

When Tobey arrived in Japan, he announced that he was "thinking very hard about settling down here for some time" to study Zen.[102] But his precipitous departure for Seattle was not prompted just by differences with Leach. On July 17, the Elmhirsts advanced Tobey money to have a folio of drawings—renderings of the nude done in England—luxuriously reproduced in Japan for sale to American and British collectors.[103] Shortly thereafter, approximately thirty of his drawings were confiscated and destroyed by Japanese authorities.[104] This poorly documented episode collided with fantasies of belonging in the meditative East and exhilaration at escaping Western strictures about the body. Tobey immediately set sail for the United States. On his return to Seattle, the new art museum mounted a show of his East Asian watercolors,

and Tobey remained in the United States for over a year before returning to Dartington in October 1935. It was there that he produced the first paintings in what came to be called "white writing." In his words, "in gentle Devonshire during the night, when I could hear the horses breathing in the field, I painted *Broadway* and *Welcome Hero*" (figures 3.19 and 3.20).[105]

Invoking the East: "White Writing"

Tobey's "white writing" made him famous as an American interpreter of the East—but not immediately and not on purpose. For Tobey, these paintings came as a surprise. A letter at the time reports that *Broadway* "astonished me as much as anyone else"; two decades later, Tobey recalled in more detail, "I was disturbed. I began to daub on a canvas and I was puzzled by the result. A few streaks of white, some streaks of blue. It looked like a distorted nest. It bothered me. What I had learned in the Orient had affected me more than I realized."[106] Again recounting how, "when I was in peaceful Devon in England, my experience in the East unexpectedly bore fruit," Tobey said, "I drew a number of white lines in a mesh, with a few dark forms in blue. I suddenly realized that it was Broadway."[107] Summarizing a series of interviews with Tobey in 1961, curator William Seitz reported, "As he painted *Welcome Hero*, in which every major postulate of his development fell together as in a catastrophe, he shook with fear."[108] In these anecdotes, white writing approaches the Burkean sublime, in which the individual experiences sensations of overpowering force.

Writing in the heyday of formalism, Seitz, who was organizing a retrospective for Tobey at the Museum of Modern Art, cast the artist's narrative of unbidden, frightening, half-resisted arrival at "maturity" in purely visual terms as "fulfilling the early desire to 'smash' form by breaking apart the perspective focus and all but reversing the yin-yang of full and empty volume, flatness and depth."[109] Explaining that "I probably experienced the most revolutionary sensations I have ever had in art because while one part of me was creating these two works [*Broadway* and *Welcome Hero*], another part was trying to hold me back," Tobey glossed his emotions with "It may be difficult for one who doesn't paint to visualize the ordeal an artist goes through when his angle of vision is being shifted."[110]

Seeing and depicting have ideological implications, however, and Tobey's new perspective confronted him with the issues that have animated this book

FIGURE 3.19 Mark Tobey, *Broadway*, 1935–36. Tempera on masonite. Metropolitan Museum of Art, New York. Arthur Hoppock Hearn Fund, 1942. © 2015 Mark Tobey/ Seattle Art Museum, Artists Rights Society (ARS), New York.

FIGURE 3.20 Mark Tobey, *Welcome Hero*, 1935–36. Tempera, destroyed. © 2015 Mark Tobey/Seattle Art Museum, Artists Rights Society (ARS), New York.

from the beginning: the deployment of Japan as what Wilde called "a mode of style" and Barthes termed "an unheard-of symbolic system . . . altogether detached from our own" that denaturalized Western norms of representation and thus what is true or real. Explaining white writing in retrospect, Tobey emphasized its long genesis and emancipatory impulse: "Already in New York in 1919 I began to react to the Renaissance sense of space and order. I felt keenly that space should be freer."[111] Writing in his journals about the paintings he was seeing in Japan, Tobey observed that the "Japanese vision" conferred the "dignity" of art on what Westerners overlooked, collapsing oppositions between the insignificant and the overwhelming: "An awareness of the smallest detail of [nature's] vastness as though the whole were contained therein and that from a leaf, an insect, a universe appeared."[112] Japan's tiny gardens, he later said, offered "a technical approach which enabled me to capture what specially interested me in the city—its lights—threading traffic, the river of humanity chartered and flowing through and around its self-imposed limitations not unlike chlorophyll flowing through the canals in a leaf."[113] Having learned to perceive universality in details, Tobey concluded, "I want to paint what nobody else sees. The ignored and forgotten things. The unregarded."[114]

Tobey—like Wilde and Barthes—did not claim to represent Japanese authenticity when he deployed Japanese aesthetics in the West. Rather, he described how his white writing synthesized crucial elements of his experience in the Orient in order to supplant Western representational conventions. When "'White writing' appeared in my art the way flowers explode over the earth at a given time," Tobey wrote,

> I found I could paint the frenetic rhythms of the modern city, something I couldn't even approach with Renaissance techniques. . . . "Writing" the painting . . . became a necessity for me. I often thought of this way of working as a performance, since it had to be achieved all at once or not at all—the very opposite of the building up as I had previously done.[115]

This emphasis on writing as performance invokes Tobey's embodied associations with East Asian calligraphy: the sensual push–pull he learned from Teng Kwei and the handsome abbot writing sutras while the monks chanted. At the same time, the frenetic streetscapes depicted in these paintings evoke the idea of the city as a form of protective cover in which individual figures merge into the calligraphic networks that twist down sidewalks

and pour into the street. "God! what a forest and I'm so lost[?] in it. . . . The life is so thick here," Tobey wrote from Shanghai, a city he repeatedly compared to New York.[116]

The effect of Tobey's white writing, then, was to undo Western ways of seeing and rendering and to apply those lessons at home, first to depictions of that symbol of urban modernity, New York's Broadway, then to his own situation in Seattle. The opening line of Tobey's 1951 memoir-as-manifesto, "Reminiscence and Reverie," sets him, very specifically, "on the third floor of Manning's Coffee Shop in the Farmer's Market in Seattle." Looking out from his perch above the Market, Tobey anticipates Barthes's "dream" of alienating language in order "to descend into the untranslatable . . . until everything Occidental in us totters and the rights of the 'father tongue' vacillate."[117] Tobey writes,

> This is the age of words and the age of fear of words.
> "Suddenly a wave carries the moon away."
> Two men dressed in white jeans with caps on their heads are climbing over a large sign of white letters. Of course, the words spell something, but that's unimportant. What is important is their white, and the white of the letters.
> The loop is small in the beginning, but widens with the strength of the arm. Horizons are small or vast."[118]

Here the interposed line from Arthur Waley's translation of a poem by the seventh-century Chinese emperor Yang-Ti allows the perception of words as color (white), as shape (loop), and as record of gesture in a way that changes the scale of the surrounding world (horizons).

After the representation of Broadway in the painting of that name, Tobey's next white writing, *Welcome Hero*, shattered Cartesian space as it depicted the kind of euphoric urban street celebration where, "completely integrated with the mass spirit," he felt freed from the sensations of alienation that Silvan Tompkins called "shame."[119] Abstract calligraphic compositions followed. Japan's role as a catalyst for Tobey's breakthrough into white writing is registered in the juxtaposition of two compositions painted on opposite sides of the same sheet during this generative winter of 1935–36. One is a dreamy evocation of robed men under a full moon that has been titled *Zen Figures* (figure 3.21).[120] The other is an abstract composition of white lines against a dark field called *Broadway Lights* (figure 3.22). The transformation of memories of Japan into a mode of abstraction that merges fundamental Western

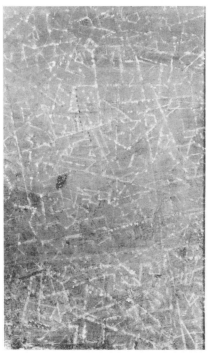

FIGURE 3.21 Mark Tobey, *Zen Figures*, 1936. Tempera. Location unknown. © 2015 Mark Tobey/Seattle Art Museum, Artists Rights Society (ARS), New York.

FIGURE 3.22 Mark Tobey, *Broadway Lights*, 1936. Tempera. Location unknown. © 2015 Mark Tobey/Seattle Art Museum, Artists Rights Society (ARS), New York.

formal binaries—light/dark, near/far, center/periphery—is encapsulated by this double-sided work, which records the interplay of recollection and invention during Tobey's winter in Devon.

The language of the sublime—mixed feelings of terror and elation associated with the rising up of great waves or mountains—permeates discussions of white writing by Tobey and others. Recalling this era, Tobey described how he continued "expressing myself in this style, and in the forties brought it to its highest peak in a painting called New York" in which "line became dominant instead of mass" (figure 3.23).[121] In the painting Tobey associated with this "peak," imagery is fully sublimated into a glowing mesh of tiny white lines. Other paintings from this period, however, retain the references to buildings and crowds that characterized Tobey's first white-writing paintings

FIGURE 3.23 Mark Tobey, *New York*, 1944. Tempera on paperboard. National Gallery of Art, Washington, D.C. Gift of the Avalon Foundation. © 2015 Mark Tobey/Seattle Art Museum, Artists Rights Society (ARS), New York.

and recall Whitman's evocation of Broadway: "When the mass is densest, / When the façades of the houses are alive with people." In the 1943 *Flow of the Night*, figures and faces swarm a ground plane, merging with stacks of box-like compartments that evoke Tobey's description of "America, my land with its great East–West parallels, with its shooting-up towers and space-eating lights—millions of them in the vast night sky" (figure 3.24).[122]

Little figures in Tobey's crowd pictures carry particular significance. A naked man in the lower left-hand corner of *Flow of the Night* seems to swim—or turn handstands—through this urban energy unnoticed; a clown in a pointed hat occupies this position in *Welcome Hero*. These figures echo Tobey's paintings of circus performers in the 1920s, conferring continuity on what critics unanimously—often pejoratively—characterize as a stylistically eclectic output. As signature figures, they recall the little naked incubus dancing in (again) the lower left-hand corner of Tobey's 1925 portrait of the handsome Cornish School pianist Paul McCoole (figure 3.25). The catalog of the 1962 Museum of Modern Art retrospective that celebrated Tobey's turn to abstraction quoted him saying, "I had a hard time, out of my love of figures, not to carry that along, because I like figures and I like people."[123] A few years

FIGURE 3.24 Mark Tobey, *Flow of the Night*, 1943. Tempera on panel, 19 3/4 × 14 1/2 in. Portland Art Museum, Portland, Oregon. Museum purchase, Helen Thurston Ayer Fund, 45.12. © 2015 Mark Tobey/Seattle Art Museum, Artists Rights Society (ARS), New York.

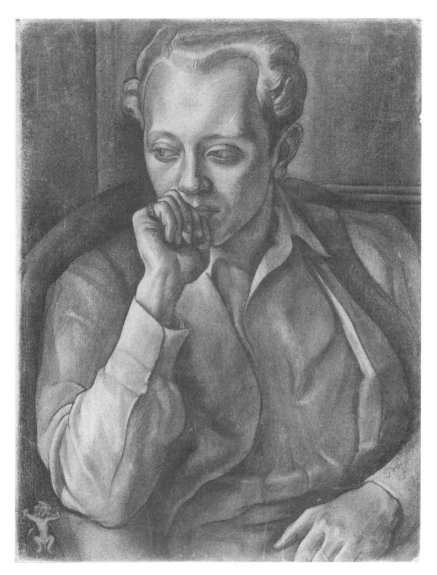

FIGURE 3.25 Mark Tobey, *Paul McCoole*, 1925. Conte crayon on paper, 24 × 18 3/8 in. Seattle Art Museum. Bequest of Mrs. Thomas D. Stimson, 63.105. © 2015 Mark Tobey/Seattle Art Museum, Artists Rights Society (ARS), New York.

earlier, another exhibition catalog reported, "Even now his greatest joy is to work directly from the model."[124] Tobey's frequent disavowal of complete abstraction and insistence that his art was "humanist" led him, in the modernist heyday of the 1950s, to complain, "So much painting I see these days tells me absolutely nothing about the artist, nothing about what he loves, what he believes in," and to praise "artists who are usually called 'minor'— but they have *something* which is their own. . . . They paint out of their own lives, and they paint those things which have personal meaning for them."[125] Notes from Tobey's conversations at this period report him saying, "If I really were to paint what I want to these days, I'd paint men. But then I have this concern for space—how do you reconcile the two in the picture[?]"[126]

Taken together, Tobey's statements focus broad claims about using Oriental calligraphy to supplant Western modes of thought and representation toward a specific concern with the artist's relationship to the male body in its surroundings. A little cartoon Tobey produced in 1962 to illustrate "my personal discovery of cubism" in the 1930s shows the trajectory of a housefly over an image of the artist representing a body in space (figure 3.26). Rejecting—or simply spoofing—explications of Cubism's engagement with the third and even fourth dimensions that undergirded theorizations of New York School abstraction in the 1960s, Tobey's dotted lines instead cast a two-dimensional calligraphic veil across the scene of representation, implying motivations for the "discovery" of white writing more meaningful than the silly story of following a fly. This anecdote, like the humorous Zen *koans* Tobey enjoyed, functions as its own kind of camouflage by evading Western logics of understanding. In the deeply homophobic context of the 1950s and '60s, Tobey's art, with its simultaneous masking and sublimating of same-sex desire, attracted other closeted men like William Seitz and Wesley Wehr, whose writings publicized the artist even as they enacted their own forms of evasion. They were not the first to gravitate to Tobey's Japanist paintings, however. Two decades earlier, this art made its first powerful impression on a small circle of artists in Seattle.

REORIENTING SEATTLE WITH MORRIS GRAVES AND JOHN CAGE

In the mid-1940s, when Tobey painted *New York* and *Flow of the Night*, he was once again living in Seattle. He had returned to the United States for the summer of 1938, then through the autumn delayed returning to England due to,

FIGURE 3.26 Mark Tobey, *My Personal Discovery of Cubism*, 1962. Ink on paper, 19.8 × 15.2 cm. Seattle Art Museum. Gift of Virginia Hazeltine, 77.7. © 2015 Mark Tobey /Seattle Art Museum, Artists Rights Society (ARS), New York.

as one letter put it, "WAR scare."[127] It was a propitious moment for an artist interested in Japanese aesthetics to be in Seattle, where, since 1933, the Seattle Art Museum had displayed a growing collection of East Asian art amassed by its director and major donor, Richard Fuller, in an elegant Art Deco building commissioned for the purpose by Fuller and his mother. Fuller, described in a museum publication as Seattle's "First Citizen and Most Eligible Bachelor," also enthusiastically promoted local artists, buying their work for himself and the museum, and paying some—including Tobey—a monthly stipend.[128] Seattle artists also found support from the Federal Art Project, overseen by Holger Cahill, once the promoter of the dubious Inge-Inge group, now a respected critic and curator, whose sympathies—and subsidies—favored modernists with a flair for the exotic. Among them was a painter twenty years Tobey's junior named Morris Graves.[129]

Among Seattle's young modernists, Graves most closely shared Tobey's interests and sensibilities. Having enlisted as a seaman in order to see China and Japan a decade earlier, Graves recalled, "In Japan I at once had the feeling that this was the right way to do everything. It was the acceptance of nature—not the resistance to it. I had no sense that I was to be a painter, but I breathed a different air." In 1935, Graves began studying Zen in a Japanophile circle in Seattle. When he met Tobey in the summer of 1938, Graves responded eagerly to the older artist's mix of worldly sophistication and exotic spirituality. Describing how Tobey "had steeped himself in Japanese aesthetics," Graves said, "Tobey had sensitivity, a Japanese-conditioned approach to nature, intuitive power."[130] In a 1939 letter to his sister, Graves described taking Tobey to property he owned on an island north of Seattle: "Mark played a Japanese bamboo flute" and "read aloud Baha'i prayers, and when we left he said in Persian the name of the Bab of Baha'i, which he translated to mean 'The Greatest Name Given by God.' This he said nine times, three to the south, three to the north, and shouted it three times to the east." Graves was impressed. "The chalice of compassion split the air above me and spilled out a great stream of water over us. It was a moment of such love of The Rock and its meaning that dramatic and sheer romantic qualities were absent." To mark the occasion, "When we left I nestled a little white rice bowl into the ground—this will not be empty when I go next—the heavens always will open and fill this vessel with water."[131] On a later visit to the house Graves built on this site, Tobey pronounced it "more Japanese than anything in America."[132]

Graves's Japanist sublimation of the mundane fact of rain in a wet climate onto the plane of an endlessly replenished "celestial chalice of compassion"

suggests the register of his relationship with Tobey, about whom he said, "He has put language in my hand."[133] Graves rapidly adapted white writing for a series of paintings of birds in moonlight (figure 3.27), explaining that "the Tobey-like writing and geometric forms in which the bird is submerged was a conscious attempt to poetically help materialize a molecular content of moonlight, to bring it into touchable proximity—make it real—give it a tangible (outer) existence—a moonlight impregnated with messages."[134] Graves's allusions to hidden messages in the night raise issues not openly addressed until the 1980s, when art critic Matthew Kangas suggested that "homosexuality is the hidden key to understanding the art" of Tobey's Seattle circle, although "by and large this aspect has been completely ignored or suppressed in commentaries on their work by critics and assiduously concealed by the artists themselves." Arguing that the Seattle artists used "Asian art traditions

FIGURE 3.27 Morris Graves, *Bird in Moonlight*, 1939. Gouache and watercolor on paper. Jordan Schnitzer Museum of Art, University of Oregon, Eugene, Oregon. Nancy Wilson-Ross Collection, 1986: 115. Permission of the Morris Graves Foundation.

and techniques as a palimpsest for building a gay erotics of painting," Kangas described "the 'look' of Asian art" as a "veil to pull over the pain of being homosexual in an alien unsympathetic culture."[135]

Kangas was right. A powerful sense of shared alienation bonded Tobey with his Seattle circle of younger artists and found expression in rhetorics of Eastern mysticism—verbal and visual—that alluded to profound meanings only initiates could understand. As I have argued elsewhere about Marsden Hartley's symbolic portraits of the 1910s, however, efforts to specify these meanings—as the pain of homosexuality or anything else—risk reducing this art to a riddle with a single answer.[136] I would emphasize, instead, the attractions of working with codes that, "at once disembodied and indecipherable," refuse reduction to a single meaning. Critics recognized this attraction when Tobey's abstract paintings were first exhibited in New York in 1944 at the show for which the rubric *white writing* was coined. A short review in *Art Digest* described Tobey's signature style in terms of shared secrets and hidden depths:

> Although his paintings are multi-colored in actuality, many appear monotonic and without character, viewed at a distance. Confidentially (and this is how you will view them in order to relish each labyrinthian composition), they are as charged with energy as the boldest expressionism or abstractionism. . . .
>
> Beneath this "white writing" (the artist's own name for it), is sometimes felt an undulation like the movement of unquiet waters.[137]

Other reviews objected to what seemed a withholding of representation. A short notice of the exhibition in *Art News* opened, "Mark Tobey of Seattle is almost certainly the man from whom Morris Graves got his ideas. Only Graves capitalized on them by turning them into pictures whereas Tobey has remained virtually in the calligraphy class." This reviewer's terms are telling, as they suggest the disorienting effect of Tobey's art on viewers committed to modern Western conventions of a painting's place on the wall. Tobey's work, in contrast, "must be read at book remove, for with distance their extraordinary wealth of symbolism . . . is lost in a chalky blur. The effect is of primitivist scratchings on a dusty plaster wall, called by the artist 'white writing.'"[138] Fluctuating between the scale and authority of book, architecture, confidential whisper, and "unquiet waters," Tobey's art struck New York audiences as a mode of concealing or obscuring that challenged fundamental ideas of what a painting should do. Unsurprisingly, in the spring of 1944, neither Tobey nor any of the reviewers suggested any link to Japan.

Japanese associations were central to Tobey's reputation among younger artists in Seattle, however, where Morris Graves was not the only one to fall under his sway in 1939. Years later, when composer John Cage used the I Ching to choose the letter M as the title of a collection of essays, he noted that M is "the first letter of many words and names that have concerned me for many years (music, mushrooms, Marcel Duchamp . . . Morris Graves, Mark Tobey, Merce Cunningham . . .)."[139] Cage moved to Seattle in 1938 to work at the Cornish School teaching music and accompanying the dancer and choreographer Bonnie Bird, a veteran of Martha Graham's troupe. Although he was "around Tobey for only a short time, in Seattle" from early 1939 until the summer of 1940, he recalled, "In that small amount of time, we saw each other often—enough for me to be impressed by some of his attitudes."[140]

Cage often recounted as the key story of Tobey's mentorship a walk "from The Cornish School down to Skid Row where there was a nice Japanese restaurant."[141] Traversing the distance between the location of Seattle's avant-garde and the precincts associated with the city's economic and racial outsiders—"a walk that would not normally take more than 45 minutes, but on this occasion it must have taken several hours"—Tobey taught Cage a new "way of seeing, which is to say involvement with painting, or my involvement with life even."[142] As they "crossed through most of the city,"

> He would continually stop to notice something surprising everywhere—on the side of a shack or in an open space. That walk was a revelation for me. It was the first time that someone else had given me a lesson in looking without prejudice, someone who didn't compare what he was seeing with something before. . . . Tobey would stop on the sidewalks, sidewalks which we normally didn't notice when we were walking, and his gaze would immediately turn them into a work of art. He was attentive to the slightest detail. For him, everything was alive.[143]

Cage later recorded this moment in a mesostic (a poem with a key term spelled vertically down the middle):

> each Thing we saw
> he asked us tO look at.
> By
> thE time we reached the japanese restaurant
> our eYes were open.[144]

Tobey's commitment to art that escaped conventional prejudices became central to Cage's practice. In Seattle he began to compose with recorded sound, radio broadcasts, and pianos "prepared" to make their strings percussive rather than tonal. In a lecture for the Seattle Artists' League in February 1940, Cage argued for "THE USE OF NOISE TO MAKE MUSIC," listing as examples "The sound of a truck at 50 m.p.h. Static between the stations. Rain."[145] A month later, he first used the "prepared piano" to accompany a dance performance by Sylvia Fort, an African-American Seattle native who had recently graduated from the Cornish School. Cage recalled, "I invited Mark Tobey and Morris Graves over to listen to it, and they were delighted."[146]

Tobey's walks and talks helped Cage apply ideas associated with Japan that were circulating in the Seattle circles he and Tobey shared. In January 1939, the novelist Nancy Wilson Ross, just back from East Asia, spoke at the Cornish School. The talk's title was "The Symbols of Modern Art," but its topic was summarized in Cage's memory of "one of the liveliest lectures I ever heard" as "called Zen Buddhism and Dada."[147] Arguing that "Dadaism and its grandchild Surrealism have many points in common with Oriental metaphysics, particularly the branch of Buddhism known as Zen," Ross summarized, "what Zen believes" as "the fact 'I am,' 'I live' is still . . . the great mind-staggering experience and mystery; one which needs no philosophical or analytical embroidery; the highest of all possible affirmations because, in a sense, the only one that there can be for each of us." Graves later called Ross "the largest influence in my life," citing their shared love of "Zen wit, the insight through paradoxes, the jest and humor in the riddle of creation." Ross went on to write three books about Zen that were central to the Buddhism boom of the 1960s, but in 1940, these ideas were new to Ross and a revelation to her audience.[148] Her journal records that Bonnie Bird was so moved by the talk that she wept.[149] Also in attendance was Mark Tobey, who arrived with his luggage straight from the train that had returned him to Seattle after his aborted return to Dartington.

If Ross's lecture crystallized the fervor over Zen among Seattle's artists, its significance beyond this circle has been doubted. Despite her importance in bringing national attention to Seattle artists and her later prominence among American advocates of Zen, Ross—like the women at the core of masculine Japanist groups in Paris and Boston—barely figures in the historical record. But it was Ross who introduced her friend, the New York

gallery owner Marian Willard, to Graves's and Tobey's art in 1939. Willard's gallery, according to a 1944 mission statement, encouraged "the development of the one spiritual denomination common to mankind—that element in all great art, that common communication of the soul, by which a doctor's daughter in Sioux City can find pleasure in a Chinese painting and so recognize a common aspiration, a unifying force beyond the power of politics and even the church"; now Willard promoted Tobey and Graves as Seattle's "mystics."[150] Ross's ambitions during her four years in Seattle between 1938 and 1942 inform her novel of academic life, *Take the Lightning*, published in 1940. In the book, a female scholar of Asian art and philosophy calmly dispenses wisdom to distraught male Freudians and Marxists and prevents them from being fired from the university. Cage scholars, however, dismiss his "frequent reference" to Ross's talk, classing it as "an isolated instance of no obvious consequence," because "throughout the late 1930s, Cage's musical rhetoric was consistently western in its expression, and even during the war years, his prose bore little overt sign of Asian influence."[151] What this assessment overlooks is that when Cage did turn to Zen in the 1940s, he returned to his Seattle experience of a subculture in which philosophies drawn from Japan redeemed bonds among bachelors—and between bachelors and the women who offered nonromantic companionship and collaboration—from the abject status Western convention would accord such relationships.

Cage's frequently repeated accounts of his turn to Zen in the mid-1940s echo the themes of his illuminating walk with Tobey to Seattle's Japantown. This time, however, the transformative agent was not Tobey himself, but his art. In 1944, leaving the first New York exhibition of Tobey's white-writing abstractions, Cage recalled, "I was waiting for the bus and I happened to look at the pavement I was standing on and I couldn't tell the difference between that and the Tobey. Or I had the same pleasure looking at the pavement." Here the shifts in scale—between painting and sidewalk, art and urban environment—that discomfited conventional art reviewers thrilled Cage. Even though "I was very poor at the time," Cage said, he felt compelled to acquire the painting that had inspired this experience, paying "five dollars a week for the next two years" for *Crystallizations* (figure 3.28). Cage concluded, "I had learned from Tobey himself, and then from his painting, that every place that you look is the same thing."[152] This memory underlies two more mesostics:

FIGURE 3.28 Mark Tobey, *Crystallizations*, 1944. Tempera on board, 45.7 × 33 cm. Iris & B. Gerald Cantor Center for the Visual Arts, Stanford University. © 2015 Mark Tobey/Seattle Art Museum, Artists Rights Society (ARS), New York.

waiting for the bus,
i happened to look at the paveMent
i wAs standing on
noticed no diffeRence between
looKing at art or away from it

and

how much do The paintings
cOst?
They were Bought
on the installmEnt plan:
there was no moneY.[153]

Shortly after this episode, Cage turned to Zen: "It was after 1945, between 1946 and 1947 I suppose, that I began to become seriously interested in the Orient. After studying Oriental thought as a whole, I took Suzuki's courses for three years, up until 1951. He taught at Columbia and I liked his lectures very much."[154]

Every account of Cage's career references these studies with D. T. Suzuki, the scholar who established the school for foreigners at Enpuku-ji where Tobey studied and who in the postwar years emerged as the leading advocate for Zen in the West. Cage's admirers, drawn to the numerous and loquacious autobiographical accounts by this advocate of silence, never queried his chronologies—this despite his warning, "I can't remember dates," and his assertion that "the past is not a fact. The past is simply a big field that has a great deal of activity in it."[155] But Cage—like Tobey—consistently misdated important events, including his invention of the prepared piano, his lecture on the future of music in Seattle, and his attendance at Columbia, where Suzuki did not begin teaching until 1952. Such backdating can be seen as a form of reorientation, conferring purpose and confidence on trajectories apparent in retrospect. While Tobey, later defined by his association with Seattle, backdated the date of his move there by a year, Cage, later famous for his association with Zen, backdated his studies with Suzuki by half a decade. Such obfuscation undoubtedly participates in common avant-garde strategies to exaggerate originality, but for both Tobey and Cage, backdating concentrates on crises over sexual attraction to other men.

Attention to sexual identity helps fill what Cage experts worry is "a historic vacuum" created when accurate chronology removes Suzuki from accounts of

Cage's engagement with East Asia during the 1940s. Because "no new information on this period has yet surfaced that might fill the void . . . there seems to be almost 'nothing to say' about these essential events related to Cage's studies of East Asian philosophy," says one scholar.[156] But this casual invocation of Cage's famous catchphrase "I have nothing to say and I am saying it" bears scrutiny in relation to Jonathan Katz's analysis of Cage's "queer silences" as a strategy of "resistance within the homophobic culture of postwar America."[157] Katz argues that, "at the height of the so-called Lavender Scare, a period when more homosexuals than Communists lost their jobs and endured public excoriation and judicial persecution, from top-level government figures on down, the leading proponents of an American Zen aesthetic were largely, though by no means exclusively, homosexual."[158] Cage specialists, however, have tended to enforce, rather than interrogate, the silences around his sexuality. His authorized biography, published the year of his death, records that "one young speaker at a conference at Stanford University in 1992 was censured by the chair for mentioning Cage's homosexuality 'because' Cage does not," then endorses the chair's proscription: "The details are not important . . . all that is important is that a crisis of a marriage and a sexual orientation occurred, and Cage's life decisions, work and thought need to be placed within that context."[159]

Scholarly policing of Cage's public image did not stop Cage himself, shortly before his death, from describing his participation in gay networks in New York and his native Los Angeles in the early 1930s.[160] When Cage moved to Seattle in 1938, however, he was a married man, albeit one who commissioned music for Cornish School productions from Henry Cowell, his former mentor who was in prison in California for homosexual activities, and who found himself powerfully attracted to Merce Cunningham, a young dancer in Bird's classes.[161] Cage's reunion with Cunningham in New York in the early 1940s precipitated the breakup of Cage's marriage. It is significant that he repeatedly dated his turn to Zen to this period, which was also the moment of his return to Tobey's art. Suzuki came later.

Katz was the first in 1999 to cite sexual identity in analyzing Cage's ambiguous but highly charged description of how "I was very disconcerted both personally and as an artist in the middle Forties." Cage described this disorientation vaguely as an alienation from the institutional structures of "our society": "There isn't much help for someone who is in trouble in our society. . . . None of the doctors can help you, our society can't help you, our education doesn't help us. . . . Furthermore, our religion doesn't help." Seeing "no reason for writing music" in this context, Cage explained that, by

working through "my personal problems at the time, which brought about the divorce," he returned to composing when "I found that the flavor of Zen Buddhism appealed to me more than any other." This is as close as Cage comes to discussing his negotiation of his sexuality in the homophobic climate of the 1940s—or the early 1970s, when this interview took place.[162] If his reorientation through Zen in the 1940s could not draw from what he had yet to learn from Suzuki, what he turned to was his memory of Seattle, where Zen was presented as a way of seeing the world without prejudice that leads to self-acceptance. "The fact 'I am,' " Ross said in her lecture, is "the highest of all possible affirmations . . . the only one that there can be for each of us."[163] Thus, it was that in 1944 Cage, visiting the exhibition by his Seattle friend and mentor, relearned from the art what "I had learned from Tobey himself": the anti-hierarchical lesson "that every place that you look is the same thing."[164]

When Cage narrated this era by jumping forward to Suzuki, he repeated a characteristic of his accounts of Seattle, which, as Leta Miller has documented, obscure how his ideas derived from—rather than directed—his "interaction with the Seattle artistic community, . . . reflecting influences both within and outside of music."[165] Cage's reorientation may be understood as in part a disavowal of dependence upon what New Yorkers dismissed as a small, provincial art community by an artist who acknowledged, "I am actually an elitist. I always have been. I didn't study music with just anybody; I studied with Schoenberg. I didn't study Zen with just anybody; I studied with Suzuki."[166] Turning attention from Seattle, however, also drew scrutiny away from the milieu of bachelor Japanists and their female friends from whom Cage drew enabling lessons in a self-acceptance based on Eastern philosophies that seemed to countermand Western prejudices.

Recent scholarship suffers from its own prejudices. Specialists rightly caution against mistaking Cage's Japanism for a personification of Japan, although his contemporaries frequently did so, lumping his use of the Chinese I Ching with "chance operations too often described superficially as Zen-like."[167] Cage himself, however, in the foreword to the essay collection in which he first cited the impact of Nancy Wilson Ross's lecture, warns, "Neither Dada nor Zen is a fixed tangible. They change; and in quite different ways in different places and time, they invigorate action. . . . What I do, I do not wish blamed on Zen."[168] If Cage's admirers were too credulous, however, followers of Edward Said are overly eager to deploy his broad theorizations of Orientalism (discussed in the introduction) to insist that, because "what Cage's interpretations of Asian material chiefly reveal, therefore, are aspects

of his own desires," his "comments on Asia acted to further the hegemony of Orientalism" and "his concept of silence could be an agent of silencing."[169]

Unless we are to condemn all imaginative agency in engagement with "Asian material" (a sweeping conceptual category so various and subjective as to call any claim to its authentic articulation into question), our impulse should not be to censure creative "misprisions," but to interrogate the nature of the "desires" they enact. In this case, Cage, quite aware that "Suzuki did not appreciate the I Ching," persisted in finding in it the lesson the Seattle Japanists taught as the essence of Zen: "This is precisely the first thing the I Ching teaches us: acceptance."[170] If, as musicologist David Patterson says, Cage's appropriations of Asian "terms and concepts . . . were not so much faithful transcriptions of ideas as they were carefully constructed intellectual subversions," we need not "lend an insidious tone to Cage's attitude toward his materials." Patterson argues that "the notion of 'subversion' could well apply to an even larger portion of Cage's activity during the 1940s, particularly in regard to the prepared piano, whose extraneous objects decisively thwarted the aesthetic function of the premier instrument of the nineteenth century." He concludes, "One could say that Cage transformed his rhetorical sources much as he did the standard piano through his use of preparation—taking delight in the historical weight these sources derived from their traditions, yet then alienating them utterly from their original contexts, manipulating their internal arguments to sound to his taste and for his purposes."[171]

Using ideas of the East to subvert or alienate authority in delighted pursuit of self-acceptance, Cage's engagement with Zen, the I-Ching, Nancy Wilson Ross, and Mark Tobey exemplifies the creative potential of bachelor Japanism. Selecting, rearranging, and reiterating, Cage created a compelling practice of self-realization backed by a narrative that put Tobey at crucial points in a story that culminated in a radical challenge to Western authority. The same dedication opens Cage's 1967 anthology A Year from Monday and his 1973 collection M: "To us and all those who hate us, that the U.S.A. may become just another part of the world, no more, no less."

A MARKETPLACE OF IDEAS: GLOBALISM AND REGIONALISM IN THE "NORTHWEST SCHOOL"

Cage's provocative Vietnam-era dedication of his writings to an ideal of American un-exceptionality is part of the turbulent legacy of the mid-twentieth century,

when American attitudes toward the East were caught up in political upheaval and military conflict. World War II kept Tobey in Seattle, where he applied principles drawn from East Asian art to the large body of work now called his "market pictures," a rubric derived from their association with campaigns to save Pike Place Market from destruction in the 1960s. In the 1940s, however, that site merged with another in Tobey's art and writings, as registered in references to this as his " 'Skid Row' period."[172] Tobey's sketchbooks teem with ink drawings of men and women—but mainly men—alone or in groups. Often turned away from the observing artist, they seem absorbed in their activities and unaware of his presence, giving the images a mood of intimate observation. In his studio, Tobey developed some sketches into watercolors washed with muted tones (figure 3.29). Others he combined into what he called "crowd pictures," which depicted the people who "flooded the markets, and they flooded the streets" and "gave me a chance for interlacing of small forms also."[173] Again, visual connections between small parts and great wholes correspond to social beliefs. Tobey saw the Market as "a slice of the Kingdom of God, reflecting his Baha'i faith in the oneness of all earth's creatures," one friend reported.[174] Another repeated

FIGURE 3.29 Mark Tobey, *Two Fruitmen*, 1942. Ink and watercolor on paper. Tacoma Museum of Art. Gift of Eli and Esther Rashkov, 1998.39.6. © 2015 Mark Tobey/Seattle Art Museum, Artists Rights Society (ARS), New York.

Tobey's story of "one ancient character, who habitually wore a pith helmet with a small unpainted duck on the top" and demanded after a long absence, "Where've you been?" When Tobey replied "Japan—the Holy Land—Great Britain," the old man's response—"Well, one has to be somewhere"—encapsulated Tobey's formal concern with relations of bodies to space and his delight in finding value among the dispossessed.[175] "Much wisdom I found among these people—much warmth," Tobey wrote of the Market men.[176]

The mix of Japanism and populism in Tobey's market pictures might seem an unlikely recipe for success in the New York art world of the 1940s, when the United States was both at war with Japan and anxious to disavow populist rhetorics that in the 1930s subtended both isolationist and socialist political movements. Tobey himself was skeptical. Arranging his first show at the Willard Gallery in 1944, he urged, "I don't think I'd go into the East–West culture too much."[177] But these were the paintings that made Tobey—briefly—famous in New York and led to his lasting international reputation. The circulation and reception of Tobey's market pictures, however, demonstrate the limits on Japanism during this era. Caught up in rapidly evolving ideas about abstraction, Americanness, and the avant-garde, the promotion and reception of Tobey's white writing shifted away from engagement with the cultural specificities of Seattle or any part of East Asia, as well as from the affirmation of marginal perspectives as a point of principle. Instead, Tobey and his art were caught up in postwar projects to extrapolate universalism confidently outward from American norms.

These dynamics concentrated on a market picture titled *E Pluribus Unum* (figure 3.30). This painting illustrated reviews of Tobey's first solo show at the Willard Gallery in 1944 and opened the selection of his works reproduced in the catalog of the Museum of Modern Art's (MoMA) *Fourteen Americans* exhibition in 1946. Its title, drawn from the Great Seal of the United States, asserts an essential Americanness for ideas Tobey associated with Zen. His short catalog statement for the MoMA exhibition, printed above the reproduction of *E Pluribus Unum*, transmutes the principle of seeing the great in the small into a universalism in which local and national categories become global. He opens with, "Our ground today is not so much the national or the regional ground as it is the understanding of this single earth." This new "global understanding" unfolded from the United States, and more specifically its northwest coast, as Tobey goes on to argue that in

the need for the universalizing of the consciousness and the conscience of man[,] . . . America more than any other country is placed geographically

FIGURE 3.30 Mark Tobey, *E Pluribus Unum*, 1942. Tempera on paper mounted on paperboard, 50.2 × 69.2 cm (19 3/4 × 27 1/4 in). Seattle Art Museum. Gift of Mrs. Thomas D. Stimson, 43.33. © 2015 Mark Tobey/Seattle Art Museum, Artists Rights Society (ARS), New York.

to lead in this understanding, and if from past methods of behavior she has constantly looked toward Europe, today she must assume her position, Janus-faced, toward Asia. . . .[178]

Tobey concludes by citing America's "growth in the arts, particularly upon the Pacific slopes. Of this I am aware. Naturally my work will reflect such a condition and so it is not surprising to me when an Oriental responds to a painting of mine as well as an American or a European."[179]

Tobey's rhetoric is exemplary of claims for American authority in the postwar years. Here Americans articulate universal understandings to which audiences in Asia and Europe "respond" affirmatively.[180] Widely critiqued today from a global perspective for over confident American exceptionalism, these claims, in their original iteration, were pitched against the isolationist ideologies that had animated the Regionalist art movements of the 1930s. Curator Dorothy Miller's introduction to the *Fourteen Americans* catalog announced,

"The idiom is American but there is no hint of regionalism or chauvinistic tendency. On the contrary, there is a profound consciousness that the world of art is one world and that it contains the Orient no less than Europe and the Americas."[181] Three years before, the catalog for MoMA's 1943 *Romantic Painting in America* exhibition, which included four Graves paintings and Tobey's *Flow of the Night*, more explicitly denounced the "extreme form" of "regionalist philosophy . . . revived in the early 1930s in Missouri and Kansas" under the auspices of "the eloquent isolationist Thomas Craven."[182]

Craven's screeds include the 1941 "Our Decadent Art Museums," which denounced "the art world of America" as "infested with inverts," claiming, "If certain leading museum directors of our country were assembled in a body, any healthy American boy would immediately brand them as sissies—and the few females among them as entirely too manly."[183] Craven's 1934 Book of the Month Club bestseller *Modern Art: The Men, the Movements, and the Meaning* promoted "the current drive for an explicitly native art" by vehemently, if incoherently, denouncing the French as anti-Semitic and dismissing Alfred Stieglitz as "a Hoboken Jew without knowledge of, or interest in, the historical American background" and, thus, no claim "for the leadership of a genuine American expression."[184] Two years later, MoMA's *Romantic Painting* catalog challenged the "snobbish" Regionalists' "stubborn denial" that "great artists have worked in foreign lands, in sections of their own countries remote from their birthplaces, or in international art centers" by proposing a history of "Romantic Meccas open to all" to undercut "the bully-boy, xenophobic and almost secessionist temper in which Midwestern realism was conducted ten years ago, that made its propaganda so perverse and inflated."[185] Also in 1943 and even more cuttingly, the expatriate German art historian Horst Janson, writing in a magazine for art teachers, debunked Regionalist claims to stand for an indigenous American art by tracing the movement's derivation from "the artistic developments accompanying the rise of nationalism in Europe since the late 1920's." Janson's conclusion addressed the ideological "struggle" between "the negative [aim] of isolating America from the rest of the world" and a vision of "America united in the spirit of international cooperation."[186] It was for this contest that the anti-regionalist regionalism of the Northwest, with its universalizing rhetoric and internationalist ideals, was made in Manhattan.

Assertions of a unified identity for the Northwest artists emerged quickly as New York sought alternatives to a Regionalism equated with isolationism. As late as 1943, *Art Digest* quoted artist Kenneth Callahan, who was also a

curator at the Seattle Art Museum, promoting the heterogeneity of Northwest art. "In contrast to most regional painting exhibitions in America, there is no identifiable regional character. . . . the range is from conservative naturalism to abstraction, and from romantic realism to surrealism," Callahan said, though he cited Tobey as the area's "top ranking creative artist" and the man who "developed the art forms credited to Graves."[187] Then the first solo show of Tobey's abstract art in New York took place at the Willard Gallery in 1944, and by 1945, Art News was backdating critical recognition of what now looked like fact, explaining that MoMA's display of Graves's art in New York in 1942 "focused interest on the whole school of Northwest painters . . . centered around Mark Tobey . . . who brought back from the Orient the secrets of simplified form and calligraphy."[188] Callahan's 1946 survey of the Pacific Northwest opened with the assertion that the region "recently before the war developed a distinctive painting style" he explained as "based on broad intellectual concepts and bound to nature as a fundamental theme," with the rather limp caveat that the artists were "unified rather than uniform." A caption under the reproduction of E Pluribus Unum in this essay identified Tobey as the "most influential painter in the Seattle region."[189] Upping the ante, Art News in 1946 illogically hyped "that group of Northwest painters whose homogeneity within a wide range of experiment is probably the most interesting regional art manifestation in America."[190] In 1947, the term "Northwest School" was introduced in the catalog of the exhibition Ten Painters of the Pacific Northwest, which toured five northeast American museums. Here Tobey was said to have "influenced many of the younger painters, not only through the quivering sensitivity of his own work, but also through his wisdom and experience."[191] By 1949, the paradox of a regionalism imposed from New York was unwittingly registered in an issue of Art News in which a review of Tobey's current show at the Willard Gallery called the artist, whose "technique derived from Oriental art," the "artistic leader of the Pacific Northwest," while an article by a local correspondent on the Northwest Annual exhibition reported that "very few paintings showed the influence of the region's two most widely recognized painters, Tobey and Graves."[192]

These tensions destroyed the community of artists New York lionized. Responding to another Art News survey of Northwest art in 1951, in which Callahan tried to explain that Tobey was locally an influence "in the inspirational sense" although his "direct influences in stylistic matters is nil," Graves published an outraged rebuttal impugning Callahan's motives and insisting, "On the contrary, Tobey's influence has here also been particularly and

unquestionably strong."[193] A few weeks later, Tobey mocked the label "North-west Mystic" in an interview with Art Digest, asserting, "There is no such thing as the Northwest School" and "I'm no more a Northwest artist than a cat."[194]

Journalists continued to promote the Northwest School, however. In 1953, the mass-market pictorial Life ran a much-cited feature on "Mystic Painters of the Northwest," which began, "For more than a decade a remarkable art of shimmering lines and symbolic forms has been coming out of the northwest corner of the U.S." The opening paragraphs were accompanied by a photo-graph of Tobey captioned as the "painter-philosopher" sitting "meditatively beneath his art and panels of Chinese writing which influenced it." Here the stylistically diverse Seattle artists' paintings were said to "have one thing in common: they embody a mystical feeling toward life and the universe. This mystical feeling stems partly from the artists' awareness of the overwhelming forces of nature which surround them, partly from the influence of the Orient whose cultures have seeped into the communities that line the U.S. Pacific Coast."[195] Thus did New York invent the "Northwest School" as a critical cate-gory justified with depersonalized claims for mystical universalism and vague allusions to Oriental "cultures" that "seeped into" the American continent.

These tendencies were present as early as New York critic Clement Green-berg's ambivalent first notice of Graves's art in 1942. Observing that "his color is somehow not American," Greenberg speculated, "Since the artist comes from Seattle, one might argue a Pacific or Oriental derivation."[196] When Graves exhibited paintings he called kakemonos and mounted on scrolls in 1945, critics described the works as derived from "Chinese painting" and "Oriental art."[197] The erasure of Japan continued after the war. Callahan's 1946 Art News survey of Pacific Northwest artists asserted the timeliness of their art: "The movement here, rather than constituting an escape from the issues of the postwar period, stems from them." But his repeated references to "China," "Asia," and "the Orient" evaded contentious issues of the day, even as his claim that "the rise of fascism in Europe and Asia directed the art-ists' thoughts toward the problems of humanity and its fate under political misdirection" echoed official American policy, which assigned guilt to politi-cal and military leaders while enacting democratic reforms in its occupied former enemies. Emphasizing the Northwest's proximity to Asia, Callahan announced that "European-filtered interpretations" of Asia "were inadequate for artists who had already stopped thinking of the Orient as a mysterious vastness of quaint people who made good servants and gardeners," but this rebuke to Japanists of Denman Ross's ilk and era ignored more recent

characterizations of the Japanese enemy as a mass of indistinguishable, ruthless automatons. Callahan's assertion that "when the atom bomb exploded over Japan," Northwest artists "saw nature reinstating supremacy over man," confirming "their conviction not only that man is irrevocably interrelated with man, but that all men were equally controlled by and bound to universal laws of solar energy," pushed the disembodied universalism associated with the Northwest School to an extreme.[198]

Life's 1953 account, still reluctant to credit Japan with artistic influence, abridged Tobey's travels "first to England, then Persia and the Near East, finally China" before generalizing about the "Orient whose cultures have seeped into" the Northwest. This critical tendency to locate the "Oriental" elements of the Northwest School in the American landscape draws from the 1947 exhibition Ten Artists of the Pacific Northwest, which allowed that the art was "Oriental in that man is seen as one with nature" but argued, "In spite of all external influences . . . the mysticism of these painters seems to derive mainly from the region itself."[199] In 1951, Callahan argued, "The geodes of Oregon or slabs of slate from Washington mountains, the alpine lakes and waterfalls of the Washington Cascades, the wind-twisted evergreens of the Oregon coast offer almost the identical material the Sung painters used."[200] Decades later, art critics were still insisting that this catalog of "topographical similarities" between the American Northwest "and the Japanese valleys of Honshu . . . account for the distinctive and somewhat Oriental flavor of Northwestern art; in other words, the contribution of environment is greater than that of cultural interchange"—a claim that persists in writings about West Coast art through the turn of the millennium.[201] The result was that the "Orient" associated with Seattle at midcentury was populated by men of European stock. And not even all of Europe. Thomas Craven's Modern Art waxed sarcastic over the idea that artists with surnames of such "fine old American families" as Kuniyoshi, Kuhn, Lachaise, Stella, or Zorach could rival the "work of unmistakably American flavor" done by Bellows, Hopper, Sloan, and Robinson.[202] But Craven would have had no objection to the Anglophone monikers of Life's Seattle mystics: Mark Tobey, Morris Graves, Kenneth Callahan, and Guy Anderson.

In a sad irony characteristic of midcentury American art, the Northwest School's homogeneity—ethnic, gendered, and conceptual—supplanted a much more diverse cohort of modernist painters working in Seattle in the 1930s. Painting in a range of Post-Impressionist styles, they exhibited under the name "The Group of Twelve," and included, along with Graves and

Callahan, three women and three Japan-born men: Kenjiro Nomura, Kame-kichi Tokita, and Takiuchi Fujii. All the artists in the Twelve were promoted by local critics and supported by Richard Fuller's purchases for himself and his museum.[203] Callahan's 1937 survey of "Pacific Northwest Painters" named Nomura, Tokita, and Fujii as "three important Japanese American painters," in whose art "the quality of line peculiar to Oriental painting is fused with their life and associations here."[204]

The diversity of the Twelve was not a point of principle, however. Two of the three women were wives of men in the group, and the recollection by one of them of the Japanese-Americans as "dear people . . . with jobs that sustained them or their families and strictly Sunday painters" suggests the social hierar-chies that structured this stylistically progressive circle.[205] George Tsutakawa, a younger Japanese-American artist whose generous policies toward credit and check cashing for fellow painters made his family's large grocery store a gathering place for Seattle artists during the Depression, recalled that when Tobey tried to interact with Nomura and Tokita, "they always shut up when they're confronted with a great artist. Because he was regarded as so supe-rior, they were modest."[206] Nancy Wilson Ross, in a not-so-fond farewell to Seattle, opened the chapter on the city in her 1941 guide to the Northwest by warning that anyone who arrived "seeking a romantic mingling of East and West . . . will go away disappointed." Recalling the Alaska–Yukon–Pacific Exposition, she remarked, "Seattle, near the century's turn, gave promise of being a really unusual American city," but now, Ross reported, "among her losses must surely be counted the failure to effect a cultural rapprochement with other lands and peoples on the shores of the Pacific."[207]

Even the stratified coexistence of Asian- and Anglo-Americans in Seattle in the 1930s was lost in 1942, when Executive Order 9066 authorized the depor-tation of all Japanese-Americans—whether citizens or not—from the West Coast. Looking back in the 1960s on the decline of the Market, Tobey wrote, "Wars came, the old men I had learned to know died. More and more stalls became empty. The Japanese, a strong element, had been sent away."[208] This indirect and retrospective acknowledgment falls well short of acknowledg-ing that when Tobey painted E Pluribus Unum in 1942, his Asian-inflected cel-ebration of American diversity registered the removal of Japanese-Americans only in their absence from the mix of Euro-American faces it depicted. At the time, neither Tobey nor any other Seattle artist joined the small group of local politicians and clergy who spoke out against the deportation of their Japanese neighbors. Like the Japanisms of late nineteenth-century Paris and

turn-of-the-century Boston, the Orient incorporated into the Northwest School was very much an Occidental idea.

THE AVANT-GARDE AND ITS EXCLUSIONS

Even without Japan or the Japanese, the Northwest School's viability in New York was short-lived. Greenberg's review of Tobey's first show in 1944 noted his relationship to Graves and his "affinity with Chinese painting," admired the "white writing . . . reaching almost to the edges of the frame; these cause the surface to vibrate in depth—or better toward the spectator," then concluded imperatively, "It is obligatory that Tobey work to expand his range."[209] And though Greenberg's review of MoMA's *Fourteen Americans* in 1946 cited Graves and Tobey "among the relatively few artists upon whom the fate of American art depends," this commendation served rhetorically to dismiss half the other artists in the show.[210] Reviewing a concurrent exhibition at the Whitney Museum, Greenberg wrote of Tobey's painting, "In the presence of the Pollock the minor quality of his achievement, original as it is, becomes even more pronounced than before."[211] By 1947, Greenberg's lengthy essay on the high-stakes topic of "The Present Prospects of American Painting and Sculpture" cited Graves and Tobey as "the two most original American painters today, in the sense of being the most uniquely and differentiatedly American," but tempered this designation with the qualification that they were "both somewhat under the influence of Oriental art," then undid it altogether with the judgment that "they turned out to be so narrow as to cease even being interesting." Ignoring Tobey's consistently urban imagery, Greenberg complained that their art "does not show us enough of ourselves and of the kind of life we live in our cities." This assertion of an urban *sine qua non* for postwar American art served to justify the primacy of New York and its resident all-over abstractionist. Championing Jackson Pollock, Greenberg wrote, "if the aspect of his art is not as originally and uniquely local as that of Graves's and Tobey's, the feeling it contains is perhaps even more radically American."[212]

Marginalized from the canon of Americanness, Tobey, Graves, and the other Northwest artists vanished from exhibitions in New York, where contemporary American art came to be equated with the so-called New York School.[213] Their exclusion reflected the incompatibility of Asian aesthetics with the New York avant-garde's articulation of Americanness, a proscription

Greenberg made explicit in "The Present Prospects of American Painting and Sculpture." There the proclamation of Pollock as "the most powerful painter in contemporary America and the only one who promises to be a major one" follows the pronouncement, "In painting today such an urban art can be derived only from cubism."[214] In 1951, Thomas B. Hess, the editor of Art News, published Abstract Painting: Background and American Phase, the first book on what came to be called Abstract Expressionism. Asserting that the "beauty" of Tobey's paintings "is almost as minor as its parts, perfectly articulated though it and they may be," Hess explained, "The flaw here is, perhaps, not so much with Tobey as it is with the Oriental models to which he is so attached. Understatement to the point of preciosity and restraint to the degree where statement is innocuous—both flaws which so often mar Oriental painting—are evident" in Tobey's "modest" and (again) "minor" art.[215]

In this climate, ambitious artists avoided intimations of the Oriental. Even as MoMA's Architecture and Design department in 1954 mounted the exhibition Abstract Japanese Calligraphy and sponsored the construction of a Japanese house in the museum's garden "because of the unique relevance of traditional Japanese design to modern Western architecture," as the press release put it,[216] New York artists, such as sculptor David Smith and the painters Robert Motherwell and Franz Kline, succumbed to pressure to deny associations with Japan. Greenberg's much-cited essay "American-Type Painting" asserted,

> Kline's apparent allusions to Chinese or Japanese calligraphy encouraged the cant, already started in Tobey's case, about a general Oriental influence on "abstract expressionism." This country's possession of a Pacific coast offered a handy received idea with which to explain the otherwise puzzling fact that Americans were at last producing a kind of art important enough to be influencing the French. . . .

Greenberg's mocking dismissal of the Northwest School set up his assertion that "Actually, not one of the original 'abstract expressionists,'—least of all Kline—has felt more than a cursory interest in Oriental art. The sources of their art lie entirely in the West."[217] In fact, Kline, in an enthusiastic correspondence with Japanese calligraphers in the early 1950s, cited the Japanese drawings at the Museum of Fine Arts in Boston as "the strongest influences of my student years." At that time, his art was widely understood in the context of Asian aesthetics, so much so that the original 1955 publication of Greenberg's denigration of Asian influence in "American-Type Painting" referred to "Kline's unmistakable allusions to Chinese and Japanese calligraphy . . .

[my italics].” As Bert Winther-Tamaki has shown, however, Greenberg's 1958 revision of this 1955 essay was “repeated piously” by commentators who insisted Kline's art had no links to Asia while the artist himself shifted “away from a formal model susceptible to comparison with East Asian calligraphy”; by 1956, Kline denied that he was ever interested in Japan.[218]

This rewriting of history to exclude New York artists’ engagement with Japan extended to denying the Abstract Expressionists’ interest in the Northwest painters. Just as other art historians wrote the Goncourts’ *japonisme* out of the history of the Parisian avant-garde, Greenberg worked to protect Pollock from any taint of Northwest School influence. In “American-Type Painting,” Greenberg insisted that although “Tobey is credited, especially in Paris, with being the first painter to arrive at ‘all-over-design” and showed “the first examples of his ‘white writing’ in New York in 1944, . . . Pollock had not seen any of these, even in reproduction, when in the summer of 1946 he did a series of all-over paintings.”[219] In fact, Pollock and Tobey had exhibited together in two shows in 1944; Marian Willard and others recalled Pollock and David Smith studying Tobey's work at her gallery in the 1940s and ’50s; and Pollock's letters reiterate his admiration for Tobey and Graves.[220] Greenberg's claims nevertheless reappeared as fact in histories of Abstract Expressionism.

The terms in which twentieth-century art critics and historians protected Pollock's primacy from imputations of Tobey's influence suggest that more was at stake than nurturing the New-Yorkiness of the New York School. A skeptical *Art News* review of Tobey's MoMA retrospective in 1962 contrasted his “delicacy and mood,” conducive to “passivity,” with Pollock's “very different . . . image-smashing as live drama,” which it insisted was developed independently and “firmly based on the actions and reactions of [a] history” of which the capital-P “Provincial” Tobey was ignorant: “Spiritually as well as technically the two men are far apart.”[221] Although Tobey characterized his work as a “performance” that “had to be achieved all at once or not at all,” William Rubin's four-part celebration of Jackson Pollock in *Artforum* in 1967 praised Pollock's “dramatic point-to-point improvisation” by comparison with Tobey's art, which “looks like it was conceived in advance as a whole, and then simply executed—hence its more decorative appearance.”[222] Irving Sandler's 1970 *The Triumph of American Painting* described Tobey's work as “too minuscule in scale, reticent, and precious to interest Pollock,” a judgment echoed two decades later when Sam Hunter explained that Tobey was “far too precious to be of any relevance to the New York School.”[223] A 1990 anthology about Abstract Expressionism justified Tobey's exclusion with

the explanation that "his works are always well-mannered and imbued with a quality of Eastern mysticism quite different from the confrontational and heroic aspects of the movement."[224] These binaries—"delicacy and mood," "decorative appearance," "well-mannered . . . mysticism," and preciousness *versus* "image-smashing live drama," "dramatic . . . improvisation," and "confrontational" heroism—now read as so starkly gendered as to seem almost parodies of the dynamics that defined the New York School. The pernicious effects of these exclusionary structures—for nonwhite and not-straight men, and for all women—have been widely documented.[225] Another aspect of these dynamics is worth attention: the way imputations of femininity to the Orient obscured associations of Japanism with bachelors.

To look from this perspective at the market pictures that first made Tobey's reputation is to engage with his extended inquiry into nonfamilial forms of intimacy. For Nancy Wilson Ross, who shared Tobey's love of the Market, its appeal lay in the contrast between the "Seattle matrons with their neat paper shopping bags" and the "aimless tide-borne fragments of humanity, men from the flop-houses and dumps, thin men in bizarre garments, standing always as Mark Tobey . . . once said, 'as though up against absolute emptiness—a big blue open space, a vacuum.' "[226] This passage published in 1941 predates the fame of the market pictures and captures one striking visual aspect of the market on the bluff above the harbor, open on the ends to vast vistas of sea and sky. But this was not the effect Tobey's market pictures depict. Rather, Tobey dwelled—perhaps even conferred—upon the market men close and complex relationships, ranging from little islands of conviviality amid the hubbub to what look like mystic forms of communion in intimate networks of Whitmanesque comradeship and spiritual union consonant with Bahá'í beliefs in the unity of world religions. In E Pluribus Unum, for instance, an overscale group of three men near the lower left corner shares an ambiguous but intense moment: one throws back his head and another reaches forward in a gesture of embrace that, in the picture's flattened perspective, reads like a caress of the third man's belly. They stand at the end of a counter laden with food, around which people gather as at a secular Last Supper—a motif explicit in Tobey's painting of that title, which was purchased by the Metropolitan Museum from the Whitney's annual survey of contemporary American art in 1946. The diverse array of types includes a rabbinic figure with a black hat and flowing white beard who is pressed up against a literal low-life: a short, squat man wearing a visored cap turned sideways. A couple of Ross's "matrons," seemingly oblivious to those around them, separate this odd couple from a figure in a fisherman's cap who, overseen by a bishop-like man

making a gesture of benediction, raises a small round loaf from the counter as if performing the Eucharist, Christ's corporeal merging with humanity.

These themes of mystic merging return in Tobey's *Market Scene* of 1944 (figure 3.31). Here a flattened birds-eye perspective creates incongruous juxtapositions of scale in a scene of packed crowds amid countertop displays of food. A stream of figures slices through the crowd in a powerful diagonal that crushes the depicted men into a tangle of arms and faces that—very prominently in the lower right quarter of the painting—seem to be kissing. A very different painting, though it is titled *Market Fantasy*, seems to be set in sparsely furnished rooms where Tobey says the market men go when they are not at the market (figure 3.32). In contrast to the

FIGURE 3.31 Mark Tobey, *Market Scene*, 1944. Tempera on paperboard, 29.9 × 19.1 cm (11 3/4 × 7 1/2 in). Seattle Art Museum. Gift of Marcia H. Sanford in memory of her mother, Edna Buckingham Cole, 79.145. © 2015 Mark Tobey/ Seattle Art Museum, Artists Rights Society (ARS), New York.

FIGURE 3.32 Mark Tobey, *Market Fantasy*, c. 1940. Tempera on paperboard, 55.88 × 40.64 cm (22 × 16 in). Seattle Art Museum. Gift of William S. and Janice K. Street in honor of the museum's fiftieth year, 83.165. © 2015 Mark Tobey/Seattle Art Museum, Artists Rights Society (ARS), New York.

crowded market scenes, this Surrealist image is striking for its emptiness. Floating in a gray vacancy, a prone man, apparently in a trance or convulsion, seems to welcome with open hands a white presence—this has been interpreted as moonlight[227]—that trails off a table by which an elderly woman dressed for outdoors (for the market?) stares through a window that is neither inside nor outside. (A white gull sits on top of its frame.) No coherent narrative emerges from this juxtaposition of staid femininity and masculine mystical/erotic communion with mysterious forces. But this sublimated vision of the private mysteries of market men rises above the criminologists' association of skid roads—in Seattle and other West Coast cities—with various forms of sexual vice.[228]

Tobey's strange sublimations, which attracted men like Morris Graves and John Cage, aroused suspicion in the New York avant-garde, where the constitution of an Artists' Club founded by the leading Abstract Expressionist artists excluded homosexuals, along with critics and women, three categories conceived as subordinate to masculine creativity. In this context, the frequent critical allusions to the femininity of East Asian aesthetics and the men who were interested in them enacted misogynist strategies that had long characterized avant-garde discourses but reached an apogee in the New York art world of the 1950s.[229] When Greenberg turned against Graves and Tobey in "The Present Prospects of American Painting and Sculpture," he complained that their "sensibility confined, intensified, and repeated," like the poetry of Emily Dickinson and Marianne Moore, constituted "an evasion" that "does not show us enough of ourselves . . . and therefore does not release enough of our feeling." Against this feminine art of evasive poetesses who cannot show a normative masculine "us" to "ourselves," Greenberg hailed "the most powerful painter in America and the only one who promises to be a major one," the "Gothic, morbid and extreme" Jackson Pollock. "Faulkner and Melville can be called in as witnesses to the nativeness of such violence, exasperation, and stridency," he wrote approvingly.[230] It was this idea of art as a cathartic release of unmediated masculinity that, ultimately, ruled the Seattle artists out of the American avant-garde.

The Northwest artists tried to adapt. Matthew Kangas makes the case that among the Northwest artists, "submission to varying degrees of modernist abstraction" was "directly in ratio to the rate of commercial success they enjoyed." The price of that success, he argues, was self-censorship of imagery that might look homoerotic as the artists "abandon[ed] an

erotics of painting in favor of a decorative abstraction soundly based on the milieu of mid-century modernism—and postwar hostility to sexual non-conformity."[231] The art historian Martha Kingsbury confirms that when she moved to Seattle in 1968, "I was given to understand" that the city's famous midcentury artists were "what would now be called 'gay,' . . . but not by so much as a raised eyebrow, much less any discussion. The innuendoes traveled more subtly, by perhaps an unfocusing or glazing-over of a speaker's eyes as they passed over certain terrain in their talk."[232] Her description of the era's restrictions on what could be said or seen suggests the dilemma for artists whose range of expression exceeded the parameters of an "abstract expressionism" that idealized normative—and even violently "morbid and extreme"—masculinity as the sign of American power and freedom.

Tobey's abstractions, like Cage's silences, met the era's paradoxical demand for apparently unfettered expression of a quite prescriptive mode of masculinity with complicated forms of reticence. The German art critic Wieland Schmied, writing about two Tobey paintings of 1959, described the "calligraphic" *Within Itself* as a surface "one seeks vainly to penetrate. . . . The longer one looks, the greater the mystery," and asked of *Targets*, "How can one hit the targets if they keep moving, if they cannot be grasped?"[233] But the evasions that interested Europeans were anathema at home. When Tobey won the Grand Prize at the prestigious Venice Biennale in 1958—the first American to do so since the 1895 Biennale gave the award to another Japanist, James Whistler—it was left to news reporters to cover an event largely ignored by the New York art press.[234]

Questions of acceptability and masking are central to a short film made about Tobey at this time. Shot in 1951, it opens with a soundtrack of cacophonous voices making contradictory claims for the artist as "famous in New York" or "so Northwest!" over an image of Tobey, seen from the back, inspecting one of his white-writing abstractions at an exhibition. When he turns to face the camera, he is wearing a mask. This image fades to a grid that is revealed as the grille covering an air vent in the gallery (figure 3.33). This allusion to an antagonistic art world is followed by foot-age of Tobey walking from his house in Seattle to the Pike Place Market while a voice-over asks, "How does it feel to be tolerated? More or less. Who offends who?" Later footage runs backward so that Tobey seems to unroll a *kakemono* and un-paint a calligraphy, his brush apparently soaking up wide strokes of black ink. Depicting people and shadows seen through

FIGURE 3.33 Film still from *Mark Tobey: Artist* (1952).

FIGURE 3.34 Film still from *Mark Tobey: Artist* (1952).

grilles, wires, and railings, the film evokes the look of Tobey's art of this era, in which figures merge with networks of lines (figure 3.34). The filmmaker with whom Tobey created this self-portrait attentive to issues of marking and masking, a young teacher at the College of Puget Sound, was the Bostonian Robert Gardner, Isabella Stewart Gardner's grandson (through her adopted nephew).

Also in 1951, Tobey published "Reminiscence and Reverie," a memoir-manifesto that reasserts his disembodied identification with his calligraphic art. The essay's opening pages illustrate two paintings—the white-writing crowd scene *Electric Night* of 1944 and the abstract-calligraphic *Transit* of 1948—both structured around the central triangle associated with Western one-point perspective, juxtaposed to suggest a left-to-right progression from depicted image to private symbol system (figure 3.35). A self-portrait illustrating the end of the essay shows the artist disappearing into a flurry of marks (figure 3.36). Tobey's text begins by situating the writer

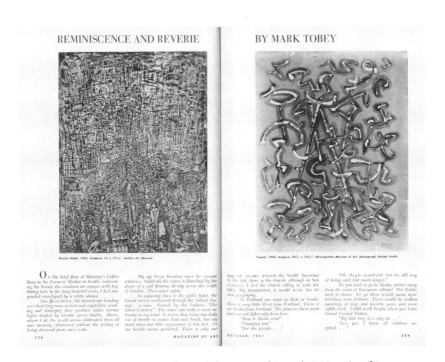

FIGURE 3.35 Opening pages of "Reminiscence and Reverie," *Magazine of* Art, October 1951. Images © 2015 Mark Tobey/Seattle Art Museum, Artists Rights Society (ARS), New York.

FIGURE 3.36 Mark Tobey, *Self-Portrait*, 1950. Pastel, as reproduced in "Reminiscence and Reverie," *Magazine of Art*, October 1951. © 2015 Mark Tobey/Seattle Art Museum, Artists Rights Society (ARS), New York.

in the Farmer's Market in Seattle, the windows are opaque with fog. Sitting here in the long deserted room, I feel suspended—enveloped in white silence.

Two floors below, the farmers are bending over their long rows of fruit and vegetables. . . . Above, where I sit, the world seems obliterated from all save memory; abstracted without the feeling of being divorced from one's roots.

Seattle—the fogged-in Market with its "opaque windows," in particular—becomes the site for a performance of memory that evades Western associations of comprehension with forms of vision and depiction grounded in the static subjectivity built into one-point perspective. Instead, the essay unfolds as a complex network of memories, including the physicality of Teng's teaching, the "mysticism that pervades" rural England, the crush of signs and people in Shanghai—all the landmarks of Tobey's Japanism. Tobey concludes with an appropriated memory quoted from "a Japanese" who "had a shop in San Francisco before the last war": " 'When I was very young,' he said, 'my mother would awaken me early in the morning and we would go into the garden to hear the morning-glories open.' "[235] The shift here to identification with a Japanese-American introduces a new and arguably long overdue dynamic to Japanism, one that fundamentally changes the relationship between Japanese aesthetics and outsider identity.

JAPANESE-AMERICAN:
AESTHETICS OF AFFILIATION IN THE POSTWAR ERA

When the dealer Tadamasa Hayashi in Paris, the connoisseur Okakura Kakuzo in Boston, and the Zen scholar D. T. Sukuzi in New York participated in the Japanism of those cities, they did so as Japanese, not Japanists. Identifying these experts with Japan, rather than with their adopted cities, Japanists ignored local communities of Japanese immigrants. While the postwar avant-garde perpetuated—even exaggerated—this pattern, other currents animated what historian Christina Klein calls the "middlebrow imagination." Klein argues that a fixation on the "heroic model" of "containment," articulated as the Truman Doctrine in 1947 and focused on the Union of Soviet Socialist Republics, overlooks a crucial complementary Cold War "ideology of integration" promulgated during the Eisenhower administration as a way of relating to Asia. The two strategies, Klein argues, were characterized by different "structures of feeling." In the language of the day, containment required constant "vigilance" and the willingness to deploy "counter-force" against intrusion. Integration implied openness and the cultivation of "empathy" though popular art forms: musicals like *The King and I*, which opened on Broadway in 1951 and became a Hollywood movie in 1956; plays like the 1953 *Teahouse of the August Moon*, adapted for the screen in 1956; novels and essays by James Michener; books on Zen; and John Hersey's best-selling *Hiroshima* of 1946, an account of the explosion of the atom bomb from the perspective of survivors. In an era when the American avant-garde enacted strategies of containment, vigorously suppressing outbreaks of Asianness while endorsing the worldwide export of its own output as evidence of American "freedom," middlebrow culture makers created "opportunities—real and symbolic—for their audiences to participate in the forging of . . . relationships with Asia."[236]

The initiatives Klein analyzes engaged all of non-Communist Asia, a geopolitical category conceived as both crucial and vulnerable following the "loss" of China in 1949. In this context, Americans took special interest in Japan, the former enemy occupied until 1952 and the United States's closest Asian ally thereafter. One concern was the status of Japanese-Americans, including the almost one hundred thousand wives servicemen brought home between 1947 and 1975, nearly doubling the population of Japanese-Americans in the continental United States. In the 1950s, an extensive social science literature—far larger than for any other category of war

brides—focused on these women, assessing their integration into middle-class American culture in such positive terms that, it has been argued, they became the paradigm for "model minority" discourses in the 1960s.[237] Postwar attitudes toward and among Japanese-Americans were especially complex in the Northwest, where many resettled from internment camps. Although official policy and unofficial enmity discouraged Japanese-Americans from recongregating in their old neighborhoods, many, particularly older people, did so. Many younger Japanese-Americans, however, acted on imperatives to integrate into the American middle class.[238]

Along with the films, plays, and books Klein discusses, art was central to initiatives to restore—or create—amity between the United States and Japan by fostering forms of personal connection across national boundaries. In Japan, classes the American Red Cross offered to Japanese women preparing to emigrate as servicemen's wives encouraged them to retain customs and manners that looked Japanese as a way of interesting their new neighbors. A 1955 article by James Michener in *Life* magazine told the story of one Japanese bride who returned with her husband to his native Chicago. Michener solicited his readers' sympathy for Sachiko Pfeiffer by emphasizing her desire for acceptance, which was finally realized in the middle-class suburb the couple moved to after being reviled by her mother-in-law and her neighbors in the working-class neighborhood where they first settled.[239] If such acceptance was inscribed as middle class, its signifiers were visual. The article juxtaposed a snapshot of the Pfeiffers on their wedding day—he in his military uniform, she in a kimono—with a photograph of the couple and their two children, all in Western civilian clothes, posing in their suburban home before a sleek wall unit decorated with Japanese pottery and woodwork, a print, a miniature theater mask, and a scabbard on a stand. This Western display of the East would, in another context, be Japanist. Here it signaled a new status: the modern middle-class American family of (in part) Japanese descent.

If Japanese objects displayed in middle-class houses signified new forms of assimilated ethnic identity for families and individuals, museum exhibitions of Japanese art marked milestones in Japanese-American political relations. One of General Douglas MacArthur's first initiatives as Supreme Commander for the Allied Powers in Japan was to endorse the organization of a major exhibition of Japanese art in the United States. Six years later in San Francisco, the *Art Treasures from Japan* exhibition at the de Young Museum coincided with the signing of the Treaty of Peace in 1951.[240] These dynamics were especially significant at the Seattle Art Museum, which acquired art from

Japanese collections dispersed after the war through the offices of Sherman Lee, the Seattle-born Advisor on Collections for the Arts and Monuments Division of the Occupation forces. After he took up a promised position as the museum's assistant director in 1948, Lee organized a triumphant exhibition of the museum's Japanese holdings in November 1949, which was seen by ten thousand visitors over the twenty days it was open, an "attendance per capita" he described as "extremely gratifying."[241]

While postwar geopolitics provoked new interest in art from Japan's past, other initiatives introduced Americans to Japanese artists who were adapting traditional media—woodblock prints, ceramics, and calligraphy—to modern ideas and styles. As the work of creative individuals seeking new and personal forms of expression, this art countered wartime propaganda produced by both sides that presented the Japanese as uniform in their submission to authority sanctioned by tradition.[242] This rapid shift in attitudes was registered when the *New York Times* welcomed eight exhibitions of "contemporary art by Orientals" opening in the same week in November 1954 with the headline "Oriental 'Invasion.'"[243] As the quantity of exhibitions devoted to contemporary Japanese artists working in traditional media suggests, a wide range of American institutions supported this form of cultural diplomacy. Foundations and universities sponsored travel in the United Sates by Japanese, including the innovative calligrapher Hasegawa Saburō. In 1954, he exhibited in New York, where he was hosted by Franz Kline and lectured at the Museum of Modern Art and at the Abstract Expressionists' club. (This was just before Greenberg declared Japanese influence anathema.) Hasegawa said of his trip, "In about one hundred days I was asked by about one hundred people about Zen and at times they told me about Zen. . . . When I go to eat and drink in Greenwich Village, inevitably somebody young or old, painter, musician, or poet, gets a hold of me and starts talking intently. How dearly they desire to learn from the Orient!"[244]

In this context, Tobey in the mid-1950s returned to the ink painting practices associated with Zen. Exemplifying the new attitudes toward Japanese-Americans, he collaborated in this exploration with Seattle artists George Tsutakawa and Paul Horiuchi under the auspices of Tamotsu Takizaki, a local antiques dealer knowledgeable about Japanese art, martial arts, and Zen. These men from prosperous Seattle families were part of a Japanese-American elite for whom the hyphen represented an optimistic fusion of cultures. The Seattle-born Tsutukawa was named for George Washington; Horiuchi took the name Paul in honor of Cézanne when he converted to Catholicism.

Both were schooled in Japan as children but took up Western modes of oil painting in Seattle before the war. After the war, they had the educational and social resources to re-establish themselves in Seattle, where the broad dynamics of Japanese–American relations described by Klein played out on a local level, making art central to ideologies of friendship. Takizaki and Horiuchi operated antique stores. Tsutakawa taught—first Japanese, then art and design—at the University of Washington. He and his bilingual wife—like her husband, American-born but schooled in Japan as a child—worked with the local State Department office, opening their spacious home for receptions to honor the many visiting Japanese artists and writers who entered or left the United States through Seattle.[245] By the mid-1950s, both Tsutukawa's sculptures and Horiuchi's collaged paintings were winning acclaim and sales as distinctive fusions of Asian and modernist aesthetics.

When these Japanese-American artists turned with Tobey to the ink-painting practices of *haboku* (drawing a line until the brush runs dry) and *hatsuboku* (ink splashing), they did so as modernists. Together they read Suzuki's essays and Eugen Herrigel's *Zen in the Art of Archery*. Tsutukawa's accounts of this era resist any imputation of native-informant status and emphasize collegiality. He recalls that "before the war . . . I used to watch Tobey work, in sumi (ink)," although at that time, he says, he was trying "hard to forget everything about Japan, and become Americanized." Now he and his wife often visited Tobey's studio, where "he would bring out his old collection of *sumi* paintings and landscapes and then also Zen paintings" and talk about "the brush strokes and the spaces and the balance and simplification. . . . He could just talk about it for hours." Tsutakawa concludes, "Mark Tobey really taught me the importance of my heritage and what to look for in Asian art. . . . Then I realized that when I was a child in Japan I was seeing these things all the time."[246]

For Tobey, this circle of Japanese-American artists replaced the now fractious and geographically dispersed Northwest School. He reported on January 1, 1956, "I start a New Year today after a Japanese binge lasting 'till 2 A.M. with sumi brush activities."[247] It was at this era that he said of Seattle, "Out here I often sit in a Japanese atmosphere which I feel deeply drawn to," and told an interviewer, "I live in Seattle because I don't like to get too far away from Eastern culture—especially Japanese."[248] Tobey's turn to *sumi* served other needs as well. Like Leach's "ethical pots," *sumi* painting, as explicated by Suzuki, enacted dissent from Western aesthetic hierarchies. "Grandeur of conception and strength of execution, to say nothing of its realism,

are the characteristics of an oil painting," Suzuki wrote, explaining that, "compared with this, a Sumiye sketch is poverty itself, poor in form, poor in contents, poor in execution, poor in material, yet we Oriental people feel the presence in it of a certain moving spirit." At the same time, the gestural dynamism of these *sumi* practices allowed Tobey to produce the larger works with bigger marks that his New York and Paris gallerists hoped could counter critical comparisons with Pollock that repeatedly turned on issues of scale.[249] Sumi painting, as Tobey and his Seattle collaborators studied it in the writings of Suzuki, also offered a model of selflessness that challenged Abstract Expressionism's emphasis on self-revelation. The *sumi* artist, Suzuki explained,

> just lets his arm, his fingers, his brush be guided . . . as if they were all mere instruments, together with his whole being, in the hands of somebody else who has temporarily taken possession of him. Or we may say that the brush by itself executes the work quite outside the artist, who just lets it move on without his conscious efforts.[250]

After a period of collaborative experimentation at *sumi* parties hosted by Tsutakawa, Tobey, working quickly over a matter of weeks between March and April 1957 and discarding as much as he preserved, created a body of one hundred or more large *sumi* paintings (figure 3.37).[251] He wrote to Willard in New York,

> I want an all black and white show. . . . I think I now have the cumulation [sic] of the Eastern influences brought to a focus and quite exciting. If not, I shall stop showing. Takizaki here says no one in Japan has done what I can and have done. I know Kline exists and Pollock, but I have another note.[252]

In the 1950s, when Tobey discussed his turn to *sumi*, he repeatedly cited Takizaki's commendation and referred to the works as "our paintings."[253] In 1957, addressing the national conference of the United States Commission for the United Nations Educational, Scientific and Cultural Organization (UNESCO), which took as its theme relations with Asia, Tobey concluded his talk by quoting "my old friend Takizaki" saying, "Let nature take over your work." Tobey explained how this imperative was "at first confusing but cleared to the idea—'Get out of the way,'" tying it to the Zen ideal of a peaceful or cleared mind from which "action proceeds."[254] In his talk, Tobey's

FIGURE 3.37 Mark Tobey, *Space Ritual No. 1*, 1957. Sumi ink on paper, 74.3 × 95.1 cm (29 1/4 × 37 7/16 in). Eugene Fuller Memorial Collection, 60.85, Seattle Art Museum. © 2015 Mark Tobey/Seattle Art Museum, Artists Rights Society (ARS), New York.

self-association with "Japanese tradition" through a Japanese-American authorized his rejection of prevailing avant-garde imperatives to self-expressive individualism. When Tobey's talk was published shortly after his Grand Prize win at the Venice Biennale (and in the same magazine for art teachers that had published Horst Janson's attack on the isolationist Regionalists a decade earlier), it was illustrated with examples of his *sumi* paintings. This UNESCO-endorsed celebration of Tobey's Japanism—as an aesthetic expression of empathy endorsed by friendship—epitomized Eisenhower-era ideals of Japanese-American affiliation.

DISORIENTING ECCENTRICITY:
JAPANISM AND/AS THE NEW NORMAL

The rhetorics of friendship that marked the high point of Tobey's worldwide reputation in the 1950s did not survive long into the next decade. By 1961, Tobey was looking back with ambivalence on his *sumi* work and its Zen associations. Answering an art historian's inquiry about the origins of his *sumi* paintings, Tobey wrote, "Offhand, I don't know really how I began this period," before ruminating over the failure inevitable "when one wants to state an inner condition" knowing that it will be misunderstood "as a symbol without reality." He speculated, "Perhaps painting that way I freed myself or thought I did. Perhaps I wanted to paint without too much thought," before concluding, "It's difficult to be faster than thought."[255] By this time Tobey had abandoned *sumi*—and Seattle. He moved to Europe in 1960, citing the better critical reception he found there. The *sumi* paintings had not won over New York critics. Harold Rosenberg, muddling Japan and China, assessed Tobey's " 'Sumi' thrown-ink paintings" as "less interesting than Pollocks and Klines in that they look Chinese" before echoing Greenberg's complaint that Tobey's art was not self-expressive: "The Tobey picture originates beyond the self of the artist."[256]

The doubts of New York critics notwithstanding, the Museum of Modern Art, attentive to the international reputation of American modernists, promised Tobey a retrospective in 1962. Tobey was positioning himself for this final effort to win over New York audiences when he offered the rambling answer to the query about his *sumi* paintings' origins. His remarks suggest a larger crisis in his relationship to the Orient. After speculating about the impossibility of self-transcendence through actions that precede thought, his written response starts over by challenging critical imperatives to explain deviance from adherence to a single, self-expressive style:

> How can I state in an understanding way why I did the Sumi paintings? Then too, why after white writing should I turn to black ink? Well the other side of the coin can be just as interesting, but to make myself simple I should remain a coin with only one side showing the imprint of man. It wouldn't be necessary to turn me over then—no need to wonder nor compare.[257]

Tobey's objection to being forced to reveal facets beyond the authoritative "imprint of man" invites analysis in relation to ideas about surface meanings

that concealed depths and the "double life" that structured understandings of homosexuality—and other forms of dissent from political and social consensus—in postwar America. Such connections are reinforced by Tobey's comment after Pehr Hallsten's death in 1965: "What was between us was so profound, but sometimes on the surface it looked like nothing."[258]

In 1961, having registered his doubts about self-transcendence and his objections to the art historian's search for motivations, Tobey finally responded to the question about *sumi* painting with a story that differs sharply from his earlier invocations of the East. Rather than associate East Asia with modern urbanism as he had in the 1940s, or cite his studies in the Zen temple or invoke the community of Japanese-American artists with whom he worked in Seattle as he had in the 1950s, Tobey said this:

> I was in Cairo when they were unearthing the 'hidden' side of the Sphinx. I sat down in the hot sand—an old Egyptian suddenly appeared before me with all the materials for a hot Turkish coffee. Boys in white gowns were rising like specters from the depths around the Sphinx with bales of sand in their hands. Two musicians were keeping up their spirits. A huge Egyptian stood by with a black whip curled in his hand. He looked like Simon Legree. The mystery of the Sphinx was being revealed. All was being exposed. But was it? Today it looks out upon the world, a tired image one sees too much; the mystery is no longer there. The head rising above the sand rises no more. Perhaps now it is nearer to a surrealist's dream.[259]

This short passage deploys a remarkable number of clichés, not of Japanism, but of older conventions of Orientalism. In an Egypt imagined as a mysterious land overseen by sphinxes, boys rise specter-like from the earth and men mysteriously appear serving coffee. There is background music and a threat of violence filtered through the West's racial guilty conscience figured in the reference to Simon Legree. The moral of this fable is the Occident's supersession of the Orient as the mystery of the sphinx is supplanted by an avantgarde associated with Surrealism.

Tobey's floundering indicates the exhaustion of bachelor Japanism. If Kōjin Karatani is right that old-fashioned Orientalism lingered on in European intellectual culture through the turn of the millennium, decades after it was displaced from an America that had learned "lessons . . . from the 1960s experiences of the Civil Rights and the antiwar movements,"[260] we might see someone like Tobey in some place like Seattle as among the first Euro-Americans

to encounter the phenomenon of normative middle-class American culture embodied by nonwhites (and perhaps assess his move to Europe as a failure to accept that dynamic and retreat to more familiar ground). The logical trajectory of the Eisenhower-era rhetorics of neighborly friendship underwritten by empathy and aesthetic appreciation was Asian assimilation into the American middle class. By the late 1950s, Seattle newspapers regularly cited men like Takizaki, Horiuchi, and Tsutakawa among the city's leading citizens, and the two artists in that triumvirate were awarded major commissions that bespoke their cosmopolitan aesthetics: Horiuchi worked with Venetian glassmakers to create a monumental abstract *Seattle Mural* for the World's Fair in that city in 1962; Tsutakawa became well known for the fountains he created for public spaces across North America.[261] These artists' prominence, with commissions centered in sites of middle-class uplift such as universities and covered more often by the news media than the art press, was not avant-garde. Both men embraced a public image as middle-class successes, acquiring substantial houses in prosperous Seattle neighborhoods, an especially significant accomplishment for the Japan-born Horiuchi, who had to wait for voters to rescind the Asian Land Law in 1966 to own property in his own name.[262] The heteronormativity of both Tsutukawa and Horiuchi was part of their public image. Both had attractive, sophisticated wives who contributed to their husbands' self-presentations as middle-class professionals (figures 3.38 and 3.39). A century after Whitman celebrated the arrival of "the swart-cheek'd two-sworded envoys" from Japan in Manhattan, the normalization of aesthetics and identities labeled "Japanese-American" brought an end to Japanism's usefulness as an alternative to normative modes of masculinity in the West.

In this context, Tobey's art in the 1960s moved away from allusions to Japan in particular or East Asia in general, as he was celebrated in Europe as the founder of an *"École du Pacifique"* that was vaguely European, American, and universal all at once. His Parisian gallerist, ranking Tobey's art as "more profound and rich than the bigger, more spectacular paintings of Pollock," told the London-based *Studio* magazine,

We consider Tobey to be the most European painter among the American artists. It is he who expresses universal poetry of the use of language which belongs specifically to his own country. As Tobey himself has said, "The more I see of the Art of the East, the more I belong to the West." And that is why we, here in France, look on him as the American Master of the Pacific School.[263]

FIGURE 3.38 Paul and Bernadette Horiuchi at the dedication of the Seattle Mural, Seattle World's Fair, 1962. Photograph by Elmer Ogawa.

Against the incoherence of such geographical identifications, more thoughtful approaches to Tobey's late work reassessed formal qualities that had earlier been understood as manifestations of the East in the West. "Where is the center?" Tobey quoted a viewer asking about one of his paintings of this period. He answered, "My paintings belong to the type that do not allow the viewer to rest on anything. He is bounced off it or he has to keep moving with it."[264] Here Tobey asserts perpetual disorientation, conceived as shared peripateticism, as a mode of engagement between artwork and viewer. The catalog for an exhibition of monotypes (figure 3.40) at Tobey's Paris gallery in 1965 carries a short essay by the critic Annette Michelson that, also responding to the viewer who asked "Where is the center?" makes an elegant case for Tobey's art as "ex-centric *par essence*": "The notion of center, the place of privilege, is subverted by a radical revision of the notion of form and of its references or correlatives in reality," Michelson explains. About the shift of media and method to the monotype, she quotes Tobey: "When man migrates, the forms he has created pursue him; they too migrate, changing their style in their new surroundings."

FIGURE 3.39 George and Ayame Tsutakawa flanking artist Thomas Hart Benton at the dedication of the Fountain of Good Life, Kansas City, 1964.

Pertinent to the monotypes, Tobey's remark more directly addresses the changing contexts in which his art was created and understood. Tobey's career, Michelson suggests, sustained an eccentricity associated with outsiderness. Comparing the monotypes to Tobey's "famous 'writing,'" she locates "the artist's skill and achievement . . . in the sublimation, the conversion of

FIGURE 3.40 Mark Tobey, untitled, 1965. Monotype. Private collection. © 2015 Mark Tobey/Seattle Art Museum, Artists Rights Society (ARS), New York.

a maximum contingency, into an absolute necessity." The title of Michelson's essay is "E pluribus unum." An allusion to the singleness of the monotype, this phrase, of course, also recalls Tobey's paradigmatic 1942 market picture, invoking his claims for both Seattle and his own art as sites where antipodes unite. There is a continuity Michelson recognizes, between such claims and Tobey's art, in which images of people and places, "as of particles, intra-molecular, or of creatures—jostle each other in an easy, gregarious co-existence."[265] By this point, however, this Whitmanesque ideal had been dis-Oriented: it was no longer associated with Japan. The end of Tobey's long career also marked the end of bachelor Japanism.

CONCLUSION

ON THE END OF JAPANISM

By 1965, the very visible realities of imperialism, immigration, World War, and Cold War diminished Japanism's viability as a mode of what, in the introduction, I call an "unlearning" of the West. Of course, this did not happen all at once or completely.[1] As with the nineteenth-century shift from the kinds of stylistically conventional depictions of Japan exemplified by Mortimer Menpes's paintings to Japanist subversions of Western representational conventions, new and old paradigms can coexist, especially where there is a taste for the old-fashioned. But change has come, and that cannot be regretted. Notwithstanding the brilliance of Wilde or Barthes, the appeal of the houses and museums that constituted spaces of Japanism in the West, the sublimations enabled by Western practices of art or spirituality that drew from Zen Buddhism, or the opportunities created for individual Japanese like Okakura by dynamics termed *Occidentalism* or *reverse Orientalism*, Japan is not best understood or appreciated simply as a solvent to Western social or aesthetic certainties. This book's demystification of Japanism is intended to contribute to

the broader scholarly project Rebecca Walkowitz describes as "the un-erasing of how primitivist discourse is produced."[2]

At the same time, however, I want to resist rhetorics that seem to correct, as in set right, Western misunderstandings of Japan—as if Japan in all its multitudinous, modernizing ways (ways profoundly affected by Japanism) can now be comprehensively or authentically represented by some other discourse. Even more strenuously, I want to challenge those who would retroactively correct, as in scold, Japanists who, in the century following the "opening" of Japan, used this final act in the global drama of encountering new civilizations to imagine Japan as a way of articulating dissent from structures of normativity in their home cultures. Although often articulated in the name of diversity, such critiques actually buttress stultifying imperatives to personify or conform to cultural norms reified as "authentic" and ultimately at odds with diversifying dynamics in the lives of individuals or on the scale of larger social groups.

My goal in this book, therefore, has been to occupy a place between two all too common positions: on one hand, *reductio-ad-absurdum* applications of Edward Said's critique of Orientalism that seek to protect the East (already a Western construction) from any form of (mis-)understanding in or by the West; and, on the other hand, the self-serving naïveté of catalogs of Japanese "influence" that celebrate quotations from a purportedly timeless aesthetic as indices of the creativity of Western artists. Where the former asserts a dubious moral high ground from which to censure creative engagement by the West with the East, the latter blinds us to, in Edmund de Waal's words, "our own understanding of the creation of our own markers of authentic ethnicity" both at home and abroad.[3] These positions grow increasingly untenable in a world where global media and mobility have—or should have—undercut easy essentialisms about identity and authenticity in relation to national or regional cultures that are themselves modern, hybrid, and contested. We know—even if we do not always act like we know—that everyone is always in the process of creating identity through mediations of text and image on screens large and small as well as through face-to-face encounters. But attention to these dynamics is too often performed as self-righteous reproof or guilty admission, foreclosing the acknowledgement, let alone the analysis, of the pleasures that attend intercultural exchange. This book has attempted to take these issues both seriously and pleasurably, documenting, analyzing, and, yes, enjoying some of the various ways that ideas of Japan were used to create and sustain structures of dissent in the West.

That variety is crucial. The modes and meanings of Japanism are multitudinous and contested. My case-study structure was intended to signal this diversity, and, even within each case-study city, I tried to tease out multiple ways that Japan was understood and represented. Amid competing interests in prints and pots, Buddhist ritual and temple architecture, geishas and samurai, projects to legitimize an authentic core of Japanism are as ideologically loaded as claims to define an authentic essence of Japan. The parade of sumo bodies admired by Hugues Krafft and Isabella Stewart Gardner; the baroque simplicity of the tea ceremonies admired by Edward Morse and carried out by Okakura Kakuzo; the ostentatious poverty of sumi painting as explicated by Suzuki's essays on Zen or of raku as performed for busloads of tourists at Leach's pottery; the ersatz temples in Boston museums; the Goncourt brothers' massive, monstrous bronze dragon vase and the house that went with it—none of these is more (or less) Japanist than another. From a rich field of Japanist practices, this book has juxtaposed issues, individuals, and objects central to authoritative canons of Japanese and Japanist visual culture with those often dismissed as unworthy of examination and appreciation. This inclusive approach, I hope, draws attention both to overlooked histories and to the criteria of inclusion and exclusion built into common scholarly terminology—words like influence, avant-garde, and even art itself—and, thus, into our sense of what counts, now and in the past, as valuable or significant.

My interest in the varieties of desire and pleasure that complicate binary identifications of East and West brings the values of queer theory to this study of Japanism. And although I have been careful to avoid anachronistically categorizing my bachelors into current forms of sexual identity, the phenomenon of bachelor Japanism has clearly had a queering effect on normative ideas about gender roles and family relationships. Japanism did more than simply dress up what medical experts labeled homosexuality in the guise of Japanese-inflected exoticism. Men cast out of familial norms in the West were able to use aesthetics and ideologies associated with Japan to affirm their otherness in ways that created bonds with one another and staked claims to scholarly expertise, aesthetic sensitivity, and spiritual insight that challenged the hierarchies that excluded them. The inflection of Western ideas of Japan by attitudes of alienation is one part of that story; the erosion of those sexual and gendered hierarchies is another.

By way of conclusion, therefore, I will return briefly to claims advanced in the introduction concerning the implications of the phenomenon I call

bachelor Japanism, in which the idea of Japan as antipode queers fundamental Western hierarchies of truth, propriety, and representation. If my arguments succeed in inserting Japanism into accounts of the construction of minority sexual identity in the West—something we might call queer history—it will be significant that the exhaustion of bachelor Japanism in the postwar era, as Japanese-Americans used the aesthetic signifiers of Japaneseness in a bid for acceptance into middle-class norms, coincided with the development of ideas of "gay" identity as a form of ethnicity with its own networks and neighborhoods analogous to those associated with diasporic ethnic groups. A substantial scholarly literature (to which I have contributed) has looked at the revivification of forms of urban ethnic-minority culture by gay neighborhoods with their own distinctive aesthetics and institutions, a phenomenon that was recognizable by the early 1960s.[4] This modeling of sexual identity on ethnicity was—and continues to be—so compelling and ubiquitous that it has come seem natural or inevitable. The result is that the historical roots that enabled the sudden efflorescence of this idea of sexual identity as ethnicity in the second half of the twentieth century have gone largely unexamined. This book can be read as an attempt to sketch that story in relation to Japanism. My conclusion, then, is less a summing up than an *envoi*—a sending out of my readers with the hope that these case studies in bachelor Japanism will inspire further exploration of a complex and contested history that is still in the making.

NOTES

INTRODUCTION

1. The term *japonisme* spread quickly from its first use in 1872 by both Jules Claretie in *L'Art français en 1872* (cited in Colta Feller Ives, *The Great Wave: The Influence of Japanese Woodcuts on French Prints* [New York: Metropolitan Museum of Art, 1974], 8) and, more famously, by Philippe Burty, who made it the title of a series of articles on Japanese art and culture. Burty bragged, "If I did not give the first impulse to the study [of 'the art and genius of Japan'], I at least originated the word for it," as he tried to bring it into English with the spelling "Japonism" ("Japonism," *The Academy*, August 7, 1875, 150). *Japonisme* remains commonly used in art history to signify an enthusiasm for Japan among artists and collectors, often distinguished from both what is claimed to be the superficial *japonaiserie* of decorators and the scholarly work of expert Japanists. But these are untenable boundaries, and *japonisme*, dropped into English prose, has stronger

connotations of Frenchness than of interest in Japan. I, therefore, use "Japanism" in Anglophone contexts, reserving *japonisme* for French contexts.

2. Oscar Wilde, "Intentions," in *The Complete Works of Oscar Wilde*, ed. Robert Ross, vol. 7 (Boston: Wyman-Fogg, n.d.), 47–48.

3. Roland Barthes, *Empire of Signs*, trans. Richard Howard (1970; repr., New York: Hill and Wang, 1982), 3–4, 6.

4. Barthes, *Image, Music, Text*, trans. Stephen Heath (New York: Hill and Wang, 1977), 40. This essay dates to 1964.

5. Barthes, *The Grain of the Voice: Interviews 1962–1980*, trans. Linda Coverdale (1981; repr., New York: Hill and Wang, 1985), 84.

6. Jan Walsh Hokenson, *Japan, France, and East–West Aesthetics* (Madison, NJ: Fairleigh Dickinson University Press, 2004), 350.

7. Barthes, *Empire of Signs*, 9.

8. Ibid., 70.

9. See, for example, Susan Sontag, "On Roland Barthes," in Roland Barthes, *A Barthes Reader*, ed. Susan Sontag (New York: Farrar, Straus and Giroux, 1982), vii–xxxvii.

10. For an exceptionally clear explication of *queer*, see Fabio Cleto, introduction to *Camp: Queer Aesthetics and the Performing Subject*, ed. Fabio Cleto (Ann Arbor: University of Michigan Press, 1999), 11–16.

11. For an overview, see Naomi Zack, *Bachelors of Science: Seventeenth Century Identity, Then and Now* (Philadelphia: Temple University Press, 1996). Arguing that "bachelors were a troubling presence within and beyond the already troubled world of the bourgeois family home" (3), Katherine V. Snyder, in *Bachelors, Manhood, and the Novel, 1850–1925* (Cambridge: Cambridge University Press, 1999), traces the popular "fascination" with the apparently contradictory characteristics of bachelordom in Anglophone fiction. Howard P. Chudacoff's *The Age of the Bachelor: Creating an American Subculture* (Princeton, NJ: Princeton University Press, 1999) identifies "the period between 1880 and 1930" as "the peak years of bachelor subculture in America," arguing, "these men became associated with a variety of images, almost all of them negative" (3). Jean Borie's *Le célibataire français* (Paris: Le Sagittaire, 1976) describes the birth of the "bachelor" as an ambiguously stigmatized, powerfully disruptive identity in nineteenth-century France.

12. On this chronology, see my *Art and Homosexuality: A History of Ideas* (New York: Oxford University Press, 2011), 149–52.

13. "The Era of Mandatory Marriage, 1850–1960" is a section title in John Gillis's study of the history of marriage in Britain, *For Better, For Worse: British Marriages, 1600 to the Present* (Oxford: Oxford University Press, 1985).

14. Jonathan Dollimore, *Sexual Dissidence: Augustine to Wilde, Freud to Foucault* (Oxford: Oxford University Press, 1991), 339, 330.

15. Dollimore, *Sexual Dissidence*, 334; Michael Warner, "Pleasures and Dangers of Shame," in *Gay Shame*, ed. David Halperin and Valerie Traub (Chicago: University of Chicago Press, 2009), 287.

16. See, for example, Donald Preziosi, "The Art of Art History," in *The Art of Art History: A Critical Anthology*, ed. Donald Preziosi (Oxford: Oxford University Press, 1998), which draws on Carol Duncan, *Civilizing Rituals: Inside Public Art Museums* (New York: Routledge, 1995) and Timothy Mitchell, "Orientalism and the Exhibitionary Order," in *Colonialism and Culture*, ed. Nicholas B. Dirks (Ann Arbor: University of Michigan Press, 1992), 289–317.

17. Thomas O. Beebee, *The Ideology of Genre: A Comparative Study of Generic Instability* (University Park: Pennsylvania State University Press, 1994), 115–16, quoting Linda Nochlin, "The Imaginary Orient," *Art in America* 71 (May 1983), 123.

18. Beebee, *Ideology of Genre*, 115–16.

19. Earl Miner, *The Japanese Tradition in British and American Literature* (Princeton, NJ: Princeton University Press, 1958), 25.

20. George T. Ferris, *Gems of the Centennial Exhibition: Consisting of Illustrated Descriptions of Objects of an Artistic Character, in the Exhibits of the United States, Great Britain, France, Spain, Italy, Germany, Belgium, Norway, Sweden, Denmark, Hungary, Russia, Japan, China, Egypt, Turkey, India, etc., etc., at the Philadelphia International Exhibition of 1876* (New York: D. Appleton, 1877), 78–81.

21. Oscar Wilde, quoted in "Oscar Wilde's Lecture," *New York Times*, January 10, 1882. A revised version of Wilde's speech can be found at http://www.online-literature.com/wilde/2310/.

22. Hokenson, *Japan, France, and East–West Aesthetics*, 22; see also Michel Melot, "Questions au japonisme," in *Japonisme in Art: An International Symposium* (Tokyo: Kodansha, 1980), 239–60.

23. Rémi Labrusse perceives a similar shift in the late nineteenth century from an old-fashioned "Orientalism" to a new "Islamophilia," in which the visual logics of Near Eastern art were applied to "a reinvention of European consciousness, located at the junction of social life and inner life, through the achievement of a new balance in decorative form" ("Islamophilia? Europe in the Conquest of the Arts of Islam," *Arts and Societies*, October 11, 2007). This dynamic attached itself more powerfully to Japan as the new site of the imagined East, however. Late nineteenth-century critics were unanimous that Japanese design offered models to overcome stultified Western conventions, and many drew the conclusion—not drawn about the Near East—that aspects of Japanese lifestyles associated with

those designs challenged Western certainties of truth and propriety. As Tomoko Nakashima points out, many of the basic features of primitivism that scholars associate with the appropriation of African art by European modernists in the early twentieth century earlier characterized Western uses of Japanese art ("Defining 'Japanese Art' in America," *Japanese Journal of American Studies* 17 (2006): 247, 254).

24. Judith Snodgrass uses "Occidentalism" to analyze how Japanese experts used Orientalist constructions of Buddhism to present doctrines constructed in relation to Western religious paradigms as authentically Japanese. Snodgrass notes that this history reveals "serious limitations" in Edward Said's construction of "Orientalism," "considering the formation of Orientalist knowledge as an engagement restores agency to Asia, and some of the complexity of the Foucauldian origins of Said's insights to the process. It makes the colonial domination a factor in the process rather than its determining mode" (*Presenting Japanese Buddhism to the West: Orientalism, Occidentalism, and the Columbian Exposition* [Chapel Hill: University of North Carolina Press, 2003], 11–12). "Reverse Orientalism" was first defined by R. A. Miller in *Japan's Modern Myth: The Language and Beyond* (New York: Weatherhill, 1982) to describe "the ideology of sociolinguistic exclusiveness." Miller explains: "It is rather as if the Japanese were, in this instance at least, determined to do it to themselves and to their own culture before others can do it for and to them—the 'doing' in both instances being the creation of an image in terms of which other cultures or traditions will consist of something radically different—what Said calls establishing the Other" (209). Although Miller's focus is on theories of Japanese language after World War II, he traces manifestations of "reverse Orientalism" to "the period of the Meiji Restoration when the spectacle of a prostrate China being picked to bits by the predatory Western powers was understandably a matter of concern" (210). His paradoxical conclusion is that this constructed authenticity is authentically Japanese: "something truly unique, a genuine innovation of Japanese society and culture" (211). Yuko Kikuchi uses "Reverse Orientalism" to analyze the presentation of Japanese crafts in the West after World War II (*Japanese Modernization and Mingei Theory* [London: Routledge Curzon, 2004], 197).

25. Ernest F. Fenollosa, *Epochs of Chinese and Japanese Art: An Outline History of East Asiatic Design*, 2nd ed. (New York: Frederick A. Stokes, 1921), 50.

26. Denman Ross, diary entry dated October 26, 1908, Denman Ross Diaries (unpublished), Harvard Depository.

27. Fenollosa, *Epochs of Chinese and Japanese Art*, 50. The Japanese government's role in interesting Fenellosa in Japanese art is noted in Timothy Clark, *Ukiyo-e Paintings in the British Museum* (London: British Museum Press, 1992), 33.

28. Cyprian A. G. Bridge, "The Mediterranean of Japan," *Fortnightly Review* 24 (1875): 208–9, and "The City of Kiyôto," *Fraser's Magazine* 17 (1878): 59–60, both in Toshio Yokoyama, *Japan in the Victorian Mind: A Study of Stereotyped Images of a Nation 1850–80* (London: Macmillan, 1987), 160–61.

29. Émile Guimet, *Promenades japonaises*, vol. 1 (Paris: G. Charpentier, 1878), 12–13: "Un groupe de jeunes Romains s'avance . . . rien d'asiatique dans leur physionomie; ce sont bien les fils de Brutus que nous voyons venir à nous. Ce groupe échappé des oeuvres de Cicéron. . . . sont les domestiques de nos Japonais. Pourquoi les maîtres sont-ils si laids et les serviteurs si beaux?"

30. James Abbott McNeill Whistler, *The Gentle Art of Making Enemies* (London: n.p., 1890), 159.

31. Mortimer Menpes, "A Personal View of Japanese Art," *Magazine of Art* 11 (1888): 199 (also in Menpes, *Japan: A Record in Colour by Mortimer Menpes* [London: Charles Black, 1901], 31).

32. Wilde, "Intentions," *Complete Works*, vol. 7, 47. For more examples of early twentieth-century comparisons of Japan to Classical Greece and Rome, see P. L. Pham, "On the Edge of the Orient: English Representations of Japan, Circa 1895–1910," *Japanese Studies* 19, no. 2 (1999): 167.

33. Sherard Osborn, "A Cruise in Japanese Waters (Part I)," *Blackwood's Edinburgh Magazine* 84 (1858): 635–46, in Yokoyama, *Japan in the Victorian Mind*, 25, 52. The historian Harold Robert Isaacs, in *Scratches on Our Minds: American Images of China and India* (New York: J. Day, 1958) calls the years 1840 to 1905 the "Age of Contempt" in American attitudes toward China; the phrase describes Europeans, too.

34. G. Lowes Dickinson, *The Autobiography of G. Lowes Dickinson*, ed. Dennis Proctor (London: Duckworth, 1973), 185.

35. Félix Régamey, *Japan in Art and Industry*, trans. M. French-Sheldon and Eli Lemon Sheldon (New York: G. P. Putnam, 1893), 4–5.

36. Edmond de Goncourt, *Journal: Mémoires de la vie littéraire*, ed. Robert Ricatte, June 17, 1875, vol. 2 (Paris: Fasquelle et Flammarion, 1956), 651: "La conversation... a été un tableau désolant fait par Cernuschi du Céleste Empire. Il a longuement parlé de la putréfaction des villes, de l'aspect cimitiéreux des campagnes, de la tristesse morne et de l'ennui désolé qui se dégagent de tout le pays. La Chine, selon lui, pue la merde et la mort." Such sentiments are echoed by other *japonistes*, as discussed by Christopher Bush ("Ideographies: Figures of Chinese Writing in Modern Western Aesthetics" [Ph.D. dissertation, University of California, Los Angeles, 2000], 67–72).

37. On assertions of links between the Japanese and Western races, see Rotem Kowner, "Lighter than Yellow, But Not Enough: Western Discourses of the

Japanese 'Race,' 1854–1904," *The Historical Journal* 43, no. 1 (2000): 114–19. On British sources, see Yokoyama, *Japan in the Victorian Mind*, 3, 15, 24–25, 50–51. The American missionary William Elliot Griffis also claimed that the Japanese had "Aryan blood in their veins" and were therefore "desirable citizens" of the United States (Robert A. Rosenstone, *Mirror in the Shrine: American Encounters with Meiji Japan* [Cambridge, MA: Harvard University Press, 1988], 251).

38. Marquis Alfred de Moges, *Recollections of Baron Gros's Embassy to China and Japan in 1857–58* (London: R. Griffin, 1860), in Kowner, "Lighter than Yellow," 115.

39. Osborn, "A Cruise in Japanese Waters," in Yokoyama, *Japan in the Victorian Mind*, 24.

40. "Japan and the Japanese," *Edinburgh Review* 113 (January 1861), 46.

41. Algernon B. Mitford [a.k.a. Lord Redesdale], *Tales of Old Japan* (1871; repr., London: Macmillan, 1908), 49. On Mitford, see Yokoyama, *Japan in the Victorian Mind*, 91, 95–96, 104–8, 173; Linda G. Zatlin, *Beardsley, Japonisme, and the Perversion of the Victorian Ideal* (Cambridge: Cambridge University Press, 1997), 7; and Edmond de Goncourt, *La maison d'un artiste*, vol. 1 (Paris: Bibliothèque Charpentier, 1881), 209.

42. Lafcadio Hearn, *Kokoro: Hints and Echoes of Japanese Inner Life* (Boston: Houghton Mifflin, 1896), 202–3.

43. Dickinson's 1913 reports from Asia are reprinted in his *Appearances* (London: J. M. Dent: 1914), 105–16.

44. Dickinson, *Autobiography*, 186. Dickinson's professed surprise at the alienation from his home culture effected by his Asian travels in 1913 seems exaggerated given that his 1901 *Letters of John Chinaman* (London: R. B. Johnson, 1901) critiqued Western values in the voice of a fictional Chinese ambassador. But Dickinson's sense, upon actually visiting East Asia, that Japan was "somehow . . . like England in the way of antiquity and homeliness and peace" heightened his estrangement from modern England (*Autobiography*, 186).

45. Bernard Leach, "A Letter to England," *Kogei* 53 (1935): 38.

46. Edward Sylvester Morse, quoted in Money Hickman and Peter Fetchko, eds., *Japan Day by Day: An Exhibition Honoring Edward Sylvester Morse and Commemorating the Hundredth Anniversary of His Arrival in Japan in 1877* (Salem, MA: Peabody Museum of Salem, 1977), 34.

47. Edward Sylvester Morse, *Japan Day by Day: 1877, 1878–9, 1882–83*, vol. 1 (Boston: Houghton Mifflin, 1917), 370, 229.

48. Rutherford. Alcock. *The Capital of the Tycoon: A Narrative of a Three Years' Residence in Japan*, vol. 1 (London: Longman, 1863), 414. The repetition of these examples by journalists is noted in Yokoyama, *Japan in the Victorian Mind*, 78.

49. Morse, *Japan Day by Day*, vol. 1, 25.

50. Basil Hall Chamberlain, *Things Japanese*, 5th ed. (London: John Murray, 1905), 481–82.

51. Yokoyama, *Japan in the Victorian Mind*, 162.

52. Henry Adams to John Hay, August 22, 1886, in *The Letters of Henry Adams*, eds. J. C. Levenson, Ernest Samuels, Charles Vandersee, and Viola Hopkins Winner, August 22, 1886, vol. 3 (Cambridge, MA: Harvard University Press, 1982), 33–34.

53. John La Farge, *An Artist's Letters from Japan* (New York: Century, 1897), 45, 190.

54. Edward Carpenter, *Intermediate Types Among Primitive Folk: A Study in Social Evolution* (London: G. Allen, 1914), 33, 137. On Carpenter's sources, see John W. de Gruchy, *Orienting Arthur Waley: Japonisme, Orientalism, and the Creation of Japanese Literature in English* (Honolulu: University of Hawai'i Press, 2003), 109.

55. G. Lowes Dickinson, *An Essay on the Civilisations of India, China & Japan* (Garden City, NY: Doubleday, 1915), 64.

56. Hugues Krafft, *Souvenirs de notre tour du monde* (Paris: Hachette, 1885), 338: "nous nous sommes liés de grande amitié. Presque aussi Parisien que les vrais enfants de Lutèce, il a puisé à Paris l'amour du bibelot, qui fait de lui un japonisant de première force et un de ceux que ce ravissant pays retiendra longtemps encore." "Mais sa passion pour le Japon l'a emporté, et il s'est décidé à y rester un temps indéfini. . . il s'initie de plus en plus aux moeurs et aux traditions japonaises; il se plaît à découvrir des choses dont les voyageurs ordinaires ne se doutent même pas, et à comprendre de mieux en mieux des délicatesses que maints autres foulent aux pieds, aussi inconsciemment ou avec le même parti pris que ces Japonais avides de progrès, qui reviennent d'Europe et d'Amérique imbus d'idées trop subversives."

57. Edmund de Waal, "Homo Orientalis: Bernard Leach and the Image of the Japanese Craftsman," *Journal of Design History* 10, no. 4 (1997): 355.

58. Kerr's essays are translated and collected in English as *Lost Japan* (Melbourne: Lonely Planet, 1996).

59. Edward W. Said, *Orientalism* (New York: Random House, 1978), 1. For critiques of Said, see John M. MacKenzie, *Orientalism: History, Theory and the Arts* (Manchester: Manchester University Press, 1995), which, although not addressing sexuality, cites Said's indifference to the visual arts, popular culture, and scholarship in gender as contributing to the "essentialising" (5) tendencies in his "binary oppositions" (xiii) of East versus West. MacKenzie regrets Said's missed opportunity to follow up on his own observation that "the East 'has helped to define Europe'" as "'a sort of surrogate and even underground self'" "that can modify and therefore even challenge the West" (10, quoting Said, 1). Lisa Lowe's *Critical Terrains: French and British Orientalisms* (Ithaca, NY: Cornell University Press, 1991)

also challenges Said's "assumption that orientalism *monolithically* constructs the Orient as the Other of the Occident" by attending to *"concerns with difference"* in relation to culture, class, and gender among Occidental writers (ix–x).

60. Hokenson, *Japan, France, and East–West Aesthetics*, 25. Alexandra Munroe argues that Said's "focus on the Middle East . . . is only partially relevant to South Asia and in one important regard fundamentally inapplicable to East Asia and Southeast Asia, where colonial and imperial domination was most brutally exercised by Japan, not the West" (*The Third Mind: American Artists Contemplate Asia, 1860–1989* [New York: Guggenheim Museum Publications, 2009], 26). For an early critique of Said's relevance to Japan, see Pham, "On the Edge of the Orient." More recently, Gayatri Spivak excludes Japan from "Asia," asserting that, "Japan had seemed to break away from Asia at a certain point" (*Other Asias* [Oxford: Blackwell, 2008], 10). Spivak does not develop the provocative implications of her remark that Asia has "two absurdities at its two ends: Israel and Japan" (11).

61. Andrew Thacker, "Mad After Foreign Notions: Ezra Pound, Imagism and the geography of the Orient," in *Geographies of Modernism: Literature, Cultures, Spaces*, eds. Peter Brooker and Andrew Thacker (London: Routledge, 2005), 41.

62. Junchiro Tanizaki, *Some Prefer Nettles*, trans. Edward S. Seidensticker (1928; repr., New York: Knopf, 1955), 75, 93–95.

63. "Japanicity" alludes to Barthes's discussion of "Italianicity" in "Rhetoric of the Image," in *Image, Music, Text*, 32–51.

64. John W. de Gruchy, *Orienting Arthur Waley: Japonisme, Orientalism, and the Creation of Japanese Literature in English* (Honolulu: University of Hawai'i Press, 2003), 122.

65. Tanizaki, *Some Prefer Nettles*, 7.

66. Christopher Benfey, *The Great Wave: Gilded Age Misfits, Japanese Eccentrics and the Opening of Old Japan* (New York: Random House, 2003), 253.

67. Krafft, *Souvenirs*, 325–27: "des milliers de spectateurs mâles, à l'exclusion de toutes femmes," "très corpulents, ou bien des hommes vraiment superbes, bâtis comme des Hercules," "parades de torses."

68. Ibid., 287–90, 331–32: "Quelle que puisse être leur conduite privée . . . conservent et perpétuent les mélodies et les chants du pays." "Malheur à nous cependant si nous ne restions pas envers ces demoiselles dans les limites de la plus stricte politesse." Krafft refers to visiting the Yoshiwara in a letter to his brother (Suzanne Esmein, "Hugues Krafft [1853–1935]. Voyageur, photographie, et collectionneur," *L'Ethnographie* 86, no. 108 [1990]: 153.)

69. Edward Morse comments repeatedly on the nakedness of his runners and other Japanese workmen. Morse notes Bigelow's delight in travel by a *kago* carried by men and in demonstrations of Japanese fencing and jiu-jitsu wrestling organized

at their shared house within days of their arrival in Japan (*Japan Day by Day*, vol. 2, 217–18, 240–43). John La Farge records discussions with Bigelow about "the Japanese indifference to nudity" occasioned by their near-naked runners (*An Artist's Letters from Japan*, 35).

70. Krafft, *Souvenirs*, 358:

> Douce, patiente, élevée dans l'idée d'une affectueuse soumission, elle consacre au bien-être de son seigneur et maître le but de son existence; toujours gaie et souriante, d'un dévouement naturel développé encore par l'éducation, elle exerce une influence, faible en apparence, mais qui pénètre cependant si loin dans tous les détails de la vie, qu'elle constitue sans aucun doute un des principaux aimants de ce pays occultement dominé par elle.
>
> Puissent les femmes de Daï-Nihon, en gardiennes fidèles des foyers, contribuer longtemps encore, par le culte des bonnes traditions du passé, au développement d'une vertu que leurs fils risquent peut-être de désapprendre: l'orgueil légitime de la 'nationalité'!

71. Ian Buruma, *The Missionary and the Libertine: Love and War in East and West* (London: Faber and Faber, 1996), xv. John Whittier Treat's autobiographical, impressionistic *Great Mirrors Shattered: Homosexuality, Orientalism, and Japan* (New York: Oxford, 1999) offers the most sustained and thoughtful treatment of this history.

72. Timon Screech, *Sex and the Floating World: Erotic Images in Japan 1700–1820* (Honolulu: University of Hawai'i Press, 1999), 287.

73. Tom Hastings, "Said's *Orientalism* and the Discourse of (Hetero)sexuality," *Canadian Review of American Studies* 23, no. 1 (1992): 127–48; Treat, *Great Mirrors Shattered*, 200. For a discussion of this painting, which is central to the Orientalist canon, see my *Art and Homosexuality*, 73–74, and Nochlin, "The Imaginary Orient."

74. Treat, *Great Mirrors Shattered*, 86, 199, 209.

75. Hastings, "Said's Orientalism," 130, 134.

76. On the importance of the illustrations in Barthes's *Empire of Signs*, see Akane Kawakami, *Travellers' Visions: French Literary Encounters with Japan, 1881–2004* (Liverpool: Liverpool University Press, 2005), 133–37.

77. Pierre Loti, dedication for *Madame Chrysanthème*, trans. Laura Ensor (New York: Modern Library, n.d.) [1888].

78. Félix Régamey to Guillaume Régamey, September 8, 1876, in Keiko Omoto and Francis Macouin, *Quand le Japon s'ouvrit au monde* (Paris: Gallimard/Réunion des Musées Nationaux, 1990), 144: "C'est donc le sens de la vue qui est en jeu surtout."

79. W. E. H. [William Ernest Henley]. "Pictures of Japan," *Magazine of Art* 7 (1884): 200–201, 203.

80. Philippe Burty, "Japonisme II," *La Renaissance littéraire et artistique* (June 15, 1872), 59–60: "Celui qui veut apprendre comment et ce que pensent les Japonais, devra rechercher ces albums . . . les clefs de sa vie et le mémento de ses pensées. . . . Ce que j'ai acquis sur la psychologie des Japonais est certain. Je ne sais pas toujours ce qui détermine leur colère, leur terreur, leur rire, leur baiser, mais je sais précisément que leurs artistes traduisaient ces sensations, ces sentiments ou ces actes avec cette netteté et cette poésie qui sont l'art et la langue universels." See also his "Japonisme VI" (February 8, 1873), 3. These passages echo Burty's 1868 *Les Emaux cloisonnés anciens et modernes* (Paris: printed for Chez Martz jewellers by J. Claye, n.d.) [1868], which dismisses travelers' accounts of Japan in favor of what can be learned from prints (58, 61). On the resistance to written Japanese among the first *japonistes*, see Bush, "Ideographies," 57–67. Despite his failings with written Japanese, Burty devoted the third of his "Japonisme" articles to Japanese poetry, which he read in English and French translations, and by 1876, he was urging that "Europeans, above all things, should set to work to translate as literally as possible" Japanese texts ("Japonism II," 84).

81. Zacharie Astruc, "L'empire du soleil levant," *L'Étendard*, February 27, 1876, 1–2; March 23, 1867, 1–2, as quoted in Bush, *Ideographies*, 65–66: "Mais qui s'est soucié de le déchiffrer? . . . Ils veulent être vus. . . . Ce n'est plus l'Arabe dérobant sa vie intime à nos regards par l'extrême circonspection de son geste—placé à distance—étalant peu ses actes et ne les figurant jamais."

82. Gustave Flaubert, writing from Cairo early in 1850, described his "initial bedazzlement . . . each detail reaches out to grip you; it pinches you; and the more you concentrate on it the less you grasp the whole. . . . The first days, by God, it is such a bewildering chaos of colours." For an analysis of this and similar passages, see Mitchell, "Orientalism and the Exhibitionary Order."

83. Joseph Alexander von Hübner, *Promenade autour du monde–1871*, in Yokoyama, *Japan in the Victorian Mind*, 157.

84. Morse, *Japan Day by Day*, vol. 1, 6.

85. Guimet, *Promenades japonaises*, 24–25: "A chaque instant on retrouve un aspect, une pose, un groupe, une scène, qu'on a déjà vus sur des faïences ou des peintures; et la scène est réelle, le groupe vous sourit, la pose n'est pas une fiction, l'aspect n'est plus un rêve; on se reveille d'un Japon qu'on croyait conventionnel, pour entrer, marcher, agir dans un Japon vrai, incontestable, qui vous accueille en ami et ne diffère en rien de celui qu'on voyait en songe."

86. Rudyard Kipling, *From Sea to Sea and Other Sketches*, vol. 1 (New York: Doubleday and McClure, 1899), 291.

87. La Farge, *An Artist's Letters from Japan*, 1.

88. Henry Adams to John Hay, July 9 1886, *Letters of Henry Adams*, vol. 3, 17.

89. Loti, *Madame Chrysanthème*, 24; Louis-Marie Julien Viaud, journal entry of July 24, 1885: "J'avais déjà vu son portrait partout, sur des paravents, au fond des tasses à thé" (in Loti, *Cette éternelle nostalgie: journal intime, 1878–1911*, eds. Bruno Vercier, Alain Quella-Villéger, and Guy Dugas [Paris: La Table Ronde, 1997], 168).

90. Louis-Marie Julien Viaud to Marcel Sémézies, July 23, 1885, in Omoto and Mac-ouin, *Quand le Japon s'ouvrit au monde*, 159: "J'ai épousé la semaine dernière pour un mois renouvelable, devant les autorités nippones, une certaine Okané-San. . . Vous avez déjà vu sur tous les éventails cette figure de poupée. . . ."

91. Pierre Loti, *Lettres de Pierre Loti à Madame Juliette Adam* (Paris: Plon, 1924), 69: "Okané-San est habillée comme ces dames minaudières qui sont sur les murs de votre salon oriental." Viaud signed his letters to Adam as "Loti"—often "votre fils, Loti"—and this one opens "Madame ma mère."

92. Bill Brown, *A Sense of Things: The Object Matter of American Literature* (Chicago: University of Chicago Press, 2003), 5–7, 84–85.

93. Kipling, *From Sea to Sea*, vol. 1, 297–98.

94. Loti, *Madame Chrysanthème*, 50. This passage is presaged in Viaud's diary (*Cette éternelle nostalgie*, 168).

95. J. M. Tronson, *Personal Narrative of a Voyage to Japan, Kamtschatka, Siberia, Tartary, and Various Parts of the Coast of China in H.M.S. Barracouta* (1859), in Hugh Cortazzi, *Victorians in Japan: In and Around the Treaty Ports* (London: Athlone, 1987), 265. On Tronson's narrative, see Yokoyama, *Japan in the Victorian Mind*, 49. Even colonials in Africa were fascinated by Japanese nakedness. A letter from an artist visiting Bernard Leach in Japan in 1910 responds to a query from his parents in South Africa about the nakedness of the drivers: "Yes, you may see the stripped figures of men almost anywhere in Japan. They always wear a loin cloth though" (in Emmanuel Cooper, *Bernard Leach: Life and Work* [New Haven: Yale University Press, 2003], 56).

96. Loti, *Madame Chrysanthème*, 173.

97. The photograph is not pictured in the 1888 illustrated version of *Madame Chrysanthème*, although prototypes exist at the Fonds Pierre Loti-Viaud. The 1923 Librarie Hachette edition illustrates Loti and his companions looking at the photograph.

98. Henry Knollys, *Sketches of a Life in Japan* (1887), in Cortazzi, *Victorians in Japan*, 282.

99. Henry Norman, *The Real Japan: Studies of Contemporary Japanese Manners, Morals, Administration, and Politics* (London: T. Fischer Unwin, 1891), 294, 305.

100. Pierre Loti, *Japoneries d'automne* (Paris: Calmann-Lévy, n.d. [1889]), 307–8. Similar sentiments were voiced in Gilbert Watson's *Three Rolling Stones in Japan* (London: Edward Arnold, 1904), in which the author is provoked by the "curious

but saddening sight" of the brothels of Kobe to write, "Silks and satins of lovely hues and quaint devices were everywhere to be seen—costumes which long afterwards would probably find a ready market in London and Paris among wealthy ladies, and be admired for their beauty in many a Western boudoir" (in Cortazzi, *Victorians in Japan*, 286). George H. Ritter's *Impressions of Japan* (New York: James Pott, 1904) warns, "Beware, reader, that in your innocence you do not copy the head-dress or *kimono* from photos you may see in albums or on fans or screens, because they nearly always represent the costumes of those frail creatures of easy virtue!" (57).

101. Guy de Maupassant, *Pierre et Jean* (Paris, 1888): "décorée en lanterne japonaise" (chapter 7).

102. Guy de Maupassant, *Bel-Ami* (1885; repr., Paris: Louis Conard, 1910), 136:

> Il songea à la façon dont il arrangerait sa chambre pour recevoir sa maîtresse et dissimuler le mieux possible la pauvreté du local. Il eut l'idée d'épingler sur les murs de menus bibelots japonais, et il acheta pour cinq francs toute une collection de crépons, de petits éventails et de petits écrans, dont il cacha les taches trop visibles du papier. Il appliqua sur les vitres de la fenêtre des images transparentes représentant des bateaux sur des rivières, des vols d'oiseaux à travers des ciels rouges, des dames multicolores sur des balcons et des processions de petits bonshommes noirs dans des plaines remplies de neige.
>
> Son logis, grand tout juste pour y dormir et s'y asseoir, eut bientôt l'air de l'intérieur d'une lanterne de papier peint.

103. Maupassant, *Bel-Ami*, 110–12:

> Madame de Marelle . . . vêtue d'un peignoir japonais en soie rose où étaient brodés des paysages d'or, des fleurs bleues et des oiseaux blancs. . . .
>
> Il la trouvait tout à fait tentante, dans son peignoir éclatant et doux, moins fine que l'autre dans son peignoir blanc, moins chatte, moins délicate, mais plus excitante, plus poivrée.
>
> Quand il sentait près de lui Mme. Forestier, . . . il éprouvait surtout le désir de se coucher à ses pieds, ou de baiser la fine dentelle de son corsage et d'aspirer lentement l'air chaud et parfumé qui devait sortir de là, glissant entre les seins. Auprès de Mme de Marelle, il sentait en lui un désir plus brutal, plus précis, un désir qui frémissait dans les mains devant les contours soulevés de la soie légère.

104. Loti, *Madame Chrysanthème*, dedication.

105. Marcel Proust, *À la recherche du temps perdu*, vol. 1 (Paris: Gallimard, 1954), 220–21.

106. Jan Walsh Hokenson, "Proust's *japonisme*: Contrastive Aesthetics," in *Marcel Proust*, ed. Harold Bloom (Philadelphia: Chelsea House, 2004), 84. (The quotations from Proust are from this source [89, 93], but the translations are mine.)

107. Loti, *Madame Chrysanthème*, 55–56.

108. Julius Meier-Graefe, *Modern Art: Being a Contribution to a New System of Aesthetics*, vol. 2, trans. Florence Simmonds and George W. Chrystal (London: W. Heinemann, 1908), 250.

109. William Rothenstein, *Men and Memories: A History of the Arts, 1872–1922* (New York: Tudor, n.d.), vol. 1, 134. Although Rothenstein implies that he bought the book on his own initiative, Beardsley's correspondence indicates that it was a request (Zatlin, *Beardsley, Japonisme, and the Perversion of the Victorian Ideal*, 233).

110. Percival Lowell, *The Soul of the Far East* (Boston: Houghton Mifflin, 1888), 114–15. Compare Edwin Arnold, *Seas and Lands* (New York: Longmans, Green, 1891), 305–6.

111. Kipling, *From Sea to Sea*, vol. 1, 311.

112. Pierre Loti, "Les femmes japonaises," in *L'Exilée* (Paris: Calmann-Lévy, n.d. [1893]), 259–60. See also Loti's *Madame Prune*, trans. S. R. C. Plimsoll, 1905. Reissued as *Japan and Corea*. (London: Kegan Paul, 2002), 123.

113. Edward Barrington de Fonblanque, *Niphon and Pe-che-jin, or Two Years in Japan and Northern China* (London: 1862), in Cortazzi, *Victorians in Japan*, 275.

1. ORIGINATING JAPANISM: FIN-DE-SIÈCLE PARIS

1. Jean-Paul Bouillon, "'À gauche': Note sur la Société du Jing-Lar et sa signification," *Gazette des Beaux-Arts*, period 6, vol. 91 (1978): 107.

2. Michel Melot, "Questions au japonisme," in *Japonisme in Art: An International Symposium* (Tokyo: Kodansha, 1980): 239.

3. William Hosley, *The Japan Idea: Art and Life in Victorian America* (Hartford: Wadsworth Atheneum, 1990), 29.

4. Michael Baxandall, *Patterns of Intention: On the Historical Explanation of Pictures* (New Haven: Yale University Press, 1985), 58–59.

5. Jonathan Katz, "Passive Resistance: On the Success of Queer Artists in Cold War American Art," *L'image* 3 (1996): 119–42.

6. Edmond de Goncourt, *La maison d'un artiste*, vol. 1 (Paris: Bibliothèque Charpentier, 1881), 208–9: "Cet album (une reproduction des scènes légendaires, figurées par des poupées, dans le temple de Kannon), acheté en 1852, a été, pour mon frère et moi, la révélation de cette imagerie d'art alors bien vaguement connue de

l'Europe, qui, depuis, a fait des enthousiastes comme le paysagiste Rousseau, et qui, à l'heure présente, a une si grande influence sur notre peinture."

7. Ibid., 194: "Ces livres d'images ensoleillées, dans lesquels, par les jours gris de notre triste hiver, par les incléments et sales ciels, nous faisions chercher au peintre Coriolis, ou plutôt nous cherchions nous-mêmes, un peu de la lumière riante de l'Empire, appelé l'Empire du LEVER DU SOLEIL."

8. Raymond Koechlin, *Souvenirs d'un vieil amateur d'art de l'extrême-orient* (Chalons-sur-Saône: Imprimerie française et orientale, E. Bertrand, 1930), 16: "Goncourt a prétendu naturellement avoir acheté les premières arrivées, par hasard, entre 1850 et 1860, mais sans doute se vantait-il."

9. Klaus Berger, *Japonisme in Western Painting*, trans. David Britt (Cambridge: Cambridge University Press, 1992), 11.

10. In André Billy, *The Goncourt Brothers*, trans. Margaret Shaw (New York: Horizon, 1960), 17.

11. Edmond de Goncourt, preface to *Journal: Mémoires de la vie littéraire*, by Edmond and Jules de Goncourt, ed. Robert Ricatte, vol. 1 (Paris: Fasquelle and Flammarion, 1956), 19: "Ce journal est . . . la confession de deux vies *inséparées* dans le plaisir, le labeur, la peine . . . , de deux esprits recevant du contact des hommes et des choses des impressions si semblables, si identiques, si homogènes, que cette confession peut être considérée comme l'expansion d'un seul *moi* et d'un seul *je.*" This unified "I" was, in fact, largely Edmond's work following Jules's death. Although the brothers' novels were coauthored, many of the original journal entries are written in the first person plural, which Edmond edited from "we" to "I" for publication. His account of their mother's deathbed gesture is in Edmond and Jules de Goncourt, *Journal*, March 18, 1892, vol. 3, 682–83.

12. On Zola, see Pamela J. Warner, "Word and Image in the Art Criticism of the Goncourt Brothers" (Ph.D. dissertation, University of Delaware, 2005), 63. See also Philippe Burty, "La maison d'un artiste," *Le Livre* 2, no. 5 (1881): 151, 153.

13. Edmond and Jules de Goncourt, *Journal*, May 1859, vol. 1, 449–50: "Ce grand *impedimentum* de l'homme, l'amour et la femme . . . l'amour nous prend cinq heures par semaine, de six à onze, et pas une pensée avant ou après. . . . L'égoïsme à deux de l'amour, nous possédons avec toute la puissance et avec une intensité sans relâche dans la fraternité."

14. E. and J. de Goncourt, *Journal*, June 3, 1866, vol. 2, 24: "C'est au mariage, au ménage de notre fraternité qu'on s'attaque. On nous déteste pour nous aimer!"

15. Roger L. Williams, *The Horror of Life* (Chicago: University of Chicago Press, 1980), ix–xi, 68, 86, 109.

16. E. and J. de Goncourt, *Journal*, December 20, 1866, quoted in Roger L. Williams, *The Horror of Life*, 66. Wanda Bannour's 1985 *Edmond et Jules de Goncourt, ou le génie androgyne* (Paris: Persona, 1985) offers a more sympathetic psycho-biographical approach to the brothers' nonnormative gender roles.

17. Debora L. Silverman, *Art Nouveau in Fin-de-Siècle France: Politics, Psychology, and Style* (Berkeley: University of California Press, 1989), 17, 35. Williams is repeatedly cited on pages 35–37.

18. These dynamics are traced in Christopher Reed, *Not at Home: The Suppression of Domesticity in Modern Art and Architecture* (London: Thames and Hudson, 1996), 7–16.

19. Paul Cézanne, quoted in Ambroise Vollard, *Paul Cézanne* (Paris: Ambroise Vollard, 1914), 133. In the conversation transcribed here, Cézanne endorses Vollard's inclusion of Edmond de Goncourt among the "vain women" (*femmes vaniteuses*) of the Paris literary world. For more instances of such appellation, see Pamela J. Warner, *Word and Image in the Art Criticism of the Goncourt Brothers*, 89n85.

20. Berger's claim that the Goncourts did not begin buying Japanese prints until the 1870s (12) is unfounded.

21. Max Put, *Plunder and Pleasure: Japanese Art in the West, 1860–1930* (Leiden: Hotei, 2000), 11, 17n2.

22. E. and J. de Goncourt, *Journal des Goncourt: Mémoires de la vie littéraire* (Paris: G. Charpentier, 1887–96), October 29, 1868, 238:

> Le goût de la chinoiserie et de la japonaiserie! Ce goût, nous l'avons eu des premiers. Ce goût, aujourd'hui envahissant tout et tous, jusqu'aux imbéciles et aux bourgeoises, qui plus que nous l'a propagé, l'a senti, l'a prêché, y a converti les autres? Qui s'est passionné pour les premiers albums, a eu le courage d'en acheter?
>
> Dans le premier de nos livres, dans *En 18 . . .* , une description de cheminée à bibelots japonais nous fit décerner l'honneur d'être traités comme une espèce de fous baroques et de gens sans goût et fit demander par Edmond Texier notre internement à Charenton" (slightly revised from E. and J. de Goncourt, *Journal*, vol. 2, 178–79). Charenton was the asylum where the Marquis de Sade died.

23. Edmond and Jules de Goncourt, *En 18 . . .* (Paris: Dumineray, 1851), 93: ". . . une fort belle chinoiserie. Sur un fond de laque noir, vernissé comme une feuille de houx, quelque Philippe Rousseau de la province de Koueï-tchéou avait jeté de grands coqs déhanchés en saillie de cinq lignes d'or."

24. Edmond and Jules de Goncourt, *Préfaces et manifestes littéraires* (Paris: Ernest Flammarion/Eugène Fasquelle, 1888), 71–72:

—Une promenade silencieuse, comme il s'en fait, en ces moments de la vie, entre gens qui s'aiment et se cachent l'un à l'autre leur triste pensée fixe. . . . "Enfin cette description d'un salon parisien meublé de japonaiseries, publiée dans notre premier roman, d' En 18 . . . , paru en 1851 . . . oui, en 1851 . . . —qu'on me montre des japonisants de ce temps là . . . —Et nos acquisitions de bronzes et de laques de ces années [. . .] et la découverte en 1860, à la *Porte Chinoise*, du premier album japonais connu à Paris . . . connu au moins du monde des littérateurs et des peintres, [. . .] ne font-ils pas de nous les premiers propagateurs de cet art . . . de cet art en train, sans qu'on s'en doute, de révolutionner l'optique des peuples occidentaux?

"[. . .] ce sont les trois grands mouvements littéraires et artistiques de la seconde moitié du XIXe siècle . . . et nous les aurons menés, ces trois mouvements . . . nous pauvres obscurs. Et bien! quand on a fait cela . . . c'est vraiment difficile de n'être pas *quelqu'un* dans l'avenir.

Et, ma foi, le promeneur mourant de l'allée du bois de Boulogne pourrait peut-être avoir raison.

25. E. and J. de Goncourt, *Journal*, April 19, 1884, vol. 2, 1064–65: "une plainte amère et douleureuse contre l'injustice que mon pauvre frère a recontrée."

26. E. and J. de Goncourt, *Journal*, June 8, 1861, vol. 1, 706–7: "Je n'ai jamais rien vu de si prodigieux, de si fantaisiste, de si admirable et poétique comme art. Ce sont des tons fins comme des tons de plumage, éclatants comme des émaux; des poses, des toilettes, des visages, des femmes qui ont l'air de venir d'un rêve; des naïvetés d'école primitive, ravissantes et d'un caractère qui dépasse Albert Dürer; une magie envirant les yeux comme un parfum d'Orient. Un art prodigieux, naturel, multiple comme une flore, fascinant comme un miroir magique."

27. E. and J. de Goncourt, *Journal*, September 14, 1861, vol. 1, 730: " . . . des croquades à l'encre d'artistes japonais, qui ont l'esprit et la tache pittoresque d'un bistre de Fragonard."

28. Klaus Berger calls Edmond de Goncourt's comparisons of Rococo and Japanese art his one "enduring contribution; but at the same time it reveals his limitations" (*Japonisme*, 12). Gustave Duchesne de Bellecourt, "La Chine et le Japon à l'Exposition universelle," *Revue des deux mondes* 70 (1867): 730: "L'art européen n'a rien à apprendre de la peinture japonaise." Pamela Warner's more positive and detailed analysis focuses on how Edmond's late writings about Japanese prints challenged Academic standards ("Compare and Contrast: Rhetorical Strategies in Edmond de Goncourt's *Japonisme*." *Nineteenth Century Art Worldwide* 8, no. 1 [2009].)

29. E. and J. de Goncourt, *Journal*, January 1862, vol. 1, 766: "L'art n'est pas un, ou plutôt, il n'y a pas un seul art. L'art japonais est un art aussi grand que l'art grec. L'art grec, tout franchement, qu'est-il? Le réalisme du beau. Pas de fantasie, pas de rêve. . . . Pas ce grain d'opium, si doux, si caressant à l'âme, dans les figurations de la nature ou de l'homme."

30. Edmond and Jules de Goncourt, *Idées et sensations* (1866; repr., Paris: G. Charpentier, 1877), 15–17.

31. E. and J. de Goncourt, *Journal des Goncourt*, January 10, 1862, 1887 edition, 4–5: "Au fond, qu'est-ce que l'art grec: c'est le réalisme du beau, la traduction rigoureuse du *d'après nature* antique, sans rien d'une idéalité que lui prêtent les professeurs d'art de l'Institut, car le torse du Vatican est un torse qui digère humainement, et non un torse s'alimentant d'ambroisie, comme voudrait le faire croire Winckelmann."

32. E. and J. de Goncourt, *Journal*, June 5, 1862, vol. 1, 821: "Décidément, j'ai horreur des des [sic] Grecs et des Romains. C'est l'art qu'on nous a seriné. Cela représente surtout le Beau du collège. Peuples académiques, arts académiques, temps académiques, qui servent à faire la gloire et les traitements de vieux professeurs. De tout ce beau, sort l'ennui d'un pensum—et je me mets à feuilleter un album japonais, je me plonge dans ces rêves colorés." (This entry is omitted from the 1887 edition of the journal.)

33. E. and J. de Goncourt, *Journal*, February 15, 1867, vol. 2, 67: "Quant aux gens qui prétendent sentir l'une et l'autre, ma conviction est qu'ils ne sentent rien."

34. E. and J. de Goncourt, *Journal*, October 1863, vol. 1, 1013: "J'ai acheté l'autre jour des albums d'obscénités japonaises. Cela me réjouit, m'amuse, m'enchante l'oeil. Je regarde cela en dehors de l'obscénité, qui y est et qui semble ne pas y être et que je ne vois pas, tant elle disparaît sous la fantasie. La violence des lignes, l'imprévu de la conjonction, l'arrangement des accessoires, le caprice des poses et des choses, le pittoresque et pour ainsi dire le paysage des parties génitales. En le regardant, je songe à l'art grec, l'ennui dans la perfection, un art qui ne se lavera jamais de ce crime: *l'académique!*" (This passage is omitted from the 1887 edition of the journal.)

35. E. and J. de Goncourt, *Journal*, September 30, 1864, vol. 1, 1103–4:

> En passant sur le Boulevard, à onze heures et demie du soir, j'accroche ce mot d'un homme à une femme: "Adieu, mon jus d'ananas!"
>
> L'art chinois et surtout l'art japonais, ces arts qui paraissent aux yeux bourgeois d'une si invraisemblable fantasie, sont puisés à la nature même. Tout ce qu'ils font est emprunté à l'observation. Ils rendent ce qu'ils voient: les

effets incroyables du ciel, les zébrures du champignon, les transparences de la méduse. . . .

Au fond, ce n'est pas un paradoxe de dire qu'un album japonais et un tableau de Watteau sont tirés de l'intime étude de la nature. Rien de pareil chez les Grecs. . . .

En mangeant une banane, on dirait qu'on mange le clitoris d'un fruit. Comme tout, jusqu'à la peau du fruit, est artiste! Tout ce qui est d'Orient est ainsi.

La nature européenne a l'air d'un travail de prison. Nos petits produits, réguliers, méthodiques, ont l'air faits au bagne.

36. Edmond and Jules de Goncourt, *Manette Salomon* (1867; repr., Paris: Flammarion-Fasquelle, 1925), 188–90. The French original is not given here due to the length of the passage and the ready availability of the novel in French.

37. E. and J. de Goncourt, *Journal des Goncourt*, March 6, 1868, 1888 edition, 195: ". . . la cruauté d'aspect de la femme contemporaine, son regard d'acier, et son mauvais vouloir contre l'homme, non caché, non dissimulé, mais montré ostensiblement sur toute sa personne." The drawing, signed "A MM Edmond et Jules de Goncourt après Manette Solomon," is at the Musées royaux des Beaux-Arts de Belgique.

38. Jules de Goncourt to Gustave Flaubert, January 13, 1868, *Lettres de Jules de Goncourt* (Paris: Bibliothèque Charpentier, 1885), 271–72.

39. Raymond Williams, "The Bloomsbury Fraction," in *Culture and Materialism: Selected Essays*, 148–69 (London: Verso, 1980). In this regard, Elissa Auther and Adam Lerner's *West of Center: Art and the Counterculture Experiment in America* (Minneapolis: University of Minnesota Press, 2011) usefully distinguishes between the avant-garde and the counterculture.

40. The pun is explained by Jennifer Criss, who notes that it was suppressed in art histories that silently corrected the spelling ("Japonisme and Beyond in the Art of Marie Bracquemond, Mary Cassatt, and Berthe Morisot, 1867–1895" [Ph.D. dissertation, University of Pennsylvania, 2007], 54.)

41. C-Y [Champfleury, pseudonym of Jules François Félix Fleury-Husson], "La mode des japoniaiseries," *La vie parisienne*, November 21, 1868: 862–63:

Il y a une dizaine d'années fut ouverte, dans les environs des Tuileries, une petite boutique mais voyante pour la coloration de l'étalage.

Un poète qui par-dessus tout avait l'amour de ces vives colorations, s'arrêta longuement devant la montre, . . . entra, feuilleta les albums japonais, s'assit, entama une conversation avec la marchande ennuyée, s'éventa avec des éventails, fuma une cigarette d'horrible tabac et s'en revint en chantant le Japon sur tous les tons.

Ce poète capricieux inventa chaque année quelque bizarrerie pour s'en amuser pendant quelques mois; mais alors son enthousiasme prenait le caractère d'une obsession, et tout le temps que durait sa manie, il l'imposait à ses amis . . . les amis du poète ne quittant plus la petite boutique et sortant rarement de l'endroit sans en emporter quelque curiosité.

. . . Les prêches du poète, les achats du peintre furent résumés en des peintures franco-américaines si bizarres qu'elles troublèrent les yeux des gens assez naïfs pour rechercher les fonctions de jurés aux expositions de peinture: comme ces colorations étaient distinguées et nouvelles, on leur ferma les portes au nez . . . le Japon contesté fit école."

42. Respectively: André Guyaux, *Baudelaire: Un demi-siècle de lectures des Fleurs du mal, 1855–1905* (Paris: Presses universitaires de Paris–Sorbonne, 2007), 125; Hokenson, *Japan, France, and East–West Aesthetics*, 29; P. Warner, "Compare and Contrast."

43. Ernest Chesneau, "Le Japon à Paris," *Gazette des Beaux-Arts*, period 2, vol. 18 (1878): 386–87:

C'est par nos peintres en réalité que le goût de l'art japonais a pris racine à Paris, s'est communiqué aux amateurs, aux gens du monde et par suite imposé aux industries d'art. C'est un peintre qui, flânant chez un marchand de ces curiosités venues de l'Extrême-Orient,—que l'on confondait alors indistinctement sous le nom commun de *chinoiseries*,—découvrit dans un récent arrivage du Havre des feuilles peintes et des feuilles imprimées en couleur, des albums de croquis au trait rehaussés de teintes plates dont le caractère esthétique—et par la coloration et par le dessin—tranchait nettement avec le caractère des objets chinois. Cela se passait en 1862. . . . qui eut le premier bonheur de main, cette pénétration du regard de découvrir dans les confusions de la Chine morte les clartés du Japon vivant? . . .

L'enthousiasme gagna tous les ateliers avec la rapidité d'une flamme courant sur une piste de poudre. On ne pouvait se lasser d'admirer l'imprévu des compositions . . . la richesse du ton, l'originalité de l'effet pittoresque. . . .

44. Edmond de Goncourt retaliated in *La maison d'un artiste* by omitting Chesneau from his list of "those who first spoke of Japan," as Chesneau put it in his letter of complaint (in Jean-Louis Cabanès, "Lettres d'Ernest Chesneau à Edmond et Jules de Goncourt [1863–1884]," *Cahiers Edmond & Jules de Goncourt* 11 [2004]: 245). Cabanès dates the cooling of the friendship between Chesneau and the surviving Goncourt to 1878 (225) without suggesting a connection to the history of *japonisme* presented in "Le Japon à Paris."

45. Philippe Burty, *Grave Imprudence* (Paris: G. Charpentier, 1880), 144.

46. Saint-Juirs [Louis-René Delorme], "Chronique," *La vie moderne* 47, November 20, 1880, 738–39, in Phylis A. Floyd, "Japonisme in Context: Documentation, Criticism, Aesthetic Reaction" (Ph.D. dissertation, University of Michigan, 1983), 134.

47. L[éonce] Bénédite, "Félix Bracquemond, l'animalier," *Art et décoration* 17 (1905): 40: "En raison de sa matière souple et élastique, il avait servi à caler des porcelaines expédiées par des Français établis au Japon."

48. Bénédite, "Félix Bracquemond," 39–40: "En 1856, la date de l'année est certaine, mais je ne sais si Bracquemond pourrait en certifier le mois et le jour, en 1856, un beau matin. . . ." "Jusqu'alors, en vérité, on peut bien dire que personne, absolument personne, en France, ne connaissait l'art du Japon." The same story reappears in Bénédite's "Whistler" [third installment], *Gazette des Beaux-Arts*, period 2, vol. 34 (1905), 142–43.

49. Martin Eidelberg, "Bracquemond, Delâtre and the Discovery of Japanese Prints," *Burlington* 123, no. 937 (1981): 222.

50. Hokenson, *Japan, France, and East–West Aesthetics*, 421n1.

51. The first quotation is from Bénédite, "Whistler," 67; the second is from Bénédite, "Félix Bracquemond," 38: "Il n'en est rien, en réalité, et le Japon n'est intervenu comme stimulant dans la carrière de Bracquemond, que lorsque cette carrière était déjà pleinement engagée" (38). Bénédite's article on Bracquemond is introduced with the claim that "he, almost alone, remained protected from outside influences" and worked "without disavowing, in a gesture of false independence, the inexhaustible richness of a people's patrimonial treasure: tradition." ("Il est, à peu près seul, resté à l'abri des influences extérieures . . . sans renier même, dans un geste de fausse indépendance, l'inépuisable richesse du trésor patrimonial des peuples: la tradition.") (37).

52. Deborah Johnson, "Japanese Prints in Europe Before 1840," *Burlington* 124, no. 951 (1982): 343.

53. Quoted in William Leonard Schwartz, *The Imaginative Interpretation of the Far East in Modern French Literature, 1800–1925* (Paris: Librairie Ancienne Honoré Champion, 1927), 35–36. An 1862 letter from the painter Henri Fantin-Latour thanking Bracquemond for a "*Japonais*" says simply, "You have given me great pleasure, really great pleasure" (H. Fantin-Latour to F. Bracquemond, April 9, 1862, in Floyd, *Japonisme in Context*, 134).

54. Théodore Duret, *Livres et albums illustrés du Japon* (Paris: Ernest Leroux, 1900), 1.

55. Illustrations from the 1859 *Recueil* are reproduced and discussed in Eidelberg, "Bracquemond." An illustration from the 1861 *Recueil* is illustrated in *Le japonisme* (Paris: Éditions de la Réunion des musées nationaux, 1988), 27; Geneviève

Lacambre cites *manga* in this publication in 1858 and 1859 ("Les milieux japoni-sants à Paris," 45).

56. E. and J. de Goncourt, *Journal*, February 17, 1859, vol. 1, 439.

57. Koechlin, *Souvenirs*, 17: "Théodore Duret me dit sa surprise, quand il aperçut un jour dans les docks de Londres ces impressions merveilleuses qui servaient à caler les marchandises dans les caisses. On ne lui en avait jamais montré au cours de son voyage au Japon avec Cernuschi, et tout au plus avait-il aperçu les acteurs gesticulants et les paysages bariolés figurés sur les crépons et dans quelques albums maculés; mais c'était d'autre chose qu'il s'agissait cette fois, et il avait senti l'oeuvre d'art." Duret's memoir of his Asian voyage with Cernuschi, published in 1874, praises Hokusai (*Voyage en Asie* [Paris: Michel Lévy, 1874], 28), whose work he enthusiastically acquired in Japan. It is implausible that the valuable older prints he later purchased to augment his collection, which he donated to the Bibliothèque Nationale in 1899, would have been used as packing materials.

58. Bénédite, "Félix Bracquemond," 41: "La propagande exercée par Bracquemond les fit rechercher . . . les frères de Goncourt, tout préparés par leur culture du XVIIIe siècle, qui rendirent à l'art japonais le service de le faire sortir des limbes confus de la curiosité pour le faire entrer dans le domaine vivant de l'Histoire." This story identifies the owners of this shop as the Desoyes, discussed below.

59. "Ernest Chesneau," *Wikipédia*, accessed March 1, 2011, https://fr.wikipedia.org/wiki/Ernest_Chesneau.

60. E. and J. de Goncourt, *Journal*, December 6, 1862, January 13, 1864, vol. 1, 896, 1045.

61. Chesneau's reviews from the journal *Constitutionnel*, November 26 and December 5, 1867, in Jean-Louis Cabanès, "Lettres d'Ernest Chesneau à Edmond et Jules de Goncourt (1863–1884)," *Cahiers Edmond & Jules de Goncourt* 11 (2004): 237–38: "Le tableau ainsi est lugubre. . . . Je voudrais que M. Prudhomme sortit un peu moins effaré de la lecture de leurs livres." Originated and played by the caricature actor Henry Monnier in the 1830s, Monsieur Prudhomme had two volumes of cartoons dedicated to him around 1860: *Mémoires de Monsieur Joseph Prudhomme* (1857) and *Monsieur Prudhomme chef de brigands* (1860).

62. A notable exception is Jean-Paul Bouillon's *Bracquemond/Goncourt* (Paris: Somogy, 2004).

63. Anita Brookner, *The Genius of the Future: Studies in French Art Criticism* (New York: Phaidon, 1971), 141.

64. Gabriel P. Weisberg, Phillip Dennis Cate, Gerald Needham, Martin Eidelberg, and William R. Johnston, *Japonisme: Japanese Influence on French Art, 1854–1910* (Cleveland: Cleveland Museum of Art, 1975), 3.

65. Berger, *Japonisme*, 16, 12.

66. Other members were the painters Henri Fantin-Latour and Alphonse Hirsch, who collected Japanese prints and ceramics; Jules Jacquemart, a printmaker and collector; artist and ceramics designer Marc-Louis Solon; and an unidentified man named Nérat.

67. Chesneau, "Le Japon à Paris," 387: "L'on n'y mangeait pas avec des bâtonnets et l'on n'y buvait d'autre boisson que le saki national comme en témoigne le titre même de la société" ("pas" is likely a printer's transcription error for "que," a reading confirmed by Bénédite's 1905 gloss of this account ["Whistler," 143]).

68. Gabriel P. Weisberg, *The Independent Critic: Philippe Burty and the Visual Arts of Mid-Nineteenth Century France* (New York: Peter Lang, 1993), 103; Bouillon (" 'A gauche,' "105) critiques Weisberg's similarly over-serious presentation of the club in Weisberg et al., *Japonisme*, 5–6.

69. L. Solon to Félix Bracquemond, in Bouillon, " 'A gauche,' " 115: "Ceux qui ne rempliraient pas leur devoir verraient immédiatement leur conduite dénoncée au Mikado au Taicoun et à tout le tremblement du tonnerre du Japon."

70. Bouillon, " 'A gauche,' " 110.

71. A dubious reading of a scrawled word under Fantin-Latour's signature on a fanciful diploma for the Jinglar Society (S. P. Avery Collection, New York Public Library, accessible at http://digitalgallery.nypl.org) has occasioned speculation that a woman named Prudence, "the wife of one of the members," was part of the group (Weisberg et al., *Japonisme*, 30), but it is implausible that one wife would be part of the society and sign with her given name not capitalized.

72. James Abbott McNeill Whistler, quoted in Bénédite, "Whistler," 144.

73. Geneviève Lacambre dates the opening of the Desoye shop to 1860 ("Les milieux japonisants à Paris," in *Japonisme in Art: An International Symposium* [Tokyo: Kodansha, 1980], 45); the annual business guides of Paris first document its existence in 1863 (Floyd, *Japonisme in Context*, 381).

74. Philippe Burty, *Grave Imprudence* (Paris: G. Charpentier, 1880), 144: "Brissot . . . était très fier d'avoir acheté, dans le magasin de Mme Desoye à son arrivée du Japon, le premier album de fleurs et d'oiseaux imprimé en couleurs."

75. C-Y, "La mode des japoniaiseries," 862: "Tout le monde ne peut connaître l'influence de Mme D . . . dite *La Japonaise*." The rest of the quotation is at note 41.

76. Quoted in William Michael Rossetti, ed., *Rossetti Papers, 1862–1870* (London: Sands, 1903), 55; the reference is to the Pre-Raphaelite painter George Price Boyce. An entry of May 24, 1865 records another visit "to Dessoye's Japanese shop" to buy silks (105); one of August 10 reads, "Bought some Japanese books and a ditto bear [sic] from Madame Dessoye [sic]" (238).

77. Quoted in Toshio Watanabe, *High Victorian Japonisme* (New York: Peter Lang, 1991), 96. Watanabe deduces that this was the Desoye shop because of the Japanese officials' reference to it selling "Japanese objects only and not Chinese, the difference between which would have been clear to a native" (96–97).

78. Quoted in Watanabe, *High Victorian Japonisme*, 96.

79. Dante Gabriel Rossetti to Frances Rossetti, November 12, 1864, in William Michael Rossetti, ed., *Dante Gabriel Rossetti: His Family Letters*, vol. 2 (Boston: Roberts Brothers, 1895), 180.

80. E. and J. de Goncourt, *Journal*, August 11, 1892, vol. 3, 742.

81. Bénédite, "Félix Bracquemond," 40; Bénédite, "Whistler," 142–43.

82. Koechlin, *Souvenirs*, 6–8: "Les marchands avaient beau jeu à propager une si belle histoire, puisque personne n'y allait voir, et le plus petit amateur de Paris pouvait se flatter, si le coeur lui en disait, de posséder les dépouilles des illustres seigneurs de l'Extrême-Orient." Geneviève Lacambre suggests that Koechlin originated the often-repeated error that the Desoye shop was called "La Jonque Chinoise"—an inapposite name for a store dealing exclusively in Japanese art (personal communication, November 8, 2012). Compounding the confusion, this name is often confused with La Porte Chinoise, a larger, older teashop that sold curios, including some Japanese things (this is where Edmond de Goncourt claimed to have first discovered Japanese prints). Léonce Bénédite misassigned the name "La Porte Chinoise" to the Desoye shop ("Whistler," 142).

83. C-Y, "La mode des japoniaiseries," 863: "Les après-midi s'écoulèrent en dissertations sur l'art japonais, auxquelles se mêlèrent quelques compliments pour la dame."

84. E. and J. de Goncourt, *Journal*, March 31, 1875, vol. 2, 640:

> En ces derniers jours, que de stations dans cette boutique de la rue de Rivoli, où trône en sa bijouterie d'idole japonaise la grasse Mme Desoye! Une figure presque historique de ce temps, que cette femme dont le magasin a été l'endroit, l'école pour ainsi dire, où s'est élaboré ce grand mouvement japonais, qui s'étend aujourd'hui de la peinture à la mode. . . . Ç'a été d'abord quelques originaux comme mon frère et moi, puis Baudelaire, puis Villot, puis Burty, tout aussi amoureux de la marchande que des bibelots; puis à notre suite, la bande des peintres fantaisisites; enfin, les hommes et les femmes du monde qui ont la prétention d'être des *natures artistiques*.
>
> Dans cette boutique aux étrangetés si joliment façonnées et toujours caressées de soleil, les heures passent rapides à regarder, à retourner, à manier ces choses d'un art agréable au toucher; et cela au milieu du babil, des rires,

des pouffements fous de la drolatique et graveleuse créature, tournant autour de vous, se frottant à votre poitrine et vous interrogeant avec des bousculades de son ventre de poussah.

Bonne fille et plus fine marchande encore, que cette blanche Juive qui a fait une révolution au Japon par la transparence de son teint—et que les fiévreux du pays, auxquels elle donnait de la quinine, croyaient très sincèrement la Vierge Marie visitant l'Extrême Orient.

The published version of the journal tones down the language of the last sentence of the penultimate paragraph to simply "the crazy outbursts of that jovial creature."

85. Ibid.

86. E. de Goncourt, Journal, October 16, 1878, vol. 2, 801: "Le commerce de japonaiserie de Mme Desoye a beaucoup profité du hasard des rencontres qui avaient lieu chez elle entre hommes et femmes entrés pour voir, pour acheter un bibelot."

87. Billy, The Goncourt Brothers, 243.

88. Criss, Japonisme and Beyond, 53.

89. Louis Gallet, and Camille Saint-Saëns, La princesse jaune: opéra-comique en un acte (Paris: A. Durand et fils, 1906), 44–45, 77, 79. The libretto sets the scene in Léna's parents' home; some versions explain that the young man is living with them after being orphaned. Nothing in the libretto supports the claim that Kornélis is a doctor based on Philipp von Siebald (Jan van Rij, Madame Butterfly: Japonisme, Puccini, and the Search for the Real Cho-Cho-San [Berkeley: Stone Bridge Press, 2001], 46). The Japanese lyrics are garbled versions of a poem in Léon de Rosny's 1871 Anthologie japonaise and scraps of conversational Japanese (Schwartz, Imaginative Interpretation, 88).

90. Camille Saint-Saëns, École buissonnière (Paris: Editions Pierre Lafitte, 1913), 27.

91. Thomas Cooper, "Nineteenth-Century Spectacle," in French Music Since Berlioz, eds. Richard Langham Smith and Caroline Potter (Farnham, UK: Ashgate, 2006), 27–28.

92. Brian Rees, Camille Saint-Saëns: A Life (London: Chatto and Windus, 1999), 169; Saint-Saëns, École Buissonnière, 27.

93. Reviews quoted in Jean Gallois, Camille Saint-Saëns (Sprimont, Belgium: Editions Mardaga, 2004), 143.

94. Rees, Camille Saint-Saëns, 190–91.

95. Simon Boubée, "Exposition des impressionnistes, chez Durand-Ruel," Gazette de France 5 (April 1876): "La Chinoise [sic] a deux têtes: une de demi-mondaine sur les épaules, une autre de monstre placée—nous n'osons dire où." See Virginia

Spate and David Bromfield, "A New and Strange Beauty: Monet and Japanese Art," in *Monet and Japan* (Canberra: National Gallery of Australia, 2001), 24. "Une saleté" is quoted from René Gimpel, *Journal d'un collectionneur, marchand de tableaux* (Paris: Calmann-Lévy, 1963), 68.

96. Burty, *Grave Imprudence*, 130, 144, 146–48: "Pauline n'aspira plus au mariage avec Brissot. Il était bien trop 'monsieur.' " "Les chairs . . . de Pauline prenaient, à cette opposition . . . les effets d'une pivoine blanche dans une poignée de coqueli-cots." " . . . sa robe, qui était brodée sur fond d'ardoise, en travers des reins, d'une langouste cardinalisée au milieu d'un semis de crevettes." " . . . elle . . . regardât derrière elle, par-dessus l'épaule"; "Il avait horreur . . . de ces sujets de nudités glacialement provocantes . . . sous prétexte d'archaïsme. . . . Il voulait . . . que l'on ne se trompât pas sur l'expression subtile du sujet . . . sa figure de courti-sane devait être naïve dans sa fonction vile." The juxtaposition of the orangy-red kimono lining against white skin also recalls James Tissot's 1864 *La japonaise au bain*, now at the Musée des Beaux-Arts de Dijon; gossip about Tissot's purchase of all Madame Desoye's kimonos for his paintings (see the 1864 letter quoted in Rossetti, ed., *Dante Gabriel Rossetti: His Family Letters*, vol. 2, 180) contributed to the context in which Monet's painting was received.

97. Melot, "Questions au Japonisme."

98. Both Somm and Guérard were in *japoniste* circles. Somm, a bachelor, studied Jap-anese language for two years in preparation for a trip to Japan that was prevented by the Franco–Prussian war; his copies of Japanese woodblock prints illustrated the 1872 articles by his friend Philippe Burty that gave *japonisme* its name. Guérard illustrated Louis Gonse's influential 1883 *L'art japonais*.

99. Elizabeth K. Menon, "The Functional Print in Commercial Culture: Henry Somm's Women in the Marketplace," *Nineteenth-Century Art Worldwide* 4, no. 2 (2005), www.19thc-artworldwide.org/index.php/summer05/213-the-functional-print-in-commercial-culture-henry-somms-women-in-the-marketplace; Elizabeth K. Menon, "Henry Somm's *Japonisme*, 1881, in Context," *Gazette des Beaux-Arts*, period 6, year 134, no. 1477 (1992); Menon's *Evil by Design: The Creation and Market-ing of the Femme Fatale* (Urbana: University of Illinois Press, 2006) places Somm among the fin-de-siècle artists who developed the trope of the femme fatale.

100. Lucien Falize [writing as M. Josse], "L'art japonais à propos de l'exposition organ-isée par M. Gonse," *Revue des arts décoratifs* 3 (1882–83): 330:

> . . . J'ai cette intime satisfaction d'avoir été parmi les premiers qui le devinèrent . . .
> Et maintenant mon amour . . . est plus calme, comme il advient quand la fièvre
> de possession s'est calmée et qu'on regarde au grand jour sa maîtresse de la

veille: elle est belle toujours, souriante et toute pleine de grâce, mais on hésite à la prendre comme femme.

. . . N'avons-nous pas, nous tous, artistes, cohabité plus ou moins avec la fée japonaise? N'avons-nous pas eu chacun des enfants nés de cet amour? Les petits ressemblent tant à leur mère qu'il y aurait crime à la répudier; mais, avant de lui donner notre nom, de la faire Française par le mariage, voyons si elle n'était point une maîtresse déjà trop absorbante, et si dans le ménage nous la saurions dominer assez pour rester maîtres chez nous. . .

Le Japon s'ouvre à nous, et tandis qu'un petit groupe d'artistes tressaille et se réjouit aux fraîches senteurs de cet art vierge, la mode, cette proxénète toujours aux aguets, s'empare de l'idée nouvelle, la livre au commerce, la prostitue à la boutique, la roule dans la fange des plus petits métiers, la déshabille, la salit; et la pauvrette, honteuse, s'étale dans nos bazars au rabais, où le dernier public en fait son régal.

101. Henri Cernuschi to Tullio Martello, August 5, 1871, in Giuseppe Leti, *Henri Cernuschi, sa vie, sa doctrine, ses oeuvres* (Paris: Presses Universitaires de France, 1936), 181: "L'atroce perte que j'ai faite de Chaudey m'a décidé à cette absence."

102. Théodore Duret to Camille Pissaro, in Ting Chang, "Disorienting Orient: Duret and Guimet, Anxious *flâneurs* in Asia," in *The Invisible Flâneuse: Gender, Public Space, and Visual Culture in Nineteenth-Century Paris*, ed. Aruna d'Souza and Tom McDonough (Manchester: Manchester University Press, 2006), 67.

103. Duret, *Livres et albums*, i–ii: ". . . ses arts étaient presque inconnus en Europe. On n'y avait encore vu que quelques rares objets à l'Exposition de 1867. . . . Le nom Hokusaï n'avait depuis transpiré qu'auprès de rares chercheurs. . . . Nous étions donc partis d'Europe sans rien connaître de l'art japonais alors caché."

104. Shigemi Inaga, "Théodore Duret et le Japon," *Revue de l'art* 79, no. 1 (1988): 81n2.

105. Duret, *Voyage en Asie*, 20: "Or il faut vous dire qu'aussitôt débarqués à Yokohama, nous avons commencé à acheter des bibelots. C'est la première chose que font tous les Européens qui mettent pied au Japon. Nous avions débuté comme tout le monde, sans dessein arrêté, sans parti pris, allant un peu au hasard, cependant nous nous sommes vite sentis attirés vers les bronzes."

106. Théodore Duret to Édouard Manet, October 5, 1872, in Shigemi Inaga, "Théodore Duret et Henri Cernuschi: journalisme politique, voyage en Asie et collection japonaise," *Ebisu* unnumbered special issue (1998): 89.

107. Jules-Antoine Castagnary in *Le Siècle*, September 6, 1873, in Ting Chang, "Asia as a Fantasy of France in the Nineteenth Century," in *Artistic and Cultural Exchanges Between Europe and Asia, 1400–1900*, ed. Michael North (Farnham, UK:

Ashgate, 2010), 49. Cernuschi also acquired a collection of Western art in one purchase from an Italian lawyer, but these objects are rarely mentioned in descriptions of his house.

108. Edmund de Waal, *The Hare with Amber Eyes: A Family's Century of Art and Loss* (New York: Farrar, Straus and Giroux, 2010), 28.

109. André Maurel, *Souvenirs d'un écrivain, 1883–1914* (Paris: Hachette, 1925), 139. Cernuschi's youthful good looks are noted in Gilles Béguin, "Henri Cernuschi: Un homme, un destin," in Musée Cernuschi, *Henri Cernuschi: Voyageur et collectionneur* [Paris: Paris-Musées, 1998], 11. A eulogistic column recalled "this elegant Italian with his gray hair and gray beard . . . imposing himself as one of the most original physiognomies in Paris. He had everything required to be at the same time French and Italian" (E. [Emmanuel Arène], "Notes d'un Parsien," *Figaro* 14 [1896], 3).

110. Maurice Demaison, "Le musée Cernuschi," *La revue de l'art ancien et moderne* 2, no. 7 (1897): 252: "Rien n'indiquerait aujourd'hui que ce musée modèle fut jadis la demeure d'un particulier, si l'extérieur, élégant et noble en sa sobriété, ne rappelait, par les lignes de la façade et par son toit à l'italienne, l'origine du fondateur et si deux dates, *Février* et *Septembre,* gravées sur les cartouches de la porte, n'attestaient l'immuable ténacité de ses ardentes convictions."

111. Béguin, "Henri Cernuschi: Un homme, un destin," in Musée Cernuschi, *Henri Cernuschi,* 21.

112. André de Fouquières, *Mon Paris et mes Parisiens,* vol. 2, *Le quartier Monceau* (Paris: Pierre Horay, 1954), 197: "Je gage que les visiteurs du musée Cernuschi pensent que l'hôte . . . ne vivait pas dans le décor qu'ils contemplent. Et pourtant il y vivait . . . au milieu de ces divinités monstrueuses, entre des meubles qui étaient surtout des vitrines. On osait à peine s'asseoir sur une chaise, tant on avait le sentiment que c'était celle du gardien."

113. Pierre Despatys, *Les musées de la ville de Paris* (Paris: G. Boudet, n.d), 60; André Maurel, "L'Hôtel Cernuschi," *Le Figaro,* May 14, 1896; Michel Maucuer, "Les collections asiatiques d'Henri Cernuschi," in Musée Cernuschi, *Henri Cernuschi,* 42.

114. Giuseppe Leti, *Henri Cernuschi,* 188: "Dans la somptueuse demeure, au milieu de ses collections, des génies, des dieux et des déesses, Cernuschi vivait tranquille et serein. Il y donna souvent des repas et des soirées à des amis, artistes, littérateurs, financiers . . . un déjeuner cordial parmi les merveilles japonaises entassées dans le logis."

115. Maurel, "L'hôtel Cernuschi": "Cernuschi était un timide qui n'aimait pas beaucoup à laisser pénétrer dans sa demeure les curieux de toutes sortes que ses collections attiraient. Le journaliste, surtout, était exclu, par crainte des articles! Il fallait être de ses amis pour être reçu."

116. Dorothy G. Wayman, *Edward Sylvester Morse: A Biography* (Cambridge, MA: Harvard University Press, 1942), 298.

117. Maurel, "L'hôtel Cernuschi": " . . . la foule—une foule *select!*—fut admise à circuler dans l'hôtel de l'avenue Vélasquez."

118. Maurel, *Souvenirs d'un écrivain*, 142. Leti, *Henri Cernuschi*, 189: "Gambetta harangua les invités aux pieds du Bouddha. Ce fut une orgie de lumières et de meubles orientaux."

119. Louis Gonse, "Les masques japonais," *Le Monde Moderne*, December 1990, quoted in François Gonse, "Louis Gonse (1846–1921) et le Japon," *Gazette des Beaux-Arts*, period 6, year 134, no. 1477 (1992): 85.

120. Fouquières, *Mon Paris et mes Parisiens*, 199.

121. Gaston Migeon, "Le musée Cernuschi," *Gazette des Beaux-Arts*, period 3, year 18 (1897): 221. E. and J. de Goncourt, *Journal*, January 17, 1885, vol. 2, 1124: "Je suis pauvre comme mon aïeul Job. . . . Je m'adresse à vous, parce que mon tigre est *superbe et japonais.*"

122. E. [Emmanuel Arène], "Notes d'un parisien," *Figaro*, May 14, 1896, 3.:

> Quand, après le café, nous passâmes dans le temple japonais, Cernuschi montrait, avec orgueil, son Bouddha, superbe et hideux à la fois puisqu'il était authentique:
> —[illegible exclamation] . . . Quelle horreur! . . . s'exclama la petite danseuse. Je ne puis pas voir cela!
> Alors, le bon Cernuschi, d'un ton paternel:
> —Regardez-le tout de même ma fille! Il a déjà fait rater quelques naissances!

123. Alphonse Daudet, *Sapho (Moeurs parisiennes)* [*Sappho to Which Is Added Between the Flies and the Footlights*] (1884; repr., Boston: Little, Brown, 1899), 6, 165. Cernuschi is cited as a source of the novel in Leti, *Henri Cernuschi*, 189, and in Béguin, "Henri Cernuschi," 21–22, although the latter garbles dates by citing the specific party Maurel recalled, which took place in 1889, five years after *Sapho* was published. Cernuschi had "the taste for masked balls" (Fouquières, *Mon Paris et mes Parisiens*, 198), however, and the Goncourt *Journal* mentions a ball at Cernuschi's that Zola attended as early as 1878 (May 17, 1878, vol. 2, 779).

124. E. and J. de Goncourt, *Journal*, July 1, 1875, 1891 edition, 211: "Le riche collectionneur a donné à sa collection le milieu à la fois imposant et froid d'un Louvre. . . . Sur les murailles blanches, sur le ton de brique Pompéi, en honneur dans nos musées, ces objets de l'Extrême-Orient semblent malheureux." Drawings and photographs of Cernuschi's display rooms document his custom-made patterned wallpaper in the red-brown color Goncourt referred to as Pompeian

brick. Goncourt's allusion to white *murailles* (the walls of a castle or fort) refers to the museum's imposing exterior .

125. E and J. de Goncourt, *Journal*, July 1, 1875, vol. 2, 651–52:

> On dirait qu'un mauvais génie les a transportés dans un palais imaginé par le goût à la fois grandiose et bourgeois. . . .
>
> Le déjeuner valait mille fois mieux . . . que la conception de l'hôtel-musée. . . .
>
> Puis aussitôt, a commencé la visite des deux mille bronzes, des faïences, des porcelaines, de toute cette innombrable réunion des imaginations de la forme. . . .
>
> Et quant aux ivoires, aux bois sculptés, aux objets de fer ciselé, quant à tous ces petits et exquis objets-là où l'on reconnaît l'amateur de haut goût, rien, rien, rien.

126. E. and J. de Goncourt, *Journal*, July 25, 1875, vol. 2, 651–52: "Le fantastique et le chimérique du Japon montrés au gaz, ça ne va pas."

127. The Goncourt apartment is described in Burty, "La maison d'un artiste," 151–53, and analyzed in Pamela Warner, "Framing, Symmetry, and Contrast in Edmond de Goncourt's Aesthetic Interior," *Studies in the Decorative Arts* 15 (2008): 38–42. Its difference from the house is important, for one way historians have minimized the Goncourts' *japonisme* is to dismiss the enormous collection of Japanese art dispersed after Edmond's death in 1896 as part of their replication of the eighteenth-century vogue for *chinoiserie*.

128. E. de Goncourt, *La maison d'un artiste*, vol. 2, 178: "Ces riens, ces *passes* de circulation, touchées et retouchées par des mains d'autrefois, et qui ont de la crasse d'une humanité disparue, me parlent plus haut que les documents de la froide et grande Histoire, et si mon frère et moi, avons fait revivre un peu de la vie du passé dans nos livres historiques, nous devons à l'étude de ces infiniment petits, méprisés jusqu'à nous."

129. E. and J. de Goncourt, *Journal*, February 4, 1891, vol. 3, 536: "C'est extraordinaire, la jouissance que procure à un amateur la possession d'un objet parfait: c'est si rare, le bibelot qui vous satisfait complètement!" (in *Journal des Goncourt*, 1895 edition, 208–9).

130. Gustave Geffroy, "La maison des Goncourt," *Revue des arts décoratifs* 12 (1891–92): 151: "Les Goncourt . . . ont su donner à cette Maison d'Auteuil une physionomie particulière et significative, semblable à leur individualité intellectuelle et artiste."

131. Louis Gonse, "La maison d'un artiste, par Edmond de Goncourt," *Gazette des Beaux-Arts*, period 2, year 23, vol. 24 (1881): 101.

132. E. and J. de Goncourt, *Journal*, November 18, 1860, vol. 1, 632: "Notre Paris, le Paris où nous sommes nés . . . s'en va. . . . La vie sociale y fait une grande évolution, qui

commence. L'intérieur s'en va. La vie retourne à devenir publique. . . . Tout cela me fait l'effet d'être, dans cette patrie de mes goûts, comme un voyageur." In fact, only Jules de Goncourt was born in Paris.

133. E. and J. de Goncourt, *Idées et sensations*, 67: "L'intérieur va mourir. La vie menace de devenir publique."

134. E. and J. de Goncourt, *Journal des Goncourt*, November 18, 1860, 1887 edition, 346: "Je vois des femmes, des enfants, des ménages, des familles dans ce café [the reference is to the Eldorado, "*un grand café-concert*"]. . . . Je suis étranger à ce qui vient, à ce qui est, comme à ces boulevards nouveaux sans tournants, sans aventures de perspective, implacables de ligne droite . . . , qui font penser à quelque Babylone américaine de l'avenir." T. J. Clark hangs an analysis of Hausmannization on the differences between the original journal entry and the way it was "tidied up . . . for publication in 1891" (*The Painting of Modern Life: Paris in the Art of Manet and His Followers* [New York: Alfred A. Knopf, 1985], 34), although these revisions were made much earlier for the 1866 *Idées et sensations* (67). The chronological analysis of these journal passages in Laure Katsaros's *New York–Paris: Whitman, Baudelaire, and the Hybrid City* (Ann Arbor: University of Michigan Press, 2012) follows Clark's incorrect dates and then gets the chronology backward (60–61).

135. E. and J. de Goncourt, *Journal*, November 18, 1860, vol. 1, 632.

136. E. de Goncourt, *La maison d'un artiste*, vol. 1, 2: "La vie d'aujourd'hui est une vie de combativité . . . l'homme, dont l'existence n'est plus extérieure comme au XVIIIe siècle, n'est plus papillonnante parmi la société depuis ses dix-sept ans jusqu'à sa mort. . . . La créature humaine . . . a été poussée à vouloir les quatre murs de son *home* agréables, plaisants, amusants aux yeux." On French uses of the English word *home*, see Temma Balducci, Heather Belnap Jensen, and Pamela J. Warner, eds., *Interior Portraiture and Masculine Identity in France, 1789–1914* (Burlington, VT: Ashgate, 2011), 11n7.

137. E. de Goncourt, *La maison d'un artiste*, vol. 1, 2–3: "Ces habitudes moins mondaines amenaient un amoindrissement du rôle de la femme dans la pensée masculine; . . . l'intérêt de l'homme, s'en allant de l'être charmant, se reportait en grande partie sur les jolis objets inanimés dont la passion revêt un peu de la nature et du caractère de l'amour. Au XVIIIe siècle, il n'y a pas de *bibeloteurs* jeunes: c'est là la différence des deux siècles. Pour notre génération, la *bricabracomanie* n'est qu'un bouche-trou de la femme qui ne possède plus l'imagination de l'homme."

138. Brookner, *The Genius of the Future*, 121.

139. Gratuitously inserting the word *erotic* in her translation to make Goncourt's "passion" partake of "the nature and character of erotic love," Debora Silverman cites this

spurious quotation as where Goncourt "explained how his objets d'art function for him as a form of sexual sublimation; unable to sustain ties to real women, he found in objets d'art a compensatory erotic energy." Silverman's translation of the rest of the passage further misrepresents the original text. Where he lists the hardships of modern life as the cause of the "general passion" for the bibelot "toward which almost a whole nation bends," Silverman makes Goncourt's personal "passion" the motivating force. Where he describes how these social forces "push, as before a flood, desires and wishes to give in to immediate pleasure" in objects that offer the "forgetfulness of the moment in artistic fulfillment," her translation offers "immediate gratification" through "momentary abandon in aesthetic debauchery" (Art Nouveau in Fin-de-Siècle France, 35–36); compare E. de Goncourt, La maison d'un artiste, vol. 1, 3: "Cette passion devenue générale, ce plaisir solitaire auquel se livre presque toute une nation doit son développement . . . à des soucis et à des préoccupations qui poussent, comme à la veille d'un déluge, les désirs et les envies à se donner la jouissance immédiate . . . l'oubli du moment dans l'assouvissement artistique."

140. Rémy Saisselin, Bricabracomania: The Bourgeois and the Bibelot (London: Thames and Hudson, 1985), xiv.

141. Brookner, The Genius of the Future, 121–22.

142. Susan Sontag, "Notes on Camp," 1964, in Against Interpretation (New York: Noonday, 1966), 275–92.

143. On Warhol, see Christopher Reed, Art and Homosexuality: A History of Ideas (New York: Oxford University Press, 2011), 159–64, 174–76. Brookner's anxiety over the Goncourts' transgression of the divide between amateur and professional (121) is similar to modernist critics' attacks on Warhol's art as a form of consumption rather than production (see Katz, "Passive Resistance").

144. E. and J. de Goncourt, Journal, September 12, 1868, vol. 2, 175: " . . . nous offrons deux mille francs, un prix dépassant un caprice d'empereur ou de Rothschild, pour un monstre japonais, un bronze fascinatoire, que je ne sais quoi nous dit que nous devons posséder." (This passage appears in the 1888 edition, 234.)

145. E. and J. de Goncourt, Journal des Goncourt, September 21, 1868, 1888 edition, 236; the original text is in E. and J. de Goncourt, Journal, vol. 2, 176.

146. E. de Goncourt, La maison d'un artiste, vol. 1, 190–91: " . . . sur un trépied, figurant les vagues en colère de la mer, s'élève un vase de bronze, haut d'un mètre, un vase pansu se terminant en forme d'une margelle de bassin. Sur la panse, sillonnée de flots, se détache, en plein relief, un dragon cornu, aux excroissances de chair en langues de flamme, aux ergots de coq, le Tats-maki, le dragon des typhons, dont le corps tordu et contorsionné de serpent apparaît par places, au-dessus des ondes rigides. Rien de plus terriblement vivant par l'artifice de l'art, que ce

monstre fabuleux dans ce bronze qui semble de cire noircie, et qui est beau de la plus sombre patine, et qui est sonore, ainsi qu'un métal de cloche plein d'argent."

147. E. and J. de Goncourt, *Idées et sensations*, 16–17: "Là-bas le monstre est partout. C'est le décor et presque le mobilier de la maison. Il est la jardinière et le brûle-parfum. . . . Pour ce monde de femmes pâles aux paupières fardées, le monstre est l'image habituelle, familière, aimée. . . ."

148. Quoted in Diana Periton, "The Interior as Aesthetic Refuge: Edmond de Goncourt's *La maison d'un artiste*," in *Tracing Modernity: Manifestations of the Modern in Architecture and the City*, ed. Mari Hvattum and Christian Hermansen (London: Routledge, 2004), 148: "ne pourrons jamais être occupées que bourgeoisement."

149. E. and J. de Goncourt, *Journal*, June 19, 1868, as translated in Lewis Galantière, *The Goncourt Journals, 1851–1870* (Garden City, NY: Doubleday, Doran, 1937), 261.

150. Angus Lockyer, "Japans in Paris," in *Identity and Universality*, ed. Volker Barth (Paris: Bureau national des expositions, 2002), 91–108; Watanabe, *High Victorian Japonisme*, 102–7.

151. Philippe Burty, "Les industries de luxe à l'Exhibition de l'Union centrale," *Gazette des Beaux-Arts*, period 2, year 11, vol. 2 (1869): 544.

152. Philippe Burty, "Un service en terre de Montereau," *La chronique des arts de la curiosité*, June 9, 1867, 181.

153. Chesneau, "Le Japon à Paris," 391–92: "Tout ce qu'il avait emprunté aux artistes japonais, c'est une liberté de disposition des motifs plus grande que de coutume dans le décor français, c'est-à-dire le déplacement arbitraire des centres, la rupture de l'équilibre et de la pondération des masses. . . . Il leur empruntait aussi leur façon de modelé sommaire, en teintes plates, qui donne l'idée de l'objet sans viser au trompe-l'oeil; puis leur mode d'accentuation dans le dessin qui consiste à fortement accuser, même au prix d'une exagération, le caractère essentiel de la forme." On Bracquemond's sources in Hokusai, Hiroshige, and other *manga* artists, see Christine Shimizu, "Les sources: l'estampe japonaise de l'ukiyo-e," *Art, industrie et japonisme: le service Rousseau*, Dossiers du Musée d'Orsay, vol. 20 (Paris: Editions de la Réunion des musées nationaux, 1988), 20–25, and Weisberg, *The Independent Critic*, 105–6.

154. E. and J. de Goncourt, *Journal*, March 31, 1878, vol. 2, 773: "un service qui a fait une révolution; mais au fond, ce ne sont que des calques d'albums japonais. . . ."; *Journal*, February 18, 1877, vol. 2, 728: "C'est curieux, la révolution amenée par l'art japonais chez un peuple esclave, dans le domaine de l'art, de la symétrie grecque et qui, soudain, s'est mis à se passionner pour une assiette où la fleur n'était plus au beau milieu." (This passage appears in the 1891 edition, 313.)

155. Jules de Goncourt to Philippe Burty, August 1, 1867, in Philippe Burty, *Maîtres et petits maîtres* (Paris: G. Charpentier, 1877), 274.

156. E. de Goncourt, *La maison d'un artiste*, vol. 1, 191: "en un temps où la japonaiserie n'était point encore à la mode." The phrase *vase-monstre* is from *Journal*, September 18, 1868, vol. 2, 175.

157. E. and J. de Goncourt, *Journal*, September 12, 1868, vol. 2, 175:

> . . . comme moulus des fièvres d'une folle nuit de jeu. Après l'achat de cette maison . . . si déraisonnable pour la raison bourgeoise devant notre petite fortune. . . .
>
> Au fond, c'est étrange cette masse de grosses émotions que nous nous faisons dans notre vie si plate, nous à si froide apparence et si fous au dedans, si passionnés, si amoureux. Car nous appelons amoureux celui-là seul qui se ruine pour la possession de ce qu'il aime: femme ou chose, objet d'art animé ou inanimé." (A very similar passage appears in the 1888 edition, 234.)

The journal entry for August 4, 1868, describes their sensations of drunkenness upon purchasing the house.

158. E. and J. de Goncourt, *Journal*, October 30, 1874, vol. 2, 595: " . . . cet art capiteux et hallucinatoire. Nous avons passé des heures, tant d'heures, qu'il était quatre heures quand j'ai déjeuné. Ces débauches d'art—celle de ce matin m'a coûté plus de cinq cents francs—me laissent comme la fatigue et l'ébranlement nerveux d'une nuit de jeu. J'emporte de là une sécheresse de bouche que l'eau de mer d'une douzaine d'huîtres peut seule rafraîchir." (This passage appears in the 1891 edition, 144.)

159. E. and J. de Goncourt, *Journal*, November 3, 1888, vol. 3, 173: "C'est vraiment curieux, cette sorte de bonheur sensuel que des gens à la rétine comme la mienne, éprouvent à faire jouir leurs yeux de la contemplation des taches porphyrisées dans la larme d'émail colorié d'une poterie japonaise. . . . Oui, bien certainement, la passion de l'objet d'art—et de l'objet d'art industriel—a tué chez moi la séduction de la femme" (ellipses in original; this passage is omitted from the 1894 edition of the journal).

160. E. and J. de Goncourt, *Journal*, July 27, 1877, vol. 2, 745:

> Le proclamation de l'union de l'homme et de la femme dans ces endroits civils ressemble vraiment trop à la condamnation prononcée par un président de cour d'assises. . . .
>
> Burty, dont la paternité semble être arrivée à la limite dernière des devoirs et des obligations, me tire solennellement d'une enveloppe de soie un coffret qu'il me fait admirer, et nous partons japoniser chez Bing et Sichel.

161. Émile Zola, "Edmond de Goncourt," *Figaro*, March 15, 1881 (repr., *Une campagne*, 1880–81 [Paris: G. Charpentier, 1882]), 205–6:

Les deux frères, alors, l'emplissaient de leur gaieté au travail, de leur fièvre à la lutte littéraire. . . . J'ai revu la maison bien triste et bien vide. Edmond, resté seul, dans cet arrachement de tout son être, l'abondonnait. Il n'avait plus le courage de faire du petit hôtel la retraite d'art que tous deux avaient rêvée, lorsqu'ils s'étaient enfuis à ce bout verdoyant de Paris. La mort était venue, quand les meubles se trouvaient à peine à leur place.

. . . la maison lentement le rattacha à l'existence . . . monter sur des échelles pour accrocher des dessins. . . .

La maison avait sauvé l'écrivain.

162. E. and J. de Goncourt, *Journal*, May 24, 1871, vol. 2, 447: "On pourrait enterrer trois hommes."

163. Pol Neveux, untitled introduction to *Exposition Goncourt* (Paris: Gazette des Beaux-Arts, 1933), 7–8: "Après la mort de son frère, Edmond de Goncourt, voulant fuir son deuil, dépayser ses visions et ses songes, s'était tout à coup passionné pour l'art de l'Extrême-Orient."

164. P. Warner, *Word and Image in the Art and Criticism of the Goncourt Brothers*, 368.

165. Zola, "Edmond de Goncourt," 217: "La maison d'Auteuil serait vide, si je n'y avais pas montré cette ombre chère et tant pleurée du frère mort. . . . C'est elle qui attendrit et chauffe d'un souvenir ce logis de vieux garcon, qui serait froid sans elle, car on n'y sent pas la tiédeur d'une femme."

166. I develop this argument in Christopher Reed, *The Chrysanthème Papers: The Pink Notebook of Madame Chrysanthème and Other Documents of French Japonisme* (Honolulu: University of Hawai'i Press, 2010), 32–41.

167. E. and J. de Goncourt, *Journal*, March 19, 1871, vol. 2, 396: "Un sentiment de fatigue d'être français; le désir vague d'aller chercher une patrie, où l'artiste ait sa pensée tranquille . . ." (This passage appears in the 1890 edition.)

168. Ting Chang "La japonerie, la chinoiserie et la France d'Edmond de Goncourt," *Cahiers Edmond & Jules de Goncourt* 18 (2011): 65–66.

169. E. and J. de Goncourt, *Journal*, April 3, 1880, vol. 2, 861: "Je prends la direction d'un des grands mouvements du goût d'aujourd'hui et de demain."

170. Dominique Pety's introduction to the 2003 edition analyzes the genre of the text in relation to other books (vi–ix). Another precedent is John Soane's *Description of the House and Museum on the North Side of Lincoln's Inn Fields*, first published in London in 1830, with expanded versions appearing in 1832 and 1835 in both English and French. Elizabeth Emery places *La maison d'un artiste* at the origin of the vogue for authors' house-museums in France (*Photojournalism and the Origins of the French Writer House Museum* [Burlington, VT: Ashgate, 2012]).

171. E. de Goncourt, *La maison d'un artiste*, n.p.: "Pourquoi n'écrirait-on pas les mémoires des choses, au milieu desquelles s'est écoulée une existence d'homme?"

172. E. de Goncourt, *La maison d'un artiste*, vol. 2, 369–71:

> la mansarde d'étudiant, où mon frère aimait à travailler, la chambre choisie par lui pour mourir. . . .
>
> De certains anniversaires et des jours de tristesse, où le long passé inoubliable de notre vie à deux revient au coeur, je monte dans cette chambre, je m'assois dans le grand fauteuil près du lit vide . . . , je me donne la douloureuse jouissance de me ressouvenir.
>
> Et je le revois, mon bon et joli frère . . . qu'il me répondait par un gros rire moqueur. . . .
>
> . . . la sueur froide de sa tête appuyée contre ma poitrine traversa mes habits, ma chemise.
>
> . . . C'étaient des élancements qui ressemblaient à des tentatives d'envolées d'oiseau blessé; . . . c'étaient des tendresses de corps pour d'autres visions qu'il appelait de ses mains tendues, leur envoyant des baisers.
>
> . . . Il n'était plus mon frère . . . le sourire indéfinissable de ses lèvres violettes, lui donnaient une ressemblance troublante avec une figure mystérieuse et non humaine du Vinci, que j'avais vue en Italie, dans un coin noir, de je ne sais quel tableau, de quel musée.

173. The notice for *La maison d'un artiste* that appeared in *Le Temps* (March 12, 1881) quoted the description of Jules's death in its entirety with the explanation, "Such is the tone of this book" (2). Philippe Burty's review called these passages as "the most elevated and harmonious in this book" ("La maison d'un artiste," 155). Edmond de Goncourt to Philippe Burty, June 20, 1870, in Alidor Delzant, *Les Goncourt* (Paris: G. Charpentier, 1889), 179: "Je viens de faire la dernière toilette au cadavre de mon frère, lavé de mes larmes."

174. Julia Daudet, in *Globe*, March 31, 1881, quoted in Brigitte Koyoma-Richard, *Japon rêvé: Edmond de Goncourt et Hayashi Tadamasa* (Paris: Hermann 2001), 32: "Quelques chapitres intimes . . . prêtant à cette oeuvre d'un contemporain, dans toute la force du talent et de la vie, le charme grave, un peu mélancolique, d'une oeuvre posthume."

175. Zola, "Edmond de Goncourt," 207: "Ce n'est pas le vestibule nu et banal des logis bourgeois. Il est égayé et comme chauffé par des faïences, des bronzes, surtout par des *foukousas*. . . ."

176. Geffroy, "La maison des Goncourt," 147: "La façade est bourgeoise et discrète. . . . Une impression d'art se dégage avec une intensité extraordinaire de tout ce qui

entoure le visiteur . . . des perroquets sur fond vert d'eau, et partout, sur ce fond, sont accrochés les foukousas, ces carrés de soie brodés, de nuances tendres, sur lesquels les artistes japonais ont mis les hardiesses et les accentuations de leur dessin."

177. E. de Goncourt, *La maison d'un artiste*, vol. 1, 4: "Sur ce cuir, dans un désordre cherché . . . toutes sortes de choses voyantes et claquantes, de brillants cuivres découpés, des poteries dorées, des broderies du Japon et encore des objets bizarres, inattendus, étonnants par leur originalité, leur exotisme, et vis-à-vis d'un certain nombre desquels je me fais un peu l'effet du bon Père Buffier quand il disait: 'Voilà des choses que je ne sais pas, il faut que je fasse un livre dessus.' "

178. E. de Goncourt, *La maison d'un artiste*, vol. 1, 5: " . . . vous représente la decoration de l'angle religieux et mystique d'une chambre de prostituée de maison de thé, l'espèce de tableau d'autel devant lequel elle place une fleur dans un vase."

179. E. de Goncourt, *La maison d'un artiste*, vol. 1, 227–228: "Un mot aux albums érotiques. L'Orient n'a pas notre pudeur, ou du moins il a une pudeur autre . . . avant tout, il faut le déclarer, ces images n'ont rien de la polissonnerie froide de l'Occident et même de la Chine. Ce sont d'énormes gaietés, et comme le portefeuille d'un dieu des Jardins où l'indécence des choses est sauvée par une naïveté de temps primitifs, et, le dirai-je? par le michelangelesque du dessin."

180. E. de Goncourt, *La maison d'un artiste*, vol. 1, 231: "Il laisse tomber en arrière ses noirs cheveux capables d'enchaîner le coeur de mille hommes."

181. E. de Goncourt, *La maison d'un artiste*, vol. 1, 232: "Une des compositions les plus excentriques sorties de la cervelle et du crayon d'un artiste en une heure de caprice libertin."

182. E. de Goncourt, *La maison d'un artiste*, vol. 2, 189–91, 193:

> Quand je me peigne ou que je me brosse les dents. . . . Et voilà pourquoi mon cabinet de toilette est littéralement couvert de porcelaines et de dessins à la gouache.
>
> . . . sur chaque porte pend, frissonnant sous les courants d'air, un *kakemono*. . . .
>
> Et autour de ces objets, du plancher au plafond . . . , des assiettes, des assiettes, des assiettes. . . .
>
> Mais, au milieu de cette poterie de l'Asie. . . . Voici ce Saxe, la statuette du petit Chinois, aux pommettes à peine rosées dans sa blanche figure. . . .

183. Alphonse Daudet, "Ultima," manuscript for an essay published in the *Revue de Paris*, August 15, 1896, in *Cahiers Edmond & Jules de Goncourt* 4 (1995–96): 45.

184. E. de Goncourt, *La maison d'un artiste*, vol. 2, 189: " . . . Au plafond, c'est une copie agrandie d'une page de l'album japonais qui a pour titre: LES OISEAUX ET LES

FLEURS DES QUATRE SAISONS . . . , une copie exécutée à l'huile par mon 'Anatole' de MANETTE SALOMON. Car Anatole Bazoche n'a pas terminé son existence au Jardin des Plantes, ainsi qu'il finit dans le roman. Il est, je crois, bien vivant encore, et même le malheureux, après la Commune, sans qu'il eût rien fait pour cela, a passé, sur les pontons, un temps assez long, pour, au jour de sa délivrance, avoir eu, à son premier repas à terre, un moment d'hésitation devant une fourchette et l'usage qu'on en fait."

185. E. de Goncourt, *La maison d'un artiste*, vol. 2, 346: "La princesse Mathilde a jeté des oiseaux et des fleurs aquarellés dans le goût japonais. . . . Sur les parois . . . sont accrochés seulement trois objets de haut goût." On *bichons*, see Bannour, *Edmond et Jules de Goncourt*, 65.

186. E. de Goncourt, *La maison d'un artiste*, vol. 2, 349: "A l'heure présente, c'est bizarre, quand je me prépare à écrire un morceau, un morceau quelconque, un morceau où il n'entre pas le moindre bric-à-brac, pour m'entraîner, pour me monter, pour faire jaillir le styliste, de l'écrivain paresseux et récalcitrant à l'arrachement douloureux du style, j'ai besoin de passer une heure dans ce cabinet et ce boudoir de l'Orient. Il me faut me remplir les yeux de la patine des bronzes, des ors divers des laques, des irisations des flambés, des éclairs des matières dures, des jades, des verres colorés, des chatoiements de la soie des foukousas et des tapis de Perse, et ce n'est que par cette contemplation d'éclats de couleur, par cette vision excitante, irritante pour ainsi dire, que peu à peu, et,—je le répète sans que cela ait aucun rapport avec le sujet de ma composition,—je sens mon pouls s'élever, et tout doucement venir en moi cette petite fièvre de la cervelle, sans laquelle je ne puis rien écrire qui vaille."

187. Koechlin, *Souvenirs*, 3–4: "un goût particulièrement raffiné."

188. Michel Beurdeley and Michèle Maubeuge, *Edmond de Goncourt chez lui* (Nancy: Presses universitaires de Nancy, 1991), 118: "On remarquera que les objets orientaux prisés par Edmond pourraient surtout être catalogués dans la catégorie *kitsch*, la richesse des materiaux et des couleurs, l'aspect cossu, le clinquant, les techniques complexes sont des critères de choix favoris qui déterminent l'élection d'un objet d'art. En cela Edmond est bien de cette époque qui affectionnait le capiton du style tapissier et le goût bibelotier traducteur d'opulence financière plutôt que de sensibilité esthétique ou de connaissances archéologiques."

189. Clement Greenberg famously defined "that thing to which the Germans give the wonderful name of *Kitsch*: popular, commercial art and literature with their chromeotypes, magazine covers, illustrations, ads, slick and pulp fiction, comics, Tin Pan Alley music, tap dancing, Hollywood movies, etc., etc." (*Art and Culture: Critical Essays* [Boston: Beacon, 1961], 9).

190. Sontag, "Notes on Camp," 286.

191. Silverman, *Art Nouveau in Fin-de-Siècle France*, 19, 21, 23. Silverman's simplisitic characterization of the Goncourts' politics is not supported by her citations to long page ranges from broad cultural histories of France that offer far more nuanced analyses of the Goncourts. Readily available studies of the Goncourts make clear that their professions of allegiance to aristocracy over democracy refer to hierarchies of beauty and sensibility and were completely compatible with their calls for "an aristocracy of talent, open to the common people and recruited on broad lines extending to intelligent minds among the working classes" (in Billy, *The Goncourt Brothers*, 189; see also 23, 27, 181).

192. E. de Goncourt, *La maison d'un artiste*, vol. 1, 1: "Cette tête, que quelques promeneurs regardent d'un oeil farouche, n'est point,—ai-je besoin de le dire?—une affiche des opinions politiques du propriétaire, elle est tout bonnement l'enseigne d'un des nids pleins de choses du XVIIIe siècle qui existent à Paris."

193. E. and J. de Goncourt, *Journal*, July 7, 1892, vol. 3, 729.

194. Silverman, *Art Nouveau in Fin-de-Siècle France*, 35. These errors and other misreprentations in Silverman's book are also noted in Pamela Warner's dissertation "Word and Image in the Art and Criticism of the Goncourt Brothers," 379–80n7; 399–400n116.

195. E. de Goncourt, *La maison d'un artiste*, vol. 2, 198, 200, 202:

> Ce lit . . . passait pour le lit où couchait la princesse. . . .
>
> Un ensemble d'objets qui, le matin, lorsque j'ouvre les yeux, me donne l'impression de me réveiller, non dans mon temps que je n'aime pas, mais bien dans le temps qui a été l'objet des études et des amours de ma vie: en quelque chambre d'un château d'une *Belle au Bois dormant* du temps de Louis XV, épargnée par la Révolution et la mode de l'acajou.
>
> . . . En les profondeurs livides de la glace obscure, en son luisant de perle noire, au-dessous de baldaquin blanc . . . , le portrait de Jules se reflète,—tout lointain."

Pamela Warner notes Silverman's mistranslation of this passage ("Framing, Symmetry, and Contrast," 63n47).

196. E. and J. de Goncourt, *Journal*, November 27, 1888, vol. 3, 182–83: "En maniant des *jolités* . . . en touchant et retournant ces navettes, ces étuis, ces flacons, ces ciseaux, qui ont été pendant des années les petits outils des travaux d'élégance et de grâce des femmes du temps, il vous arrive de vouloir retrouver les femmes auxquelles ils ont appartenu et de les rêver, ces femmes—le petit objet d'or ou de Saxe, amoureusement caressé de la main."

197. Sontag, "Notes on Camp," 275, 280, 290.

198. Robert de Montesquiou, *Pas effacés*, vol. 2 (Paris: Paul-Louis Couchoud, 1923), 102, 106–7: "les volumes cent fois feuilletés de *La maison d'un artiste*"; "Il ne se passa guère de jour qui ne me vît rapporter dans ma 'maison d'un artiste' à moi, quelqu'un de ces objets d'un attrait si captivant"; on the ivy, see 214.

199. W[alford] Graham Robertson, *Time Was: The Reminiscences of W. Graham Robertson* (London: Hamilton, 1933), 100.

200. J.-K. Huysmans, *Lettres inédites à Edmond de Goncourt*, Pierre Lambert and Pierre Cogny, eds. (Geneva: Droz, 1956), 16, 67: "Et enfin cet exquis et précieux art du Japon, démonté et expliqué, rendu visible, palpable, transmué en une égale orfèvrerie de mots, par une savante alchimie d'artiste. . . . Si j'ai eu l'ambition d'écrire, c'est à vos livres que je le dois."

201. E. and J. de Goncourt, *Journal*, May 16, 1884, vol. 2, 1074: "Ça a l'air d'un livre de mon fils bien-aimé." Edmond de Goncourt to J.-K. Huysmans, May 15, 1884, in J.-K. Huysmans, *Lettre inédites à Edmond de Goncourt*, 80: "Cela a un peu l'air de la monographie du mari que devrait épouser *Chérie*."

202. E. and J. de Goncourt, *Journal*, June 9, 1881, vol. 2, 1081: "Ces mêmes gens, je les trouve dans une stupefaction admirative de l'*orangé* découvert par Huysmans pour son intérieur de des Esseintes dans A REBOURS, de cet *orangé* qui est, au fond, un ton de tableau et non d'appartement."

203. Sontag, "Notes on Camp," 276. This statement does not fully acknowledge Sontag's investments, which were complex and contradictory, torn between her grappling with her own sexuality and her aspirations toward masterful cultural authority.

204. Paul Bourget, *Nouveaux essais de psychologie contemporaine*, 4th ed. (Paris: Alphonse Lemerre, 1886), 137–38, 155–56: "Personne depuis Balzac n'avait modifié à ce degré l'art du roman. . . . En plein milieu du second Empire, ils étaient l'un et l'autre des hommes de lettres de 1880 . . . une hyperacuité de sensations . . . leur maladie volontaire."

205. Bourget, *Nouveaux essais*, 145, 147–49:

> . . . Ils ont ramassé autour d'eux les dessins et les eaux-fortes, les bronzes et les porcclaines, les meubles et les tapisseries, jusqu'aux foukousas et aux kaké-monos du Japon. Ils ont vécu dans un petit musée sans cesse aggrandi, et ils en ont vécu. . . .
>
> L'oeuvre d'art est ici comme déracinée . . . un moyen d'entrée dans des per-sonnalités étrangères. . . .
>
> Les frères de Goncourt ont été des hommes de musée, et en cela des mo-dernes, dans toute la force du mot. . . . Les formes imprévues de l'art japonais

flattent ses yeux, qu'une éducation trop complexe a rendus pareils, dans un ordre différent, à un palais de gourmand dégoûté.

206. Goncourt recorded the new look of these rooms for the benefit of "those curious about art and literature who, in the twentieth century, will take an interest in the memory of the two brothers," describing the *kakemonos*, the *foukousa* on the red ceiling, the violet *obi* decorated with owls flying across white wisteria on the red walls, "the bibelots set with translucent colored materials, fabricated as is the custom for things from the Empire of the Rising Sun" (E. and J. de Goncourt, *Journal*, December 14, 1894, vol. 3, 1046–47: "Aux curieux d'art et de littérature qui dans le XXe siècle s'intéresseront à la mémoire des deux frères" "bibelots au sertissement de matières colorées, translucides, en cette fabrication habituelle à l'article de l'Empire du Lever du Soleil.") This text, including many more references to Japanese objects and clearly written as a sequel to *La maison d'un artiste*, was published in the 1896 edition of the *Journal des Goncourt*, 268–89, and as an article, "Le Grenier," *Gazette des Beaux-Arts*, period 3, year 38, vol. 15 (February and March 1896), 101–11, 185–94.

207. E. and J. de Goncourt, *Journal*, April 15, 1886, vol. 2, 1241.

208. Max Nordau, *Degeneration*, anonymous translation (1892, 1895; repr., New York: Howard Fertig, 1968), 10, 15, 27, 486.

209. Brookner, *The Genius of the Future*, 125.

210. *Journal des Goncourt*, July 1, 1875, 1891 edition, 211: "Je regrette qu'il ne lui ait pas donné le milieu hospitalier et plaisant d'une habitation de là-bas, d'un petit coin de patrie retrouvée."

211. Historians err in describing Krafft's house as a response to Émile Guimet's display of objects "glorifying the exalted spiritual traditions of Japan" (Annette Leduc Beaulieu, "Hugues Krafft's Midori-no-sato," in *Twentieth Century Perspectives on Nineteenth Century Art: Essays in Honor of Gabriel P. Weisberg*, ed. Petra ten-Doesschate Chu and Laurinda S. Dixon [Newark: University of Delaware Press, 2008], 162), for Guimet's Parisian museum of comparative religions did not open until 1889.

212. Michelle Morlet, "Hugues Krafft," *Regards sur notre patrimoine: Bulletin de la Société des amis du Vieux Reims* 6 (1999): 5.

213. Robert Nye's *Masculinity and Male Codes of Honor in Modern France* (Oxford: Oxford University Press, 1993) identifies these duties as central to bourgeois forms of "social reproduction" (9).

214. Hugues Krafft, *Souvenirs de voyage au Japon: Communication faite avec accompagnement de projections photographiques à la lumière oxhydrique à la séance de la Société de Géographie de Paris du 4 avril 1884* (Reims: Imprimerie Coopérative, 1884), in Suzanne Esmein,

Hugues Krafft au Japon de Meiji (Paris: Hermann, 2003), 106. This text was also published by Krafft as "Au Japon: Notes et souvenirs de voyage et de séjour," *Revue économique française* 6, no. 4 (February 1884): 205–14.

215. Hugues Krafft to Félicie Krafft, November 12, 1882, in Beaulieu, "Hugues Krafft's Midori-no-sato," 164. The frequency of Krafft's letters home fell off when his friends left Japan. Of the seven bound books of Krafft's letters from Japan preserved at the Musée Le Vergeur in Reims, the first six cover the five months with his friends, leaving just one volume to cover the two months when he was there on his own.

216. The penchant for secrecy demonstrated in Krafft's *Souvenirs de notre tour du monde* extends to the obfuscation of dates and names and even to changing the name of his hotel. Dedicating the book to his travel companions, he said that it was "written before your eyes, and yet still unknown to you ("Ecrites sous vos yeux, et pourtant encore inconnues de vous") (np).

217. Krafft, *Souvenirs de notre tour du monde*, 336–37: "Le théâtre éclaire à l'étranger sur la philosophie et la force de résistance inouïes que déploie la race japonaise. . . . Le théâtre manifeste encore la froideur et l'impassibilité extérieures qu'on remarque dans les rapports journaliers, où les affections et les amitiés sont dissimulées sous des manières empreintes de la politesse la plus compassée. . . ."

218. Krafft's personality is described in Morlet, "Hugues Krafft," 7.

219. Krafft, *Souvenirs de notre tour du monde*, 338: "Il a adopté un genre de vie auquel se prêteraient peu d'Occidentaux, mais qui est le seul admissible pour qui veut rester journellement en contact avec la civilisation nationale du pays."

220. Annette Leduc Beaulieu, "Promenade japonaise avec Hugues Krafft," *Regards sur notre patrimoine: Bulletin de la Société des Amis du Vieux Reims* 17 (2005): 15.

221. Hugues Krafft to Félicie Krafft, March 11, 1883, in Beaulieu, "Hugues Krafft's Midori-no-sato," 165.

222. Krafft, *Souvenirs de notre tour du monde*, 339–40: "le lawn-tennis, où les dames brillent au premier rang!"; "les fausses notes de Mrs. X . . . , les gazouillements de Miss Y . . . et la rêverie mélodieuse de Mrs. Z. . . . Ces dames sont vraiment bien bonnes de se donner ainsi en spectacle les unes aux autres" (ellipses in original). Krafft's presentation of these vignettes as examples of Englishness abroad contrast with his admiring comments about male British diplomats (345–46).

223. Krafft, *Souvenirs de notre tour du monde*, 331–33; Esmein, *Hugues Krafft au Japon de Meiji*, 60–61.

224. Isabella Stewart Gardner to M. Howe, June 30, 1883, in Alan Chong, and Noriko Murai, eds., *Journeys East: Isabella Stewart Gardner and Asia* (Boston: Isabella Stewart Gardner Museum, 2009), 123.

225. Hugues Krafft to Félicie Krafft, 1882, in Beaulieu, "Promenade japonaise avec Hugues Krafft," 13: "Pauvre femme, je crois que je la plains plus que le monde ne la blâme, son intérieur de famille ne doit pas luire beaucoup en rose, et il me semble qu'elle se cramponnerait volontiers au Japon et à ceux qu'elle y rencontre. . . . Nous sommes maintenant en meilleurs termes."

226. Hugues Krafft to Félicie Krafft, March 24, 1883, Musée Le Vergeur.

227. Krafft, *Souvenirs de notre tour du monde*, 258: "Il défie absolument toute description par ses mille détails ravissants. Certaines pièces comme certains petits jardins sont des bonbonnières adorables, de petits chefs-d'oeuvre de patience et de goût que l'on voudrait pouvoir emporter et installer chez soi au delà des mers."

228. Albert Maumené, "Les jardins de la villa des lotus," *La vie à la campagne* 1, no. 10 (1907), 307. Maumené describes a group of Japanese workers brought by the duchess but refers to a single Japanese carpenter constructing Krafft's house ("Le parc de Midori, *La vie à la campagne*, year 4, vol. 5, no. 61 [1909]: 199); Régamey's account of Krafft's house also refers to a single Japanese carpenter (*Japan in Art and Industry*, trans. M. French-Sheldon and Eli Lemon Sheldon [1891; repr., New York: G. P. Putnam, 1893], 228).

229. Krafft, *Souvenirs de notre tour du monde*, 321.

230. Félix Régamey, *Japan in Art and Industry*, trans. M. French-Sheldon and Eli Lemon Sheldon (1891; repr., New York: G. P. Putnam's Sons, 1893), 226–28.

231. Beaulieu, "Hugues Krafft's Midori-no-sato," 166–67. The dates of Hata's work for Krafft are unclear, as he worked for other clients as well. Beaulieu says Hata worked for Krafft until 1896. Junji Suzuki suggests that Krafft did not employ him until 1896, although he had visited the garden before then ("Le jardinier japonais de Robert de Montesquiou—ses évocations dans les milieux littéraires," *Cahiers Edmond et Jules de Goncourt* 18 [2011]: 109), but the bonsai garden that Hata is credited with creating is pictured, at least in preliminary form, in photographs of the 1886 opening ceremony and is described in Félix Régamey's *Le japon pratique* [*Japan in Art and Industry*] (Paris: J. Hetzel et Cie, 1891).

232. Albert Maumené, "Le parc de Midori," *La vie à la campagne*, year 4, vol. 5, no. 61 (1909): 202: "Ce n'est pas sans émotion que cette scène sera contemplée par ceux qui en ont vu de semblables au Japon." See also Maumené's "Le jardin japonais miniature de Midori." *La vie à la campagne*, year 6, vol. 9, no. 114 (June 15, 1911), 369–73.

233. Junji Suzuki, "Le jardinier japonais de Robert de Montesquiou," 107–8.

234. Quotations from Krafft's guestbook, *Le livre d'or de "Midori-no-sato,"* Musée Le Vergeur, translated into French and annotated by Junji Suzuki. The first two are from Masatomo Hagiwara and Senri Nagasaki (Tadamasa Hayashi's brothers):

"Contemplant la verdure des collines, je prends du thé et je me crois être dans ma patrie"; "J'ai eu l'impression de me retrouver dans ma patrie." The last, signed Tangaku, reads: "Quelle surprise! Dans cette terre lointaine / le paysage, tout comme la maison / baigne dans la brume / comme dans ma patrie au printemps." Okakura's reads, "Le décor du jardin surprend mon Coeur de voyageur. . . . Loin de ma patrie, mon âme est triste."

235. Louis Gonse, "L'art japonais et son influence sur le goût européen," *Revue des arts décoratifs* 18, no. 1 (1898): 101–2: "Quand on se trouve au milieu de ce jardin ou dans cette maison, avec les baies ouvertes, par une belle journée de printemps ou d'automne, on éprouve absolument les sensations que le Japonais peut avoir devant la nature."

236. Régamey, *Japan in Art and Industry*, 218–19.

237. Régamey, *Japan in Art and Industry*, 66. Hugues Krafft to Masamoto Hagiwara, November 15, 1895, in Institut de Tokyo, Institution Administrative Indépendante, Centre National de Recherche pour les Propriétés Culturelles, *Correspondance adressée à Hayashi Tadamasa* (Kokushokankôkai, 2001), 197: "À mon sentiment, Madame la Baronne Durieux ne trouvera pas dans mon petit 'zashiki' japonais de Jouy en Josas des objets quelconques pouvant lui donner des indications pour l'ameublement d'un salon moderne 'à la japonaise.' "

238. Krafft, *Souvenirs de voyage au Japon*, as cited at note 214, in Esmein, *Hugues Krafft au Japon de Meiji*, 105–6:

Je me permets d'insister particulièrement sur ce point essentiel, parce que j'ai trouvé, contre mon attente, à mon arrivée au Japon, l'installation intérieure du Japonais toute différente de ce que j'imaginais et que je crois avoir partagé, à ce point de vue, l'erreur de tous ceux qui connaissent le Japon de réputation seulement. . . .

Il n'y a donc, Messieurs, dans les habitations de toutes catégories, ni grandes porcelaines décoratives, ni broderies multicolores en tentures ou en ornements, ni meubles extraordinaires de laque ou de bois, ni bibelots de bronze ou d'ivoire, ni enfin aucun de ces objets luxueux ou bizarres dont nous garnissons nos appartements "à la japonaise."

Compare Krafft, *Souvenirs de notre tour du monde*, 256–59.

239. Beaulieu, "Hugues Krafft's Midori-no-sato," 162–63, 169nn14,17. Krafft's friend William Sturgis Bigelow also used dry-plate photography, as did Percival Lowell.

240. Esmein, *Hugues Krafft au Japon de Meiji*, 10–11; Beaulieu, "Hugues Krafft's Midori-no-sato," 169n18. Krafft's adopted role of explorer-photographer led him to further expeditions of documented travel throughout eastern Europe and the Near

East. As an architectural souvenir of these trips, he built a "Moorish Court" on the grounds of Midori-no-sato in 1893.

241. Krafft, *Souvenirs de notre tour du monde*, 254, 259: "Le Japon est bien décidément le pays des excursions par excellence. . . ."; "Quel cortège! Quatorze jin-riki-sha à deux coureurs chacune, soit avec Ito un ensemble de trente-deux hommes! Tout un petit bataillon!" One of Krafft's French companions who had fallen ill stayed in Yokohama to recover, joining the group only for the return journey, which is why Krafft counts 32 in the party.

242. Krafft, *Souvenirs de notre tour du monde*, 260, 267, 292: "Admirerez-vous avec nous nos infatigables et gais coureurs. . . . Ils lavent au courant des fontaines leurs membres nus admirablement musclés"; "Les dessins de couleurs mates en bleu et rouge se marient admirablement avec la teinte hâlée des épidermes, qui sont remarquablement doux et lisses."

243. This sedan chair is now at the Musée de la voiture at the Château de Compiègne.

244. Identified with the name Ito when he appears in Krafft's personal pictures with family and friends, this man was at Midori-no-sato when it opened in 1885–86, to judge from both the newness of the plantings and the ages of the identified children pictured with him; he is likely the carpenter brought from Japan to assemble the house and may also have assisted with the gardens.

245. E. and J. de Goncourt, *Journal*, April 3, 1887 vol. 3, 27: "Pour les objets que j'ai possédés, je ne veux pas après moi de l'enterrement dans un musée, dans cet endroit où passent des gens ennuyés de regarder ce qu'ils ont sous les yeux. Je veux que chacun de mes objets apporte à un acquéreur, à un être bien personnel, la petite joie que j'ai eue en l'achetant." (This passage appears in the 1894 edition.)

246. "Revue de Ventes de Février," *Le Figaro artistique*, April 2, 1925, 394.

247. Alan Scott Pate, *Japanese Dolls: The Fascinating World of Ningyo* (Rutland, VT: Tuttle, 2008), 36–37.

248. Jules Adeline, *Le chat d'après les japonais* (Rouen: Cagniard, 1893).

249. This image has been interpreted as symbolizing Bing himself, "the tireless warrior doing battle for Japonisme" (Gabriel P. Weisberg, "The Creation of Japonisme," in *The Origins of L'Art Nouveau: The Bing Empire*, ed. Gabriel P. Weisberg, Edwin Becker, and Evelyne Possémé [Ithaca, NY: Cornell University Press, 2004], 70).

250. Schwartz's *The Imaginative Interpretation of the Far East* offers a heterosexualizing gloss of this poem, inventing an unhappy love affair between Mi-Ki-Ka and another doll and overlooking the two fathers (107–8). The poem is discussed in relation to the type of doll it represents in Pate, *Japanese Dolls*, 36–37.

251. Roland Barthes, *The Rustle of Language*, trans. Richard Howard (New York: Hill and Wang, 1986), 144.

252. These fantasies of stepping outside convention are no less relevant when performed—as in the case of Adeline and Brieux—by married men.

253. Hugues Krafft to Félicie Krafft, January 25, 1883, Musée Le Vergeur: "Le fait c'est que je me sens on ne peut plus à l'aise et satisfait ici."

2. BACHELOR BRAHMINS: TURN-OF-THE-CENTURY BOSTON

1. Edo-Tokyo Museum and Peabody Essex Museum, *Worlds Revealed: The Dawn of Japanese and American Exchange* (Tokyo: Edo-Tokyo Museum, 1999), 32, 60–61, 63.

2. *Salem Directory and City Register* (Salem, MA: Henry Whipple, 1842), 119.

3. Oliver Wendell Holmes, *The Autocrat of the Breakfast Table* (1858; repr., Boston: Houghton Mifflin, 1883), 125–26. On these columns, see Edwin M. Bacon, *Bacon's Dictionary of Boston* (Boston: Houghton Mifflin, 1886), 206–7.

4. Bacon, *Bacon's Dictionary of Boston*, 30.

5. Paul DiMaggio, "Cultural Entrepreneurship in Nineteenth-Century Boston": part 1, "The Creation of an Organizational Base for High Culture in America"; part 2, "The Classification and Framing of American Art," *Media, Culture and Society* 4, 1982: 34.

6. Oliver Wendell Holmes, "The Professor's Story," *Atlantic Monthly* 5, no. 27 (1860): 93–96. This story was republished as a novel titled *Elsie Venner*.

7. Ibid., 91–93, 98.

8. Christine Guth, *Longfellow's Tattoos: Tourism, Collecting, and Japan* (Seattle: University of Washington Press, 2004), 22, 29; see also 169–70.

9. James D. McCabe, *The Illustrated History of the Centennial Exhibition, Held in Commemoration of the One Hundredth Anniversary of American Independence* (Philadelphia: National Publishing, 1876), 414–17.

10. Neil Harris, "All the World a Melting Pot? Japan at American Fairs, 1876–1904," in *Mutual Images: Essays in American–Japanese Relations*, ed. Akira Iriye (Cambridge, MA: Harvard University Press, 1975), 30.

11. Van Wyck Brooks, *Fenollosa and His Circle, with Other Essays in Biography* (New York: Dutton, 1962), 17.

12. Ernest Fenollosa to Edward Morse, 1884, in Brooks, *Fenollosa and His Circle*, 25; Ernest F. Fenollosa, *Epochs of Chinese and Japanese Art: An Outline History of East Asiatic Design*, 2nd ed. (New York: Frederick A. Stokes, 1921), 3–4.

13. John La Farge, *An Artist's Letters from Japan* (New York: Century, 1897), 140.

14. Basil Hall Chamberlain to Lafcadio Hearn, August 5, 1893, in Kazuo Koizumi, ed., *Letters from Basil Hall Chamberlain to Lafcadio Hearn* (Tokyo: Hokusaido Press, 1936), 33.

15. DiMaggio, "Cultural Entrepreneurship in Nineteenth-Century Boston," 39, 314; Hina Hirayama, "A True Japanese Taste: Construction of Knowledge about Japan in Boston, 1880–1900" (Ph.D. dissertation, Boston University, 1999), 4. Bigelow's letters exemplify this dynamic as they ricochet from condemnation of Catholic art and exhortations to "rout up" the Catholics in Boston to accounts of buying Japanese art (William Sturgis Bigelow to Henry Cabot Lodge, April 6, 1875, "Selected Letters of Dr. William Sturgis Bigelow," ed. Akiko Murakata [Ph.D. dissertation, George Washington University, 1971], 42).

16. DiMaggio, "Cultural Entrepreneurship in Nineteenth-Century Boston," 47.

17. Bill Brown, A Sense of Things: The Object Matter of American Literature (Chicago: University of Chicago Press, 2003), 87, 109; the term "object lesson" is credited to G. Brown Goode's 1889 "The Museums of the Future" (215n28).

18. DiMaggio, "Cultural Entrepreneurship in Nineteenth-Century Boston," 317.

19. Henry James, The American Scene (New York: Harper and Brothers, 1907), 240–41, 243.

20. Boston Sunday Herald, September 7, 1890, in Lawrence W. Chisolm, Fenollosa: The Far East and American Culture (New Haven: Yale University Press, 1963), 91.

21. James, The American Scene, 244–45.

22. Arthur Fairbanks, "The Museum of Fine Arts in Boston in Its New Quarters," Museums Journal 9, no. 10 (1910): 366.

23. Mary B. Hartt, "The Boston Museum: A New Way of Showing Works of Art," Outlook, January 22, 1910, 207.

24. DiMaggio, "Cultural Entrepreneurship in Nineteenth-Century Boston," 34. See also Carol Duncan, Civilizing Rituals: Inside Public Art Museums (New York: Routledge, 1995). On the pedagogical origins of the Boston Museum of Fine Arts, see Neil Harris, "The Gilded Age Revisited: Boston and the Museum Movement," American Quarterly 14, no. 4 (1962). Taking the founders at their populist word and using modern museums as a standard of appropriate practice, Harris is baffled by critics who characterize the Museum of Fine Arts as elitist.

25. Both as an individual and—with Percival Lowell, Edward Morse, and Salem notables Charles S. Rea, William Crowninshield Endicott Jr., and Robert Osgood—as part of a group called the "Six Friends," Bigelow also gave extensive collections of Japanese textiles, sword guards, ceramics, and lacquerware to the Peabody Academy of Science in Salem.

26. Bigelow, "Selected Letters," 42.

27. Walter Muir Whitehill, Museum of FineArts, Boston: A Centennial History, vol. 1 (Cambridge, MA: Harvard University Press, 1970), 47, 108–9.

28. Henry Wadsworth Longfellow to Charles Longfellow, October 18, 1872; Charles Longfellow to Henry Wadsworth Longfellow, February 10, 1873, in Christine

Wallace Laidlaw, ed., *Charles Appleton Longfellow: Twenty Months in Japan, 1871–1873* (Cambridge, MA: Friends of the Longfellow House, 1998), 165, 181; Guth, *Longfellow's Tattoos*, 103. See also Henry Wadsworth Longfellow to Mary Appleton Mackintosh, March 3, 1874, *The Letters of Henry Wadsworth Longfellow*, ed. Andrew R. Hilen (Cambridge, MA: Harvard University Press, 1982), 723.

29. Guth, *Longfellow's Tattoos*, xiii, 180–93.

30. Laidlaw, *Charles Appleton Longfellow*, 186. A statue of tattooed grooms carrying a sedan chair thought to have been purchased in Japan by Charles Longfellow is in the collection of the Peabody Essex Museum, Salem, Massachusetts (Guth, *Longfellows's Tattoos*, 147).

31. Mark Twain, *A Tramp Abroad*, vol. 1 (Leipzig, Germany: Bernhard Tauchnitz, 1880), 165.

32. Quoted in A. Lawrence Lowell, *Biography of Percival Lowell* (New York: Macmillan, 1935), 11.

33. La Farge, *An Artist's Letters from Japan*, 17–22.

34. Théodore Duret, "Hokousaï," in *Critique d'avant-garde* (1882; repr., Paris: G. Charpentier, 1885), 208–9, 239. Félix Régamey repeated this anecdote in relation to attitudes toward Japan among rightwing Frenchmen, as discussed in my *The Chrysanthème Papers: The Pink Notebook of Madame Chrysanthème and Other Documents of French Japonisme* (Honolulu: University of Hawai'i Press, 2010), 26.

35. Louis Gonse, *L'art japonais* (Paris: Société française d'éditions d'art, n.d. [1883]), 48: "l'école dite vulgaire"; 88: "Hokusai a été un artiste du peuple; il est mort ignoré ou même méprisé de la classe noble"; 87: "À notre point de vue européen, il en est même le plus grand, le plus genial."

36. Ernest F. Fenollosa, *Review of the Chapter on Painting in Gonse's "L'art japonais"* (Boston: James R. Osgood, 1885), 33, 48.

37. Gonse, *L'art japonais*, 6: "avec leur esprit précis et pratique"; 48–50: "Aux yeux des Japonais, il [le style populaire] est resté dans un rang inférieur, bon pour satisfaire les instincts de la populace, main indigne de l'attention des personnes comme il faut. . . . L'école vulgaire, sortie des entrailles mêmes de la nation, est l'expression populaire et sans aucun mélange étranger du génie japonais; à mes yeux, il en est la forme la plus originale, la plus complète, celle qui nous fair pénétrer le plus intimement dans l'esprit du Nippon." My discussion draws from Jan Walsh Hokenson, *Japan, France, and East–West Aesthetics* (Madison, NJ: Fairleigh Dickinson University Press, 2004), 124–25.

38. Satoko Fujita Tachiki, "Okakura Kakuzo (1862–1913) and Boston Brahmins" (Ph.D. dissertation, University of Michigan, 1986), 37.

39. Edward Morse, letter to the *Boston Evening Transcript*, September 28, 1883, repr. as "Alleged 'Satsuma' in Boston," *The Art Amateur* 9, no. 6 (November 1883).

40. Edward Sylvester Morse, "Japanese Pottery," *The Nation*, November 13, 1890, 383. Although this review was initially published anonymously, Morse quickly affirmed his authorship. My analysis is indebted to Hirayama, "A True Japanese Taste," 117–39.

41. Edward Sylvester Morse, *Japanese Homes and Their Surroundings* (New York: Harper and Brothers, 1885), xviii–xix, xxxiii–xxxiv.

42. Edward Sylvester Morse, "Old Satsuma," *Harper's New Monthly Magazine*, September 1888, 524–26.

43. Edward Sylvester Morse, *Japan Day by Day: 1877, 1878–9, 1882–83* (Boston: Houghton Mifflin, 1917), 44; see also 125, 131, 194.

44. William Sturgis Bigelow to Edward Morse, in E. Morse, *Japan Day by Day*, vol. 1, x. Bigelow's "forty years ago" exaggerates the time separating this letter from their experience in Japan.

45. Ellen Conant, "Captain Frank Brinkley Resurrected," in *Meiji no takara: Treasures of Imperial Japan, Selected Essays, Nasser D. Khalili Collection of Japanese Art*, vol. 1, eds. Oliver Impey and Malcolm Fairly (London: Kibo Foundation, 1995), 126, 130, 136.

46. Frank Brinkley, "Professor Morse on Old Satsuma," *Japan Weekly Mail*, December 1, 1888: 514. This article appeared in the *Boston Herald*, January 21, 1889 (Hirayama, "A True Japanese Taste," 136).

47. James L. Bowes, *Japanese Pottery* (London: Edward Howell: 1890), x.

48. James L. Bowes, *A Vindication of the Decorated Pottery of Japan* (n.p.: privately printed, 1891), 4. This booklet reprints letters to the editor, articles, and reviews supportive of Bowes's scholarship.

49. Untitled editorial, *The Japan Weekly Mail*, in Bowes, *A Vindication of the Decorated Pottery of Japan*, 56–58. Basil Hall Chamberlain's 1890 *Things Japanese*, 5th ed. (1890; repr., London: John Murray, 1905) notes debates "among collectors" over the tea ceremony, summarizing how one side "asserts that their influence has cramped the genius of Japanese art," whereas the other argues that their "influence . . . has kept the Japanese from leaving the narrow path of purity and simplicity for the broad road of meretricious gaudiness" (404), but his sympathies are clear in his conclusion that, "to a European the ceremony is lengthy and meaningless. When witnessed more than once it becomes intolerably monotonous" (409).

50. E. Morse, "Old Satsuma," 513.

51. Dorothy G. Wayman, *Edward Sylvester Morse: A Biography* (Cambridge, MA: Harvard University Press, 1942), 234.

52. E. Morse, "Japanese Pottery," 383.

53. Edmond and Jules de Goncourt, *Journal: Mémoires de la vie littéraire*, ed. Robert Ricatte, vol. 3, May 1859 (Paris: Fasquelle and Flammarion, 1956), April 21, 1894, 948: "en général composées d'objets n'ayant pas la délicatesse que nous demandons."

54. E. and J. de Goncourt, *Journal*, August 12, 1889, vol. 3, 310.

55. Conant, "Captain Frank Brinkley Resurrected," 132.

56. E. Morse, *Japan Day by Day*, vol. 2, 344; see also 399–400.

57. The dates and topics of the twelve lectures, as printed on the tickets and in newspaper advertisements, were, in order, "1) Country, people, language. 2) Traits of the people. 3) Houses, food, toilet. 4) Homes and their surroundings. 5) Children, toys, games. 6) Temples, theatres, music. 7) City life and health matters. 8) Country life and natural scenery. 9) Educational matters and students. 10) Industrial operations. 11) Keramic and pictorial Arts. 12) Antiquities."

58. Unidentified newspaper clipping, Morse Papers, quoted in Hirayama, "A True Japanese Taste," 94.

59. "Comparative Civilization," *Boston Evening Transcript*, in Wayman, *Edward Sylvester Morse*, 276; Hirayama, "A True Japanese Taste," 97.

60. E. Morse, "Japanese Pottery," 383.

61. Hirayama, "A True Japanese Taste," 129–30. As "Keeper," Morse produced the *Catalogue of the Morse Collection of Japanese Pottery* (Cambridge, MA: Riverside Press, 1901), which carried a preface describing his goals. The "main one"—apparently the only one, since no other goals are articulated—was "to make a collection of the pottery of Japan which should parallel the famous collections of the potteries of England, Holland, France, and adjacent countries, as seen in the museums of Europe" (iii). Where the national museums of Europe have an obvious rationale for representing their national art, Boston's frequently reiterated boasts to rival in quantity and quality the Japanese imperial art collection assert allegiance to an ideal of transnational aristocratic taste.

62. *Handbook of the Museum of Fine Arts Boston* (Boston: Museum of Fine Arts, 1907), 288.

63. The common art-historical habit of defining an aesthetic essence for non-Western cultures by excluding objects that demonstrate that culture's participation in the dynamics of innovation and adaptation characteristic of modernity is particularly misplaced in this case, for Japan's attention to the revenue from its decorative arts exports made it an active contributor to late nineteenth-century discourses of authenticity. The Japanese commission for the 1893 Columbian Exposition, for instance, defensively asserted that the goods on display were "the same items employed in domestic use," although what was shown in Chicago was a new kind of exportware, less obviously adapted to Occidental forms but still scaled for Western décor (Harris, "All the World a Melting Pot?", 38; Judith Snodgrass, *Presenting Japanese Buddhism to the West: Orientalism, Occidentalism, and the Columbian Exposition* [Chapel Hill: University of North Carolina Press, 2003], 41). On Japanese revenues from the decorative arts trade, see Olive

Checkland, *Japan and Britain After 1859: Creating Cultural Bridges* (London: Routledge Curzon, 2003), 50–55.

64. Hina Hirayama, "With Éclat": *The Boston Athenæum and the Origins of the Museum of Fine Arts, Boston* (Boston: Boston Athenæum, 2013), 142; Harris, "The Gilded Age Revisited," 553.

65. F[rank] J[ewett] Mather, "Art in America," *Burlington* 16, no. 83 (1910): 296. A "Guide to the Museum" printed in the *Bulletin of the Museum of Fine Arts* in 1903 "for the convenience of summer visitors to the Museum" advised viewers that "the most rugged and severe in taste may be seen in cases 2 and 3, the most aesthetic and delicate pottery in case 8, the finest effect of glazes in cases 18 and 20, the most beautifully decorated in cases 27, 28 and 38" (21). A more detailed description of each case appears in Edward Morse's 1902 "Report of the Keeper of Japanese Pottery," *Twenty-Seventh Annual Report for the Year 1902* (Boston: Museum of Fine Arts, 1903). The arrangements in each case were preserved when the collection was moved to the new museum building in 1909.

66. Matthew S. Prichard, "Current Theories of the Arrangement of Museums of Art and Their Application to the Museum of Fine Arts," *Museum of Fine Arts Boston: Communication to the Trustees Regarding the New Building* (Boston: privately printed by authority of the Committee of the Museum, 1904), 15–16.

67. Mather, "Art in America," 296. The *Nation* reviewer who signed simply "M"—possibly also Mather—reached the same conclusion (M., "Boston Art Museum," *Nation* 89, no. 2316 [1909]: 496).

68. Frederic Alan Sharf, *Art of Collecting: The Spaulding Brothers and Their Legacy* (Boston: MFA Publications, 2007), 32; K. T. [Kojiro Tomita], "The William S. and John T. Spaulding Collection of Japanese Prints," *Bulletin of the Museum of Fine Arts* 39, no. 235 (October 1941): 73.

69. Quoted in Museum of Fine Arts, Boston, *Bekkan Shunga meihinsen*, vol. 4 of ボストン美術館肉筆浮世絵/*Ukiyo-e paintings Museum of Fine Arts, Boston*, ed. Tsuji Nobuo (Tokyo: Kodansha, 2000–2001), 7, 13. This 2001 catalog cites the display of one handscroll "this past winter" as Japanese erotic art's "debut in the Museum galleries" (7). Another handscroll from Bigelow's donation, Torii Kiyonobu's *Erotic Contest of Flowers*, was included in a 2007 exhibition (Anne Nishimura Morse, ed. *Drama and Desire: Japanese Paintings from the Floating World, 1690–1850* [Boston: Museum of Fine Arts, 2007], no. 6).

70. William Sturgis Bigelow to Theodore Roosevelt, January 17, 1908, "Selected Letters," 299.

71. Museum of Fine Arts, Boston, *Bekkan Shunga meihinsen*. Other erotic prints were donated anonymously during this era, and there are erotic *ukiyo-e* in the

collection without provenance or accession data (for example, see *Dawn of the Floating World*, no. 20).

72. Hirayama, "With Éclat," 147. By 1903, the museum had a system of "Life Tickets" for a donation of $500; a $10 gift earned the status of Annual Subscriber, with the benefit of free admission of up to four people for that year (*Museum of Fine Arts Bulletin* 1, no. 3, [July 1903], 12).

73. *Handbook of the Museum of Fine Arts Boston*, 302.

74. E. and J. de Goncourt, *Journal*, April 21, 1894, vol. 3, 948. Such arrangements were not unprecedented. William Anderson, a British collector of Japanese prints, sold his collection to the British Museum and became its curator.

75. "The Listener," unidentified clipping, Museum of Fine Arts archive.

76. Ernest Fenollosa, *Hokusai, and His School: Museum of Fine Arts Department of Japanese Art Special Exhibitions of the Pictorial Art of Japan and China, No. 1* (Boston: Museum of Fine Arts, 1893), iv–xiv.

77. DiMaggio, "Cultural Entrepreneurship in Nineteenth-Century Boston," 303.

78. Rita Felski, *Beyond Feminist Aesthetics: Feminist Literature and Social Change* (Cambridge, MA: Harvard University Press, 1989), 168.

79. Conant suggests that Fenollosa as a young philosophy teacher "uncertain as to how many times his two-year contract . . . would be renewed and anxious to secure suitable employment on his return to Boston . . . aggressively set about assembling a consciously comprehensive collection of Japanese paintings that he hoped to sell to the Museum of Fine Arts" and have himself appointed curator (Ellen Conant with Steven D. Owyoung and J. Thomas Rimer, *Nihonga: Transcending the Past; Japanese-Style Painting, 1868–1968* [New York: Weatherhill, 1995], 23). Warren Cohen cites Fenollosa's prolonged negotiations with the museum for a long-term contract (*East Asian Art and American Culture*, 40). Morse's decision to go deeply into debt to acquire almost three thousand examples of Japanese ceramics in less than nine months in Japan in 1882–83 and his exertions to preserve the collection for the Museum of Fine Arts (Wayman, *Edward Sylvester Morse*, 292, 305–6, 350) suggest a similar strategy. Dealer Edward Greey impugned Morse's motives in a letter attempting to sell Frank Brinkley's East Asian ceramics collection to the Museum of Fine Arts in 1883: "Mr. Morse only took up the subject when he found it was a profitable investment and in his late rush through Japan has not had a chance of making a really fine collection" (in Conant, "Captain Frank Brinkley Resurrected," 132).

80. Scholars have assessed Fenollosa's and Morse's personal motivation and identity in various ways. Lawrence Chisolm's admiring biography, *Fenollosa: The Far East and American Culture*, asserts that he was "opposed temperamentally and philosophically" to the "aristocratic exclusiveness" of his "Boston milieu" but allows that "his

milieu might have drawn him toward elitist views" (116). Warren Cohen's *East Asian Art and American Culture* suggests that Morse may "have been insecure about lacking a Harvard degree" and recognizes that "the knowledge he gained of Japanese art would fill that gap, provide him with an expertise . . . and arm him for his forays into high-toned Boston society" (26). Fenollosa's letters to Morse, in the library of the Peabody Essex Museum, discuss schemes for professional advancement with a candor and enthusiasm that suggests the two men's allegiance.

81. Christopher Benfey, *The Great Wave: Gilded Age Misfits, Japanese Eccentrics and the Opening of Old Japan* (New York: Random House, 2003), 138.

82. Henry Adams to John Hay, July 9, July 27, 1886; Henry Adams to John White Field, August 4, 1886, *Letters of Henry Adams*, vol. 3, ed. J. C. Levenson, Ernest Samuels, Charles Vandersee, Viola Hopkins Winner (Cambridge, MA: Harvard University Press, 1982), 17, 24, 27.

83. E. Morse, *Japan Day by Day*, vol. 2, 246, 264, 283.

84. William Sturgis Bigelow to Edward Morse, September 3, 1883, "Selected Letters," 60–63.

85. Ernest Fenollosa to Edward Morse, April 26, 1884, Peabody Essex Museum; Josephine Nock-Hee Park, *Apparitions of Asia: Modernist Form and Asian American Poetics* (New York: Oxford University Press, 2008), 11.

86. E. Morse, *Japan Day by Day*, vol. 2, 413–14; on fleabites, vol. 1, 87, 161; on foot warming, vol. 2, 427–28.

87. E. Morse, *Japan Day by Day*, vol. 2, 379.

88. Wayman, *Edward Sylvester Morse*, 361; Cohen, *East Asian Art and American Culture*, 26.

89. "Mary McNeil-Scott's Literary Work," *Current Literature* 15, no. 2 (1894): 106.

90. Charles Lang Freer to Mary Fenollosa, November 17, 1908, Freer Gallery of Art; Mary Fenollosa draws attention to this stipulation of her husband's sale of his collection in her 1912 introduction to Fenollosa's *Epochs of Chinese and Japanese Art*. At this time, the *Museum of Fine Arts Bulletin* cited art collected by Fenollosa and purchased for the museum by Charles Goddard Weld as the "Weld Collection."

91. When the Fenollosas returned to the United States in 1900, they split their time between New York and Alabama.

92. William Sturgis Bigelow to Mary Fenollosa, December 9, 1908, Houghton Library, Harvard University.

93. Chisolm, *Fenollosa*, 119–20.

94. Fenollosa, *Hokusai, and his School*, xi; *Ninth Report of the Class Secretary of the Class of 1874 of Harvard College* (Cambridge, MA: Riverside Press, 1909), 42.

95. Ernest F. Fenollosa, *The Masters of Ukiyoe: A Complete Historical Description of Japanese Paintings and Color Prints of the Genre School* (New York: W. H. Ketcham, 1896),

III, I, 100. On Fenollosa's subsequent promotions of *ukiyo-e*, see Timothy Clark, *Ukiyo-e Paintings in the British Museum* (London: British Museum Press, 1992), 35.

96. Untitled editorial note, *The New Cycle* 9, no. 6–7 (December 1895–January 1896): 458. The last issue of *The Lotos* appeared in September 1896.

97. "An Exhibition of Japanese Color Prints and Paintings," *The Lotos* 9, no. 8 (1896): 634, 636.

98. Ernest F. Fenollosa, "Art Museums and Their Relation to the People," *The Lotos* 9, no. 11 and vol. 1 (new series), no. 5 (1986): 841–42.

99. Untitled review, *New York Times*, March 30, 1901.

100. Sidney McCall [Mary McNeil Fenollosa], *Truth Dexter* (1901; repr., Boston: Little, Brown 1906), 3–4, 118, 305.

101. Holmes, "The Professor's Story," 93.

102. George Santayana to Daniel Cory, in Daniel Cory, *Santayana: The Later Years* (New York: George Braziller, 1963), 158.

103. George Santayana, *The Last Puritan* (New York: Scribner, 1936), 1.

104. Santayana, *The Last Puritan*, 72, 63–64, 70, 581.

105. George Santayana, *The Letters of George Santayana*, vol. 5, ed. William G. Holzberger (Cambridge, MA: MIT Press, 2003), 291.

106. Santayana, *The Last Puritan*, 600. Santayana acknowledged that "there are some passages too much like my philosophy books" in the novel (George Santayana to Daniel Cory, in Cory, *Santayana*, 129).

107. Santayana, *Letters*, vol. 5, 333.

108. Oliver leaves the "Boston Museum of Art" a substantial legacy in memory of his father, "who was a collector of curios" (Santayana, *The Last Puritan*, 587).

109. Santayana, *The Last Puritan*, 156, 177.

110. Ralph Waldo Emerson, "The Transcendentalist: A Lecture Read at the Masonic Temple, Boston, January, 1842," in *The Complete Essays and Other Writings of Ralph Waldo Emerson*, ed. Brooks Atkinson (New York: Modern Library, 1940), 91–92.

111. Thomas A. Tweed, *The American Encounter with Buddhism, 1844–1912: Victorian Culture and the Limits of Dissent*, 2nd ed. (Chapel Hill: University of North Carolina Press, 2000), xvi–xvii, 3–5.

112. Tweed, *The American Encounter with Buddhism*, xxxv–xxxvi, 1, 13–19.

113. William Sturgis Bigelow, "Notes on Buddhism," unpublished manuscript of conversations between Dr. and Mrs. Frederick Winslow, transcribed by Bigelow's secretary and corrected in Bigelow's hand, 1922. William Sturgis Bigelow collection, Houghton Library, Harvard University.

114. Ernest Fenollosa to Isabella Stewart Gardner, n.d. [c. 1894], Isabella Stewart Gardner Museum Archive, Boston. Fenollosa responds here to Gardner's interest

in her friend F. Marion Crawford's article "A Modern View of Mysticism," published in four parts *Book Review* 2, nos. 2–4, 7 (June-August, November 1894): 49–57, 109–15, 149–53, 231–36.

115. Bigelow, "Notes on Buddhism."

116. Ibid.

117. William Sturgis Bigelow, *Buddhism and Immortality: The Ingersoll Lecture, 1908* (Boston: Houghton Mifflin, 1908), 4–5.

118. Snodgrass, *Presenting Japanese Buddhism to the West*, 113; "An American Professor Honored in Japan," *Current Opinion* 70 (February 1921): 248.

119. William Sturgis Bigelow Papers, Massachusetts Historical Society.

120. In Van Wyck Brooks, *Fenollosa and His Circle, with Other Essays in Biography* (New York: Dutton, 1962), 51. Bigelow did not reference customs of erotic bonding between Buddhist priests and novices, which would have been known to his Japanese interlocutors and are mentioned in early twentieth-century Anglophone texts (see Edward Carpenter's *Intermediate Types Among Primitive Folk: A Study in Social Evolution* [London: G. Allen, 1914], quoted in the introduction).

121. Bigelow, "Notes on Buddhism."

122. Bigelow, *Buddhism and Immortality*, 51, 57–58, 64. On Bigelow's substitution of "non-apparent" for "esoteric" Buddhism, see *Buddhism and Immortality*, 62, and Tweed, *The American Encounter with Buddhism*, 76.

123. Bigelow, "Notes on Buddhism"; a slightly edited quotation of this passage is in Brooks, *Fenollosa and His Circle*, 54.

124. William Sturgis Bigelow to Phillips Brooks, August 19, 1889, "Selected Letters," 84. Brooks, who was then visiting Japan, had toured a Buddhist shrine in India in 1883, explaining, "In these days when a large part of Boston prefers to consider itself Buddhist rather than Christian, I consider it to be a duty of a minister who preaches to Bostonians" (in Tweed, *The American Encounter with Buddhism*, 27).

125. Mrs. [Margaret] Winthrop Chanler, "Bohemian and Buddhist," *Atlantic Monthly* 158 (1936): 275; Yamanaka Sadajiro, "An Introduction to the Catalogue of the Auction of Paintings from the Late Dr. Bigelow's Collection," Tokyo Art Club, 1935, in Bigelow, "Selected Letters," 8. Jackson Lears analyzes Bigelow's submission to the authority of the Japanese "archbishop" as "leaving a stern father for a benign Ajari [teacher]" (*No Place of Grace: Antimodernism and the Transformation of American Culture, 1880–1920* [New York: Pantheon, 1981], 229).

126. Chanler, "Bohemian and Buddhist," 275. Sadly, this memoir does not specify Bigelow's incarnations. Despite his contempt for Catholicism, Bigelow also admired the all-male mystical community of the "very active, very intelligent,

very admirably organized" Jesuits (William Sturgis Bigelow to Kanriyo Naobashi, July 16, 1895, "Selected Letters," 123).

127. Lowell's letters at the Houghton Library, Harvard University, document his activities with Bigelow.

128. David Strauss, *Percival Lowell: The Culture and Science of a Boston Brahmin* (Cambridge, MA: Harvard University Press, 2001), 9, 17, 35.

129. Percival Lowell to William Putnam, March 7, 1893, in Strauss, *Percival Lowell*, 122. A letter from Lowell to his sister offers the "amusing" fact that members of the American diplomatic corps could not attend the parties he threw at his house because doing so would acknowledge their awareness that he was "breaking the treaty regulations," although "no one really cares and no one would think of disturbing me" (Percival Lowell to Elizabeth Lowell, May 28, 1884, Houghton Library, Harvard University).

130. John L. Gardner to George P. Gardner, July 5, 1883, in Alan Chong and Noriko Murai, eds., *Journeys East: Isabella Stewart Gardner and Asia* (Boston: Isabella Stewart Gardner Museum, 2009), 133.

131. Isabella Stewart Gardner to George A. Gardner, July 15, 1883, in Chong and Murai, *Journeys East*, 138.

132. Percival Lowell, *The Soul of the Far East* (Boston: Houghton Mifflin, 1888), 43–44. In its first year of publication, *The Soul of the Far East* was was reprinted at least six times.

133. Percival Lowell, *Chosön, The Land of the Morning Calm: A Sketch of Korea* (Boston: Ticknor, 1886), 1.

134. Percival Lowell, *Noto: An Unexplored Corner of Japan* (Boston: Houghton Mifflin, 1891), 1–2.

135. Percival Lowell to Barrett Wendell, July 20, 1883, Houghton Library, Harvard University; Percival Lowell to Frederic Stimson, in Strauss, *Percival Lowell*, 35. Lowell eventually married in 1908, years after turning his attention from Japan to Mars.

136. Basil Hall Chamberlain to Lafacadio Hearn, August 27, 1893, in Kazuo Koizumi, ed., *More Letters from Basil Hall Chamberlain to Lafcadio Hearn and Letters from M. Toyama, Y. Tsubouchie and Others* (Tokyo: Hokusaido Press, 1937), 97. Lowell reported an earthquake "last night while Bigelow and I were discussing esoteric Buddhism" (Percival Lowell to Barrett Wendell, May 21, 1884, Houghton Library, Harvard University).

137. Percival Lowell to Elizabeth Lowell, November 28, 1883, Houghton Library, Harvard University.

138. Percival Lowell, *Occult Japan or the Way of the Gods: An Esoteric Study of Japanese Personality and Possession* (1894; repr., Boston: Houghton Mifflin, 1895), 2, 5–7, 14, 16.

139. Percival Lowell to William Putnam, August 16, 1891, Houghton Library, Harvard University.

140. P. Lowell, *Occult Japan*, 19–20. This argument is worked out in detail on 232–69.

141. Ibid., 157–58, 188, 377–79.

142. Lears, *No Place of Grace*, 235.

143. Basil Hall Chamberlain to Lafcadio Hearn, January 10, August 5, 1893, in Koizumi, *Letters from Basil Hall Chamberlain to Lafcadio Hearn*, 2–3, 34; compare 40. Chamberlain's skepticism was not unique. Unlike Brahmin ideas about Japanese art, their ideas about Japanese spirituality had little reach outside Boston. Judith Snodgrass explains that Bigelow's *Buddhism and Immortality* was published too late to influence what was by then a large body of Western literature on Buddhism (*Presenting Japanese Buddhism to the West*, 199). Though W. G. Aston's scholarly *Shinto: The Way of the Gods* (London: Longmans Green, 1905) included one description of a spirit possession from Lowell's *Occult Japan*, Aston dismissed Lowell's vocabulary of "esoteric Shintoism" and ignored his analysis (354–57). Too mystical to impress the scientists, Lowell was too supercilious for the Theosophists, who also cited his descriptions but complained, "We find him looking on sceptically at a real act of abnormal power . . . he doubts the evidence of his own senses, because he *cannot* believe anything that is unknown to Western science" (Echo, "The Houses of Rimmon," *Theosophical Review* (American edition) 178, no. 212 (1905): 178.

144. Christopher Nealon, *Foundlings: Lesbian and Gay Historical Emotion Before Stonewall* (Durham: Duke University Press, 2001), 1–2, 14–15, 99, 134.

145. George Quaintance, interview, *Grecian Guild Pictorial*, Spring 1956, in Nealon, *Foundlings*, 132–33.

146. Bigelow, "Selected Letters," 125, 496.

147. Nealon, *Foundlings*, 133–34.

148. Bacon, *Bacon's Dictionary of Boston*, 312. Comparative statistics for 1890 and 1920 are in Howard P. Chudacoff, *The Age of the Bachelor: Creating an American Subculture* (Princeton: Princeton University Press, 1999), 283–89.

149. Clarence Cook, *The House Beautiful: Essays on Beds and Tables, Stools and Candlesticks* (1877; repr., New York: Scribner, Armstrong, 1878), 288.

150. William Hosley, *The Japan Idea: Art and Life in Victorian America* (Hartford: Wadsworth Atheneum, 1990), 31, 164.

151. Thomas Russell Sullivan, *Passages from the Journal of Thomas Russell Sullivan* (Boston: Houghton Mifflin, 1917), 53. Sullivan married in 1899 at age 49, but in the 1890s, he and Theodore Dwight shared a valet in what Sullivan called "our pleasant bachelor apartment-house" (*Passages from the Journal of Thomas Russell Sullivan*, 168; on Dwight and Sullivan, see Douglass Shand-Tucci, *The Art of Scandal: The*

Life and Times of Isabella Stewart Gardner [New York: HarperCollins, 1997], 87). The "Japanese gold carvings" were likely gilded woodcarvings or bronzes.

152. Chanler, "Bohemian and Buddhist," 274. Bigelow's 1922 "Notes on Buddhism" makes casual reference to a picture of two Buddhist priests in his room where the conversation is taking place.

153. Bigelow, "Selected Letters," 474.

154. Charles Warren Stoddard, "Tuckernuck," *Ave Maria* (1904): 16. Tuckanuck was on Tuckernuck Island, hence the alternative spelling in some titles and quotations.

155. Sullivan, *Passages from the Journal of Thomas Russell Sullivan*, 181.

156. George Cabot Lodge to William Sturgis Bigelow, May 16, 1900, in Henry Adams, *The Life of George Cabot Lodge* (Boston: Houghton Mifflin, 1911), 95.

157. La Farge, *An Artist's Letters from Japan*, 35.

158. William Sturgis Bigelow to Henry Cabot Lodge, April 15, 1915, "Selected Letters," 398.

159. John W. Crowley, *George Cabot Lodge* (Boston: G. K. Hall, 1976), 126.

160. Santayana, *The Last Puritan*, 153–54.

161. This history is outlined in my *Art and Homosexuality: A History of Ideas* (New York: Oxford University Press, 2011), 2, 69–72, 149–52.

162. John W. Crowley, "Eden off Nantucket: W. S. Bigelow and 'Tuckanuck,'" *Essex Institute Historical Collections* 109 (1973): 6; Roger Austen, *Genteel Pagan: The Double Life of Charles Warren Stoddard*, ed. John W. Crowley (Amherst: University of Massachusetts Press, 1991), 140.

163. Stoddard, "Tuckernuck," *Ave Maria*, 16–17.

164. Addressed to a female readership, the *Ave Maria*, published at Notre Dame University, is claimed as the world's largest Anglophone Catholic journal of this era (www.avemariapress.com). Its mix of features included articles on literature and Catholic families with poetry and essays by female authors.

165. Sinclair Lewis, *Main Street* (1920; repr., New York: New American Library of World Literature, 1961), 97, 81.

166. Stoddard, "Tuckernuck," *Ave Maria*, 17–19, 47.

167. Adams, *Life of George Cabot Lodge*, 17–18, 47–48.

168. William Sturgis Bigelow to Kanrio Naobayasji, July 16, 1895, "Selected Letters," 122.

169. George Cabot Lodge to William Sturgis Bigelow, December 10, 1897, in Adams, *Life of George Cabot Lodge*, 68.

170. First published in *Harper's New Monthly Magazine* 93, no.554 (1896), 285, a revised version of "Tuckanuck" with several additional sections appeared in George Cabot Lodge, *The Song of the Wave* (New York: Scribner, 1898), 83–86.

171. George Cabot Lodge to William Sturgis Bigelow, July 1909, in Adams, *Life of George Cabot Lodge*, 202–3. This source also reprints Lodge's marriage rant in a 1904 letter

to Langdon Mitchell (129–30). Mitchell's hit play of 1906, *The New York Idea*, satirized modern marriage.

172. William Sturgis Bigelow to Anna Lodge, September 1, 1911, "Selected Letters," 334.

173. Quoted in Bigelow, "Selected Letters," 15.

174. Alden Hatch, *The Lodges of Massachusetts* (New York: Hawthorne, 1973), 155, 158.

175. Cohen, *East Asian Art and American Culture*, 49. A widely syndicated article on "the alliance that gave Back Bay society quite a shock" reported, "The bridegroom has obtained a position in the Museum of Fine Arts" (http://oregonnews.uoregon .edu/lccn/sn83025138/1911-09-14/ed-1/seq-3/ocr.txt).

176. John Ellerton Lodge to Arthur Fairbanks, July 26, 1923, in Cohen, *East Asian Art and American Culture*, 80. On Lodge's delays in opening the Freer and resistance to admitting visitors, see Thomas Lawton, "John Ellerton Lodge, First Director of the Freer Gallery of Art," *Orientations* 29, no. 5 (1998): 79–80.

177. Trustees of the Museum of Fine Arts, *Twenty-Sixth Annual Report for the Year Ending December 31, 1901* (Boston: Museum of Fine Arts, 1902), 21.

178. Cabot's entry in the Harvard class of 1894 twenty-fifth reunion book reads, "My only active work with a salary since graduation was three years spent in the Museum of Fine Arts, Boston, as curator of Japanese and Chinese collections, from September, 1899, to 1902, when I resigned on account of poor health." Born in 1872, he married in 1914 and had no children. Chalfin, born to a prominent New York family in 1874, attended Harvard College for two years. Later known as a flamboyant interior decorator, he has been described as "very self-confident, something of a dandy, affected in manner and speech, and openly homosexual (Witold Rybczynski and Laurie Olin, *Vizcaya: An American Villa and Its Makers* [Philadelphia: University of Pennsylvania Press, 2007],. 15).

179. Helen Merritt, *Modern Japanese Woodblock Prints* (Honolulu: University of Hawai'i Press, 1990), 9. Paradoxically, this trip to Paris is credited with changing Fenollosa's attitudes about Japanese prints, as he realized how esteemed they were by European collectors (Merritt, 13). Okakura Kakuzo described the academy's curriculum as "painting, sculpture in wood and ivory, metal work, bronze casting, lacquer work, and decorative design—all taught in the Japanese style, though the students were also required to study perspective, anatomy and modern notions of science, especially in reference to industrial design" ("Notes on Contemporary Japanese Art," *Studio* 25 [1902]: 127).

180. Christine Guth, "Charles Longfellow and Okakura Kakuzo: Cultural Cross-Dressing in the Colonial Context," *positions* 8, no. 3 (2000): 625.

181. Although his ouster was precipitated by anonymous letters exposing his affair with the former wife a high-ranking government official, it reflected,

in Okakura's words, "differences of opinion . . . chiefly in regard to the part that Western methods should play in the curriculum" (Okakura, "Notes on Contemporary Japanese Art," 127). On this episode, see John Clark, "Okakura Tenshin [Kakuzô] and Aesthetic Nationalism," *Arts: The Journal of the Sydney University Arts Association* 25 (2003): 77–78; F. G. Notehelfer, "On Idealism and Realism in the Thought of Okakura Tenshin," *Journal of Japanese Studies* 16, no. 2 (1990): 343–44.

182. Kakuzo Okakura, "The Bijutsu-in or the New Old School of Japanese Art," in *Okakura Kakuzo, Collected English Writings*, vol. 2 (Tokyo: Heibonsha, 1984), 58. On Okakura's translations, see Victoria Weston, *Japanese Painting and National Identity: Okakura Tenshin and His Circle* (Ann Arbor: Center for Japanese Studies, The University of Michigan, 2004), 246.

183. "In Memory of Okakura-Kakuzo," *Museum of Fine Arts Bulletin* 14, no. 82 (1916): 15.

184. Nivedita or Ramakrishna-Vivekânanda [Margaret Elizabeth Noble], introduction to Kakuzo Okakura, *The Ideals of the East with Special Reference to the Art of Japan* (New York: E. P. Dutton, 1904), x.

185. Director's notes, "Memorandum," April 11, 1904, in Okakura, *Collected English Writings*, vol. 3, 351.

186. William Sturgis Bigelow to John Templeman Coolidge, March 16, 1904, in Tachiki, "Okakura Kakuzo (1862–1913) and Boston Brahmins," 92.

187. William Sturgis Bigelow to Paul Chalfin, March 8, 1904, in Emiko K. Usiui, "National Identity, the Asiatic Ideal, and the Artist: Okakura Presents the Nihon Bijutsuin in Boston," in *Okakura Tenshin and the Museum of Fine Arts Boston* (Nagoya: Nagokya/Bosuton Bijutsukan, 1999), 170. This broad directive contrasts with the specificity of an article in the *New York Times* of March 4, 1904, announcing Okakura's arrival on the East Coast: "He comes to America to classify the collections of prints and paintings at the Boston Museum."

188. Okakura Kakuzo, "Japanese and Chinese Paintings," *Museum of Fine Arts Bulletin* 3, no 1 (1905): 5–6; *Handbook of the Museum of Fine Arts Boston*, 1906 edition, 164–65.

189. Director's notes, "Conversation with Mr. Okakura," November 27, 1904, in Okakura, *Collected English Writings*, vol. 3, 352. Okakura here also belittled the Morse collection as being in "great measure wrongly named and catalogued" and more appropriate to "an industrial museum and not here" (354).

190. Director's notes, "Memorandum of Okakura's Conversation with E. R.," February 13, 1905, in Okakura, *Complete English Writings*, vol. 3, 355.

191. Quoted in *Okakura Tenshin and the Museum of Fine Arts*, 38.

192. *Museum of Fine Arts, Boston, Thirtieth Annual Report for the Year 1905* (Cambridge, MA: University Press, 1906), 35; the acquisitions are listed on 37.

193. Museum of Fine Arts, Boston, Thirty-First Annual Report for the Year 1906 (Cambridge, MA: University Press, 1907), 63.

194. Prichard, "Current Theories of the Arrangement of Museums of Art," 20, quoting Julien Guadet, Eléments et théories de l'architecture: "Il n'y a de contre-sense plus choquant que la conception fausse qui consiste à placer des collections japonaises par exemple dans un décor faux-japonais."

195. Museum of Fine Arts, Boston, Thirty-First Annual Report for the Year 1906 (Cambridge, MA: University Press, 1906), 72.

196. Ibid., 63.

197. Tachiki, "Okakura Kakuzo (1862–1913) and Boston Brahmins," 68, 84; Weston, Japanese Painting and National Identity, 226.

198. Usiui, "National Identity, the Asiatic Ideal, and the Artist," 170.

199. "Boston Man Robbed in Italian Train," Boston Evening Transcript, May 22, 1913.

200. Okakura, Ideals of the East, 1, 5.

201. Kōjin Karatani, "Japan as Museum: Okakura Tenshin and Ernest Fenollosa," trans. Sabu Kohso, in Japanese Art After 1945: Scream Against the Sky, ed. Alexandra Munro (New York: Harry N. Abrams, 1994), 33–39. Nagahiro Kinoshita argues that Okakura's nationalism was largely a product of his posthumous followers ("Okakura Kakuzō: The Distance Between East and West," in Noriko Murai and Alan Chong, eds., Inventing Asia: American Perspectives Around 1900 [Boston: Isabella Stewart Gardner Museum, 2014], 39–61). For an insightful analysis of Okakura's Ideals of the East, see Noriko Murai, "Authoring the East: Okakura Kakuzo and the Representations of East Asian Art in the Early Twentieth Century" (Ph.D. dissertation, Harvard University, 2003), 26–75.

202. Okakura, Ideals of the East, 6, 7, 243–44.

203. Tachiki, "Okakura Kakuzo (1862–1913) and Boston Brahmins," 114. Okakura dedicated The Book of Tea to "John La Farge, Sensei [the learned]."

204. The origin myth was propagated by Museum of Fine Arts curator Kojiro Tomita, who came to the museum in 1908, two years after the book was published. Okakura's lectures for the female volunteers are registered in the 1906 annual report, which records that "at each meeting Mr. Rokkaku made floral arrangements from material furnished by the different ladies" (64) and that "during the year there were made by the ladies attending these meetings about sixty silk and leather cases for important and valuable articles in the collection of the Department" (65). But Okakura's 1905 lecture published as "Talk Given to Ladies Who Assisted in the Work of the Chinese and Japanese Department" (Collected English Writings, vol. 2, 88–92) is not a direct source for The Book of Tea, the opening two chapters of which first appeared as "The Cup of Humanity" in International Quarterly 2, no. 1 (1905): 39–51.

205. Kakuzo Okakura, *The Book of Tea* (1906; repr., New York: Dover, 1963), 3, 18, 44, 47. On the masculinization of tea in this text, see Noriko Murai "Okakura's Way of Tea: Representing Chanoyu in Early Twentieth-Century America," *Review of Japanese Culture and Society* 24 (2012): 70–93. This masculine presentation of the tea ceremony contrasts with Okakura's earlier participation in the movement to shift the practice to middle-class women in Japan and was part of broader efforts by the Japanese to masculinize Westernize perceptions of Japan (Murai, "Authoring the East," 84, 97–116).

206. William Sturgis Bigelow to the trustees and president of the museum, in Murai, "Authoring the East," 175. Murai documents the museum's efforts to acquire a Japanese room from Japan in 1906.

207. Joseph Randolph Coolidge Jr., "The New Museum," *Museum of Fine Arts Bulletin* 5, no. 7 (1907): 41.

208. Mather, "Art in America," 294.

209. Okakura Kakuzo to Edward Jackson Holmes, July 1, 1908, in Okakura, *Collected English Writings*, vol. 3, 94–95.

210. Walter Pach, "Boston's New Museum of Fine Arts," *Harper's Weekly*, December 18, 1909, 15.

211. Mather, "Art in America," 296.

212. *Museum of Fine Arts Bulletin* 7, nos. 40–42 (December 1909): 56.

213. Fairbanks, "The Museum of Fine Arts," 368.

214. Pach, "Boston's New Museum of Fine Arts," 15.

215. Julia de Wolf Addison, *The Boston Museum of Fine Arts* (Boston: L. C. Page, 1910), 409. The Japanese Court remained until 1981, when its double-height space was floored over to create additional exhibition space; the original pilasters remain visible in the upstairs gallery.

216. Mather, "Art in America," 296. Curtis's Aizen (09.383) is now dated to the fourteenth century.

217. "The New Museum," special issue, *Museum of Fine Arts Bulletin* 7, nos. 40–42 (1909): 56.

218. Francis Stewart Kershaw, quoted in William Howe Downes, "The Art Museum's Fenway Home," *Boston Evening Transcript*, November 6, 1909, in Murai, "Authoring the East," 184.

219. M., "The Boston Art Museum," *Nation* 89, no. 2316 (1909): 496.

220. Addison, *The Boston Museum of Fine Arts*, 332.

221. Murai, "Authoring the East," 179–80.

222. Before its use in *The Book of Tea*, this phrase appeared in Okakura's speech at the 1904 World's Fair in St. Louis, "Modern Problems in Painting," and in a talk delivered to the women who volunteered in his department at the Museum of Fine Arts (*Collected English Writings*, vol. 2, 61, 89).

223. Fairbanks, "The Museum of Fine Arts," 369.

224. Mather, "Art in America," 296.

225. M., "The Boston Art Museum," 495.

226. Hartt, "The Boston Museum," 203.

227. Chong and Murai, *Journeys East*, 45n171, 51. Although later secondary sources credit Okakura, Cram is credited in period sources, including Hartt, "The Boston Museum," 206; Mather, "Art in America, 296; and M., "The Boston Art Museum," 495. Okakura's letter assessing the new design on his return to Boston in November 1910 confirms his absence from the design and installation process (Okakura, *Collected English Writings*, vol. 3, 115–16).

228. Ernest F. Fenollosa, "The Significance of Oriental Art," *The Knight Errant* 1, no. 3 (1892): 68. Bigelow donated this piece to the Museum of Fine Arts in 1911, although it had likely been deposited before; it is now cataloged as Nishiyama Hôen (1804–1867), *White-robed Kannon* (11.8272). On the *Knight Errant*, see Douglass Shand-Tucci, *Boston Bohemia, 1881–1900: Ralph Adams Cram; Life and Architecture*, vol. 1 (Amherst: University of Massachusetts Press, 1995), 84–88.

229. Herbert Copeland, "Of Camera Obscura and Japanese Crystals," *The Knight Errant* 1, no. 3 (1892): 89, 91–92.

230. Knapp's "From the Japanese of the Manyoshu" appeared in *The Knight Errant* 1, no. 4 (1893): 105. On the Knapp house, see Shand-Tucci, *Boston Bohemia*, vol. 1, 405–9. Shand-Tucci makes a detailed case for the intensity of Cram's relationships with other men (140–47).

231. Ralph Adams Cram to Bertram Goodhue, April 18, 1898, Boston Public Library.

232. Ralph Adams Cram to Bertram Goodhue, March 18, 1898, Boston Public Library.

233. Ralph Adams Cram to Bertram Goodhue, March 11, 1898, Boston Public Library.

234. Ralph Adams Cram to Bertram Goodhue, March 18, 1898, Boston Public Library.

235. Ralph Adams Cram, *Impressions of Japanese Architecture and Allied Arts* (New York: Baker and Taylor, 1906), 22, 39, 43–44, 63.

236. Shand-Tucci, *Boston Bohemia*, vol. 2, 132; see also 536–37n64; "The New Museum," 56.

237. Cram, *Impressions of Japanese Architecture and Allied Arts*, 29, 83.

238. Ibid., 75.

239. Edward Perry Warren, quoted in David Sox, *Bachelors of Art: Edward Perry Warren and The Lewes House Brotherhood* (London: Fourth Estate, 1991), 128. Martin Green's *The Mount Vernon Street Warrens: A Boston Story, 1860–1910* (New York: Scribner, 1990) offers a sensationalistic account of the Warren family and its many dealings with the Museum of Fine Arts.

240. See accession numbers 13.73, 13.76. These had been on deposit as loans to the museum since 1877.

241. C. Pelletan, "Une Chapelle Bouddhiste." This enthusiastic notice was published in the same journal that was serializing Burty's "Japonisme" essay in 1872 but did not attract further attention.

242. Chong and Murai, *Journeys East*, 51n166.

243. Arthur Knapp, who commissioned the Japanesque house and tea pavilion from Cram, was a missionary.

244. Guth, *Longfellow's Tattoos*, 168–69.

245. Morse criticized Western domestic norms as not just aesthetically suspect but evil: "The monstrous bills for carpets, curtains, furniture, silver, dishes, etc., often entailed by young house-keepers" lead to "criminal debt," with "the premonition even of such bills often preventing marriage" (*Japanese Homes and Their Surroundings*, 114–15; see also 309–11).

246. F[rancis] G[ardner] C[urtis], "Chinese and Japanese Art," *Handbook of the Museum of Fine Arts Boston*, 13th edition (1919), 297.

247. Bigelow, "Notes on Buddhism."

248. Anne Nishimura Morse, "Promoting Authenticity: Okakura Kakuzō and the Japanese Collection of the Museum of Fine Arts, Boston," in *Okakura Tenshin and the Museum of Fine Arts Boston*, 148.

249. On Ross's overconfidence, see Marie Frank, *Denman Ross and American Design Theory* (Hanover: University Press of New England, 2011), 13–16; on Fenollosa's impact on Ross's pedagogy, see 69, 81–89; and on Ross's teaching at Harvard, see 172–214.

250. Denman Ross, September 29, October 10, November 17, 1908, unpublished diaries, Harvard Depository.

251. D. Ross, September 5, October 18, 1908, unpublished diaries. Similar remarks characterize other entries during this trip to Japan.

252. D. Ross, July 4, August 14, August 19, 1910, unpublished diaries.

253. Kōjin Karatani, "Uses of Aesthetics: After Orientalism," *boundary 2* 25, no. 2 (1998): 146, 148, 150, 154–55.

254. Karatani, "Uses of Aesthetics," 151.

255. D. Ross, October 4, 1908, unpublished diaries.

256. Denman Ross, "Exhibition of Additions to the Ross Collection," *Museum of Fine Arts Bulletin* 11, no. 67 (1913): 75.

257. Bernard Berenson and Charles Hopkinson, quoted in M. Frank, *Denman Ross*, 128, 13.

258. Cohen, *East Asian Art and American Culture*, 112.

259. Although Anne Higonnet advocates the term *collection museum* to characterize the Gardner and similar institutions "intended, from the start, to become public museums of art" (*A Museum of One's Own: Private Collecting, Public Gift* [Pittsburgh:

Periscope, 2009], xii), I retain the standard term to emphasize the gender politics distinguishing Gardner's establishment from the Museum of Fine Arts. During Gardner's lifetime, this was very much her house, open to a paying public only occasionally and with many rooms off limits. Higonnet acknowledges that what audiences responded to at the Gardner was the sense that, in the words of a 1903 newspaper review, "the whole has an atmosphere of being lived in, which adds so greatly to the charm of any dwelling" (22).

260. John Jay Chapman, "Mrs. John L. Gardner," *Boston Evening Transcript*, July 18, 1924, in Shand-Tucci, *The Art of Scandal*, 13.

261. Morris Carter, *Isabella Stewart Gardner and Fenway Court* (Boston: Houghton Mifflin, 1925), 24.

262. "Mrs. Jack Gardner Interesting Bostonian," *Chicago Daily Tribune*, June 29, 1895, 16.

263. Lewis Hyde, "Isabella's Will," in *Lee Mingwei: The Living Room*, ed. Jennifer R. Gross (Boston: Isabella Stewart Gardner Museum, 2000), 17.

264. Various versions of this story appear in Morris Carter, *Did You Know Mrs. Gardner? Morris Carter's Answer* (Boston: Industrial School for Crippled Children, 1964), 52–53; Carter, *Isabella Stewart Gardner*, 241; Whitehill, *Museum of Fine Arts, Boston*, vol. 1, 128–29.

265. John L. Gardner to George P. Gardner, July 5, 1883, in Chong and Murai, *Journeys East*, 133. Details of the Gardners' itinerary are reported in Jack Gardner's travel diary, reprinted in *Journeys East*, 112, 114, 119, 134, 136.

266. Isabella Stewart Gardner to Maud Howe, June 30, 1883, and to Anna Lyman Gray, July 5, 1883, in Chong and Murai, *Journeys East*, 123, 133.

267. William Sturgis Bigelow to Isabella Stewart Gardner, September 9, 1883, in Chong and Murai, *Journeys East*, 23.

268. William Sturgis Bigelow to Isabella Stewart Gardner, September 9, 1883, Isabella Stewart Gardner Museum Archives.

269. William Sturgis Bigelow to Isabella Stewart Gardner, March 12, 1895, "Selected Letters," 116–17.

270. Isabella Stewart Gardner to Bernard Berenson, September 19, 1896, in Rollin Van Nostrand Hadley, ed., *Letters of Bernard Berenson and Isabella Stewart Gardner, 1887–1924* (Boston: Northeastern University Press, 1987), 66.

271. John La Farge, "The Collection of Mrs. John Lowell Gardner," in *Noteworthy Paintings in American Private Collections*, ed. John La Farge and August F. Jaccaci (New York: August F. Jaccaci, 1907), 2.

272. Uncited newspaper clippings in Carter, *Isabella Stewart Gardner*, 182, 189.

273. *New York World*, January 2, 1902, in Carter, *Isabella Stewart Gardner*, 194.

274. Sullivan, *Passages from the Journal of Thomas Russell Sullivan*, 5.

275. S. Hollis Clayson, "Anders Zorn's Etched Portraits of American Men, or the Problem with French Masculinity," in *Interior Portraiture and Masculine Identity in France, 1789–1914*, ed. Temma Balducci, Heather Belnap Jensen, and Pamela J. Warner (Farnham, UK: Ashgate, 2010), 178, 191.

276. Henry Adams to Isabella Stewart Gardner, February 9, 1906, in Carter, *Isabella Stewart Gardner*, 204. On the portrait, see 147.

277. La Farge, "The Collection of Mrs. John Lowell Gardner," 1–2.

278. Quoted in Shand-Tucci, *The Art of Scandal*, 214.

279. Matthew S. Prichard, manuscript dated March 11–24, 1914, 8, Isabella Stewart Gardner Museum Archive.

280. Carter, *Do You Know Mrs. Gardner?*, 24.

281. Carter, *Isabella Stewart Gardner*, 224.

282. Louise Hall Tharp, *Mrs Jack* (Boston: Little, Brown, 1965), 242.

283. Matthew Prichard to Isabella Stewart Gardner, February 20, 1905, in Whitehill, *Museum of Fine Arts, Boston*, vol. 1, 178.

284. Bernard Berenson to Isabella Stewart Gardner, August 3, 1901, in Hadley, *Letters*, 261.

285. Isabella Stewart Gardner to Bernard and Mary Berenson, May 12, 1904, in Hadley, *Letters*, 335.

286. Isabella Stewart Gardner to Bernard Berenson, August 2, 1904, December 19, 1904, in Hadley, *Letters*, 342, 354.

287. William Sturgis Bigelow to Isabella Stewart Gardner, January 24, 1905, Isabella Stewart Gardner Museum Archive.

288. Isabella Stewart Gardner to Bernard Berenson, May 3, 1905, in Hadley, *Letters*, 364.

289. On the 1886 visit of the Japanese Village Company to Boston, see Hirayama, "A True Japanese Taste," 206–8.

290. Isabella Stewart Gardner to Maud Howe, August 24, 1883, Isabella Stewart Gardner Museum Archive.

291. Ernest Fenollosa to Isabella Stewart Gardner, n.d. [c. 1894], Isabella Stewart Gardner Museum Archive; see note 114.

292. On Okakura's participation in women's social networks, see Murai, "Authoring the East," 86–88, 122–23; Noriko Murai, "Matrons of the East: Okakura Kakuzo and His Female Friends in America," in Chong and Murai, *Journeys East*, 72–94; and Weston, *Japanese Painting and National Identity*, 227, 245, 249.

293. Denman Ross to Isabella Stewart Gardner, February 22, 1910, Isabella Stewart Gardner Museum Archive.

294. The poem is quoted in its entirety in Carter, *Isabella Stewart Gardner*, 239. Okakura's *The White Fox*, subtitled "A Fairy Drama in Three Acts Written for Music," and dedicated to Gardner on March 2, 1913, is in the Isabella Stewart Gardner Museum Archive.

295. Hina Hirayama suggests that Gardner stopped buying East Asian art from Boston dealers on Okakura's advice ("A True Japanese Taste," 231–32n42).

296. Chong and Murai, *Journeys East*, 37–38.

297. Ibid., 40, 401–4.

298. Denman Ross to Isabella Stewart Gardner, August 27, 1916, Isabella Stewart Gardner Museum Archive.

299. Quotations from Maud Elliott, Theodosia Hawley, and James Michael Curley in Chong and Murai, *Journeys East*, 40–41.

300. This case is made in Shand-Tucci, *The Art of Scandal*, 260–61.

301. Murai, "Authoring the East," 182–83.

302. Chong and Murai, *Journeys East*, 45.

303. Barrett is quoted in Walter Muir Whitehill, "The Vicissitudes of Bacchante," *New England Quarterly* 27, no. 4 (1954): 444. For an analysis of this controversy in relation to ethnic tensions, see Julia B. Rosenbaum, "Ordering the Social Sphere: Public Art and Boston's Bourgeoisie," in *The American Bourgeoisie: Distinction and Identity in the Nineteenth Century*, ed. Sven Beckert and Julia B. Rosenbaum (London: Palgrave Macmillan, 2010). This comparison was suggested by Linda J. Docherty, "Going Public: Sculpture and the Art of Isabella Stewart Gardner," paper presented at the College Art Association annual conference, February 10–13, 2010, Chicago.

304. Mary Berenson, letter of 1914, in Barbara Strachey and Jayne Samuels, eds., *Mary Berenson: A Self-Portrait from Her Letters and Diaries* (London: V. Gallancz, 1983), 194.

305. William Sturgis Bigelow to William Cabot Lodge, April 14, 1914, Isabella Stewart Gardner Museum Archive.

306. Chong and Murai, *Journeys East*, 46.

307. Memo for trustee meeting, quoted in Chong and Murai, *Journeys East*, 46.

308. Strachey and Samuels, *Mary Berenson*, 112. Mary Berenson was by no means always uncritical of Gardner (113–14, 237).

309. Louis Mumford, *The Golden Day: A Study in American Experience and Culture* (New York: Boni and Liveright, 1926), 215.

310. Linda Docherty argues that, by treating the two "consecrated spaces" of Christian worship at Fenway Court as "exhibition spaces," art historians have ignored Gardner's engagement with Anglo-Catholic religious practice ("Religion and/as Art: Isabella Stewart Gardner's Palace Chapels" [paper presented at the College Art Association annual conference, February 23–26, New York, 2000]), another social structure of upper-crust Boston dominated by men. In contrast to the gender politics of Japanism in Boston at the turn of the century, important collections of Japanese art were amassed and institutionalized by women elsewhere:

Jane Stanford at the museum at Stanford university (Christine Guth, "Asia by Design: Women and the Collecting and Display of Oriental Art," in Chong and Murai, *Journeys East*, 56–58) and, later, Gertrude Bass Warner at the museum of the University of Oregon and Grace Nicholson at the Asia Pacific Museum in Pasadena (Joan M. Jensen, "Women on the Pacific Rim: Some Thoughts on Border Crossings," *Pacific Historical Review* 67, no. 1 (1998): 19–26).

311. On Amy Lowell's "appropriation of bachelorhood" and strategic eccentricities, see Melissa Bradshaw, *Amy Lowell: Diva Poet* (Burlington, VT: Ashgate, 2011), 20.

312. Amy Lowell, "Guns as Keys: And the Great Gate Swings," *The Seven Arts* 2 (1917): 432, 435.

313. Amy Lowell to Paul K. Hisada, August 13, 1917, in S. Foster Damon, *Amy Lowell: A Chronicle* (Boston: Houghton Mifflin, 1935), 55; see also 420.

314. William Leonard Schwartz, "A Study of Amy Lowell's Far Eastern Verse," *Modern Language Notes* 43, no. 3 (1928): 148.

315. Lowell cited the source (Seichi Naruse, "Young Japan," *Seven Arts* 1 [April 1917], 616–26) when she anthologized "Guns as Keys" in *Can Grande's Castle* (New York: Macmillan, 1918).

316. Amy Lowell, "Guns as Keys," 450–51.

317. In S. Foster Damon, *Amy Lowell*, 474.

318. Elizabeth Robins Pennell and Joseph Pennell, *The Life of James McNeill Whistler* (London: William Heinemann, 1908), 1.

319. Bryher [Annie Winifred Ellerman], *Amy Lowell: A Critical Appreciation* (London: Eyre and Spottiswoode, 1918), 39.

3. SUBLIMATION AND ECCENTRICITY IN THE ART OF MARK TOBEY: SEATTLE AT MIDCENTURY

1. Walt Whitman, "The Errand-Bearers," 1860, repr. in David Ewick, *Japonisme, Orientalism, Modernism: A Bibliography of Japan in English-Language Verse of the Early Twentieth Century* (http://themargins.net/). Although the original text in quoted here, the line breaks follow the revised version, titled "Broadway Pageant" in *Leaves of Grass*, rather than the columnar presentation of the original newspaper format.

2. This institution, referred to officially as the Public Market and commonly as the Farmers' Market, became known as the Pike Place Market during the debates over its preservation in the 1960s.

2. Mark Tobey, "Pike Place Market" [draft introduction to *The World of a Market*], Mark Tobey Papers, box 6, folder 61, Special Collections, University of Washington

Libraries. Only the opening anecdote appears in the published introduction and not as the lead.

4. Marzieh Gail, "The Days with Mark Tobey," World Order 2, no. 3 (1977): 15–16.

5. Tobey's 1916 drawing of Winthrop Parkhurst is at the Museum of Modern Art; his 1917 portrait of Wymer Mills is illustrated in Rétrospective Mark Tobey (Paris: Musée des Arts Décoratifs, Palais du Louvre, 1961), plate 1. On his murals, see Lucretia H. Giese, "Mark Tobey's 1939 Murals for the John A. Baillargeons: A Transition," Archives of American Art Journal 23, no. 2 (1983): 10.

6. Marzieh Gail, "At 48 West Tenth (Memories of Juliet Thomson)," in Juliet Thompson, The Diary of Juliet Thompson with a Preface by Marzieh Gail (Los Angeles: Kalimat, 1983), xv. Full text is available at http://bahai-library.com/thompson_diary.

7. Mark Tobey, "The Dot and the Circle," World Order 2, no. 3 (1977): 40. There is no published biography of Tobey.

8. "Conversation with Mark Tobey," interview by Arthur L. Dahl, September 21, 1963, Mark Tobey Papers, Special Collections, University of Washington Libraries. What Tobey five decades later remembered as a photograph was more likely a much admired painted portrait of 'Abdu'l-Bahá by Juliet Thompson, which is cited in all accounts of her.

9. John Morse, "Oral History Interview with Holger Cahill," April 12, 1960, Archives of American Art, Smithsonian Institution, www.aaa.si.edu/collections /oralhistories/transcripts/cahill60.

10. Christopher Buck, "Alain Locke and Cultural Pluralism," in Search for Values: Ethics in Baha'i Thought, ed. John Danesh and Seena Fazel, (Los Angeles: Kalimát, 2004), 111.

11. Tobey, "The Dot and the Circle," 40–41. Compare Tobey in William C. Seitz, Mark Tobey (New York: Museum of Modern Art, 1962), 45.

12. Matthias Bärmann, "Patterns of Nomadism: The Transcultural Art of Mark Tobey," in Matthias Bärmann and Kosme de Barañano, Mark Tobey (Madrid: Museo Nacional Centro de Arte Reina Sofia, 1997), 59–60.

13. Morris Graves to Charles Krafft, April 12, 1992, in Morris Graves: Selected Letters, ed. Vicki Halper and Lawrence Fong (Seattle: University of Washington Press, 2013), 101.

14. Mark Tobey to Muriel Draper, undated letters [summer 1918], Muriel Draper Papers, Beinecke Rare Book & Manuscript Library, Yale University.

15. Mark Tobey, interview by William Seitz, 1961, Mark Tobey Papers, box 10, folder 23, Special Collections, University of Washington Libraries.

16. Aidan Day, Romanticism (London: Routledge, 1996), 185–86.

17. For Freud's explanation of sublimation as "desexualized libido," see his The Ego and the Id, trans. James Strachey (1923; repr., New York: Norton, 1960), 62–64.

18. Following his conversion in 1918, Tobey joined a Bahá'í study group, and he painted backdrops for a Bahá'í convention in the spring of 1919 (Arthur L. Dahl, *Mark Tobey: Art and Belief* [Oxford: George Ronald, 1984], 4; Bahíyyih Randall Winckler, and M. R. Garis, *William Henry Randall: Disciple of ʾAbduʾl-Bahá* [Oxford: One World, 1996], 103).

19. Gail, "The Days with Mark Tobey," 21.

20. Ibid., 16. This essay rehearses more accounts of Tobey's evasive remarks about sexuality, exemplifying the dynamic Eve Sedgwick calls the "open-secret structure" that characterized homosexuality through much of the twentieth century (*Epistemology of the Closet* [Berkeley: University of California Press, 1990], 22). Tobey is quoted elsewhere saying of his relationship with Hallsten, "Many friends think it's a homosexual relationship but it's not. He came and I need someone helpless to take care of. That is what my nature requires." But this report comes from Elizabeth Willis, who had professional and personal reasons to deny Tobey's homosexuality. Willis was one of Tobey's most energetic dealers and he had proposed marriage to her, provoking an unhappy episode in which he broke off his friendship with Morris Graves because Graves warned Willis that Tobey was homosexual. See Deloris Tarzan Ament, *Iridescent Light: The Emergence of Northwest Art* (Seattle: University of Washington Press, 2002), 30, 32, 118.

21. Charles Seliger, in Helen Westgeest, *Zen in the Fifties* (Zwolle, Netherlands: Waanders Uitgevers, 1996), 87n29. Seliger and Tobey were friends in the mid-1950s.

22. Mark Tobey to Muriel Draper, undated letter, Muriel Draper Papers, Beinecke Rare Book & Manuscript Library, Yale University.

23. Mark Tobey to Muriel Draper, October 29, 1923, Muriel Draper Papers, Beinecke Rare Book & Manuscript Library, Yale University.

24. Adelaide Hansom (designer of the seal), in "An Exposition Emblem," *Sunset Magazine* 19 (1907): 605.

25. Mark Tobey to Muriel Draper, undated letter, Muriel Draper Papers, Beinecke Rare Book & Manuscript Library, Yale University.

26. Mark Tobey to Muriel Draper, letter dated "2 A.M. Sunday morning," Muriel Draper Papers, Beinecke Rare Book & Manuscript Library, Yale University.

27. Janet Flanner, "Sage from Wisconsin," in *The Selective Eye: An Anthology of the Best from l'Oeil, the European Art Magazine*, ed. Georges Bernier and Rosamond Bernier (New York: Random House, 1955), 172; Betty Bowen, introduction to Seattle Art Museum, *Tobey's 80: A Retrospective* (Seattle: University of Washington Press, 1970), n.p..

28. Kenneth Rexroth, "Mark Tobey: Painter of the Humane Abstract," *Art News* (1951; repr. in Kenneth Rexroth, *Bird in the Bush: Obvious Essays* [New York: New Directions, 1959], 170).

29. Mark Tobey to Muriel Draper, undated letter, Muriel Draper Papers, Beinecke Rare Book & Manuscript Library, Yale University. This letter can be dated by its reference to a recent appearance at Seattle's Cornish School by "a dancer named Martha Graham"; her first visit took place in 1930.

30. Exhibition of Paintings and Drawings by Mark Tobey (London: Beaux Arts Gallery, 1934).

31. Mark Tobey to Muriel Draper, undated letter [c. 1934], Muriel Draper Papers, Beinecke Rare Book & Manuscript Library, Yale University.

32. Wesley Wehr, notes on conversation with Tobey, August 18, 1965, Wesley Wehr Papers, Special Collections, University of Washington Libraries. Janet Flanner, who knew Tobey at this period, reports, "Of friends of his own generation among serious American painters, the closest was the late Marsden Hartley" ("Sage from Wisconsin," 175). The still life is noted in Wesley Wehr's account of the 1962 inventory of Tobey's studio (Wesley Wehr Papers, box 22/18, Special Collections, University of Washington Libraries). The Whitman photograph is noted in Paul Dahlquist, "A Day with Mark Tobey: Excerpt from the Journal of Paul Dahlquist, April 27, 1969," Olde Seattle Star, March 1971 [in the Mark Tobey Papers, Special Collections, University of Washington Libraries].

33. Wesley Wehr, The Accidental Collector: Art, Fossils, and Friendships (Seattle: University of Washington Press, 2004), 236–37.

34. Marsden Hartley, "Mark Tobey" [introduction to an exhibition at the Contemporary Arts Gallery, New York], in Marsden Hartley, On Art, ed. Gail R. Scott (New York: Horizon, 1982), 182–84.

35. Mark Tobey to Leonard Elmhirst, n.d. [1931], Dartington Hall Trust Archive.

36. Jonathan Weinberg, Speaking for Vice: Homosexuality in the Art of Charles Demuth, Marsden Hartley, and the First American Avant-Garde (New Haven: Yale University Press, 1993), 29–32, 180–93.

37. In Seitz, Mark Tobey, 12. On Hartley's racial ideologies, see Donna M. Cassidy, Marsden Hartley: Race, Religion, and Nation (Hanover, NH: University Press of New England, 2005), 251–86.

38. David A. Takami, Divided Destiny: A History of Japanese Americans in Seattle (Seattle: University of Washington Press, 1999), 20–32; "Pike Place Market Centennial," www.seattle.gov/cityarchives/exhibits-and-education/online-exhibits/pike-place-market-centennial.

39. Flanner, "Sage from Wisconsin," 172.

40. Mark Tobey, "Reminiscence and Reverie," Magazine of Art 44, no. 8 (1951): 228, 230. Tobey often dated the start of his studies with Teng to 1923, but Teng did not arrive in Seattle until so late in December 1924 that the lessons' earliest plausible date would be in 1925; a photograph of Teng inscribed by him to Tobey has been

dated to December 1926 (Mark Tobey Papers, Special Collections, University of Washington Libraries). On Teng's career, including his popularity with students, see David Clarke, "Cross-Cultural Dialogue and Artistic Innovation," in *Shanghai Modern 1919–1945*, ed. Jo-Anne Birnie Danzker, Ken Lum, and Zheng Shengtian (Ostfildern-Ruit, Germany: Hatje Cantz, 2004), 84–103.

41. On Teng, see Alex Jay, *Chinese American Eyes: Famous, Forgotten, Well-Known and Obscure Visual Artists of Chinese Descent in the United States* (blog), posts of August 16–23, 2013, http://chimericaneyes.blogspot.com/2013_08_01_archive; Jo-Anne Birnie Danzker and Scott Lawrimore, *Mark Tobey/Teng Baiye: Seattle/Shanghai* (Seattle: Frye Art Museum, 2014).

42. *Rétrospective Mark Tobey*; untitled text, Mark Tobey Papers, Special Collections, University of Washington Libraries, n.p.

43. Mark Tobey, "Japanese Traditions and American Art," *College Art Journal* 18, no. 1 (1958): 22; Seitz, *Mark Tobey*, 27 (Seitz also quotes the first question; see 38); Alexander Watt, "Paris Commentary," *Studio* 162, no. 824 (1961): 223.

44. Dartington Hall's application for Tobey's work permit refers to him "coming over as an instructor to the school and the School of Dance Mime here," specifying that "he has particular and special qualifications in science and costume art." His appointment letter (dated August 21, 1931) specifies that "you should be attached to the School of Dance Mime so that you could carry on in connection with it similar work to what you have been doing at the Cornish School" (Dartington Hall Trust Archive). Michael Young reports a vaguer remit for Tobey's work at Dartington Hall (*The Elmhirsts of Dartington*, 2nd ed. [Totnes, Devon: Dartington Hall Trust, 1996], 221).

45. In Bernard Leach, *Beyond East and West: Memoirs, Portraits and Essays* (New York: Watson-Guptil, 1978), 165–66. See also Young, *The Elmhirsts of Dartington*, 221–22.

46. Mark Tobey to Muriel Draper, undated letter [summer 1931], Muriel Draper Papers, Beinecke Rare Book & Manuscript Library, Yale University.

47. This phrase is used by two of Tobey's interlocutors: Flanner, "Sage from Wisconsin," 175; Wesley Wehr, undated chronology of Tobey's life, Wesley Wehr Papers, Special Collections, University of Washington Libraries. On Waley, see Young, *The Elmhirsts of Dartington*, 210, 225.

48. Mark Tobey to Leonard Elmhirst, undated letter [1931–32], Dartington Hall Trust Archives.

49. B. Leach, *A Potter's Book*, 2nd ed. (London: Faber and Faber, 1945), 25–37.

50. Charles Marriot, "Mr. Bernard Leach," *Times* (London), December 5, 1933. On Leach's role in shifting British ideas about studio ceramics, see Julian Stair, "Re-Inventing the Wheel: The Origins of Studio Pottery," in *The Persistence of Craft: The Applied Arts Today*, ed. Paul Greenhalgh (London: A & C Black, 2002).

51. Mark Tobey, untitled autobiographical fragment recalling Bernard Leach, Mark Tobey Papers, box 6, folder 34, Special Collections, University of Washington Libraries.

52. Bernard Leach, "Mark, Dear Mark," *World Order* 2, no. 3 (1977): 28.

53. Emmanuel Cooper, *Bernard Leach: Life and Work* (New Haven: Yale University Press, 2003), 180.

54. Mark Tobey to Bernard Leach, January 1, 1933, Crafts Study Centre, Surrey University College of Art and Design.

55. Leach quoted in E. Cooper, *Bernard Leach*, 181.

56. Wehr, *The Accidental Collector*, 224–25. Wehr's notes on his conversations with Tobey specify that Tobey's "first great romance" at age twenty-one was with an older Swiss man and quote Tobey explaining, "My attachments have been something beautiful inside myself even if on the outside of it they didn't go well" (notes on conversation, January 1958, Wesley Wehr Papers, Special Collections, University of Washington Libraries).

57. Mark Tobey, untitled autobiographical fragment recalling Bernard Leach, Mark Tobey Papers, box 6, folder 34, Special Collections, University of Washington Libraries.

58. Mark Tobey, letter [likely to Dorothy Elmhirst], undated [April 1934], Dartington Hall Trust Archive.

59. Mark Tobey, untitled autobiographical fragment recalling Bernard Leach, Mark Tobey Papers, box 6, folder 34, Special Collections, University of Washington Libraries.

60. E. Cooper, *Bernard Leach*, 83–84, 175–76.

61. Silvan Tomkins, *Affect, Imagery, Consciousness*, vol. 2, *The Negative Affects* (1963; repr. in Eve Kosofsky Sedgwick and Adam Frank, eds., *Shame and Its Sisters: A Silvan Tomkins Reader* (Durham: Duke University Press, 1995), 133, 135, 152; Michael Franz Basch, "The Concept of Affect: A Re-examination," *Journal of the American Psychoanalytic Association* 24 (1976): 765.

62. Eve Kosofsky Sedgwick, "Shame, Theatricality, and Queer Performativity: Henry James's *The Art of the Novel*," (1993; repr. in *Gay Shame*, ed. David Halperin and Valerie Traub (Chicago: University of Chicago Press, 2009), 51, 58. Although, as Sedgwick acknowledges, the conventional distinction between guilt and shame rests on a distinction between "what one does" and "what one is," the rehearsal of sexual sins understood as habitual and indicative of personality clearly qualifies as shame.

63. Michael Warner, "Pleasures and Dangers of Shame," in *Gay Shame*, 284, 290, 292.

64. Mark Tobey to "Jerry," April 1, 1934, Dartington Hall Trust Archive.

65. Mark Tobey [likely to Dorothy Elmhirst], undated letter [April 1934], Dartington Hall Trust Archive.

66. Leach, *Beyond East and West*, 168–69; Leach, "Mark, Dear Mark," 29.

67. Mark Tobey, untitled autobiographical fragment recalling Bernard Leach, Mark Tobey Papers, box 6, folder 34, Special Collections, University of Washington Libraries.

68. Mark Tobey to Bernard Leach, undated letter [April 1932], Dartington Hall Trust Archive. Leach's memoirs overlook this document, claiming Tobey never told him of his decision to stay in China but simply "stayed ashore . . . throwing streamers" when the boat left for Japan (*Beyond East and West*, 173).

69. Mark Tobey, journal entry, March 21, 1934, Mark Tobey Papers, box 7, folder 6, Special Collections, University of Washington Libraries.

70. Mark Tobey, journal entry, April 1, 1934, Mark Tobey Papers, box 7, folder 8, Special Collections, University of Washington Libraries.

71. Mark Tobey to "Jerry," April 1, 1934, Dartington Hall Trust Archive.

72. Mark Tobey, "Eight Hours in Colombo," manuscript, Mark Tobey Papers, box 6, folder 34, Special Collections, University of Washington Libraries.

73. Leach, *Beyond East and West,* 170–71.

74. Ibid., 171.

75. Tobey, "Reminiscence and Reverie," 230.

76. Mark Tobey to Dorothy and Leonard Elmhirst, April 25, 1934, Dartington Hall Trust Archive.

77. Mark Tobey, journal entry, March 21, 1934, Mark Tobey Papers, University of Washington Library, Special Collections, box 7, folder 6.

78. Mark Tobey to Dorothy Elmhirst, May 3, 1934, Dartington Hall Trust Archive.

79. Mark Tobey to Dorothy Elmhirst, undated letter [May 1934], Dartington Hall Trust Archive. A typed transcript of Tobey's journal entry for May 7, 1934, describes visiting the house Ascough shared with her female companion (Mark Tobey Papers, box 7, folder 14, Special Collections, University of Washington Libraries).

80. Mark Tobey to Dorothy Elmhirst, undated letter [May 1934], Dartington Hall Trust Archive.

81. Mark Tobey to Dorothy and Leonard Elmhirst, April 25, 1934, Dartington Hall Trust Archive.

82. Mark Tobey to Dorothy Elmhirst, undated letter ["Friday," June/July 1934], Dartington Hall Trust Archive.

83. Eliza E. Rathbone, *Mark Tobey City Paintings* (Washington, DC: National Gallery of Art, 1984), 71n5.

84. "Japanese Provide for Study of Buddhism by Foreigners," *New York Times*, December 25, 1932. Tobey's presence at Enpuku-ji was first documented in Bert Winther-Tamaki, "Mark Tobey: White Writing for a Janus-Faced America," *Word & Image* 13, no. 1 (1997): 80. The facilities designed for Westerners to study Zen were in place by 1930 (Thomas Yuho Kirchner, editor's prologue to Yixuan, *The Record of Linji*, ed. Thomas Yuho Kirchner [Honolulu: University of Hawai'i Press, 2008], xviii).

85. Daisetz T. Suzuki, *Essays in Zen Buddhism (First Series)* (1927; repr., London: Rider, 1949), 268. On Suzuki, see Thomas A. Tweed, "American Occultism and Japanese Buddhism," 256–57.

86. Mark Tobey, undated journal entries [June 1934], copies in the Wesley Wehr Papers, Special Collections, University of Washington Libraries.

87. Mark Tobey, interview by William Seitz, 1961, Mark Tobey Papers, Special Collections, University of Washington Libraries, quoted (slightly modified) in Seitz, *Mark Tobey*, 50).

88. Tobey, "Japanese Traditions and American Art," 24, 22. This memory of contemplation is matched by recollections of how, at the temple, "I used to practice making strokes in front of a moon window" (Mark Tobey, interview by William Seitz, 1961, Mark Tobey Papers, box 10, folder 23, Special Collections, University of Washington Libraries).

89. In Watt, "Paris Commentary," 223; Tobey, "Japanese Traditions and American Art," 22.

90. Mark Tobey to Dorothy Elmhirst, undated ["Friday," June/July 1934], Dartington Hall Trust Archive. Virtually the same passage appears in pages identified as Tobey's journal, Mark Tobey Papers, box 7, folder 28, Special Collections, University of Washington Libraries.

91. Belle Krasne, "A Tobey Profile," *Art Digest* 26, no. 2 (1951): 26.

92. Mark Tobey to Dorothy Elmhirst, undated draft of letter ["Friday," June/July 1934], in Tobey's journal, Mark Tobey Papers, box 7, folder 28, Special Collections, University of Washington Libraries. The words "and fleur-de-lis" in Tobey's journal draft of this passage are omitted from the letter.

93. Mark Tobey to Dorothy Elmhirst, undated letter ["Friday," June/July 1934], Dartington Hall Trust Archive.

94. Mark Tobey, undated journal entry [June/July 1934], Mark Tobey Papers, box 7, folder 30, Special Collections, University of Washington Libraries.

95. Yuko Kikuchi, *Japanese Modernism and Mingei Theory: Cultural Nationalism and Oriental Orientalism* (London: Routledge, 2004), 12–16, 68–69, 197–98; Edmund de Waal, "Homo Orientalis: Bernard Leach and the Image of the Japanese Craftsman," *Journal of Design History* 10, no. 4 (1997), 355–61.

96. Bernard Leach, "A Letter to England," *Kogei* 53 (1935): 40.

97. Leach, "A Letter to England," 20; see also his *Beyond East and West*, 194.

98. Leach, "A Letter to England," 40, 21–22.

99. Bernard Leach, "Impressions of Japan After Fourteen Years," *Kogei* 53 (1935), 10; E. Cooper, *Bernard Leach*, 186; see also Leach, *Beyond East and West*, 174.

100. Leach, *Beyond East and West*, 181.

101. Bernard Leach to Dorothy and Leonard Elmhirst, August 24, 1934, Dartington Hall Trust Archive.

102. Mark Tobey to Dorothy and Leonard Elmhirst, June 9, 1934, Dartington Hall Trust Archive.

103. Dorothy Elmhirst to Mark Tobey, telegram, July 17, 1934, Dartington Hall Trust Archive.

104. Ament, *Iridescent Light*, 25. Ament speculates, "Possibly they considered his sketches of nude men pornographic." Tobey discussed a set of the printed reproductions that remained in his possession, though not the destruction of the originals, in Seldon Rodman, *Conversations with Artists* (New York: Capricorn, 1961), 5–6, 18. A related drawing is at the Seattle Art Museum (no. 10 in Seattle Art Museum, *Tobey's 80*, n.p).

105. In Katharine Kuh, *The Artist's Voice: Talks with Seventeen Modern Artists* (1962; repr., Cambridge, MA: Da Capo Press, 2000), 236–37. Ambiguities about the dating of these works, completed some time in the autumn of 1935 or winter of 1935–36, are discussed in Seitz, *Mark Tobey*, 85n47.

106. Mark Tobey to Kenneth Callahan, undated letter [c. 1935], in Rathbone, *Mark Tobey*, 30; interview in *Seattle Daily Times*, May 3, 1957, quoted in Ament, *Iridescent Light*, 25–26.

107. In Watt, "Paris Commentary," 224. William Seitz reports that Tobey told him the composition began as a still life in a crystal bowl (*Abstract Expressionist Painting in America* [Cambridge, MA: Harvard University Press, 1983], 44, 129). Tobey's account complicates Elizabeth Willis's claim that "I named *Broadway Norm*. . . . In fact I named practically all Tobey's paintings for him for many years" (in Ament, *Iridescent Light*, 30). Willis and Tobey had not met in 1935, and the work titled *Broadway*, painted shortly after the abstraction later titled *Broadway Norm*, quite clearly represents New York. If Willis invented specific titles, she drew on visual cues in Tobey's art and on their conversations.

108. Seitz, *Mark Tobey*, 51.

109. Ibid.

110. Kuh, *The Artist's Voice*, 236–37.

111. Mark Tobey to Katharine Kuh, October 28, 1961, in Kuh, *The Artist's Voice*, 240.

112. In Rathbone, *Mark Tobey*, 25.

113. In Kuh, *The Artist's Voice*, 243–44.

114. Quoted in "Texts from Mark Tobey: Selected Notes," Committee Mark Tobey website, Kosme de Barañano, Matthias Bärmann, and Heiner Hachmeister, eds., www.cmt-marktobey.net.

115. In Kuh, *The Artist's Voice*, 236, 240. Tobey continually invoked and disavowed the term *white writing*, sometimes in the same document (e.g., Kuh, *The Artist's Voice*, 237). Tobey has been quoted asserting, "People say I called my painting 'white writing.' I didn't. Someone else did" (in Rathbone, *Mark Tobey*, 41). Elizabeth Willis, who worked at the Willard Gallery at Tobey's behest, claimed to have coined the term *white writing* for his first show at the gallery in 1944. Gallery publicity credited the term to Tobey, however, and the attribution was picked up in reviews (e.g., Maud Riley, "Mark Tobey's White Writing," *Art Digest* 18, no. 13 [1944]; "The Passing Shows," *Art News* 43, no. 5 [1944]). On Willis's role in shaping Tobey's career, see Patricia Junker, *Modernism in the Pacific Northwest: The Mythic and the Mystical; Masterworks from the Seattle Art Museum* (Seattle: University of Washington Press, 2014), 57–61; see also note 107.

116. Mark Tobey to Dorothy Elmhirst, undated letter [April 1934], Dartington Hall Trust Archive; compare his use of the forest metaphor in the letter quoted in note 80. Tobey's comparisons of Shanghai with New York were not always enthusiastic. Perhaps in deference to Leach's anti-urban prejudices, Tobey told him, "Shanghai in itself is the worst aspect of New York" (Mark Tobey to Bernard Leach, undated letter [April 1934], Crafts Study Centre, Surrey University College of Art and Design).

117. Roland Barthes, *Empire of Signs*, trans. Richard Howard (1970; repr., New York: Hill and Wang, 1982), 6 (as discussed in the introduction).

118. Tobey, "Reminiscence and Reverie," 231. The interpolated line is from Arthur Waley, *A Hundred and Seventy Chinese Poems* (London: Constable, 1918), 92.

119. Tobey, cited at note 11. William Seitz links the subject matter of *Welcome Hero* to "the early years in New York that Tobey remembers so vividly, and to the reception of Lindbergh after his transatlantic flight (*Mark Tobey*, 51), but those are different moments. Tobey moved to Seattle in 1923. Lindbergh crossed the Atlantic in 1927. Tobey's biographical record is too fragmentary to exclude definitively the possibility that he might have been visiting New York for the Lindbergh parade on June 13, 1927, but the public celebration his memoirs repeatedly describe is the Armistice.

120. The robes and headgear of these figures more closely resemble Shinto vestments.

121. Mark Tobey to Katharine Kuh, October 28, 1961, in Kuh, *The Artist's Voice*, 240.

122. Quoted in "Texts from Mark Tobey: Selected Notes," Barañano et al., eds., Committee Mark Tobey website, www.cmt-marktobey.net.

123. Seitz, *Tobey*, 33.

124. Edward B. Thomas, untitled introduction to Seattle Art Museum, *Mark Tobey: A Retrospective Exhibition from Northwest Collections* (1959), n.p.

125. Wesley Wehr, notes on conversations with Tobey dated "1956 NYC" and "Christmas Day 1977 Seattle," Wesley Wehr Papers, Special Collections, University of Washington Libraries. William Seitz's Museum of Modern Art catalog attempts to negotiate Tobey's "humanism" in relation to "his movement toward abstraction" (33).

126. Wesley Wehr, notes on conversation with Mark Tobey, April 27, 1962, Wesley Wehr Papers, Special Collections, University of Washington Libraries. This statement was amended in Wehr's notes from "If I painted what I really wanted to these days, I suppose I'd paint the male figure. But then how to reconcile it with the spatial?" When Wehr published this exchange, he amended it to read, "If I really were to paint what I want these days, I'd paint the human figure " (Wesley Wehr, "Conversations with Mark Tobey," *Northwest Arts* 5, no. 1 (1979); this ephemeral publication is also in the Wehr Papers. Wehr neutered gender references in many of his quotations of Tobey.

127. Sheryl Conkleton, and Laura Landau, *Northwest Mythologies: The Interactions of Mark Tobey, Morris Graves, Kenneth Callahan, and Guy Anderson* (Seattle: University of Washington Press, 2003), 31n50. Tobey stayed in New York, uncertain whether to go to England, until he returned to Seattle in January 1939.

128. Richard E. Fuller, *A Gift to the City: A History of the Seattle Art Museum and the Fuller Family* (Seattle: Seattle Art Museum, 1993), 2, 33. On the Fullers, see Warren I. Cohen, *East Asian Art and American Culture* (New York: Columbia University Press, 1992), 104–11. Matthew Kangas writes that "Richard Fuller did not marry until the age of 54 and though it would be heresy in Seattle to suggest he was homosexual, it is undeniable that he enjoyed or preferred male company, especially that of Tobey and Graves" ("Prometheus Ascending: Homoerotic Imagery of the Northwest School," *Art Criticism* 2, no. 3 [1986]: 92).

129. When Cahill came through Seattle in 1937 assigning stipends, he gave Graves an especially high salary (Graves, *Selected Letters*, 228).

130. In Frederick W. Wight, *Morris Graves* (Berkeley: University of California Press, 1956), 7, 19.

131. Morris Graves to Celia Graves, October 12, 1939, *Selected Letters*, 49–50.

132. Journal of Nancy Wilson Ross, in Kay Larson, *Where the Heart Beats: John Cage, Zen Buddhists, and the Inner Life of Artists* (New York: Penguin, 2012), 76.

133. Morris Graves to Marian Willard, February 24, 1942, *Selected Letters*, 261.

134. Morris Graves to Elizabeth Willis, April 30, 1944, *Selected Letters*, 268–69.

135. Kangas, "Prometheus Ascending," 89–91.

136. Christopher Reed, Art and Homosexuality: A History of Ideas (New York: Oxford University Press, 2011), 128.

137. Riley, "Mark Tobey's White Writing."

138. "The Passing Shows," 25.

139. John Cage, foreword to M: Writings '67–'72 (Middletown, CT: Wesleyan University Press, 1973), n.p..

140. John Cage, For the Birds: John Cage in Conversation with Daniel Charles (Boston: Marion Boyars, 1981), 158.

141. Paul Cummings, "Oral History Interview with John Cage," May 2, 1974, Archives of American Art, Smithsonian Institution, www.aaa.si.edu/collections/interviews /oral-history-interview-john-cage-12442.

142. Richard Kostelanetz, Conversing with Cage (New York: Limelight, 1987), 174–5.

143. Cage, For the Birds, 158.

144. Cage, M, 187.

145. John Cage, "The Future of Music: Credo," in John Cage, Silence: Lectures and Writings (1961; repr., Middletown, CT: Wesleyan University Press, 2011), 3–6. Cage misdates this lecture to 1937 (Leta E. Miller "Cultural Intersections: John Cage in Seattle (1938–1940)," in John Cage: Music, Philosophy, and Intention, 1933–1950, ed. David W. Patterson [New York: Routledge, 2002], 54–56).

146. In Stephen Montague, "John Cage at Seventy: An Interview," American Music 3, no. 2 (1985): 210. Cage misdates this episode to 1938 (L. Miller "Cultural Intersections," 65).

147. Cage, Silence, xxxi.

148. In Wight, Morris Graves, 20. On this passage, see Larson, Where the Heart Beats, 76.

149. The talk is quoted and its reception described in Larson, Where the Heart Beats, 139.

150. In Junker, Modernism in the Pacific Northwest, 56. Martha Kingsbury, "Four Artists in the Northwest Tradition," in Northwest Traditions (Seattle: Seattle Art Museum, 1978), 13. Tobey's identification as a "mystic" was already present in Marsden Hartley's 1931 essay on him (quoted at note 34), and this terminology characterized Willard's presentation of Tobey and Graves in 1944 and 1945. When Tobey's art was featured in the Museum of Modern Art's 1946 Fourteen Americans exhibition curated by Dorothy C. Miller, the wife of his old friend Holger Cahill, her catalog introduction referred to his "mystical vision" (7).

151. David W. Patterson, "Cage and Asia: History and Sources," in The Cambridge Companion to John Cage, ed. David Nicholls (Cambridge: Cambridge University Press, 2002), 43.

152. John Cage, Musicage: Cage Muses on Words, Art, Music, ed. Joan Retallack (Hanover, NH: University Press of New England, 1996), 54; compare 101.

153. Cage, M, 188, 190.

154. Cage, For the Birds, 94.

155. In Thomas S. Hines, "Then Not Yet 'Cage,'": The Los Angeles Years, 1912–1938," in John Cage: Composed in America, ed. Marjorie Perloff and Charles Junkerman (Chicago: University of Chicago Press, 1994), 66.

156. Patterson, "Cage and Asia," 53. Patterson notes that, "unfortunately, this spurious citation to Suzuki's lectures has been the predominant (and often only) historical reference to Cage's early East Asian studies" (53). Leta Miller similarly observes, "Faulty information about Cage's Seattle years in general has been repeated so often that at times it has been considered 'documented'" ("Cultural Intersections," 47).

157. Jonathan Katz, "John Cage's Queer Silence; or, How to Avoid Making Matters Worse," GLQ 5, no. 2 (1999): 231.

158. Jonathan Katz, "Agnes Martin and the Sexuality of Abstraction," in Agnes Martin, ed. Lynne Cooke, Karen Kelly, and Barbara Schröder (New Haven: Yale University Press, 2011), 99.

159. David Revill, Roaring Silence: John Cage, A Life (London: Bloomsbury, 1992), 84. The revised second edition, published in 2014, augments this statement with the garbled warning, "It is important not to apply contemporary ideas of openness, and calumniation of those today who live their sexuality discreetly or even hide it, to older generations and the internal and external pressures which led them to hide (so many married for the sake of a social place and for appearances) or deny who they were." Kenneth Goldsmith criticizes "this type of veiled biography" by Cage's closest associates as "irresponsible and unthinkable in 1992" and blames their timidity for diminishing "the cultural power and pull that he had in his heyday of the 1960's and 1970's" ("Review of John Cage: Composed in America," RIF/T 5, no 1 (1995), wings.buffalo.edu/epc/rift/rift05/revio501).

160. Hines, "Then Not Yet 'Cage,'" 81–84, 91–92. See also Harry Hay's memoir of Cage in the early 1930s in Radically Gay: Gay Liberation in the Words of Its Founder (Boston: Beacon, 1996), 319–23.

161. Kenneth Silverman, Begin Again: A Biography of John Cage (Evanston, IL: Northwestern University Press, 2012), 35; Hines, "Then Not Yet 'Cage,'" 99n60.

162. Cummings, "Oral History Interview with John Cage."

163. As cited at note 148. Unsurprisingly, given American hostility toward Japan during the war years, there is no evidence of other input about Zen during the 1940s, although Cage studied Coomaraswamy's ideas at this period (Patterson, "Cage and Asia"; Edward James Crooks, "John Cage's Entanglement with the Ideas of Coomaraswamy" [Ph.D. dissertation, University of York, 2011].)

164. Cage, *Musicage*, 54; compare 101.

165. L. Miller, "Cultural Intersections," 56.

166. In William Duckworth, "Anything I Say Will Be Misunderstood: An Interview with John Cage," in *John Cage at Seventy-Five*, ed. Richard Fleming and William Duckworth (Lewisburg, PA: Bucknell University Press, 1989), 27.

167. Alexandra Munroe, introduction to *The Third Mind: American Artists Contemplate Asia, 1860–1989* (New York: Guggenheim Museum Publications, 2009), 22.

168. Cage, *Silence*, xxxi.

169. Crooks, "John Cage's Entanglement," 285, 281.

170. Cage, *For the Birds*, 158.

171. Patterson, "Cage and Asia," 43.

172. Rodman, *Conversations with Artists*, 7.

173. Mark Tobey, interview by William Seitz, 1961, in Rathbone, *Mark Tobey*, 35–36. Tobey's process is described in William Cumming, *Sketchbook: A Memoir of the 1930s and the Northwest School* (Seattle: University of Washington Press, 1984), 104.

174. Betty Bowen, introduction to Seattle Art Museum, *Tobey's 80*, n.p.

175. Gail, "The Days with Mark Tobey," 17.

176. Mark Tobey, untitled introduction to *Mark Tobey: The World of a Market* (Seattle: University of Washington Press, 1964), n.p..

177. Mark Tobey to Elizabeth Willis, March 2, 1944, in Junker, *Modernism in the Pacific Northwest*, 58. Although his advice was ignored, the Willard Gallery's next exhibit of Tobey's art in 1945 was divided into four sections—War, City, Indian (meaning Native American), and Religion—none of which referenced East Asia.

178. Mark Tobey, untitled artist's statement, in Dorothy C. Miller, *Fourteen Americans* (New York: Museum of Modern Art, 1946), 70. Wesley Wehr's notes from a conversation with Tobey, dated January 11, 1960, report that *E Pluribus Unum* was titled by Pehr Hallsten, a Swedish immigrant who was Tobey's partner from about 1940, adding a personal implication to this invocation of American diversity.

179. Mark Tobey, untitled artist's statement, in D. Miller, *Fourteen Americans*, 70.

180. Serge Guilbaut, *How New York Stole the Idea of Modern Art* (Chicago: University of Chicago Press, 1983), 174–77.

181. D. Miller, *Fourteen Americans*, 8.

182. James Thrall Soby, "Romantic Painting in America," in *Romantic Painting in America*, ed. James Thrall Soby and Dorothy C. Miller (New York: Museum of Modern Art, 1943), 45.

183. Thomas Craven, "Our Decadent Art Museums," *American Mercury* (1941): 683.

184. Thomas Craven, *Modern Art: The Men, the Movements, and the Meaning* (New York: Simon and Schuster, 1934), 312–13.

3. SUBLIMATION AND ECCENTRICITY IN THE ART OF MARK TOBEY 375

185. Soby, "Romantic Painting in America," 45.

186. H. W. Janson, "The International Aspects of Regionalism," *College Art Journal* 2, no. 4, part 1 (1943): 114–15.

187. "Northwest Artists Work, Fight, Paint," *Art Digest* 18, no. 3 (1943): 22. MoMA's *Romantic Painting in America* exhibit in 1943 also presented Graves's paintings as "related to Mark Tobey's 'white writing'" (Soby, "Romantic Painting in America," 48). Looking back further, Martha Kingsbury observes no stylistic affinities among the five Seattle artists—not including Tobey—included in the 1933 MoMA exhibition *Painting and Sculpture from Sixteen American Cities*, and in 1937, the *Magazine of Art* reported, "There is no single school of northwest painting, as is apparent in California" (Martha Kingsbury, "Seattle and the Puget Sound," in *Art of the Pacific Northwest from the 1930s to the Present* [Washington, DC: Smithsonian Institution Press, 1974]), 48.

188. Aline B. Louchheim, "Graves New World," *Art News* 44, no. 1 (1945): 18.

189. Kenneth Callahan, "Pacific Northwest," *Art News* 45, no. 50 (1946): 22, 24.

190. Rosamund Frost, "Callahan Interrelates Man and Nature," *Art News* 44 (February 1946), in Kingsbury, "Seattle and the Puget Sound," 59.

191. Harris K. Prior, "Ten Painters of the Pacific Northwest," in *Ten Painters of the Pacific Northwest* (Utica, NY: Munson-Williams-Proctor Institute, 1947), 4.

192. Kingsbury "Seattle and Puget Sound," 60.

193. Kenneth Callahan, "This Summer in the Northwest," *Art News* 50, no. 4 (1951): 58; Morris Graves, letter to the editor, *Art News*, September 1951, 6. On the enmity that emerged among the Northwest artists at this time, see Conkleton and Landau, *Northwest Mythologies*, 83

194. Krasne, "A Tobey Profile," 5.

195. "Mystic Painters of the Northwest," *Life*, September 28, 1953: 84. For background on this article, see Junker, *Modernism in the Pacific Northwest*, 61–63.

196. Clement Greenberg, untitled review, *Nation*, November 21, 1942, repr. in Clement Greenberg, *The Collected Essays and Criticism*, vol. 1, *Perceptions and Judgments, 1939–1944*, ed. John O'Brian (Chicago: University of Chicago Press, 1986), 126.

197. C. Greenberg, untitled review, *Nation*, February 17, 1945, repr. in Clement Greenberg, *The Collected Essays and Criticism*, vol. 2, *Arrogant Purpose, 1945–1949*, ed. John O'Brian (Chicago: University of Chicago Press, 1986), 7–8; Louchheim, "Graves New World," 18.

198. Callahan, "Pacific Northwest," 24–25. Other articles on Tobey in 1946 similarly reported that he "went to China to study Chinese brushwork from which he evolved his 'white writing'" (Jo Gibbs, "Tobey the Mystic," *Art Digest* 20, no. 4 [1945]: 39).

199. Prior, "Ten Painters," 5.

200. Callahan, "This Summer in the Northwest," 41, 58.

201. W[allace] S. Baldinger, "Regional Accent," *Art in America* 53 (1965): 34. This claim is repeated in the 1999 edition of Peter Plagens, *The Sunshine Muse: Art on the West Coast, 1945–1970* (1974; repr., Berkeley: University of California Press, 1999), 10.

202. Craven, *Modern Art*, 315–16.

203. Barbara Johns, *Signs of Home: The Paintings and Wartime Diary of Kamekichi Tokita* (Seattle: University of Washington Press, 2011), 19–37, 57–98.

204. Kenneth Callahan, "Pacific Northwest Painters," *Art and Artists Today* (1937): 6.

205. Martha Kingsbury, "Oral History Interview with Viola Patterson," October 22–29, 1982. Archives of American Art, Smithsonian Institution, www.aaa.si.edu/collections/interviews/oral-history-interview-viola-patterson-12618. Nomura and Tokita worked together as sign painters in the Japanese community and painted sets for local *kabuki* productions.

206. George Tsutakawa, "A Conversation on Life and Fountains," *Journal of Ethnic Studies* 4, no. 1 (1976): 12; Martha Kingsbury, "Oral History Interview with George Tsutakawa," September 8–19, 1983, Archives of American Art, Smithsonian Institution, www.aaa.si.edu/collections/interviews/oral-history-interview-george-tsutakawa-11913.

207. Nancy Wilson Ross, *Farthest Reach: Oregon and Washington* (New York: Alfred A. Knopf, 1941), 170, 174.

208. Mark Tobey, "Pike Place Market" [draft introduction for *The World of a Market*], Mark Tobey Papers, Special Collections, University of Washington Libraries.

209. Clement Greenberg, untitled review, *Nation*, April 22, 1944, repr. in Clement Greenberg, *The Collected Essays and Criticism*, vol. 1, *Perceptions and Judgments 1939–1944*, ed. John O'Brian (Chicago: University of Chicago Press, 1986), 205–6.

210. Clement Greenberg, "Review of the Pepsi-Cola Annual, the Exhibition *Fourteen Americans*, and the Exhibition *Advancing American Art*," *Nation*, November 23, 1946, repr. in Greenberg, *Collected Essays*, vol. 2, 113.

211. Clement Greenberg, "Review of the Whitney Annual," *Nation*, December 28, 1946, repr. in Greenberg, *Collected Essays*, vol. 2, 118.

212. Clement Greenberg, "The Present Prospects of American Painting and Sculpture," *Horizon*, October 1947, repr. in Greenberg, *Collected Essays*, vol. 2, 165–66. Michael Freeman quotes more examples of this rhetoric in which New York critics make residence in New York a prerequisite for producing credible abstract art (Michael Russell Freeman, "'The Eye Burns Gold, Burns Crimson, and Fades to Ash': Mark Tobey as a Critical Anomaly" [Ph.D. dissertation, Indiana University, 2000], 137–38). These prejudices echo through Barry Schwabsky's 2009 review of the Guggenheim exhibition *The Third Mind: American Artists Contemplate Asia*, which

questions "the presence here of the great New York Abstract Expressionists," complaining that "the comparison ignores the fundamentally urban and secular turbulence and clamor that inhabit the paintings of Pollock or Franz Kline," before deciding "on second thought, it's right that Abstract Expressionists are prominently featured," because, like Whitman, "their Asian dimension came entirely from within themselves" ("Disquieting and Enraptured," *The Nation,* April 20, 2009, 32–33).

213. Martha Kingsbury documents the disappearance of Northwest artists from the Whitney Museum surveys of new art during the 1950s ("Seattle and the Puget Sound," 62).

214. Greenberg, "Present Prospects," 166.

215. Thomas B. Hess, *Abstract Painting: Background and American Phase* (New York: Viking, 1951), 121.

216. Museum of Modern Art, "Japanese Exhibition House Opens in Museum of Modern Art Garden," press release June 20, 1954, www.moma.org/momaorg/shared/pdfs/docs/press_archives/1845/releases/MOMA_1954_0066_61.pdf

217. Clement Greenberg, *Art and Culture: Critical Essays* (Boston: Beacon, 1961), 220.

218. Bert Winther-Tamaki, "The Asian Dimensions of Postwar Abstract Art: Calligraphy and Metaphysics," in Munroe, *The Third Mind,* 152; Bert Winther-Tamaki, *Art in the Encounter of Nations: Japanese and American Artists in the Early Postwar Years* (Honolulu: University of Hawai'i Press, 2001), 46, 57–58.

219. Clement Greenberg, "'American-Type' Painting," *Partisan Review* (Spring 1955), repr. in Clement Greenberg, *The Collected Essays and Criticism,* vol. 3, *Affirmations and Refusals, 1950–1955,* ed. John O'Brian (Chicago: University of Chicago Press, 1993), 225.

220. Judith S. Kays, "Mark Tobey and Jackson Pollock: Setting the Record Straight," in Bärman et al., *Mark Tobey,* 93–97.

221. Sarah C. Faunce, "Tobey: Painter or Prophet?," *Art News* 61, no. 5 (1962): 39, 60.

222. In Kays, "Mark Tobey and Jackson Pollock," 103.

223. Irving Sandler in Winther-Tamaki, *Art in the Encounter of Nations,* 55; Sam Hunter, interviewed in Jeffrey Wechsler, *Abstract Expressionism: An Introduction to Small Scale Painterly Abstraction in America, 1940–1965* (New Brunswick, NJ: Jane Voorhees Zimmerli Art Museum, Rutgers University, 1989), 71.

224. Clifford Ross, ed., *Abstract Expressionism: Creators and Critics* (New York: Harry N. Abrams, 1991), 11.

225. The scholarly literature on this topic is enormous. For overviews, see Ann Eden Gibson, *Abstract Expressionism: Other Politics* (New Haven: Yale University Press, 1997), and Reed, *Art and Homosexuality.*

226. N. Ross, *Farthest Reach,* 178.

227. Martha Kingsbury, "Northwest Art: The Mid-Century Seen from the End of the Century," in *What It Meant to Be Modern: Seattle Art at Mid-Century*, ed. Sheryl Conkelton (Seattle: Henry Art Gallery, University of Washington, 1999), 29.

228. Peter Boag, *Same-Sex Affairs: Constructing and Controlling Homosexuality in the Pacific Northwest* (Berkeley: University of California Press, 2003), 62, 70, 80, 85,

229. Reed, *Art and Homosexuality*, 153–54.

230. Greenberg, "Present Prospects," 166.

231. Kangas, "Prometheus Ascending," 90.

232. Kingsbury, "Northwest Art," 29. The first published allusion to Tobey's homosexuality seems to have been in a small Seattle newspaper shortly after his death in 1976 (Roger Downey, "The Mystery of Mark Tobey," *Weekly* (Seattle), July 14–20, 1976).

233. Wieland Schmied, *Tobey*, trans. Margaret L. Kaplan (New York: Harry N. Abrams, 1966), 48, 50.

234. Freeman, "The Eye Burns Gold," 70–83; Seitz, *Mark Tobey*, 87n99.

235. M. Tobey, "Reminiscence and Reverie," 228, 230, 232.

236. Christina Klein, *Cold War Orientalism: Asia in the Middlebrow Imagination, 1945–1961* (Berkeley: University of California Press, 2003), 7, 21–24. On this era's paradoxical construction of the highly restrictive American avant-garde as an exemplar of freedom, see Guilbaut, *How New York Stole the Idea of Modern Art*, 200–203.

237. On the situation of Japanese war brides, see Masako Nakamura, "Families Precede Nation and Race? Marriage, Migration and Integration of Japanese War Brides After World War II" (Ph.D. dissertation, University of Minnesota, 2010), which narrows Robert G. Lee's argument about Asians as model minorities (*Orientals: Asian Americans in Popular Culture* [Philadelphia: Temple University Press, 1999], 180–203) to focus particularly on Japanese war brides who worked for acceptance into their husbands' families.

238. Caroline Chung Simpson, *An Absent Presence: Japanese Americans in Postwar American Culture, 1945–1960* (Durham: Duke University Press, 2001), 152–64; Takami, *Divided Destiny*, 75–76.

239. James A. Michener, "Pursuit of Happiness by a GI and a Japanese," *Life*, February 21, 1955. This article is discussed in Simpson, *An Absent Presence*, 178–84.

240. Gordon H. Chang, "Deployments, Engagements, Obliterations: Asian American Artists and World War II," in Gordon H. Chang, Mark Dean Johnson, and Paul J. Karlstrom, eds., *Asian American Art: A History 1850–1970* (Palo Alto, CA: Stanford University Press, 2008), 132. Despite MacArthur's endorsement, the 1951 show was not the outcome of a long-term plan; the catalog for *Art Treasures from Japan: A Special Loan Exhibition in Commemoration of the Signing of the Peace Treaty in San Francisco September 1951* emphasizes that the exhibition was organized in just a few weeks.

241. Cohen, *East Asian Art and American Culture*, 136.

242. Christopher Reed, "Aesthetic Diplomacy: 'Creative Prints' in the Post-War Era," in *Japan/America: Points of Contact, 1876–1970*, ed. Christopher Reed (Ithaca, NY: Herbert F. Johnson Museum of Art, Cornell University, forthcoming); Jonathan Abel and Christopher Reed, "The Utility of Aesthetics: Exhibition, Pedagogy, and Critical Questions for Postcolonialism," *Verge: Studies in Global Asias* 1, no. 2 (2015), 42–57.

243. Howard Devree, "Oriental 'Invasion,'" *New York Times*, November 28, 1954.

244. In Winther-Tamaki, *Art in the Encounter of Nations*, 40. On Hasegawa in the United States, see also Ellen Pearlman, *Nothing and Everything: The Influence of Buddhism on the American Avant-Garde, 1942–1962* (Berkeley: North Atlantic, 2012), 124–28. The popular enthusiasm for Zen troubled those who, making a name for themselves as experts, had done the most to promote it; see Daisetz T. Suzuki, "Zen in the Modern World," *Japan Quarterly* 5, no. 4 (1958), and Alan Watts, "Beat Zen, Square Zen, and Zen," *Chicago Review* 12, no. 2 (1958).

245. Martha Kingsbury, *George Tsutakawa* (Seattle: University of Washington Press, 1990), 39–88; Barbara Johns, *Paul Horiuchi: East and West* (Seattle: University of Washington Press, 2008), 22–70. The experience of these men contrasts with the less privileged characters in John Okada's novel of postwar Seattle, *No-No Boy*, and with the impulse of the next generation to engage aesthetically and politically with issues of oppression, resistance, and reparation (see, for example, Delphine Hirasuma, *The Art of Gaman* [Berkeley: Ten Speed Press, 2005].)

246. Martha Kingsbury, "Oral History Interview with George Tsutakawa," in Kingsbury, *George Tsutakawa*, 75.

247. Mark Tobey to Marian Willard, January and May 1956, in *Rétrospective Mark Tobey*, n.p.

248. Rodman, *Conversations with Artists*, 16.

249. Lisa Mintz Messinger, *Abstract Expressionism: Works on Paper, Selections from the Metropolitan Museum of Art* (New York: Metropolitan Museum of Art, 1992), 154; Rathbone, *Mark Tobey*, 64–66; Kays, "Mark Tobey and Jackson Pollock," 108–9.

250. Daisetz T. Suzuki, *Essays in Zen Buddhism (Third Series)* (1934; repr., London: Rider, 1953), 341.

251. Horiuchi recalled Tobey keeping ninety *sumi* paintings (Rathbone, *Mark Tobey*, 104); a 1957 column in the *Seattle Times* put the number at 150 (Louis Guzzo, "Color Is Distraction Says Learned Takizaki," *Seattle Times*, November 6, 1957 [clipping in Mark Tobey Papers, Special Collections, University of Washington Libraries]).

252. Mark Tobey to Marian Willard, July 1957, in *Rétrospective Mark Tobey*, n.p.

253. Guzzo, "Color Is Distraction." Other letters citing Takizaki are reprinted in Stanford Art Gallery, *Mark Tobey: Paintings from the Collection of Joyce and Arthur Dahl*

(Palo Alto, CA: Department of Art and Architecture, Stanford University, 1967), 12, and in *Rétrospective Mark Tobey*, n.p.

254. Tobey, "Japanese Traditions and American Art," 24. Takizaki endorsed Tobey's *sumi* paintings, in which "you will see no calligraphy and no writings. . . . Actually he has come closer to nature" (in Guzzo, "Color Is Distraction").

255. Mark Tobey to Katharine Kuh, November 9, 1961, in Kuh, *The Artist's Voice*, 245.

256. Harold Rosenberg, *The Anxious Object: Art Today and Its Audience* (New York: Horizon, 1964), 35.

257. Mark Tobey to Katharine Kuh, November 9, 1961, in Kuh, *The Artist's Voice*, 245.

258. Wesley Wehr, notes on conversation with Mark Tobey, October 13, 1966, Wehr Papers, Special Collections, University of Washington Libraries. The "double life," a key term in George Chauncey, *Gay New York: Gender, Urban Culture, and the Making of the Gay Male World 1890–1940* (New York: Harper Collins, 1994), was also ubiquitous in postwar discourses concerning spies, Communist agents, and other forms of deviance. See also David K. Johnson, *The Lavender Scare: The Cold War Persecution of Gays and Lesbians in the Federal Government* (Chicago: University of Chicago Press, 2004).

259. Mark Tobey to Katharine Kuh, November 9, 1961, in Kuh, *The Artist's Voice*, 245.

260. Kōjin Karatani, "Uses of Aesthetics: After Orientalism," *boundary 2* 25, no. 2 (1998): 46.

261. Johns, *Paul Horiuchi*, 55–58; Kingsbury, *George Tsutakawa*.

262. Johns, *Paul Horiuchi*, 62.

263. Jean-François Jaeger, in Watt, "Paris Commentary," 224.

264. In Schmied, *Tobey*, 6.

265. Annette Michelson, "E pluribus unum," in *Les monotypes de Tobey* (Paris: Galerie Jeanne Bucher, 1965), n.p. (The text appears in both French and English.) A copy of this catalog carries an admiring inscription from Tobey, beginning "Dear Anette [*sic*] Michelson: I am very happy with what you have written" (accessed at http://lameduckbooks.com/shop/detail/24898AB/).

CONCLUSION

1. Kōjin Karatani's charge that a Japanism that disempowers as it aestheticizes remained current in French intellectual culture far longer than in North America ("Uses of Aesthetics: After Orientalism," *boundary 2* 25 [1998]: 146) might be cited as context for Barthes's *Empire of Signs*.

2. I borrow this phrase from Walkowitz's introductory remarks at the conference Modernism and the Folk, Rutgers University, March 23, 2012.

3. Edmund de Waal, "Altogether Elsewhere: The Figuring of Ethnicity," in *The Persistence of Craft: The Applied Arts Today*, ed. Paul Greenhalgh (London: A & C Black, 2002), 194.

4. Christopher Castiglia, and Christopher Reed, *If Memory Serves: Gay Men, AIDS, and the Promise of the Queer Past* (Minneapolis: University of Minnesota Press, 2012), 91–112. By the time of Ann Bannon's 1962 *Beebo Brinker*, coming-out plots were staged as stories of migration to the paradigmatic gay neighborhood of New York's Greenwich Village.

BIBLIOGRAPHY

Abel, Jonathan, and Christopher Reed. "The Utility of Aesthetics: Exhibition, Pedagogy, and Critical Questions for Postcolonialism." *Verge: Studies in Global Asias* 1, no. 2 (2015): 42–57.

Adams, Henry. *The Letters of Henry Adams.* Edited by J. C. Levenson, Ernest Samuels Charles Vandersee, and Viola Hopkins Winner. 6 vols. Cambridge, MA: Harvard University Press, 1982–88.

———. *The Life of George Cabot Lodge.* Boston: Houghton Mifflin, 1911.

Addison, Julia de Wolf. *The Boston Museum of Fine Arts.* Boston: L. C. Page, 1910.

Adeline, Jules. *Le chat d'après les japonais.* Rouen: Cagniard, 1893.

Alaska–Yukon–Pacific Exposition. N.p.: n.d. [Seattle, 1909].

Alcock, Rutherford. *The Capital of the Tycoon: A Narrative of a Three Years' Residence in Japan.* 2 vols. London: Longman, Green, Longman, Roberts, and Green, 1863.

Ament, Deloris Tarzan. *Iridescent Light: The Emergence of Northwest Art.* Seattle: University of Washington Press, 2002.

"An American Professor Honored in Japan." *Current Opinion* 70 (1921): 247–48.

Arnold, Edwin. *Seas and Lands.* New York: Longmans, Green, 1891.

Art Treasures from Japan: A Special Loan Exhibition in Commemoration of the Signing of the Peace Treaty in San Francisco September 1951. San Francisco: M. H. De Young Memorial Museum, 1951.

Aston, W. G. *Shinto: The Way of the Gods.* London: Longmans Green, 1905.

Astruc, Zacharie. "L'empire du soleil levant." *L'Étendard,* February 27, 1876, 1–2; March 23, 1867, 1–2.

Austen, Roger. *Genteel Pagan: The Double Life of Charles Warren Stoddard.* Edited by John W. Crowley. Amherst: University of Massachusetts Press, 1991.

Auther, Elissa, and Adam Lerner, eds. *West of Center: Art and the Counterculture Experiment in America.* Minneapolis: University of Minnesota Press, 2011.

Bacon, Edwin M. *Bacon's Dictionary of Boston.* Boston: Houghton Mifflin, 1886.

Baldinger, W[allace] S. "Regional Accent: The Northwest." *Art in America* 53 (February 1965): 34–39.

Balducci, Temma, Heather Belnap Jensen, and Pamela J. Warner, eds. *Interior Portraiture and Masculine Identity in France, 1789–1914.* Burlington, VT: Ashgate, 2011.

Bannour, Wanda. *Edmond et Jules de Goncourt, ou le génie androgyne.* Paris: Persona, 1985.

Barañano, Kosme de, Matthias Bärmann, and Heiner Hachmeister, eds. "Texts from Mark Tobey: Selected Notes," Committee Mark Tobey website, www.cmt-marktobey.net.

Bärmann, Matthias, and Kosme de Barañano. *Mark Tobey.* Madrid: Museo Nacional Centro de Arte Reina Sofia, 1997.

Barthes, Roland, *A Barthes Reader.* Edited by Susan Sontag. New York: Farrar, Straus and Giroux, 1982.

——. *Empire of Signs.* 1970. Translated by Richard Howard. New York: Hill and Wang, 1982.

——. *The Grain of the Voice: Interviews 1962–1980.* 1981. Translated by Linda Coverdale. New York: Hill and Wang, 1985.

——. *Image, Music, Text.* Translated by Stephen Heath. New York: Hill and Wang, 1977.

——. *The Rustle of Language.* Translated by Richard Howard. New York: Hill and Wang, 1986.

Basch, Michael Franz. "The Concept of Affect: A Re-examination." *Journal of the American Psychoanalytic Association* 24 (1976): 759–77.

Baxandall, Michael. *Patterns of Intention: On the Historical Explanation of Pictures.* New Haven: Yale University Press, 1985.

Beaulieu, Annette Leduc. "Hugue Krafft's Midori-no-sato." In *Twentieth Century Perspectives on Nineteenth Century Art: Essays in Honor of Gabriel P. Weisberg,* edited by

Petra ten-Doesschate Chu and Laurinda S. Dixon, 162–70. Newark: University of Delaware Press, 2008.

———. "Promenade japonais avec Hugues Krafft." *Regards sur notre patrimoine: Bulletin de la Société des Amis du Vieux Reims* 17 (June 2005): 10–17.

Beebee, Thomas O. *The Ideology of Genre: A Comparative Study of Generic Instability.* University Park: Pennsylvania State University Press, 1994.

Bénédite, L[éonce]. "Félix Bracquemond, l'animalier." *Art et Décoration* 17 (1905): 37–47.

———. "Whistler" [third installment]. *Gazette des Beaux-Arts,* period 2, vol. 34 (1905): 142–58.

Benfey, Christopher. *The Great Wave: Gilded Age Misfits, Japanese Eccentrics and the Opening of Old Japan.* New York: Random House, 2003.

Berger, Klaus. *Japonisme in Western Painting.* 1980. Translated by David Britt. Cambridge: Cambridge University Press, 1992.

Beurdeley, Michel, and Michèle Maubeuge, *Edmond de Goncourt chez lui.* Nancy: Presses universitaires de Nancy, 1991.

Bigelow, William Sturgis. *Buddhism and Immortality: The Ingersoll Lecture, 1908.* Boston: Houghton Mifflin, 1908.

———. "Notes on Buddhism." Unpublished manuscript of conversations with Dr. and Mrs. Frederick Winslow, transcribed by Bigelow's secretary and corrected in Bigelow's hand, 1922. William Sturgis Bigelow Collection, Houghton Library, Harvard University.

———. "Selected Letters of Dr. William Sturgis Bigelow," edited by Akiko Murakata. Ph.D. dissertation, George Washington University, 1971.

Billy, André. *The Goncourt Brothers.* 1956. Translated by Margaret Shaw. New York: Horizon, 1960.

Boag, Peter. *Same-Sex Affairs: Constructing and Controlling Homosexuality in the Pacific Northwest.* Berkeley: University of California Press, 2003.

Borie, Jean. *Le célibataire français.* Paris: Le Sagittaire, 1976.

Boubée, Simon. "Exposition des impressionistes, chez Durand-Ruel." *Gazette de France* 5 (April 1876).

Bouillon, Jean-Paul. "'À gauche': Note sur la Société du Jing-Lar et sa signification." *Gazette des Beaux Arts,* period 6, vol. 91 (March 1978): 107–18.

———. *Bracquemond/Goncourt.* Paris: Somogy, 2004.

Bourget, Paul. *Nouveaux essais de psychologie contemporaine.* 4th ed. Paris: Alphonse Lemerre, 1886.

Bowes, James L. *Japanese Pottery.* London: Edward Howell, 1890.

———. *A Vindication of the Decorated Pottery of Japan.* N.p.: privately printed, 1891.

Bradshaw, Melissa. *Amy Lowell: Diva Poet.* Burlington, VT: Ashgate, 2011.

Brieux, Eugène. *Mi-Ki-Ka, japonaiserie rouennaise rimée* [illustrated by Jules Adeline]. N.p.: privately published, n.d. [1893].

Brinkley, Frank, "Professor Morse on Old Satusma." *Japan Weekly Mail*, December 1, 1888: 514–15.

Brookner, Anita. *The Genius of the Future: Studies in French Art Criticism*. New York: Phaidon, 1971.

Brooks, Van Wyck. *Fenollosa and His Circle, with Other Essays in Biography*. New York: Dutton, 1962.

Brown, Bill. *A Sense of Things: The Object Matter of American Literature*. Chicago: University of Chicago Press, 2003.

Bryher [Annie Winifred Ellerman]. *Amy Lowell: A Critical Appreciation*. London: Eyre and Spottiswoode, 1918.

Buck, Christopher. "Alain Locke and Cultural Pluralism." In *Search for Values: Ethics in Baha'i Thought*, edited by John Danesh and Seena Fazel, 95–160. Los Angeles: Kalimát, 2004.

Burty, Philippe. *Les émaux cloisonnés anciens et modernes*. Paris: printed for Chez Martz jewellers by J. Claye, n.d. [1868].

———. *Grave Imprudence*. Paris: G. Charpentier, 1880.

———. "Les industries de luxe à l'Exhibition de l'Union centrale." *Gazette des Beaux-Arts*, period 2, year 11, vol. 2 (December 1869): 529–46.

———. "Japonism." *The Academy*, August 7, 1875, 150–51; October 16, 1875, 413–15; January 22, 1876, 83–84.

———. "Japonisme." *La renaissance littéraire et artistique*, May 18, 1872, 25–26; June 15, 1872, 59–60; July 8, 1872, 83–84; July 27, 1872, 106–7; August 10, 1872, 102–3; February 8, 1873, 3–4.

———. "La maison d'un artiste." *Le Livre* 2, no. 5 (1881): 147–60.

———. *Maîtres et petits maîtres*. Paris: G. Charpentier, 1877.

———. "Un service en terre de Montereau." *La chronique des arts de la curiosité*, June 9, 1867, 181–82.

Buruma, Ian. *The Missionary and the Libertine: Love and War in East and West*. London: Faber and Faber, 1996.

Bush, Christopher Paul. "Ideographies: Figures of Chinese Writing in Modern Western Aesthetics." Ph.D. dissertation, University of California, Los Angeles, 2000.

C-Y [Champfleury, pseudonym for Jules François Félix Fleury-Husson]. "La mode des japonaiseries." *La vie parisienne*, November 21, 1868: 862–63.

Cabanès, Jean-Louis. "Lettres d'Ernest Chesneau à Edmond et Jules de Goncourt (1863–1884)." *Cahiers Edmond & Jules de Goncourt* 11 (2004): 225–45.

Cage, John. *For the Birds: John Cage in Conversation with Daniel Charles*. Boston: Marion Boyars, 1981.

———. *M: Writings '67–'72*. Middletown, CT: Wesleyan University Press, 1973.

———. *Musicage: Cage Muses on Words, Art, Music*. Edited by Joan Retallack. Hanover, NH: University Press of New England, 1996.

———. *Silence: Lectures and Writings*. 1961. Reprint, Middletown, CT: Wesleyan University Press, 2011.

Callahan, Kenneth. "Pacific Northwest." *Art News* 45, no. 50 (1946): 22–27, 53–55.

———. "Pacific Northwest Painters." *Art and Artists Today* (September–October 1937): 6–7, 17.

———. "This Summer in the Northwest." *Art News* 50, no. 4 (June–August 1951): 41, 58–59.

Carpenter, Edward. *Intermediate Types Among Primitive Folk: A Study in Social Evolution*. London: G. Allen, 1914.

Carter, Morris. *Did You Know Mrs. Gardner? Morris Carter's Answer*. Boston: Industrial School for Crippled Children, 1964.

———. *Isabella Stewart Gardner and Fenway Court*. Boston: Houghton Mifflin, 1925.

Cassidy, Donna M. *Marsden Hartley: Race, Religion, and Nation*. Hanover, NH: University Press of New England, 2005.

Castiglia, Christopher, and Christopher Reed. *If Memory Serves: Gay Men, AIDS, and the Promise of the Queer Past*. Minneapolis: University of Minnesota Press, 2012.

Chamberlain, Basil Hall. *Things Japanese*. 1890. 5th ed. London: John Murray, 1905.

Chang, Gordon H, Mark Dean Johnson, and Paul J. Karlstrom, eds. *Asian American Art: A History 1850–1970*. Palo Alto, CA: Stanford University Press, 2008.

Chang, Ting. "Asia as a Fantasy of France in the Nineteenth Century." In *Artistic and Cultural Exchanges Between Europe and Asia, 1400–1900*, edited by Michael North, 45–52. Farnham, UK: Ashgate, 2010.

———. "Disorienting Orient: Duret and Guimet, Anxious Flâneurs in Asia." In *The Invisible Flâneuse: Gender, Public Space, and Visual Culture in Nineteenth-Century Paris*, edited by Aruna d'Souza and Tom McDonough, 65–78. Manchester: Manchester University Press, 2006.

———. "La japonerie, la chinoiserie et la France d'Edmond de Goncourt." *Cahiers Edmond & Jules de Goncourt* 18 (2011): 55–68.

Chanler, Mrs. [Margaret] Winthrop. "Bohemian and Buddhist." *Atlantic Monthly* 158 (September 1936): 271–78.

Chauncey, George. *Gay New York: Gender, Urban Culture, and the Making of the Gay Male World 1890–1940*. New York: Harper Collins, 1994.

Checkland, Olive. *Japan and Britain After 1859: Creating Cultural Bridges*. London: Routledge Curzon, 2003.

Chesneau, Ernest. "Le Japon à Paris." *Gazette des Beaux-Arts*, period 2, vol. 18 (September and November 1878): 385–97, 841–56.

Chisolm, Lawrence W. *Fenollosa: The Far East and American Culture*. New Haven: Yale University Press, 1963.

Chong, Alan, and Noriko Murai, eds. *Journeys East: Isabella Stewart Gardner and Asia*. Boston: Isabella Stewart Gardner Museum, 2009.

Chudacoff, Howard P. *The Age of the Bachelor: Creating an American Subculture*. Princeton: Princeton University Press, 1999.

Clark, John. "Okakura Tenshin [Kakuzô] and Aesthetic Nationalism." *Arts: The Journal of the Sydney University Arts Association* 25 (2003): 64–89.

Clark, T. J. *The Painting of Modern Life: Paris in the Art of Manet and His Followers*. New York: Alfred A. Knopf, 1985.

Clark, Timothy. *Ukiyo-e Paintings in the British Museum*. London: British Museum Press, 1992.

Clarke, David. "Cross-Cultural Dialogue and Artistic Innovation." In *Shanghai Modern 1919–1945*, edited by Jo-Anne Birnie Danzker, Ken Lum, and Zheng Shengtian, 84–103. Ostfildern-Ruit, Germany: Hatje Cantz, 2004.

Clayson, S. Hollis. "Anders Zorn's Etched Portraits of American Men, or the Problem with French Masculinity." In *Interior Portraiture and Masculine Identity in France, 1789–1914*, edited by Temma Balducci, Heather Belnap Jensen, and Pamela J. Warner, 178–95. Farnham, UK: Ashgate, 2010.

Cleto, Fabio, ed. *Camp: Queer Aesthetics and the Performing Subject*. Ann Arbor: University of Michigan Press, 1999.

Cohen, Warren I. *East Asian Art and American Culture*. New York: Columbia University Press, 1992.

Conant, Ellen. "Captain Frank Brinkley Resurrected." In *Meiji no takara: Treasures of Imperial Japan, Selected Essays, Nasser D. Khalili Collection of Japanese Art*, vol. 1, edited by Oliver Impey and Malcolm Fairly, 124–51. London: Kibo Foundation, 1995.

Conant, Ellen, with Steven D. Owyoung and J. Thomas Rimer. *Nihonga: Transcending the Past; Japanese-Style Painting, 1868–1968*. New York: Weatherhill, 1995.

Conkelton, Sheryl, and Laura Landau. *Northwest Mythologies: The Interactions of Mark Tobey, Morris Graves, Kenneth Callahan, and Guy Anderson*. Seattle: University of Washington Press, 2003.

Cook, Clarence. *The House Beautiful: Essays on Beds and Tables, Stools and Candlesticks*. 1877. Reprint, New York: Scribner, Armstrong, 1878.

Coolidge, Joseph Randolph, Jr. "The New Museum." *Museum of Fine Arts Bulletin* 5, no. 7 (June 1907): 27–42.

Cooper, Emmanuel. *Bernard Leach: Life and Work.* New Haven: Yale University Press, 2003.

Cooper, Thomas. "Nineteenth-Century Spectacle." In *French Music Since Berlioz*, edited by Richard Langham Smith and Caroline Potter, 19–52. Farnham, UK: Ashgate, 2006.

Copeland, Herbert. "Of Camera Obscura and Japanese Crystals." *The Knight Errant* 1, no. 3 (October 1892): 88–92.

Cortazzi, Hugh. *Victorians in Japan: In and Around the Treaty Ports.* London: Athlone, 1987.

Cory, Daniel. *Santayana: The Later Years.* New York: George Braziller, 1963.

Cram, Ralph Adams. *Impressions of Japanese Architecture and Allied Arts.* New York: Baker and Taylor, 1906.

Craven, Thomas. *Modern Art: The Men, the Movements, and the Meaning.* New York: Simon and Schuster, 1934.

———. "Our Decadent Art Museums." *American Mercury* (December 1941): 682–88.

Crawford, Marion. "A Modern View of Mysticism." *Book Review* 2, nos. 2–4, 7 (June-August, November 1894): 49–57, 109–15, 149–53, 231–36.

Criss, Jennifer T. "Japonisme and Beyond in the Art of Marie Bracquemond, Mary Cassatt, and Berthe Morisot, 1867–1895." Ph.D. dissertation, University of Pennsylvania, 2007.

Crooks, Edward James. "John Cage's Entanglement with the Ideas of Coomaraswamy." Ph.D. dissertation, University of York, 2011.

Crowley, John W. "Eden off Nantucket: W. S. Bigelow and 'Tuckanuck.'" *Essex Institute Historical Collections* 109 (January 1973): 3–8.

———. *George Cabot Lodge.* Boston: G. K. Hall, 1976.

Cumming, William. *Sketchbook: A Memoir of the 1930s and the Northwest School.* Seattle: University of Washington Press, 1984.

Cummings, Paul. "Oral History Interview with John Cage." May 2, 1974. Archives of American Art, Smithsonian Institution. www.aaa.si.edu/collections/interviews /oral-history-interview-john-cage-12442.

C[urtis], F[rancis] G[ardner]. "Chinese and Japanese Art." In *Handbook of the Museum of Fine Arts Boston*, 13th ed. 297–309. N.p.: n.p. 1919.

Dahl, Arthur L., ed. *Mark Tobey: Art and Belief.* Oxford: George Ronald, 1984.

Dahlquist, Paul. "A Day with Mark Tobey: Excerpt from the Journal of Paul Dahlquist, April 27, 1969." *Olde Seattle Star*, March 1971, [clipping in Mark Tobey Papers, Special Collections, University of Washington Libraries].

Damon, S. Foster, *Amy Lowell: A Chronicle.* Boston: Houghton Mifflin, 1935.

Danzker, Jo-Anne Birnie, and Scott Lawrimore, eds. *Mark Tobey/Teng Baiye: Seattle /Shanghai*. Seattle: Frye Art Museum, 2014.

Daudet, Alphonse. *Sapho (Moeurs parisiennes)* [*Sappho to Which Is Added Between the Flies and the Footlights*]. 1884. Reprint, Boston: Little, Brown, 1899.

———. "Ultima." Manuscript for essay published in the *Revue de Paris*, August 15, 1896. In *Cahiers Edmond & Jules de Goncourt* 4 (1995–96): 30–51.

Day, Aidan. *Romanticism*. London: Routledge, 1996.

Delzant, Alidor. *Les Goncourt*. Paris: G. Charpentier, 1889.

Demaison, Maurice. "Le musée Cernuschi." *La revue de l'art ancien et moderne* 2, no. 7 (October 1897): 251–66.

Despatys, Pierre. *Les musées de la ville de Paris*. Paris: G. Boudet, n.d.

Devree, Howard. "Oriental 'Invasion,'" *New York Times*, November 28, 1954.

Dickinson, G. Lowes. *Appearances*. London: J. M. Dent, 1914.

———. *The Autobiography of G. Lowes Dickinson*. Edited by Dennis Proctor. London: Duckworth, 1973.

———. *An Essay on the Civilisations of India, China and Japan*. Garden City, NY: Doubleday, Page, 1915.

———. *Letters of John Chinaman*. London: R. B. Johnson, 1904.

DiMaggio, Paul. "Cultural Entrepreneurship in Nineteenth-Century Boston," part 1: "The Creation of an Organizational Base for High Culture in America"; part 2: "The Classification and Framing of American Art." *Media, Culture and Society* 4 (1982): 33–50, 303–322.

Docherty, Linda J. "Going Public: Sculpture and the Art of Isabella Stewart Gardner." Paper presented at the College Art Association annual conference, February 10–13, 2010, Chicago.

———. "Religion and/as Art: Isabella Stewart Gardner's Palace Chapels." Paper presented at the College Art Association annual conference, February 23–26, 2000, New York.

Dollimore, Jonathan. *Sexual Dissidence: Augustine to Wilde, Freud to Foucault*. Oxford: Oxford University Press, 1991.

Downey, Roger. "The Mystery of Mark Tobey." *Weekly* (Seattle). July 14–20, 1976: 9–10.

Duchesne de Bellecourt, [Gustave]. "La Chine et le Japon à l'Exposition universelle," *Revue des deux mondes* 70 (August 1867), 710–42.

Duckworth, William. "Anything I Say Will be Misunderstood: An Interview with John Cage." In *John Cage at Seventy-Five*, edited by Richard Fleming and William Duckworth, 15–33. Lewisburg, PA: Bucknell University Press, 1989.

Duncan, Carol. *Civilizing Rituals: Inside Public Art Museums*. New York: Routledge, 1995.

Duret, Théodore. *Critique d'avant-garde*. 1882. Reprint, Paris: G. Charpentier, 1885.

———. *Livres et albums illustrés du Japon.* Paris: Ernest Leroux, 1900.

———. *Voyage en Asie.* Paris: Michel Lévy, 1874.

E. [Emmanuel Arène]. "Notes d'un parisien," *Figaro,* May 14, 1896, 3.

Echo. "The Houses of Rimmon." *Theosophical Review* (American edition) 178, no. 212 (April 1905): 175–78.

Edo-Tokyo Museum and Peabody Essex Museum. *Worlds Revealed: The Dawn of Japanese and American Exchange.* Tokyo: Edo-Tokyo Museum, 1999.Eidelberg, Martin. "Bracquemond, Delâtre and the Discovery of Japanese Prints." *Burlington* 123, no. 937 (April 1981): 220–225, 227.

Emerson, Ralph Waldo. "The Transcendentalist: A Lecture Read at the Masonic Temple, Boston, January, 1842." In *The Complete Essays and Other Writings of Ralph Waldo Emerson,* edited by Brooks Atkinson, 85–92. New York: Modern Library, 1940.

Emery, Elizabeth. *Photojournalism and the Origins of the French Writer House Museum.* Burlington, VT: Ashgate, 2012.

"Ernest Chesneau," *Wikipédia,* accessed March 1, 2011, https://fr.wikipedia.org/wiki /Ernest_Chesneau.

Esmein, Suzanne. *Hugues Krafft au Japon de Meiji.* Paris: Hermann, 2003.

———. "Hugues Krafft (1853–1935). Voyageur, photographie, et collectionneur." *L'Ethnographie* 86, no. 108 (1990): 150–79.

Ewick, David. *Japonisme, Orientalism, Modernism: A Critical Bibliography of Japan in English-Language Verse.* 2003. http://themargins.net.

"An Exhibition of Japanese Color Prints and Paintings." *The Lotos* 9, no. 8 (Febuary 1896): 634–36.

Exhibition of Paintings and Drawings by Mark Tobey. London: Beaux Arts Gallery, 1934.

"An Exposition Emblem." *Sunset Magazine* 19 (May–October 1907): 605.

Exposition Goncourt. Paris: Gazette des Beaux Arts, 1933.

Fairbanks, Arthur. "The Museum of Fine Arts in Boston in Its New Quarters." *Museums Journal* 9, no. 10 (April 1910): 365–70.

Falize, Lucien [writing as M. Josse]. "L'art japonais à propos de l'Exposition organizée par M. Gonse." *Revue des arts décoratifs* 3 (1882–1883): 329–38.

Faunce, Sarah C. "Tobey: Painter or Prophet?" *Art News* 61, no. 5 (September 1962): 38–41, 59–60.

Felski, Rita. *Beyond Feminist Aesthetics: Feminist Literature and Social Change.* Cambridge, MA: Harvard University Press, 1989.

Fenollosa, Ernest F. "Art Museums and Their Relation to the People. *The Lotos* 9, no. 11, and vol. 1 (new series), no. 5 (May and September 1986): 841–47, 930–35.

———. *Epochs of Chinese and Japanese Art: An Outline History of East Asiatic Design.* 2nd ed. New York: Frederick A. Stokes, 1921.

————. *Hokusai, and His School: Museum of Fine Arts Department of Japanese Art Special Exhibitions of the Pictorial Art of Japan and China, No. 1.* Boston: Museum of Fine Arts, 1893.

————. *The Masters of Ukiyoe: A Complete Historical Description of Japanese Paintings and Color Prints of the Genre School.* New York: W. H. Ketcham, 1896.

————. *Review of the Chapter on Painting in Gonse's "L'art japonais."* Boston: James R. Osgood, 1885.

————. "The Significance of Oriental Art." *The Knight Errant* 1, no. 3 (October 1892): 65–70.

Ferris, George T. *Gems of the Centennial Exhibition: Consisting of Illustrated Descriptions of Objects of an Artistic Character, in the Exhibits of the United States, Great Britain, France, Spain, Italy, Germany, Belgium, Norway, Sweden, Denmark, Hungary, Russia, Japan, China, Egypt, Turkey, India, etc., etc., at the Philadelphia International Exhibition of 1876.* New York: D. Appleton, 1877.

Flanner, Janet. "Sage from Wisconsin." In *The Selective Eye: An Anthology of the Best from l'Oeil, the European Art Magazine,* edited by Georges Bernier and Rosamond Bernier, 171–75. New York: Random House. 1955.

Floyd, Phylis A. "Japonisme in Context: Documentation, Criticism, Aesthetic Reaction." Ph.D. dissertation, University of Michigan, 1983.

Fouquières, André de. *Mon Paris et mes parisiens.* Vol. 2, *Le quartier Monceau.* Paris: Pierre Horay, 1954.

Frank, Marie. *Denman Ross and American Design Theory.* Hanover, NH: University Press of New England, 2011.

Freeman, Michael Russell. "'The Eye Burns Gold, Burns Crimson, and Fades to Ash': Mark Tobey as a Critical Anomaly." Ph.D. dissertation, Indiana University, 2000.

Freud, Sigmund. 1923. *The Ego and the Id.* Translated by James Strachey. New York: Norton, 1960.

Fuller, Richard E. *A Gift to the City: A History of the Seattle Art Museum and the Fuller Family.* Seattle: Seattle Art Museum, 1993.

Gail, Marzieh. "The Days with Mark Tobey." *World Order* 2, no. 3 (Spring 1977): 10–26.

Gallet, Louis, and Camille Saint-Saëns. *La princesse jaune: Opera-comique en un acte.* Paris: A. Durand et fils, 1906.

Gallois, Jean. *Camille Saint-Saëns.* Sprimont, Belgium: Editions Mardaga, 2004.

Gardner, Robert. *Mark Tobey.* Film. Cambridge: Harvard Film Archive, 1952. Distributed by Documentary Educational Resources.

Geffroy, Gustave. "La maison des Goncourt." *Revue des arts décoratifs* 12 (1891–92): 146–51.

Gibbs, Jo. "Tobey the Mystic." *Art Digest* 20, no. 4 (November 15, 1945), 39.

Gibson, Ann Eden. *Abstract Expressionism: Other Politics*. New Haven: Yale University Press, 1997.

Giese, Lucretia H. "Mark Tobey's 1939 Murals for the John A. Baillargeons: A Transition," *Archives of American Art Journal* 23, no. 2 (1983): 3–12.

Gillis, John R. *For Better, For Worse: British Marriages, 1600 to the Present*. Oxford: Oxford University Press, 1985.

Gimpel, René. *Journal d'un collectionneur, marchand de tableaux*. Paris: Calmann-Lévy, 1963.

Goldsmith, Kenneth. "Review of *John Cage: Composed in America*." *RIF/T* 5, no 1 (1995). wings.buffalo.edu/epc/rift/rift05/revio501.

Goncourt, Edmond de. *La maison d'un artiste*. 2 vols. Paris: Bibliothèque Charpentier, 1881.

Goncourt, Edmond de, and Jules de Goncourt. *En 18* Paris: Dumineray, 1851.

———. *Idées et sensations*. 1866. Reprint, Paris: G. Charpentier, 1877.

———. *Journal: Mémoires de la vie littéraire*. Edited by Robert Ricatte. 3 vols. Paris: Fasquelle and Flammarion, 1956. Most citations of the Goncourts' journal are to this source; variant quotations are from the first published editions, *Journal des Goncourt: Mémoires de la vie littéraire*, Paris: G. Charpentier, 1887–96 (cited as *Journal des Goncourt*).

———. *Manette Salomon*. 1867. Reprint, Paris: Flammarion-Fasquelle, 1925.

———. *Préfaces et manifestes littéraires*. Paris: Ernest Flammarion/Eugène Fasquelle 1888.

Goncourt, Jules de. *Lettres de Jules de Goncourt*. Paris: Bibliothèque Charpentier, 1885.

Gonse, François. "Louis Gonse (1846–1921) et le Japon." *Gazette des Beaux-Arts*, period 6, year 134, no. 1477 (February 1992): 81–88.

Gonse, Louis. *L'art japonais*. Paris: Société française d'éditions d'art, n.d. [1883].

———. "L'art japonais et son influence sur le goût européan." *Revue des arts décoratifs* 18, no. 1 (April 1898): 97–116.

———. "La maison d'un artiste, par Edmond de Goncourt." *Gazette des Beaux-Arts*, period 2, year 23, vol. 24 (July 1881): 100–104.

Graves, Morris. *Morris Graves: Selected Letters*. Edited by Vicki Halper and Lawrence Fong. Seattle: University of Washington Press, 2013.

Grccn, Martin. *The Mount Vernon Street Warrens: A Boston Story, 1860–1910*. New York: Scribner, 1990.

Greenberg, Clement. *Art and Culture: Critical Essays*. Boston: Beacon, 1961.

———. *The Collected Essays and Criticism*. Vol. 1, *Perceptions and Judgments, 1939–1944*. Edited by John O'Brian. Chicago: University of Chicago Press, 1986.

———. *The Collected Essays and Criticism*. Vol. 2, *Arrogant Purpose, 1945–1949*. Edited by John O'Brian. Chicago: University of Chicago Press, 1986.

———. *The Collected Essays and Criticism*. Vol. 3, *Affirmations and Refusals, 1950–1955*. Edited by John O'Brian. Chicago: University of Chicago Press, 1993.

Gruchy, John Walter de. *Orienting Arthur Waley: Japonisme, Orientalism, and the Creation of Japanese Literature in English*. Honolulu: University of Hawai'i Press, 2003.

"Guide to the Museum." *Museum of Fine Arts Bulletin* 1, no. 3 (July 1903), 12–21.

Guilbaut, Serge. *How New York Stole the Idea of Modern Art*. Chicago: University of Chicago Press, 1983.

Guimet, Émile. *Promenades japonaises*. 2 vols. Paris: G. Charpentier, 1878, 1880.

Guth, Christine. "Asia by Design: Women and the Collecting and Display of Oriental Art." In Chong and Murai, *Journeys East*, 52–68.

———. "Charles Longfellow and Okakura Kakuzo: Cultural Cross-Dressing in the Colonial Context." *positions* 8, no. 3 (Winter 2000): 605–36.

———. *Longfellow's Tattoos: Tourism, Collecting, and Japan*. Seattle: University of Washington Press, 2004.

Guyaux, André. *Baudelaire: Un demi-siècle de lectures des Fleurs du mal, 1855–1905*. Paris: Presses universitaires de Paris–Sorbonne, 2007.

Guzzo, Louis. "Color Is Distraction Says Learned Takizaki." *Seattle Times*, November 6, 1957 [clipping in Mark Tobey Papers, Special Collections, University of Washington Libraries].

Hadley, Rollin Van Nostrand, ed. *The Letters of Bernard Berenson and Isabella Stewart Gardner, 1887–1924*. Boston: Northeastern University Press, 1987.

Handbook of the Museum of Fine Arts Boston. Boston: Museum of Fine Arts, 1907.

Harris, Neil. "All the World a Melting Pot? Japan at American Fairs, 1876–1904." In *Mutual Images: Essays in American–Japanese Relations*, edited by Akira Iriye, 24–54. Cambridge: Harvard University Press, 1975.

———. "The Gilded Age Revisited: Boston and the Museum Movement." *American Quarterly* 14, no. 4 (Winter 1962): 545–66.

Hartley, Marsden. *On Art*. Edited by Gail R. Scott. New York: Horizon, 1982.

Hartt, Mary B. "The Boston Museum: A New Way of Showing Works of Art." *Outlook*, January 22, 1910, 202–11.

Hastings, Tom. "Said's *Orientalism* and the Discourse of (Hetero)sexuality." *Canadian Review of American Studies* 23, no. 1 (Fall 1992): 127–48.

Hatch, Alden. *The Lodges of Massachusetts*. New York: Hawthorne, 1973.

Hay, Harry. *Radically Gay: Gay Liberation in the Words of Its Founder*. Boston: Beacon, 1996.

Hearn, Lafcadio. *Kokoro: Hints and Echoes of Japanese Inner Life*. Boston: Houghton Mifflin, 1896.

Hess, Thomas B. *Abstract Painting: Background and American Phase*. New York: Viking, 1951.

Hickman, Money, and Peter Fetchko, eds. *Japan Day by Day: An Exhibition Honoring Edward Sylvester Morse and Commemorating the Hundredth Anniversary of His Arrival in Japan in 1877*. Salem, MA: Peabody Museum of Salem, 1977.

Higonnet, Anne. *A Museum of One's Own: Private Collecting, Public Gift*. Pittsburgh: Periscope, 2009.

Hines, Thomas S. "Then Not Yet 'Cage'": The Los Angeles Years, 1912–1938." In *John Cage: Composed in America*, edited by Marjorie Perloff and Charles Junkerman, 65–99. Chicago: University of Chicago Press, 1994.

Hirasuma, Delphine. *The Art of Gaman*. Berkeley: Ten Speed, 2005.

Hirayama, Hina. "A True Japanese Taste: Construction of Knowledge About Japan in Boston, 1880–1900." Ph.D. dissertation, Boston University, 1999.

———. *"With Éclat": The Boston Athenæum and the Origins of the Museum of Fine Arts, Boston*. Boston: Boston Athenæum, 2013.

Hokenson, Jan Walsh. *Japan, France, and East–West Aesthetics*. Madison, NJ: Fairleigh Dickinson University Press, 2004.

———. "Proust's *japonisme*: Contrastive Aesthetics." In *Marcel Proust*, edited by Harold Bloom, 83–103. Philadelphia: Chelsea House, 2004.

Holmes, Oliver Wendell. *The Autocrat of the Breakfast Table, 1858*. Reprint, Boston: Houghton Mifflin, 1883.

———. "The Professor's Story." *Atlantic Monthly* 5, no. 27 (1860): 88–99.

Hosley, William. *The Japan Idea: Art and Life in Victorian America*. Hartford: Wadsworth Atheneum, 1990.

Huysmans, J.-K. *À Rebours*. Paris: Charpentier, 1884.

———. *Lettres inédites à Edmond de Goncourt*. Edited by Pierre Lambert and Pierre Cogny. Geneva: Droz, 1956.

Hyde, Lewis. "Isabella's Will." In *Lee Mingwei: The Living Room*, edited by Jennifer R. Gross, 15–21. Boston: Isabella Stewart Gardner Museum, 2000.

"In Memory of Okakura-Kakuzo." *Museum of Fine Arts Bulletin* 14, no. 82 (1916): 15–16.

Inaga, Shigemi. "Théodore Duret et Henri Cernuschi: Journalisme politique, voyage en Asie et collection Japonaise." Unnumbered special issue, *Ebisu* (Winter 1998): 79–93.

———. "Théodore Duret et le Japon." *Revue de l'art* 79, no. 1 (1988): 76–82.

Institut de Tokyo, Institution Administrative Indépendente, Centre National de Recherche pour les Propriétés Culturelles. *Correspondance adressée à Hayashi Tadamasa*. N.p.: Kokushokankôkai, 2001.

Isaacs, Harold Robert. *Scratches on Our Minds: American Images of China and India*. New York: J. Day, 1958.

Ives, Colta Feller. *The Great Wave: The Influence of Japanese Woodcuts on French Prints*. New York: Metropolitan Museum of Art, 1974.

James, Henry. *The American Scene*. New York: Harper and Brothers, 1907.

———. *The Europeans*. London: Macmillan, 1878. Full text online at www.gutenberg. org/files/179/179-h/179-h.htm [n.p.].

Janson, H. W. "The International Aspects of Regionalism." *College Art Journal* 2, no. 4, part 1 (May 1943): 110–15.

"Japan and the Japanese." *Edinburgh Review* 113 (January 1861): 37–73.

"Japanese Provide for Study of Buddhism by Foreigners." *New York Times*, December 25, 1932, E8.

Le japonisme. Paris: Éditions de la Réunion des musées nationaux, 1988.

Jay, Alex. *Chinese American Eyes: Famous, Forgotten, Well-Known and Obscure Visual Artists of Chinese Descent in the United States* (blog). Posts of August 16–23, 2013, http:// chimericaneyes.blogspot.com/2013_08_01_archive.

Jensen, Joan M. "Women on the Pacific Rim: Some Thoughts on Border Crossings." *Pacific Historical Review* 67, no. 1 (February 1998): 3–38.

Johns, Barbara. *Paul Horiuchi: East and West*. Seattle: University of Washington Press, 2008.

———. *Signs of Home: The Paintings and Wartime Diary of Kamekichi Tokita*. Seattle: University of Washington Press, 2011.

Johnson, David K. *The Lavender Scare: The Cold War Persecution of Gays and Lesbians in the Federal Government*. Chicago: University of Chicago Press, 2004.

Johnson, Deborah. "Japanese Prints in Europe Before 1840." *Burlington* 124, no. 951 (June 1982): 343–48.

Junker, Patricia. *Modernism in the Pacific Northwest: The Mythic and the Mystical; Masterworks from the Seattle Art Museum*. Seattle: University of Washington Press, 2014.

Kangas, Matthew. "Prometheus Ascending: Homoerotic Imagery of the Northwest School." *Art Criticism* 2, no. 3 (1986): 89–101.

Karatani, Kōjin. "Japan as Museum: Okakura Tenshin and Ernest Fenollosa." Translated by Sabu Kohso. In *Japanese Art After 1945: Scream Against the Sky*, edited by Alexandra Munro, 33–39. New York: Harry N. Abrams, 1994.

———. "Uses of Aesthetics: After Orientalism." *boundary 2* 25, no. 2 (Summer 1998): 145–60.

Katsaros, Laure. *New York–Paris: Whitman, Baudelaire, and the Hybrid City*. Ann Arbor: University of Michigan Press, 2012.

Katz, Jonathan. "Agnes Martin and the Sexuality of Abstraction." In *Agnes Martin*, edited by Lynne Cooke, Karen Kelly, and Barbara Schröder, 93–120. New Haven: Yale University Press, 2011.

———. "John Cage's Queer Silence; or, How to Avoid Making Matters Worse." *GLQ* 5, no. 2 (1999): 231–52.

————. "Passive Resistance: On the Success of Queer Artists in Cold War American Art." *L'image* 3 (December 1996): 119–42.

Kawakami, Akane. *Travellers' Visions: French Literary Encounters with Japan, 1881–2004*. Liverpool: Liverpool University Press, 2005.

Kays, Judith S. "Mark Tobey and Jackson Pollock: Setting the Record Straight." In Bärmann and Barañano, *Mark Tobey*, 91–114.

Kerr, Alex. *Lost Japan*. Melbourne: Lonely Planet, 1996.

Kikuchi, Yuko. *Japanese Modernization and Mingei Theory: Cultural Nationalism and Oriental Orientalism*. London: Routledge, 2004.

Kingsbury, Martha. "Four Artists in the Northwest Tradition." In *Northwest Traditions*, 9–63. Seattle: Seattle Art Museum, 1978.

————. *George Tsutakawa*. Seattle: University of Washington Press, 1990.

————. "Northwest Art: The Mid-Century Seen from the End of the Century." In *What It Meant to Be Modern: Seattle Art at Mid-Century*, edited by Sheryl Conkelton, 21-31. Seattle: Henry Art Gallery, University of Washington, 1999.

————. "Oral History Interview with George Tsutakawa." September 8–19, 1983. Archives of American Art, Smithsonian Institution. www.aaa.si.edu/collections /interviews/oral-history-interview-george-tsutakawa-11913.

————. "Oral History Interview with Viola Patterson." October 22–29, 1982. Archives of American Art, Smithsonian Institution. www.aaa.si.edu/collections/interviews /oral-history-interview-viola-patterson-12618.

————. "Seattle and the Puget Sound." In *Art of the Pacific Northwest from the 1930s to the Present*, 39–92. Washington, DC: Smithsonian Institution Press, 1974.

Kipling, Rudyard. *From Sea to Sea and Other Sketches*. 2 vols. New York: Doubleday and McClure, 1899.

Klein, Christina. *Cold War Orientalism: Asia in the Middlebrow Imagination, 1945–1961*. Berkeley: University of California Press, 2003.

Knapp, Arthur. "From the Japanese of the Manyoshu." *The Knight Errant* 1, no. 4 (1893): 105.

Koechlin, Raymond. *Souvenirs d'un vieil amateur d'art de l'extrême-orient*. Chalons-sur-Saône: Imprimeric française et orientale, E. Bertrand, 1930.

Koizumi, Kazuo, ed. *Letters from Basil Hall Chamberlain to Lafcadio Hearn*. Tokyo: Hokusaido Press, 1936.

————. *More Letters from Basil Hall Chamberlain to Lafcadio Hearn and Letters from M. Toyama, Y. Tsubouchie and Others*. Tokyo: Hokusaido Press, 1937.

Kostelanetz, Richard. *Conversing with Cage*. New York: Limelight, 1987.

Kowner, Rotem. "'Lighter than Yellow, But Not Enough': Western Discourse of the Japanese 'Race,' 1854–1904." *The Historical Journal* 43, no. 1 (2000): 103–31.

Koyoma-Richard, Brigitte. *Japon rêvé: Edmond de Goncourt et Hayashi Tadamasa*. Paris: Hermann, 2001.

Krafft, Hugues. *Souvenirs de notre tour de monde*. Paris: Hachette, 1885.

Krasne, Belle. "A Tobey Profile." *Art Digest* 26, no. 2 (October 15, 1951): 5, 26.

Kuh, Katharine. *The Artist's Voice: Talks with Seventeen Modern Artists*. 1962. Reprint, Cambridge, MA: Da Capo Press, 2000.

Labrusse, Rémi. "Islamophilia? Europe in the Conquest of the Arts of Islam." *Arts and Societies*. October 11, 2007. www.artsetsocietes.org/a/a-labrusse.

Lacambre, Geneviève. "Les milieux japonisants à Paris." In *Japonisme in Art: An International Symposium*, 43–55. Tokyo: Kodansha, 1980.

La Farge, John. *An Artist's Letters from Japan*. New York: Century, 1897.

———. "The Collection of Mrs. John Lowell Gardner." In *Noteworthy Paintings in American Private Collections*, edited by John La Farge and August F. Jaccaci, 1–141. New York: August F. Jaccaci, 1907.

Laidlaw, Christine Wallace, ed. *Charles Appleton Longfellow: Twenty Months in Japan, 1871–1873*. Cambridge, MA: Friends of the Longfellow House, 1998.

Larson, Kay. *Where the Heart Beats: John Cage, Zen Buddhists, and the Inner Life of Artists*. New York: Penguin, 2012.

Lawton, Thomas. "John Ellerton Lodge, First Director of the Freer Gallery of Art." *Orientations* 29, no. 5 (May 1998): 74–81.

Leach, Bernard. *Beyond East and West: Memoirs, Portraits and Essays*. New York: Watson-Guptil, 1978.

———. *Drawings, Verse, and Belief*. Park Ridge, NJ: Noyes, 1973.

———. "Impressions of Japan After Fourteen Years." *Kogei* 53 (May 1935): 9–17.

———. "A Letter to England." *Kogei* 53 (May 1935): 18–41.

———. "Mark, Dear Mark." *World Order* 2, no. 3 (Spring 1977): 28–30.

———. *A Potter's Book*. 1940. 2nd ed. London: Faber and Faber, 1945.

Lears, Jackson. *No Place of Grace: Antimodernism and the Transformation of American Culture, 1880–1920*. New York: Pantheon, 1981.

Leduc-Beaulieu, Annette. See Beaulieu.

Lee, Robert G. *Orientals: Asian Americans in Popular Culture*. Philadelphia: Temple University Press, 1999.

Leti, Giuseppe. *Henri Cernuschi, sa vie, sa doctrine, ses oeuvres*. Paris: Presses universitaires de France, 1936.

Lewis, Sinclair. *Main Street*. 1920. Reprint, New York: New American Library of World Literature, 1961.

Lockyer, Angus. "Japans in Paris, 1867." In *Identity and Universality*, edited by Volker Barth, 91–108. Paris: Bureau nationale des expositions, 2002.

Lodge, George Cabot. *The Song of the Wave*. New York: Scribner, 1898.

Longfellow, Henry Wadsworth. *The Letters of Henry Wadsworth Longfellow*. Edited by Andrew R. Hilen. Cambridge, MA: Harvard University Press, 1982.

Loti, Pierre. *Cette éternelle nostalgie: Journal intime, 1878–1911*. Edited by Bruno Vercier, Alain Quella-Villéger, Guy Dugas. Paris: La table ronde, 1997.

———. *L'Exilée*. Paris: Calmann-Lévy, n.d. [1893].

———. *Japoneries d'automne*. Paris: Calmann-Lévy, n.d. [1889].

———. *Lettres de Pierre Loti à Madame Juliette Adam*. Paris: Plon, 1924.

———. *Madame Chrysanthème*. 1888. Translated by Laura Ensor. New York: Modern Library, n.d.

———. *Madame Prune*. 1905. Translated by S. R. C. Plimsoll, 1905. Reissued as *Japan and Corea*. London: Kegan Paul, 2002.

Louchheim, Aline B. "Graves New World." *Art News* 44, no. 1 (February 15, 1945): 18.

Lowe, Lisa. *Critical Terrains: French and British Orientalisms*. Ithaca, NY: Cornell University Press, 1991.

Lowell, A. Lawrence. *Biography of Percival Lowell*. New York: Macmillan, 1935.

Lowell, Amy. *Can Grande's Castle*. New York: Macmillan, 1918.

———. "Guns as Keys: And the Great Gate Swings." *Seven Arts* 2 (August 1917): 428–51.

Lowell, Percival. *Chosön, The Land of the Morning Calm: A Sketch of Korea*. Boston: Ticknor, 1886.

———. *Noto: An Unexplored Corner of Japan*. Boston: Houghton Mifflin, 1891.

———. *Occult Japan or the Way of the Gods: An Esoteric Study of Japanese Personality and Possession*. 1894. Reprint, Boston: Houghton Mifflin, 1895.

———. *The Soul of the Far East*. Boston: Houghton Mifflin, 1888.

M. "The Boston Art Museum." *Nation* 89, no. 2316 (November 18, 1909): 494–95.

MacKenzie, John M. *Orientalism: History, Theory and the Arts*. Manchester: Manchester University Press, 1995.

Marriot, Charles. "Mr. Bernard Leach." *Times* (London), December 5, 1933: 12.

"Mary McNeil-Scott's Literary Work." *Current Literature* 15, no. 2 (February 1894): 106.

Mather, F[rank] J[ewett]. "Art in America." *Burlington* 16, no. 83 (February 1910): 293–96.

Maumené, Albert. "Le jardin japonais miniature de Midori." *La vie à la campagne*, year 6, vol. 9, no. 114 (June 15, 1911), 369–73.

———. "Les jardins de la villa des lotus." *La vie à la campagne*, year 1, no. 10 (February 5, 1907), 304–8.

———. "Le parc de Midori." *La vie à la campagne*, year 4, vol. 5, no. 61 (April 1, 1909), 198–205.

Maupassant, Guy de. *Bel-Ami*. 1885. Reprint, Paris: Louis Conard, 1910.

———. *Pierre et Jean.* Paris: 1888. Full text online at www.gutenberg.org/ebooks/11131.

Maurel, André. "L'hôtel Cernuschi." *Le Figaro,* May 14, 1896, 3.

———. *Souvenirs d'un écrivain, 1883–1914.* Paris: Hachette, 1925.

McCabe, James D. *The Illustrated History of the Centennial Exhibition, Held in Commemoration of the One Hundredth Anniversary of American Independence.* Philadelphia: National Publishing, 1876.

McCall, Sidney [Mary McNeil Fenollosa]. *Truth Dexter.* 1901. Reprint, Boston: Little, Brown, 1906.

Meier-Graefe, Julius. *Modern Art: Being a Contribution to a New System of Aesthetics,* vol. 2, 1904. Translated by Florence Simmonds and George W. Chrystal. London: W. Heinemann, 1908.

Melot, Michel. "Questions au japonisme." *Japonisme in Art: An International Symposium.* Tokyo: Kodansha, 1980: 239–60.

Menon, Elizabeth K. *Evil by Design: The Creation and Marketing of the Femme Fatale.* Urbana: University of Illinois Press, 2006.

———. "The Functional Print in Commercial Culture: Henry Somm's Women in the Marketplace." *Nineteenth-Century Art Worldwide* 4 no. 2 (Summer 2005). www.19thc-artworldwide.org/index.php/summer05/213-the-functional-print-in-commercial-culture-henry-somms-women-in-the-marketplace.

———. "Henry Somm's Japonisme, 1881, in Context." *Gazette des Beaux-Arts,* period 6, year 134, no. 1477 (February 1992): 89–99.

Menpes, Mortimer. *Japan: A Record in Colour by Mortimer Menpes.* London: Charles Black, 1901.

———. "A Personal View of Japanese Art." *Magazine of Art* 11 (1888): 192–99, 255–61.

Merritt, Helen. *Modern Japanese Woodblock Prints.* Honolulu: University of Hawai'i Press, 1990.

Messinger, Lisa Mintz. *Abstract Expressionism: Works on Paper, Selections from the Metropolitan Museum of Art.* New York: Metropolitan Museum of Art, 1992.

Michelson, Annette. "E pluribus unum." In *Les monotypes de Tobey.* Paris: Galerie Jeanne Bucher, 1965, unpaginated. (The text appears in both French and English.)

Michener, James. A. "Pursuit of Happiness by a GI and a Japanese." *Life* February 21, 1955, 124–41.

Migeon, Gaston. "Le musée Cernuschi." *Gazette des Beaux-Arts,* period 3, year 18 (September 1897): 217–28.

Miller, Dorothy C. *Fourteen Americans.* New York: Museum of Modern Art, 1946.

Miller, Leta E. "Cultural Intersections: John Cage in Seattle (1938–1940). In *John Cage: Music, Philosophy, and Intention, 1933–1950,* edited by David W. Patterson, 47–82. New York: Routledge, 2002.

Miller, R. A. *Japan's Modern Myth: The Language and Beyond.* New York: Weatherhill, 1982.

Miner, Earl. *The Japanese Tradition in British and American Literature.* Princeton: Princeton University Press, 1958.

Mitchell, Timothy. "Orientalism and the Exhibitionary Order." In *Colonialism and Culture,* edited by Nicholas B. Dirks, 289–317. Ann Arbor: University of Michigan Press, 1992.

Mitford, A. B. [a.k.a. Lord Redesdale]. *Tales of Old Japan.* 1871. Reprint, London: Macmillan, 1908.

Monet and Japan. Canberra: National Gallery of Australia, 2001.

Montague, Stephen. "John Cage at Seventy: An Interview." *American Music* 3, no. 2 (Summer 1985): 205–16.

Montesquiou, Robert de. *Pas effacés.* 3 vols. Paris: Paul-Louis Couchoud, 1923.

Morlet, Michelle. "Hugues Krafft (1853–1935)." *Regards sur notre patrimoine: Bulletin de la Société des Amis du Vieux Reims* 6 (December 1999), 4–7.

Morse, Anne Nishimura, ed. *Drama and Desire: Japanese Paintings from the Floating World, 1690–1850.* Boston: Museum of Fine Arts, 2007.

———. "Promoting Authenticity: Okakura Kakuzō and the Japanese Collection of the Museum of Fine Arts, Boston." In *Okakura Tenshin and the Museum of Fine Arts Boston,* 145–51.

Morse, Edward Sylvester. "Alleged 'Satsuma' in Boston. *The Art Amateur* 9, no. 6 (November 1883), 131.

———. *Catalogue of the Morse Collection of Japanese Pottery.* Cambridge, MA: Riverside Press, 1901.

———. *Japan Day by Day: 1877, 1878–9, 1882–83.* 2 vols. Boston: Houghton Mifflin, 1917.

———. *Japanese Homes and Their Surroundings.* New York: Harper and Brothers, 1885.

———. "Japanese Pottery." *The Nation,* November 13, 1890, 383–84.

———. "Old Satsuma." *Harper's New Monthly Magazine,* September 1888: 512–29.

———. "Report of the Keeper of Japanese Pottery." *Twenty-Seventh Annual Report for the Year 1902,* 76–92. Boston: Museum of Fine Arts, 1903.

———. *Reviews from the New York Nation, Boston Transcript and New York Studio of the Work of James L. Bowes, Esq., Entitled "Japanese Pottery."* N.p. [Salem, MA]: Salem Press Publishing and Printing Co., 1891.

Morse, John. "Oral History Interview with Holger Cahill." April 12, 1960. Archives of American Art, Smithsonian Institution. www.aaa.si.edu/collections/oralhistories /transcripts/cahill60.

Mumford, Louis. *The Golden Day: A Study in American Experience and Culture.* New York: Boni and Liveright, 1926.

Munroe, Alexandra. *The Third Mind: American Artists Contemplate Asia, 1860–1989.* New York: Guggenheim Museum Publications, 2009.

Murai, Noriko. "Authoring the East: Okakura Kakuzo and the Representations of East Asian Art in the Early Twentieth Century." Ph.D. dissertation, Harvard University, 2003.

———. "Okakura's Way of Tea: Representing Chanoyu in Early Twentieth-Century America." *Review of Japanese Culture and Society* 24 (December 2012): 70–93.

Murai, Noriko, and Alan Chong, eds. *Inventing Asia: American Perspectives Around 1900.* Boston: Isabella Stewart Gardner Museum, 2014.

Musée Cernuschi. *Henri Cernuschi: Voyageur et collectionneur.* Paris: Paris-Musées, 1998.

Museum of Fine Arts, Boston. *Bekkan Shunga meihinsen.* Vol. 4 of ボストン美術館肉筆浮世絵/*Ukiyo-e Paintings Museum of Fine Arts, Boston.* Edited by Tsuji Nobuo. Tokyo: Kodansha, 2000–2001.

Museum of Fine Arts, Boston, Thirtieth Annual Report for the Year 1905. Cambridge, MA: University Press, 1906.

Museum of Fine Arts, Boston, Thirty-First Annual Report for the Year 1906. Cambridge, MA: University Press, 1907.

Museum of Fine Arts, Boston, Thirty-Second Annual Report for the Year 1907. Cambridge, MA: University Press, 1908.

Museum of Fine Arts, Boston, Twenty-Ninth Annual Report for the Year 1904. Cambridge, MA: University Press, 1905.

"Mystic Painters of the Northwest." *Life,* September 28, 1953: 84–89.

Nakamura, Masako. "Families Precede Nation and Race? Marriage, Migration and Integration of Japanese War Brides After World War II." Ph.D. dissertation, University of Minnesota, 2010.

Nakashima, Tomoko. "Defining 'Japanese Art' in America." *Japanese Journal of American Studies* 17 (2006): 245–62.

Nealon, Christopher. *Foundlings: Lesbian and Gay Historical Emotion Before Stonewall.* Durham, NC: Duke University Press, 2001.

"The New Museum." Special issue, *Museum of Fine Arts Bulletin* 7, nos. 40–42 (December 1909).

Ninth Report of the Class Secretary of the Class of 1874 of Harvard College. Cambridge, MA: Riverside Press, 1909.

Nochlin, Linda. "The Imaginary Orient." In *The Politics of Vision: Essays on Nineteenth-Century Art and Society,* 33–59. New York: Harper and Row.

Nordau, Max. 1892. *Degeneration.* Anonymous translation. 1895. Reprint, New York: Howard Fertig, 1968.

Norman, Sir Henry. *The Real Japan: Studies of Contemporary Japanese Manners, Morals, Administration, and Politics.* London: T. Fischer Unwin, 1891.

"Northwest Artists Work, Fight, Paint." *Art Digest* 18, no. 3 (November 1, 1943): 22.

Notehelfer, F. G. "On Idealism and Realism in the Thought of Okakura Tenshin." *Journal of Japanese Studies* 16, no. 2 (Summer 1990): 309–55.

Nye, Robert. *Masculinity and Male Codes of Honor in Modern France.* Oxford: Oxford University Press, 1993.

Okakura, Kakuzo [Okakura Tenshin]. *The Book of Tea.* 1906. Reprint, New York: Dover, 1963.

———. *The Ideals of the East with Special Reference to the Art of Japan.* New York: E. P. Dutton, 1904.

———. "Japanese and Chinese Paintings in the Museum." *Museum of Fine Arts Bulletin* 3, no 1 (January 1905): 5–6.

———. "Notes on Contemporary Japanese Art." *Studio* 25 (April 1902), 126–28.

———. *Okakura Kakuzo, Collected English Writings.* 3 vols. Tokyo: Heibonsha, 1984.

Okakura Tenshin and the Museum of Fine Arts Boston. Nagoya: Nagokya/Bosuton Bijutuskan, 1999.

Omoto, Keiko, and Francis Macouin. *Quand le Japon s'ouvrit au monde.* Paris: Gallimard /Réunion des musées nationaux, 1990.

Osborn, Sherard. "A Cruise in Japanese Waters (Part I)" *Blackwood's Edinburgh Magazine* 84 (1858): 635–46.

"Oscar Wilde's Lecture." *New York Times,* January 10, 1882.

Pach, Walter. "Boston's New Museum of Fine Arts." *Harper's Weekly.* December 18, 1909: 15–16.

Park, Josephine Nock-Hee. *Apparitions of Asia: Modernist Form and Asian American Poetics.* New York: Oxford University Press, 2008.

"The Passing Shows." *Art News* 43, no. 5 (April 1944): 25.

Pate, Alan Scott. *Japanese Dolls: The Fascinating World of Ningyo.* Rutland, VT: Tuttle, 2008.

Patterson, David W. "Cage and Asia: History and Sources." In *The Cambridge Companion to John Cage,* edited by David Nicholls, 41–60. Cambridge: Cambridge University Press, 2002.

Pearlman, Ellen. *Nothing and Everything: The Influence of Buddhism on the American Avant-Garde, 1942–1962.* Berkeley: North Atlantic, 2012.

Pelletan, Camille. "Une Chapelle Bouddhiste." *La renaissance littéraire et artistique,* year 1, no. 29 (November 9 1872): 225-26.

Pennell, Elizabeth Robins, and Joseph Pennell. *The Life of James McNeill Whistler.* London: William Heinemann, 1908.

Periton, Diana. "The Interior as Aesthetic Refuge: Edmond de Goncourt's *La maison d'un artiste*." In *Tracing Modernity: Manifestations of the Modern in Architecture and the City*, edited by Mari Hvattum and Christian Hermansen, 137–55. London: Routledge, 2004.

Pham, P. L. "On the Edge of the Orient: English Representations of Japan, circa 1895–1910." *Japanese Studies* 19, no. 2 (1999): 163–81.

Plagans, Peter. *The Sunshine Muse: Art on the West Coast, 1945–1970*. 1974. Reprint, Berkeley: University of California Press, 1999.

Preziosi, Donald. "The Art of Art History." In *The Art of Art History: A Critical Anthology*, edited by Donald Preziosi, 507–25. Oxford: Oxford University Press, 1998.

Prichard, Matthew S. "Current Theories of the Arrangement of Museums of Art and Their Application to the Museum of Fine Arts." *Museum of Fine Arts Boston: Communication to the Trustees Regarding the New Building*. Boston: privately printed by authority of the Committee of the Museum, 1904.

Proust, Marcel. *À la recherche du temps perdu*. 3 vols. Paris: Gallimard, 1954.

Put, Max. *Plunder and Pleasure: Japanese Art in the West, 1860–1930*. Leiden: Hotei, 2000.

Rathbone, Eliza E. *Mark Tobey City Paintings*. Washington, DC: National Gallery of Art, 1984.

Reed, Christopher. "Aesthetic Diplomacy: 'Creative Prints' in the Post-War Era." In *Japan/America: Points of Contact, 1876–1970*, edited by Christopher Reed. Ithaca, NY: Herbert F. Johnson Museum of Art, Cornell University, forthcoming.

———. *Art and Homosexuality: A History of Ideas*. New York: Oxford University Press, 2011.

———. *The Chrysanthème Papers: The Pink Notebook of Madame Chrysanthème and Other Documents of French Japonisme*. Honolulu: University of Hawai'i Press, 2010.

———. *Not at Home: The Suppression of Domesticity in Modern Art and Architecture*. London: Thames and Hudson, 1996.

Rees, Brian. *Camille Saint-Saëns: A Life*. London: Chatto and Windus, 1999.

Régamey, Félix. *Japan in Art and Industry*. 1891. Translated by M. French-Sheldon and Eli Lemon Sheldon. New York: G. P. Putnam, 1893.

Rétrospective Mark Tobey. Paris: Musée des Arts Décoratifs, Palais du Louvre, 1961.

Revill, David, *Roaring Silence: John Cage, A Life*. London: Bloomsbury, 1992.

"Revue de Ventes de Février." *Le Figaro Artistique*, April 2, 1925, 394–95.

Rexroth, Kenneth. "Mark Tobey: Painter of the Humane Abstract." *Art News*, May 1951. Reprinted in *Bird in the Bush: Obvious Essays*, 168–76. New York: New Directions, 1959.

Riley, Maud. "Mark Tobey's White Writing." *Art Digest* 18, no. 13 (April 1, 1944): 19.

Ritter, George H. *Impressions of Japan*. New York: James Pott, 1904.

Robertson, W[alford] Graham. *Time Was: The Reminiscences of W. Graham Robertson.* London: Hamilton, 1933.

Rodman, Seldon. *Conversations with Artists.* New York: Capricorn, 1961.

Rosenbaum, Julia B. "Ordering the Social Sphere: Public Art and Boston's Bourgeoisie. In *The American Bourgeoisie: Distinction and Identity in the Nineteenth Century,* edited by Sven Beckert and Julia B. Rosenbaum, 193–208. London: Palgrave Macmillan, 2010.

Rosenberg, Harold. *The Anxious Object: Art Today and Its Audience.* New York: Horizon, 1964.

Rosenstone, Robert A. *Mirror in the Shrine: American Encounters with Meiji Japan.* Cambridge, MA: Harvard University Press, 1988.

Ross, Clifford, ed. *Abstract Expressionism: Creators and Critics.* New York: Harry N. Abrams, 1990.

Ross, Denman. Denman Ross Diaries (unpublished). Harvard Depository.

———. "Exhibition of Additions to the Ross Collection." *Museum of Fine Arts Bulletin* 2, no. 67 (December 1913): 75–76.

Ross, Nancy Wilson. *Farthest Reach: Oregon and Washington.* New York: Alfred A. Knopf, 1941.

———. *Take the Lightning.* New York: Harcourt Brace, 1940.

Rossetti, William Michael, ed. *Dante Gabriel Rossetti: His Family Letters.* Boston: Roberts Brothers, 1895.

———. *Rossetti Papers, 1862–1870.* London: Sands, 1903.

Rothenstein, William. *Men and Memories: A History of the Arts, 1872–1922.* New York: Tudor, n.d.

Rybczynski, Witold, and Laurie Olin, *Vizcaya: An American Villa and Its Makers.* Philadelphia: University of Pennsylvania Press, 2007.

Said, Edward W. *Orientalism.* New York: Random House, 1978.

Saint-Saëns, Camille. *École Buissonnière.* Paris: Editions Pierre Lafitte, 1913.

Saisselin, Rémy. *Bricabracomania: The Bourgeois and the Bibelot.* London: Thames and Hudson, 1985.

Salem Directory and City Register. Salem, MA: Henry Whipple, 1842.

Santayana, George. *The Last Puritan.* New York: Scribner, 1936.

———. *The Letters of George Santayana.* Edited by William G. Holzberger. 8 vols. Cambridge: MIT Press, 2003.

Scharf, Frederic A. *Art of Collecting: The Spaulding Brothers and Their Legacy.* Boston: MFA Publications, 2007.

Schmied, Wieland. *Tobey.* 1966. Translated by Margaret L. Kaplan. New York: Harry N. Abrams, n.d.

Schwabsky, Barry. "Disquieting and Enraptured." *The Nation,* April 20, 2009, 32–34.

Schwartz, William Leonard. *The Imaginative Interpretation of the Far East in Modern French Literature, 1800–1925*. Paris: Librairie Ancienne Honoré Champion, 1927.

———. "A Study of Amy Lowell's Far Eastern Verse." *Modern Language Notes* 43, no. 3 (March 1928): 145–52.

Screech, Timon. *Sex and the Floating World: Erotic Images in Japan 1700–1820*. Honolulu: University of Hawai'i Press, 1999.

Seattle Art Museum. *Mark Tobey: A Retrospective Exhibition from Northwest Collections*. N.p.: n.p., 1959.

———. *Tobey's 80: A Retrospective*. Seattle: University of Washington Press, 1970.

Sedgwick, Eve Kosofsky. *Epistemology of the Closet*. Berkeley: University of California Press, 1990.

———. "Shame, Theatricality, and Queer Performativity: Henry James's *The Art of the Novel*." 1993. Reprinted in *Gay Shame*, edited by David Halperin and Valerie Traub, 49–62. Chicago: University of Chicago Press, 2009.

Sedgwick, Eve Kosofsky, and Adam Frank, eds. *Shame and Its Sisters: A Silvan Tomkins Reader*. Durham, NC: Duke University Press, 1995.

Seitz, William C. *Abstract Expressionist Painting in America*. Cambridge, MA: Harvard University Press, 1983.

———. *Mark Tobey*. New York: Museum of Modern Art, 1962.

Shand-Tucci, Douglass. *The Art of Scandal: The Life and Times of Isabella Stewart Gardner*. New York: HarperCollins, 1997.

———. *Boston Bohemia, 1881–1900: Ralph Adams Cram; Life and Architecture*, vol. 1. Amherst: University of Massachusetts Press, 1995.

Sharf, Frederic Alan. *Art of Collecting: The Spaulding Brothers and Their Legacy*. Boston: MFA Publications, 2007.

Shimizu, Christine. "Les sources: l'estampe japonaise de l'ukiyo-e," Art, industrie et japonisme: le service Rousseau, Dossiers du Musée d'Orsay, vol. 20, 20-25. Paris: Editions de la Réunion des musées nationaux, 1988.

Silverman, Debora L. *Art Nouveau in Fin-de-Siècle France: Politics, Psychology, and Style*. Berkeley: University of California Press, 1989.

Silverman, Kenneth. *Begin Again: A Biography of John Cage*. Evanston, IL: Northwestern University Press, 2012.

Simpson, Caroline Chung. *An Absent Presence: Japanese Americans in Postwar American Culture, 1945–1960*. Durham, NC: Duke University Press, 2001.

Snodgrass, Judith. *Presenting Japanese Buddhism to the West: Orientalism, Occidentalism, and the Columbian Exposition*. Chapel Hill: University of North Carolina Press, 2003.

Snyder, Katherine V. *Bachelors, Manhood, and the Novel, 1850–1925*. Cambridge: Cambridge University Press, 1999.

Soane, John. *Description of the House and Museum on the North Side of Lincoln's Inn Fields.* London: James Moyes, 1830).

Soby, James Thrall. "Romantic Painting in America." In *Romantic Painting in America,* edited by James Thrall Soby and Dorothy C. Miller, 7–48. New York: Museum of Modern Art, 1943.

Sontag, Susan. "Notes on Camp." 1964. In *Against Interpretation,* 275–92. New York: Noonday, 1966.

Sox, David. *Bachelors of Art: Edward Perry Warren and the Lewes House Brotherhood.* London: Fourth Estate, 1991.

Spivak, Gayatri Chakravorty. *Other Asias.* Oxford: Blackwell, 2008.

Stair, Julian. "Re-Inventing the Wheel: The Origins of Studio Pottery." In *The Persistence of Craft: The Applied Arts Today,* edited by Paul Greenhalgh, 49–60. London: A & C Black, 2002.

Stanford Art Gallery. *Mark Tobey: Paintings from the Collection of Joyce and Arthur Dahl.* Palo Alto, CA: Department of Art and Architecture, Stanford University, 1967.

Stoddard, Charles Warren. "Tuckernuck," *The Ave Maria,* January 1904, 16–19, 107–11.

Strachey, Barbara, and Jayne Samuels, eds. *Mary Berenson: A Self-Portrait from Her Letters and Diaries.* London: V. Gallancz, 1983.

Strauss, David. *Percival Lowell: The Culture and Science of a Boston Brahmin.* Cambridge, MA: Harvard University Press, 2001.

Sullivan, Thomas Russell. *Passages from the Journal of Thomas Russell Sullivan.* Boston: Houghton Mifflin, 1917.

Suzuki, Daisetz T. *Essays in Zen Buddhism (First Series).* 1927. Reprint, London: Rider, 1949.

———. *Essays in Zen Buddhism (Third Series).* 1934. Reprint, London: Rider, 1953.

———. "Zen in the Modern World." *Japan Quarterly* 5, no. 4 (October 1958): 452–61.

Suzuki, Junji. "Le jardinier japonais de Robert de Montesquiou—ses evocations dans les milieux littéraires." *Cahiers Edmond et Jules de Goncourt* 18 (2011): 103–12.

Tachiki, Satoko Fujita. "Okakura Kakuzo (1862–1913) and Boston Brahmins." Ph.D. dissertation, University of Michigan, 1986.

Takami, David A. *Divided Destiny: A History of Japanese Americans in Seattle.* Seattle: University of Washington Press, 1999.

Tanizaki, Junchiro. *Some Prefer Nettles.* 1928. Translated by Edward S. Seidensticker. New York: Alfred A. Knopf, 1955.

Ten Painters of the Pacific Northwest. Utica, NY: Munson-Williams-Proctor Institute, 1947.

Thacker, Andrew. "Mad After Foreign Notions: Ezra Pound, Imagism and the Geography of the Orient." In *Geographies of Modernism: Literature, Cultures, Spaces,* edited by Peter Brooker and Andrew Thacker, 31–42. London: Routledge, 2005.

Tharp, Louise Hall. *Mrs. Jack.* Boston: Little, Brown, 1965.

Thompson, Juliet. *The Diary of Juliet Thompson with a Preface by Marzieh Gail.* Los Angeles: Kalimat, 1983. Full text online at http://bahai-library.com/thompson_diary.

Tobey, Mark. "The Dot and the Circle." *World Order* 2, no. 3 (Spring 1977): 39–42.

———. "Japanese Traditions and American Art," *College Art Journal* 18, no. 1 (Fall 1958): 20–24.

———. *Mark Tobey: The World of a Market.* Seattle: University of Washington Press, 1964.

———. "Reminiscence and Reverie." *Magazine of Art* 44, no. 8 (October 1951): 228–32.

K. T. [Kojiro Tomita]. "The William S. and John T. Spaulding Collection of Japanese Prints." *Bulletin of the Museum of Fine Arts* 20, no. 119 (June 1922): 31–35.

———. "The William S. and John T. Spaulding Collection of Japanese Prints." *Bulletin of the Museum of Fine Arts* 39, no. 235 (October 1941): 73.

Treat, John W. *Great Mirrors Shattered: Homosexuality, Orientalism, and Japan.* New York: Oxford University Press, 1999.

Trustees of the Museum of Fine Art. *Twenty-Sixth Annual Report for the Year Ending December 31, 1901.* Boston: Museum of Fine Arts, 1902.

Tsutakawa, George. "A Conversation on Life and Fountains." *Journal of Ethnic Studies* 4, no. 1 (Spring 1976): 5–36.

Twain, Mark. *A Tramp Abroad.* 2 vols. Leipzig, Germany: Bernhard Tauchnitz, 1880.

Tweed, Thomas A. *The American Encounter with Buddhism, 1844–1912: Victorian Culture and the Limits of Dissent.* 2nd ed. Chapel Hill: University of North Carolina Press, 2000.

Usiui, Emiko K. "National Identity, the Asiatic Ideal, and the Artist: Okakura Presents the Nihon Bijutsuin in Boston." In *Okakura Tenshin and the Museum of Fine Arts Boston,* 169–75.

Van Rij, Jan. *Madame Butterfly: Japonisme, Puccini, and the Search for the Real Cho-Cho-San.* Berkeley: Stone Bridge Press, 2001.

Vollard, Ambroise. *Paul Cézanne.* Paris: Ambroise Vollard, 1914.

Waal, Edmund de. "Altogether Elsewhere: The Figuring of Ethnicity." In *The Persistence of Craft: The Applied Arts Today,* edited by Paul Greenhalgh, 185–94. London: A & C Black, 2002.

———. *The Hare with Amber Eyes: A Family's Century of Art and Loss.* New York: Farrar, Straus and Giroux, 2010.

———. "Homo Orientalis: Bernard Leach and the Image of the Japanese Craftsman," *Journal of Design History* 10, no. 4 (1997): 355–61.

Waley, Arthur. *A Hundred and Seventy Chinese Poems.* London: Constable, 1918.

Warner, Michael. "Pleasures and Dangers of Shame." In *Gay Shame,* edited by David Halperin and Valerie Traub, 283–96. Chicago: University of Chicago Press, 2009.

Warner, Pamela J. "Compare and Contrast: Rhetorical Strategies in Edmond de Goncourt's Japonisme." *Nineteenth Century Art Worldwide* 8, no. 1 (Spring 2009).

www.19thc-artworldwide.org/index.php/spring09/61-compare-and-contrast
-rhetorical-strategies-in-edmond-de-goncourts-japonisme.

———. "Word and Image in the Art Criticism of the Goncourt Brothers." Ph.D. dissertation, University of Delaware, 2005.

Watanabe, Toshio. *High Victorian Japonisme*. New York: Peter Lang, 1991.

Watson, Gilbert. *Three Rolling Stones in Japan*. London: Edward Arnold, 1904.

Watt, Alexander. "Paris Commentary." *Studio* 162, no. 824 (December 1961): 222–24, 235.

Watts, Alan. "Beat Zen, Square Zen, and Zen." *Chicago Review* 12, no. 2 (Summer 1958): 3–11.

Wayman, Dorothy G. *Edward Sylvester Morse: A Biography*. Cambridge, MA: Harvard University Press, 1942.

Wechsler, Jeffrey. *Abstract Expressionism, Other Dimensions: An Introduction to Small Scale Painterly Abstraction in America, 1940–1965*. New Brunswick, NJ: Jane Voorhees Zimmerli Art Museum, Rutgers University, 1989.

W. E. H. [William Ernest Henley]. "Pictures of Japan." [Review of Louis Gonse, *L'art japonais*.] *Magazine of Art* 7 (September 1884): 199–206.

Wehr, Wesley. *The Accidental Collector: Art, Fossils, and Friendships*. Seattle: University of Washington Press, 2004.

———. "Conversations with Mark Tobey," *Northwest Arts* 5, no. 1 (1979).

Weinberg, Jonathan. *Speaking for Vice: Homosexuality in the Art of Charles Demuth, Marsden Hartley, and the First American Avant-Garde*. New Haven: Yale University Press, 1993.

Weisberg, Gabriel P. "The Creation of Japonisme." In *The Origins of L'Art Nouveau: The Bing Empire*, edited by Gabriel P. Weisberg, Edwin Becker, and Evelyne Possémé, 50–71. Ithaca, NY: Cornell University Press, 2004.

———. *The Independent Critic: Philippe Burty and the Visual Arts of Mid-Nineteenth Century France*. New York: Peter Lang, 1993.

Weisberg, Gabriel P., Phillip Dennis Cate, Gerald Needham, Martin Eidelberg, and William R. Johnston. *Japonisme: Japanese Influence on French Art, 1854–1910*. Cleveland: Cleveland Museum of Art, 1975.

Westgeest, Helen. *Zen in the Fifties*. Zwolle, Netherlands: Waanders Uitgevers, 1996.

Weston, Victoria. *Japanese Painting and National Identity: Okakura Tenshin and His Circle*. Ann Arbor: Center for Japanese Studies, University of Michigan, 2004.

Whistler, James Abbott McNeill. *The Gentle Art of Making Enemies*. London: n.p., n.d. [1890].

Whitehill, Walter Muir. *Museum of Fine Arts, Boston: A Centennial History*. 2 vols. Cambridge, MA: Harvard University Press, 1970.

———. "The Vicissitudes of Bacchante in Boston." *New England Quarterly* 27, no. 4 (December 1954): 435–54.

Wight, Frederick W. *Morris Graves*. Berkeley: University of California Press, 1956.

Wilde, Oscar. *The Complete Works of Oscar Wilde*. Edited by Robert Ross. 10 vols. [unnumbered]. Boston: Wyman-Fogg, n.d.

Williams, Raymond. "The Bloomsbury Fraction." In *Culture and Materialism: Selected Essays*, 148–69. London: Verso, 1980.

Williams, Roger L. *The Horror of Life*. Chicago: University of Chicago Press, 1980.

Winckler, Bahíyyih Randall, and M. R. Garis, *William Henry Randall: Disciple of `Abdu'l-Bahá*. Oxford: One World, 1996.

Winther-Tamaki, Bert. *Art in the Encounter of Nations: Japanese and American Artists in the Early Postwar Years*. Honolulu: University of Hawai'i Press, 2001.

——. "The Asian Dimensions of Postwar Abstract Art: Calligraphy and Metaphysics." In Alexandra Munroe, *The Third Mind*, 145–57.

——. "Mark Tobey: White Writing for a Janus-Faced America." *Word & Image* 13, no. 1 (1997), 77–91.

Yixuan. *The Record of Linji*. Edited by Thomas Yuho Kirchner. Honolulu: University of Hawai'i Press, 2008.

Yokoyama, Toshio. *Japan in the Victorian Mind: A Study of Stereotyped Images of a Nation 1850–80*. London: Macmillan, 1987.

Young, Michael. *The Elmhirsts of Dartington*. 2nd ed. Totnes, Devon: The Dartington Hall Trust, 1996.

Zack, Naomi. *Bachelors of Science: Seventeenth-Century Identity, Then and Now*. Philadelphia: Temple University Press, 1996.

Zatlin, Linda Gertner. *Beardsley, Japonisme, and the Perversion of the Victorian Ideal*. Cambridge: Cambridge University Press, 1997.

Zola, Émile, "Edmond de Goncourt." *Figaro*, March 15, 1881. Reprinted in *Une campagne, 1880–81*, 205–17. Paris: G. Charpentier, 1882.

INDEX

165–67, 352n179, 352–53n181; and
La Farge, 166; at Museum of Fine
Arts, 165–70, 182, 353n187
Orientalism, 10–11, 15, 20, 284; as
defined by Said, 19, 25–26, 36, 257,
292–93, 301–2n59, 302n60. *See also*
reverse Orientalism
Osborn, Sherard, 13–14

Pach, Walter, 173
Park, Josephine, 143
Pasteur, Louis, 149
Patterson, David, 258
Peabody, Elizabeth Palmer, 150
Perry, Matthew, 11, 117, 120, 199
Persigny, Albine Maria Napoléone Ney
de La Moskowa, Duchess de, 7,
102, 104
Pfeiffer, Sachiko, 278
physique magazines, 158–59
Pissarro, Camille, 69
Pollock, Jackson, 267–69, 272, 281, 283,
285
Pop Art, 79
pornography. See *shunga*
Potter, John Briggs, 192–93
Prichard, Matthew, 168, 192–93
primitivism, 10–11, 38, 203, 292, 343n63;
Tobey's, 205, 224, 250
prints, Japanese, 26, 127, 135; Beardsley's
use of, 34; Goncourts on, 44, 46, 49;
Impressionists' use of, 33; Japanese
collectors of, 21; Loti on, 33–34; at
Museum of Fine Arts, Boston, 136–
37; Occidental admiration of, 26–27;
Occidental collectors of, 39, 54, 136–
37; Occidental discovery of, 38–39,
44, 50–56, 59; postwar, 279; Proust's

use of, 33–34; van Gogh's use of, 8.
See also Hokusai, Katsushika; *ukiyo-e*
prints, *japoniste*, 66, figs. 1.4, 1.5
Proust, Marcel, 18, 32–34, 105, 113
Puccini, Giacomo: *Madama Butterfly*, 64

Quaintance, George, 158–59
queer theory, 4, 6, 158–59, 222–23,
293–94

race, 159; Japanese as Aryan, 13;
Japanese as assimilable, 204, 277–78,
285, 294, 299–300n37; Japanese
as unconquered, 169; Japanese as
un-evolved, 134, 154, 157; segregation
based on, 216
Rafaelli, Jean-François, 85, fig. 1.13
Régamey, Félix, 13, 26, 106–7
Regionalism, 261–62
reverse Orientalism, 11, 19–20, 291,
298n24
Rexroth, Kenneth, 210
Richelieu, Marie Alice, Duchesse de, 32
Roosevelt, Theodore, 137, 162–63
Rops, Félicien, 50
Rosenberg, Harold, 283
Rosny, Léon de, 91
Ross, Denman, 194, 264; as collector,
185; in Japan, 11, 182–83; as teacher,
182, 184–85
Ross, Matthias Denman, 182
Ross, Nancy Wilson, 7, 252–53, 257–58;
on Seattle, 266, 270
Rossetti, Dante Gabriel, 60–61
Rossetti, William Michael, 59–61
Rothenstein, William, 34
Rousseau, Théodore, 39
Rousseay, Philippe, 42